SCHEDARIO
BAUMGARTEN

DESCRIZIONE DIPLOMATICA
DI BOLLE E BREVI ORIGINALI
DA INNOCENZO III A PIO IX

Riproduzione anastatica
con introduzione e indici
a cura di
GIULIO BATTELLI

II

ALESSANDRO IV - BENEDETTO XI
(An. 1254-1304)

CITTA' DEL VATICANO
PRESSO L'ARCHIVIO SEGRETO VATICANO
1966

Imprimatur·

† Fr. Petrus Canisius van Lierde, Vic. Gen.
E Vicariatu Civit. Vatic.

die 21 decembris 1966

SOMMARIO

BOLLE DA ALESSANDRO IV A BENEDETTO XI

BOLLE
DA ALESSANDRO IV A BENEDETTO XI
(An. 1254-1304)

Marseille Archives Départem.
H. P. A. 5
P. 15602 1254 Decembr. 22
Alexander IIII universis arch
epis et epis ac abbatibus, prio
ribus, decanis, archidiaconis,
archipresbiteris et aliis ecclesia
rum prelatis et ceteris perso
nis ecclesiasticis tam secula
ribus quam regularibus cuius
cumque ordinis vel professio
nis existunt
Nec insolitum est
Neapoli XI Kl. Jan. a° 1°
Bulle an Hanf
Rand oben Mitte ogr ყt ჳ

Neapoli Curie Eccles. Vol. 3°
P. 15602 1254 Decembris 22
Alexander IIII univ. archepis
et epis ac dil. fil. abb. prior. dec.
archid. archipresb. et aliis eccl
sirum prelatis et ceteris perso
nis ecclisticis tam secular. quam
regul. cuiuscumque ordinis vel
professionis existunt
Nec insolitum est
Neapoli XI Kl. Jan. a° 1°
Bulle und Hanf fehlen
Plica Abgeschnitten
Rand oben Mitte multiplicetur

Instr. mon. F. Dom. c. I 1254 Dec. 22
Non insolitum est P. 15602
Bulle fehlt. Hanfschnur
In plica rechts: Jac Ro
Sub plica links: .ჳ
 a. g.

A tergo : predicatorum

Bayer. Haupt. Staatsarchiv
Bisthum Chiemsee fasc. 1
P. vacat 1254 Decembris 24
Alexander IIII (Gitterschrift dünn, nie
drig). . Epo Clunen
 Hijs que ad
Neapoli VIII Kl. Januarij anno
primo

Bulle fehlt. Seide erhalten
 Ecke oben links : Rჳ
Ecke oben rechts : a
A tergo Mitte schlank

 ჳ XVI capt anno primo
Kleine unruhige
Schrift, eckig.

Firenze, Vallombrosa
P. 15612 1254 Decembris 28
Alexander III. . . abbi et con-
ventui mon. vallis Vmbrose
ad Rom. ecclesiam nullo
medio pertinentis Reg. Vat. ohne
Aplice sedis benignitas Plutte
Neapoli V Kl. Ian. a° 10
Bulle fehlt, Seide erhalten
In plica rechts
Sub pl. links ..
auf Umbug
 Ecke oben rechts R
Rund oben Mitte Rx ala). I dentur Conserv.
A tergo oben Mitte schmal
gross schön Registres cap. 16
Oberste Zeile unbenutzt
Sub plica unliniirt
nichtgrosse schwungvolle
schöne Schrift
 XIII capl anno primo

Archives Nationales Paris
L 249 n. 1 1255 Ianuarii 12
Br. 32,7 hoch 23.4 Plica 2.5
oberer Rand 6.2 links 1.5
rechts 1.5
 Alexander III (Marius culse)
Archiepis et Epis et dil filio ar-
chidiaconis ad quos littere iste
pervenerint
 Cum dilecti filij
Dat Neapoli V Id Ianuar a° 10

Bulle und Seide ausgerissen
 In plica rechts : Iac
Ecke oben rechts a
 A tergo oben Mitte grosses +
Mitte kleine fette Schrift, mit gestreckten
Ligaturen,

Erste Linie für Sittenschrift und
 untere Oberlängen
P. vacat

Bayer. Haupt. Staatsarchiv
Berchtesgaden n. 49
P. 15633 1255 Ianuarii 12
Alexander III. . preposito ecclie
sci Petri de Berchtesgaden ordinis
sci Augustini . Salzburgen. dioc.
 Cum in prelatorum
Neapoli V Id. Ianuarii Anno Primo

Bulle an feiner Seide
In plica rechts : Angelus R
Sub plica links : S
 Rund oben links : Rx drum
.. drum tergo drum : mittlere
domino
A tergo Mitte schlank ohne Kappe
 XXXIII
 Capl anno primo

Bayer. Haupt. Staatsarchiv
Herrenchiemsee Fasc. 5
P. 15635^x 1255 Ianuarii 12
Alexander III (roman. Mri.) . . Re-
posito et Capitulo ecclie Kimen-
 Iustis petentium desideriis
Neapoli V Id. Ianuarii Anno
 Primo

Bulle an feiner Seide
 Sub plica links : XVI
Ecke oben rechts : a und Io
 Breite 64.9 Höhe 57.4
 Plica 3.5
Eines der wenigen grösseren Perga-
mente, die nicht für ein feierli-
ches Privileg gedient haben.

2279

Archives Nationales Paris

L 249 n. 2 1255 Januarii 13

Br. 30.4 hoch 22.7 Plica 3.7
 oberer Rand 5.4 links 0.8
rechts 0.8
 Alexander IIII (Gitterschrift,
Initiale verziert) . . magro et
Fratribus Hospitalis Jerlimitan
 Justis petentium desideriis
dat Neapoli Id Januar a° 10

Bulle und Seide ausgerissen
 In plica rechts : R. O.
A tergo oben mitte kleine grosses +

Kleine Regeln. Schrift mit gestreck.
Ligaturen, mit 3 verzierten Satzanfängen
 In 1. Zeile 1 ver. Buchstabe

Ohne erste freie Linie

 P. vacat

2280

Marseille Archives Départem.
H. O. m. 19
P. — 1255 Januar 13
Alexander IIII . . . magro et fribus
Hospitalis Jerosolimitan.
 Justis petentium desideriis
Neapoli W. Jan. a° 10
Bulle und Seide ausgerissen
In plica rechts Jo. 5.
 Sub plica links . .
Rand oben mitte car
Ecke oben rechts JS
Erste Zeile frei
Gestreckte Ligaturen
A tergo langes Regest ausgestri-
chen

2281

Archives Nationales Paris
L 249 n. 3 1255 Januarii 15

Br. 37, hoch 25.9 Plica 2.9
 oberer Rand 5.5 links 1.3
rechts 1.6
 Alexander IIII (Gitterschrift Ini-
tiale verziert) Archiepis et Epis et
dil. filijs Abbatibus Prioribus Deca
nis Archidiaconis ; alijs ecclas
Prelatis ad quos littere iste perve-
nerint
 Si diligenter attenditis
dat Neapoli XVIII Kl Februarij a° 10

Bulle und Seide ausgerissen
 Ecke oben rechts : a
A tergo oben mitte grosses +
 P. vacat
Kleine Regeln. Schrift mit gestreckten
Ligaturen, mit 6 verzierten Satzan-
fängen. In 1. Zeile 1 ver. Buchstabe

Papstnamen im Text in Gitterschrift

Erste Linie für Gitterschrift und Oberlängen

2282

Reg. 62 - 63 1255 Jan. 16

Zwei Bullen für Berthold
von Hohenburg

Reg. 226 - 236 Bullen für
die Marchiones de Hohen
burg. meistens mit
grossem Datum
Hohenberg III cap. 356 pag. 324
1255 Jan. 16 , - ap 357. pag.
325. 1255 Jan. 16

Archives Nationales Paris

L 249 n. 4 1255 Januarii 16

Br. 32.5 hoch 24.8 Plica 3.8
oberer Rand 5.5 links 1.2
rechts 1.5

Alexander IIII (Gitterschrift,
Initiale verziert) Archiepis et Epis
et dil. filiis Abbatibus Prioribus
Archidiaconis Prepositis Archipbris
et aliis ecclie Prelatis ad quos
littere iste pervenerint
Pervenit ad nos
Dat neapoli XVI XVII Kl Febr a° 1°

Bulle und Seide ausgerissen
In plica rechts: a. s.
A tergo oben Mitte: grosses +

Kleine regelm. Schrift, mit gestr.
Ligaturen, mit drei betonten Sch
anfängen. In 1. Zeile 1 verz. Buchstabe

Papstname im Text in Gitterschrift

P. vacat

R. Sigillator

Archives Nationales Paris

L 249 n. 5 1255 Januarii 17

Br. 23.4 hoch 24.9 Plica 2.9
oberer Rand 5.8 links 1.4
rechts 1.4

Alexander IIII (Gitterschrift. Ini
tiale verziert). . Archiepo Rotho
magen et Suffraganeis eius ac
dilectis filiis Abbatibus Prioribus
Prepositis decanis Archidiaconis
et aliis ecclie Prelatis per Rotho
magen provinciam constitutis
Non absque dolore
Dat neapoli XVI Kl febr a° 1°

Bulle fehlt, Seide erhalten
In plica rechts: . P. B.
A tergo oben Mitte: R. Sigillator
Cis H G

Kleine fette regelm. Schrift ohne
jede gestreckte Ligatur, mit 2 ver
zierten Sch anfängen
In 1. Zeile 1 verz. Buchstabe
Erste Linie für Gitterschrift.

P. vacat.

Archives Nationales Paris

L 249 n. 6 1255 Januarii 18

Br. 19.7 hoch 14.9 Plica 2.4
oberer Rand 2.8 links 1.1
rechts 1.

Alexander IIII . . Magro ordinis fra
trum Predicatorum
Devotionis tue precibus
Dat neapoli XV Kl Februar a° 1°

Bulle und Hanf fehlen
In plica rechts: J. Pad
A tergo oben Mitte: Predicator

Kleine fette regelmäßige Schrift

mit einem betonten Buchstaben

Erste Linie für Oberlängen

P. vacat

R. Sigillator

Archives Nationales Paris

L 249 n. 7 1255 Januarii 20

Br. 30.7 hoch 27.5 Plica 2.7
oberer Rand 4.9 links 1.2
rechts 1.2

Alexander IIII (Gitterschrift,
Initiale verziert). Archiepo Se
nonen et eius Suffraganeis ac
dil. filiis Abbatibus Prioribus Pre
positis decanis Archidiaconis
et aliis ecclie prelatis per Senonen
provinciam constitutis
Non absque dolore
Dat neapoli XIII Kl Febr a° 1°
P. vacat
Bulle fehlt, Seide erhalten
In plica rechts: . P. B.
Sub plica links: . .
Ecke oben rechts: a
A tergo Ecke oben links: Y
oben Mitte: R. Sigillator Cit
Fette kleine Schrift, mit mehreren gestr.
Ligaturen mit 1 betonten Schanfang
In 1. Zeile 1 verz. Buchstabe
Erste Linie für Gitterschrift und Oberlängen

2287

Bayer. Haupt- Staatsarchiv
Würzburg n. 3475

P. 15646 1255 Januarii 21

Alexander IIII (dünne, weite, schöne
Gitterschrift) .. Magro et universis
prioribus ordinis Predicatorum
 Ordinis vestri generosa
Neapoli XII Kl. februarij a° Primo

Bulle an Seide
In plica rechts : . Sm .

Leitenlinien, erste Zeile frei

Etwas gebrochene regelmässige Schrift

2288

Marseille, Archives Départem.
H. P. A. 5
P. 15646 1255 Jan. 21

Alexander IIII .. magro et uni-
versis prioribus or. Predicat.
 Ordinis vestri generosa
Neapoli XII Kl. febr. a° 1°
Bulle an Seide
In plica rechts cat rō
Erste Zeile frei
Gestreckte Ligaturen
Schmale Leitenränder

2289

Archives Nationales Paris
L 249 n. 8 1255 Januarii 21

Br. 27.9 hoch 21. Plica 3.
 oberer Rand 5.3 links 1.
rechts 1. 2
 Alexander IIII Archiepis et Epis
ac dil. filijs Abbatibus, prioribus Deca-
nis Archidiaconis et alijs ecclesijs
Prelatis ad quos littere iste pervenerint
 Deum in sanctis
dat neapoli XII Kl Februar a° 1°

Bulle und Brief fehlen
 In plica rechts : . Æ. ar.
Ecke oben rechts : a
 a tergo oben mitte : Predicatory

Kleine eng zusammenhängende Schrift

Erste Linie für Oberlängen

Ohne jeden betonten Buchstaben

 P. 15647

2290

Instr. mon. F. Dom. C. 156 1255 Jan. 21
 P. 15657 aul Int. Jan. 26
Ne pro dilatione
Bulle an Seidenfäden
In plica rechts : pro do M unr tp
a tergo : predicatorum

Archivio di Stato Milano
Bolle e Brevi
 Imbulliertes Original
P. — 1255 Ianuarii 26
Alexander IIII dil. in xpo filiab.
. . Abbatissæ et Conv. mon. S. Joh
nis de Pipo Cisto. Cremonen. dioc.
Religionis vestræ meretur
Neapoli VII Kl. febr. a° 1°
Ohne plica
Randoben Suppl. cor
ascultetur tenor.
Attende tenorem quod inceptus . . .
R a
Das inserierte Document ist unter
ganz unrichtig transcribirt, da der
Minutant bei der Abschrift vie-
le fehler machte, die in die Rein-
schrift übergiengen. die hev-

. . . ausfertigung erfolgte noch
. . Kl. Iunii a° 3°
1257 Aprilis 29

2292

Firenze, Camaldoli
P. 15655 1255 Ianuarii 28
Alexander IIII . . præposito eccle-
siæ Aretin.
 Sicut dilecti filii
Neapoli V Kl. febr . a° 1°
 Bulle und Buch fehlen
In plica rechts I
 Oberste Linie unterbricht
Eckige, fettige Schrift.

2293

Napoli Curia Eccles. Vol. 3°
P. 15657 1255 Ianuarii 28
Alexander IIII . . guardino et
fratribus Ominn. S. Angeli de Lom-
bardis
Cum sicut lecta
Neapoli V Kl. febr. a° 1°
Bulle und Seide fehlen
plica abgeschnitten

Archives Nationales Paris

L249 u9 1255 Januarii 31

Br. 28. hoch 19,5 Plica 3,5
 oberer Rand 4,2 links 1,2
rechts 1,2
 Alexander IIII (Gitterschrift, dui
viele variiert) . . . Magistro et uni
versis fratribus ordinis Predicatorum·
 Ut ea que
Dat Neapoli ☩ Kl februar. a° 1°

Bulle und Seide fehlen
 In plica links :. B. S. T.
 A tergo oben mitte : Predicator.

Feste kleine Schrift, mit gestreckten
Ligaturen, mit 3 verz. Schäuflingen

Im 1. Teile 1 verz Buchstabe

Erste Linie für Gitterschrift und Ober
 längen

 P. 15661

Archivio di Stato Milano
Bolle e Brevi
 P. 15668 1255 februarii 3
Alexander IIII univ. archepis
epis ac dil filiis abbibus prior.
archidiac. decan. prepos. et aliis
ecclarum et religiosorum ordi
nis cuiuscumque prelatis.
 Magna magnalia de
Neapoli III non. febr. a° 1°
 Schöne Bulle an Seide
 In plica rechts pro deo V G
 P.
 j
 Sub plica rechts [] en
 Rand oben mitte ascultet

Instr. mon. F. dom. c. 32 1255 febr. 3
 P. 15669
Sanctis desideriis et
Bulle an Hanfschnur
In plica rechts : pro deo W d
A tergo : predicatorum

Instr. mon. F. dom. c. 124 1255 Febr. 3
 P. 15668
Alex IIII univ. archepis et epis ac abba
tibus etc. prelatis.
Magna magnalia de
Neapoli III non. Februarii a° 1°
Bulle fehlt. Seidenfäden.
Sub plica links : T
 a. g.

Oben Rand links :
 fiat sub nova Dat. I.
grosse Rasuren.
A tergo : predicatorum

2298

Public Reccord Office London
Papal Bulls bundle 1 n. 35
Reg 226 Bulliertes Transcriptum
P. 15677 1255 Februarii 9

Hoc est transcriptum cuiusdam pri-
vilegii ... concessi Bertoldo et Od-
doni ac Lodoico fratribus marchioni-
bus de Hohenburch (halbe Zeile frei,
dann neue Zeile) Alex. IIII etc fide-
libus nostris. Clemens semper et
Dat. Neapoli per mandatum Guillermi
magistri scolarum Parmen. SRE vice-
cancellarii V id. febr. etc. a° primo
Bulla Alex. IIII an Hanf
 Registre cap. 226
 Rodenberg III 337 cap. 373
Reg Vat hat Lodoxico
 Odoni

2299

Public Reccord Office London
Papal Bulls bundle 1 n. 36
 Bulliertes Transcriptum
P 15678 1255 Februarii 10

Hoc est transcriptum - concessi
nob. viris Bertoldo, Oddoni et Lodoy-
co fratribus marchionibus de Hohenberg
Alexander (IIII) etc. fidelibus nostris
 Decet et expedit
Dat Neapoli IIII id febr. etc dompni
Alex. pp. IIII a° I°
Bulla Alex. IIII an Hanf
sub plica links
 Registres cap. 235
 Rodenberg III 338 cap. 374

2300

Bayer. Haupt. Staatsarchiv
 Würzburg N. 44 61
P. 15685ᵃ 1255 Februarii 12

Alexander (...) ver. romani. Mai.) IIII e.
s. s. dei fil. in xpo filiabus ... Abbatissa
Monasterii see Marie de Celi porta eius-
que sororibus tam pres. quam futuris
Regul. ... in profess IN PPM
 Religiosam vitam eligentibus
pacis invenerunt AMEN amen amen

R. Ego Alexander cath. ecclie ep. M.
2 presb. 2 epi 4 diaconi
Dat. Neapoli per manum Guitte Magriscoli
... Parmen sancte Roman. ecclie viceca-
cellarii V id. febr. Ind. XIII Inc. dominice
anno M. CC LIIII pontf. vero domni
ALEXANDRI pp. IIII anno primo
 Bulle an Seide

Kleine schöne Gitterschrift. Fünf f und
s dreistöckige Oberlängen; die anderen
nudelgross. Nudellängen klein.
für die grossen Oberlängen ist Linie
gezogen, für die mittleren nicht.
Je zwei Randlinien
Runde schöne Schrift.

2301

Public Record Office London
Papal Bulls bundle 1 n 29
 Bulliertes Transcriptum
P. 15693 1255 Februarii 15
Hoc est transcriptum ... concessi nobi-
libus viris B. Oddon et Lodoyco
fratribus marchionibus de Hohenberde
Alexander eps s. s. Dei dil. filiis
nob. viris ut supra fidelibus nostris.
Eximia devotionis et
Dat. Neapoli XV kel. Martii ind. XIII
Inc. Dominice anno 1254
pont. vero dompni Al. pp. IIII
anno primo
 Bulla Alexandri IIII in canappo
Sub plica links
 Registres cap. 236
 Reg. Vat hat Odoni
 Lodoico
Rodenberg III 339 cap. 375
 Dat. ut supra gibt Februarii 15

2302

Public Record Office London
Papal Bulls bundle 1 n. 30
 Bulliertes Transcriptum
 P 15691 1255 Februarii 15
Hoc est transcriptum etc. nob. viris
B. Oddoni et Lodoyco fratribus
marchionibus de Hohemburch.
Alexander B. Oddoni etc. fide-
libus suis.
 Nos cupientes indempnitati
Neapoli XV kl. Martii ind. XIII
Inc. Dominice anno 1254 pont.
vero domni Alexandri pp. IIIJ a° 1°
Bulle Alex. IIIJ an Hanf
 In plica rechts Ja Nar.
 Photo

2303

Public Record Office London
Papal Bulls bundle 1 n 34
 Bulliertes Transcriptum
 P. 15692 1255 Februarii 15
Hoc est transcriptum ... concessi
nob. viris Bertoldo, Oddoni ac
Lodoyco fratribus marchionibus
de Hohemburch. Alexander IIIJ
etc fidelibus nostris
 Quia Manfredus princeps
Dat. Neapoli XV kl. Martii etc. a°
primo
 Bulla Alex. IIIJ an Hanf
Sehr zerstört
 Registres cap. 228
 Reg. Vat. hat Lodoico
 Rodenberg III 343 cap. 380

2304

Marseille Archives départem.
H. P.Q. 5
P. 15699 1255 februarii 22
Alexander IIIJ universis fratri-
bus ordinis Predicatorum
Cum ... magister et
Neapoli VIII kl. martii a° 1°
Bulle und Seide fehlen
In plica rechts G. āt
Gestreckte Ligatuur
Schöne Schrift.

2305

Instr. mon. F. Dom. c. 64 1255 febr. 22
Cum magister et P. 15699
Bulle an Seidenschnur
A terço : predicatorum

Graz Landesarchiv n. 693ª.

P. — 1255 februarii 25

Alexander IIII dil. in xpo filia-
bus .. priorisse mon. Sce Marie
in pede montis Radelach eiusque
etc. in ppm

Religiosam vitam eligentibus
Amen A . Amen.

R. Ego Alexander catholice
 ecclie Ep ss M

2 presb. 2 epi 2 diac.

Dat. neapoli p. m. Guillermi
magri scolarum Parmen. SRE
vice. V kl. martii ind. XIII In-
carnac. aº M. CC. LIIII pont. vero
domni ALEX pp. IIII aº primo

Latein Bulle an Seide
Ecke oben rechts a po ?

Archivio di Stato Milano
Bolle e Brevi Vicennaell.
Nachbildung 1255 februarii 27

Alexander IIII dil in xps filia bi,
Abbatisse mon. Theodotis Rpienz
eiusque sororibus etc. in ppm

Religiosam vitam eligentibus

R. Ego Alex. etc. M.

2 presb. 2 epi 4 diac.

Neapoli p. m. Guillermi mag.
Scolarum Parmen. SRE vice
canc. IIII kl. martii aº 1º

P. 15707 *

Cautiones

Archives Nationales Paris
L 249 n. 10 1255 Martii 6

Br. 30. hoch 21. Plica 2,5
 oberer Rand 4.6 links 1.5
rechts 1.4

Alexander IIII (Gitterschrift, Ini-
tiale verziert) . . Magro et fratri-
bus Hospitalis Jerlimitan
 Cum a nobis
Dat Neapoli II non Martij aº 1º

Bulle an Seide
 In plica rechts : Bonosf
Sub plica links : ?
 Ecke oben rechts : po
A tergo Ecke oben links : y
 " oben Mitte grosses +
 " Mitte : de Carmanico ... pour
.. Magr etc
Angelerius pour impetrat fiat cautio
Johanni de Castro clerico pour ...
Archiepo Nicosien pro eodem Archiepo
 Item fiat cautio Johi de Sto Sergio
procur principis Antiochen pro eodem
principe P. vacat

Item fiat cautio Alberto can. Sti Petri
.. Florentin pro comite Joppen s
dno Ramco ..
Alles durchstrichen

Feste kleine Schrift , mit gestreckten
dichstaben , mit vier variierten Seite
Anfängen .
 In 1. Zeile 1 verzierter Buchstabe

Erste Linie für Gitterschrift

2309

Archives Nationales Paris

L 249 u. 11 <u>1255 Martii 11</u>

Br. 56.5 hoch 74.9 Plica 3.5
 oberer Rand 7.6 links 2.4
rechts 2.3
 Alexander IIII (Gitterschrift, Ini-
tiale verziert) Archiepis et epis ac
dil filiis abbatibus Prioribus
Decanis Archidiaconis Archipbris
et alijs ecdiaz Prelatis ad quos
littere iste pervenerint
 Cum dilectis filijs
Dat Neapoli V jd Martij a° 1°

Bulle an Seide
 In Plica rechts: Bonifac?
A tergo oben Mitte grosses †

Fette eilige Schrift mit gestreckten Liga-
turen, mit S° verzierter Schaufigur
 In 1. Zeile 1 verz. Buchstabe

Erste Linie für Gitterschrift

<u>P. vacat</u>

2310 (recto)

Archives Nationales Paris

L 249 u. 12 <u>1255 Martii 15</u>

Br. 62.2 hoch 74.5 Plica 4.7
 oberer Rand 8.7 links 4.4
rechts 3.9
 Alexander IIII (Minusculae, dann
Gitterschrift) ... dilis dil. Filijs Magro
et Fratribus Hospitali Jerlosmitan
tam presentibus ... IN PPM
 Dis Dilectis uns H in Hospitalis (Maz)
 Xpiane fidei religio
inveniunt AMEN a —c AMEN

R ? ☧ Ego Alexander catholico M
 ecclie eps

 2 preb. 2 epi 5 diac

 Dat Neapoli per manum Guil-
lermi Magriscolarum Parmen sce Ro-
mane ecclie Viecancellarij jd Martij
Indict XIII Incarnationis dnice Anno
M CC L VII Pontificatus vero domni
ALEXANDRI pp IIII anno primo

 Bulle an feiner Seide P. vacat verte

<u>P. vacat</u>

2310 (verso)

In plica rechts: Jo. by
A tergo oben Mitte: FR Barthol
Papstnamen im Text in Gitterschrift
Capitelanfänge mit verz. Buchstaben
Vergl. Von der Apost. Kanzlei, pag. 77.

2311

Archives Nationales Paris

L 249 u. 13 1255 Martii 18

Br. 29.4 hoch 25.4 Plica 2.5
 oberer Rand 5.6 links 1.3
rechts 1.4
 Alexander IIII (Gitterschrift, Ini-
tiale verziert) . . . Abbati Cistercij
ejusque coabbatibus ? Conventibus
vniversis Cisterciien ordinis
 Intimantibus nobis accepimus
Dat Neapoli XV kl Aprilis a° 1°

Bulle und Seide fehlen
 In plica rechts: P. B.
A tergo oben Mitte: †
 Anselmus
Fette klare Schrift †
mit gestreckten Ligaturen, mit der
verzierten Schaufigur
 In 1. Zeile 1 verz. Buchstabe

Ohne freie erste Linie

<u>P. 15753</u>

2312

Toulouse, archives départem.
H. 23

P. — 1255 Martii 21

Alexander IIII archiepis et epis et
abbat. prior. decanis archidiac
et aliis eccles. prelatis ad quos lit.
tere iste pervenerint
 Si discrimina que
Neapoli XII kl. Apr. a° 1°
Bulle an Seide
In plica rechts B. p m

Erste Zeile frei
Seitenlinien

2313

Instr. misc. 1250–1875 cap. 4

P. 15765 1255 Martii 25

Alex. IIII ad certitudinem presenti
um et memoriam futurorum
Quia nobilis vir
Athm neapoli VIII bal. Apilis in
die videlicet Cene domini, ponti
ficatus nostri a° primo
Seide und Bulle fehlen
In plica rechts : vt p

Gegen Manfredus princeps Taren
tinus

Scriptor : Ubertus de Placentia
 1252 octobris 31 cap. 6057

2314

Joh. Cart. Toletanus

Archives Nationales Paris
L249 n. 14 1255 Martii 30
Br. 35. hoch 25. Plica 3.9
 oberer Rand 5.2 links 1.7
rechts 1.2
 Alexander IIII (Gitterschrift, Ini
tiale verziert) . . Cartusie et uni
versis Prioribus Cartusien ordinis
 Celestis amor patrie
Dat Neapoli III kl aprilis a° 1°

Bulle fehlt, Seide erhalten
 In plica rechts : G. S.
A tergo Mitte unten : petit drius
J. de Malton . Card pro ordine cart
 Tolet. (Toledo)
Fette nach links geneigte Schrift, mit
gestr. Lignturen, mit 3 oberen
Schnauzungen
 In 1. Zeile ein verz. Buchstabe
Erste Linie für Gitterschrift und
 untere Schnörungen

P. vacat

2315

Wien Staatsarchiv Chronol.
P. — 1255 Martii 30
Alexander IIII . . Cartusie et uni
versis prioribus Cart
 Celestis amor patrie
Neapoli III kl. apr. a° 1°
Bulle an Seide
In plica rechts G la
Rand oben Mitte vor
Gestreckte Ligaturen
oberste Zeile frei

Graz Landesarchiv. no 717
P. – 1255 Martii 30
Alexander IIII .. Cartusie et
universis prioribus Cartusiani
ordinis
Celestis amor patrie
Neapoli III Kl. aprilis aᵒ 1ᵒ
Bulle an Seide
Seitenlinien. Oberste Zeile
unbeschrieben.
Gestreckte Ligaturen
Ohne alle Notizen

Archives Nationales Paris
L 249 n. 15 1255 Aprilis 8
Br. 40.8 hoch 31.5 Plica 4.1
obere Rand 6.4 links 1.5
rechts 1.5
Alexander IIII (Gitterschrift In=
itiale verziert) Archiepis et Epis
et dil. filijs Abbatibus prioribus
Decanis Archidiaconis Repositis
archipbris Plebanis et alijs ecli
ax Prelatis ad quos littere iste
pervenerint
Non absque dolore
Dat Neapoli VI ꝓ Aprilis. aᵒ 1ᵒ

Bulle und Seide fehlen
Ecke oben rechts : ⍺ P. vacat
Sub plica links : . . .
a tergo oben Mitte grosses +

Ecke gerade Schrift mit gestreckten
Ligaturen, mit einem verzierten
Schauanfang
In 1. Zeile 1 ver. Buchstabe
Erste Linie für Gitterschrift und
Oberlängen

Archives Nationales Paris
L 249 n. 16 1255 Aprilis 9
Br. 36.7 hoch 26.8 Plica 3.7
obere Rand . 5.9 links 1.3
rechts 1.1
Alexander IIII Archiepis et Epis
ac dil. filijs Abbatibus, Prioribus Re
positis Decanis Archidiaconis Archi
pbris et alijs ecliax Prelatis presen
tes litteras inspecturis
Patris eterni benignitas
Dat Neapoli V ꝓ Aprilis aᵒ 1ᵒ

Bulle und Hanf fehlen
In plica rechts : p. c.
A tergo oben Mitte : predicatoꝝ

Kleine flüssige Zusammenhängen
de Schrift

Mit einem betonten Buchstaben

Erste Linie für Oberlängen

P. 15790

Firenze, Badia di Ripoli
P. – 1255 Aprilis 9
Alexander IIII .. abbati et con
ventui monasterii Vallis Um
brose Fesulan. dioc.
Ea que iudicis Reg. Vat. Vallis=
umbrose
Neapoli V iꝰ . apr. aᵒ 1ᵒ
Bulle und Seide fehlen
84 breit. 65 hoch
Plica 2.6 cm. 71 Zeilen
Zu durchschnittlich 43 Worten = 3053
In plica links Lxx, sub pl. links XLV
Ecke oben links Rᷝ
A tergo gross schön
schlank
Oberste Zeile unbenutzt
Zwei kleine plica
Sub plica unliniiert
Kräftige schöne Schrift
CCLXXVI Capts
Regestres
cap. 327

2320

Marseille Archives Départem.
H. P. a. 5
P. 15790 1255 Aprilis 9
Alexander IIII archiepis et epis
et abbatibus, prioribus, decanis,
archidiaconis, prepositis, archi-
presbiteris et aliis ecclesiarum pre-
latis presentes litteras inspecturis
 Patris eterni benignitas
Neapoli V. id. apriles a° 1°
Bulle an Hanf
In plica rechts R. Plac
unruhige nach links geneig-
te Schrift. Hohe Oberlängen

2321

Madrid Arch. Histór. Nacional
Santa Maria de Huerta 1 E
P. — 1255 Aprilis 9
Alexander IIII . . abbi Cistercii
eiusque coabbatibus et conven-
tibus universis Cist Ord.
Intimantibus vobis accepimus
Neapoli V. id. apr. a° 1°
Bulle fehlt. Seide erhalten

Ligaturen gestreckt
prächtige Schrift .

 cf. 1255 Maii 1

2322

Archives Nationales Paris
L249 n. 17 1255 Aprilis 12
Br. 55.3 hoch 39.2 Plica 4.
 oberer Rand 7. links 1.8
rechts 2.1
 Alexander IIII . . Magro et
Capitulo generali ordinis Predica
torum
 Comes honoris onus
Dat Neapoli II. Id Apriles a° 1°

Bulle fehlt, Hanf erhalten
 In plica rechts : Ja de Sers
Rand oben Mitte : Y
 a tergo Ecke oben links : l
Fette unordentliche Schrift
Mit einem betonten Buchstaben
Erste Linie für Oberlängen

 P. vacat

2323

Archives Nationales Paris Rx
L249 n. 18 1255 Aprilis 14
Br. 34.8 hoch 24.5 Plica 1.9
 oberer Rand 5.4 links 1.2
rechts 1.1
 Alexander IIII . . Aurelianen et
. . Antisiodoren Epis
 Controversiam dudum inter
Dat Neapoli XVIII Kl maij a° 1°

Bulle fehlt. Hanf erhalten
 In plica rechts : Jat pp
A tergo oben Mitte : Predicator

Schluck, schwungvoll
 2.5
Capitelsangabe unter
der Hasta
 ccl xx vij. capta annus prim
Fette deutliche Schrift
Mit einem betonten
 Buchstaben
Ohne erste freie Linie P. 15802

Archives Nationales Paris

L249 n. 19 1255 Aprilis 14

Br. 74.8 hoch 58.8 Plica 2.8
oberer Rand 7.5 links 2.7
rechts 2.7
Alexander IIII (maiusculae)
universis Magris ⁊ scolaribus
Parisien
 Quasi lignum vite
Dat Neapoli XVIII kl maij a° 1°

Bulle fehlt, Seide erhalten
A tergo oben mitte: Predicatores

Sehr schöne regelmäßige Schrift, mit
gestr. Ligaturen, mit zahlreichen
verzierten Capitels anfängen
In 1. Zeile 2 verz. Buchstaben
Erste Linie für Zittuerschrift und
 Oberlingen

P. 15801

Public Record Office London
Papal Bulls bundle 1 n. 10
 Clausa

P. 15811 1255 Aprilis 19

Alexander IIII. H. illustri regi Anglie
Cum inter conditiones
Neapoli XIII kl. Maii a° 1°
Bulle und Hanf fehlen
Rechts und links kein Rand, so
dass die Schnitte in die Schrift gehen.
A tergo rechts unten quer geschrieben:
 VI

Rymer, Foedera I. I. 194
dr. P. 15814

Poitiers Archives Départem.
Ste Radegonde
P. 1255 aprilis 20
Alexander IIII. Helie de Brolio
canonico Atrienen. Cenoma-
nen. Dioc.
 Priori et capitulum
Neapoli XIII kl. maii a° (1°)
Bulle und Hanf fehlen.
Links ganz fleckig
Kleines neuwzdt. Erste Zeile frei.
Seitenlinien, keine Ränder
Sub plica ohne Linien
Scriptormann unleserlich

Firenze, S. Croce di Firenze
P.- 1255 Aprilis 20
Alexander IIII [ohne Punkte] uni-
versis epis et abbibus, priori-
bus, et aliis eccles. prelatis per
Tusciam constitutis
 Cum dilecti filii
Neapoli XIII kl. maii a° 1°
Bulle und Hanf fehlen
In plica links St
 Erste Linie unbenutzt
Kleine, feine äußerst zierli-
che Schrift
Sub plica unliniiert

Public Record Office London
Papal Bulls bundle 1 n. 16
 Clausa
P 15814 1255 Aprilis 21
Alexander H. illustri regi Anglie
 Quia inter conditiones
 Neapoli X͞I kl. Maii a° 1°
 Bulle an Hanf hängt links

Archivio di Stato Milano
 Bolle e Brevi
P. 15824 1255 Aprilis 25
Alexander IIII Raynerio ac aliis
fribus Ostredic. inquisitoribus
her. pravitatis in Lombardia
 Cum auctoritate felicis
 Neapoli VII kl. Maii a° 1°
 Bulle und Hanf fehlen
In plica links B. fu

Paris Archives Nationales R͞t
 J 447. h. 53
Breite 30.1 Rand links 1. rechts 0.9
Höhe 21.7 Rand oben 4. plica 3.7
Erste Linie für Oberlängen / Je
eine Seitenlinie
P. vacat 1255 Aprilis 25
Alexander IIII . - Archiepo
Bituricen
 Volumus et presentium
Dat Neapoli VII kl. Maii /
a° 1°
 Bulle an dickem Hanf
 In plica rechts : B. p.
 Sub plica links : ş
 Rand oben links R͞t
 verte

a tergo
 +
 + Ber +
 +
darunter Schlauck

cccxlix
ccc x L ix cesso anno primo

2331 (recto)

Rx

Paris Archives Nationales

J 585 n. 53

Breite 35. Rand links 1.2 rechts 1.2

Höhe 27.8 Rand oben 5.2 plica 3.9

Erste Linie für Maj. mit kleinen

Oberlängen / Je eine Seitenlinie

P. 15822 1255 Aprilis 25

Alexander IIII (ähnlich wie Maj)

Carmo in xpo filio . . Illustri

Regi Francie (regni

Sublime ... Francie

Dat Neapoli VII Kl Maij / a° 10

Bulle an Seide

In plica links : J. V.

Rand oben links : Rx

A tergo oben mitte : + Rex +

2331 (verso)

A tergo oben mitte schlank
zierlich

cccxlix capt anno primo

Prachtvolle kleine feste Schrift.

2332

Paris Archives Nationales Rx

J 683 n. 1

Breite 38.6 Rand links 4.3 rechts 1.8

Höhe 32.4 Rand oben 5.8 plica 3.7

Erste Linie für Maj und kleinere

Oberlängen / Je eine Seitenlinie

P. 15822 1255 Aprilis 25

Alexander IIII (verz. Maj-) Carmo in

xpo filio . . Illustri Regi Francie

Sublime Regni Francie

Dat Neapoli VII Kl Maij / a° 1°

Bulle an Seide

In plica links : J. V.

Rand oben links : Rx

A tergo oben mitte : + Rex +

Schlank zierlich

Schwungvolle
prachtvolle
Schrift

unterer Theil
fehlt

2333

Archives Nationales Paris

L 249 n. 10 1255 Aprilis 27

Br. 31.5 hoch 23. Plica 2.9

oberer Rand 5. 5 links 0.9

rechts 1.1

Alexander IIII (Gitterschrift, Ini-

tiale variiert) Abbati et Con

ventui Monasterij Vallis beate ma

rie Cistertien ordinis Parisien dioc

Ex serie nostre

Dat Neapoli V kl maij a° 1°

In plica rechts : Jo . . .

Sub plica links : . . .

A tergo oben mitte : + A de Mallorca

Schöne kleine Schrift, mit mehreren

getr. Ligaturen, mit 3 variierten

Satzanfängen

In 1. Zeile 1 verz. Buchstabe

Erste Linie für Gitterschrift und Ober-
längen

Schreibfehler : oportet nos decimas
cohibere — statt nos

P. vacat

Archives Nationales, Paris R̄
L 249 n. 21 1255 Aprilis 27
 P. vacat
Br. 27.2 hoch 18.6 Plica 3.6
 oberer Rand 4.5 links und
rechts ohne Seitenlinien 1.2 , 1.2
 Alexander IIII (Gitterschrift
Initiale verziert) . Magro y
fratribus Hospitalis sancti Samso-
nis de Duaco Atrebaten diõc ad
Hospitale S̄ti Samsonis Constantinopo-
litanū spectantis
 devotionis vestre precibus
Dat Neapoli V Kl Maii aº 1º

Bulle an Seide
 In plica rechts : Ja de Sc̄s
Sub plica rechts : ?
 Ecke oben rechts : Ja
A tergo Ecke oben links : Ja
 oben Mitte schlank LA
rund 2.5
Darüber
Signum Sc̄t. Samsonis
 ccclxviij . Capꝉ layxo pri-
 mo

Firenze , Badia Fiorentina
P. — —1255 Aprilis 29
Alexander IIII [ohne Punkte] con-
ventui monasterii see Marie
Florentin. OSB ad Rom. Eccl.
ut dicitur nullo medio perti-
nentis Reg. Vat. mediante
 Religionis vestre mereretur
Neapoli III Kl. Maii aº 1º
Bulle und Seide fehlen
 Sehr beschädigt
Ecke oben links R̄
A tergo oben Mitte halb
überklebt Sc̄pt.
Registres cap. 411.
 cap. CCCXXXX X

Archivio di Stato, Milano
 Bolle e Brevi
 R 15831 1255 Aprilis 30
Alexander IIII fribus OPred. in-
quisitoribus ~~hr par.~~ hereticõ-
rum in provincia Lombardie
 Cum secundum tenorem
Neapoli II Kl. Maii aº 1º
 Bulle fehlt. Seide erhalten
In plica rechts A. de St.
Rand oben etwas rechts : fiant
quinque de curia
Ligaturen gemischt.

Marseille Archives départem.
B 357
P. — 1255 Aprilis 30
Alexander IIII nob. viro Carolo co-
miti Andegavie e Provincie ger-
mano cñi in xp̄o filii nri . . .
Francie regis illustris
 Cum ad archana
Neapoli II Kl. Maii aº 1º
Bulle an Seide
In plica rechts Ja Nar
Sub plica links ? . .
Rand oben links R̄
A tergo oben Mitte groß schmal
elegant Registres cap. 429
CCCXX
 CCCXX cap̄tõ añ primo

Rx

Paris Archives Nationals
 J 684 n. 25
Breite 28.8 Rand links 1.6 rechts 1.6
Höhe 24.6 Rand oben 5.1 plica 3.2
 Erste Linie für Mrg und kleinere
Oberlängen / Je eine Seitenlinie
P. vacat 1255 Aprilis 30
Alexander IIII (ver Mrg) Carmo
in xpo filio . . Illustri Regi
Francie
 Cum contingat interdum
Dat Neapoli T De Maij / a° 1°
Bulle an Seide
 In plica rechts : R · plai
Sub plica links : ?
Rand oben links : Rx vate

a tergo oben Mitte : +
 + Rex +
 +

Mittelgroß schlank mit dickem
Strich :

cccXLIX . capto / anno primo
Große schöne weitgelegerte Schrift

2339

Madrid Arch. Histor. Nacional
 P Poblet E n. 57
 1255 Maii 1
Alexander IIII . . . abbi Cisterciï
eiusque coabbatibus et conventi-
bus universis Cist O.
Intimautibus vobis accepimus
Neapoli Kl. Maii a° 1°
Bulle fehlt. Gröbere Seide erhalten
In plica rechts B p n.
 cf. 1255 Apr. 9

2340

Public Record Office London
Papal Bulls bundle 1 n. 13
 P — 1255 Maii 3
Alexander IIII . . archiepiscopo Can-
tuariensi et magistro Rostando
capellano nostro
 Carissimo in Christo
Neapoli T non. Maii a° 1°
Bulle und Hanf fehlen
In plica rechts G. P.
Rand oben in winziger Schrift :
 Inhaltsangabe.
Es sind noch andere mit diesen
Randregesten vorhanden.

2341

Marseille Archives départem.
H. S. r. 132
P. — 1255 Maii 9
Alexander III . . officiali Treca.
 Cum dilectus filius
Neapoli III iḋ. Maii aº 1º
 Bulle fehlt, Hanf erhalten
In plica links)(
Erste Zeile beschrieben
Sub plica links . . .

2342

Instr. misc. 1250–1275 cap. 5
 P. — 1255 Maii 10
Alexander III Ruffino canonico Veral.
len. rectori eccle S. Petri de Agantico
Mngalonen. diœc.
 Ea que iudicis
Neapoli II iḋ. Maii aº 1º
Bulle und Seide fehlen
In plica rechts: Angt p
Ecke oben rechts : 1. a //

A tergo

2343

Wien Staatsarchiv Chronol.
 P. — 1255 Maii 10
Alexander III . . priorisse ac
conventui mon. de Belle Saincte
Marie in Milchelstein Ostkng.
Aquilegen. diœc.
 Iustis petentium desideriis
Neapoli II iḋ. Maii aº 1º
Bulle an grober Seide
In plica rechts p. c
Sub plica links ganz zart und
dünn, daun sichtbar (?
Zerbrochte Ligaturen ///
Oberste Zeile frei

2344

Public Record Office London
 Papal Bulls bundle 1 n. 11
 P. 15 863 1255 Maii 15
Alexander III . . archiepiscopo
Cantuariensi et magistro Rostando
capellano nostro.
 Intelleximus quod nonnullos
Neapoli iḋ. Maii aº 1º
Bulle und Seide fehlen
In plica rechts G. P
Rand oben in winzig kleiner Schrift
langes Regest für die Abfassung der
Bulle oder für andere Zwecke.
Auf jeden Fall kuriale Schrift.

2345

Firenze, S. Croce di Firenze
P. 15874 1255 Maii 21
Alexander IIII. . generali mi
nistro et universis fribus ordi
nis fratrum Minorum
Induciunur pie conversa.
 tionis
Neapoli XII Kl. Iunii a° 1°
Bulle und Seide fehlen
In plica rechts. œ. ar.
 Erste Zeile unbenutzt
 Sub plica unliniiert

2346

Archivio di Stato Milano
Bolle e Brevi vicecancell.
Nachbildung 1255 Iunii 1
Alexander IIII. . . priori ecclie S.
M. in porta Ravennat. eiusque
fribus etc. in ppm
Commune nobis apostolice
 R Ego Al. etc. m
 2 presb. 2 epi 4 diac.
Neapoli p. m. Guitti magrisro
larum Parmen. SRE vicecancel.
liii Kl. Iunio a° 1°
 P. 15892

2347

Barcelona Corona de Aragón
 Leg. 140 n. 1°
P. — falsche Initiale
 1255 Iunii 2
Alexander IIII. . Illusti Re
gi Aragon:
Excellentie tue literas
Neapoli IIII Non. Iunii a° 1°
Bulle an Hanf
In plica rechts G. Mutin
 Hanfbesiegelung oberhen
 Initiale schrägl. rein

2348

Archives Nationales Paris
L 249 n. 23 1255 Iunii 19
Br. 37. 3 hoch 27.9 Plica 2.8
 oberer Rand 6.2 links 2.8
rechts 2.1
 Alexander IIII. . priori fratrum
Beticstorum in Burgundia
 Terre Jerlimitani periculosa
Dat Anagnie XIII Kl Iulij a° 1°

Bulle und Hanf fehlen
 In plica rechts : adeg p
Mitte oben a tergo: Terra Sca
Mit einem betonten Buchstaben
Kleine regelmässige Schrift
Ohne erste Linie für Oberlängen
In plica halbrechts : ministro fratrum
 Minorum . . .
 P. vacat

2349

Archives Nationales Paris

L 249 n. 24 __1255 Junii 20__

Br. 35.3 hoch 26.2 Plica 3.4
oberer Rand 4.2 links 1.2
rechts 1.1

Alexander IIII. (Gitterschrift, die
Nähe verziert). . Cartusie ? uni-
versis prioribus Cartusien ordinis

Liceat ad hoc

[Da] Anagnie XII Kl. Julij a° 1°

Bulle fehlt, Seide erhalten

A tergo oben Mitte : Cartusia

Eckige kleine Schrift, mit gestreckten
Ligaturen, mit 3 verzierten Schriftauf.
In erster Zeile 2 verz. Buchstaben

Erste Linie für Gitterschrift

Je zwei Seitenlinien

Da Anagnie __P. vacat__

2350

Graz Landesarchiv n. 721

P. — __1255 Junii 20__

Alexander IIII . . . Cartusie et
universis prioribus Cartu-
sien . ordinis

Liceat ad hoc

Anagnie XII Kl. Julii a° 1°

Bulle an Seide

In plica rechts 8. p.

Seitenlinien . oberste Zeile
überschrieben

Gestreckte Ligaturen

2351

Archives Nationales Paris

L 249 n. 25 __1255 Junii 22__

Br. 31.8 hoch 25.2 plica 2.7
oberer Rand 6.7 links 1.6
rechts 1.6

Alexander IIII (Gitterschrift, Initia-
le verziert) (ohne Punkte) Priori-
bus et Monachis constitutis in loco
qui dicitur beati Bernardi Parisien
Cartusien ordinis in theologica facul-
tate studentib.

Dudum personis vestris
Da Anagnie X Kl. Julij a° 1°

Bulle fehlt, Seide erhalten

A tergo oben Mitte : Claremont

Klare fette Schrift, gestr. Ligaturen, mit
3 verzierten Schriftanfängen

In 1. Zeile 1 verz. Buchstabe

Erste Linie für Gitterschrift

Papstname im Text in Gitterschrift

Punkte __P. vacat__

2352

Firenze, S. Croce di Firenze

P. 15906 __1255 Junii 26__

Alexander IIII . . . generali ac
nostro et fribus de ordine Mi-
norum

Ut in vestris

Anagnie VII Kl. Julii a° 1°

Bulle und Seide fehlen

In plica rechts p. Sabell

Oberste Linie überschrieben

Sub plica eingeliniert

Schmale Seitenränder

Grosser oberer Rand

2353

Archivio di Stato Milano
Bolle e Brevi
P. — 1255 Julii 2
Alexander IIII .. abbatisse ~~et~~
conv. mon. S. Agathe de Papia
OSDamiani
 Cum a nobis
Anagnie VI non. Jul. a° 1°
Bulle fehlt; grobe Seide erhalten
In plica links : B.S. 8

2354

Archivio di Stato, Milano
Bolle e Brevi
P. — 1255 Julii 2
Alexander IIII dil. in xpo filia
bus.. abbatisse et conv. mon. S.
Agathe de Papia OSDamiani
 Paupertati vestre quam
Anagnie VI non. Jul. a° 1°
Bulle rund regelmässig an
gröberer Seide.
In plica links B.S. 8
Gestreckte Ligaturen

2355

Archives Nationales Paris
L249 n. 26 1255 Julii 3
Br. 32,7 hoch 23.5 plica 2,6
 oberer Rand 5. links 1.8
rechts 1.8
 Alexander IIII (Gitterschrift, Initio
de variiert) Guillermus Notarius noster
Abbati Cluniacen
 Ex parte tua
Dat Anagnie V non. Julij a° 1°
Bulle und Seide fehlen. Pp vacat
 In plica rechts : a. G.
 A tergo oben Mitte : Philipp

Sehr zierliche schöne Schrift, mit gestr.
Ligaturen, mit 3 verz. Satzanfängen.
 In 1. Zeile 2 verz. Buchstaben

Erste Linie für Gitterschrift und unten
 Obenlängen

// Guillermus notarius aplice
 sedis

2356

Madrid Arch. Histór. nacional
Orense S. Maria de Osera 4 E.
P. — vicecancellarius
 1255 Julii 4
Alexander IIII .. abbati monast.
~~de~~ S. Marie de Vrsaria eiusque
etc. in ppm
Officii nostri nos
(R) Ego Alex. Cath. Eccl. epo s (M)
6 presb. 1 epo. 3 diac.
 SRE
Dat ... per m. G vicecancellarii
vicecancellarii et notarii IIII
non. Julii ind. III. . ——
Bulle und Seide fehlen.

fast ganz zerstört und un-
leserlich.

Archives Nationales Paris

L 249 n. 27 1255 Julii 5

Br. 27.5 hoch 24.6 Plica 2.9
oberer Rand 6.4 links 1.4
rechts 1.4
Alexander IIII (Gitterschrift, Initia-
le verziert) Archiepis et Epis ac. dil.
fs filijs Abbatibus Prioribus decanis
Archidiaconis et alijs ecclesiar Prela-
tis ad quos littere iste pervenerint
 Militum Templi professio
Dat Anagnie III Non Julij aᵒ 1ᵒ

Bulle fehlt, Seide erhalten
 In plica rechts : Jo. G.
Sub plica links : ...
 Ecke oben rechts : a
A tergo Expe oben links : ϡ
 „ oben Mitte : ⊤

Eckige kleine Schrift, mit gestr. Ligaturen
mit zwei verz. Schwänzchen
In 1. Zeile 2 verz. Buchstaben
Erste Linie für Gitterschrift und Ober-
 längen
 P. vacat

Archives Nationales Paris

L 249 n. 28 1255 Julii 6

Br. 38 hoch 30.8 Plica 3.8
oberer Rand 7. links 1.6
rechts 1.6
Alexander IIII (Gitterschrift, Ini-
tiale verziert) . . magro et
patribus Militie Templi Jerusalem
 Ex parte nra
Dat Anagnie (später mit anderer
Tinte eingeschoben) III Non Julij aᵒ 1ᵒ

Bulle fehlt, Seide erhalten
 In plica halbrechts : + Anagnie
Ecke oben rechts : a
A tergo oben Mitte : ⊤ P. vacat

Weiße Seide schöne Schrift, mit gestr.
Ligaturen, mit 3 variierten Schwänzchen
In 1. Zeile 1 verz. Buchstabe

Papstname im text in Gitterschrift

Kleine Linie für Gitterschrift
 Anagnie

Archives Nationales Paris

L 249 n. 29 1255 Julii 6

Br. 28.2 hoch 24.2 Plica 2.7
oberer Rand 7. links und
rechts ohne Seitenlinien 1.6 , 1.4
Alexander IIII (Gitterschrift, Ini-
tiale verziert) Archiepis et Epis et
dil. filijs abbatib; Priorib; decanis
Archidiaconis J alijs ecclesiar Prelatis
ad quos littere iste pervenerint
 Ex parte dilectorum
Dat Anagnie III Non Julij aᵒ 1ᵒ

Bulle und Seide ausgerissen
 In plica rechts : Mauf
Sub plica links : ϡ
 Ecke oben rechts : a P. vacat
A tergo Ecke oben links : ϡ
 „ oben Mitte : ⊤
Sehr regelmäßige eckige Schrift, mit
gestr. Ligaturen, mit 1 verz. Schwänzg
In 1. Zeile 2 verz. Buchstaben
Erste Linie für Gitterschrift und Pfeilingen
Papstnamen im text in Gitterschr.

 Innovata

Archives Nationales Paris

L 249 n. 30 1255 Julii 6

Br. 31.5 hoch 24.6 Plica 2.7
oberer Rand 5.6 links und
rechts ohne Seitenlinien 1.2 , 1.2
Alexander IIII Archiepis J Epis J dil.
filijs Archidiaconis ad quos littere
iste pervenerint
 Cum dilecti filij
Dat Anagnie III Non Julij aᵒ 1ᵒ

Bulle fehlt , Seide erhalten
 In plica rechts : J. mj
links (nicht unter der plica) : ...
 Rand oben links : Innovata
Ecke oben rechts : a
A tergo Ecke oben links : ϡ P. vacat
 „ Mitte oben : ⊤

Kleine kräftige sehr schöne Schrift, mit
gestr. Ligaturen (mit 2 Ausnahmen)
und zwei betonten Schwänzchen
In 1. Zeile 1 verz. Buchstabe

Erste Linie für Gitterschrift

2361

Firenze, Cestello
P.— 1255 Julii 8
Alexander IIII .. abbi Cistercii
eiusque coabbatibus universis
Cistercien ordinis
 Licet ad fratrum
Anagnie VIII id Jul. a° 1°
 Bulle fehlt, Seide erhalten
In plica links und rechts 1300
 Oberste Zeile frei
Sub plica unliniirt

2362

Archives Nationales Paris
L 249 n. 31 1255 Julii 8
Br. 31.4 hoch 22.8 Plica 4
 oberer Rand 4.7 links 1.3
rechts 1.3
 Alexander IIII (Gitterschrift und
viele variiert).. Magro 7 fratribus
Templi Jerlingten
 Ex parte una
 Dat Anagnie VIII id julij a° 1°

Bulle fehlt, Seide erhalten
 In plica rechts: S B
Ecke oben rechts: a
 A tergo oben mitte: T

nachlässige fette kleine Schrift, mit ge-
streckten Lipturen, mit 2 ver.
Satzanfängen
 In 1. Zeile 2 ver. Buchstaben
Erste Linie für Gitterschrift

Papstname im Text in Gitterschrift
 P. vacat

2363

Archives Nationales Paris
L 249 n. 32 1255 Julii 11
Br. 36 hoch 26.3 Plica 3.2
 oberer Rand 5.7 links 1.2
rechts 1.2
 Alexander IIII. . Magro et
fratribus domus Militie Templi Je-
limiten
 Cum felicis recordationis
Dat Anagnie V id julij a° 1°

Bulle fehlt, Seide erhalten
 In plica rechts: p. B
Links (nicht sub plica) S.
 Ecke oben rechts: a
A tergo Ecke oben links: y
 „ oben mitte: T
 P. vacat
Fette kleine Schrift, mit mehreren geste.
Lipturen, mit drei verzierten Satz-
anfängen In 1. Zeile 2 ver. Buchstaben

Papstnamen im Text nicht in Gitterschr.

Erste Linie für Gitterschrift

2364

 ex Regesto
Archives Nationales Paris
L 248 n. 274 1255 Julii 15
Br. 40.2 hoch 26.2 Plica 3.7
 oberer Rand 5.6 links und
rechts ohne Seitenlinien 1.2, 1.4
 Alexander IIII. . Priori Gene-
rali 7 universis fratribus Heremi-
tis de Tuscia ordinis Sci Augustini
 Litteras quasdam felicis
Dat Lateran Anagnie id Julij a° 1°

Bulle fehlt, Hauf erhalten
 In plica rechts: aud. s.
Sub plica links: S
 A tergo oben „ „ mitte:
 Albert Florentinus
Brief Dat Lateran IV Kl huntij
ex Regesto erneut Innocentii
 IV P. 15236
Mit 1 betonten Buchstaben

 P. 15927

2365

Archives Nationales Paris
L 249 n. 33 1255 Julii 15

Br. 27.9 hoch 21.7 Plica 3.4
oberer Rand 5 links 2.2
rechts 1.8
Alexander IIII (Gitterschrift, Initiale verziert) Archiepis et Epis et
dil. filijs alijs Eccliax Prelatis
ad quos littere iste pervenerint
Cum dilectos filios
Dat Anagnie Id Julij a° 1°

Bulle an feiner Seide
In plica rechts : pt. B
Sub plica links : ?
Ecke oben rechts : a
A tergo Ecke oben links (A
oben mitte P. vacat

Regelmässige feste Schrift, ohne gestreckte
Ligaturen, mit einem verzierten
Satzanfang
Papstname nur text nicht in Gitterschr.
Erste Linie für Gitterschr. und untere
Oberlängen

2366

Archives Nationales Paris
L 249 n. 34 1255 Julii 15

Br. 33.2 hoch 27.6 Plica 2.8
oberer Rand 5.1 links und
rechts ohne Titelinien a 1.1, 1.1
Alexander IIII (Gitterschrift,
Initiale verziert) . Abbati Cister-
cij eiusque Coabbatibus universis
Cisterciens ordinis
Celestis amor patrie
Dat Anagnie Id Julij a° 1°

Bulle und Seide fehlen
In plica rechts : . a. q.
A tergo oben mitte : +
Anselmus

Ganz kleine, sehr zierliche Schrift, mit
gestr. Ligaturen, mit 3 verz. Satzanfäng
In 1. Zeile 1 verz. Buchstabe

Erste Linie für Gitterschrift und untere
Oberlängen

P. 15930

2367

Madrid Arch. Histór. Nacional
Santa maria de Huerta 3 E
P. — 1255 Julii 15
Alexander IIII abbati Cistercii eius
que coabbatibus universis Cist.
ORD.
Licet ad hoc
Anagnie id. Julii a° 1°
Bulle und Seide fehlen
In plica rechts p. e.
In plica links J. IIII
Io. oj III
Rand oben mitte sunt tres

2368

Madrid Arch. Histór. Nacional
Santa maria de Huerta 2 E
P. 15930 1255 Julii 15
Alexander IIII . . abbi Cistercii
eiusque coabbatibus universis
Cist. Ord.
Celestis amor patrie
Anagnie id. Julii a° 1°
Bulle und Seide fehlen
In plica rechts ob. p.

Ligaturen gestreckt.
Duplicat

2369

Madrid Arch. Histór. Nacional
Poblet C. n. 58

P. 15930 1255 Julii 15

Alexander III... abbi Cistercii
eiusque coabbatibus universis
Cist. Ord.

Celestis amor patrie

Anagnie iN. Julii a° 1°

Bulle und Seide fehlen

 Ohne alle Notizen

Ligaturen gestreckt.

Ausstattung regelmäßig

 Duplicat

2370

Archives Nationales Paris

L 249 n. 35 1255 Julii 18

Br. 33.7 hoch 27.8 Plica 3.3
 oberer Rand 6.3 links 1.3
rechts 1.1

 Alexander III (Gitterschrift, im
Siele verrückt). . Abbati Conven-
tui Monasterij s.c. Gunnar de
Pratis Parisien. ad Romana ecli.
am nullo modo pertinentis

 Cum olim felicis
dat Anagnie XV Kl. Aug a° 1°

Bulle fehlt, Seide erhalten
 In plica rechts : la . o)
Sub plica links : . .
 Ecke oben rechts : a P. vacat
A tergo oben Mitte :
 Petrus de sto Andrea
Sehr weite schöne Schrift, mit gestreckt.
Ligaturen (mit 1 Ausnahme), mit
3 variirten Satzanfängen
 In 1. Zeile 1 verz. Anfangsbuchstabe
Erste Linie für Gitterschrift und Ober-
 längen.

2371

Firenze, S. Spirito di Firenze

P.- 1255 Julii 20

Alexander IIII.. - priori et fri-
bus Heremitarum ord. S. Aug.

 Ut eo liberius

Anagnie XIII Kl. Aug. a° 1°

Bulle und Seide fehlen

Seitenränder abgeschnitten

Erste Linie unbenützt

2372

Arch. dép. de la Gironde Bordeaux
 G. 270

P.- 1255 Julii 21

Alexander IIII.. - archidiacono
Braten. in ecclesia Aquen.

Sua nobis dilectus

Anagnie XII Kl. Aug. a° 1°

Bulle fehlt. Hanf vorhanden

 Ohne jede Notiz

2373

Instr. Mon. F. Dom. c. 7 1255 Julii 21

P. 15940

Alex. IIII .. abbati Cisterci. ac generali

capitulo Cistercien. ordinis

Licet apostolica sedes.

Anagnie XII bal. Aug. anno 1°

Bulle an Hanffchnur

A tergo: Predicatorum

2374

Brit. Mus. Add. Chart. 11280

P. — 1255 Julii 23

Alexander IIII .. magistro et fra-

tribus Militie Templi

Quanto maiori religione

Dat. Anagnie X kl. Aug. a° 1°

Bulle und Seide fehlen

In plica rechts Ja sub

2375

Archivio di Stato Milano

Bolle e Brevi

P. — 1255 Julii 25

Alexander IIII fratri Raynerio

Placentin. ac aliis fribus Ord. Pred.

inquisitoribus her. prav. in Lom-

bardia et Marchia Januen.

Cum auctoritate felicis

Anagnie VIII kl. Aug. a° 1°

In plica rechts n. c. (n. o)

Bulle und regelmässig an

Hanf

Erste Zeile beschrieben

2376

Instr. Mon. F. Dom. c. 63 1255 Julii 26

P. 15948

Alex. IV fratri Raynerio Placentin. et aliis fra-

tribus ord. Pred. inquisitoribus heretice

pravitatis in Lombardia et Marchia Ja-

nuen.

Cum auctoritate felicis —

Anagnie VII kal. Aug. anno I°

Bulle an Hanffchnur

In plica rechts : n. o. (n. x)

2377

Instr. mon. F. Dom. c. 85 1255 Jul. 29

P. 15952

Dilectus filius frater
Kaufmann. Bulle fehlt.
In plica rechts: p. c.
A tergo: predicatorum

2378

Public Record Office London
 Papal Bulls bundle 3 n 34
 P. 15959 1255 Julii 28
Alexander IIII fratri Johanni
de Canter OFM Wigornien. et
archidiacono Midelsexie Londoniae. dioe.
 Lecta coram nobis
 Anagnie V kl. Aug. a° 1°
 Bulle an Hanf
 Initiale nicht ganz schwarz
 Rand oben Mitte In ald
 Ecke oben rechts Jo
 Jd
 No. 45 Duplicat mit schwarzem A

2379

Archives Nationales Paris
L249 n. 36 1255 Julii 30
Br. 29.6 hoch 24.9 Plica 3.5
 oberer Rand 6.6 links 1.6
rechts 1.6
 Alexander IIII (Gitterschrift,
Initiale variiert). . abbati et
Conventui Monasterii sancti
Dionisii in Francia ad Romanam eccle-
siam nullo medio pertinentis
 Cum super provisione
dat. Anagnie III Kl Aug a° 1°

Bulle an feiner Seide
 A tergo oben Mitte : Apenini

Sehr kleine Schrift, mit gestr. Ligaturen, mit 3 vcas Schwänzchen.
 In 1. Zeile 1 vcas. Aufstriche

Erste Linie für Gitterschrift

P. vacat

2380

Archivio di Stato, Milano
 Bolle e Brevi
 P. — 1255 Julii 31
Alexander IIII dil. in xpo fil... ab
batisse et conv. mon. S. Francisci
Mantuan. Ord. Damiani ad Rom.
Ecclam pleno iure spectanti-
bus.
 Paupertati vestre quam
Anagnie II Kl. Augusti a° 1°
In plica links R daneben :
pro fratre Rainaldo
 nur ganz vereinzelte ge-
streckte Ligaturen

2381

Archives Nationales Paris

L 249 n. 37 1255 Julii 31

Br. 37.5 hoch 29.3 Plica 2.9
 oberer Rand 4.9 links 1.3
rechts 1.4
 Alexander IIII (Gitterschrift, im
Titel verziert) . . Priori generali et
universis prioribus et fratribus Hue-
miliis ordinis S̄t̄i Augustini
 Pia desideria devotorum
Dat Anagnie II kl Aug a° 1°

Bulle fehlt. Seide erhalten
 In plica rechts : ∫ So: Bo:
Sub plica links :
 A tergo Ecke oben links : A
 Mitte : Albertin Florentin
Unruhige kleine fette Schrift, mit gestr.
Ligaturen, mit 6 verz. Satzanfängen
 In 1. Zeile 1 verz. Buchstabe

Erste Linie für Gitterschrift

P. vacat

2382

Archives Nationales Paris

L 249 n. 38 1255 Julii 31

Br. 26.6 hoch 22.1 Plica 3.5
 oberer Rand 5.6 links 0.9
rechts 1.
 Alexander IIII . . . Abbati Compen-
dien Suessionen dioc
 Sua nobis dilecti
Dat Anagnie II kl Aug a° 1°

Bulle fehlt. Hanf erhalten
 In plica rechts : . G. S.
Ecke oben rechts : . . .

Nachlässige kleine Schrift

Mit einem betonten Buchstaben

P. vacat

2383

Datum Papstname
Archives Nationales Paris

L 249 n. 39 1255 Augusti 1

Br. 28.7 hoch 23.6 Plica 3.2
 oberer Rand 6.3 links und
rechts ohne Seitenlinien 1.2 1.1
 Alexander IIII Gitterschrift, im
Titel verziert) . . Magro et fratribus
Militie Templi Jerlimitan
 Cum nos tanquam
Dat Anagnie kl Augusti a° 1°

Bulle an feiner Seide
 In plica rechts : ठ
Sub plica links :
 Ecke oben rechts : a
A tergo Ecke oben links : k
 " oben mitte : T
 foa P. vacat
Fette kleine Schrift, mit gestr. Ligaturen
mit 4 verzierten Satzanfängen
 In 1. Zeile 1 verz. Buchstabe
Erste Linie für Gitterschr. und untere
 Oberlängen
Papstname im Text nicht in Gitterschrift

2384

Archives Nationales Paris

L 249 n. 39 bis 1255 Augusti 1

Br. 30.6 hoch 24.1 Plica 3.5
 oberer Rand 5.6 links 1.1
rechts 1.1
 Alexander IIII (Gitterschrift, im
Titel verziert) . . Magro et fratri-
bus Militie Templi Jerlimitan
 Cum nos tanquam
Dat Anagnie kl Aug a° 1°

Bulle an feiner Seide
 In plica rechts : N trust
A tergo oben mitte : T

 Frater Reg.

Fette nachlässige Schrift, mit gestreckten
Ligaturen, mit 4 verz. Satzanfängen
 In 1. Zeile 1 verz. Buchstabe
Erste Linie für Gitterschrift und ober.
 laufen
Papstname im Text in Gitterschrift

P. vacat

Archivio di Sto. Milano
Bolle e Brevi
P. — 1255 Augusti 8
Alexander IIII dil. in xpo filiabus
.. abbatisse et conv. mon. pauperum
dominarum sci francisci Minuti..
an. S. Damiani
Cum a nobis
Anagnie VI id. Aug. aº 1º
Bulle und Seide fehlen
In plica links
Sub plica links

Firenze, Cestello
P. — 1255 Augusti 8
Alexander IIII .. abbi et con-
ventui mon. Sci Galgani
Cist. ordinis Wlteran. dioc.
Religionis vestre meretur
Anagnie VI id. Aug. aº 1º
Bulle fehlt, Seide erhalten
In plica rechts Scriptor
Erste Linie unbenutzt

Napoli Curia Eccles. vol. 30
P. — 1255 Augusti 9
Alexander IIII .. magro et fratri-
bus O.Præd.
Devotionis vestre precibus
Anagnie V id. Aug. aº 1º
Bulle und Seide fehlen
Ohne alle Notizen

Initiale mit Arabesken
aber keine gestreckte Liga-
turen.

Instr. Mon. F. Min. cap. 89 1255. Aug. 9
P. —
Alex. IV .. mag. et fratribus Ord. Predic.
Devotionis vestre precibus —
Anagnie V id. Aug. anno primo
Bulle an dicken Seidenfäden
A tergo: predictorum

Instr. Mon. F Dom. C. 129 1255 Aug. 12
P. 15986ᵃ p. 1315
Alex IV fratri Raynerio Placentin. et alijs
fratribus ord. Predic. inquisitoribus here-
tice pravitatis in Lombardia et Mar-
chia Tannen.
Cum felicis recordationis
Anagnie V id. Augusti anno primo
Bulle an Hanfschnur
In plica rechts: la. m.
A tergo: predicatorum
 Alexander
 Dupliat

———

C. 112

Bulle an Hanfschnur

In plica rechts: S p

Oben Rand Mitte: Ista petitur
innovetur

Instr. Mon. F. Dom. C. 67 1255 Aug. 21
 P. 15995
Alex IIII .. priori et fratribus Predicat.
de Bisuntio
Cum sicut asseritis
Anagnie XII Kal. Sept. a° 1°
Bulle an Hanfschnur
In plica rechts: pro deo
A tergo: predicatorum

2391

Firenze, S. Chiara di Cortona
P.— 1255 Augusti 30
Alexander IIII dil. in xpo filia-
bus [ohne Rubba] universis
abbatissis et monialibus inclu-
sis monasteriorum ordinis s.
Damiani
 Ut in vestris
Anagnie II Kl Sept. a° 1°
In plica rechts. a. s.
Bulle fehlt, Seide erhalten
 Erste Linie unbenutzt
Schmale Seitenränder
Breiter oberer Rand
Grosse plica, sub plica
unliniert

2392

Archives Nationales Paris
L249 n. 42 1255 Septembris 1
Br. 28.6 hoch 19 Plica 2.6
 oberer Rand 5.6 links 1.4
rechts 1.4
 Alexander IIII (Gitterschrift, Zwi-
schenraum versiert) .. Abbati et Conventui
sui Monasterij Fontaten ordinis
s. Benedicti Parisien. dioc.
 Justis petentium desideriis
Dat Anagnie. Kl. Septembr. a° 1°

Bulle fehlt, Seide erhalten
 Ecke oben rechts: J
A tergo oben Mitte: Ja
 Feria cang

Kleine fette Schrift, mit mehreren gest.
Ligaturen, mit 3 var. Schnörpingen
 In 1. Zeile 1 var. Buchstabe

Erste Linie für Gitterschrift
 P. vacat

Instrum. Mon. J. Domen. Cap. 54 1255 Septembris 2

Alexander episcopus servus servorum dei dilectis filiis inquisitoribus heretice pravitatis in partibus Provincie a sede apostolica deputatis salutem et apostolicam benedictionem.

Ex parte Aymerici de Bresols laici de Castro Sarraceno Tholosan. diocesis fuit nobis humiliter supplicatum, ut cum ipse penitentiam impositam ei ab inquisitoribus pravitatis heretice pro hiis que in huiusmodi pravitate elapsis iam triginta annis commiserat pro magna parte duxerit percomplendum, quia residuum non potest perficere confectus senio et paupertate gravatus, dispensare cum eo super hoc misericorditer curaremus. Quocirca discretioni vestre per apostolica scripta mandamus quatinus huiusmodi residuum comnutetis eidem in alia opera pietatis, prout anime sue saluti videritis expedire.

Dat. Anagnie IIII Non. Septembris pontificatus nostri anno primo.

P. 16007

Bulle an Hanfschnur.

Instr. Mon. F. Dom. Cap. 54 1255 Sept. 2

P. 16007

Alex IV inquisitoribus heretice pravitati in partibus provincie a sede apostolica deputatis
Ex parte Aymerici —
Anagnie IIII Non. Septembris a° 1°
Bulle an Hanfschnur
In plica rechts: a (?)
A tergo: fratri Ro (?) und
 Alexander.

Vollständig
Text abgeschrieben

Archives Nationales Paris
L 249 n. 43 1255 Septembris 4

Br. 32.1 Hoch 22.7 Plica 2.6
 oberer Rand 4.7 links 1.2
rechts 1.3
Alexander IIII Archiepis et Epis
ad quos littere iste pervenerint
 dilecti filij fratres
Dat Anagnie IIII Non Septembris a° 1°.

Bulle und Seide fehlen
In plica rechts: N. quat
Ecke oben rechts: a
A tergo oben Mitte: ↄ

Teste feine Schrift, mit geschriebenen, mit 3 verzierten Satzanfängen

In 1. Zeile 1 verz. Buchstabe
Erste Linie für Gitterschrift und untere Oberlänge

P. vacat

2396

Archives Nationales Paris

L 249 n. 44 1255 Septembris 4

Br. 27.8 hoch 18 Plica 2.6
 oberer Rand 4.4 links 1.1
rechts 1.1

Alexander IIII (Gitterschrift, im
Siale verziert) .. Magro et fratribus
domus Militie Templi Jerlimitan
Denotionis uro precibus
Dat Anagnie II non Septembr a° 1°

Bulle an feiner Seide

Sehr kleine Schrift, mit gestr. Ligatu-
ren, mit 3 betonten Satzanfängen

In erster Zeile 1 betonter Buchstabe

Erste Linie für Gitterschrift und unteren
Oberlängen

Papstname im Text in Gitterschrift

P. vacat

2397

duplicetur renovetur

Archives Nationales Paris

L 249 n. 45 1255 Septembris 6

Br. 31.6 hoch 25.3 Plica 2.7
 oberer Rand 6. links 1.3
rechts 1.5

Alexander IIII (Gitterschrift, im
Siale verziert) .. Preceptori et fratribus
domus Militie Templi in Francia
dignum esse conspicimus
Dat Dat... Anagnie VIII Jd Septembr a° 1°

Bulle an feiner Seide
 In plica rechts : A. G.
links daneben : In Italia
Sub plica links : .. P. vacat
 a. G.
Rand oben Mitte : Renovetur de verbo
ad verbum preceptor et fratres de
A tergo Ecke oben links : Y
 " oben Mitte : T duplicetur
Kleine sehr schöne Schrift scpe
mit gestr. Ligaturen (mit 2.9
1 Ausnahme), mit 4 var. Satz- schlank
anfängen. In 1. Zeile 1 var. Buch.
Erste Linie für Gitter- DCXV caplo anno pri
schrift und untere Oberlängen mo

2398

P.— Paris Arch. nat.

L 249 cap. 45 1255 Sept. 6

Alex IIII .. preceptori et fratribus do-
mus militie Templi in Francia
dignum esse conspicimus

Anagnie VIII id Sept. a° 1°

Bulle an Seide

In plica rechts a. g.
Sub plica links .. item
 a. g.
In plica halbrechts : In Italia
Rand oben links RX dann weiter
rechts : innovetur de verbo ad ver
bum ... hunc preceptor. et ...de
(Rasur)

A tergo Mitte T duplicetur
 scpe
Registres R
cap. 772 DCXV caplo anno primo

2399

Madrid Arch. Histór. General
 xx Sahagun 1540
P. — 1255 Septembris 8

Alexander IIII .. abbi et conv.
monast. S. Facundi OSB
Legionen. dioc.

Cum a nobis
Anagnie VI id. Sept. a° 1°
Bulle und Seide ausgeschnitten
In plica rechts Bor....
Über der plica links v
Rand oben rechts : x
 x
Cor Ecke rechts : Ja

2400

Madrid Arch. Histór. nacional
Poblet C n. 60
P. —
1255 Septembris 17
Alexander IIII. . abbi Cistercii
eiusque coabbatibus universis
Cist. O.
Licet ad hoc
Anagnie xv Kl. Oct. a° 1°
Bulle und Seide fehlen
In plica rechts . f.

2401

Stnats archiv Wien Chronol.
P. —
1255 Septembris 17
Alexander IIII. . Cartusie ac
universis prioribus et fratri-
bus Cartusien. Ord.
Religionis vestre meretur
Anagnie xv Kl. octobris a° 1°
Bulle an Seide
In plica rechts B. parm
Gestreckte Ligaturen
Prachtvolle feste schwungvolle
ganz gerade Schrift
Oberste Zeile frei

2402

Graz Landesarchiv n. 720
P. —
1255 Septembris 17
Alexander IIII. . Cartusie et
universis prioribus et fratri-
bus Cartusien. ordinis
Religionis vestre meretur
Anagnie xv Kl. octob. a° 1°
Bulle an Seide
In plica rechts B. Parm.
Seitenlinien . oberste Zeile
unbeschrieben
Die gestreckten Ligaturen der
ersten Zeile sehr umständlich,
die anderen sehr einfach.

2403

Public Record Office London
Papal Bulls bundle 3 n° 31
Clausa
P. 16 018 1255 Septembris 18
Alexander IIII . . Illustri regi Anglie
De multa cordis
Anagnie XIIII kel Oct. a° 1°
Bulle an Hanf hängt links

Firenze, Badia fiorentina
P. — 1255 Septembris 22
Alexander III .. abbi see maria
florentin.
Conquesti sunt nobis
Anagnie X Kl. oct. a° 1°
Bulle an Hanf
In plica rechts. And. s.
 Kleines Mundat
Erste Linie benutzt
Sub plica unliniirt
Ecke oben rechts Jac
A tergo Ecke oben links a

Datum

Paris, Archives Nationales
 J 684 n. 30
Breite 29.2 Rand links 1.4 rechts 1.6
Höhe 21.3 Rand oben 3.8 plica 3.6
 Erste Linie für Maj und kleinen
Obelängen/ Je eine Seitenlinie
P. vacat 1255 Septembris 22
Alexander III (Maj) Carmo in xpo
filio illustri .. Regi Francie
 Cum sicut ex
Dat /Anagnie X Kl Octobr a° 1°
 Bulle an feiner Seide
 In plica rechts: Jo. Anag
Sub plica links : --
A tergo oben mitte : + Rex +
Papstname im Text in Gitterschrift
Kleine schöne Schrift

Paris, Archives Nationales
 J 686 n. 70
Breite 29.3 Rand links 4.4 rechts 1.3
Höhe 24.8. Rand oben 4.2 plica 3.8
 Erste Linie für Maj und kleinen
Obelängen/ Ohne Seitenlinien
P. vacat 1255 Septembris 23
Alexander III (Maj) Carmo
in xpo filio . Lr. Regi Fran
coRs Illustri
 Illa filialis devotio
Dat Anagnie/ VIII Kl Octobr
a° 1°
 Bulle an feiner Seide
 In plica rechts: Johes parm
A tergo oben mitte: + Rex +
Nachlässige weite fette Schrift

ascultetur

Archives Nationales Paris
L 249 n. 47 1255 Septembris 24
Br. 57.9 hoch 43.9 Plica 3.
ober Rand 7. 8 links 2,
rechts 2.3
 Alexander III (minusculae)
Archiepis et Epis et Dil. filijs abba
tibus Prioribus decanis Archidiã
conis Prepositis Archipbris et alijs
ecclie Prelatis ad quos littere
iste pervenerint
 Cum dilectis filijs
Dat Anagnie VIII Kl Octobr a° 1°
 Bulle an feiner Seide
 In plica rechts: Johes pr cõn;
Sub plica links : ̈
 Rand oben links: ascultetur
Daneben : /. Ecke oben rechts : a
A tergo Ecke oben links: / P. vacat
Fette kurze Schrift, mit gestr. Ligaturen
und g. versierten Satzanfängen
In 1. Zeile 2 ver. Buchstaben
Erste Linie für Papstname und ober
orratora längen

2408

Paris Archives Nationales
J 686 n. 61
Breite 26. Rand links 1.5 rechts 2
Höhe 20. Rand oben 4. 2 plica 3.4
Ohne erste und Seitenlinien
P. vacat — 1255 Septembris 28
Alexander IIII Carmo in xpo
filio Lodoico Regi Franc orp
Illustrj
Cum felicis recordationis
Dat Anagnie IIII Kl Octobr a° I°
Prachtvoll geprägte Bulle an
Hanf
In plica rechts : Hugo. V.
Rand oben links : R+
A tergo oben Mitte : Rex

2409

Paris Archives Nationales
J 686 n. 70 bis.
Breite 31.4 Rand links 1.5 rechts 1.3
Höhe 27.9 Rand oben 7.5 plica 2.5
Erste Linie für Nerj und kleiner
Oberlängen] Je eine Seitenlinie
P. 16030 — 1255 Octobris 1
Alexander IIII (Maj) Carmo in xpo
filio Lodoico Regi Francorum
Illustri
Illa filialis denotio
Dat Anagnie Kl Octobr] a° I°
Bulle an feiner Seide
In plica rechts : xpe
Sub plica links : —
A tergo oben Mitte : Rex
fette stumpfe Schrift / Papstname
in Gitterschr.

2410

Bayer. Haupt Staatsarchiv
Würzburg n. 5396
fast quadratisch
P. 16038ˣ — 1255 Octobris 5
Alexander IIII (radiert) etc. dil. in Xpo
filiabus .. Abbatisse Monsterii
Uallis Sce Crucis eiusque soror-
bus etc. ntrm professis Jk OPM
Religiosam uitam eligentibus
in uenient AMEN a—c AMEN
R Ego Alexander catholice
ecclie eps SS M
2 pbosb. 1 epus 2 diac.
Dat. Anagnie per manum Guiller
mi Magistriscolarum Parmen. Sce
Roman. ecclie Vicecancellarij III
non. Octobris Ind. XIII Incarn.
duice anno M. CC LV pontif. uero
domni ALEXANDRI IIII pp anno
primo
Schwere schöne Bulle an dünner Seide
Cepe oben rechts : Jo
Besondere Linie für die Oberlängen der
ersten Zeile.

2411

Archivio di Stato, Milano
Bolle e Brevi
P. — 1255 Octobris 10
Alexander IIII . – abbi mon. de Mu
tebello OSB Placentin . dioc.
Sua nobis dilectus
Anagnie VI it. Oct. a° I°
Bulle und Hanf fehlen
In plica rechts J. R
Sub plica links .:.

2412

Bayer. Haupt. Staatsarchiv
Nürnberger Archiv fasc. 274

P. 16058 1255 Octobris 13

Alexander (Gitterschrift) IIII . . Dec-
no et Capitulo Onolspacen. ecclie.
Herbipolen. dioc.
 Inter alias sollicitudines
Anagnie III jd. Octobris Anno Primo

Quer herumragend geprägte Bulle
 an feiner Seide
An plica rechts : 'f'
Sub plica links : .'.
 Rand oben mitte : L (certa)

liest.

2413

Firenze, S. Croce di Firenze
P. 16063 1255 Octobris 16

Alexander IIII . . generali et
univ. provincialibus minis-
tris ordinis fratrum Minorum
 Convenit ut sacer
Anagnie XVII kl. nov. a° 1°
Bulle und Seide fehlen
In plica rechts Th. S.
 Erste Zeile unbenutzt

2414

Firenze, S. Croce di Firenze
P. 16071 1255 Octobris 21

Alexander IIII . . generali et
provincialibus ministris, Custo-
dibus et guardianis necnon uni-
veris fratribus ordinis Min.
 Ex parte vestra
Anagnie XII kl. nov. a° 1°
Bulle und Seide fehlen
Erste Zeile unbenutzt
Sub plica unliniirt
Breite Ränder überall

2415

Firenze, S. Croce di Firenze
P. - 1255 Octobris 21

Alexander IIII [ohne Punkte] uni-
versis archiepis et epis ac abba-
tibus, prioribus, archipresbris, de-
canis, archidiac. plebanis et ali-
is ecclarum prelatis et rectoribus
ad quos littere iste pervenerint.
 Cum sicut ex
Anagnie XII kl. nov. a° 1°
Bulle und Hanf fehlen. Offenes
A im Titel
O erste Zeile unbenutzt
Sub plica unliniirt.
Sehr regelmäßige etwas fette
Schrift

2416

Firenze, Frati della Doccia

P. — 1255 Novembris 2

Alexander IIII [ohne Punkte] uni-
versis archepis et epis ac abb(at)ib(us),
prioribus, prepositis, archipres-
biteris, decanis, archidiaconis
et aliis ecclarum prelatis presen-
tes litteras inspecturis

Benigna divine operatio

Anagnie IIII Non. Nov. a° 1°

Bulle, Seide, plica fehlen

Oberste Zeile unbenutzt
Zierliche, dünne, runde Schrift
mit schwungvollen Längen

2417

Marseille Archives Départem.
H. S. C. Q. 1

P. — 1255 Nov. 24

Alexander IIII .. vicario nobilis
viri .. comitis Provincie et Ande-
ganie in Arelato.

Apud eternorum regem

Lateran. VIII Kl. Dec. a° 1°

Bulle und Hanf ausgerissen
In plica links R₀
Sub plica links ;
Kleine regelmässige Schrift

2418

Archivio di Stato Milano
Bolle e Brevi vierzncell.

P. — 1255 Novembris 29

Alexander IIII dil. in aps filiab(us)
.. abbatisse mon. S. M. de Porta
Pedrioli Brixien. eiusque sor. iuxta

Religiosam vitam eligentibus
inveniunt Amen a Amen

R Ego Alexander catholice
ecclie eps Ss m

2 presb. 2 epi 3 diac.

Laterann. p. m. Guitti magistri
scolarum Parmen. SRE. vice-
Cancellarii IIIKl. Dec. ind XIII. Inc.
Dnice a° M. CC. LV pont. uero dn-
ni Alex. pp. IIII a° primo

Bulle fehlt; Seide erhalten.

2419

Archives Nationales Paris
L 249 n. 49 1255 Decembris 2

Br. 23.6 hoch 20.7 Plica 2.
oberer Rand 5.3 links und
rechts ohne Leitenlinien 1.6, 1.6

Alexander IIII .. Abbati et Con-
uentui Monasterii Furniacen
Cistercien ordinis Laudunen dioc
devotionis vre precibus
Dat Laterann IIII Non decembr a° 1°

Bulle und Seide fehlen
In plica rechts: L. de Jul
A tergo Ecke oben links : X
" oben Mitte : frater . F

Weite kräftige Schrift mit gestr. Ligatur
ren, mit 3 verzierten Satzanfängen
In 1. Zeile 1 verz. Buchstabe

Erste Linie für Gitterschrift

frater F bullator ?

P. vacat

2420

Archives Nationales Paris
L 249 n. 50 1255 Decembris 4

Br. 33.2 Loch 26.8 Plica 3.3
 oberer Rand 6.2 links 1.6
rechts 1.6
 Alexander IIII (Gitterschrift, initiale verziert) Archiepis z Epis in quorum diocesibus ecclie ac domus Militie Templi consistunt
 Quanto amplius ene
dat Lateran. ij non decembr a° 1°

Bulle an feiner Seide
 In plica rechts : Jo. by
A tergo oben mitte

Kleine ortentliche Schrift, mit gestr. Ligaturen, mit 3 verzierten Satzanfängen
 In 1ter Zeile 1 ver. Buchstabe
Erste Linie für Gitterschrift und oberhalb
freien
Papstname im Text in Gitterschrift

P. vacat

2421

Madrid Arch. Histór. Nacional
P. — Poblet E n. 63
 1255 Decembr. 4

Alexander IIII .. archepo Terra chonen. eiusque suffraganeis et aliis eccliarum prelatis per Terraconen. provinciam constitutis
Felicis recordationis Honorii
Lateran. ij non. Dec. a° 1°
Bulle an Seide
In plica links jc

2422 (recto)

Paris Archives Nationales
 J 431 n. 32
Breite 30.9 Rand links 1.3 rechts 1.1
Höhe 21.6 Rand oben 5.2 plica 2.3
Ohne freie erste Linie / Je eine Seitenlinie

P. vacat 1255 Decembris 7
Alexander IIII .. priori provin ciali fratrum Predicatorum z ..
Guardiano fratrum Minorum
Parisien
 Licet nobis per
dat Lateran. vij jd Decembr 1
a° primo
 Bulle an Hanf.
In plica rechts : Jac p
Rand oben halbrechts : Dno Jo. G.
Links : ..
 zweite

2422 (verso)

A tergo
Ecke oben links : 2
 Mitte oben : + Rex +
Feste prachtvolle mittelgrosse
Schrift

Archives Nationales Paris

L 249 n. 51 _1255 Decembris 7_

Br. 21.8 hoch 14.7 Plica 2.2
 obern Rand 3.9 links 0.9
rechts 0.9
 Alexander IIII . . Cancellario
Parisien
Dat Literarum VII Id Decembr a°10
 Licet nos olim

Bulle an Hanf
 In plica rechts: Jo. anag
A tergo oben Mitte: Predicator

Kleine runde Schrift

Mit einem betonten Buchstaben

Erste Linie zwecklos

P. 16104

Archives Nationales Paris

L 249 n. 51 bis _1255 Decembris 7_

Br. 23.8 hoch 16.5 Plica 3.3
 obern Rand 5.6 links 1.
rechts 1.1
 Alexander IIII .. Cancellario Pa-
risien
Dat Literarum . VII . Id Decembr a°10
 Licet nos olim

Bulle an Hanf
 A tergo oben Mitte : Predicator

Kleine runde zusammenhängende
Schrift

Mit einem betonten Buchstaben

Erste Linie zwecklos

P. 16104

Archives nationales Paris

L 249 n. 52 _1255 Decembris 7_

Br. 21.1 hoch 15.2 Plica 2.3
 obern Rand 4.5 links 1.2
rechts 1.2
 Alexander IIII .. Cancellario See
Genovefe Parisien
Dat Literarum . VII. Id. Decembr a°10
 Licet nos olim

Bulle fehlt, dicker Hanf erhalten
 A tergo oben Mitte : Predicator

Sehr regelmässige zusammenhängen-
de Schrift

Ohne jeden besonderen Buchstaben
Erste Linie zwecklos

P. vacat

Triplicatur

Archives Nationales Paris

L 249 n. 53 _1255 Decembris 7_

Br. 28.2 hoch 20. Plica 2.
 obern Rand 4.9 links 1
rechts 1.1
 Alexander IIII . .. Aurelianen et
Antisiodoren Epis
Dat Literarum VII Id Decembr a°10
 Cum nos olim

Bulle fehlt Hanf erhalten
 In plica rechts: Lat. p
Sub plica links
 Rand oben Mitte Triplicatur
A tergo Ecke oben links : J
 " oben Mitte Predicator

Enge kleine Schrift
 mit einem betonten Buchstaben

Ohne erste freie XX Linie

P. 16105

2427

Instr. Mon. F. Dom. c 16 1255 Dec. 7
P. 16104
Alex IIII .. cancellario Parisien.
Licet nos olim —
Lateran VII id. decembris a° 1°
Bulle an Hanfschnur
In plica rechts : Jo Anag.
A tergo : predictorum
In plica links additio : nisi prius tibi
bona fide promiseret predictam ordinatio-
nem nostram et mandata in ea contenta
se firmiter et inviolabiliter servaturum
Hinter firmiter ist servaturum ausgestrichen
Darunter : Simili modo scribitur can-
cellario Sce Genovefe Parisien.

2428

P. — Paris Arch. nat.
J 431 cap. 32 1255 Dec. 7
Alex IIII .. priori provinciali
fratrum Pred. in Francia et
.. guardiano fratrum Minorum
Parisien.
Licet vobis per
Lateran VII id. Dec. a° 1°
Bulle an Hanf
In plica rechts Jac p
Sub plica links —
Rand oben Mitte :
Dno Jo. G.

Johannes Gaetanus

2429

Bayer. Hauptst. Staatsarchiv
Regensburg Augustiner fasc. 1
P. 16115 1255 Decembris 9
Alexander IIII (roman. Mai.) e. s. s.
Dei dil. filijs .. Priori et fratribus
Heremitis in Alamania consti-
tis tam pres. quam futuris regularem
vitam professis TH PPM
Religiosam vitam eligentibus
pacis inveniant AMEN a ——— AMEN
R. Ego Alexander Cath. Ecclie Epus M
2 presb 2 epi 3 diaconi
Dat. Lateran. per manum Guilli
Magriscolarum parmen. Sce Romane
ecclie vicecancellarij V id. Decem-
bris Ind. XIV pre. diva anus. Obs
M. CC LV pontif. vero domni
ALEXANDRI pp IIII anno primo
Bulle an Seide
Ecke oben rechts : a
Kleine schöne Gitterschrift mit mittel-
grossen nur sehr grossen bichsta-
gen und etwas betonten Unterlängen

2430

Firenze, Vallombrosa
P. 16118 1255 Decembris 9
Alexander IIII .. potestati ..
capitaneo, antianis et con-
silio Florentie.
Cum sicut accepimus
Lateran. V id. Dec. a° 1°
Bulle und Hanf fehlen
In plica rechts . v C. p.
Oberste Zeile bemutzt
Sub plica unliniirt

2431

Archives nationales. Paris

L279 n. 54 1255 Decembris 10

Br. 32 Hoch 26. Plica 2.2
oberer Rand 5.2 links 0.9
rechts 1.1
Alexander IIII .. Aurelianen. et
.. Antisiodoren. Epi.
Ad audientiam nram
Dat Lateran. IIII Jd. Decembr a° 10

Bulle an Hanf
In plica rechts : a. S.
A tergo oben Mitte : Bedycatoz

Kleine sehr schwungvolle Schrift
mit 1 betonten Anchstaben
Erste Linie für Oberlängen

P. 16121

2432

Instr. Mon. F. Dom. c. 10 1255 Dec. 10
P. 16121

Alex. IIII .. Aurelinuen. et .. Anti-
siodoren. episcopis.
Ad audientiam nostram
Lateran. IIII id. Decembr a° 1°
Bulle an Hanfschnur
In plica rechts: adg. Orden IV P
A tergo : predicatorum

2433

Madrid Arch. Histór. Nacional
Poblet C n. 64
P. 16124 1255 Decembris 11

Alexander IIII .. abbi Cistercii et
ceteris coabbatibus et conventibus
CistO
Sacre vestre religionis
Lateran. III id. Dec. a° 1°
Bulle fehlt. Snüre erhalten
In plica rechts adep P

feine Snüre

2434

Madrid Arch. Histór. Nacional
Poblet E n. 62
P. 16123 1255 Decembris 11

Alexander IIII .. abbi Cistercii
eiusque coabbatibus et conventi-
bus universis CistO
Religionis vestre meretur
Lateran. III id. Dec. a° 1°
Bulle fehlt Snüre fehlen erhalten
In plica rechts Ja S.

2435

Firenze, CamalDoli
P.16122 *1255 Decembris 11*
Alexander IIII .. abbi sci Salvi
ordinis Vallis Umbrose Floren.
diu. dioc.
Dilecti filii .. abbates
Lateran. III iu. Dec. a°1°
Bulle und Hanf fehlen
In plica rechts 2
//// 'J. pad' //
Ecke oben rechts Jo
Rand oben breit.
Seitenränder schmäler
Oberste Linie unbenutzt
Sub plica unliniirt

2436

Madrid Arch. Histór. Nacional
Zaragoza Rueda 23 E
Fälschung
1255 Decembris 11
Alexander IIII abbati Cisterci
ens. eiusque coabbatibus et
conventibus universis Cist.
ord.
Religionis vestre meretur
Dat. Aninion. III iu. Dec. a°1°
Bulle und Seide fehlen
In plica rechts Jo de Frutis
Sub plica links Absaldus de Fabri..
A tergo alte Klosterarchiv-
notiz, dass es Alexandri IIII
bulla sein soll.

2437

Firenze, S. Croce di Firenze
P.(16129) *1255 Decembris 12*
Alexander IIII .. Perusin. et .. se
ener. epis
Quedam ab apostolica
Lateran. II iu. Dec. a°1°
Bulle und Hanf fehlen
A Initiale. Keine gestr. Lig
In plica rechts Hug. V.
Erste Zeile unbenutzt
Sub plica unliniirt
Seitenlinien, schmale Ränder
Enge kleine Schrift mit erheb
lichen Längen

2438

Archives Nationales Paris
L249 n.55 *1255 Decembris 13*
Br. 22.8 hoch 18.2 Plica 3.1
oben Rand 3.9 links 0.9
rechts 1.
Alexander IIII (Gitterschrift, Initiale
verziert) .. Abbati et Conventui mo-
nasterij sancti dionisij in Francia
ordinis sancti Benedicti ad Romanam
ecclesiam nullo medio pertinentis
Ne privilegia vestra
Dat. Lateran. id decembr a°1°
Bulle an feiner Seide
In plica rechts: C. la (?)
Sub plica links: ;
Rand oben links: Rx
Feste kleine Schrift, mit gestr. Ligaturen
mit 3 verzierten Oberbögen
In 1. Zeile 1 verz. Buchstabe
Erste Linie für Gitterschrift und untere
Oberlängen
P. 16134

2439 (recto)

Archives Nationales Paris R.

L 249 n. 56 *1255 Decembris 13*

Br. 33.2 Hoch 28.3 Plica 4.1
oberer Rand 7.2 links 1.7
rechts 1.7

Alexander IIII (. Gitterschrift, im
Titel variiert). Abbati et Conventui
Monasterij sancti Dionisij in Francia
ordinis sancti Benedicti ad Romanam
ecclesiam nullo medio pertinentis.
Exigentibus nestre devotionis
Dat. Laterani Id decembr. a° 1°

Bulle an feiner Seide
In plica rechts : . O . la (?)
Sub plica links : . .
Rand oben links : R. P. vacat
nitte cor
A tergo Ecke oben links : a
a tergo oben nitte
schwungvoll 3.
Jcc lxj. capto anno primo

Ungelenke Schrift mit fast . Ligaturen
mit 3 verz. Schraufingeln verte

2439 (verso)

Erste Zeile 1 verz. Buchstabe
Erste Linie für Gitterschrift und
nichts Überlängen

2440

Firenze, Vallombrosa
P. 16131 *1255 Decembris 13*

Alexander IIII . . abbi et con
ventui monasterii Vallis
Umbrose

Cum a nobis
Laterani id Dec . a° 1°
Bulle und Seide fehlen
In plica rechts . a . p .
Sub plica links . .
Ecke oben rechts R.
A tergo oben Mitte
gross schlank schön
Erste Zeile unbeamtet
Sub plica unliniert
Registres cap. 960 DCCLXXI capto anno prino

ganz schmale Seiten
ränder

2441

Paris Archives Nationales R.
J 431 n. 30
Breite 60.7 Rand links 7.5 rechts 1.5
Höhe 39.7 Rand oben 6 plica 4.7
Zwei freie Linien / Je 1 Seitenlinie
P. 16132 *1255 Decembris 13*
Alexander IIII -- priori Provinciali
frum Predicatorum in Francia et --
Guardiani frum Minorum Parisien.
Pre cunctis mentis
Dat Laterani Id decembr. / a° 1°
Bulle an Hanf
A tergo oben Mitte : Rex
Darunter gross Präsig schön

Jccc l 111 capto anno primo

Firenze, Vallombrosa
P. 16139 1255 Decembris 14
Alexander IIII Magistro Petro
Henrici basilice Principis
Apostolorum canonico
 Audiendo vix credimus
Lateran XVIIII Kl. Ian. a° 1°
 Bulle und Hanf fehlen
In plica rechts Iar...
 Oberste Zeile unbenutzt
Sub plica unliniirt

Wiesbaden Staatsarchiv
Kl. Eberbach
P. 16137 1255 Decembris 14
Alexander IIII .. archepo Magun-
tin. eiusque suffraganeis
et aliis ecclesiarum prelatis
per Maguntin. provinciam
constitutis
Felicis recordationis Honorii
Lateran XVIIII Kl. Ian. a° 1°
 Bulle an Seide

 Sub plica zwei Zeilen un-
liniirt Bullenanfang

Firenze, Vallombrosa
P. 16138 1255 Decembris 14
Alexander IIII .. abbi Sci Mi-
chaelis Pistorien.
 Cum olim ad
Lateran. XVIIII Kl. Ian. a° 1°
 Bulle und Hanf fehlen
Sub plica links ..
 Oberste Zeile unbenutzt
Raumberechnung schlecht ge-
macht, so dass gegen Schluss die
Schrift immer enger wird und
die plica ganz klein und trotz
dem noch die letzte Zeile deckt.

Portici Archivio depart.
St. Helmire Evêché
P. — 1255 Decembris 15
Alexander IIII .. epo Pictaviens.
 Ex devotionis tue
Lateran. XVIIII Kl. Ian. a° 1°
Bulle nur Seide ausgerissen
In plica rechts pax g
A tergo oben Mitte

 dcclxxix capt anno primo
 Registres cap. 968

2446

Archives Nationales Paris
L 4 x 9 n. 57 _1255 Decembris 18_

Br. 26.1 hoch 20.3 Plica 2.4
oberer Rand 5.3 links 1.8
rechts 1.8
Alexander IIII dil. in X̅p̅o̅ filia
bus .. Abbatisse et Conventui Mo
nasterij S̅t̅e̅ Marie Suessionen or-
dinis S̅t̅i̅ Benedicti
Ex suscepte amministrationi
Dat Lateran̅ X̅V̅ kl Januar̅ a° 10

Bulle und Seide ausgerissen
In plica rechts 1 pt R
A tergo oben Mitte: Paulus S̅S̅S̅

Eckige enge regelm. Schrift nur st
in Ligatur, et, mit Ausnahme von ersten
Zeile, ohne Ligatur, mit 5 verzierten
Satzanfängen,

Papstnamen in Text in Gitterschrift
Erste Linie für Gitterschrift und unteru
Oberlängen
P. vacat

2447

Archivio di Stato Milano
Bolle e Brevi Fälschung
(1254 dec. 20 -
– 1255 dec. 19) 1254/55
Alexander universis et singuli
viris Religiosis ord. Sci Dominici
provincie Lombardie
Dignum est et
Dat. apud Lateranen. anno d̅n̅i̅
m̅ cc̅ quinquagesimo ducentesimo pont. d̅n̅i̅ Ale
xandri ppe IIII anno primo
plica. War besiegelt 1 Löcher
Schnur war stark angezogen.

2448

Madrid Arch. Histor. Nacional
Valencia Roqueta 5 E
vicecancellarius
Nachbildung
P. –
1255 Decembris 22
Alexander IIII abb̅i̅ de mon. de B-
puleto eiusque etc. in p̅p̅m
Religiosam vitam eligentibus
inveniant Amen. A. A.
R. Ego etc. (M)
2 presb. 2 epi 3 diac.
Lateran. p. m. Guillermi magri
scolarum Parmen. SRE vicecan
cellarii XI kl. Jan. ind. XIII J. dce
a° m̅ cc̅ LV pont. vero Domni
Allx. pp. quarti a° 20

2449

Marseille Archives Départem.
H. o. m. 19
P. –
1256 Januar 15
Alexander IIII .. magro et fra-
tribus Hospitalis sancti Johannis
Jerosolimitani
Ad arriduum xpi
Lateranen. XVIII kl. febr. a° 20
Bulle an Seide
Ohne Notizen
Erste Zeile frei
Sehr kräftige, regelmässige, schöne
Schrift.

2450

Archives Nationales Paris

L250 n. 58 **1256 Januarii 18**

Br. 31.5 hoch 22.3 Plica 2.7
oberer Rand 5.3 links 0.8
rechts 0.8

Alexander IIII. - - Decano et
Capitulo Laudunen
Conquestione dilectorum filion
Dat Lateran XV Kl Febr a° 2°

Bulle auf dickem Hauf
In plica rechts : . a. p.
Sub plica links : S
Ecke oben rechts : a
A tergo oben Mitte : Scs Antonius

Feste Klare Schrift
mit einem betonten Buchstabe

Erste Linie für Oberlängen

P. vacat

2451

ad instar

Archives nationales Paris

L250 n. 59 **1256 Januarii 20**

Br. 29.7 hoch 22.8 Plica 2.9
oberer Rand 5.5 links 1.2
rechts 1.4

Alexander IIII (Gitterschrift, Ini-
tiale verziert). - Magro et fra-
tribus Militie Templi Jerlimitan
Quanto devotius divino
Dat Lateran XIII Kl Februar a° 2°

Bulle an feiner Seide
In plica rechts : . A. G.
Rand oben Mitte : fiat ad instar . a
A tergo oben Mitte : T frater

Schwungvolle kleine Schrift, mit gestr.
Ligaturen, mit 4 verzierten Litt aufzügen
In 1. Zeile 1 var. Buchstabe

Erste Linie für Gitterschrift und unteren
Oberlängen

P x 16198

2452

R

Archives Nationales Paris

L250 n. 60 **1256 Januarii 21**

Br. 48 hoch 39.5 Plica 4.2
oberer Rand 7.4 links 2.
rechts 1.9

Alexander IIII (Minusculae)
Universis has litteras inspecturis
Universitati vre presentibus
Dat Lateran XII Kl Februar a° 2°

Bulle an feiner Seide
In plica rechts : R. Alat
A tergo oben Mitte :
paulus 777

Schwungvoll, 4.2 R P. vacat
schmal, dicker Strich
lxxx capte (anno o)o

Besonders grosse und feine
liche Schrift, mit gestr Ligaturen
mit 3 verzierten Litt aufzügen
In 1. Zeile 2 var. Buchstaben
Erste Linie für Papstnamen und Ober-
längen

2453

Firenze, Bonifazio
Abschrift

P. — **1256 Januarii 26**

Alexander IIII priori eccle. S.
Crucis de Ornianorio eiusque
fribus etc

Religiosam vitam eligentibus
Unterschriften fehlen

Lateran. p. m. Guillermi
magistri Scholarum Parmen. SRE
vicecancellarii VII Kl. febr. Ind.
XIIII Inc. Dnice a° 1255 pont. 2°

Register exp. 1089
Eine zweite ausgezeichnet
nachgemachte beglaubigte
Abschrift: Firenze, Monte
Pulciano

Archives Nationales Paris
L250 n. 61 1256 Januarii 28

Br. 29.2 hoch 21.4 Plica 2.7
 oberer Rand 4.9 links 1.3
rechts 1.2
 Alexander iiii .. Abbati Case
dei Claromonten. dioc. .. Offi-
ciali et magro Petro bodini Ca-
nonico ecclie scī Genesii Claro-
monten.
 Petitio nobilis viri
Dat Lateran. V Kl februar. a° 20

Bulle an Hanf
 In plica rechts : Guitt
Ecke oben rechts: pe
A tergo lange dreizeilige Kanzlei-
bemerkung über die Ausfertigung
anderer Bullen in der gleichen
Streitsache

Kleine nachlässige Schrift
 Ohne jeden betonten Buchstaben
 P. 16215

Archives Nationales Paris
L250 n. 62 1256 Januarii 28

Br. 37. hoch 27.6 Plica 2.5
 oberer Rand 6.4 links 1.3
rechts 1.4
 Alexander iiii .. Antoni Belna
cen et magro Roberto de Duaco
Canonico Siluanecten.
 Felicis recordationis Innocen. (hic)
Dat Lateran. V Kl februar. a° 20

Bulle fehlt, Hanf erhalten
 In plica rechts : Jac p
A tergo oben mitte : Predicatorum

Schöne kleine Schrift

Mit einem betonten Buchstaben

Ohne freie erste Linie
Papstname Text nicht in Gitterschrift
 P. vacat

Archives Nationales Paris
L 250 n. 62 bis 1256 Januarii 28

Br. 35.2 hoch 27.6 Plica 3.
 oberer Rand 6.3 links 1.3
rechts 1.2
 Alexander iiii .. Aurelianen.
et .. Antisiodoren. Epis
 Felicis recordationis Innoc.
Dat Lateran. V Kl Februar. a° 2°

Bulle fehlt Hanf erhalten
 a tergo oben mitte : Predicator.

Kleine regelm. Schrift

 Mit einem betonten Buchstaben

Ohne freie erste Linie

Papstname im Text nicht in
 Gitterschrift
 P. vacat

Anstr. misc. 1250-1275 cap. 8
 P — 1256 Jan. 28

Alex. IIII ..epo Magalonen.

La que a

Lateran. V Kal. Februarii a° 20

Bulle und Seide fehlen
In plica rechts : Gen J.

 Duplicat

Cap. 7
Bulle und Seide fehlen
In plica rechts : Th. S.

2458

Montpellier, Ville de Montp.
E. V. Louvet 2244

P. — 1256 Februarii 2

Alexander IIII consulibus Montis
Pessulani. Magalonen. dioc.
Ex parte dilectorum
Lateran. IIII non. febr. a° 2°
Dicke unförmliche Bulle an Hanf
In plica rechts p de st

Erste Zeile frei.

2459

Archives Nationales Paris
L250 n. 64 1256 Februarii 3
Br. 27.8 hoch 24.3 Plica 3.4
oberer Rand 5.3 links 0.9
rechts 1.
Alexander IIII (Gitterschrift, In
Linie verziert) Archiepis et Epis
et dil filijs alijs eccliar Prelatis
ad quos littere iste pervenerint
Cum dilectos filios
Dat Lateran IIII non Februar a° 2°

Bulle an Seide
In plica links: B. S. V.
Seite oben rechts: a
A tergo oben mitte: ⊓ P. vacat

Kleine unordentliche Schrift mit
gestr. Ligaturen mit einem be-
sonten Satzanfang
In 1. Zeile 1 ver. Buchstabe

Papstname im Text in Gitterschrift
Erste Linie frei Gitterschr. und Ober-
längen

2460

Archives Nationales Paris
L250 n. 64 bis 1256 Februarii 3
Br. 29. hoch 18.4 Plica 3.1
oberer Rand 5.7 links 1.6
rechts 1.6
Alexander IIII (Gitterschrift, In
Linie verziert) Archiepis et Epis et
Dil filijs alijs ecclar prelatis ad
quos litteri iste pervenerint
Cum dilectos filios
Dat Lateran IIII non Februar a° 2°

Bulle an feiner Seide
In plica rechts: J. b°
A tergo oben mitte: ⊓ P. vacat

Schöne kleine Schrift, mit gestr.
Ligaturen, mit einem verzierten
Satzanfang

Papstname im Text in Gitterschrift

Erste Linie frei Gitterschrift

2461

Papstnamen

Archives Nationales Paris
L250 n. 65 1256 Februarii 4
Br. 34. hoch 376.5 Plica 3.7
oberer Rand 6.8 links 1.
rechts 1.
Alexander IIII (Gitterschrift, In
Linie verziert) . . Magro (fratribus
7 univese familie Hospi-
talis jerlimitan
Felicis recordationis Honorius
Dat Lateran IIII non Februar a° 2°

Bulle fehlt, Seide erhalten

Kleine fette schöne Schrift, mit gestreck.
Ligaturen, mit 4 verz. Satzanfängen
In 1. Zeile 1 ver. Buchstabe

Papstnamen im Texte nicht in Gitter-
schrift
Erste Linie frei Gitterschrift und Ober-
längen

P. vacat

2462

Public Record Office London
Papal Bulls bundle 2 n. 16
Clausa

Cedula interclusa
P. 16 229 1256 Februarii 5
Alexander IIIj .. epo Hereforden.
Pluries nobis extitit
Lateran. non. Febr. a° 2°
Bulle rechts an Hanf

An der Schnur hängt auch
eine cedula interclusa
aus Pergament, die im
Bullentext nicht er-
wähnt wird.

Scire te volumus ——
id specialiter per te fiat

2463

Instr: Monast. Monium. Trident.
P. 16233 1256 Februarii 6
Alexander IIII dilectis in xpo filia-
bus .. abbatisse et conventui Mona-
sterii s. Marie Montis Sancti Tuder-
tin. ordinis Sancti Damiani
Grate deo religionis
Latern. VIII id. Februarii a° 2°
Bulle an Seidenfäden.

2464

Archivio di Stato Milano
Bolle e Brevi
P. 16236 1256 Februarii 8
Alexander IIII ven. fri Rainerio
de Papia epo Magnen.
Dilecte in xpo
Latern. VI id Febr. a° 2°
Prachtvolle runde regelmäßi-
ge Bulle an Hanf
A tergo oben Mitte schlank
schön

Registres cap.
1291

CCXLIIII c apto anno 6°

2465

Marseille Archives Départem.
H. S. C. A. 1
P. — 1256 Februarii 8
Alexander IIII dil. in xpo filiab
Meraude et aliis sororibus mon.
See Clare Arelatan. ord s. Damian
Vestre mentis religionis
Latern. VI id. febr. a° 2°
Bulle fehlt, Seide erhalten
In plica rechts. Hugo. V.
Mittelmässige Schrift
Hässliche Ligaturen

2466

Marseille Archives Départem.
H. S. C. a. 1
. P. —

__1256 Februarii 9__

Alexander IIII univ. xpi fidelibus pres. litt. inspecturis
Quoniam ut ait
Lateran. V id. Febr. a° 2°
Bulle an Seide
In plica rechts Hugo . V.
Hässliche aber plane Schrift
Ungelenke Ligaturen

2467

Archives Nationales Paris
L250 n. 66 1256 Februarii 11
Br. 35. hoch 28.1 Plica 2.3
obere Rand 6.2 links 1.3
rechts 1.2
Alexander IIII . . Epo Parisien
Cum felicis recordationis
Dat Lateran PII Id Februar a° 2°
Bulle fehlt, Hanf erhalten
In plica rechts : Jac p̄
A tergo oben mitte : Predicatores
Kleine regelm. Schrift
Mit einem betonten Buchstaben
Ohne freie erste Zeile

P. vacat

2468

Public Record Office London
Papal Bulls bundle 2 n. 19
P— 1256 Februarii 12
Alexander IIII .. Magistro religiose
militie Templi quod Jerosolimis
situm est eiusque fratribus tam...
in perpetuum
Omne datum optimum
Amen Amen Amen
(R) Ego Alex. Cath. Ec. Epo so. (M)
2 presb. 2 epi̅ 4 diac.
Dat. Lateran. per manus Guillelmum
mag. scholarum Parmen. SRE vice-
cancellarium II id. Febr. ind. XIIII
Incarn. Dominice 1255 pont. vero domni
Alex. IIII a° 2°
Bulle an Seide
Ecke oben rechts a p̄t

2469

Ascultetur Fr. S bulla
 tor²
Archives Nationales Paris
L250 n. 67 1256 Februarii 22
Br. 32.4 hoch 25.6 Plica 2.5
obere Rand 6.4 links 1.6
rechts 1.6
Alexander IIII (Gitterschrift 2ui
Siebe veriert) .. Abbati Cistertij
eiusque Coabbatibus T Conventibus
vniuersis Cistertien ordinis
Religionis uestre meretur
Dat Lateran VIII Kl Martij a° 2°

Bulle und Seide fehlen
In plica rechts : a . vit
Rand oben mitte : ascultetur . l
Ecke oben rechts : a
A tergo oben mitte : Fr S P. vacat

Kleine nachlässige Schrift, mit gestr.
Ligaturen, mit 4 verz. Litt aufzügen
In 1. Zeile 1 verz. Buchstabe
Erste Linie für Gitterschrift

2470

Firenze, S. Croce di Firenze
P.16261 1256 Februarii 22
Alexander IIII [ohne Punkte]
miis. epis per Tusciam con-
stitutis
Recordamur liquido et
Lateran. VIII kl. Martii a° 2°
Bulle und Hanf fehlen
In plica rechts Hugo. V.

Oberste Linie unbenutzt
Sub plica zum Theil unliniirt

2471

Firenze, S. Croce di Firenze
P.- 1256 Martii 2
Alexander IIII [ohne Punkte] ven.
archiepis et epis et abbibus, prio-
ribus, decanis, archidiaconis,
prepositis, rectoribus et aliis eccle-
siarum prelatis per Tusciam
constitutis ad quos littere iste
pervenerint
De pia et
Lateran. VI Non. Martii a° 2°
Bulle und Hanf fehlen
In plica rechts ē pm
Oberste Linie unbenutzt.

2472

Archives Nationales Paris
L 250 n. 68 1256 Martii 3
Br. 39. hoch 29.9 Plica 2.9
oberer Rand 6.4 links 1.3
rechts 1.4
Alexander IIII
- Epo Parisien
De quibusdam Magnis
dat Lateran V non Martij a° 2°
Bulle fehlt, dicker Hanf erhalten
In plica rechts : Jac. P̄
A tergo oben mitte: Predicatorum
Fehlt kleine klare Schrift
Ein betonter Buchstabe
Ohne erste freie Linie

P. 16271

2473

Sustr. Mon. T. Tom. cap. 34 1256 Martii 3
P. 16271
Alex. IV .. epo Parisien
De quibusdam magistris —
Lateran. V non. Martii a° 2°
Hanfschnur. Bulle fehlt.
In plica rechts : Jac. ap.
links nicht sub plica : sublato
In plica links : ⌐ sublato appellationis
ob (straculo)
non cassentur
Reg. pag. I.

A tergo : predicatorum

2474

Bayer. Haupt. Landesarchiv
Oberschönfeld Fasc. 2

P. vacat 1256 Martii 4

Alexander IIII dil. in xpo filiabus
- - Abbatisse et Conventui Mo-
nasterii superioris Scloneveld Cis-
terciens. ordinis Augusten. dioc.
 Solet annuere sedes
Lateran. III non. Martij a° Secundo

Ausgezeichnete Prüfung, nur Schrift
seit. rechts unten Fehlerhaft. Lesb.
In plica rechts : aud. S.
Sub plica links : S
Rand rechts ziemlich oben : ~
Ecke oben rechts :

A tergo Ecke oben links : A

Gitterschrift, Übergang

2475

Archives Nationales Paris
L250 n.69 1256 Martii 7

Br. 35 hoch 27.5 Plica 2
oberer Rand 4.4 links 1.2
rechts 1.2
 Alexander IIII - - abbati Case
dei Claromonten dioc.
 Ex parte nobilis
Dat Lateran non Martij a° 2°

Bulle an Hanf
 In plica rechts : J. May
Sub plica links : S.
 A tergo oben mitte : unleserlich

Kleine gezogenes mit ungewohntem
ductus ausgeführte eckige Schrift

Mit einem leicht betonten Buchstaben

Erste freie Linie fehlt

P. 16284

2476

Instr. Mon. F. Dom. C. 53. 1256 Mart. 7
 P. 16286.

Alex. IIII inquisitoribus hereticorum
in Lombardia et Marchia Januen.
Exortis in agro.
Dat. Lateran non. Martii a° 2°
Bulle an Leinenfäden.
In plica rechts : Avm parm
In plica links : Ben. p - - A. de Cur.
Daneben additis : et simplici aes.
Tuns etc. Dann die Leiste :
Rx . Paul
sc. de Curia
Rand oben mitte : I. e. m. fratribus
ord. min. inquis. her. prav. in Vrbe
ac administratione ipsius presen-
tibus et futuris.
Daneben ausgestrichen :
 ostendantur dns Hug. et dns Ja.
 Cesetni.

2477

Toulouse, Archives Départem.
H. 23

P. - 1256 Mart. 8-14

Alexander IIII - - magro et prib.
Hospitalis Jerosolim.
 Ipsa nos cogit
Lateran. [F iv. Martii a° 2°
Etwas unregelmässige Bulle
an Seide
Ohne alle notizen

erste Zeile frei
Gestreckte Ligaturen

cf. 1256 Aug. 23
 1257 Jan. 2

Firenze, S. Chiara di Cortona
P.— 1256 Martii 9
Alexander IIII .. abbatisse et
conventui mon. beate Marie
de Tarcia iuxta muros Corton.
O. S. Damiani Aretin. dioc.
. Paupertati vestre quam
Lateran. VII iď. Martii a° 2°
Bulle fehlt, Seide erhalten
In plica links .). V.
In plica rechts petunt duas similes
Sub plica links S

Rand oben Mitte prior fieri fecit

Firenze, S. Chiara di Cortona
P.— 1256 Martii 10
Alexander IIII .. abbi de Farneta
Aretin. dioc.
Ex parte dilectorum [et. arum]
Lateran. VI iď. Martii a° 2°
Bulle und Hanf fehlen
In plica rechts ben nur
duas petunt similes pro monas.
terio Forlinien. et Imol.
Oberste Zeile unbenutzt
Sub plica unliniirt

Firenze, S. Maria di Cortona
P.— 1256 Martii 10
Alexander IIII dil. in xpo filiabus
.. abbatisse et conventui mon.
beate Marie de Tarcia iuxta
muros Corton. ord. Sci Damini
ani Aretin. dioc.
Devotionis vestre precibus
Lateran. VI iď. marcii a° 2°
Bulle fehlt, Seide erhalten
In plica rechts unbeserliche No.
tiz; darunter petunt duas simi
les pro monasterio forlinien.
et Imolen.
Sub plica links S / rechts v
Rand oben Mitte prior fieri fecit

Firenze, S. Chiara di Cortona
P.— 1256 Martii 13
Alexander IIII .. abbisse et con
ventui mon. beate Marie de
Tarcia iuxta muros Corton. ord.
sci Damiani Aretin. dioc.
Licet in de
Lateran. III iď. Martii a° 2°
Bulle und Seide fehlen
In plica rechts petunt similes
pro monasterio Forlinien
Rand oben Mitte prior fieri fecit
Oberste Linie frei
Sub plica unliniirt

2482

Montpellier, ville de Montp.
E. V Konvolut 22 45

P. — <u>1256 Martii 14</u>

Alexander IIII consulibus ville Mon-
tispessulan. Magalonen. dioc.
 Gaudemus in domino
Lateran. II id. Martii a° 2°
 Bulle an Hanf
An plica rechts R. Plat

Erste Zeile frei
Sehr schöne, flotte runde Schrift

2483 (recto)

Paris Archives Nationales
 J 585 n. 41
Breite 32.6 Rand links 1.8 rechts 1.7
Höhe 25.1 Rand oben 6. plica 2.8
 Erste Linie nur für Gitterschrift
Je eine Seitenlinie
<u>P. vacat</u> <u>1256 Martii 20</u>
Alexander IIII (Gitterschr) Carmo
in xpo filio Ludovico Regi Fran-
cie jllustri
 Curia proni sunt
Dat Lateran XIII Kl Aprilis a° 2°
 Bulle an feiner Seide
In plica rechts : Ger . p̄m
Sub plica links : ,··
 vacat
A tergo Ecke oben links : y

2483 (verso)

A tergo oben Mitte
 † Porta †
Schöne sehr regelm. weite
 Schrift

2484 (recto)

Paris Archives Nationales
 J 689 n. 129c
Breite 32.4 Rand links 1.6 rechts 1.3
Höhe 26.7 Rand oben 5.5 plica 3.
Erste Linie für Gitterschr nur
Kleinere Oberlängen (<u>Links und
rechts zwei Seitenlinien</u>
<u>P. vacat</u> <u>1256 Martii 20</u>
Alexander IIII (Gitterschr)
Carmis in xpo filijs Ludovico
Regi et Margarete Vxori eius
Regine Francie jllustribus
 Jlla Regalium excellentiam
Dat Lateran XIII Kl Aprilis
a° 2°
 Bulle an Seide vacat
In plica rechts : Ger. p

2484 (verso)

Sub plica links : ..
Ecke oben links : R̶
Rand oben Mitte : 2
A tergo oben Mitte :
+ Porta +
Darunter schlank

Scpt

CCXVIII Capte anno secundo

Schöne feste kleine Schrift

2485

Madrid Arch. Histór. Nacional
Gumiel Burgos 10. G
P.— 1256 Martii 20
Alexander IIII . . — abbi et conv.
monasterii S. Petri de Go-
miel Cist Ord. Oxomen. diöc.
Sedes aplica olim
Lateran. XIII Kl. Aprilis a° 2°
Sub plica links ..
Rand oben Mitte auscultata

Duplicat

2486

Madrid Arch. Histór. Nacional
Palazuelos h. 4
1256 Martii 20
Alexander IIII . . abbi et conv.
mon. de Palatiolis Cist Ord.
Palentin. diöc.
Sedes apostolica olim
Lateran. XIII Kl. Apr. a° 2°
Bulle und Seide fehlen
Duplica rechts Schreibername
Sub plica links ..

Duplicat

2487

Graz Landesarchiv n. 735
P.— 1256 Martii 27
Alexander IIII . . priorisse et
Conventui monasterii de Fon-
te Gratie in Studeniz O S.
Aug. Aquilegen. diöc.
Pie postulatio voluntatis
Lateran. VI Kl. Aprilis a° 2°
Bulle und Seide liegen bei
In plica rechts b. p.
Seitenlinien . Oberste Zeile
unbeschrieben
Gestreckte Ligaturen

P 16313 Paris Arch. nat.
J 683 cap. 16 bis **1256 Mart. 31**
Alex III Lodowico regi Francie
illustri
 Illo caritatis affectu
Lateran. II Kl. Aprilis a° 2°
 Bulle an Seide
In plica rechts Vbr p. 2
 pro I . de Mel 2
Ecke oben links Rx
Rand oben mitte Rx p y
A tergo + porta +

[scpt] [scpt] Registres
ccom caplo anno sec. cap. 1247

Firenze, S. Chiara di Cortona
P. — **1256 Martii 31**
Alexander III dil. in xpo filiabus
.. abbatisse [Punkte] mon.
sce Marie de Tiercia iuxta mu-
ros de Cortona. eiusque — in ppm
 Religiosam vitam eligentibus
inveniunt amen A Amen.
R Ego Alexander catholice
 Ecclie Eps. m
2 presb. 2 epi 3 diac.
Lateran. p. m. Guillermi magis-
tri scolarum Parmen. SRE
vicecancellarii II Kl. Aprilis
ind. XIIII I.D. a° m. cc Lvi p. uno
domni ALEXANDRI pp. IIII a° 2°
Bulle an Seide

Firenze, Camaldoli
P. 16316 **1256 Aprilis 2**
Alexander III . . priori Camald.
dulen.
 Quia liberius consuevit
Lateran. IIII non. Apr. a° 2°
 Bulle und Seide fehlen
In plica rechts F. R
In plica mitte duplicetur
Sub plica links i ?
Rand oben mitte
ausculteter und ad instar di
Ecke oben rechts a und

Archives Nationales Paris
L 250 n. 70 **1256 Aprilis 4**
Br. 36.9 hoch 30.7 Plica 3.
 oberer Rand 6.4 links 1.3
 rechts 1.4
 Alexander IIII dx universis
magistris scolaribus r Auditoribus
Parisien
 Si filialis obedientie
dat Lateran. II non Aprilis a° 2°
 Bulle fehlt, dicken Hanf erhalten
In plica rechts : . a.a
Sub plica links : . . .
 i

A tergo Ecke oben links : J
 " oben mitte : Predicatores
Schöne kleine runde Schrift
Mit einem leicht betonten Buchstaben
g ohne erste freie Linie P. 16320

2492

Archives Nationales Paris

L 259 n. 71 1256 Aprilis 4

Br. 36.5 hoch 31.4 Plica 3.4
 oberer Rand 7.1 links 2.
rechts 2.
 Alexander IIII . . . Epo Parisien
 dilecti filii fratres
Dat Lateran. π non. Aprilis a° 20

Bulle an Hanf
 In plica links : J. Q
A tergo oben Mitte : Predicatory

Weite kleine runde Schrift

Mit einem betonten Buchstaben

Erste Linie für Oberlingen

 P. 16324

2493

Staatsarchiv Wien Chronol.
 P. 16321 1256 Aprilis 4

Alexander IIII . . abbati Sce.
cis Cistercien. ord. Patavien.
diocesis
 Conquestus est nobis
 Lateran. π non. Apr. a° 20
Prachtvolle Bulle an Hanf.
In plica rechts Th. S
Ecke oben rechts ⌗ ?

Oberste Zeile frei.

Ganz kleines rundes.

2494

Instr. Misc. F. Dom. c. 35 1256 Apr. 4
 P. 16320
Alex IIII univ. magistris, scolaribus et
auditoribus Patavien.
Si filiis obedientie
Lateran. π non. Aprilis a° 20
Hanfschnur. Bulle fehlt.
In plica rechts : Jac
A tergo : Predicatorum

2495

Marseille Archives départem
B 350
 P. — 1256 Aprilis 5

Alexander IIII .. epo Bellicen.
Sua nobis dilecta
Lateran. non. Apr. a° 20
Bulle an Hanf
In plica rechts J. Si
 pro B a f
Schlechte hässliche, leicht nach
links geneigte Schrift. Klein
fett.

Schreibschule

Archives Nationales Paris
L 250 n. 73 <u>1256 Aprilis 10</u>

Br. 30.3 hoch 23.7 Plica 3.
obcrer Rand 5.4 links 0.9
rechts 0.9
 Alexander IIII (Gitterschrift,
Initiale verziert) Vgninio decan'
ecclie sci Gengulfi Tullen
 Tua nobis exhibita
Dat Lateran IIII id Aprilis a° 2°

Bulle fehlt, Seide erhalten
 In plica rechts: Johes parm

Fette kleine eckige Schrift, mit gestr.
Ligaturen, mit drei verzierten Schäften
fen. In 1. Zeile 1 verz. Buchstabe

Erste Linie frei Gitterschrift und Oberlängen

 (nunes (sic) , capud (sic)

 P. vacat

Archives Nationales Paris
L 250 n. 74 <u>1256 aprilis 12</u>

Br. 39.2 hoch 33. Plica 2.7
obcrer Rand 5.4 links 1.7
rechts 1.5
 Alexander IIII Carissimo in xpo
filio . . Regi Francorz Illustri
 dilecti filij fratres
Dat Lateran † id Aprilis a° 2°

Bulle fehlt, dicker Hanf erhalten
 In plica rechts: Angt
Sub plica links : . . .
 A tergo oben Mitte : Predicatoz

Weite klare sehr fette Schrift

Mit einem betonten Buchstaben

Erste Linie frei Oberlängen
pposito

 P. 16338

2498

Firenze, S. Lorenzo di Pistoia
P. —
 <u>1256 Aprilis 12</u>
Alexander IIII . . generali et
provincialibus prioribus ac
universis fratribus Herenita
rum Ord Sci Aug.

 Ut eo fortius
Lateran. II iv. Apr. a° 20
Bulle und Seidefehlen
In plica links J. V.
Oberste Linie frei
Sub plica unliniirt

2499

Instr. Misc. F. tom. c. 45. 1256 Maius
 P. 16365 rep.11290
Alex. IV . . mag. et universis fratribus
ord. fratrum Predicatorum
cum eam per.
Lateran. III non. Maii anno 20
Seidenfäden. Bulle fehlt.
In plica links : Henns mit ste
frickel in Maul, drunter
 Ja. har.
Sub plica links : .
A tergo: predicatorum

2500

Instr. mon. F. Dom. c. 50 1256 Maii 5
P. 16360 reg. 7917
Alex. IIII fratribus ord. Predic.
Cum paupertatem et —
Laterani III non. Maii anno 2°
Bulle an Seidenfäden
In plica rechts: Ia . Nar.
Über der plica links: ?
A tergo : predicatorum

2501

Instr. mon. F. Dom. Cap. 58 1256 Maii 5
P. 16366 reg. 11239
Alex IV .. mag. et prioribus ac fratribus ord.
Predical.
Vestra semper in —
Laterani III non. Maii a° 2°
Seidenfäden. Bulle fehlt.
In plica rechts : Ia Nar
" " Mitte links neben Besiegelung:
P. B
sub plica links: ?
A tergo : Predicatorum

2502

Instr. mon. F. Dom. c 69 1256 Maii 5
P. 16361
reg. 11041
vobis extremam patientibus
Bulle an Seidenfäden
In plica rechts: Hanar (?)
sub plica links: ?
A tergo : predicatorum

Alex. IIII magistro et fratribus
ord. fratrum Praedic.

Dat. Laterani . III non. maii
anno 2°.

2503

Instr. mon. F. Dom. c. 83 1256 Maii 5
P. 16359 reg. 11245
Alex. IV .. mag. et fratribus ord. Predic.
Odore suavi ordinis —
Laterani III non. Maii a° secundo
Bulle an Seidenfäden
Letzte Zeile von der plica ganz be-
deckt.
In plica rechts : Ia. Nar.
In plica links bei der Bulle :. P. B.
A tergo : predicatorum

P. B. = Petrus de Baninca (Benevento) archi-
diaconus Brotiensis in ecclesia
Agenensi
Arndt-Tangl, Schriftspelen
III pag. 50 col. 1 Bresslau
289. Anm. 8
Guiraud 1008 , 1142 . 1168. 1225 . 1481
1679 . 1682 . 1961 . 2567

2504

Instr. Mon. F. Dom. c. 128 1256 Maii
 ora 332 P. 16362 reg. 11303
Quia confusio habilibus
Bulle an Kaufschum

In plica rechts: Ja Nar
A tergo : predicatorum

 c. 77 ora Fondo Dom. 333
Duplicat
Bulle an Seidenfäden
In plica rechts: Th. J.
A tergo : predicatorum

Alex. IIII archiepiscopis et epi-
 scopis
Dat. Laterani. III non. maii
 anno 2°.

2505

Karlsruhe Gr. Bad. Gen. Landesar.
Select der Papsturk. cap. 193
P. — 1256 Maii 5
Alexander III preposito eccle in Pe-
ningen eiusque in perp.
Religiosam vitam eligentibus
 Capitelsanfänge leise betont
Amen Amen Amen
(R) Ego Alexander etc. (M)
Bei Reihen (2. 2. 4) Unterschriften
Dat. Laterani per manum Guillel
mi magistri scolarum Parmen.
SRE. vicecancellarii III non.
Maii anno secundo
Bulle an Seide
In plica rechts : J. Pad.
Ecke oben rechts a

2506

Bayer. Haupt. Staatsarchiv
Regensburg St. Emmeram fasc. 8
P. 16371 1256 Maii 6
Alexander III (Gitterschrift) — Ab-
bati et Conuentui Monasterij sancti
Emerammi Rationen ordinis
sancti Benedicti
 Cum a nobis
Laterani. III Non. Maij Anno Secundo

Bulle an Seide
In plica rechts : adeg p
Sub plica links :
 5
Ecke oben rechts. Ja . Mitte |. [(esta)
A tergo Ecke oben links : y lecta

Erste Zeile frei. Seiten linien
Kleine etwas. fahrige Schrift

2507

Firenze, Camaldoli
P. — 1256 Maii 6
Alexander IIII [ohne Punkte]
univ. abbibus et prioribus
ad quos littere iste peruenerint
 Cum sicut scire
Laterani III non. maii a° 2°
 Bulle fehlt, durch erhalten
Rand oben halbrechts pe
Rand oben Mitte ad instar

2508

Instr. Mon. F. Dom. c. 95 1256 Maii 8
P. 16378, rep. 11423
Alex IIII .. mag. et fratribus ord. Predic.
Meminimus vobis olim
Laterani VIII iď. Maii a° 2°
Bulle an Seidenfäden
In plica rechts: Ta mai
Duplica bei Besiegelung: P. B.
Sub plica links: ..
 M
Oben Rand rechts: fiat (narratione
habita qualiter eam fecerit prede-
cessor) ita quod si inibitio procemi
(a dno nro) quod et declaracio (a...
lis) eius fiat. das Eingeklammerte ist
A tergo: predicatorum übergeschrieben

2509

P. – Paris Arch. Nat.
J 391 cap. 8 1256 Maii 9
Alex IIII .. magistro scolarum
ecclesie Cenomanen.
Ut ex prerogativa
Laterani VII iď. Maii a° 2°
Nicht bullirt hat aber plica
In plica rechts Augf
Rand oben Mitte Rx ut at

2510

Firenze, Badia Fiorentina
P. – 1256 Maii 11
Alexander IIII Bartholomeo ab-
bati et conventui mon. See
Marie Florentin. OSB ad Ro-
man. Ecclesiam ul dr immul-
lo medio pertinentis
Exigentibus vestre deotionis
Laterani. V iď. Maii a° 2°
Bulle fehlt, Seide erhalten
Erste Linie frei

2511

Napoli Curia Eccles. vol. 3°
P. – 1256 Maii 11
Alexander IIII .. abbati et conven-
tui mon. Sci Laurentii de Aver-
sa
Credentes illa vos
Laterani. V iď. Maii a° 2°
Bulle an Hanf
In plica rechts a. c.

25 12

Firenze, Badia Fiorentina
P. — _1256 Maii 14_
Alexander IIII . . abbati et
conventui monasterii sce
Marie Florentin. OSB ad
Rom. eceliam prout dicitur
nullo medio pertinentis
 Lecta coram nobis
Laterani. II id. Maii a° 2°
Bulle fehlt, Seide erhalten
Oberste Linie frei
Sub plica keine Linien

25 13

Archives Nationales Paris
L250 n. 75 _1256 Maii 20_
Br. 27.1 hoch 21.5 Plica 3.2
oberer Rand 6.3 links und
rechts ohne Seitenlinien 1.6, 1.2
 Alexander IIII (Gitterschrift,
Initiale variiert) . . Abbati e Conven-
tui Monasterii sancti Germani de
Pratis Parisien ordinis sci Benedicti
ad Romam ecclesiam nullo medio
pertinentis
 Solet annuere sedes
Dat Laterani XIII kl Junij a° 2°

Bulle fehlt, Seide erhalten
 In plica links : G.
a tergo oben mitte :
 Scs Germanus de Pratis
. Ecke oben links : J **P vacat**

Kleine runde Schrift, mit gestr. Ligaturen
(mit 1 Ausnahme), mit 4 verzierten
Satzanfängen. In 1. Zeile 1 verz. Buchstabe
. Erste Linie für Gitterschrift und Ober-
 längen

25 14

Archives Nationales Paris
L250 n. 76 _1256 Maii 21_
Br. 34.5 hoch 30.3 Plica 3.3
oberer Rand 8. links 1.9
rechts 1.8
 Alexander IIII coo (Gitterschrift
Initiale variiert) Conventui Mona-
sterii sco Germani de Pratis Parisien
ad Romam ecclesiam nullo medio per-
tinentis ordinis sci Benedicti
 Petitio vra nobis
Dat Laterani XII kl Junij a° 2°

Bulle und Seide fehlen
 A tergo Ecke oben links : Y
 " oben mitte :
 Scs Germanus de Pratis
Kleine eckige Schrift, mit gestreckten
Ligaturen, mit 3 verzierten Satzanfängen
In 1. Zeile 1 verz. Buchstabe
Erste Linie für Gitterschr und Oberlängen

Zwei grössere Initialen über
 übergeschrieben, was sehr selten
P vacat ist

25 15

Firenze, Camaldoli
P. 16395 _1256 Maii 21_
Alexander IIII (ohne Punkte)
archiepis et epis presentes
litteras inspecturis
 Cum dilectis filiis
Laterani. XII kl. Jun. a° 2°
 Bulle und Hanf fehlen
Sub plica rechts in
Rand oben links duplica-
tur ; Ecke oben rechts a

2516

Archives Nationales de Paris
L 250 n. 77 1256 Maii 23

Br. 24.3 hoch 19.3 Plica 2,7
oberer Rand 5.4 links 1.1
rechts 1.1
 Alexander IIII - - Abbati Monas
terij sancti dionisij in Francia ad Ro
manam ecclam nullo medio perti
nentis ordinis sancti Benedicti
 Ex parte tua
Dat. Laterani X Kl junij a° 2°

Bulle und Hanf fehlen
 In plica rechts: Ber. f
Rand oben mitte : duplicet f
a tergo oben mitte :
 Helias de Poylleio

Fette ruruhige Schrift

Ohne jeden betonten Buchstaben

Erste Linie für Oberlängen
 P. vacat

2517

Firenze, S. Croce di Firenze
P 16598 1256 Junii 1
Alexander IIII [ohne Praesule]
ministris provincialibus et
fribus univ. ord. frum Minor.
 Pressi gravi orbis
Anagnie Kl Junii a° 2°
 Bulle und Hanf fehlen
In plica rechts Hugo. f.
 Oberste Zeile beschrieben
Sub plica unliniiert

2518

Marseille Archives Departem.
H. O. M. 19
P. — 1256 Junii 9
Alexander IIII .. magro et fribus
Hospitalis Jerosolom.
Cum preter pauperem
Anagnie V id — Junii a° 2°
Bulle und Seide ausgerissen
Ohne notizen
Erste Leite frei
Schwungvolle Ligaturen und Schrift

2519 (recto)

 P. — Paris Arch. nat.
L 250 cap. 78 1256 Junii 12
Alex IIII dilecte in xpo filie filia
li nobili mulieri Helizabet nate clare
memorie regis Francorum
 Benedicta filia tu
Anagnie II id Junii a° 2°
 Bulle an Hanf
In plica rechts Angl R
Links neben Bulle in plica :
Duplicetur per meliorem scrip.
torem ; daneben von anderer Hand:
Rx A St[atim] de Curia
rechts neben Bulle : scribatur
statim per meliorem scriptorem
statim de curia

 verte

2519 (verso)

Auf dem Rand oben mitte : cor-
duplicetur per meliorem scrip-
torem

Alle drei Notizen von derselben
Hand.

Die Urkunde weist viele Correctu-
ren auf; die Schrift ist klar
aber schlecht

cap. 78 bis ist dieselbe
Brief als clausa

2520

per meliorem scriptorem

Archives Nationales Paris
L 250 n. 78 1256 Iunii 12
Br. 54.6 hoch 41.5 Plica 5
oberer Rand 6.8 links 2.2
rechts 2.2
Alexander IIII dilecte in Xpo fi-
lie Nobili mulieri Helizabet nate
clare memorie Regis Francorum
Benedicta filia tu
Dat Anagnie II Id Iunij a° 2°

Bulle an dickem Hanf
In plica rechts : Angl R (A2)
In plica halblinks : Duplicetur per me-
liorem scriptorem R A. A de cur...
In plica halbrechts : scribatur statim
per meliorem scriptorem statim. de cu...
Rand oben Mitte : duplicetur per me-
liorem scriptorem
A tergo oben halblinks : dne Helisabet

Kleine etwas eckige Schrift
Ohne jeden betonten Buchstaben
Erste Linie für Oberlänger

2521

Archives Nationales Paris
L 250 n. 78 bis 1256 Iunii 12
Br. 55, hoch 45 Plica —
oberer Rand 6.8 links 2.1
rechts 1.6
Alexander IIII dilecte in Xpo filie
Nobili mulieri Helisabeth nate clare
memorie Regis Francox
Benedicta filia tu
Dat Anagnie II Id Iunij a° 2°
Ohne Plica Ohne Bullenlöcher

Kleine deutliche Schrift
Ein betonter Buchstabe
A tergo Ecke oben links : A
In n. 78 : Helizabet
Hier : Helisabeth

Beachtenswerth, da diese umpe...
Sige Urkunde ausgeliefert worden
ist
P. vacat

2522

P. — Arch. Nat. Paris
L 250 cap. 78 bis 1256 Iunii 12
Alex IIII idem ac cap. 78

clausa

nobili mulieri Elisabeth so-
rori regis Francie

Photo

Duplicat

2523

Archives Nationales Paris

L 250 n. 79 1256 Junii 13

Br. 37,5 hoch 27,9 Plica 3,6
oberer Rand 5,1 links 1,9
rechts 1,9

Alexander IIII . . Officiali Bel-
uacen

Sua nobis dilectus

Dat Anagnie Id Junij a° 2°

Bulle an Hanf
Sub plica rechts : Angls k
A tergo oben Mitte : +
Cluniacum

Kleine runde Schrift

Ohne jeden betonten Buchstaben

Erste freie Linie zwecklos

P. vacat

2524

Archives Nationales Paris

L 250 n. 79 bis 1256 Junii 13

Br. 37,8 hoch 27,6 Plica 3,9
oberer Rand 6,1 links und
rechts ohne Seitenlinien 1,1, 1.

Alexander IIII . . decano eccl⸒e
S̅c̅i Johis de Nongento Retrodi Car
notēn dioc

Sua nobis dilectus

Dat Anagnie Id Junij a° 2°

Bulle und Hanf fehlen
Sub plica links : ∴
A tergo oben Mitte : +
Cluniacum

Ganz kleine zierliche Schrift

Mit einem betonten Buchstaben

P. vacat

2525

Bayer. Haupt - Staatsarchiv
Memmingen Hospital Fasc. 1

P. 16418 1256 Junii 13

Alexander IIII .: Magro et fribus Hos-
pitalis n̅r̅i Sc̅i Spiritus in Saxia -
de Urbe

Ut eo libentius

Anagnie Id. Junij anno Secundo

Bulle an feiner Seide
In plica rechts : m c
 pro se

2526 (recto)

Firenze, Camaldoli

P. 16422 1256 Junii 14
 Jun. 15

Alexander IIII . . priori Camaldu-
len. eiusque etc. in ppm

Officii nostri nos
inueniant Amen A. Amen

R. Ego Alexander catholice
Eclie Eps SS. m

2 presb. 2 epi 4 diac

Anagnie p. m. magistri Jordani
dni pp. subdiaconi et notarii
XVIII Kl. Julii Ind. XIIII Inc. D.a̅
M°. CC. LVI p. uero domni ALE.
XANDRI pp IIII anno secundo

Bulle und Seide fehlen

Ecke oben rechts à mit ausge-
strichener Name

 verte

2526 (verso)

A tergo oben Mitte ziemlich gross schlank, doch halb verwischt.

𝔅

CCCLV

ccc · · (capto anni sec)

Regestres cap · 1436

WD XVII Kl Juli = Jann. 15

2527

Archives Nationales Paris
L 250 n. 80 1256 Junii 17

Br. 65.8 hoch 49.3 Plica 4.1
 oberer Rand 6.8 links 1.5
rechts 1.5
 Alexander IIII · · Ep̄o Parisien
 Cunctis proceribus et
Dat Anagnie XV kl Julij a° 2°

Bulle fehlt, Hanf erhalten
 In plica rechts : a · ar.

Kleine regelmässige Schrift
 mit einem betonten Buchstaben
Ganz schiefe Plica, sehr unordentlich.

Erste freie Linie zwecklos

P. 16424

2528

Firenze, J. Annunziata di
 Firenze
P. — 1256 Junii 17
Alexander IIII · · priori et fratribus servis beate Marie de
Capzio iuxta Florentiam
O Sau.
 Decens et debitum
Anagnie XV kl. Jul. a° 2·
 Bulle fehlt, Seide erhalten
In plica rechts umgekehrt
 Bret
Sub plica links ?
 Rand oben Mitte Cor
Beinahe Curial schrift ganz
geschlossene Worte

2529

Firenze S. Croce di Firenze
 P. (16426) 1256 Junii 17
Alexander IIII · · ministro
et fribus ord. frum Minorum Florentin.
 Cum ad promerenda
Anagnie XV kl. Jul. a° 2°
 Bulle und Seide fehlen
In plica rechts Bzo · J.
 oberste Linie frei

Firenze, Badia di Coltibuono
P.— 1256 Iunii 18
Alexander IIII . . priori et k̄.
gilii Seren. Camaldulen. ord.
 Conquesti sunt nobis
Anagnie XIIII Kl . Iul . a° 2°
 Bulle und Hanf fehlen
In plica rechts Th. S.
 Ecke oben rechts Iac
Ohne Seitenlinien
Oberste Zeile beschrieben
Sub plica unliniirt
 Ganz kleines Mandat

Marseille Archives Départem.
H . P. A. 5
 P. 16428 1256 Iunii 19
Alexander IIII . . magro et prio-
ribus ord. Predicatorum
Iustis petentium desideriis
Anagnie XIII Kl. Iul . a° 2°
Bulle an Seide
In plica rechts Iac mut
Gestreckte Ligaturen
Sehr schöne Schrift

Archives Nationales Paris
L 250 n. 81 1256 Iunii 27
Br. 46.3 hoch 36.2 Plica 3.5
 Oberer Rand 5.9 links 1.4
rechts 1.3
 Alexander IIII . . Epo Parisien
 Licet olim pro
Dat Anagnie V Kl. Iulij a° 2°
Bulle fehlt, dicker Hanf erhalten
 In plica rechts : G. ar
Kleine regelmässige Schrift
 Mit einem betonten Buchstaben
Erste Linie zwecklos

 P. 16435

Archives Nationales Paris
L 250 n. 82 1256 Iunii 27
Br. 52.5 hoch 37.2 Plica 3.5
 Oberer Rand 5.9 links 1.4
rechts 1.3
 Alexander IIII Carissimo in
Xpo filio . . Regi Francie Illustri
 Vere fidei t
Dat Anagnie V Kl. Iulij a° 2°
Bulle fehlt, Hanf erhalten
 In plica rechts : α. ar
Kleine regelmässige Schrift
 Mit 2 betonten Buchstaben :
 Carissimo und Iustium
Erste freie Linie zwecklos

 P. 16436

Instr. Mon. F. Dom. 1256 Junii 27
P. 16436
Alex IIII. .. regi Francie illustri
Vere fidei et —
Anagnie V Kl. Julii aᵒ 2⁰
Bulle an Hanfschnur
In plica rechts : G. ar.

Madrid Arch. Histór. Nacional
Zamora Toro 2 E
P. 16438 1256 Junii 27
Alexander IIII. .. priori provin
ciali fratrum predicatorum in
Spania
Cum hora undecima
Anagnie V Kl. Julii aᵒ 2⁰
Bulle und Seide fehlen
In plica rechts Hugo V.
Rand oben Mitte
duplicetur cum adiectionibus
de Cueta
die adiectiones stehen links
Mitte und rechts in plica

Firenze, Camaldoli
P— 1256 Junii 28
Alexander IIII. .. preposito ec
clesie Faventin.
 Inter notos dilecti
Anagnie III Kl. Jul. aᵒ 2⁰
Bulle, Hanf, plica, fehlen
Sub plica links
 i
Rand oben Mitte duplicetur
Ecke oben rechts Joh
Seitenlinien ganz schmale
Ränder. Erste Zeile frei

Archives nationales Paris
L 250 n. 84 1256 Julii 1
Br. 32.4 hoch 24.4 Plica 2.8
 oberer Rand 4.1 links 1.1
rechts 1
 Alexander IIII. .. Priori z fratribus
ordinis Predicatorum Parisien
 Vehementi ammiratione ducimur
Dat Anagnie Kl Julii aᵒ 2⁰
Bulle fehlt, Hanf erhalten
 In plica rechts : Ta. cj
A tergo oben Mitte: Predicatorij
Mitte kleine etwas nachlässige Schrift
Ohne jeden betonten Buchstaben
Ohne erste freie Linie
 Schreibfehler
P. 16445

Archives Nationales Paris

L 250 n. 84 bis __1256 Julii 1__

Br. 31.8 hoch 21. Plica 2.2
 oberer Rand 4.8 links 1.3
rechts 1.3

 Alexander IIII . . Priori 2 fratribus
ordinis Predicatory Parisien.
 Vehementi ammiratione du-
dat Anagnie Kl Julij a° 2° cimus

Bulle fehlt, Hanf erhalten
 In plica rechts : La . o) .

A tergo oben Mitte : Predicatory

Kleine fette nachlässige Schrift

Ohne jeden betonten Buchstaben

Erste Linie für Oberlängen

 __P. 16445__ __Schreibfehler__

Bayer. Haupt. Staatsarchiv
 Ottobeuren Kl. nr. 16

P. 16451* __1256 Julii 5__

Alexander IIII (zierliche dünne Gitter-
schrift) .. Abbati et conventui
Monasterij de Ottenburron ordinis
sci Benedicti Augusten. dioc.
 Justis petentium desiderijs
Anagnie IIII non Julij a° Secundo

Gutgeprägte Bulle an Seide

In plica links : ſ

Ecke oben rechts : Joh.

Fette kleine regelmässige Schrift.
Rahmenlinien. Erste Zeile un be-
schrieben

Instr. Mon. F. Tom. c. 28 1256 Julii 6
 P 16453
Alex IIII .. archiepo Sennen.
Dilecti filii fratres —
Anagnie IIII non. Julii a° 2°
Bulle an Hanfschnur
In plica rechts : 2
A tergo : predicatorum

Archives Nationales Paris

L 250 n. 85 __1256 Julii 7__

Br. 32.5 hoch 19.5 Plica 3.2
 oberer Rand 4.5 links 1.2
rechts 1.1
 Alexander IIII Archiepis et Epis
ac dil. filijs Abbatib3 Priorib3 Deponi-
bus decanis Archidiaconis 7 alijs
Eccliay Prelatis ad quos __presentes__
littere pervenerint
 Ea parte dilectorum
dat Anagnie non Julij a° 2°

Bulle an dickem Hanf
 In plica rechts : a . s.
A tergo oben Mitte : Sanctus Antonius

Kleine feste schöne Schrift

mit einem betonten Buchstaben

Erste Linie für Oberlängen

 __P×16457__

2542

Marseille Archives Départem.
H. P. A. 5
P. 16458 1256 Julii 8
Alexander IIII pribus ordinis
fratrum Predicatorum
Ut in vestris
Anagnie VIII id. Jul. aº 2º
Bulle an Seide
ohne alle Notizen
Gestreckte Ligaturen
Sehr schöne Schrift

cf. P. 12397

2543

Archives Nationales Paris
L250 n. 86 1256 Julii 11
Br. 32.4 hoch 22.3 Plica 3.4
Oberer Rand 5.1 links 1.5
rechts 1.5
Alexander IIII (Gitterschrift, Lin-
ile versiert) — Magro et fratribus
Hospitalis Jeroslimitan
Cum preter pauperem
Dat Anagnie V id. Julii aº 2º
Bulle an Seide
A tergo oder Mitte: grosses +

Kleine runde Schrift, mit gestr.
Ligaturen, mit 2 versierten Schau-
fängen, mit 2 ver. Buchstaben in
1. Zeile

Erste Linie für Gitterschrift und Ober-
längen

P. 16470

2544

Frieuse, Frati della Drocia
P. 16466 1256 Julii 11
Alexander IIII [ohne Punkte] ...
neusti ministro et pribus ord.
frum Minorum
Cum non decet
Anagnie V id. Jul. aº 2º
Bulle und Seide ausgeschnitten
In plica rechts J. bn
Erste Linie frei
Sub plica liniirt bis unten

Ligaturen gemischt.

2545

Instr. mon: F. Dom. C 113 1256 Julii 13
P. 16480
Alex. IIII fratribus predic. inquisi toro
bus hereticorum in Lombardia
Cum vos olim —
Anagnie III id. Julii anno 2º
Aufschnur. Bulle fehlt.
In plica rechts: Ja. mo
pro Curia
Oben Mitte: duplicetur de Curia
A tergo: predicatorum

2546

Madrid Arch. Histór. Nacional
S. Estéban de Salamanca k.19
P. 16489 1256 Julii 18
Alexander IIII universis epis
et abbatibus, prioribus, decanis,
archidiaconis, archipresbiteris,
et aliis ecclesiarum prelatis ac
universis clericis cuiuscumque
ordinis vel professionis per Hyspa-
niam constitutis ad quos littere
iste pervenerint
De pia et
Anagnie XV Kl. Aug. a° 2°
Bulle fehlt. Hanf erhalten
Inplica rechts Jac. Mut.

2547

Marseille Archives Départem.
H. P. A. 75
P. 16489 1256 Julii 18
Alexander IIII . . Arelaten. et
. . Aquen archepis et eorum
suffraganeis ac abbatibus,
prioribus, decanis, archidia-
conis, prepositis, archipresbi-
teris et aliis ecclesiarum pre-
latis et clericis universis cuius-
cumque ordinis vel professio-
nis per Arelaten. et Aquen.
provincias constitutis ad quos
littere iste pervenerint
De pia et
Anagnie XV Kl. Aug. a° 2°
Bulle an Hanf
Ohne alle Notizen

2548 (recto)

Instr. Miscell. F. Dom. Cap. 145 1256 Jul. 18
P. 16489 i. e. m.
Alex. IV univ. archepis et epis ac abba-
tibus, prioribus, decanis, archidia-
conis archipris et aliis ecclesiarum
prelatis et clericis universis cuius-
cumque ordinis vel professionis per
regnum Sicilie et Apulie constitutis
ad quos littere iste pervenerint.
De pia et. —
Anagnie XV Kal. Aug. anno 2°
Bulle an Hanfschnur.
Die plica bedeckt die letzte Zeile
Sub plica links : L. ?
 a. S.
In plica links bis rechts : pro conventu.
narbonen. et Arel. dioc. constituti
item H Lombardiam etc. constitutis
item H per boemiam polomiam et
prussiam provincias etc.
A tergo : predicatorum

Die i. e. m. sind nur zum Theil bei
 Ripoll verzeichnet [Note]

2548 (verso)

Über Rand links : fiant II [...]
vidata, duplicentur per di-
versas provincias
 Rx Alex. (dann grösser: Rann)
In plica links verschieden Rx

2549

Madrid Arch. Histór. Nacional
Poblet C n. 58

Fehlt P. — 1256 Julii 21

Alexander IIII .. abti Populeti
ordinis Cisterciensis.

Exhibita nobis ex
Anagnie XII klas Augusti a° 2°
sub plica links ...
Bulle fehlt. Grobe Schnur erhalten

)) Von einem neuen Schrei-
)) ber geschrieben, der die
)) Kanzleigebräuche noch
)) nicht kennen konnte

2550

Firenze, S. Croce di Firenze
P. — 1256 Julii 29

Alexander IIII .. aretin. ..
florentin. et .. Lunen episcopis

Nimis inique vicissitudine
Anagnie IIII Kl. Aug. a° 2°
Bulle und Hauf fehlen
In plica rechts - Hugo . T.

2551

Marseille Archives départem.
H. P. A. 6

P. — 1256 Augusti 2

Alexander IIII universis arch.
et epis ac ab., prior., archipresb.
dec. archidiac. et aliis ecclar.
prelatis ad quos littere iste per-
venerint

Cum felicis recordationis
Anagnie IIII non. Aug. a° 2°
Bulle an Seide
In plica rechts Jac hut
 pro Magro hul.
Gestreckte Ligaturen

2552

Instr. Mon. F. Dom. c. 126 1256 Aug. 3
 P. 16571 reg. 11242

Alex IIII .. mag. et prioribus ac fratri-
bus ord. Predic.
vobis assidue regnum
Anagnie III non. Aug. anno 2°
Bulle an Seidenschnur
In plica rechts: vt. p.
A tergo : predicatorum

Scriptor : Ubatus de Placentia
 1252 octobris 31 cap. 6057

Nice Archives Départem.
H. ℔ 14
P. — 1256 Augusti 4
Alexander IIII fratri Bernar-
do capellano nostro abti et
conv. mon. S. Honorati Linnen.
ad R. Eccles. nullo m. pert.
OSB Grassen diöc.
Vestre querentes pacis
Anagnie non. Aug. a° 2°
Bulle an Seide
In plica rechts Schreiber
Sub plica links ..
Erste Zeile frei. Seitenlinien
Ligaturen

Firenze S. Chiara di Cortona
P. — 1256 Augusti 18
Alexander IIII .. potestati et ca-
pitaneo de Corton. aretin. diöc.
Cum sicut et
Anagnie XV Kl. Sept. a° 2°
Bulle fehlt, Hanfschnüre
In plica rechts . Ro.
Erste Zeile frei
Sub plica unliniirt

Archives Nationales Paris
L250 n. 87 1256 Augusti 23
Br. 25.2 hoch 28.8 Plica 2.6
Oberer Rand 4.2 links 1.2
rechts 1.2
Alexander IIII .. Priorib. et fr.
tribus heremitis ordinis sci Willermi
Grossetan. diöc
Devotionis vre precibus
Dat Anagnie X Kl Septembr. a° 2°
Bulle an Seide
In plica rechts : La. 9
A tergo oben Mitte : ordinis sci Willermi

Weite kräftige Schrift, mit gestreckten
Ligaturen, mit 3 verzierten Satzanfängen
In 1. Zeile vur. Buchstabe

Erste Linie für Gitterschrift und Ober-
längen

P. 16531

Marseille archives Départem.
H. O. J. 5
P. — 1256 Augusti 23
Alexander IIII magistro et fratribus
militie Templi Jerosolimitan.
Ipsa nos cogit
Anagnie X Kl. Sept. a° 2°
Bulle fehlt, Seide erhalten
In plica links R

Oberste Zeile frei
Seitenlinien
Betonte Satzanfänge
Ligaturen gemischt.
cf. 1256 März 8-14
1257 Jan. 2

2557

Archives Nationales Paris

L250 n. 88 **1256 Augusti 28**

Br. 34.8 hoch 24.1 Plica 3.3
oberer Rand 5.1 links 1.2
rechts 1.4

Alexander IIII .. Magro y fratribus et domus Militie Templi Jolui...
Cum felicis recordationis
Dat. Anagnie V Kl Septembr. a° 2°

Bulle an Seide
In plica rechts: Hugo. V.
poo p. met
Ecke oben rechts : a
A tergo oben mitte : T

Eckige unruhige Schrift, mit gestr.
Ligaturen, mit 4 verz. Schranfängen
in 1. Zeile 1 verzierter Buchstabe
Erste Linie für Gitterschrift

Papstnamen in Text nicht in
Gitterschrift

P. vacat

2558

Bayer. Haupt. Staatsarchiv
Franc. Orden in Bayern fasc. 1
P. 16534. 1256 Augusti 28

Alexander IIII .. Generali et provincialibus ministris ac alijs fratribus ordinis fratrum Minorum
Nimis iniqua vicissitudine
Anagnie V Kl. Sept. anno Secundo

Bulle an feiner Seide
In plica rechts : G. as

Die im Texte genannten Papstnamen
sind in Gitterschrift und stehen
in folgender Anordnung :

Innocentio II Honorio Gregorio et
Innocentio IIII

2559

Public Record Office London
Papal Bulls bundle 3 n 2
P – 1256 Septembris 1

Alexander IIIj universis archidiaconis
per regnum Anglie constitutis
Cum decima ecclesiasticorum
Dat. Anagnie kl. Sept. a° 2°
Bulle an Hanf
In plica rechts Abam. s
In plica links ganz klein Befehl:
In e. mo. universis archidiaconis
per Vasconiam constitutis
Rx Alex.

2560

Karlsruhe Gr. Bad. Gen. Landesarchiv
Select der Papsturk. cap. 206
P. – 1256 Septembris 5

Alexander IIII archiepis et episcet
abbatibus..... ad quos littere
iste pervenerint
Dilecti filii .. abbas
Anagnie non. Sept. a° 2°
Bulle an Seide
In plica rechts BP
In plica links s(chede)
et II S(enani)
Sub plica links s

Archives nationales Paris
L 250 n. 89 1256 Septembris 23
Br. 33.9 hoch 26.4 Plica 2.5 2.5
obere Rand 6.1 links und
rechts ohne Seitenlinien 1.3, 1.4
 Alexander IIII (Gitterschrift, Ini=
tiale versiert) .. decano et Capitulo
Parisien
 In Ecclesia nostra
Dat Anagnie VIIJ kl Octobr a° 2°

Bulle an Seide
Sub In plica rechts : pe. vi
Sub plica links : . .]
Rand oben mitte]
 a tergo oben mitte: Heremita
 not]
Eckige unruhige Schrift, mit gestr.
Ligaturen, mit 3 ver. Satzanfängen
Ohne erste freie Zeile

 P. 16555

Archives nationales Paris
L 250 n. 89 bis 1256 Septembris 23
Br. 30.7 hoch 23.1 plica 3.4
obere Rand 6.1 links 1.4
rechts 1.4
 Alexander IIII
 wie n. 89
In plica rechts : tac. ro
a tergo oben mitte :
 Heremita not]

Sehr schwungvolle, schöne, kleine
Schrift, mit gestreckten Ligaturen,
mit 2 versierten Satzanfängen
 In 1. Zeile 2 ver. Buchstaben

ꝓ Erste Linie für Gitterschrift

 P. 16555

Marseille Archives départem.
H. O. M. 19
P. — 1256 Octobris 3
Alexander IIII .. magro et fri=
bus Hospitalis Jerosolimitan
Intellecto per nos
Anagnie V non. Oct. a° 2°
 Bulle an Hanf
Ohne Notizen
Nachlässige aber deutliche
Schrift
 Erste Zeile frei

Public Record Office London
Papal Bulls bundle 1 n. 20
P. — 1256 Octobris 3
Alexander IIII universis archiepis et
epis per regnum Anglie consti-
 tutis
Cum sicut intelleximus
Anagnie V non. Oct. a° 2°
Bulle fehlt. Hanf vorhanden.
In plica rechts. M
Sub plica links]
 . .
]
Rand oben längeres Regest.

Archives Nationales, Paris
L250 n. 90 1256 Octobris 4
Br. 39. Hoch 29.5 Plica 3.
oberer Rand 5.5 links 0.9
rechts 1.2
 Alexander IIII . . Magro 7 fratribus
Hospitalis Jerlimitan
 Intellecto per nos
Dat Anagnie IIII non Octob. a° 2°

Bulle an Hanf
 In plica rechts : Johes parm
A tergo oben Mitte großes +

Eckis kleine Schrift
 mit einem betonten Buchstaben
Erste Linie für Oberlängen

 P. vacat

Marseille Archives Départem.
H. O. M. 19
P.— 1256 Octobris 4
Alexander IIII .. Magro et fribus
Hospitalis Jerosol.
Intellecto per nos
Anagnie IIII non. Octobris a° 2°
Bulle fehlt, Seide erhalten
In plica rechts Aug5 m
Schöne, schwungvolle Schrift

Marseille Archives Départem.
H. O. M. 19
P.— 1256 Octobris 4
Alexander IIII .. magro et
fribus Hospitalis Jerosolim.
Intellecto per nos
Anagnie IIII non. Octobris a° 2°
Bulle an Hanf
In plica rechts Johes parm
Erste Zeile frei

Archives Nationales Paris
L250 n. 91 1256 Octobris 5
Br. 56. Hoch 41. Plica 3.1
oberer Rand 6.3 links 2.1
rechts 2.2
 Alexander IIII (maiusculae; der
Übrige in Gitterschrift ; eps servus sa
vorum dej Ad perpetuam Rej memoriam
 Romanus Pontifex de
Dat Anagnie IIII non Octobr a° 2°

Bulle an Seide
 A tergo oben Mitte : Predictor

Sehr regelmässige runde kleine Schrift
gestreckte Ligaturen mit vier ver
Zierten Satzanfängen

 Proscriptio libelli famosi

 P. 16565

2569

Public Record Office London
Papal Bulls bundle 2 no. 10
P. 16566 1256 Octobris 6

Alex. IIII Henrico Anglie et Ed-
mundo Sicilie regibus illustribus
Supplicantibus olim nobis
Anagnie II non. Oct. a° 2°
 Bulle an Seide

A tergo oben Mitte schmal und lang

Registres springt
von cap. 429
(n. 1516) nach Duplicat
Cap. 440 (n. 1517)

 CCCC XXX VIII° capitło anno sec.

→ Duplicat: n. 14
 auch R. — Zeichen

2570

Bayer. Haupt. Staatsarchiv
 Bamberg Jac. 25

P. 16567* 1256 Octobris 6

Alexander IIII .. preposito. - decano
et Capitulo Babenbergen.
 Justis p(etentium desideriys) Loch
Anagnie 4 Non. Octobris anno
 Secundo

Gutgeprägte Bulle an feiner Seide.
In plica rechts : Alex
 Ecke oben rechts : Jo
Die beiden obersten Zeilen für
 Seitenränder

Sehr ungelenke gestreckte Ligaturen

2571

 Datum

Paris Archives Nationales
 J 684 n. 25 bis
Breite 22.4 Rand links 2.6 : rechts 1.3
Höhe 19.7 Rand oben 4.5 plica 14.3
 Erste Linie für Oberlängen
Links keine, rechts eine Seitenlinie
P. vacat 1256 Octobris 10
Alexander IIII Carmo in xpo fi
lio - - Regi Francie Jelustri
 Cum participemus scienter
Dat / Anagnie VI Jd Octobr a° 2°
Bulle an Hanf
 In plica rechts :: Ja. Mar.
A tergo oben Mitte : Rex
Etwas nachlässige Schrift

2572

 duplicetur
Archives Nationales Paris
L250 n. 92 1256 Octobris 15
Br. 50.4 hoch 35.2 Plica 2.9
 oberer Rand 6.9 links 2.4
rechts 2.4
 Alexander IIII . . Archiepis et Epis
p Lombardiam, Tusciam 4 Romaniae
+ Laun ac trevisin Anconitan mar
chias ducatum Spoletan Patrimo-
nium beati Petri in Tuscia Campa
niam et maritimam ac Reg-
num Sycilie constitutis
 litteras nras urobis
Dat Anagnie Jd Octobr a° 2°

Bulle fehlt, dicker Hanf erhalten
 Randoben links : Provincie 4 Fran
cia 4. Alamanie Ungarie Anglie
ac Sicilie Regna constitutis
 Randoben rechts : duplicetur et
ponantur provincie juxta nelle
datum
Kleine regelm. Schrift P. 16583
 Ohne jeden betonten Buchstaben
Erste Linie für Oberlängen

2573

P. 16583 Paris Arch. Nat.

L 250 cap. 92 _1256 Octobris 18_

Alex IIII .. archeps et epis per Lom-
bardiam, Tusciam etc. consti-
tutis

Litteras nostras vobis

Anagnie Idus Octobris a° 2°

Bulle fehlt; Hanf erhalten

Auf dem oberen Rande rechts:
duplicentur et ponentur pro-
vincie iuxta velle fratrum [He-
remitarum S. Augustini]

dann links: _provinciarum_ et
Francie Alamanie Ungarie
Anglie ac Sicilie regule consti:
tutis

2574

Firenze Badia Fiorentina

P. — _1256 Octobris 17_

Alexander IIII abbati Sce Marie
Florentin.

Sua nobis dilecti

Anagnie XVI kl. Nov. a° 2°

Bulle fehlt, Hanf erhalten

Ganz kleines Mandat

Obere Zeile unbenutzt.

2575

Archives Nationales Paris

L 250 n. 93 _1256 Octobris 17_

Br. 53.5 hoch 41.2 Plica 2.8
oberer Rand 8.2 links 1.5
rechts 1.5

Alexander IIII Carissimo in Xpo
filio . . Illustri Regi Francie
Veri solis radius

Dat Anagnie XVI kl novembr a° 2°

Bulle fehlt, Hanf erhalten

A tergo oben Mitte: Predicatory

Fette regelm. Schrift

In erster Zeile 3 betonte Buch-
staben: _Cariss. Illustri Veri_

Erste Linie für Oberlängen

Königsbullen ohne Schreibernamen

P. 16585

2576

Archives Nationales Paris

L 250 n. 94 _1256 Octobris 19_

Br. 46.8 hoch 34.2 Plica 3.1
oberer Rand 6.7 links 1.4
rechts 1.3

Alexander IIII Carissimo in Xpo
filio . . Illustri Regi Francie
Non sine multa

Dat Anagnie XIIII kl novembr a° 2°

Bulle fehlt, Hanf erhalten

A tergo oben Mitte: Predicatory

Kleine regelmäßige Schrift
mit einem betonten Buchstaben
Erste Linie für Oberlängen

Ohne Schreibernamen

P. 16586

Archives Nationales Paris
L250 n. 95 1256 Octobris 21
Br. 42.6 hoch 30.8 Plica 3.5
oberer Rand 6.7 links 1.8
rechts 1.8
Alexander IIII . . Turonen. et
. . Rothomagen Archiepis ac . .
Epo Parisien
Quidam scripture sacre
Dat Anagnie XII Kl Novembr̄ a° 2°

Bulle fehlt, dicker Hanf erhalten
In plica rechts : Jac̄ Buc (Var)
A tergo oben Mitte : Predicatoȳ

Sehr regelm. kleine Schrift
Mit einem betonten Buchstaben
Erste Linie Zwecklos

P· 16590

Archives Nationales Paris
L250 n. 96 1256 Octobris 21
Br. 42.3 hoch 33 Plica 3.2
oberer Rand 5.2 links 0.8
rechts 0.9
Alexander IIII vniuersis Archiep̄
ꝫ Ep̄is ac dil filijs Abbib̄ Priorib̄
Archidiacon̄is Archipbr̄is ꝫ alijs ecclj
aȳ Pelatis cuiuscunque ordinis vel
professionis per Franciam Burgundiam
Picardiam Brittaniam ꝫ Norman.
mam Constitutis
Non sine multa
Dat Anagnie XII Kl Novembr̄ a° 2ª

Bulle fehlt Hanf erhalten
A tergo oben Mitte : Predicatoȳ

Kleine runntige Schrift
Ein betonten Buchstabe
Erste Linie für Oberlängen

Ohne Schreibername

P· 16589

Arch. Arcis
Arm. IX Caps. 7 cap. 4
P. — 1256 oct. 23
Alex. IIII . . epo Burgen.
Venerabilis frater noster
Anagnie X Kl. Nov. a° 2ª
Bulle an Hanfschnur
In pl. rechts : A de Jt̊
A tergo procurator en.
esculici
Löcher

Archivio di Stato Milano
Bolle e Brevi
P. — 1256 Novembris 6
Alexander IIII dil. in xpo fil . .
abbatisse et conv. S. M. Theodotis
Papien. ad R. Ecliam nullo me.
dio pertinentis OSB
Meritis vestre religionis
Anagnie VIII Id Nov. a° 2°
Bulle an Hanf
In plica rechts ✠ de Jt.
Sub plica links : �..

A tergo oben Mitte : Papia. bis
rescripta

2581

Paris Archives Nationales
J 431 n. 13
Breite 68.4 Rand links 2.5 rechts 2.7
Höhe 47.3 Rand oben 6.4 plica 4.4
Erste Linie für Oberlängen / Links
2, rechts 1 Vertenlinie

P. 16611 1256 Novembris 9

Alexander IIII . . priori Parisien̄
de ordine Predicator̄
 Pre cunctis mentis
 Dat Anagnie / V Jd Novembr̄
anno 2°
 Bulle an Hanf
 In plica rechts: Abam) . S.
 A tergo oben mitte :: Pre
Leicht nach links geneigte Zette flüchtige
Schrift

2582

Firenze, Piombino
P. – 1256 Decembris 11

Alexander IIII . . abbatisse et
conventui Monasterii sce Ma
rie de Massa OSDamiani
 Iustis petentium desideriis
Lateran . III Id. Dec . a° 2°
 Bulle und Seide fehlen
 In plica rechts Th. S.
 Rand oben halbrechts prior
fieri fecit
 Ecke oben rechts a
 Erste Linie unbenutzt
 Sub plica fast ganz liniiert

2583

Firenze, Vallombrosa
P. 16624 1256 Decembris 18

Alexander IIII . . abbi̅ sc̄i
Rusorii Pisan. dioc.
 Dilectus filius . . abbas
Lateran . XV kl. Jan . a° 2°
 Bulle und Hanf fehlen
 In plica rechts Jo. S.
 Sub plica links L.
 Rand oben mitte | und cor
Ecke oben rechts dt ōu ste
 A tergo Ecke oben links y
 Oberste Linie unbenutzt. Sub
plica unliniiert
 Bulle und Hanf fehlen

2584

Brit. Mus. Add. Chart. 1546
P. 16203 1256 Decembris 21

Alexander IIII . . abbati et con-
ventui Cluniacen.
 Exigentibus vestre devotionis
Lateran XII kl. febr. a° 2°
 Bulle und Seide ausgerissen
 In plica rechts B p . . .
 die plica deckt die
 letzte Zeile völlig
 A tergo mitte oben

LXXXII cap. anno secundo

Registres 1098

25 85

Wörbelin Staatsarchiv
Kl. Eberbach
P. — 1256 Decembris 23
Alex. IIII .. abbati Cistercii eius
que patribus coabbatibus uni
versis Cistercien. ordinis
 Cum sicut ex
Literis. X kl. Januarii
anno 2°
Bulle an Seide
In plica rechts A. Ro
Sub plica links ..
Rand oben Mitte
ascultatur cum bullata
 Eine Bemerkung fehlt
 auf mehreren anderen
 allgemeinen Privile
 gien wieder

25 86

Firenze, Badia Fiorentina
 1256
Alexander IIII [ohne Punkte]
conventui mon. See Marie
de Florentia O.S.B. ad Rom.
Ecclam nullo medio perti
nentis
 Olim monasterio vestro
Bulle fehlt, Hanf erhalten
 In plica rechts Mayf
Sub plica links .

25 87

Marseille Archives Départem.
H. O. M. 20
P. — 1257 Januarii 2
Alexander IIII .. magro et
fribus Hospitalis Jerosol.
 Religionis vestre meretur
Literis. IIII non. Jan. a° 3°
Bulle und Seide fehlen
In plica links .S.
Erste Zeile frei
Sehr gezogene Ligaturen

25 88

Marseille Archives Départem.
H. O. M. 20
P. — 1257 Januarii 2
Alexander IIII .. magro et fri
bus Hospitalis Jerosolim.
 Ipsa nos cogit
Literis IIII non. Jan. a° 3°
Bulle an Seide
In plica links .S.
Erste Zeile frei
Gestreckte Ligaturen
feste, regelmäßige Schrift
 cf. 1256 Mart. 8–14
 cf. 1256 Aug. 23

2589

Archives Nationales Paris
L257 n. 97 1257 Januarii 7
Br. 21.2 hoch 16.1 Plica 2.1
oberer Rand 4.1 links 1.2
rechts 1.3
Alexander IIII . . Cancellario
sancte Genovefe Parisien
Dat Literarum ... licet nos olim ... Januar a°30

Bulle fehlt, Hanf erhalten
In plica rechts: Iac Mut
A tergo oben Mitte: Predicatox

Feste kleine schöne Schrift

Ohne jeden betonten Buchstaben

Erste Linie für Oberlängen

P. vacat

2590

Archives Nationales Paris
L257 n. 98 1257 Januarii 7
Br. 21. hoch 15.6 Plica 2.1
oberer Rand 4. links 1.5
rechts 1.2
Alexander IIII . . Cancellario
Parisien
Dat Literarum ... licet nos olim ... Januar a°30

Bulle fehlt, Hanf erhalten
In plica rechts: Iac Mut
A tergo oben Mitte: Predicatox

Feste kleine schöne Schrift

Ohne jeden betonten Buchstaben

Erste Linie für Oberlängen

P. 16657

2591

Firenze, Camaldoli
P. 16665 1257 Januarii 9
Alexander IIII . . priori et pre-
latis aliis ordinis Camaldu-
len.
Cum sicut asseritis
Literarum. ... Ian. a°3°
Bulle und Seide fehlen
In plica rechts: scriptor
Sub plica links . .

Oberste Linie unbenutzt
Sub plica unliniiert

2592

Archives Nationales Paris
L257 n. 99 1257 Januarii 11
Br. 72.5 hoch 53.6 Plica 4.
oberer Rand 7.7 links 2.5
rechts 2.5 Je 2 Seitenlinien
Alexander IIII (minusculae)
Capitulo Generali Cartusien ordinis
Dat Literarum ... Hiis que digne ... Januar a°30

Bulle fehlt, Seide erhalten
In plica rechts: n de ---
Ecke oben rechts: a und pe
A tergo Ecke oben links: A
und Mitte: Cartusia

Sehr schöne Regeln. Schrift, mit
gezier. Ligaturen, mit 4 verzierten
Satzanfängen
In 1. Zeile 2 var. Buchstaben
Erste Linie für Papstnamen und Oberlängen

P. vacat

Instr. mon. F. dom. c. 48　　1257 Jan. 11
cf. 1259 Apr. 19.　　P. 16667
Alex̄ fratribus ord. Pred. inquisitori-
bus haeret. prav. in provincia Lombar-
die ac Marchia Januen.
Ad expiendum vulpeculas
Lateran. III id. Januarii a° 3°
Bulle an Hanfschnur
In plica links: petit frater Raineri̇us
quod istas litteras innovetis secundum
formam aliarum litterarum, videlicet
inquisitoribus h. prov. tabs authoritate
sedis apostolice et imposterum deputan-
dis salutem etc.
Atergo: fratris Raineri̇i
　　　　Bedicatorum
cf. auch 1267 Jul. 27 P. 20095

innovata 1266 Jan. 19
P. 19522
deutlich zu
　atitis
cf. 1259 April. 19
P. 11596

Staatsarchiv Wien Chronol.
P. —　　　　1257 Januarii 12
Alexander III archiepis et epis
ac abbatibus, prioribus, decanis,
archidiaconis, prepositis, archi-
presbiteris et aliis ecclarum
prelatis, ad quos littere iste per-
venerint.
　　Cum dilectis filiis
Lateran. II id Jan. a° 3°
Bulle an Seide
Ecke oben rechts a
Procurator frater Hugolinus
mit spada a tergo oben Mitte
nur in Plica Mitte
Registraren gemischt

Archives Nationales Paris
L 257 n. 100　　　1257 Januarii 13
Br. 29.9　hoch 22.　Plica 3.1
oberer Rand 4, 2　links 1.4
rechts 1.3
Alexander III. .　Epo Parisien
　　　　Ad nostram noveris
Dat Lateran id Januar a° 3°
Bulle fehlt, Hanf erhalten
　　In plica rechts: Jac mut
a tergo oben Mitte: Bedicatox
Prachtvolle feste kleine Schrift
　mit einem betonten Buchstaben
Erste Linie für Oberlängen

　　P. vacat

Archives Nationales Paris
L 257 n. 101　　1257 Januarii 16
Br. 35.1　hoch 23.8　Plica 4.1
oberer Rand 4.　links 1.1
rechts 1
　Alexander III (Gitterschrift im
Seide versieet) generali Capitulo Car-
tusien ordinis
　　　　　Licet sicut accepimus
Dat Lateran XVII kl Februar a° 3°

Bulle fehlt, Seide erhalten

Schöne fette kleine Schrift, gestreckte di-
gitaren (mit 1 Ausnahme), mit 3
versierten Buchstaben dat anfängen
　In 1. Zeile 2 ver. Buchstaben
Erste Linie für Gitterschrift und Ober-
　　　　　längen

P. 16680

2597 (recto)

Firenze, Vallombrosa
P 16698 1257 Januarii 28
Alexander IIII .. abbi ceterisque
Vallis Umbrose. ~~congregationis~~
congregationis fribus transpo-
sentibus etc. in p̄p̄m
Desiderium quod ad
invenirent Censen a amen
R. Ego alexander catholice
 Ecclie Eps. M
2 presb.. 2 epi 3 diac
Laterani p. m. magistri Rol-
landi SRE vicecancellarii
V kl. febr. Jnd. XV J. D. a°
M°·CC· LVII p. vero domni ALE-
XANDRI pp IIII annstertio
Bulle und Seide fehlen
 verte

2597 (verso)

In plica rechts P. B.
Rand oben Mitte
pro vall. vmbrose ad matro
ost. (ensi privilegii vel ense
 bulle)
a tergo Mitte etwas unten
gros schnuck schön

D.L XXX ... capto annster

2598

Bayer. Haupt- Staatsarchiv
 Würzburg n. 3062
P. vacat 1257 Januarii 30
Alexander IIII .. Abbatisse ac so-
roribus Monasterij Sce Agnetis
Herbipolen. ordinis Sce Clare
 Religionis nostre meretur
Laterani. V kl. februarii a° Tertio
 Bulle an dickem Hanf
 In plica rechts : A l A Sein
 die plica läßt zwei Zeilen frei
 Table
 kleine hurchrige Schrift
 Unter- und Oberlängen gleich-
 mäßig lang

2599

Bayer. Haupt- Staatsarchiv
 Würzburg n. 3061
P. vacat 1257 Januarii 30
Alexander IIII (Gitterschrift) .. Ab-
batisse et ~~conventui~~ ac sororibus
Monasterij Sce Agnetis Herbipolen.
ordinis Sce damiani
 Paupertati nestre quam
Laterani. V kl. febr. annus Tertio
 Bulle an Seide
 In plica rechts : A l A Sein
 Sub plica links : ..
 1
 Unter- und Oberlängen gleich groß

2600

Madrid Arch. Histor. Nacional
Palencia San Pablo n. 11
P. — 1257 Januarii 31
Alexander IIII - . epo Palentin.
Laudabilis et fructuose
Lateran. X Kl. Febr. a° 3°
Bulle fehlt. Sehr dünner
 Hanf erhalten
In plica rechts unleserlich
Kleine breite etwas zitterige
Schrift

2601

Montpellier ville de Montp.
E. V. Louvet 22 46

P. — 1257 Januarii 31

Alexander IIII consulibus et uni-
versitati hominum montispe-
sulan. Magalonen. dioc.
 His qui ad
Lugdun. II Kl. Febr. a° 3°

Sehr unförmliche Bulle an Seide

Ohne jegliche Notiz

Erste Zeile frei
Gestreckte Ligaturen

Sehr schöne runde Schrift

2602

Archives Nationales Paris
L 257 n. 102 1257 Februarii 2
Br. 33 hoch 25. Plica 2.4
 oberer Rand 5.6 links 1.4
rechts 1.5
 Alexander IIII . . Epo Parisien
 Olim felicis recordationis
Dat. Lateran. IIII Non Februarii a° 3°
Bulle fehlt, Hanf erhalten
 In plica rechts: Jac. p̄
A tergo oben Mitte: Bedicatoy
Fette kleine Schrift
 mit einem betonten Buchstaben
Erste freie Linie fehlt
Papstnamen im Text nicht in
 Gitterschrift
 P. vacat

2603

Archives Nationales Paris
L 257 n. 102 bis 1257 Februarii 2
Br. 30.5 hoch 23.1 Plica 3.2
 oberer Rand 5.6 links 1.1
rechts 1.2
 Alexander IIII wie in 4. 110
Bulle fehlt. Hanf erhalten
 In plica rechts: Jac. p̄
A tergo oben Mitte: Predicatoy
Kleine deutliche Schrift
 mit einem betonten Buchstaben
Erste freie Linie fehlt
Papstnamen im Text nicht in
 Gitterschrift
 P. vacat

2604

Salutatio fehlt

Archives Nationales Paris
L 257 n. 103 _1257 februarii 8_
Br. 32.7 hoch 21.7 Plica 3.3
oberer Rand 6.6 links 1.3
rechts 1.5
Alexander IIII (Gitterschrift, Initiale variiert). .. Cartusien is ce
teris Prioribus ⸗ fratribus Cartu
sien. ordinis
//// fehlt : _Salutem et aplicam_
ben
Exhibita nobis devotionis
Dat Lateran VI Jd Februar. a° 3°
Bulle fehlt, Seide erhalten
In plica rechts : Jac ⊙ ...
A tergo oben mitte : Cartusien
Fette kleine klare Schrift, mit gestreck.
Ligaturen, mit 3 variierten Satz.
Anfängen.
In 1. Zeile 2 var. Buchstaben.
Erste Linie für Gitterschr. und einige Ober
lingen
Grober Fehler P. 16721

2605

Archives Nationales Paris
L 257 n. 104 _1257 februarii 8_
Br. 35.4 hoch 26. Plica 3.3
oberer Rand 5.2 links 1.7
rechts 1.7
Alexander IIII (Gitterschrift, Ini
tiale variiert). .. Cartusien c ce
teris prioribus z fratribus Cartusien
ordinis
Thesauro virtutum sic
Dat Lateran VI Jd Februar. a° 3°
Bulle fehlt, Seide erhalten
A tergo oben mitte : Cartusia
Fette kleine Schrift, mit gestr. Ligaturen
mit 3 betonten Satzanfängen.
In 1. Zeile 1 betonter Buchstabe
Erste Linie für Gitterschrift

P. 16722

2606

Graz Landesarchiv n. 748
P. 16721 _1257 Februarii 8_
Alexander IIII .. - priori Cartusien.
et ceteris prioribus ac fratri-
bus Cartusien. ordinis
Exposita nobis devotionis (exhibita?)
Lateran VI id. febr. a° 3°
Bulle an Seide
In plica rechts B. P.
Seitenlinien. Oberste Zeile
unterschrieben
Gestreckte Ligaturen

2607

Graz Landesarchiv n. 747
P. 16722 _1257 Februarii 8_
Alexander IIII. - priori Cartu
sien. et ceteris prioribus
ac fribus Cartusien. ordinis
Thesauro virtutum sic
Lateran VI id. febr. a° 3°
Bulle an Seide
In plica rechts J. P
Seitenlinien ganz nahe am
Rande. Oberste Zeile unter
schrieben
Gestreckte Oberlingen
Sehr fahrige und undeutli
che Schrift

2608

Gran. Landesarchiv n. 748
P. 16721 1257 Februarii 8
Alexander IIII - - priori Cartu-
sien. et ceteris prioribus ac
fribus Cartusien. ordinis
Exhibita nobis devotionis
Lateran. VI iď. febr. a° 3°
Bulle fehlt. Seide erhalten
Seitenlinien. Oberste Zeile
unbeschrieben
Gestreckte Ligaturen, in der
ersten Zeile umständlich,
nachher einfach.

2609

Gran. Landesarchiv n. 749
P. 16720 1257 Februarii 8
Alexander IIII - - priori Cartu-
sien. et ceteris prioribus Cartu-
sien. ordinis
Animarum salutem plenis
Lateran. VI iď febr. a° 3°.
Bulle an Seide
In plica rechts B. p.
Seitenlinien. Erste Zeile un-
beschrieben.
Gestreckte Ligaturen, umständ-
lich in der 1. Zeile, nachher
einfach.

2610

Archivio di Stato Milano
Bolle e Brevi
P. 16723 1257 Februarii 8
Alexander IIII univ. xpo fideli-
bus pres. litter. inspecturis
Vite perennis gloria
Lateran. VI iď. febr. a° 3°
Bulle und Seide fehlen
A tergo oben Mitte Schlenk

2611

Archivio di Stato Milano
Bolle e Brevi
P. 16724 1257 Februarii 9
Alexander IIII . . priori et fribus
O Praed. Mediolanen.
Pro reverentia beati
Lateran. V iď. febr. a° 3°
Bulle und Seide fehlen
In plica rechts Ay 9
Ecke oben links R
A tergo oben Mitte Schlenk

2612

Madrid Arch. Histór. Nacional
Poblet E n. Vrcat

P. —

1257 februarii 13

Alexander IIII .. abbi Belli Podii
Vrgellen. diöc.
Conquesti sunt nobis
Lateran. id. febr. a° 3°
Bulle fehlt. Hanf erhalten
In plica rechts bar
Ecke oben rechts Dar

Kleines Mandat
fast ohne Ränder l.
nur rechts

2613

Firenze, Innocenti di Firenze

Abschrift

P. — _1257 februarii 13_

Alexander IIII rectori Hospitalis S.
Marie ad Scm Gallum florentie
eiusque fratres — in ppm
Religiosam vitam eligentibus
R. Ego Alex. m
2 presb. 2 epi 4 diac
Lateran. p. m. Magistri Rollandi
SRE. vicecancellarii id. febr.
1256. a° 3°

2614

Montpellier, ville de Montp.
E. V Louvet 2791

P. — _1257 februarii 17_

Alexander IIII consulibus et uni
versitati Montispesulan. Maga
lonen. diöc.
Cum a nobis
Lateran. XIII kl. martii a° 3°
Bulle an Seide

Ohne alle Notizen
erste Zeile frei
Seitenlinien, ziemliche Ränder
gestreckte Ligaturen
Schöne Schrift.

2615

Montpellier, ville de Montp.
E. V Louvet 2792

P. — _1257 febr. 25_

Alexander IIII consulibus et comm
comuni Montispesulan.
Tenore vobis presentium
Lateran. V kl. martii a° 3°
Bulle an Hanf
Ohne Notizen
erste Zeile frei. Seitenlinien

A tergo oben Mitte

CXLVI capto anno tertio

- 90 -

2616

Archivio di Stato Milano
Bolle e Brevi
P. — *1257 Februarii 24*
Alexander III d. in xpo f. . . abb
tim et conv. mon. S. Johannis
de Pipia Cist. Ord. Cremonen.
dioc.
Religionis vestre meretur
Lateran. III Kl. Martii a° 3°
Bulle und Seide fehlen

2617

Archives Nationales Paris
L 257 n. 105 *1257 Februarii 27*
Br. 32.3 hoch 26.2 Plica 3.
oberer Rand 5. links 1.
rechts 1.1
 Alexander III (Gitterschrift, Ini-
tiale verziert) — Abbati Cisterciij
eiusque Coabbatibus et Conventi-
bus universis Cisterciensis ordinis
 Plantatus olim in
Dat Lateran III Kl Martij a° 3°

Bulle fehlt, Seide erhalten

Dünne eckige kleine Schrift, mit gestr.
Ligaturen, mit 4 verz. Satzanfängen
 In 1. Zeile 1 verz. Buchstabe
Erste Linie für Gitterschrift und
 untere Überlängen

P. vacat

2618

Firenze, Vallombrosa
P. 16757 *1257 Februarii 28*
Alexander III . . abbi mon.
Vallis Umbrose ad Rom. Eccl
nullo medio pertinentis
 Ad audientiam nostram
Lateran. II Kl. Martii a° 3°
 Bulle fehlt. Hanf erhalten
In plica rechts

2619

Archives Nationales Paris
L 257 n. 106 *1257 Martii 6*
Br. 40.7 hoch 31.5 Plica 3.6
 oberer Rand 6.3 links 1.5
rechts 1.2
 Alexander III (minusculae)
. . nigro et fratribus Hospitalis Je-
rusolim. Ad asidaum xpe
Dat Lateran II non Martij a° 3°

Bulle fehlt, Seide erhalten
 In plica rechts : a. a
A tergo oben Mitte grosses +

Ungemein schöne und schwungvolle
Schrift, mit gestr. Ligaturen, mit
2 verzierten Satzanfängen
 In 1. Zeile 2 verzierte Buchstaben
Erste Linie für Papstnamen und
 untere Überlängen

P. 16767

Toulouse, Archives départem.
H. 23

P. 16767 1257 Mart. 6

Alexander IIII . . magro et frat-
bus Hospitalis Jerosolimitan.
Ad audiendum epi
Laterani. II non. Martii a° 3°
Bulle fehlt, Seide erhalten
In plica rechts. a . s.
Erste Zeile frei
Schöne kleine weite Schrift

Gerückte Ligaturen

Firenze, Camaldoli
P. 16770 1257 Martii 7
Alexander IIII . . abbati et
conventui monasterii de
Vran. Camaldulen. ordinis
Iustis petentibus desideris
Lateran. non. Mart. a° 3°
Bulle und Seide fehlen
Oberste Zeile unbenutzt
Sub plica frei ganz liniert.

Archives Nationales Paris
L257 n. 107 1257 Martii 11
Br. 26.8 hoch 21.5 Plica 3.1
obuer Rand 5.1 links 1.3
rechts 1.5
 Alexander IIII . . Cancellino
Sca Genovefe. Parisien.
 licet nos olim
Dat Lateran V Jd Martii a° 3°

Bulle fehlt, Seide erhalten
 In plica rechts : Ge Ra
A tergo oben mitte : Predicator

Kleine regelmässige Schrift
 Erste Linie für Oberlängen
Ohne jeden betonten Buchstaben

P. vacat

Archives Nationales Paris
L257 n. 108 1257 Martii 13
Br. 35.8 hoch 31.2 Plica 3.4
obuer Rand 5. links 1.7
rechts 1.9
 Alexander IIII . . Epo Parisien.
 olim felicis recordationis
Dat Lateran II Jd Martii a° 3°

Bulle fehlt, Hanf erhalten Ge Ra
 In plica rechts : Ge Ra
A tergo oben mitte : Predicator

Kleine sehr schöne Schrift
 Mit einem betonten Buchstaben
Erste Linie für Oberlängen

ex adverso

P. vacat

Wien Staatsarchiv Chronol.

P. — 1257 Martii 13

Alexander III. - - priori et con-
ventui domus Sancte Marie
in Frowe Cartaus. Aqui-
legen. dioc.

Solet annuere sedes

Lateran. III id. Martii a° 3°

Bulle an Seide

In plica rechts Th. S.

Sub plica links pro Mayff
 ..

Ecke oben rechts Jac

Oberste Zeile unbeschrieben

Gestreckte Ligaturen

Graz, Landesarchiv n. 757

P. — 1257 Martii 13

Alexander III. - - priori et con-
ventui domus de Sito Cartu-
sien. ord. Aquilegen. dioc.

 Cum a nobis

Lateran. III id. Martii a° 3°

. Bulle an Seide.

In plica rechts Th. S.

 pro Mayff.
Sub plica links ..

 J

Ecke oben rechts Jac

Seitenlinien obeste Zeile un-
beschrieben

Gestreckte Ligaturen

A tergo Ecke oben links J

Archives Nationales Paris

L257 n. 109 1257 Martii 15

Br. 20.2 hoch 12.1 Plica vacat
 oberer Rand 2.4 links 1.1
rechts 0.9
 Alexander III. . . Abbati et Con-
ventui Monasterij sancti Germa-
ni de Pratis Parisien ordinis sancti
Benedicti Cum dilectus filius
Dat Lateran. Jd. Martij a° 3°

 Plica und Besiegelung fehlen

Zwei kleine fette Schrift

Erste Linie für einige Obatungen

Links zwei Leitenlinien

 P. vacat

Marseille Archives Départem.
H. P. a. 6
P. 16785 1257 Martii 16

Alexander III. . . magro et uni-
versis prioribus ac fribus or-
dinis Predicatorum

 Cum hii qui

Lateran. XVII kl. Aprilis
 a° 3°

Bulle an Seide

In plica rechts S. p.

Gestreckte Ligaturen

2628

Instr. Mwd. F. Dom. c. 8 1257 Martii 16
P. 16786
Alex IIII .. mag. et univ. prioribus ac fratri-
bus ord. Predic.
Ut ea que —
Laterani XVII Kal. Aprilis a° 30
Bulle an Seidenfäden
In plica rechts: And) S.
Sub plica links: ?
a. g.
Rand oben Mitte: petitur renovari
de verbo ad verbum
A tergo: predicatorum
Duplied

cap. 35
Bulle und Seide fehlen.
In plica rechts: Ber
pro deo
A tergo: predicatorum and

2629

Instr. Mon. F. Dom. c. 94 1257 Martii 16
P. 16785
Alex IIII .. mag. et universis prioribus ac
fratribus ord. Predic.
Cum his qui —
Laterani XVII Kal. Aprilis a° 30
Bulle an Seidenfäden.
In plica rechts:
Sub plica links: a. g.
Rand oben Mitte: petitur renovari de
verbo ad verbum
A tergo: predicatorum

2630

Archives Nationales Paris
L 257 n. 110 1257 Martii 17
Br. hoch plica
oberer Rand links
rechts
Alexander IIII . . Magro et fra-
tribus domus Militie Templi Jer-
limitan
Quia nonnullis personis
Dat. Laterum XVI Kl Aprilis a° 30
Bulle und Hanf ausgerissen
A tergo oben Mitte: T
Fette unruhige Schrift
mit einem betonten Buchstaben
Erste Linie für Oberlängen
P. vacat

2631

Archives Nationales Paris
L 257 n. 110 bis 1257 Martii 17
Br. 33.2 hoch 23.2 plica 4.8
oberer Rand 4, links 1.5
rechts 1.6
Alexander IIII . . Magro et fra-
tribus domus Militie Templi Jerlimitan
wie n. 110
Bulle an Hanf
A tergo oben Mitte: T
Fette kleine unruhige Schrift
Erste Linie für Oberlängen
P. vacat

2632

Archives Nationales Paris

L 257 n. 111 _1257 Martii 21_

Br. 19.4 hoch 12.2 Plica 2.
oberer Rand 2.6 links und
rechts ohne Seitenlinien
Alexander IIII. - Officiali Bel
nacen
Conqueste sunt nobis
Dat Laterani XII Kl Aprilis a° 3°
Bulle an Hanf
In plica rechts: - do pm (?)
Kleine klare Schrift, kaum zu lesen,
teil verblichen

P. vacat

2633

Marseille Archives Départem.
H. P. a. 6
P. 16797 _1257 Martii 23_
Alexander IIII. - magro et pri
oribus ac fribus ord. Bedicat.
De meritorum vestrorum
Laterani. X Kl. Apr a° 3°
Bulle an Seide
In plica rechts g. ār
Gemischte Ligaturen

2634

Instr. Mon. F. Dom. c. 68 _1257 Mart. 23_
P. 16797
Alex. IIII. - mag. et prioribus ac fratribus
ord. Pred.
De meritorum vestrorum
Laterani X Kal. Aprilis a° 3°
Bulle an Seidenfaden
In plica rechts: an la
Sub plica links: ?
A tergo: predicatorum

2635

Graz Landesarchiv n. 752
P. - _1257 Martii 25_
Alexander IIII. - patriarche Aqui
legen. et eius suffraganeis ac
.. abbibus, prioribus, decanis, ar
chidiaconis, prepositis, archipresb.
et aliis ecclesiarum prelatis plui Aqui
legen. provinciam constitutis
Non absque dolore
Laterani VIII Kl. Aprilis a° 3°
Bulle an Seide
Seitenlinien. oberste Zeile
unbeschrieben
Gestreckte Ligaturen

2636

Archives Nationales Paris

L251 n. 112 *1257 Martii 28*

Br. 28,2 hoch 21,2 Plica 2,5
oberer Rand 5,3 links 4,2
rechts 1,2

Alexander IIII (Gitterschrift, Initiale variiert) .. Magro et Prioribus
ac fratribus ordinis Predicatorum
Exultatione spiritu frequenter
Dat Literarii V Kl. Aprilis aº 3º

Bulle fehlt, Seide erhalten
In plica rechts : a · a ·
A tergo oben mitte : Bedicstorg

Sehr feine schöne Schrift, mit gestr.
Ligaturen, mit 4 vern. Sakaufängen
In 1. Zeile ein vern. Buchstabe
Erste Linie für Gitterschrift und Ober-
längen

P. 16804

2637

Marseille Archives Départem.
H. P. a. 6
P. 16804 *1257 Martii 28*

Alexander IIII .. magro el prio-
ribus ac fratribus ord. Predic.
Exultante spiritu frequenter
Literarum. V Kl. Aprilis aº 3º
Bulle an Hanf
Gestreckte Ligaturen
Keine Notizen
Prächtige , feste Schrift.

2638 (recto)

Instr. Misc. F. Dom. c. 94 1257 Martii 28
P. 16804 i. c. m.
Alex. IIII .. mag. el prioribus ac fratribus
ord. Predic.
Exultante spiritu frequenter
Literarii V Kl. Aprilis aº 3º
Bulle an Seidenfäden
In plica rechts : g. ar
pro deo
A tergo : predicatorum

Duplicat

Cap. 100
Bulle an Seidenfäden
In plica rechts : A. g. (der be-
kannte computista)
A tergo : predicatorum
·
Triplicat

Cap. 29

2638 (verso)

Bulle an Seidenfäden
In plica rechts : A. g. (der
bekannte computista)
Sub plica links : ..
Rand oben mitte : petitur re-
noveri de verbo ad verbum
A tergo : predicatorum

verte

Basel Staatsarchiv
Klingenthal Urk. Nr. 16
P. — 1257 Martii 29
Alex III .. priorisse et con-
ventui monialium in
clusarum monasterii de Klein-
gental Ostang Constantien.
dioc. secundum instituta
fratrum O Praed. viventibus
 Cum a nobis
Laterani IIII kl. Aprilis a° 3°
Bulle an Seide
In plica rechts .d.
Sub plica links ~

Rand oben Mitte Fiant flores
dann ad preces fratris Alberti
Ecke rechts Iac

Archives Nationales Paris
L257 n. 113 1257 Martii 30
Br. 52.5 hoch 39 Plica 4.7
 oberer Rand 4.9 links 1.5
rechts 1.3
 Alexander IIII Patriarchis Archi-
epis et Epis ad quos litere iste
 pervenerint
Dat Laterani Non sine multa kl Aprilis a° 3°
 IIII
Bulle an Hanf
 In plica rechts : Ia . nar.
A tergo oben Mitte +0
Kleine enge krumhige Schrift
Mit einem betonten Buchstaben
Erste Linie für Oberlängen

 P. 16808

Archives Nationales Paris
L257 n. 114 1257 Martii 30
 3,5
Br. 36.1 hoch 44.6 Plica 3.7
 oberer Rand 8.7 links 2.5
rechts 2.5
 Alexander IIII .. Turonen. el..
Rothomagen Archiepis et .. Epo
Parisien
 Non sine multa
Dat Laterani IIII kl Aprilis a° 3°
Bulle fehlt, Hanf erhalten
 A tergo oben Mitte : Predicatory
Sehr zierliche, schöne Schrift
 Mit einem betonten Buchstaben
Erste Linie für Oberlängen

 P. 16808

Archives Nationales Paris
L257 n. 115 1257 Martii 30
Br. 43.5 hoch 34. Plica 3.7
 oberer Rand 5.8 links 1.4
rechts 1.4
 Alexander IIII Patriarchis Archi
epis et Epis
 Quidam scripture sacre
Dat Laterani IIII kl Aprilis a° 3°
Bulle fehlt, Hanf erhalten
 In plica rechts : Ia . me.
A tergo oben Mitte : Predicatory
Schöne kleine Schrift
 Mit einem betonten Buchstaben
Erste Linie für Oberlängen

 P. 16809

2643

Marseille Archives Départem.
H . P . a . 6
P. 16808 1257 Martii 30
Alexander IIII patriarchis, archi
epis et epis ad quos littere iste
pervenerunt
 Non sine multa
Laterum III kl. aprilis a° 3°
 Bulle fehlt, Hanf erhalten
In plica rechts Ge Ra
 Ohne weitere Notizen

2644

Marseille Archives Départem.
H . P . a . 6
P. 16809 1257 Martii 30
Alexander IIII patriarchis, archi
epis et epis
 Quidam scripture sacre
Laterum . III kl. aprilis a° 3°
 Bulle an Hanf
 Ohne alle Notizen

2645

Barcelona Corona de Aragón
 Leg. 14° n. 2°
 P. — 1257 Aprilis 2
Alexander IIII .°. Regi arago
num Illustri
 Dum sinceritatem plene
Laterum . IIII non. Apr. a° 3°
 Bulle an Hanf
In plica rechts Jekes pat

2646

Staatsarchiv Wien Chronol.
 P. — 1257 Aprilis 4
Alexander IIII .°. priori et fra
tribus domus Sce Marie in
Frowa Cartusien Ord. tam
presentibus etc. in ppm
Religiosam vitam eligent.
Amen a Amen
R. Ego Alexander catho-
lice ecclie eps ſſ M
2 presb. 2 epi 3 diac
Laterum . p. m . magri Roben
di SRE vice canc. II non. Apr.
ind. IV ino. D. a° m . cc L vii p.
v. Domni Alex pp. IIII a° 3°
Bulle an Seide
Rand oben Mitte B. ſ u. dem
alia manu Orm. prio. Cartus. ord.

2647

Madrid Arch. Histór. Nacional
Moveruela 11 E

P. — falsche Besiegelung
1257 Aprilis 14

Alexander III .. decano et .. can-
tori Zamoren.
Ad audientiam nostram
Lateran. XVIII Kl. Mai a° 3°
Bulle und Hanf fehlen
In plica rechts Hugo V
Sub plica links
Ecke oben rechts Jac
Rand oben Mitte

Duplicat

Initiale schwarz-weiss, ohne
gestreckte Ligaturen, wie an-
zweifelhaft mit Hanf besie-
gelt.

2648

Madrid Arch. Histór. Nacional
Nogales León 9 E

P. — falsche Besiegelung
1257 Aprilis 14

Alexander III .. decano et ..
cantori Zamoren.
Ad audientiam nostram
Lateran. XVIII Kl. Mai a° 3°
Bulle fehlt. Hanf erhalten
In plica rechts Hugo. V.
Sub plica links .5

Ecke oben rechts Jac

Initiale schwarz und weiss
Hanffaden.
Keine gestreckte Ligaturen

Duplicat

2649

Frank. do.
Archives Nationales Paris
L257 n. 116 1257 Aprilis 22

Br. 33.7 hoch 21.5 Plica 2.6
oberer Rand 4.8 links 1.4
rechts 1.4
Alexander III (Gitterschrift, Ini-
tiale variiert) Archieps et Eps i
dil. filiis Abbatibus Prioribus deca-
nis Archidiaconis Archpbris z aliis
Ecclia y Prelatis ad quos littere iste
pervenerint
Preces que continent
Dat Lateran X Kl Maii a° 3°

Bulle an Seide P. vacat
In plica halblinks: Franc drie
In plica rechts: d Zusatz zum Bullen-
text.
Rand oben Mitte: Franc drie R L. A.
A tergo oben Mitte: Soo Antoni 9
Hospit. S. Antonii Viennense
Kleine ungelenke Schrift ohne jede gestr.
Ligatur, mit 3 betonten Satzanfängen
In 1. Zeile 1 betonter Buchstabe
Erste Linie für Gitterschr und Oberlängen
Papstnamen im Text in Gitterschrift

2650

Bayer., Haupt. Staatsarchiv
St. Emmeram fasc. 8

P. 16832 1257 Aprilis 27

Alexander III (Gitterschrift) .. Abbti
et Conventui Monasterii ki Eme-
ramm Ratisponen. ordinis sancti
Benedicti.
Exigentibus vestre devotionis
Lateran. V Kl. Maii anno Tertio

Bulle an feiner Seide:
In plica links: B. S. V
Sub plica links: ..
Rand oben Mitte: V
Ecke oben rechts: Jac
A tergo Ecke oben links Y

Erste Zeile frei, Leitenlinien

Innsbruck Sonnenburger Archiv
P. — 1257 Aprilis 30
Alexander IIII dil. in xpo filiabus . . abbatisse et conventui monasterii sancte Marie in Sunburch ordinis sancti Benedicti Brixinen. dioc.
 Iustis petentium desideriis
Dat. Lateran. II Kl. Maii a° 3°
 Bulle an Seide
In plica rechts · f · R
Sub plica links j·
Ecke oben rechts Jac
A tergo Ecke oben links A
 Oberste Zeile frei
Leiturlinien . Schriftlinien
 gehen bis zum Rande
 Gestreckte Ligaturen. Enge eckige Schrift.

Toulouse, Archives départem.
H. 23
 vide : 1257 martii 6
(P. 16767 ?) 1257 Aprilis 30
Alexander IIII .. magistro et fratribus Hospitalis Ierosolim.
 Ad assiduum xpi
Lateran. [II] Kl. Maii a° 3°
 Bulle fehlt, Seide erhalten
Ohne alle Notizen

Erste Zeile frei
Gestreckte Ligaturen

Napoli Curia Eccles. soppressi vol. 2°
P. 16837 1257 Maii 3
Alexander IIII .. magro et fratribus Hospitalis See Marie Theutonicorum Ierosolimitan.
Qui ex apostolici
Lateran. V non. Maii a° 3°
Bulle und Seide fehlen
plica abgeschnitten

Napoli Curia Eccles. vol. 3°
P. 16838 1257 Maii 3
Alexander IIII .. magro et fratribus Hospitalis See Marie Theuton. Ieros.
De fervore sincerissime
Lateran. V non. Maii a° 3°
Bulle und Seide fehlen
In plica rechts nomen

Innsbruck Sonnenburger Archiv
P.— 1257 Maii 3
Alexander III dil. in xpo filia
bus .. abbatisse et conventui
mon. S. M. in Sunburch OSB
Brixinen. dioc.
Solet annuere sedes
Lateran. V non. Maii a° 3°
 Bulle, an Seide
 In plica rechts archid
Sub plica links ♃
 Ecke oben / rechts Dat
A tergo Ecke oben link A
 „ Mitte

CCLXXX capto anno d̄oi

Innsbruck Sonnenburger Archiv
P.— 1257 Maii 3
Alexander III dil. in xpo filia
bus .. abbatisse et conventui
mon. S. Marie in Sunburch
OSB Brixinen. dioc.
 Cum a nobis
Lateran. V non. Maii a° 3°
 Bulle an Seide
 In plica rechts archid
 Sub plica links / ♃
Ecke oben rechts : Dat
Sehr fahrige nach links ge-
neigte kursive Schrift
 Gestreckte Ligaturen
 Seitenlinien, schmale Rän-
der. // A tergo links oben : A
Oberste Linie frei

Archives Nationales Paris
L257 n. 117 1257 Maii 4
P. vacat
Br. 30.7 hoch 23.4 Plica 3
 oberer Rand 6.2 links 1.
rechts 1.
 Alexander III . . Priori sancti
Stephani de Beln Eduen dioc
 Lieux dilecti filij
Dat Lateran III non maii a° 30
Bulle an Hanf
 In plica rechts : Dat gmen (?)
Sub plica links : . .
Rand oben mitte :
Ecke oben rechts : ja
 A tergo Ecke oben link : /
A tergo oben mitte : grosses +
Kleine feste sehr schöne Schrift
 Mit einem betonten Buchstaben
Erste Linie für Oberlingen

Marseille Archives départem.
H. P. a. 6
P.— 1257 Maii 11
Alexander IIII .. magistro et pri
oribus ord. fratrum Predicat.
In gravem corû
Lateran. V id. Maii a° 3°
Bulle an Hanf
 In plica rechts G. ar

Archives Nationales Paris
L 257 n. 118 1257 Maii 12

Br. 66.6 hoch 53. Plica 3.9
oberer Rand 6.7 links 1.5
rechts 1.6
Alexander IIII wie in n. 118 bis

Bulle an feiner Seide
In plica rechts: R Plac.
pro Magro Milo
a tergo oben mitte: Predicator

Mit nur je einer Seitenlinie

P. 16842

Archives Nationales Paris
L 257 n. 118 bis 1257 Maii 12

Br. 70. hoch 53.1 Plica 4.6
oberer Rand 6.7 links 2.7
rechts 2.7
Alexander IIII (minusculae. alle
Anfänge in Gitterschrift) epo seruus se-
norum dej Ad perp. memoriam fu-
turorum
Circa frequens cotidiane
Dat Lateran IIII Jd Maij a° 3°

Bulle an feiner Seide
In plica rechts: RR R Plac

Weite feste sehr regelm. Schrift, mit ge-
streckten Ligaturen, mit 3 variierten
Schauflügen

Je zwei Seitenlinien

P. 16842

Archives Nationales Paris
L 257 n. 119 1257 Maii 15

Br. 28.7 hoch 22.8 Plica 3.4
oberer Rand 6.3 links 1.3
rechts 1.
Alexander IIII (weite Gitterschrift,
Initiale variiert) Archiepis et Epis et
dil. filijs Archidiaconis ad quos litteræ
iste pervenerint
Cum dilecti filij
Dat Lateran Jd Maij a° 3°

Bulle und Seide ausgerissen
Ecke oben rechts: a
A tergo oben mitte: T

Sehr schöne kleine Schrift, gestr. Liga-
turen, mit einem variierten Schauflug
In 1. Zeile 1 vers. Buchstabe

Erste Linie für Gitterschrift

Papstname und Text nicht in Gitter-
schrift

P. vacat

Marseille Archives Départem.
H. P. Q. 6
P. 16847 1257 Maii 23
Alexander IIII uni uersis archiepi
et epis ac abbatibus, prioribus, de-
canis, archidiaconis et aliis eccle-
siarum prelatis ad quos litteræ
iste pervenerint
Celestis ille agricola
Viterbii X kl. Junii a° 3°
Bulle an Hanf
In plica rechts Jac p
Erste Zeile beschrieben

Archives Nationales Paris
L257 n. 120 1257 Maii 23
Br. 46.3 hoch 35.3 plica 4.9
 oberer Rand 7.9 links 1.6
rechts 1.7
 Alexander IIII .. venerabilis Archiep.
et Eps ac dil. filijs abbatibus prio-
ribus decanis Archidiaconis y alijs
Ecclie Prelatis ad quos littere iste
pervenerint.
 Celestis ille agricola
Dat Viterbij X Kl Junij a° 3°

Bulle fehlt, Hanf erhalten
 In plica rechts : Johes parmen
A tergo oben mitte : Bridicstorf

Fette kleine Schrift
 Mit einem betonten Buchstaben
Erste Linie für Oberlängen

 P. 16847

Bayer. Haupt- Staatsarchiv
 Ebersberg Fasc. 2
P. 16857 x 1257 Maii 29
Alexander IIII (Gitterschrift schlecht)
.. Abbati et Conventui Mo-
nasterij de Eberspech. ordinis
sancti Benedicti Frisingen. dioc.
 Cum a nobis
Viterbij III Kl. Junij a° Tertio
 Bulle an feiner Seide
In plica links : J. ..

Weite kleine, unsichere Schrift
Stark betonte, weit nach links
auslautende Unterlängen

Seitenränder ziemlich klein

Bayer. Haupt. Staatsarchiv
Regensburg St. Emmeram fasc. 8
P. 16863 x 1257 Junii 2
Alexander IIII (roman. Mai.) Univer-
sis xpi fidelibus presentes litteras
inspecturis
 Vite perennis gloria
Viterbij IIII Non. Junij Anno Tertio

Bulle an feiner Seide
In plica rechts Jo. S
Sub plica links : ..

A tergo Ecke oben links ..
Erste Zeile unbeschrieben, Seitenlinien
Oberer Rand breit.
Erste Zeile U (ninusis) betont vergiert

Regelmäßige feste Schrift .

Stift Rein
P. — 1257 Junii 2
Alexander IIII .. abbati et conven-
tui monasterii Runen. Cister-
tien. ordinis Salzeburgen. dioc.
 Sacrosancta Romana ecclia
Viterbii IIII non. Junii a° 3°
Bulle an Seide liegt bei
In plica rechts h. T. Pmd.
Sub plica links, ..

Rand oben mitte con
Ecke oben rechts ..
Gestreckte Ligaturen
Seitenlinien Oberste Zeile
beschrieben

2667

Marseille Archives Départm.
H. P. a. 7
P. — 1257 Junii 5
Alexander IIII . . archepo Are.
Inter.
Nulla dubietas xpi
Viterbii non. Jun. a° 3°
Bulle an Hauf
In plica rechts Jo. S.
Enge schöne Schrift
Erste Zeile frei

 cf. 1257 Jul. 7

2668

Montpellier ville de Montp.
E. V. Konvolut 2866
P. — 1257 Junii 5
Alexander IIII . . consulibus et uni
versitati hominum Monhispessu-
lan. Magalonen. dioc.
Fidei ac devotionis
Laterani. non. Jun. a° 3°
 Bulle an Seide

Ohne jede Notiz

Erste Zeile frei. Seitenlinien

Gestreckte Ligaturen
 Kleine, regelmäßige etwas eckige
 Schrift.

2669

Stift Rein
 P. — 1257 Junii 6
Alexander IIII . — abbati et con-
ventui monasterii Run. Ord.
Cist. Salzeburgen. dioc.
 Solet annuere sedes
Viterbii VIII id. Jun. a° 3°
 Bulle an Seide
 In plica rechts N. G.
 Sub plica links ?

Ecke oben rechts 1 ¼ ?
Seitenlinien. Oberste Zeile frei
 Gestreckte Ligaturen

2670

Bayer. Haupt. Staatsarchiv
Regensburg St. Emmeram Fasc. 8
P. 16870 1257 Junii 7
Alexander IIII (Gitterschrift, weit und
klein) Universis presentes litteras
inspecturis.
 Vite perennis gloria
Viterbij VII jd Junij Anno Tertio
 Bulle an Seide
 In plica rechts : . a. S.
 Sub plica links . .
Ecke oben links : Ja . x l. dierum
 oben Mitte : L
Erste Zeile frei, Seitenlinien
 Oben und unten sehr breite Ränder

2671

Marseille Archives départem.
H. P.a. 7
P. 16874 1257 Junii 9
Alexander IIII . . magro et prioribus provincialibus eorumque vicariis ord. frum Predic.
Sacre religionis bestre
Viterbii V id. Junii a° 3°
Bulle an Seide
Ohne alle Notizen
Gemischte Ligaturen

2672

Stift Rein
P. — 1257 Junii 9
Alexander IIII . . abbati Cistercii eiusque coabbatibus et conventibus universis Cisterciensis ordinis
Iustis petentium desideriis
Viterbii V id. Junii a° 3°
Bulle an Hanf
Gestreckte Ligaturen
Seitenlinien, oberste Zeile unbeschrieben

2673

Instr. hum. F. dom. c. 118 1257 Junii 9
 P. 16874
Alex. IIII . . mag. et prioribus provincialibus eorumque vicariis ord. fratrum Predic.
Sacre religionis vestre.
Viterbii V id. Junii a° 3°
Bulle an Seidenfäden.
Duplica rechts: Ja ff

A tergo: predicatorum
 Duplicat

cap. 114 Bulle an Seidenfäden
In plica rechts G. M.
Sub plica links: .?.
 a. g.

2674

Marseille, Archives départem.
H. P.a. 7
P. — 1257 Junii 11
Alexander IIII . . priori et fratribus Predicatoribus Arelaten.
Cum ad promovenda
Viterbii III id. Jun. a° 3°
Bulle an Seide
In plica rechts Hugo. V.
Ligaturen gemischt
Weite ruhige Schrift

Public Record Office London
Papal Bulls bundle 38 n. 1
P — 1257 Junii 12
Alexander IIII .. epo decano et
capitulo Saresbiriem.

Ad gaudium plurimum
Viterbii II id. Junii ao 3o
Bulle fehlt, Hanf erhalten
Initiale weiss und schwarz
In plica rechts Jac p̄

Paris Archives Nationales
J 431 n. 33
Breite 23.8 Rand links 1.2 rechts 1.
Höhe 98.4 Rand oben 3.4 plica 1.9
Erste Linie für Oberlängen / Je eine
Seitenlinie
P. vacat 1257 Junii 12
Alexander IIII .. Priori fratrum
Predicatorum Parisien z aliis inquisi-
toribus heretice pravitatis in terra
dil filij Nob viri .. Comitis Tolosani
Cum negotium inquisitionis
Dat Viterbij II Id Junij / ao 3o
Bulle an Hanf
A tergo oben Mitte: Caput Leonis
Prachtvolle kleine Schrift

Stift Rein
P — 1257 Junii 13
Alexander IIII archiepis et epis
et abbatibus, prioribus, decanis,
archidiaconis et aliis ecclarum
prelatis ad quos littere iste
pervenerint
Cum abbates Cisterciem.
Viterbii iv. Junii ao 3o
Bulle an Seide
In plica rechts . d.
Seitenlinien. Drei Zeilen
unbeschrieben
Gestreckte Ligaturen

Stift Rein
P — 1257 Junii 20
Alexander IIII .. abbati Cister-
tii et universis coabbatibus
eius Cisterciem . ordinis
Quia refrigescente caritate
Viterbii XII Kl. Julii ao 3o
Bulle an Seide
Ecke oben rechts a.
Seitenlinien. Oberste Zeile
unbeschrieben
Ligaturen gemischt.

2679

Instr. Mon. F. Dom. C. 167 1257 Jun. 22

P. 16899 rep.
14408

Alex IIII .. mg. et prioribus ac fratribus

ord. Predic.

Cum olim felicis.

Viterbii X Kal. Iulii a° 3°

Bulle an Seidenfäden.

In plica rechts: G. S.

Sub plica links: ..

A tergo: predicatorum

2680

Marseille Archives Départem.
H. P. A. 7

P. 16899 1257 Junii 22

Alexander IIII .. magro et prio-

ribus ac fratribus ord. Predic.

Cum olim felicis

Viterbii X Kl. Iulii a° 3°

Bulle an Seide

In plica rechts Ja Nar

Erste Zeile frei

Ligaturen gemischt

Fahnige etwas nach links

liegende Schrift

cf. P. 14408

2681

Marseille Archives Départem.
H. P. A. 7

P. 16900 1257 Junii 22

Alexander IIII .. priori et fratri

ord. Predic. Arelaten.

Necessitatibus vestris be-

nigno

Viterbii X Kl. Iulii a° 3°

Bulle an Seide

In plica rechts Jo S

Sub plica links ..

1

gestreckte Ligaturen

2682

Marseille Archives Départem.
H. P. A. 7

P. — 1257 Junii 22

Alexander IIII .. priori et fra-

tribus ordinis Predic. Arela-

ten.

Licet is de

Viterbii X Kl. Iul. a° 3°

Bulle an Seide

In plica rechts Ja S.

Sub plica links 1 ..

gestreckte Ligaturen

2683

Bayer. Haupt- Staatsarchiv
Formbach F. 3

P. 16901 1257 Iunii 24

Alexander IIII (Gitterschrift) .. Ab-
bati et Conventui Monasterii
beate Marie de Vormbach ordinis
sancti Benedicti Patavien. dioc.
 Liceat is de
Viterbii VIII Kl. Julii a° Tertio

Bulle an Seide
In plica rechts: Tur 2
Oberste Zeile frei, Seitenlinien

Pontificatus und andere Theile
der letzten Zeile abgeklatscht
auf deckender plica.

2684

Firenze, Badia fiorentina
P.— 1257 Julii 3

Alexander IIII .. abbi mon. de
Septimo Florentin. dioc.
Exhibita nobis dilectorum
Viterbii V non. Julii a° 3°
Bulle und Hanf fehlen
In plica rechts Ubam S.
Oberste Zeile frei
Sub plica unliniirt

2685

Firenze, Camaldoli
P. 16914 1257 Julii 6

Alexander IIII .. preposito ecclie
Aretin.
Sua nobis dilecti
Viterbii tt non. Julii a° 3°
Bulle und Hanf fehlen
Kleines Mandat. Erste Zeile
beschrieben; sub plica unliniirt

2686

Instr.- mon. F. Dom. c. 44 1257 Julii 7
 P. 16916
Alex IIII .. priori et fratribus or. Predic.
Arelaten.
De venerabili fratre —
Viterbii non. Julii anno 3°
Hanfschnur. Bulle fehlt.
In plica rechts: Ja. S.
Sub plica links: ...

Rand oben Mitte Rf ut al
A tergo: predicatorum

2687

Marseille, Archives Départem.
H. P. a. 7
P. 16916 1257 Julii 7
Alexander IIII .. priori et pr.
tribus ord. Praedic. Arelaten.
 De venerabili fratre
Viterbii non. Julii a° 3°
Bulle an Hanf
Ohne alle Notizen
Erste Zeile frei.

2688

Marseille Archives Départem.
H. P. a. 8
P. 16915 1257 Julii 7
Alexander IIII .. epo Biterren
Nulla dubietas xpi
Viterbii non. Jul. a° 3°
Bulle fehlt, Hanf erhalten
In plica rechts Jo. S
mittelmäßige Schrift

 cf. 1257 Jun. 5

2689

Marseille Archives Départem.
H. P. a. 8
P. — 1257 Julii 10
Alexander IIII univ. archepis
et epis ac abbatibus, prioribus,
decanis, archidiaconis, archi-
presbiteris et aliis ecclarium
prelatis et clericis universis
cuiuscumque ordinis vel pro-
fessionis per Arelaten. et Aquen.
provincias et civitates ac diòce-
ses earundem provinciarum
constitutis ad quos litt. iste perv.
 De pia et
Viterbii VI id. Jul. a° 3°
Bulle fehlt, Hanf erhalten
In plica rechts J. ar
Schöne regelmäßige Schrift

2690

Archives Nationales Paris
L257 n. 121 1257 Julii 14
Br. 52,5 hoch 38.4 Plica 3.
obern Rand 6.9 links 1.9
rechts 1.9
 Alexander IIII . . Epo Parisien.
 Cum adversus provisionis
Dat Viterbii II id. Julij a° 3°

Bulle an Hanf
 In plica rechts : Jac m̄
a tergo obin mitte : Predicatory
Gedrungene feste regelm. Schrift
 Mit einem betonten Buchstaben
Freie erste Linie fehlt

 P. 16924

2691

Instr. Mon. F. Dom. c. 35 1257 Julii 20

P. 16933

Alex. IV .. mag. prioribus et fratribus
univ. ord. fratrum Praed.
Nimis iniqua vicissitudine —
Viterbii XIII Kal. Aug. anno tertio
Seidenfäden. Bulle fehlt.
In plica rechts: g̅ mo
 g̅. mo
A tergo: Predicatorum

 Wird wiederholt am
 17. Februar 1258
 P. 17188

2692

Madrid Arch. Histor. Nacional
S. Estéban de Salamanca h. 18
 P.- 1257 Julii 25
Alexander IV .. priori et fratribus
predicatoribus Salmantin.
Cum ad promerenda
Viterbii VIII Kl. Aug. a° 3°
Bulle fehlt. Seide erhalten

Ohne jede Kanzleinotiz

Sehr schöne regelmässige Schrift
Ligaturen alle gestreckt.
Eingezäunter Rand rechts und
links

2693

Coblenz Staatsarchiv
 Domcapitel
 P. - 1257 Julii 28
Alex. IV .. decano Remensi
Cum questionem nobis
Viterbii V Kl. Aug. a° 3°
Bulle und Hanf ausgerissen
plica deckt die letzte Zeile.
In plica links j. V.
Ecke oben rechts Jac̅ (?)
A tergo Walterus de Clevia

2694

Madrid Arch. Histor. Nacional
San Marcos de Leon h. 62
 P. - 1257 Julii 30
Alexander IV .. magistro seculorum Legionen.
Dignum esse conspicimus
Viterbii III Kl. Aug. a° 3°
In plica rechts · a̅ R
Ecke oben rechts Jac̅
Zwischen den letzten Textworten
nur Dat. ist grosser Raum
von acht Worten, was gegen
die Kanzleigebräuche ist. Bei
der Revision ist das übersehen
worden.

Rechts und links zierlicher Rand

2695

Archives Nationales Paris
L 257 n. 122 1257 Julii 31

Br. 38.9 hoch 28.4 Plica 2.5
 oberer Rand 8.2 links 1.5
rechts 1.4
 Alexander IIII Carissimo in Xpo
filio . . Regi Francorum Illustri
 Bona meritoria per
Dat Viterbij II Kl Aug a° 3°

Bulle fehlt, Seide erhalten
 In plica rechts : Jac p̄
A tergo oben Mitte : Predicator

Sehr regelm. feste schöne Schrift

 Mit einem [zwei] betonten Buchstaben
Carissimo nur Initium

Freie erste Linie fehlt

 P. 16954

2696

Instr. Mon. F. Dom. C. 47 1257 Julii 31
 P. 16954.
Alex. IV . . regi Francorum illustri
Bona meritoria per.
Viterbii II Kal. Augusti anno 3°
Hanfschnur. Bulle fehlt.
Sub plica links : 9

 7

A tergo : predictorum

2697

Marseille Archives Départem.
H. P. A. 8
P. — 1257 Augusti 8
Alexander IIII . . priori et pribus
Ord. Predic. Arelaten.

dilecti is de
Viterbii VI id. Aug. a° 3°
Bulle an Seide
In plica rechts Jac Ind
Gestreckte Initialen

2698

 Annotatio
Archives Nationales Paris
L 257 n. 123 1257 Augusti 9

 Br. 27.2 hoch 18.8 Plica 2.5
 oberer Rand 3.5 links 1.
rechts 1.1
 Alexander IIII Guillermo de Sco.
Amore in bonum dirigere premsaus
 cum propter multiplices
Dat Viterbij V id Aug a° 3°

Bulle fehlt, Hanf erhalten
 In plica rechts : Hugo. V
A tergo oben Mitte : Predicator

feste etwas eilige Schrift

 Ohne jeden betonten Buchstaben

Erste Linie zwecklos

 P. 16977.

2699

Marseille Archives Départem.
H. O. M. 20
P. 16972 1257 Augusti 9
Alexander IIII .. magro et fr.
tribus Hospitalis Jerosolim.
Quandam constitutionem nos
Viterbii V. id. augusti a° 3°
Bulle und Hanf fehlen
Ohne Notizen
Erste Zeile frei
Ziemliche schöne Schrift

2700

Archives Nationales Paris
L 257 n. 124 1257 Augusti 11
Br. 34.5 hoch 25.7 Plica 2.2
obern Rand 4.7 links 1.2
rechts 1.5
 Alexander IIII Carissimo in xpo
filio .. Illustri Regi Francie
 Cum propter multiplices
Dat Viterbij III Jd Aug. a° 3°

Bulle an Hanf
 In plica rechts : Hugo. V.
A tergo oben Mitte : Predicatores
Weite sehr regelm. Schrift
Ohne jeden betonten Buchstaben
Erste Linie frei Oberlängen

P. 16978

2701

Instr. Mon. F. Dom. C. 48. 1257 Aug. 17
 P. 16987
Alex. IIII .. priori provinciali ac fr.
tribus ord. Predic. Francie.
Prior etc.
Viterbii XVI Dal. Sept. a° 3°
Bulle an Seidenfäden.
In der Mitte unten ausgepressen in
der Falte
In plica rechts : Jac a.
Sub plica links : ¿
 B
A tergo : Predicatorum

Scriptor : Jacobus Anconitanus
 1252 octobris 31. cap. 6057

2702

Archives Nationales Paris
L 257 n. 125 1257 Augusti 23
Br. 37.8 hoch 27.1 Plica 2.6
obern Rand 4.8 links 1.5
rechts 1.3
 Alexander IIII .. Epo Parisien
 Cum propter multiplices
Dat Viterbij X Kl Septembris a° 3°
Bulle fehlt, Hanf erhalten
 In plica rechts : Hugo. V.
Kleinere sehr regelmässige, schöne
 Schrift
 mit einem leicht betonten Buch-
 staben
Über dem Text zwei leere Linien

P. post. num. 16993

Firenze, Vallombrosa
P. — 1257 Augusti 30
Alexander IIII . . abbi et con-
ventui mon . vallis Vmbro-
se Fesulan . dioc . . ad Roman
eccliam nullo medio per-
tinentis
Paci et tranquillitati
Anagnie Viterbii III Kl. Sept. a° 3°
Bulle und Seide fehlen
Ohne alle Notizen
Erste Linie unbenutzt
Sub plica unliniirt.

Archives Nationales Paris
L 257 n. 126 1257 Septembris 3
Br. 36.7 hoch 29.2 Plica 2.3
oberer Rand 5.2 links 1.4
rechts 1.2
Alexander IIII (Gitterschrift, Initiale
verziert) . . Abbati Cisterciy
eiusque coabbatibus et Conventibus
vniuersis Cisterciensis ordnis
Sacre nre religionis
Dat Viterbij III non Septembres a° 3°

Bulle und Seide fehlen
In Ecke oben rechts : a
A tergo oben Mitte : Bonifontis
cisty
Eckige klare Schrift, mit ganz reinen
gestr. Ligaturen, mit 3 verzierten
Satzanfängen
In 1. Zeile 1 verz. Buchstabe
Erste Linie für Gitterschrift

Papstnamen im Text nicht in Gitterschrift
P. vacat

vicecancellarius
Archives Nationales Paris
L 257 n. 127 1257 Septembris 4
Br. 29. hoch 23.4 Plica 2.5
oberer Rand 4.9 links 1.7
rechts 1.6
Alexander IIII (Gitterschrift, Initiale
verziert) — — Abbati — et Conventui mo-
nasterij de Boherijs Cisterciensis ordnis
laudunen dioc
Cum sepe contingat
Dat Viterbij III non Septembr a° 3°

Bulle und Seide ausgerissen
A tergo oben Mitte : Cisty Bonifontis
A tergo zweizeilige Supplik über Ausfertigun-
gen ähnlicher art : idem mandare vice
Cancellario

Feine weite Schrift, mit gestr. Ligaturen,
mit 3 verzierten Satzanfängen
In 1. Zeile 1 verz. Buchstabe
Erste Linie für Gitterschrift

Non aus Jo verbessert P. vacat

Instr., Monast. Monum. Tudertina
P. — 1257 Septembris 5
Alexander IIII dil in xpo filiabus
.. abbatisse et conventui monaste-
rij S. Marie de Montimaucti
Tudertin . dioc . ord. S. Damiani
Dudum inter vos
Viterbii non Sept. a° 3°
Bulle an Seidenfäden
In pl. links : Ro B
A tergo oben Mitte
frater Andreas
de Camera auch
1258 Aug. 27

2707

Archives Nationales Paris

L 257 n. 128 _1257 Septembris 5_

Br. 23.1 hoch 18.1 Plica 3.2
oberer Rand 4.5 links 1.1
rechts 1.2
 Alexander IIII (Gitterschrift, Initiale
variiert) . . Abbati et Conventui Mona-
sterij de Fusniaco Cisterciensis ordinis
Laudunen. dioc

 Devotionis vestre supplicationibus
Dat Viterbij Non Septembr. aº 3º

Bulle und Seide fehlen
 Ecke oben rechts : a
A tergo oben linke : Cist. Bonifontis

Sehr regelm. feste gerade Schrift, mit gestr.
Ligaturen, mit 3 verz. Schaufängern
 In 1. Zeile 1 verz. Buchstabe
Erste Linie für Gitterschrift nur Ober-
 längen

 P. vacat

2708

Archives Nationales Paris

L 257 n. 129 _1257 Septembris 11_

Br. 23.9 hoch 25.3 Plica 4.1
oberer Rand 5.2 links 1.7
rechts 1.8 .
 Alexander IIII (Gitterschrift, Initia-
le variiert) . . Abbati Cistercij eiusque
coabbatibus et Conventibus universis
Cisterciensis ordinis
 Religionis vestre meretur
Dat Viterbij III Jd Septembr. aº 3º

Bulle fehlt, Seide erhalten
 In plica rechts : benedcs. de Terentin.
Ecke oben rechts : a
 A tergo oben linke : Cist. boni Fontis

Kleine fette ruuhige Schrift, mit gestr.
Ligaturen, mit 4 verz. Schaufängern
 In 1. Zeile 1 verz. Buchstabe
Erste Linie für Gitterschrift nur Oberlän-
 gen

 P. vacat

2709

Archives Nationales Paris

L 257 n. 130 _1257 Septembris 11_

Br. 31.8 hoch 21.8 Plica 3.3
oberer Rand 5.3 links 1.1
rechts 1.1
 Alexander IIII (Gitterschrift, Initiale
variiert) . . Abbati Cistercij eiusque
coabbatibus et Conventibus Universis
Cisterciensis ordinis
 Sedes aplica duxit
Dat Viterbij III Jd Septembr. aº 3º

Bulle und Seide fehlen
 In plica rechts : Mayfs
A tergo oben linke : Cist. boni Fontis

Weite sehr regelm. Schrift, gestr. Ligatu-
ren (mit 1 Ausnahme), mit 3 verzier-
ten Schaufängern
 In 1. Zeile 1 verz. Buchstabe
Erste Linie für Gitterschrift und Ober-
 längen

 P. vacat

2710

Archives Nationales Paris

L 257 n. 131 _1257 Septembris 11_

Br. 34.3 hoch 26.9 Plica 3.
oberer Rand 4.5 links 1.4
rechts 1.7
 Alexander IIII (Gitterschrift, Initiale
variiert) . . Abbati Cistercij eiusque
Coabbatibus et Conventibus univer-
sis Cisterciensis ordinis
 Cum felicis recordationis
Dat Viterbij III Jd Septembr. aº 3º

Bulle fehlt, Seide erhalten
 In plica rechts : Hugo . s.
A tergo oben linke :
 Cist. boni Fontis

feste schöne Schrift, mit gestr. Liga-
turen, mit 3 verzierten Schaufängern
 In 1. Zeile 1 verz. Buchstabe
Erste Linie für Gitterschrift

Papstnamen im Text nicht in Gitter-
 schrift

 P. vacat

2711

Npoli Curia Eccles. Vol. 2°
P. 17005 1257 Septembris 13
Alexander IIII . . magro et fra-
tribus Hospitalis Sce Marie Theu-
tonicorum Jerosolimitan.
Quotiens a nobis
Viterbii id. Sept. a° 3°
Bulle und Seide fehlen
plica abgeschnitten

2712

Archives Nationales Paris
L 257 n. 132 1257 Septembris 17
Br. 31.6 Hoch 26.3 Plica 2.2
oberer Rand 4.7 links 1.2
rechts 1.3
Alexander IIII (Gitterschrift, Initia-
le ausziert) . . Abbati Cistertij eiusque
coabbatibus z Conventibus universis
Cisterciensis ordinis
Plantatus olim in
Dat Viterbij XV Kl Octobr a° 3°

Bulle und Seide ausgeschnitten
Ecke oben rechts : a
A tergo oben Mitte: Bonifontis Cist(?)

Fette nachlässige Schrift
Ohne jede gestreckt Ligatur

mit 3 varierten Satzanfängen
In 1. Zeile 1 ver. Buchstaben
Erste Linie für Gitterschrift und abschlau-
sen

P. vacat

2713

Instr. Mon. F. Dom. c.9 1257 Sept. 20
P 17009
Alex. IIII .. mag. et fratribus ord. Praed.
Convenit ut sacer.
Viterbii XII Kal. Oct. a° 3°
Bulle an Seidenfäden
In plica links : I V und zwei ver-
blinte Notizen
Sub plica links : ä. g.

A tergo : predicatorum

Duplicat

2714

Madrid Arch. Histo. Nacional Español
Palencia San Pablo n. 12
P. 17009 1257 Septembris 20
Alexander IIII .. magro et fra-
tribus Ord Praed.
Convenit ut sacer
Viterbii XII Kl. Oct. a° 3°
Bulle fehlt. Seide erhalten
Ohne alle Notizen

Duplicat

Marseille Archives Départem.
H. P.a. 8
P. 17009 1257 Sept. 20
Alexander III. ., magro et fri-
bus ord. Predicatorum
 Convenit ut inter
Viterbii XII kl. Oct. a° 3°
Bulle an Seide
In plica rechts G. ar
 (alia manu) pro W. W.
Unruhige aber regelmässige
Schrift
Gestreckte Ligaturen

Graz Landesarchiv n. 760
P. — 1257 Septembris 21
Alexander III. ., decano eccle-
sie Salzburgen.
Quia refrigescente caritate
Viterbii XI kl. octobris a° 3°
Bulle an Hanf
In plica rechts al p
Sub plica links ?
 :3
Seitenlinien. Oberste Zeile
 beschrieben

Archives Nationales Paris
L2 n. 133 1257 Septembris 22
Br. 30.9 hoch 22.8 Plica 3.2
 oberer Rand 5.2 links 1.8
rechts 1.6
 Alexander III (Gitterschrift, In-
tiale verziert). . Abbati Cistertii
eiusque Coabbatibus et Conventibus
universis Cisterciers ordinis
 Sedes aplica duxit
Dat Viterbii X kl Octobr a° 3°

Bulle fehlt, Seide erhalten
 In plica rechts : F. R.
A plica terys oben hatte : (C.à.I) Bonifortis
Ungemein schöne, feste kleine schwung-
volle Schrift, mit gestr. Ligaturen
mit drei verzierten Schauffingen.
In 1. Zeile 1 verz. Buchstabe
Erste Linie für Gitterschrift und Ober-
 längen.

 P. vacat

Firenze, Camaldoli
P. 17010 1257 Septembris 22
Alexander III [ohne Punkte]
univ. abbibus, prioribus et
fribus Camaldulen ordinis
 Lecta coram nobis
Viterbii X kl. Oct. a° 3°
Bulle Seide plica fehlen
Sub plica links ?.
 :3
Rund oben hatte V
Kleine zierliche schöne Schr

2719

Archives Nationales Paris
L 257 n. 134 1257 Septembris 24

Br. 29.4 hoch 22.3 Plica 3.1
oberer Rand 5.1 links 0.9
rechts 0.8
Alexander IIII . . Abbati Cister-
tij eiusque coabbatibus c Conuen-
tibus diuersis Cisterciens ordinis
Intimantibus nobis accepimus
Dat Viterbij VIII Kl Octobrs a° 3°

Bulle und Seide fehlen
A tergo oben Mitte: Ciuis Bonifontis

Kleine unruhige Schrift, gestreckte
Ligaturen (mit 2 Ausnahmen)
mit 3 verzierten Satzanfängen
Erste Linie für Gitterschrift und
Oberlängen

P. vacat

2720

Archives Nationales Paris
L 257 n. 135 1257 Octobris 2

Br. 75 hoch 54 Plica 5.1
oberer Rand 9.5 links 3.1
rechts 3
Alexander IIII . . Epo Parisien
Cum olim apud
Dat Viterbij VI non Octobr a° 3°

Bulle fehlt, Hanf erhalten
In plica rechts : R Plac
A tergo oben Mitte : Predicatoy

grosse regelmässige runde Schrift
Mit einem betonten Buchstaben
Erste Linie für Oberlängen

Je 2 Seitenlinien

Papstnamen im Text nicht in
Gitterschrift

2721

Instr. misc. F. dom. c. 61 1257 Oct. 5
P. 17022
Alex. IIII .. abbati Sci Seueri de Urbeueteri
Premonstraten. ordinis
Paci et tranquillitati —
Viterbii III non. Octobris a° 3°
Bulle an Hanfschnur
In plica rechts: Iac
A tergo: Predicatorum

2722

Firenze Vallombrosa
P. 17029 1257 Octobris 12
Alexander IIII . . abbi et con-
uentui Vallis Vmbrose
Ea que iudicio
Viterbii III N. Oct. a° 3°
Bulle und Seide ausgerissen
In plica rechts: P. B.
Grosses Querformat
Sub plica mit roter Tinte
Ecke oben rechts
a Jar
A tergo Ecke oben
links J

Erste Linie frei
Sub plica unliniirt

2723

Archives Nationales Paris

L257 n. 236 *1257 Octobris 13*

Br. 42.1 Hoch 31.5 plica 2.5
 oberer Rand 6. links 1.9
rechts p. 8

Alexander IIII universis Archiep͞s
et Ep͞is ac dil. filijs Abbatibus Priori-
bus Archipbr͞is Decanis Archidia-
conis et alijs eccliar Prelatis ad
quos iste littere peruenerint
 Cum propter multiplices
Dat Viterbij III Jd Octobr͞s a° 3°

Bulle fehlt, Hanf erhalten
 In plica rechts: R. Plac
A tergo oben mitte : Redicator

Etwas steife klare Schrift
 mit einem betonten Buchstaben
Erste Linie für Oberlängen

 P. 17030

2724

Public Record Office London
Papal Bulls bundle 2 n. 32
 P. 17035 *1257 Octobris 15*

Alexander IIII magistro Rostanno
subdiacono et capellano nostro
Exhibita nobis dilecti
Viterbii id. Oct. a° 3°
Bulle fehlt; Hanf erhalten
Sub plica links mit roter Tinte

2725

Firenze, Camaldoli
P. 17056 *1257 Novembris 3*
Alexander IIII . . archeps Pisan.
 Oblata nobis ex
Viterbii III non. nov. a° 3°
 Bulle Hanf plica fehlen
Sub plica links mit roter Tinte
 Ecke oben links dieps
 Rand oben mitte L
 Ecke oben rechts
Oberste Linie beschrieben

2726

Poitiers Archives départem.
Ordre de malte

P. — *1257 Novembris 3*

Alexander IIII . . archidiacono
Transvigenen. in ecclesia Turron
dignum esse conspicimus
Viterbii III non. nov. a° 3°
Bulle und Hanf fehlen
In plica links F
Erste Zeile frei
Seitenlinien, schmale Ränder
Schwungvolle Schrift mit Schnör-
keln

2727

Firenze, Camaldoli
P.17055 1257 Novembris 3
Alexander IIII. . . priori sci Pe-
tri Lucani.
 Oblata nobis ex
Viterbii III non. . nov. a° 3°
 Bulle und Hanf fehlen
In plica rechts . al. p
 Oberste Linie beschnitten
Sub plica unliniirt

2728

Firenze, Camaldoli
P.17058 1257 Novembris 3
Alexander IIII. . . priori sci Bar-
tholomei de porta Ravennat.
Bononien.
 Significantibus dilectis filiis
Viterbii II non. nov. a° 3°
 Bulle an Hanf. Plica fehlt
 Sub plica bis an die falte
liniirt

2729

Public Record Office London
Papal Bulls bundle 2 n. 26
 Investitur
P.17060 1257 Novembris 7
Alex IIII . . priori Sce Trinitatis
 Londonien.
 Olim venerabili fratre
Oddonem vicecomitem capella-
num nostrum per suum
pilleum ipsum Ubaldini nomine
(de ecclesia de Bisle) investiens
Viterbii VII id. Nov. a° 3°
 Bulle an Hanf
 In plica rechts Johes Campt

2730

Firenze, Camaldoli
P.17064 1257 Novembris 8
Alexander IIII - - priori Ca-
 maldulen.
Tuis et dilectorum
 Viterbii VI id. nov. a° 3°
Bulle und Seide fehlen
 In plica rechts B. hug.
Sub plica links mit roten Tinte
S In dilectis drei Fach
S gestreckte dipthen mit
 doppelten Oberlängen.
Bei dem Buchstaben b sehr
gestreckte Aufwärtsstriche

2731

Firenze, Castello

P. — *1257 Novembris 9*

Alexander IIII . . abbi et conven.
tui mon. Sci Galgani Cist.
ordinis Wolterran. diœ.

Vestre merito religionis

Viterbii V iđ. nov. a° 3°

In plica rechts: Iac. Mar.
Ligaturen gemischt.

2732

Archives Nationales Paris

L 257 n. 137 *1257 Novembris 13*

Br. 29.3 hoch 21.3 Plica 2.4
obere Rand 4.7 links 1.5
rechts 1.6

Alexander IIII . . Abbti Cistertij
eiusque Coabbatibus z Conventibus
universis Cistercien ordinis

Religionis ure merentur

Dat Viterbij Id Novembris a° 3°

Bulle fehlt, Seide erhalten
In plica rechts: p... ab..
A tergo oben halblinks: P. de Assisio
pro Cist)

Kleine regelm. Schrift mit gestreckten
Ligaturen (mit einer Ausnahme)
mit 4 verzierten Schauffängern
In 1. Zeile ein betonter Buchstabe
Erste Linie für Gitterschrift und
Oberlängen

P. vacat

2733

Archives Nationales Paris

L 257. n. 138 *1257 Novembris 13*

Br. 26.5 hoch 17.4 Plica 3.2
obere Rand 5.4 links 1.1
rechts 1.

Alexander IIII . . decano et Capi-
tulo Parisien

Significastis nobis quod

Dat Viterbij Id Novembris a° 3°

Bulle fehlt, Hanf erhalten
In plica rechts: Maths
Sub plica links mit rother Tinte) .. il

Rand oben Mitte [
A tergo Ecke oben links: y
" oben Mitte + Joħs de Betisiaco t

Schwungvolle kleine Schrift
Mit einem betonten Buchstaben
Erste Linie für Oberlängen

P. 17069

2734

Archives Nationales Paris

L 257. n. 139 *1257 Novembris 16*

Br. 31.7 hoch 21.3 Plica 3.
obere Rand 6.1 links 1.6
rechts 1.7

Alexander IIII (weite Gitterschrift
Initiale verziert) . . Magro et patribus
ordinis Predicatorum

Inspirationis divine gratie

Dat Viterbij XVI kl Decembris a° 3°

Bulle fehlt, Seide erhalten
In plica links: st pro S. pdicatoriσ

Kleine regelm. Schrift mit gestr. Liga-
turen (mit einer Ausnahme), mit
3 verzierten Schauffängern
In 1. Zeile 2 ver. Buchstaben
Erste Linie für Gitterschrift

P. 17072

2735

Archives Nationales Paris

L 257. n. 140 __1257 Novembris 17__

Br. 29.3 hoch 20.7 Plica 3.5
oberer Rand 6.5 links 1.5
rechts 7.5

Alexander IIII (Gitterschrift, Ini
tiale verziert) .. Abbati et Conventui
Monasterij Vallis Sancte Marie Cis-
tertien ordinis Parisien dioc
Animarum salutem desidero
Dat Viterbij XV kl decembr a° 3°

Bulle fehlt, Seide erhalten
In plica rechts : ay ..
A tergo oben mitte : P. de Ass
Cisti
Fette unruhige Schrift, mit gestr. Liga
turen, mit 3 verz. Satzanfängen
In 1. Zeile 1 verz. Anfststbe
erste Linie für Gitterschrift und unten
Obulängen

__P. vacat__

Schreibfehler desidero für desiderio

2736

Instr. hon. F. tom. c. 81 1257 nov. 20
p. 17077

Alex. IV fratribus ord. fratrum Predicet
tribut Ut in vestris
Viterbii XII kal. decembris anno tertio
Bulle an Seidenfäden
In plica rechts : R. Plat
Sub plica links : ?
a. g.

A tergo : predicatorum

2737

Staatsarchiv Wien Chronol.
P. — __1257 Novembris 27__
Alexander IIII. .. preposito et
capitulo Salzeburgen.
Cum a nobis
Viterbii V kl. Dec. a° 3°
Bulle an Seide
In plica rechts
Sub plica link mit rother
Tinte XVI
[
Ecke oben rechts
a Sto
Oberste Zeile beschrieben

2738

Madrid Arch. Histor. Nacional
Dominicos de S. Pablo Burgos 25 E
P. — __1257 Novembris 27__
Alexander IIII .. priori et fratribus
predicatoribus Burgen.
Cum ad promovenda
Viterbii V kl. Dec. a° 3°
Bulle fehlt. Seide erhalten
In plica links a

Ligaturen gemischt.
Rechts und links kleine Räu-
der

Duplicat

2739

Madrid Arch. Histór. Nacional
Dominicos Huesca 8 E
P. — 1257 Novembris 27
Alexander IIII — — priori et fratri
Predicatoribus Oscen.
Cum ad promerenda
Viterbii V kl. Dec. a° 3°
Bulle fehlt. Seide erhalten
In plica links A

Nur einzelne Ligaturen ge-
streckt.
Schmale Ränder

Duplicat

2740

Neapel Perg. Farn. Bolle n° 8
Rothe Tinte P. — 1257 Novembris 29
Alexander IIII . . archiepo
et capitulo Ecclie sancti Sisti
Viterbien. OSAug.
Viris religiosis annuere
Viterbii IIII kl. Dec. a° 3°
Bulle und Seide fehlen
In plica rechts A. Gol Guat
Sub plica links mit
rother Tinte

A tergo lange gross geschriebene
Kurslenschr.: Mandat dnus
cardinalis quod serva
die fest griev verris dt ist.

2741

Duplicetur
Archives Nationales Paris
L 257 n. 141 1257 Decembris 1
Br. 29. hoch 20.2 plica 3.3
oberer Rand 5.6 links 1.6
rechts 1.6
(Alexander IIII (Gitterschrift Zwi
linke versiert) . . Magro et fra-
tribus ordinis fratrum Predicatori
Devotionis nestre precibus
Dat Viterbij kl. Decembr a° 3°

Bulle fehlt. Seide erhalten
Rechte plicaseite abgerissen
Rand oben halblinks: dupt
A tergo oben mitte: Predicatox

Unruhige etwa eckige Schrift mit
gestr. Ligaturen, mit 3 versierten
Schlaufbögen
In 1. Zeile 1 vers. Buchstabe
Erste Linie für Gitterschrift und
unter Oberlängen

P. 17092

2742

Firenze, Arch. Fiorentino
P. — 1257 Decembris 1
Alexander IIII . . abbi et conven
sui mon. See Marie Floren.
Tin OSB ad Rom. Eccl. nullo
medio pertinentis
Cum dilectus filius
Viterbii kl. Decembris a° 3°
Bulle fehlt. Hanf erhalten
In plica rechts A. L. a. Sen
In plica links mit rother
Tinte ;)
oberste Linie frei
Sub plica unliniirt

2743

Stratsarchio trien Chronol.
P. 17096 1257 Decembris 4
Alexander IIII .. epo Chinen
In contemptum veniens
Viterbii π non. Dec. a° 3°
Bulle an Hanf
In plica rechts ʃ
Sub plica links mit rother
Tinte ..
 9

Oberste Zeile beschrieben

2744

Stratsarchio trien Chronol.
P. 17096 1257 Decembris 4
Alexander IIII universis ministerialibus et vasallis ecclesie
Salzeburgen.
In contemptum veniens
Viterbii π non. dec. a° 3°
Bulle an Hanf
In plica rechts ʃ
Sub plica links mit rother
Tinte ..
 9

Oberste Zeile beschrieben

2745 (recto)

Firenze, R° Acquisto Bigazzi
P. - 1257 Decembris 7
Alexander IIII .. magro Hospi-
talis bee Marie de Asnello eius
que fribus tam pres. — in ppm
Religiosam vitam eligentibus
 Amen a . Amen
R Ego Alexander catholice
 Ecclie Eps ss M
2 presb. eppi 5 diac.
Viterbii p. m. magistri Jordani
SRE notarii et vicecancellarii
VII id. decembris indictione pri-
ma [keine Zahl] Incarnationis
dominice anno m̄. CC LVII pont-
iero domni ALEXANDRI pp IIII
anno tertio
 Bulle fehlt. Seide erhalten Bast

2745 (verso)

In plica rechts C. Mutin.
Sub plica rechts pars unter C
Ecke oben rechts Jac
 Nur Alexander und in
PPM etwas verziert, alles in
derselben einfachen, weiten Gitter-
schrift.

 Photo

2746

Staatsarchiv Wien Chronol.

P. — __1257 Decembris 8__

Alexander IIII .. archepo Salzburgen.

Ne canonica censura

Viterbii VI iv. Dec. a° 3°

__Bruchvolle__ Bulle an Hanf

In plica rechts ⌐

Sub plica

links __mit rother Tinte__ - - - -

Ecke oben rechts ...

Oberste Zeile beschrieben

2747

Wiesbaden Staatsarchiv

Kl. Thron cap. 15

P. — __1257 Decembris 8__

Alexander IIII dil. in xpo filiabus .. abbatisse monasterii throni beate Marie virginis eiusque sororibus etc.

Religiosam vitam eligentibus

Amen Amen Amen

(R) Ego Alexander etc. (M)

Drei Reihen Unterschriften

Dat. Viterbii per manum mag.

Jordani de Romana Eccle notarii et vicecancellarii VI iv. Dec. a° tertio

Bulle mit Seide ausgeschnitten

2748

Instr. Mon. F. Dom. c. 119 1257 Dec. 10

P 17102

Alex. IIII fratribus Predic. inquisitoribus provintie lectire in partibus Tholosan.

Cupientes ut inquisitionis

Viterbii IIII iv. decembris a° 3°

In plica rechts : Andr. S.

de Curia

Bulle an Hanffaden

Rand oben mitte :

__Re Fran. I de Curia__

Sunt quinque sub dat. presenti

In der Adresse ist partibus Tholosan durch Unterpunctiun getilgt und darüber steht : Lombardie et Marchie Janven. Auch noch andere Verbesserungen

a tergo : predicatorum

cf. Tilgung wie oben bei

1257 Dec. 15. P. 17112

2749

Bayer. Haupt - Staatsarchiv

Kl. Biburg fasc. 3

P. 17704.* __1257 Decembris 11__

Alexander IIII (minus. Mai.) e. p. s.

Dei dil. filiis .. Abbati monasterij beate Marie in Biburch eiusque fratribus etc. In PRM

Religiosam vitam eligentibus

.... Amen Amen

R. Ego Alexander Cath. Ecclie Eps SS M

2 presb. 2 epi 5 diaconi

Dat. Viterbii per manum Magri Jordani sancte Romane ecclie notarii et vice cancellerij VI Jd. decembr. Ind. j mense dominice Anno M. CC L VII Pontif. vero domni Alexandri pp. IIII Anno tertio

Bulle an dicker Seide. Schriftseite gut ausgezeichnet geprägt

Niedrige Gitterschrift mit hohen Oberlängen und kleinen Unterlängen. Gute Leitenlinie

Eine Linie für Oberlängen und eine Linie für Gitterschrift

Schrift eckig; mittelschön

Public Record Office London
Papal Bulls bundle 2 n. 22
P. 17 105 1257 Decembris 12
Alexander IIIJ .. regi Anglorum
 illustri
 Ad reformandum negotium
Dat. Viterbii II id. Dec. a° 3°
 Bulle an Hanf
In plica rechts A. S.
Sub plica links mit roter Tinte:

 - - - -

a tergo Mitte script

DCCLXI Capitulum anno tercio

Public Record Office London
Papal Bulls bundle 2 n. 31
P. 17 107 1257 Decembris 13
Alexander IIIJ .. illustri regi
 Anglie
 Glorie perennis obtentu
Viterbii id. Dec. a° 3°
 Bulle fehlt, Hanf erhalten
In plica rechts .J. pō.

Sub plica links mit roter Tinte

 S
 · ·

Archives Nationales Paris
L 257 n. 142 1257 Decembris 13
Br. 22 hoch 17.5 Plica 1.9
oberer Rand 4,4 links 0.5
rechts 0.3
 Alexander IIIJ . - Epō Parisien
 Inundans malitia perversorum
Dat Viterbij a° Jd decemb a° 3°

Bulle fehlt, Hanf erhalten
 In plica rechts :.J. pō.
Sub plica links mit rother Tinte

- - 2 ·J) Ecke oben rechts : Jac̄o
a tergo Ecke oben links : J
 " oben Mitte : Predicatorum

Unruhige kleine Schrift
 Mit einem betonten Buchstaben
Erste Linie für Oberlängen

 P. vacat

Archives Nationales Paris
L 257 n. 143 1257 Decembris 13 31
Br. 34.3 hoch 27.8 Plica 2.6
oberer Rand 5.8 links 1.3
rechts 1.3
 Alexander IIIJ . . Abbati Cister
tij eiusque coabbatibus 7 Conuen
tibus Vniuersis Cisterciens ordinis
 Sacre ure religionis

Bulle und Seide nebst Datum aus
 gerissen
 Ecke oben rechts : a
 a tergo oben Mitte : Castagnola
 Ast
Nachlässige Schrift.

Ohne jede gestreckte Ligatur

Mit 3 verz. Satzanfängen. In 1. Zeile
1 verz. Buchstabe
Erste Linie für Gitterschrift

Instr. Mon. F. Dom. c.13 1257 Dec. 15

P. 17112

Alex. IIII .. fratribus ord. Praed. inquisi
toribus her. prav. in partibus Tholosan.
firmissime teneat vestra.

Viterbii XVIII kal. Ianuarii a° 3°

Bulle an Hanfschnur

In plica rechts: N. S. Prud
 de Curia

In plica links: Reo A Deg R . a.
Oben links Ecke: Ego Curia renovetur
dann ausgestrichen: Rx d. a. de Curia
dann nicht " " Rx d. a. de Curia ad
alios inquisitores; dann dupl.

 dann rechts: Rx Fran
de Curia fiant quinque sub dat.
presenti

A tergo: predicatorum
In der Adresse durch Unterpunktieren selbst:
partibus Tholosan und darüber steht: Lombar-
 die et marchia Tarvisin.

Instr. Mon. F. Dom. c. 102 1257 Dec. 16

P. —

Alex IIII .. provinciali ac ceteris ceteris
conventualibus prioribus et suppriori
bus eorumque vicariis ord. Praed. Lom
bardie et marchie Tarvisin.

Ne catholice fidei —

Viterbii XVII kal. Ianuarii a° 20

Bulle an Hanfschnur

In plica links: Angelus Ro
 de Curia
unter dem Bug abgeschnitten durch
Strichen: Rx Idaur et remitte mi
chi ad Alexandrum
 P. Reat.

Rand oben Mitte: innovetur J

A tergo: predicatorum

 pro camera dni cardinalis

 Scriptor: Angelus Ro.
 minnus = Angelus canon.
 S. Laurentii in Damaso
 1252 Aprilis 26. cap. 5841

Public Record Office London
Papal Bulls bundle 2 n. 28
P. 17117 1257 Decembris 18
Alexander IIII .. regi Anglie
illustri
 Sue dona gratie
Viterbii XV kl. Jan. a° 3°
 Bulle an Hanf
In plica links von der Besiegelung
reduzierte Notiz, an deren Ende
· J. steht
 Darunter:
Rx Bar. et fac rescribi
Sub plica links mit roter Tinte

Firenze, Camaldoli
P. 17125 1257 Decembris 29
Alexander IIII .. abbi see Tri
nitatis Florentin. ordinis
Vallis umbrose
 Conquesti sunt nobis
Viterbii IIII kl. Ianuarii a° 4°
 Bulle und Hanf fehlen
In plica rechts C. Mutin
Ecke oben links
Ecke oben rechts
Seitenlinien. Ganz winzige
Ränder. Oberste Linie frei
Sub plica unliniert.
Verhältnismässig grosse plica
Ganz kleine Schrift.
14.5 hoch, davon 2.7 plica
 16.1 breit.

2758

Public Record Office London
Papal Bulls bundle 2 n. 35.
P. 17135 = 17 117 1258 Januarii 2
Alexander IIII .. regi Anglie
 illustri
 Sue dona gratie
Viterbii IIII non. Jan. aº 4º
 Bulle an Hanf
In plica rechts Rx · Plac
Sub plica links mit roter Tinte
 4
 · - -
 ? 2

2759

Archives Nationales Paris
L252 n. 144 1258 Januarii 2
Br. 25.7 hoch 19.6 Plica 2.5
 oberer Rand 4.3 links 1.1
rechts 1.4
 Alexander IIII (Gitterschrift, In-
itiale verziert) · Abbati E Con-
ventui monasterii Vallis sancte
Marie Cisterciensis ordinis Pictaven
diö Devotionis vestre precibus
Dat Viterbij IIII non Januarij aº 4º
Bulle fehlt, Seide erhalten
 A tergo Ecke oben links : |
 4 oben mitte :
 P. de Aſſ (cist)
Fette kleine nachlässige Schrift, mit
sehr gezogenen hässlichen Ligatu-
ren, mit 3 verzierten Satzanfängen
 In 1. Zeile 1 verz. Buchstabe
Erste Linie für Gitterschrift und
 Oberlängen
 P. vacat

2760

Archives Nationales Paris
L252 n. 145 1258 Januarii 8
Br. 31.2 hoch 26.4 Plica 2.6
 oberer Rand 6.5 links 1.0
rechts 1.3
 Alexander IIII fratri Bernardo Au-
tisiodorii ordinis fratrum Predica-
torum Circa gratiarum concessiones
Dat Viterbij VI Jd Januarij aº 4º
Bulle fehlt, Hanf erhalten
 In plica recht : Herr · p
A tergo oben mitte : Predicatores
Kleine fette klare Schrift
 Mit einem betonten Buchstaben
Erste Linie für Oberlängen
 P. vacat

2761

Archives Nationales Paris
L252 n. 146 1258 Januarii 18
Br. 37.5 hoch 27.6 Plica 4.1
 oberer Rand 6. links 1.6
rechts 1.7
 Alexander IIII (maiuscule)
Archiepo et Epis ac dil. filijs
Abbatibus Prioribus decanis Archidia-
conis Archipbris et alijs ecclesiar
prelatis ad quos littere iste pervene-
rint Cum Abbates Cistercien
Dat Viterbij XV kl Februarij aº 4º
Bulle fehlt, Hanf erhalten
 In plica rechts : R. Plat
A tergo oben mitte : C
Enge schöne Schrift, mit gestreckten
Ligaturen, mit einem verzierten
Satzanfang
 In 1. Zeile 1 verz. Buchstabe
Erste Linie für Papstname und Oberlän-
 gen
Papstname in tad nicht in Gitterschr.
 Papstname P. vacat

2762

Instr. mon. F. Dom. c. 135 1258 Jan. 20
p — 9

Alex. IV .. decano ecclesie Columbrien.
Postularunt ad audientiam —
Anagnie XIII kal. febr. anno 4°
Bulle an Hanfschnur 5°!
Letzte Zeile von plica bedeckt.
In plica rechts: Ja Nar.
Sub plica links: ſ
 j

Rand oben Mitte: Cor L

2763

Firenze, Camaldoli
. Fehler 1258 Januarii 28
Alexander IIII - - priori Camal
dulen.
Ex significatione dilectarum
Viterbii T kl. febr. a° 4°
Bulle Hanf plica fehlen

P. 17163

2764

Archives Nationales Paris
L 252 n. 147 1258 Januarii 31
Br. 29.2 hoch 24. Plica 2.5
 obere Rand 5.4 links 1.3
rechts 1.3
 Alexander IIII (maiusculae)
 Abbati Monasterij sancti
Dionisij in Francia ordinis sancti
Benedicti Parisien. dioc
 Constitutus in presentia
Dat Viterbii T kl Februarii a° 4°

Bulle an Seide
 In plica rechts : A. G.
 Sub plica links: j
 j
A tergo oben Mitte:
 Stephs de Menolio

Schöne kleine Schrift, mit gestreck.
 Ligaturen (mit einer Ausnahme)
mit 4 variirten Schaufängen
 In 1. Zeile 1 var. Buchstab
Erste Linie für Oberstramen und
 untere Oberlingen

P. vacat

2765

Archives Nationales Paris
L 252 n. 148 1258 Januarii 31
Br. 28.7 hoch 17.7. Plica 3.5
 obere Rand 4.4 links 1.3
rechts 1.3
 Alexander IIII (Gitterschrift, in
Titel verziert) . . Abbati T Con-
ventui Monasterij sancti Dio-
nisij in Francia
 Nestrisca inclinati precibus
Dat Viterbii T kl Februarii a° 4°

Bulle an Seide
 In plica rechts : Ia. p
Sub plica links: ſ
 j

Weite kleine Schrift, mit gestreck.
Ligaturen, mit drei verzierten
Schaufängen

 In 1. Zeile 1 var. Buchstabe
Erste Linie für Gitterschrift

P. 17171

Archives Nationales Paris
L252 n.149 __1258 Januarii 31__
Br. 27. hoch 20 Plica 4.3
oberer Rand 4.2 links 1.2
rechts 1.3
Alexander IIII (Gitterschrift. Ini-
tiale verziert).. Abbati et Conven-
tui Monasterij sancti Dionisij in
Francia ordinis sancti Benedicti
Parisien̄
Dat Viterbij ⳨ II. Februarii a° 4°

Bulle an Seide
Sub plica links: §
A tergo oben Mitte:
Stephanus de menolis

Kleine schöne Schrift, mit gestr.
Ligaturen, mit drei verzierten
Satzanfängen

In 1. Zeile 1 verz. Buchstabe
Erste Linie für Gitterschrift

__P. 17172__

Archives Nationales Paris
L252 n.150 __1258 Januarii 31__
Br. 23 hoch 18.2 Plica 2.5
oberer Rand 4.1 links 1.1
rechts 1.3
Alexander IIII.. Decano ecclie
Roseten̄ Lingonen̄ dioc
Rerum exie dinoscitur
Dat Viterbij ⳨ II. Februarii a° 4°

Bulle an Hanf
In plica rechts: Fr (?)
Ecke oben rechts: Bar̄
A tergo oben mitte: Stephanus de menolis

Kleine fette Schrift

Mit einem betonten Buchstaben
Erste Linie zwecklos

__P. vacat__

Archives Nationales Paris
L252 n.151 __1258 Januarii 31__
Br. 34.5 hoch 27.2 Plica 4.
oberer Rand 5.8 links 1.3
rechts 1.2
Alexander IIII (Gitterschrift. Ini-
tiale verziert).. Abbati et Conventui
Monasterij sancti Victoris Parisien̄
Cum a nobis
Dat Viterbij ⳨ II. Februarii a° 4°

Bulle an Seide
Sub plica links: §
A tergo oben Mitte:
Stephanus de menolis

Fette deutliche Schrift, mit gestreckten
Ligaturen, mit drei verzierten Satzan-
fängen
In erster Zeile 1 verz. Buchstabe
Erste Linie für Gitterschrift

__P. vacat__

Instr. mon. F. tom. C. 20 1258. febr. 17.
__P. 17188__ reg.
16933
Alex IIII .. mag., prioribus et fratribus
universis ord. fratrum Predic.
Nimis iniqua vicissitudine.
Viterbii XIIII Kal. Martii a° 4°
Seidenfäden. Bulle fehlt.
In plica rechts: §
Sub plica links: §
a. g.
In plica rechts lange additio: vobis
quoque locorum etc.
A tergo: predicatorum
Duplicat

cop. g Seidenfäden. Bulle fehlt.
In plica rechts: B.P. Sub plica
links: Pontificatus abgebröckelt. Nicht

2769 (verso)

Triplicat

Seidenfaden. Bulle fehlt.

In plica rechts : ·B·P·

A tergo : Prefectorum

Scriptor : Benjaminus sub.
dinconus Parmensis.

1257 februarii 18. cap. 5713

2770

Archives Nationales Paris
L252 n. 152 1258 februarii 18

Br. 29.8 hoch 22. Plica 3.9
oberer Rand 5.4 links 0.9
rechts 1.2

Alexander IIII (Gitterschrift, Jui
tiale variiert). . Magro et priori̲b̲s
universis ordinis Predicatorum
Paupertati una quam
Dat Viterbij XI Kl. Martij a° 4°

Bulle fehlt Seide erhalten
In plica rechts : ꝑ deo a·s·

Rand oben halblinks : dupl
A tergo oben mitte : Predicatory

Feste schöne Schrift, mit gestreckten
Ligaturen (mit 1 Ausnahme), mit
3 betonten Satzanfängen

In 1 Zeile 1 variierter Buchstabe

Erste Linie für Gitterschrift und
Oberlängen

P. 17191 Duplicatur

2771

Barcelona Corona de Aragón
Leg. 14° n. 3°
1258 februarii 19

Alexander IIII ·· Epo Oscen.
Sua nobis dilecta
Viterbii XI Kl. Martii a° 4°
Bulle an Hanf
In plica rechts maths
Rand oben mitte dup

2772

Archives Nationales Paris
L252 n. 153 1258 februarii 21

Br. 41.3 hoch 32.4 Plica 3.7
oberer Rand 6.8 links 1.6
rechts 1.5

Alexander IIII . Abba Epo Belvacen
Cum olim inter
Dat Viterbij VIIII Kl. Martij a° 4°

Bulle an Hanf
In plica rechts : g. ar.
Sub plica links :
Ecke oben rechts : a
und : ꝑꝑ

A tergo oben mitte : Stephanus de Mens
Schwungvolle schöne Schrift
Mit einem betonten Buchstaben
Erste Linie für Oberlängen

P. 17194

Instr. mon. F. Dom. c 46 1258 Martii 5
P. 17202
Alex. IV universis prioribus et fratribus
Heremitis ord. S. Aug. ac Sanct. Willelmi.
Vestrum et vestrorum —
Viterbii III non. Martii anno 4°
Bulle an Seidenfäden.
In plica rechts : g. ar.
Subplica links : ꝫ
In plica links : Rev za 13/ a

Duplicat

cap. 78
Bulle an Seidenfäden
In plica rechts : Jo. ar.
A tergo : predicatorum

Coblenz Staatsarchiv
Domkapitel
P. — 1258 Martii 7
Alex. IIII .. decano Remensi
Sua nobis .. decanus
Viterbii non. Martii a° 4°
Bulle und Hanf fehlen
In plica rechts a. de. M (?)
Ecke oben rechts pe

Archives nationales Paris
L 252 n. 154 1258 Martii 17
Br. 44.5 hoch 31.5 Plica 4.5
oberer Rand 6.1 links und
rechts ohne Seitenlinien 1.7, 1.5
Alexander IIII (maiusculae)
.. Archiepo Remen et suffraganeis
eius et dil. filijs Abbatibus Prioribus
Decanis Archidiaconis et alijs Eccliar
Prelatis per Remen provinciam con
stitutis. Non absque dolore
Dat Viterbij XVI kl Aprilis a° 4°

Bulle und Seide ausgerissen
In plica rechts ! g). p
Ecke oben rechts : a
A tergo oben mitte : + R. P. +

Weite deutliche Schrift, mit gestreckten
Lschstaben, mit zwei versierten
Schaftfingen
In 1. Zeile 1 vers. Buchstabe
Erste Linie für Papstnamen und Ober-
längen

P. vacat

Instr. mon. F. Dom. c. 36 1258 Martii 18
P. 17216 cp. 11319
Alex. IIII .. mag. et universis prioribus ac vica
priorum gerentibus ord. frat. Predic.
Licet ad hoc —
Viterbii XV kal. Aprilis a° 4°
Bulle an Seidenfäden
In plica rechts : Jo. S.
Sub plica links : ä. g.
In plica sub fin. : .. et aliis fratribus eius
dem ordinis ad cap. ... - - - - - -
Darunter Rev Ro de teth g. ar.
Rand oben : fiat vacat sub eadem datp
A tergo : predicatorum

cf. 1261 Apr. 10

2777

Carcassonne Archives départem.
H. 318

P. 17216 1258 Martii 18

Alexander IIII - - magistro et universis prioribus ac vices priorum gerentibus ord. frm Predicatorum
Licet ad hoc
Viterbii XV Kl. Aprilis a° 4°
Bulle und Seide ausgerissen
In plica rechts Sm

Erste Zeile frei
Leitenlinien, ziemliche Ränder

cf. P. 11319

2778

Brit. Mus.
Add. Charters 12779
P. - 1258 Aprilis 3
Alex IIII .. abbatisse mon.
de Parco eiusque sororibus
Religionem vitam eligentibus
pacis in benirus Amen A.a.
R. Ego Alex cath. eccl. eps M
2 presb. 2 epi 3 diaconi
Dat. Viterbii per manum magistri Jordani S. R. E. notarii
et vicecancellarii III non.
Apr. ind. prima J. dre
anno ii CC L VIII p. uero .. quarto
Bulle und Seide fehlen
A tergo oben mitte Leodien dioc
Cist. ord.

2779

Archives Nationales Paris
L252 n. 155 1258 Aprilis 8
Br. 35 hoch 25.7 Plica 2.7
oberer Rand 6.2 links 1.7
rechts 1.7
Alexander IIII (minuscula)
Magro et fratribus domus militie Templi Ierusalem
Petitio vra notis
Dat Viterbii VI Id Aprilis a° 4°

Bulle fehlt, Seide erhalten
In plica rechts: R. Plat

Etwas eckige deutliche Schrift, mit großen Ligaturen, mit 3 verzierten Versen
In 1. Zeile drei ver. Buchstaben
Erste Linie für Papstnamen und unteren Oberlängen

P. vacat

2780

Archives Nationales Paris
L252 n. 156 1258 Aprilis 9
Br. 28.5 hoch 22.5 Plica 3.7
oberer Rand 6.1 links 1.6
rechts 1.5
Alexander IIII Matheo Abbati monasterij S'ti dionisij in Francia ordinis S'ti Benedicti Parisien dioc
Intemperantie monasterij hui
Dat Viterbii V Id Aprilis a° 4°

Bulle an Seide
In plica rechts: A de Bg
A tergo oben mitte: Stephanus de menobis

Sehr unbeholfene Schrift, mit großen Ligaturen, mit 3 verzierten Satzanfängen
In 1. Zeile 1 ver. Buchstabe
Erste Linie für Gitterschrift und untere Oberlängen

P. 17226

2781 (recto).

(Datum) Rx

Paris Archives Nationales
J 686 n 76
Breite 48.7 Rand links 2.2 rechts 2.1
Höhe 32.8 Rand oben 6.6 plica 4.4
Erste Linie für Gitterschr und Ober-
längen / Je eine Seitenlinie
P. 17233 1258 Aprilis 11
Alexander IIII (Gitterschr) Carmo
in xpo filio . . Illustri Regi
Francie
 Sic ille Lucifer
Dat Viterbij III Jd Aprilis / a° 4°
 Bulle an Seide
In plica rechts : Ber F
Sub plica links : V

2781 (verso)

A tergo oben Mitte :
 Johes de braia
Darunter schlauk mit einer
sehr langen cauda

Lxxxxv / Capto anno quinto

fette kleine stumpfe Schrift

2782

Bayer. Haupt. Staatsarchiv
Kl. Roth a./Inn fasc. 4
P. 17240 1258 Aprilis 13
Alexander IIII (Gitterschrift). Ab-
bati et Conuentuj Monasterij
sci Martinj de Rot ordinis sci
Benedict Frisingen. dioc.
 Licet is de
Viterbij Jd Aprilis anno Quarto

Bulle an feiner Seide
In plica rechts: ber
Sub plica links : . .

Rand oben Mitte [Xo
A tergo Ecke oben links Y

Kleine zierliche schöne Schrift
Erste Zeile frei. Seitenlinien

2783

Paris Archives Nationales Rx
J 431 n. 31
Breite 30.8 Rand links 1.6 rechts 1.5
Höhe 22.6 Rand oben 5 plica 4.6
Erste Linie ganz frei / Je eine Sei-
tenlinie
P. 17236 1258 Aprilis 13
Alexander IIII . . priori fratrum
Predicatorum Parisien
Meminimus olim tibi
Dat Viterbij Jd Aprilis / anno 4°
Bulle an Hanf
In plica rechts: Petra lata
 de cra
A tergo oben Mitte
schlank schwungvoll (679)
 Lxxxxvij apto anno
 Quarto
Prachtvolle Schrift

2784 (recto)

Rx

Paris Archives Nationales
) 686 n. 76 (bis)
Breite 29.7 Rand links 1.4 rechts 1.3
Höhe 21.7 Rand oben 5.1 plica 3.3
Erste Linie für Gitterschr und
kleinere Oberlängen (Je eine Seitenlinie
P. 17237 1258 Aprilis 13
Alexander IIII (Gitterschr) Carmo
in xpo filio.. Illustri Regi Franc
Francie
 Cum in te
Dat Viterbij Jd Aprilis a° 4°
 Bulle au Seide
In plica rechts: Aba. S
a Tergo oben Mitte:
 Johes de Bra.. rate

2784 (verso)

Schlank schwungvoll

Lxxxiiij Capto anno Quarto
(ist ausgestrichen)

Jette kleine struppfe Schrif

2785

Instr. Mon. F. Dom. c. 39 1258 Aprilis 11
 P. 17245
Alex. IIII rectoribus ecclesiarum Calatauban
Tyrasonen.
In generalem Christi
Viterbii XIII Kal. Maii a° 4°
Bulle an Hanfschnur
In plica rechts . T. p.
a Tergo : predicatorum

2786

Poitiers Archives depart.
St. Hilaire
P. — 1258 Maii 3
Alexander IIII .. Cantori Dau
raten.... capicerio et magro
Riccardo dicto Anglico ca-
nonicis Caynonen. ecclie
Lemovicen. et Turonen. dioc
 Sua nobis dilecti
Viterbii V non . Maii a° 4°
Balle fehlt. Hanf erhalten
In plica rechts Arch
Erste Zeile beschrieben.
Seitenlinien . Sehr schmale
Räuder

2787

Archives Nationales Paris
L 252 n. 157 1258 Mai 5
Br. 28.7 hoch 24.6 Plica 2.4
 oberer Rand 5.1 links 1.8
rechts 1.9
 Alexander IIII .. sancti Dionisij
in Francia Parisien. dioc. et .. Athana-
cen. Lugdunen. Monasteriorum
ordinis sancti Benedicti Abbatibus
 Importabili debitorum sarcina
Dat Viterbij III non. Maij aº 4º

Bulle an Hanf
 In plica rechts: R. Plac
A tergo oben Mitte: Cluniacum

Enge sehr regelm. Schrift
 Mit einem betonten Buchst.
Erste Linie für Oberlängen

 P. vacat

2788

Instr. Miscellanea Tom. F. Num. c. 62 1258 Mai 6
 P. 17260
Alex. IIII .. episcopo Perusin.
Vehementer nimis cogimur
Viterbij II non. Maii aº 4º
Hanfschnur. Bulle fehlt.
In plica rechts: B. pm
In plica links: Rec A g. d. a.
Rand oben links: dupl.
A tergo: predicatorum
 et Minorum

Scriptor: Beniaminus subdia-
conus Parmensis

 1257 februarii 18. cap. N 413

2789

Barcelona Corona de Aragón
 Leg. 14º n. 4º
 P. — 1258 Mai 10
Alexander IIII .. sancti Petri
de Rosis .. sancti Cucufatis et
.. de Cardona abbatibus Jerum.
den. Barchinonen. et Urgellen.
dioc.
In causa que
Viterbii II id. Maii aº 4º
Bulle an Hanf
In plica rechts Maÿf
Ecke oben rechts ausgestrichen
Notiz

2790

Archives Nationales Paris
L 252 n. 158 1258 Mai 11
Br. 33.8 hoch 28.2 Plica 3.1
 oberen Rand 6.6 links 1.9
rechts 0.8
 Alexander IIII Archiepis z Epis
presentes litteras inspecturis
 Ad nram audentiam
Dat Viterbij V id. Maij aº 4º

Bulle an Hanf
 In plica rechts: ... p
A tergo oben Mitte: Scs Antonius

Flüssige eckige Schrift
 Mit einem leicht betonten Buchst.
Papstname im Text nicht in Gitterschr.

hadhiberi
Papstname P. vacat

2791

Instr. mon. F. d m. c. 1449 1258 Maii 13

ora 365 P. 17269

Devotionis vestre piribus
Bulle an Seidenfäden

In plica rechts : J-

Sub plica links : Jo
 a. g.

A tergo : predicatorum

Alex. IIII magistro et fratribus
ord. fr. Praedicator.

Dat. Viterbii , III id. maii anno
quarto

2792

Firenze, S. Croce di Firenze
P. — 1258 Maii 15

Alexander IIII . . . generali ac
provincialibus ministris et uni-
versis fratribus ordinis Minorum
 Pium est et
Viterbii iU. Maii a° 4°
 Bulle fehlt, Seide erhalten
In plica rechts R · Pter
Oberste Linie frei
Sub plica unliniert
Breite Seidenränder
Prachtvolle Schrift

2793

<u>Papstname</u>

Archives Nationales Paris
L252 n. 159 <u>1258 Maii 27</u>

Br. 23.2 hoch 20. Plica 2.2
oberer Rand 4.2 links 1.4
rechts 1.5
 Alexander IIII (Gitterschrift, Initi-
le variiet) . . Abbati et Conventui
Monasterij sancti Dionisij in Fran-
cia Parisien diöc
 Quia melius est
Dat Viterbij VI kl Junij a° 4°

Bulle an Seide
 In plica rechts : P. lat
A tergo oben Mitte : Stephanus de Menelio

Offene etwas eckige Schrift, mit gestreckten
Ligaturen, mit 3 Schriftkäufigen
 In 1. Zeile 1 betonte Buchstabe
Erste Linie für Gitterschrift und Ober-
 längen
 P. 17287
Papstnamen im Text nicht in Gitterschr.

2794

Archives Nationales Paris
L252 n. 160 <u>1258 Maii 28</u>

Br. 39.1 hoch 30.5 Plica 3.
oberer Rand 6.5 links 1.2
rechts 1.4
 Alexander IIII (Gitterschrift, Ini-
tiale variiet) . - Cantuariensi ar-
chiepo y eius Suffraganeis ac dil
filijs Abbatibus Prioribus Decanis
Archidiaconis Prepositis y alijs
ecclie prelatis per Cantuariensem
provinciam constitutis
 Non absque dolore
Dat Viterbij V kl Junij a° 4°

Bulle an Seide
 In plica rechts : Cr · ar ·
Weite etwas eckige Schrift, mit gestr.
Ligaturen, mit zwei oder Schriftäufigen
 In 1. Zeile 1 variiet Buchstabe
Erste Linie für Gitterschr. und Oberlängen

Papstname im Text in Gitterschrift
 P. 17288

2795

Archives Nationales Paris

L 252 n. 161 1258 Maii 28

Br. 38.9 hoch 31.1 Plica 2.5
oberer Rand 6.6 links 1.4
rechts 1.4
 Alexander IIII (Gitterschrift,
Initiale verziert) . . Bituricen
et . . Remen Archiepis y eorum
Suffraganeis ac dil. filijs Abbati-
bus Prioribus decanis Archidia-
conis Prepositis y alijs eccliarj
Prelatis per Bituricen et Remen
prouincias constitutis
 Non absque dolore
Dat Viterbij V kl Junij a° 4°

Bulle an sehr feiner Seide
 In plica rechts : G. ar.
A tergo oben Mitte : Stephanus de Menolio
 weite offene Schrift, mit gestreckten
Ligaturen, mit 2 ver. Schaufüngen
 In 1. Zeile 1 ver. Buchstabe
Erste Linie für Gitterschr. und Oberlinge
Papstname im Text in Gitterschrift

☙ P. 17288

2796

Poitiers Archives dépat.
St. Hilaire

P. — 1258 Maii 29

Alexander IIII . . emitori tru
ntem . . capicerio et ma900
Ricardo dicto Anglico canonico
Caynomen. ecclie. Lemovicen. et
Turonen. dioc.
 Suam ad nos
Viterbii IIII kl. Junii a° X°

Bulle fehlt Hanf erhalten
In plica rechts Arch
Ohne Seitenlinien, einzige
Ränder. Erste Zeile frei.

2797

Archives nationales Paris

L 252 n. 162 1258 Maii 30

Br. 37.8 hoch 29.2 Plica 2.9
oberer Rand 5.6 links 1.8
rechts 1.7
 Alexander IIII (minusculae)
. . Abbati et Conuentui Monaste-
rij Cluniacen
 Super prouisione paupi
Dat Viterbij III kl Junij a° 4°

Bulle fehlt, Seide erhalten
 In plica rechts : R. Plac
A tergo oben Mitte : Cluniacen

Etwas nachlässige fette Schrift, mit ge-
streckten Ligaturen, mit 3 versch.
Schaufüngen
 In 1. Zeile 1 ver. Buchstabe
Erste Linie für Papstnamen und
 untere Oberlingen

P. 17291

2798

Archives Nationales Paris

L 252 n. 163 1258 Junii 2

Br. 34.1 hoch 27.2 Plica 3.5
oberer Rand 7.2 links 1.5
rechts 1.7
 Alexander IIII (Gitterschrift, Ini-
tiale verziert) Matheo abbati mona-
sterij sancti dionisii in Francia
ad Roman Eccliam nullo medio
pertinentis ordinis sancti Benedicti
Parisien dioc
 Exponit nobis Dilectus
Dat Viterbij III non Junij a° 4°

Bulle an feiner Seide
 In plica rechts : n. c
Sub plica links :
Ecke oben rechts : Ma ꝛꝛ P. vacat

A tergo oben Mitte : Stephanus de
 Menolio
Sehr lockere Schrift mit einer ungewöhn-
lichen ductus. Ohne alle gestreckten
Ligaturen mit 3 ver. Schaufüngen
In 1. Zeile sein ver. Buchst. Erste Linie
 für Gitterschr. und Oberling

2799

Instr. Mon. F. dom. C. 90 1258 Jun. 12

P. 17302

~~Innoc.~~ Alex. IIII .. electo Ravennat. apo-
stolice sedis legato.

Implacida relatio nuper .

Viterbii II id. Junii a° 4°

Bulle an Hanfschnur

Implica rechts: N. e.

A tergo : predicatorum

2800

Archivio di Stato Milano
Bolle e Brevi vicecancell.

P. — 1258 Junii 13

Alexander IIII dil. in xpo filiabus
.. priorisse mon. S. M. Regin. Virgi-
num Porte Vercellen. Mediolanen
eiusque sororibus etc. in ppm

Religiosam vitam eligentibus
inveniant Amen a . Amen

R. Ego Alexander cattholice
ecclie eps SS M

1 presb. 2 cardepi 4 diac.

Viterbii p. m. magri Jordani S.
RE notarii et vicecancellarii
id. Junii ind. I° Inc. Dnice
a° M.CC.L VIII pont. vero domni
ALEXANDRI pp. IIII a° quinto.

Bulle an Seide

2801 (recto)

Instr. Mon. Monum. Tridentina

P. 17310 1258 Junii 16

Alexander IIII dilectis in xpo filiabus
.. abbatisse monasterii S. Fran-
cisci Tridentin. eiusque sororibus
tam presentibus quam futuris
regularem vitam professis in per-
petuum

Religiosam vitam eligentibus
Amen Amen Amen

R. Ego Alexander c. e. eps. M

2 presb. 2 epi 5 diac.

Dat. Viterbii per manum magistri
Jordani S.R.E. notarii et vice can-
cellarii XVI Kl. Julii ind. I Incarn.
Dom. a° M.CC.LVIII pont. vero don.

2801 (verso)

...ni ALEXANDRI pp. IIII a° 4°

.. Bulle an Seidenfäden

Rand oben Mitte :

co̅e p ord. S. Damiani

2802

Instr. mon. F. Dm. c. 14 1258 Jun. 20

P. 17311 reg.
11226

Alex. m. mag. et fratribus ord. Predic.

Inter alia gratias.

Viterbii XII Kal. Julii a° 4°

Bulle an Seidenfäden.

In plica rechts: ber

Sub plica links: ...

A tergo: predicatorum

2803

Archives nationales Paris
L 252 n. 164 1258 Junii 22

Br. 34.6 hoch 25.6 plica 2.9
oberer Rand 5.1 links 1.3
rechts 1.3
Alexander IIII . . Burdegalen
z. . Turonen Archiepis z eorum
suffraganeis ac dil. filiis Abbatibus
Prioribus Decanis Archidiaconis, Pre-
positis Archipbris z aliis eccliaz
prelatis p Burdegalen et Turonen
provincias constitutis
Dat Viterbii X Kl Julii a° 4° Non absque dolore

Bulle an Seide
Rand oben halblinks : dupl
Ecke oben rechts : a

A tergo oben mitte : Stephanus de Mens-
lio

Fette kleine Schrift

Ohne jede gestreckte Ligatur

Mit 2 versierten Satzanfängen

In 1. Zeile 1 vers. Buchstabe

Erste Linie für Gitterschrift

Reptname im Text in Gitterschrift

P. vacat

2804

Archives nationales Paris.
L 252 n. 164 bis 1258 Junii 22

Br. 39.3 hoch 31.5 plica 3.3
oberer Rand 5.6 links 1.7
rechts 2.2
Alexander IIII (Gitterschrift,
Initiale versiert) Wie n. 164

Bulle an Seide
A tergo oben mitte :
Stephanus de menolis

Ganz ungewöhnliche Schrift ; sehr hohe
ober- und Unterlängen und ganz
riesige Buchstaben
Nur eine gestreckte Ligatur

Mit zwei versierten Satzanfängen
In 1. Zeile 1 vers. Buchstabe

Reptname im Text in Gitterschrift

P. vacat

2805

Archives. Nationales Paris
L 252 n. 165 1258 Junii 22

Br. 37.7 hoch 28.2 plica 3.3
oberer Rand 5.3 links 1.1
rechts 0.9
Alexander IIII (Gitterschrift, Ini-
tiale versiert). . Turonen . et .
. . Rothomagen Archiepis et
eorum suffraganeis ac dil. filiis
Abbatibus Prioribus Decanis Archi-
diaconis Prepositis Archipbris et
aliis ecclias prelatis per Turonen
et Rothomagen provincias con-
stitutis
Dat Viterbii X Kl Julii a° 4° Non absque dolore

Bulle an Seide
In plica rechts : . p . alor (?)
pro ptr. R

A tergo oben mitte :
Stephs de menolis

Kleine fette Schrift, mit gestreckten
Ligaturen, mit einem versierten
Satzanfang.
In 1. Zeile 1 vers. Buchstabe

Erste Linie für Gitterschrift

P. vacat

2806

Firenze, Polverini

Abschrift

P. 17352 1258 Julii 23

Alexander IIII priori Camaldulensi
ac univ. abbatibus prioribus et
abbatissis eorumque fratribus et
sororibus Camald. ordinis tam
pres. in ppms

Officii nostri nos

R. Ego Alex. M

2 presb. 1 epus 2 diac.
Viterbii p. m. magistri Jordani
SRE vicecancellarii et nota-
rii X Kl. Augusti ind. I Inc.
D. a° 1258 pont. a° 4°

2807

Archives Nationales Paris
L 252 n. 166 1258 Junii 24
Br. 28.6 hoch 19.2 Plica 2.5
obere Rand 4.5 links und
rechts. Ohne Seitenlinien 0.6 . 1.1
Alexander IIII . . Priori ser min
rii de Campis Parisien.
Sub religionis habitu
Dat Viterbij VIII Kl Julij a° 4°

Bulle an Hanf
In plica rechts: ... Bu (?)
A tergo oben Mitte : Stephan. de monolis

Prachtvolle feste Schrift

Mit einem betonten Buchstaben
Erste freie Linie zwecklos

P. 17316

2808

Archives Nationales Paris
L 252 n. 167 1258 Junii 25
Br. 57.2 hoch 69.3 Plica 4.8
obere Rand 8. links 2.
rechts 2.
Alexander IIII (majusculae)
Priori Monasterij sancti Michaelis
de Carasio eiusque fratribus . . . professis
IN PPM (Carasio)
Religiosam vitam eligentibus
inveniant AMEN d—c AMEN

R ‖ Ego Alexander Catholice Ecclie Eps M

2 presb 2 epi 5 diac.
2 Zeile frei 2 Zeile frei

Dat Viterbij per manum Magni Jor-
dani sancte Romane Ecclie Notarii et
Vicecancellarij VII Kl Julij Inditione
prima Incarnationis dominice Anno
M. CC LVIII Pontificatus vero domni
ALEXANDRJ pp IIII Anno quarto

Bulle und Seide fehlen
Das J in Jordani schön variiert
de Carasio Vicarius dixit P. vacat

Alle Capitelsanfänge mit vers. Buchstaben
Feste kleine klare Schrift
Vergl. Von der Apost. Kanzlei, pag. 78

2809

Archives Nationales Paris
L 252 n. 171 1258 Julii 25
Br. 40.3 hoch 30.7 Plica 2.9
obere Rand 6.6 links 2.7
rechts 2.5
Alexander IIII (weite Gitterschrift,
Initiale verziert) . . Maguntin.
Trevirem et . . Coloniem Archiepis
et eorum Suffraganeis ac Dil. filiis
Abbatibus Prioribus Decanis Archidia-
conis Prepositis Archipbris et aliis Ecli-
ar. Prelatis p. Maguntin Trevirem ? Co-
loniem provincias constitutis
non absque dolore
Dat Viterbij VIII Kl Augusti a° 4°

Bulle an feiner Seide
In plica rechts in weiter Abständen:
a l a Sen .
A tergo oben Mitte : Stephanus de Mel molis

Feste kleine nachlässige Schrift mit gestri-
chelten, mit 4 ver. Schnörkeln
In 1. Zeile 2 ver. Buchstaben Venera-
bilibus und Dilectis

Papstname im Text in Gitterschrift
Erste Linie für Gitterschrift und Oberlängen

P. vacat

2810

P. — Paris Arch. Nat.
L252 cap. 167 1258 Iunii 25

Alex III .. priori monasterii S. Mi-
chaelis de Carasio (Vivarien. dioc)

Religiosam vitam eligentibus

Dat. Viterbii p. m. Iordani SRE
notarii et vicecancellarii VII kl.
Iulii a.° (1258) quarto

Bulle und Seide fehlen.

vicecancellarius

2811

Archives Nationales Paris
L252 n. 168 1258 Iunii 26

Br. 21.3 hoch 13.3 Plica 2.1
oberer Rand 1.4 links und
rechts ohne Seiten unter 0.5, 0.6
Alexander III .. abbati f¨c Eligii
Noviomen.
Dilecti filii — — abbas
Dat Viterbij VI kl Julij a° 4°

Bulle am Hanf
In plica rechts: Angls
Ecke oben rechts: Fe
A tergo oben mitte:
Stephanus de Menolis

Ganz kleine fette Schrift
Ohne jeden betonten Buchstaben
Erste freie Zeit fehlt

P. 17321

2812

Archives Nationales Paris
L252 n. 169 1258 Iunii 26

Br. 21.6 hoch 14. Plica 2.
oberer Rand 1.8 links und
rechts ohne Seiten unter 0.6, 0.5
Alexander III . . abbati f¨c Eligii
Noviomen. Sua nobis dilecti
Dat Viterbij VI kl Julij a° 4°

Bulle am Hanf
In plica rechts: Angls
Ecke oben rechts: Fe
A tergo Ecke oben links: a
" oben mitte:
Stephan de Menolis

Ganz kleine fette Schrift

Ohne jeden betonten Buchstaben
Erste freie Linie fehlt

P. 17320

2813

Archives Nationales Paris
L252 n. 170 1258 Iunii 28

Br. 31.4 hoch 25.9 Plica 3.2
oberer Rand 6.1 links 1.6
rechts 1.7
Alexander III (weite große Gitterschr.
Initiale verziert) Universis xpi fide
libus ad quos littere iste pervenerint
vite perennis gloria
Dat Viterbij III kl Julij a° 4°

Bulle fehlt, Seide erhalten
In plica rechts: Wa
A tergo oben mitte:

frata Epdius de ordine Captinorum
Weite kleine fette Schrift, weit gestreck.
Ligaturen, mit 2 verz. Satzanfängen
In 1. Zeile 1 verz. Buchsstbn
Erste Linie für Gitterschrift und Ober-
längen

P. vacat

2814

Instr. Mon. F. Tom. c. 44 1258 Jun. 29

P. 17327

Alex. IIII .. mag. et fratribus ord. Praed.

In gravem ordi.

Viterbii III Kal. Julii a° 4°

Bulle an Seidenfäden.

In plica rechts: Jo S.

Sub plica links: ..

A. G.

Rand oben Mitte:

a tergo: Predica Formen

2815

Madrid Arch. Histor. Nacional

Zaragosa Rueda 16 €

P. - 1258 Julii 31

Alexander IIII .. abbi Cistercii

eiusque coabbatibus et conventi-

bus universis Cist. Or.

Religionis vestre meretur

Viterbii II Kl. Aug. a° 4°

Bulle fehlt. Seide erhalten

In plica links B. V

Ecke oben rechts a

Kleine Ränder, sonst regelmäs-

sige Ausstattung

Ligaturen gestreckt

Sehr schöne gerade Schrift

2816

Firenze, S. Croce di Firenze

P. 17356 1258 Augusti 2

Alexander IIII .. generali et

provincialibus ministris ac

univ. fribus ord. frum Min.

Virtute conspicuos sacri

Viterbii III non. Aug. a° 4°

Bulle und Seide fehlen

Kleine plica, schmale Seiten-

ränder

59.5 hoch 70.3 breit

plica 2.4 cm

16 Zeilen schönster Schrift zu

etwa 42 Worten = 2352 Worte

Mare magnum Alexan-

dri III

2817

Archives Nationales Paris

L252 n. 173 1258 Augusti 9

Br. 34.7 hoch 23.2 Plica 3.6

oberer Rand 2.8 links 1.2

rechts 1.5

Alexander IIII (Gitterschrift, Ini-

tiale verziert) Archiepis et Epis et Dil

filijs Abbatibus Prioribus Decanis Ar-

chidiaconis et alijs Ecclesiarum Prelatis

ad quos littere iste pervenerint

Si diligenter attenditis

Dat Viterbij V Id Aug a° 4°

Bulle an Seide

a tergo Mitte: Frater roz

Fette kleine Schrift mit einigen gestreck-

Ligaturen, mit einem verzierten

Satzanfang

In 1. Zeile 1 ver. Buchstabe

Erste Linie für Gitterschrift und unten

überlängen

Repetitionen im Text nicht in

Gitterschrift

P. vacat

2818

Archives Nationales Paris
L 252 n. 174 __1258 Augusti 13__

Br. 29. hoch 25. Plica 3.4
oberer Rand 5.4 links 1.2
rechts 1.3
Alexander IIII (Gitterschrift. Im
linke variiert) Archiepo et Epis ac
dil. filijs Abbatibz Prioribus Decanis
Archidiaconis z alijs ecclearum Pela
tis ad quos litere pervenerint
 Religiosos viros patres
Dat Viterbij Jd Aug a° 4°

Bulle an feiner Seide
 In plica halblinks eine verblichene
 Kanzleibemerkung
A tergo oben mitte : T

Kleinere deutliche Schrift mit gestr.
Ligaturen (mit 1 Ausnahme), mit
4 variierten Satzanfängen

In 1. Zeile 1 variierter Buchstabe

Erste freie Linie über einer zweiten, die

für Gitterschrift und Oberlängen dient

P. vacat

2819

Archives Nationales Paris
L 252 n. 175 __1258 Augusti 13__

Br. 31.3 hoch 26.2 Plica 4.6
oberer Rand 7. links und
rechts ohne Seitenlinien 0.8, 7.2
Alexander IIII (Gitterschrift. Im
ijabe variiert) . Magro et pratribz
domus Milicie Templi in Aquitania
 Intimantibus nobis accepimus
Dat Viterbij Jd Augusti a° 4°

Bulle an Seide
 In plica rechts ausradierte Bemerkung
Sub plica links : j
 Rand oben mitte : L

A tergo Ecke oben links : l
 " oben mitte : l T

Fette kleine Schrift mit gestreckten
Ligaturen, mit über 2 variierten
Satzanfängen

In 1. Zeile 1 var. Buchstabe

Erste Linie für Gitterschrift und
 untere Oberlängen

P. vacat

2820

Archives Nationales Paris
L 252 n. 176 1258 Augusti 16

Br. 21.7 hoch 16. Plica 1.6
oberer Rand 3.7 links 2.
rechts 1.2
Alexander IIII . . Archiepo Rothoma
gen Exhibita nobis dilectorum
Dat Viterbij XVII Kl Septembr a° 4°

Bulle an Hanf
 In plica rechts: Jo lat (?)
A tergo oben mitte Nomen überschrieben
 mit Regest

Sehr klare feste Schrift

Ohne jeden betonten Buchstaben

Erste Linie für Oberlängen

P. vacat

2821

Marseille Archives Departem.
H. P. A. 8
P. — 1258 Augusti 18

Alexander IIII universis xpi fide
libus presentes litteras inspect
 Vite perennis gloria
Viterbij XV Kl Aug. a° 4°
Bulle an Seide
In plica rechts a - g.
Sub plica links C
herrliche zierliche Schrift
Schön geschwungene Ligaturen

2822

Archives Nationales Paris
L 252 n. 177 *1258 Augusti 23*

Br. 35. hoch 25. Plica 2.7
obere Rand 5.6 links 2.3
rechts 2.3
Alexander IIII universis Archiep.
et Epis per Regnum Francie constitutis
Ii olim in
Dat Viterbij X Kl Septembr a° 4°

Bulle fehlt, Hanf erhalten
In plica rechts: R. Plac.
A tergo oben Mitte: Fundam

Schöne feste Schrift

Mit einem betonten Buchstaben
Erste Linie für Oberlängen
Mit + grösseren Unterbrechungen

P. vacat

2823

Instr. Mon. Monum. Tudertina
P. – 1258 Augusti 27
Alexander IIII dil. in xpo filiabus
.. abbatisse et conventui mones-
terii S. Marie montis Sancti pro-
pe Tudertum Ord. S. Damiani ad
Romanam Ecclesiam nullo me-
dio pertinentis
Materi percepimus in
Viterbii VI Kl. Septembris a° 4°
Bulle an Seidenfäden
Dupl. links: B. V. g̈ pro fratre
Andrea de camera dni ppe.
A tergo oben Mitte: frater Andreas
de Camera dni ppe auch 1257
Sept. 5

2824

Archives Nationales Paris
L 252 n. 178 *1258 Septembris 3*

Br. 31.4 hoch 26.2 Plica 3.3
obere Rand 5.9 links 1.3
rechts 1.4
Alexander IIII nobili viro – – Du
cj Burgundie
In sacris generali
Dat Viterbij III Non Septembr a° 4°

Bulle fehlt. Hanf erhalten
A tergo oben Mitte:
Michael

Schöne weite fette Schrift
Mit einem betonten Buchstaben
Erste Linie für Götterschrift

P. vacat

2825

Archives Nationales Paris
L 252 n. 179 *1258 Septembris 3*

Br. 32. hoch 23. Plica 2.6
obere Rand 5.4 links 1.3
rechts 1.6
Alexander IIII Nobili viro Carolo
Andegavie et Provincie Comiti
In sacris generali
Dat Viterbij III Non Septembr a° 4°

Bulle fehlt, Hanf erhalten
A tergo oben Mitte
Michael

Schöne feste Schrift
Mit einem betonten Buchstaben
Erste Linie für Oberlängen

P. vacat

2826

Archives Nationales Paris
L 252 n. 180 **1258 Septembris 3**
Br. 31.7 hoch 22.5 Plica 3.2
oberer Rand 5.3 links 1.3
rechts 1.5
Alexander IIII Carissimo in Xpo
filio .. Regi Francie Illustri
Dat Viterbij III non. Septembr a° 4°
Bulle fehlt, Hanf erhalten
A tergo oben Mitte:

Michael

Weite kleine fette Schrift
Mit einem betonten Buchstaben
Erste Linie für Oberlängen

P. vacat

2827

Instr. Mon. F. Tom. c. 2 1258 Sept. 21
P. 17376
Alex IIII .. mag. et prioribus ord. fratrum
Predic.
Decens et dignum —
Viterbii XI Kal. Octobris a° 4°
Bulle an Seidenfäden
In plica rechts : Har p
Sub plica links : s
A tergo : predicatorum
Litte cuts paus sub plica

2828

Firenze, CamaldToli
P. 17379 **1258 Septembris 26**
Alexander IIII .. epo Massan.
Sua nobis .. abbas
Viterbii IV Kl. Octobris a° 4°
Bulle und Hanf fehlen
In plica rechts scriptor
Sub plica links f
Ecke oben rechts Nome
ganz schmale Seitenränder
Erste Linie unbeschrieben
Sub plica unliniirt

2829

Archives Nationales Paris
L 252 n. 181 **1258 Novembris 11**
Br. 33.4 hoch 26.3 Plica 2.5
oberer Rand 5.2 links 1.3
rechts 1.3
Alexander IIII (Gitterschrift, im
Siele variiert) .. Abbati Cisterciensi
que Grabbatibus 7 Conventibus uni-
versis Cisterciens ordinis
Circa sacrum et
Dat Anagnie III Id Novembr a° 4°
Bulle und Siede fehlen
In plica rechts : restliches
Sub plica links : a. g.
Sehr zierliche runde Schrift, mit gestör
Ligaturen, mit 5 variirten Satzanfängen
In 1. Zeile 1 vers Buchstabo
Erste Linie für Gitterschrift und
Oberlängen

P. vacat

2830

Firenze, S. Croce di Firenze
P. — 1258 Novembris 13
Alexander IIII [ohne Penukel]
univ. abbibus, prioribus, pr.
positis et conventibus monas
teriorum S. Bened., S. Aug.,
Premonstraten., Camaldulen.
et Vallis Vmbrose ordinum
 Vestram et vestrorum
Anagnie iď. nov. a° 4°
 Bulle und Seide fehlen
In plica salts . c . la.
 pro. W. astor.

2831

Stift Rein
 P. — 1258 Novembris 13
Alexander IIII .. illustri regi
Vngarie
Dilecti filii .. abbas
Anagnie iď. nov. a° 4°
Bulle an Hanf
In plica rechts n. 0
Seidenmudel. Oberste Zeile
beschrieben

2832

Madrid Arch. Histór. Nacional
 P. — Poblet C n. 9
 1258 Novembris 13
Alexander IIII .. abbé et conv. mo
nasl. Populeti Cist0. Terra
conen. dioc.
Speciali gratia et
Anagnie iď. nov. a° 4°
Bulle und Seide fehlen
In plica rechts benedco de ferentia

2833

Archivio di Stato Milano
Bolle e Brevi
 P. — 1258 Novembris 14
Alexander IIII dil. in xpo fil. con
ventui mon. Senatoris Papien
OSB
 Volentes vos gratia
Anagnie XIII kl. dec. a° 4°
 Bulle und Seide fehlen
Sub plica links

2834

Wiesbaden Staatsarchiv
Kl. Eberbach
P. 17420–17326/2 5 8 Novembris 27
Alex. IIII .. abbati Cistercii eius
que coabbatibus et conuentibus
uniuersis Cistercien. ordinis
Circa iacrum et
Anagnie V Kl. Dec. aº 4º
Bulle an Seide
In plica rechts At M (?)
Leicht betonte Capitelschrift

Bullenränder sehr unregel
mässig; halt nicht erkenn
bar

2835

Barcelona Corona de Aragón
Leg. 14º u. 5º
P. — 1258 Decembris 1
Alexander IIII nob. viro Philip
po nato cmi in xpo filii noi..
Illustris Regis Francie
Attenta sedis apostolice
Anagnie Kl. Dec. aº 4º
Bulle fehlt. Seide erhalten
Ohne Notizen

2836

Paris Archives Nationales PX
J 435 u. 3
Breite 32.2 Rand links 1.5 rechts 1.5
Höhe 25.6. Rand oben 5.8 plica 4.2
Erste Linie für P Maj. und kleine
Oberlängen / Je eine Leerzeile
P-vacat 1258 Decembris 1
Alexander (Maj) IIII nob viro Phi
lippo nato Carmi in xpo filij noi
.. Illustris Regis Francie
Attenta sedis aplice
Dat Anagnie Kl decembr / aº 4º
Bulle an Seide
Kleine dünne unruhige Schrift
In plica rechts: (p
A tergo schlank Scriptto
CCLI R Capo

2837

Arch. Dép. de la Gironde Bordeaux
G. 270
P. — Rothe Tinte
1258 Decembris 3
Alexander IIII .. decano et ca
pitulo Burdegalen.
Mentis vestre devotionis
Viterbii III non. Dec. aº 4º 2
Bulle an Seide
In plica rechts A. de Warien ?
Sub plica links in rother Tinte
..
9 Sehr unruhe und ge
schlossene Schrift
fast cursiv.

Archives Nationales Paris

L 252 n. 182 __1258 Decembris 3__

Br. 36.6 hoch 28. Plica 3.2
oberer Rand 7.3 links 1.5
rechts 1.5
 Alexander IIII (fette, grosse
Gitterschrift, Initiale verziert).
Abbati z Conventui Monasterii
sancti Germani de Pratis Parisien
ordinis sancti Benedicti ad Roman
Ecclesiam nullo medio pertinentis
 sic per devotionis
Dat. Anagnie III non. Decembre a° 4°

Bulle fehlt, Seide erhalten.
__Sub plica links__ :
♦ Mitte oben : HHH

A tergo Ecke oben links : a
 „ Mitte oben :
 + Sanctus Germanus de Pratis +

Weite kleine fette Schrift, mit gestr.
Ligaturen, mit 4 verzierten Schaft-
 zügen
In 1. Zeile 1 verz. Buchstabe

Linie für Gitterschr. nicht erkennbar

mit 6 Rasuren

P. vacat

Archives Nationales Paris

L 252 n. 182 bis __1258 Decembris 3__

Br. 30.7 hoch 24. Plica 2.8
oberer Rand 5.5. links 1.6
rechts 1.5
 Alexander IIII (Gitterschrift, Ini-
tiale verziert).. Abbati et Conventui
Monasterii S̃ti Germani de Pratis Pari-
sien ordinis S̃ti Benedicti ad Romana
ecclesiam nullo medio pertinentis
 sic per devotionis
Dat Anagnie III Non Decembre a° 4°

Bulle fehlt. Seide erhalten
 In plica rechts : der
__In plica__ links : s̃.
 Ecke oben rechts : Bx
A tergo oben Mitte :
 + S̃ctus Germanus de Pratis +
Darunter schlank
und betont 2.5

Enge eckige Schrift, mit
gestr. Ligaturen, mit
zwei verzierten Schrau-
fängen
 Zeile
Erste ohne verz. Buch- CCLXII Capto anno
 staben XIII

Erste Linie für Gitterschrift und Oberlängen

P. vacat

Archives Nationales Paris.

L 252 n. 183 __1258 Decembris 3__

Br. 29.3 hoch 21.4 Plica 3.9
oberer Rand 4.9 links 1.
rechts 0.9
 Alexander IIII (Gitterschrift, Ini-
tiale verziert).. Abbati et Conventui
Monasterii sancti Germani de Pratis
Parisien ordinis S̃ti Benedicti ad
Romana ecclesiam nullo medio pertinentis
 Hijs que nobis
Dat Anagnie III non Decembre a° 4°

Bulle fehlt. Seide erhalten
 In plica rechts : B. P.
A tergo oben Mitte :
 + S̃ctus Germanus de Pratis +
Darunter schlank
leicht betont 2.5 :

Wegen Registierung.
Mir viell 182 bis,
ra die gleiche auge.
merkt ist
 CCLXII Capto an
 no XIII

Schöne regelm. Schrift,
mit gestreckten Ligaturen,
mit 4 verzierten Schrauffängen
 In 1. Zeile ein verz. Buchstabe

Erste Linie für Gitterschrift und unteren
 Oberlängen

P. vacat

Archives Nationales Paris

L 252 n. 183 bis __1258 Decembris 3__

Br. 37.4 hoch 24.5 Plica 1.9
oberer Rand 7.3 links 2.1
rechts 1.6
 Alexander IIII (Gitterschrift, Ini-
tiale verziert).. Abbati et Conventui
Monasterii sancti Germani de Pratis
Parisien ordinis sancti Benedicti
ad Roman Ecclesiam nullo medio per-
tinentis
 Hijs que nobis
Dat Anagnie III non Decembre a° 4°

Bulle fehlt. Seide erhalten
__Sub__ plica links :
A tergo Ecke oben
links : a
A tergo oben Mitte :
 + S̃ctus Germanus de Pratis +

Weite fette kleine Schrift, mit gestr.
Ligaturen, mit 4 verzierten Schrauffän-
gen
 In 1. Zeile 1 verz. Buchstabe
Kleine Linie für Gitterschr. erkennbar

P. vacat

Archives Nationales Paris
L 252 n. 184 __1258 Decembris 3__

Br. 28.3 hoch 20 Plica 2.3
oberer Rand 5.2 links 1.5
rechts 1.3
Alexander IIII .. Abbati [et]
Benigni Divinimonis Lingonen
Sua nobis .. Abbas
Dat Anagnie III non Decembris a° 4°

Bulle und Hanf fehlen
In plica rechts: Jac
A tergo oben Mitte
+ Sctus Germanus de Pratis +

Ganz kleine fette Schrift

Mit 1 betonten Buchstaben
Erste Linie für Oberlängen

P. vacat

Archives Nationales Paris
L 252 n. 186 __1258 Decembris 4__

Br. 32.6 hoch 22.3 Plica 2.8
oberer Rand 5. links 1.1
rechts 1.1
Alexander IIII (Gitterschrift
Initiale verziert) .. Abbati et Con-
ventui Monasterii Sci Germani
de Pratis Parisien ordinis Sci Bene-
dicti ad Romanam ecclesiam nullo me-
dio pertinentis
Ut vere consulamus
Dat Anagnie III non Decembris a° 4°

Bulle fehlt, Seide erhalten
In plica rechts: . a. S.
A tergo oben Mitte: ?
Sctus German de Pratis
darunter klein mit
betonten Schrift 2.5
Fette enge deutliche
Schrift, mit einigen
gestr. Ligaturen, mit
3 verzierten Schrauffän-
gen. In 1. Zeile 1 ver. Buchstab. CC l xx Capto
anno domini
Erste Linie für Gitterschrift und Ober-
längen

P. vacat

__ad instar__

Archives Nationales Paris
L 252 n. 186 bis __1258 Decembris 4__

Br. 33 hoch 23.7 Plica 3.1
oberer Rand 5.3 links 1.2
rechts 1.3
Alexander IIII (Gitterschrift 1.
Zeile verziert) .. Abbati [et] Conven-
tui Monasterii Sci Germani de
Pratis Parisien ordinis Sci Bene-
dicti ad Romanam ecclesiam nullo
medio pertinentis
Ut vere consulamus
Dat Anagnie III non Decembris a° 4°

Bulle fehlt, Seide erhalten
In plica rechts: B: p
Sub plica links
g. ?

Rand oben Mitte: ad instar L
und :
A tergo oben Mitte :
+ Sanctus Germanus de Pratis +
kleine eckige Schrift, mit gestrek.
Ligaturen (mit 2 Ausnahmen), mit
3 verzierten Schrauffängen

In 1. Zeile 1 ver. Buchstabe
Erste Linie für Gitterschrift und
untere Oberlängen

__P. vacat__

Archives Nationales Paris
L 252 n. 187 __1258 Decembris 4__

Br. 34.3 hoch 25.9 Plica 2.4
oberer Rand 6.1 links 1.6
rechts 1.6
Alexander IIII (maiusculae)
.. Abbati usw.
wie n. 187 bis

Bulle fehlt, Seide erhalten
Sub plica links: . S.
Rand oben Mitte S S. S

A tergo oben Mitte :
+ Sanctus Germanus de Pratis +
Fette etwas unruhige Schrift, mit
gestreckten Ligaturen, mit 4 verzierten
Schrauffängen

In 1. Zeile 1 ver. Buchstabe
Erste Linie für Papstnamen und
untere Oberlängen

__P. vacat__

2846

Archives Nationales Paris
L 252 n. 187 bis **1258 Decembris 4**

Br. 33.3 hoch 24.9 Plica 2.7
oberer Rand 6.3 links 1.6
rechts 1.6

Alexander IIII (Gitterschrift,
Initiale verziert) .. Abbati 7 Con-
ventui Monasterij sancti Ger-
mani de Bratis Parisien ordinis
sci Benedicti ad Romam Ecclam
nullo medio pertinenti

Ut monasterij vestri
Dat Anagnie II Non Decembr a° 4°

Bulle fehlt. Seide erhalten
In plica rechts : at. p.

A tergo oben Mitte :
+ S Germani de Bratis +

Schön geschwungene klare Schrift,
mit gestreckten Ligaturen, mit
4 verzierten Satzanfängen

In 1. Zeile 1 verz. Buchstabe
Erste Linie für Gitterschrift

P. vacat

2847

Papstnamen

Archives Nationales Paris
L 252 n. 188 **1258 Decembris 4**

Br. 40.6 hoch 29.9 Plica 3.7
oberer Rand 6.2 links 1.5
rechts 1.4

Alexander IIII (Gitterschrift, Ini-
tiale verziert) .. Abbati 7 Conven-
tui sancti Germani de Bratis
Parisien ordinis sci Benedicti
ad Romam ecclam nullo medio
pertinentis

Ex fide
Dat Anagnie II Non Decembr a° 4°

Bulle fehlt. Seide erhalten
In plica rechts : g. ar.
Sub plica links :

Rand oben Mitte : L [· F] P. vacat

A tergo Ecke oben links : a
oben Mitte :
+ Sous Germanus de batis +

Weite runmäßige Schrift, mit gestr.
Ligaturen, mit fünf verzierten Satz-
anfängen
In 1. Zeile 1 verz. Buchstabe

Papstname im Text nicht in Gitterschr.
Erste Linie für Gitterschr. und Oberlängen

2848

Archives Nationales Paris
L 252 n. 188 bis **1258 Decembris 4**

Br. 43.9 hoch 30.7 Plica 4.4
oberer Rand 5.9 links 1.6
rechts 1.6

Alexander IIII wie in
n. 187 188

Bulle fehlt. Seide erhalten
In plica rechts : A. ar.
Rand oben links ℞

A tergo oben Mitte
+ Sco Germani de Bratis +
Darunter etwas steif
mit betontem Strich 3.5

Weite klare eckige c c L X j apto
Schrift, mit gestreck- Annus Quarto
Ligaturen, mit 5 verz.
verziert Satzanfänger

Erste Zeile mit 1 verz. Buchstaben
Erste Linie für Gitterschr. und Ober-
längen

Papstnamen im Text nicht in
Gitterschrift

Papstnamen P. vacat

2849

Archives Nationales Paris
L 252 n. 189 **1258 Decembris 4**

Br. 28. hoch 19.5 Plica 2.1
oberer Rand 4.7 links 1.1
rechts 1.1

Alexander IIII (Gitterschrift
Initiale verziert) .. Abbati Mo-
nasterij sci Germani de Bratis
Parisien ordinis sancti Benedicti
ad Romam ecclam nullo medio
pertinentis

His que tibi
Dat Anagnie II Non Decembr a° 4°

Bulle fehlt. Seide erhalten
In plica rechts : g. ar.
Ecke oben links : ℞

A tergo oben Mitte :
+ Sanctus Germus de Bratis +

Darunter etwas steif 2.7

Weite eckige Schrift
mit ... gestreck c c L X iiij apto Annus
Ligaturen Quarto
mit 4 verzierten
Satzanfängen
In 1. Zeile 1 verz. Buchstabe
Erste Linie für Gitterschrift und Ober-
längen
In plica links : · S P. vacat

2850

Archives Nationales Paris

L 252 n. 189 bis **1258 Decembris 4**

Br. 28.6 hoch 19.2 Plica 2.1
oberer Rand 5.2 links 1.3
rechts 1.3

Alexander IIII

wie in n. 189

Bulle fehlt. Seide erhalten
Sub plica links : ⠸

Rand oben mitte : [3 ⨍]

ut distringere debeant
penas adiectas ; diese Worte sind
im Texte auf Rasur radenent

A tergo Ecke oben links : a
„ oben mitte :
✠ sanctus Germanus de
Bratis ✠

Etwas nachlässige Schrift
mit gestreckten Ligaturen
mit 4 verzierten Schaufängen

In 1. Zeile 1 verz. Buchstabe

Erste Linie für Gitterschrift und
untere Oberlängen

P. vacat

2851

Archives Nationales Paris

L 252 n. 190 **1258 Decembris 4**

Br. 28.5 hoch 21.8 Plica 2.2
oberer Rand 6.1 links 1.4
rechts 1.4

Alexander IIII (Gitterschrift
Initiale verziert) . . Abbati et
Conventui Monasterij sancti
Germani de Bratis ordinis sancti
Benedicti ad Romanam Ecclesiam
nullo medio pertinentij
Non est ab
Dat Anagnie II non Decembre a° 4°

Bulle fehlt. Seide erhalten
In plica rechts : ⸱⸱

A tergo oben mitte :
✠ Sctus Germanus de Bratis ✠

Eckige klare Schrift, mit gestr.
Ligaturen, mit vier verzierten
Schaufängen

Erste Zeile mit 1 verz. Buchstaben

Erste Linie für Gitterschrift und
Oberlängen

P. vacat

2852

Archives Nationales Paris

L 252 n. 190 bis **1258 Decembris 4**

Br. 27.9 hoch 20.3 Plica 1.9
oberer Rand 5.1 links 1.4
rechts 1.4

Alexander IIII (Gitterschrift
Initiale verziert) . . Abbati
et Conventui Monasterij sti
Germani de Bratis ordinis
sancti Benedicti ad Roman
Ecclesiam nullo medio pertinentij
Non est ab
Dat Anagnie II non Decembre a° 4°

Bulle fehlt. Seide erhalten
Sub plica links : ⠸

Rand oben mitte : [4 ⨍]

A tergo oben mitte :
✠ Sanctus Germanus de Bratis ✠

Ecke oben links a
In der mitte
etwas steif 7.3
und vom Ansatz
ab 8.7

cclxxvii [Capto
anno
Ansatz]

P. vacat

2853

Archives Nationales Paris R

L 252 n. 191 **1258 Decembris 4**

Br. 30.7 hoch 26 Plica 3.4
oberer Rand 5.9 links 1.5
rechts 1.5

Alexander IIII (Gitterschrift
Initiale verziert) . . Abbati z Con
ventui Monasterij sti Germani
de Bratis Parisien ordinis sti
Benedicti ad Roman ecclesiam
nullo medio pertinentis
Debet ex aplice
Dat Anagnie II non Decbre a° 4°

Bulle fehlt. Seide erhalten

A tergo oben mitte :
✠ Sctus Germanus de Bratis ✠
Darunter klein
etwas steif 2.7

Teils kleine etwas nachlässige Schrift, mit gestr.
Ligaturen, mit fünf verzierten Schaufängen CCLXVIII [Capto
anno Quarto]
Erste Zeile mit 1 verz.
Buchstaben
Erste Linie für Gitterschr.
und untere Oberlängen

P. vacat

Papstnamen

Archives nationales Paris RX
L 252 n. 192 1258 Decembris 4

Br. 30.8 hoch 22.6 Plica 2.6
oberer Rand 6. links 1.5
rechts 1.5
 Alexander IIII (Gitterschrift
Initiale verziert) . . (Abbati mo-
nasterij sci Germani de Pratis
Parisien ordinis sci Benedicti ad
Roman Ecclam nullo medio per
tinentis
 Habemus tue devotionis
Dat Anagnie II Non decembr a° 4°

Bulle fehlt, Seide erhalten
 In plica rechts: at. p..
Ecke oben links B4

A tergo oben Mitte:
 + sci Germanus de pratis +
Darunter etwas steif 3.1 (sept)
mit 6.7 cauda

fette kleine Schrift mit
gestr. Ligaturen
und 4 verzierten CCLXIII Capto
Sota aufzurgen anno christo
In 1. Zeile 1 vorz Buchstabe
Erste Linie für Gitterschr.

Papstname im text nicht in Gitter
 schrift
 P. vacat

2856

Archives nationales Paris
L 252 n. 194 1258 Decembris 4

Br. 24.2 hoch 15.8 Plica 2.2
oberer Rand 2.8 links 0.8
rechts 0.8
 Alexander IIII . . Abbati sci
Genovefe Parisien
 Sua nobis dilecti
Dat Anagnie II non decembr a° 4°

Bulle fehlt, Hanf erhalten
 In plica rechts: B°. parm
Sub plica links: .i.

 [Zeichen]

A tergo oben Mitte:
 + sci Germanus de Prat +
folgt lange Bemerkung über anda.
 rücksige Ausputzingen

Kleine fette Schrift
 mit einem betonten Buchstaben
Ohne freie erste Linie

 p. vacat

Archives nationales Paris
L 252 n. 193 1258 Decembris 4

Br. 23.7 hoch 18.8 Plica 2.9
oberer Rand 5.4 links 1.3
rechts 1.3
 Alexander IIII . . Abbati mo-
nasterij sancti Germani de Pratis
Parisien ordinis sancti Benedicti
dilecti filij . . Prior
Dat Anagnie II Non decembr a° 4°

Bulle fehlt, Hanf erhalten
 In plica rechts: Ben. p
Sub plica links:

Rand oben [[Zeichen]]
Mitte: [

A tergo oben Mitte:
 + sci Germanus de Pratis +
Kleine klare Schrift
 mit einem betonten Buchstaben
Erste Linie zwecklos

 P. 17426

2857

 (Name und Punkte)

Paris Archives nationales
 J 687 n. 94
Breite 25. Rand links 2.2 rechts 2.1
Höhe 21.4 Rand oben 4.4 plica 2.1
Erste Linie für Gitterschr. und oben
hängen, je eine Leerzeilinie
P. vacat 1258 Decembris 4
Alexander IIII (Gitterschr) Carmo
in Xpo filio . . Ludovico Illustri
Regi Francie
 Tuis notis illis
Dat Anagnie, II non Decembr
a° 4°
 Bulle an feiner Seide
In plica rechts: p. lar
A tergo oben Mitte: R . E . X . F
fette regelm . Schrift

2858

Archives Nationales Paris

L 252 n. 195 1258 Decembris 5

Br. 29.6 hoch 23.5 Plica 3.3
oberer Rand 7.3 links 1.3
rechts 1.4

Alexander IIII (Gitterschrift, Ini-
tiale variiert)

wie n. 195 bis

Bulle fehlt. Seide erhalten
Zu plica rechts: m. g.
links daneben eine Kanzleibemerkung
über Erneuerung des Privilegs

A tergo oben Mitte:
+ sēs Germain de Pratis Parisien +

Sehr feste weite Schrift, mit gestr. Liga-
turen, mit 3 verzierten Satzanfängen

In 1. Zeile 1 verz. Buchstabe

Erste Linie für Gitterschrift und
Oberlängen

P. vacat

2859

Archives Nationales Paris RX

L 252 n. 195 bis 1258 Decembris 5

Br. 29.2 hoch 23.6 Plica 3.1
oberer Rand 6. links 1.5
rechts 1.4

Alexander IIII (Gitterschrift Ini-
tiale variiert) .. Abbati Monasterij
sancti Germani de Pratis Parisien
ad Romam ecclīam nullo medio per
tinentis ordinis sancti Benedicti

Dat Anagnie non decembr aᵒ 4ᵒ
Ut ex sincere

Bulle fehlt. Seide erhalten
sub plica links

A tergo oben Mitte:
+ Scus Germanus de pratis +
Darunter in schöner
Rundung 2.8

recht schöne mittelgrosse
Schrift, mit gestr.
Ligaturen, mit 3 CCLXXVIII
verzierten Satzanfängen
In 1. Zeile 1 verz. Buchstabe
Erste Linie für Gitterschrift

lepto
anno quarto
40

P. vacat

2860

Archives Nationales Paris RX

L 252 n. 196 1258 Decembris 5

Br. 28.4 hoch 23.6 Plica 3.3
oberer Rand 6.5 links 1.1
rechts 1.1

Alexander IIII (Gitterschrift, Initia-
le variiert) .. Abbi et Conventui
Monasterij sancti Germani de Pratis
Parisien ad Romanam ecclīam
nullo medio pertinentis ordinis sanc-
ti Benedicti

Meritis nestre devotionis
Dat Anagnie non decembr aᵒ 4ᵒ

Bulle fehlt. Seide erhalten
In plica rechts: p. S. pen
pro Petro B. de sco Vito

A tergo oben Mitte:
+ sēs Germanus de Pratis +
darunter schmal schlank 2.6

feste etwas unordentliche Schrift
mit gestreckten Ligaturen
mit 5 verzierten
Satzanfängen CCLXX
Erste Zeile mit 1 verz.
Buchstaben
Erste Linie für Gitterschrift
und Oberlängen

lepto
anno
quarto

P. vacat

2861

Corrector

Archives Nationales Paris

L 252 n. 196 bis 1258 Decembris 5

Br. 29.9 hoch 22.4 Plica 2.9
oberer Rand 5.5 links 1.4
rechts 1.3

Alexander IIII (Gitterschrift, Ini-
tiale variiert) .. Abbati 7 Conven-
tui monasterij sancti Germani de
Pratis Parisien ad Romam ecclīam
nullo medio pertinentis ordinis sanc-
ti Benedicti

Meritis nestre devotionis
Dat Anagnie non decembr aᵒ 4ᵒ

Bulle fehlt. Seide erhalten
sub plica links:

A tergo oben Mitte:
+ Scus Germanus de Pratis +

kleine schöne Schrift, mit gestr.
Ligaturen, mit 4 verzierten Satz-
anfängen
In 1. Zeile 1 verz. Buchstabe

Erste Linie für Gitterschrift und Oberlän-
gen

Diese Ausfertigung wurde zuerst ge-
macht und zwei Verbesserungen an-
gebracht. In n. 196 steht ein glatter
Text

P. vacat

innovetur

Archives Nationales Paris
L 252 n. 197 **1258 Decembris 5**

Br. 31.7 hoch 21.6 Plica 3.2
oberer Rand 5.3 links 1.4
rechts 1.3

Alexander III . . Abbati et Conventui sancti Germani de Pratis sitis ad Romanam ecclesiam nullo medio pertinentis ordinis sancti Benedicti Cum a nobis

Dat Anagnie non Decembris a° 4°

Bulle fehlt. Seide erhalten.
In plica rechts : B. pu

An plica links Kanzleibemerkung für neue Ausfertigung der Urkunde.

A tergo oben Mitte :
+ sco Germano de Pratis +

Ecke etwas nachlässige Schrift, mit gestr. Ligaturen, mit 4 verzierten Satzanfängen
In 1. Zeile 1 vers. Buchstabe

Erste Linie für Gitterschrift und Oberlängen

P. vacat

duplicetur

Archives Nationales Paris **R̶X̶**
L 252 n. 198 **1258 Decembris 5**

Br. 26.6 hoch 20.5 Plica 2.8
oberer Rand 5.9 links 1.3
rechts 1.

Alexander IIII (Gitterschrift, Initiale verziert). . Abbati et Conventui monasterii sancti Germani de Pratis Parisien ad Romanam ecclesiam nullo medio pertinentis ordinis sancti Benedicti Inducunt nos vestre

Dat Anagnie non Decembris a° 4°

Bulle fehlt. Seide erhalten.
In plica rechts : Ay. gi.
Rand oben Mitte : dupt

A tergo oben Mitte :
+ sco Germano de Pratis +

Darunter schlank dünn 2.9

Fette kleine Schrift, mit gestr. Ligaturen, mit 5 vers. Satzanfängen
Erste Zeile mit 1 vers. Buchstaben
Erste Linie für Gitter- CCLXXVIII
schrift und Oberlängen

Capto anno Quarto

P. vacat

Archives Nationales Paris **R̶X̶**
L 252 n. 199 **1258 Decembris 12**

Br. 21.4 hoch 17. Plica 3.2
oberer Rand 4.6 links 0.8
rechts 0.8

Alexander III (Gitterschrift, Initiale verziert). . Abbati et Conventui monasterii sci Germani de Pratis Parisien ordinis sci Benedicti ad Romanam ecclesiam nullo medio pertinentis Nostris peccavere dispendiis

Dat Anagnie II Id. decembris a° 4°

Bulle fehlt, Seide erhalten.
In plica rechts : · B · P ·

A tergo oben Mitte :
+ sco Germanus de Pratis +

Darunter schlank 2.5 :

Sehr schöne kleine Schrift mit gestr. Ligaturen mit 3 vers. Satzanfängen

In 1. Zeile 1 vers. Buchstabe
Erste Linie für Gitterschrift und Oberlängen

CCLXXX Capto anno Quarto

P. vacat

Nîmes. Archives départem.
G. 1319

P. — **1259 Jan. 2**

Alexander IIII . . preposito et capitulo Remensen. Obsug.
Justis petentium desideriis
Anagnie IIII non. Januar. a° 5°
Bulle fehlt Seide erhalten
In plica rechts Al P
Sub plica links i·
g f.

Rand oben Mitte Lecta
Ecke oben rechts p̶e̶

2866

Madrid Arch. Histór. Nacional
Logroño S. M. de Herrera 4.9
P. — 1259 Januarii 9
Alexander III . . abbati Cisterciensi
eiusque coabbatibus et conven-
tibus universis Cist. Ord.
 Circa factum et
Anagnie V iď. Jan . aº 5º
Bulle und Siűde fehlen
In plica rechts G. ar.

Die gestreckten Ligaturen
sind sehr eng, aber schön.

2867

Bryn. Hupt. Staatsarchiv
 Bamberg fasc. 26
P. 17449 1259 Januarii 11
Alexander III . . Patriarche Aquilegensi
 Ex parte dilectorum
Anagnie III iď. Januarij anno
 Quinto

Bulle an dickem Hanf
 In plica rechts : Aŕ . M
Sub plica links : . y.

 y. f

 A tergo mitte halbrechts
 schlank schön :

 V

 Sehr abgerieben

2868

Instr. Mon. F. Dom. c. 34 1259 Jan. 18
 P. 17452
Alex III . . mag. et fratribus ord. Pred.
Cum olim quidam
Anagnie XV Kal. Februarii aº 5º
Bulle an Seidenfäden.
In plica rechts : Hem p (?)
Sub plica links : — —
 a . g.
A tergo : predicatorum

2869

Madrid Arch. Histór. Nacional
Palencia San Pablo 4. 13
P. — 1259 Januarii 20
Alexander III . . apo Legionensi
Pertulerunt ad audientiam
Anagnie XIII Kl. febr . aº 5º
Bulle fehlt. Sehr dicker gro-
ber Hanf erhalten
In plica rechts . 9.9.

Kleine sehr feine rundliche
Schrift von schönstem
Gleichmass

2870

Poitiers Archives départem.
Ordre de Malte

P. —

1259 Januarii 31

Alexander IIII archepis et epis per
Aquitaniam constitutis
Amavit sit grave
Anagnie II Kl. febr. a° 5°
Bulle fehlt. Hanf erhalten
In plica links fiat similis per Fran-
ciam constitutis de verbo ad verbum
R J

2871

Bayer. Haupt - Staatsarchiv
Fürstenfeld Kl. n. 24

P. vacat 1259 Februarii 9

Alexander IIII (Gitterschrift) . . Abbati
et conventui de Vallesalutis Cister-
cien. ordinis Frisingen. dioc.
 Necessitatibus vestris benigno
Anagnie V Jd. febr. anno Quinto

Bulle an Seide
In plica rechts : An. M
Sub plica links :

 ʒ·f

Rand oben Mitte :

A Tergo Ecke oben links : y

Erste Zeile frei. Seitenlinien
Sehr schöne Schrift. Gestreckte Ligaturen
in den verschiedensten Formen. Ober-
und Unterlängen gleich gross

Oberer Rand breit, plica gross

2872

Marseille Archives départem.
H. P. A. 8
P. — 1259 februarii 10
Alexander IIII univ. xpi fideli-
bus pres. litteras inspecturis
 Vite perennis gloria
Anagnie IIII id. febr. a° 5°
Bulle an Seide
In plica rechts J. M
Sehr feine prachtvolle Schrift
Gestreckte Ligaturen

2873

Paris Archives Nationales
 J 687 n. 93
Breite 37. Rand links 1.8 rechts 1.7
Höhe 27.7 Rand oben 5.6 plica 3.5
 Zweite freie Linie für Maj und
Oberlängen / Je eine Seitenlinie
P. vacat 1259 februarii 22
Alexander IIII (Vers. Maj) Carmo
in xpo filio . . Regi Francie Jllustri
 Inter alia ~~sace~~ sacre
dat Anagnie VIII Kl Martij / a° 5°
Bulle an feiner Seide
 In plica rechts : Rob Sc (?)
A tergo oben Mitte : Frater Man-
sultus
Kleine sehr regelm. Schrift
fünf betonte Initialen

2874

Instr. Mon. F. Dom. c. 23 1259 Febr. 27

P. 17497

Alex IIII archiepis et epis et abbatibus
et ad quos littere iste pervenerint
Quoniam habundavit iniquitas.
Anagnie III Kal. Martii a° 5°
Bulle an Hanfschnur
In plica rechts: bn. et
A tergo: predicatorum

rep. A 1235 Jan. 12. P. 9821
bez v. P. 7896

& prioribus, decanis, archidiaco
nis, plebanis, archipresbiteris
et aliis eccl. prelatis

2875

Instr. Mon. F. Dom. c. 144 1259 Martii 6
P. 17506

Alex. IV. . abbati S. Sofie de Benevento
Retulerunt ad audentiam –
Anagnie II non. Martii anno 5°
Bulle an Hanfschnur
In plica rechts: . C. la.
 pro Jo de Camp.
Sub plica links: . –
Unter dem Bug: Er Menth. et pe.
In plica links: Scriptori priori Sancti
Michaelis de Brasto extra muros bono
nien. pro priore et fratribus or. Predica
torum de Regis similis horum
Rand oben links: petit frater Troianus
quod ista littera pro fratribus predicatori
bus de Regis renovetur et concedatur, ut
possit eam habere pro quocumque conven
tu sui ordinis voluerit
Im andern Hand: Renovetur et fiat sibi
de illis conventibus de quibus voluerit
A tergo Predicatorum. M.

2876

Firenze, Carmine di Firenze
P. 17517 1259 Martii 18
Alexander IIII. . generali et
universis prioribus sororum bea
te Marie de Monte Carmely(?)
 Provisionis nostre cupimus
Anagnie XV Kl. Apr. a° 5°
. Bulle und Seide fehlen
In plica rechts Scriptor
 Oberste Linie frei
Sub plica fast ganz liniert
Sehr schmale Seitenränder

2877

Archives nationales Paris
L 253 n. 205 1259 Martii 23
Br. 26.5 hoch 19,8 plica 2.2
oberer Rand 5.4 links 1.1
rechts 1.2
 Alexander IIII. . Priori Provincia
li fratrum Predicatorum in Regno
Francie
 Cum exigentibus pupilia
dat Anagnie X Kl. aprilis a° 5°
Bulle fehlt, Hanf erhalten
In plica rechts : . G. Saon. de luna
Rand oben Mitte : G

 A tergo Ecke oben links : a
 " oben Mitte : Lombardia
Enge etwas eckige Schrift
 Ohne jeden betonten Buchstaben
Erste Linie drecklos

 De Curia

P. vacat

Marseille Archives Départem.
H. O. J. #5
P.— 1259 Martii 24
Alexander IIII .. magistro et fratri-
bus domus Militie Templi Iero-
solimitan.
 Desideriis vestris in
Anagnie VIIII kl. Apr. a° 5
 Bulle an Seide
 In plica rechts Jac mut
 Betonte Sitzanfänge
 Oberste Zeite frei. Seitenlinien
 Gestreckte Ligaturen

Firenze, Camaldoli
P. 17526 1259 Martii 28
Alexander IIII .. abbi Sancti Lau-
rentii Cesenat. OSB
 Dilecti filii .. abbas
Anagnie V kl. Aprilis a° 5°
 Bulle und Hanf fehlen
 Erste Linie unbeschrieben
 Sub plica halb unliniiert

Firenze, SS. Annunziata
 di Firenze
 P. 17528 1259 Aprilis 1
Alexander IIII .. generali et
ceteris prioribus ac fribus
Servorum See Marie OrdSAug.
 Religionis vestre meritis
Anagnie kl. Aprilis a° 5°
 Bulle fehlt, Seide erhalten
 In plica rechts Jo Anagnie
 Sub plica links
 g. f
Rand oben Mitte

Archives nationales Paris
L 253 n. 208 1259 Aprilis 4
Br. 25.2 hoch 20.9 Plica 2.4
 oberer Rand 5.2 links 1.1
rechts 1.1
 Alexander IIII .. Decano eccle
Camenacen
 Ad domum Militie
Dat Anagnie II non Aprilis a° 5°
 Bulle und Hanf fehlen
 In plica rechts weit ausein.
anten: a. d. a. Sew
 A tergo oben Mitte :
 Kleine Fette runde Schrift
 mit einem betonten Buchstaben
 Erste Linie für Oberlängen

 P. vacat

2882

Instr. mov. T. Tom. C 110 1259 Aprilis 18

P 17536

Alex IV fratribus Praedicat. inquisitoribus pravitatis hereticae in partibus Lombardie et Marchie Jannen.

Ne inquisitionis negotium

Anagnie XIV kal. Maii anno 5

Bulle an Seidenschnur.

In plica rechts: p. Lalis y
de curia

Rand oben links: Rp Ser. de curia re
noretur et Intim

Darunter Junta zur Adresse: x auctori
tate (sedis) aplicae deputatis et in po-
sterum deputandis

In plica links: Addatur in salutatio
re deputatis aut. aplica et in poste-
rum deputandis

nur: ubi de quantitate dicitur decem
et octo

Potthast XIV kal.
Maii

cf. 1257 Jan. 11
" 1267 Jul. 27
renovata 1266 Jan. 13
P. 19522

2883

Napoli Curia Eccles. Vol. 3°

P. 17539 1259 Aprilis 24

Alexander IIII -- magro et fra
tribus Hospitalis See Marie Theu
tonicorum Jaco.

Ex parte vestra

Anagnie VIII Kl. Maii a° 5°

Bulle und Hanf fehlen

Keine gestreckten Ligaturen,
aber Initiale nicht ganz ohne

Ohne alle Notizen

2884

Staatsarchiv Wien Chronol.

P. — 1259 Aprilis 30

Alexander IIII -- patriarche
Aquilegen.

Ex parte dilecti

Anagnie II Kl. Maii a° 5°

Bulle liegt bei. Hanf vorhanden

In plica links ʃ

Sub plica links ʃ

Rand oben (Mitte l oor

dann Ju aprd .

Ecke oben rechts c ff

Oberste Zeile unbeschrieben

2885

Madrid Arch. Histór. Nacional
Logroño S. Millan 1. 36
abschrift viecancellarius

P. 17554 1259 Aprilis 30

Alexander IIII abbi mon. S. Emi
liani de Cuculla eiusque etc.

Religiosam vitam eligentibus
invenient Amen A . Amen
(R) Ego Alex. etc. (M)
2 presb. 2 epi 5 diac.

Anagnie p. m. magri Jordani
S R E notarii et
viecancellarii II Kl. Maii
ind. II J. D. a 1219 (!!) pont.
Alex pp IIII a° 5°

Firenze, S. Trinita di Fi
reuse

P— _1259 Maii 5_

Alexander IIII .. abbi sci In
cubi Senen.

. Significavit nobis di
lectus

Anagnie III non. Maii
a° 5°

In plica rechts scriptor

Bayer. Haupt. Staatsarchiv
Tielenhofen F. 2

1259 Maii 11

Alexander IIII (Gitterschrift) ..
Abbatisse et Conventui Mona
sterij de Pielenhoven, Cisterciem
ordinis Ratisponen. dioc.
Solet annuere sedes
Anagnie V jd. maij a° Quinto

Bulle an Seide
In plica rechts : F. R
pro xpiano

Seitenlinien, Erste Zeile frei

Kleine, zierliche Schrift mit großen
Ober- und Unterlängen

Inio Archives Departem.
H. 14 P.— Vice cancellarii
Abschrift _1259 Maii 13_
Alexander IIII abbi non. Lerin
eiusque fribus — in perp.
Vitam professis
Quotiens illud a
Rome 1259 pont. a° 5°
per m. maj. Iordan notarii
et vice cancellarii
Sehr schlechte Abschrift.
Bruchstück des originals
(rechte Seite) mit Unterschrif
ten der Diacone, Rota, Presb.
unterschrift Monogramm vor
handen
Zweite bessere Abschrift hat III id. Maii

Toulouse, Archives Départem..
Ste Servin
Ste Claire

P.— _1259 Maii 14_

Alexander IIII dil. in xpo filiabz
.. abbatisse monasterii Sce Ma
rie Tholosan. eiusque — in ppm
Religiosam vitam eligentibus
inveniant Amen a. amen
R. Ego Alexander catholice ecclie
Epo SS. m.
2 presb. 2 epi 5 diac
Anagnie per manum magri
Iordani Sce Rom. ecclie notarii
ni et vicecancellarii II id. maii
Ind. IIa Inc. dnice a° m. ĉ
LV IIII pont. vero dmni Aleĥ
ANDRI pp. IIII anno quinto
Bulle an Seide.
In plica links J. V

Gestreckte Ligaturen

2890

Bayer. Hauptstaatsarchiv
Rheinpfälz. Urk. fasc. 89

P. 17575 1259 Mai 15

Alexander IIII (Gitterschrift) . . Abba-
tine et Conventui Monasterij in
Rosendal Cisterciensis . ordinis Wor-
matien. diöc.
 Devotionis vestre precibus
Anagnie Id. Maij Anno Quinto

Bulle an feiner Seide
In plica rechts: Herr ƒ
Sub plica links: ƒ

Rand oben mitte:
Ecke oben rechts: Gō ?
 a tergo Ecke oben links : J
Erste Seite frei, Seitenlinien

2891

Madrid Arch. Histó. Nacional
 Poblet E 2. 8
 P. —
 1259 Mai 18

Alexander IIII . . Abbati et conv.
mon. de Populeto Cist. O. Terra-
chonen. diöc.
 Cum a nobis
Anagnie XV Kl. Junii a° 5°
Bulle fehlt. Seide erhalten
Sub plica links ƒ
 ƒ

Ecke oben rechts Ma
Rand oben halblinks C

2892

Graz Landesarchiv n. 774
 P. — 1259 Mai 21
Alexander IIII . . preposito et
conventui ecclesie Secoven.
ord Skug.
 Gloriosus Deus in
Anagnie XII Kl. Junii a° 5°
Bulle an Seide
In plica rechts p. Angeli
Sub plica links ƒ

Rand oben mitte C
Seitenlinien. Oberste Zeile un-
beschrieben
Lignatur gemischt.

2893 (recto)

Instr. mon. F. Dom. c. 8 1259 Mai 25
 P. —

Alex. IIII fratribus Galterico Aurelia-
cen. et Everardo vallis Scolarum
ordinum monachis, Egidio archidia-
cono et Roberto de Quincii cano-
nicis Rothomagen. et Petro dicto
Rufo canonico eccle Corboliacen.
Parisien. diöc. magistris in theo-
logica facultate Parisius consti-
tutis.
Vestre sollicitudinis operosa
Anagnie VIII Kal. Junii a° 5°
Aufschnur. Bulle fehlt.
In plica rechts: Hen. p
Sub plica links : .
 a. G. vacat

2893 (verso)

Rand oben Mitte: cor
A tergo: predicatorum

2894

Basel Staatsarchiv
Klingenthal Urk. No. 25
P. — 1259 Maii 31
Alex IIII univers. xpi fideli
bus presentes litteras inspecturis
vite perennis gloria
Anagnie † Kl. Junii a° 5°
Bulle an Seide
In plica rechts B. p.

In plica halbrechts für die Er-
neuerung:
⌐ nec non in anniversariis
die liste dedicationis eius
dem ecclesie
Rₒ . p̂ .]

2895

Firenze, Badia Fiorentina
P. — 1259 Junii 8
Alexander IIII .. priori Predi
catorum et .. ministro fratrum
Minorum de Florentia
Ex parte dilectorum
Anagnie VI id. Jun. a° 5°
Bulle und Hanf fehlen
In plica rechts A. L. a .. tam
Sub plica links ·¦·
 ẹ. f̂.
Rand oben Mitte ⌐
 └ A tergo oben
Ecke links]

2896

Firenze Badia Fiorentina
P. — 1259 Junii 9
Alexander IIII .. abbi mon. S.
Marie, .. priori S. Michae-
lis Butelǐ et .. preposito
ecclesie Florentie
Sua nobis cleras
Anagnie V id. Junii a° 5°
Bulle fehlt, Hanf erhalten
In plica rechts . m. p.
Sub plica links ·¦·
 ẹ. f̂.
Die plica deckt zwei
 Zeilen

2897

Madrid Arch. Histór. nacional
Poblet C n. 16

P. — 1259 Junii 17

Alexander IIII.. abbi et conven
monast. de Populeto Cist. O. Tar-
raconen. dioc.

Cum a nobis

Anagnie XV Kl. Iulii a° 5°

Bulle fehlt. Seide erhalten

In plica rechts Ja nar

Sub plica links ..

Ecke oben rechts
Rand oben halblinks
Ligaturen gemischt

2898

Instr. mon. F. Dom. c. 74 1259 Jun. 19

P. —

Alex. IIII .. priorisse et conventui mo-
nialium inclusarum monasterii
beate Marie de Pruliano ordinis
Sancti Augustini secundum insti-
tuta et etiam sub cura Fratrum
ordinis Predicatorum viventibus
Tholosan. dioc.

Meritis vestre religionis

Anagnie XIIII Kl. Iunii anno 5°

Bulle an Seidenfäden

In plica rechts: g. ar.

Sub plica links: ...
y. f.
a. g.

Rand oben links: Dup

A tergo: Predicatorum

Datum?

2899

Madrid Arch. Histór. nacional
Poblet C n. 16

P. — 1259 Junii 20

Alexander IIII .. abbi et conv.
monast. de Populeto Cist. O.
Tarraconen. dioc.

Cum a nobis

Anagnie XII Kl. Iulii a° 5°

Bulle fehlt. Seide erhalten

In plica rechts . C . La .

2900

Madrid Arch. Histór. nacional
San Marcos de Leon nº 25

P. — 1259 Junii 26

Alexander IIII .. episcopo Legio-
nen.

Ad audientiam nostram

Anagnie VI Kl. Iulii a° 5°

Bulle fehlt. Hanf erhalten

In plica rechts L. de. Ju

flotte nicht unschöne, Kleine
Schrift

fingerbreiter Rand

2901

Madrid Arch. Histór. Nacional
Alcocer 1 E
P. — 1259 Julii 31
Alexander IIII .. abbatisse
et conventui monasterii de
Alcocer O. S. Damiani Concheñ.
dioc.
Speciali gratia et
Anagnie II kl. Aug. a° 5°
Bulle angebunden. Seide fehlt.
Sub plica links ..

, a . g.
Rand oben links dupt. v.

Ligaturen alle gestreckt.
duplicat mit Schreiber
ut supra

2902

Madrid Arch. Histór. Nacional
Alcocer 2 E
P. — 1259 Julii 31
Alexander IIII .. abbatisse
et conventui mon. de Al-
cocer O. S. Damiani Con-
chen. dioc.
Speciali gratia et
Anagnie II. kl. Aug. a° 5°
Bulle fehlt. Seide erhalten.
In plica rechts B. nard' parm

duplicat mit Taxe
et registrum

2903

Archives Nationales Paris
L 253 n. 216 1259 Augusti 7
Br. 34. hoch 24.1 Plica 3.1
obere Rand 6. links 1.4
rechts 1.3
Alexander IIII Universitati Ma-
gistrorum et scolarium Parisien-
ex parte nostra
sium Anagnie VII id Aug a° 5°
Mülle an Seide
In plica rechts weiter auseinander:
a . L . a . Ten
Sub plica links :

A tergo Ecke oben links : a
" Obere Mitte : Universitas
Parisiens
Weide schöne Schrift, mit gestr. Ligaturen
mit vier verzierten Satzanfängen.
In 1. Zeile 2 vers. Anfstaben
Erste Linie für Gitterschrift mit Ober-
längen

P. × 17653

2904

P. 17676 R
Archives Nationales Paris
L 253 n. 220 1259 Octobris 11
Br. 54.3 hoch 70.3 Plica 2.1
obere Rand 7.2 link 3.
rechts 3. mit je zwei Seitenlinien
Alexander IIII (maiusculae, das
Andere Gitterschrift mit 5 verzierten
Wortanfängen) dej. del. filij .. Abbati
monasterij sc. Romidij in Francia
ejusq.. fratribus tam ... IN REM
Religiosorum vitam eligentibus
inniandi AMEN a—e amen
R (Klein) go Alexander Catholice M
eclie eps
Kreuz ganz Da A in Alexander versiert
winzig klein und stark betont
2 presb. 1 eps 2 diac
Dat Anagnie per manum Magri Jordani
sce Romane eclie notarij et Vicecancel
larij V id Octobre Indictione tertia
Incarnacionis dnice Anno m°cc°Lviiij
Pontificatus vero domini ALEXANDRI PP
IIII anno quinto
Bulle und Seide fehlen.
J in Jordani versiert und stark betont
Alle Capitelsanfänge sehr versiert
a tergo gewöhnlich oben Registratur
sehr stark abgerieben R
Vergl. Von der Apost. Kanzlei, p.78

Paris Arch. Nat.

L. 253 cap. 249 1259 XXX. Oct. 11

Alex. IIII abbati monasterii S.
Dionisii in Francia eiusque et
Religiosam vitam eligentibus
Dat. Anagnie p. m. magistri Jor-
dani S.R.E. notarii et vice can-
cellarii V iď. Oct. a° 5°

Bulle und Seide fehlen

vice cancellarius

Potthast 17676

Madrid Arch. Histor. Nacional
S. Esteban de Salamanca 2. 21
fehlt Zwei Schreibfehler
P. 17679 1259 Octobris 14
Alexander IIII prioribus et fratri-
bus ordinis Predicatorum per
Yspaniam constitutis
Meritis religionis vestre
Anagnie II iď. Oct. a° 5°
Bulle fehlt. Seide erhalten
Rand oben Befehl: fiat similiter
Kur Kanzleinotizen

fehlen :
vestris supplicationibus in-
clinati omnes senten-
tias
Ligaturen gemischt.
fingerbreite Ränder links
und rechts.

Archives Nationales Paris
L 253 n. 221 1259 Novembris 7
Br. 25.7 hoch 19.7 Plica 2.1
oberer Rand 4.6 links 0.8
rechts 0.7
Alexander IIII Archiepis et Epis
ac dil. filiis abbatibus Prioribus Decanis
archidiaconis z aliis eccliarg Prelatis
per Regnum Francie constitutis
Ex parte dilectorum
Dat Anagnie VII id Novembris a° 5°
Bulle fehlt. Hanf erhalten
An plica rechts : Jo. Ro.
A tergo oben Mitte : C
Erste pina Linie zwecklos
Ohne jeden betonten Buchstaben
Kleine fette Schrift

P. vacat

Madrid Arch. Histor. Nacional
Poblet E. n. 21
P. — 1259 Novembris 14
Alexander IIII .. abbi et conv.
Monast. de Populeto Cist. O.
Terraconen. dioc.
Cum a nobis
Anagnie XVIII Kl. Dec. a° 5°
Bulle und Seide fehlen
Ecke oben rechts

2909

P. vacat

Archives Nationales Paris
L 253 n. 223 1259 Novembris 26

Br. 61.5 hoch 66.5 Plica 4
oberer Rand 7.7 links 3.9
rechts 3.5 mit je 2 Seidenlinien

Alexander IIII G maiusculae. der
Anfang in Gitterschrift mit 6 ♁ verziert
(verschnörkelt) (ohne Punkte oder
Lücke) Priori domus de Vallevirids
Parisien. Cartusien ordinis eiusque fra-
tribus IN ...

Religiosam vitam eligentibus
inveniunt AMEN ω—c

R ʃ go Alexander catholice M
ecclie eps
A in Alex. gross und verziert

2 preb. 1 eps 4 diac.

Dat Anagnie per manum Magri Jor-
dani sancte Romane ecclie Notarii
7 Vicecancellarij VI kl decembris se-
cundum Incarnationis dominice
Anno m° CC L VIII Pontificatus vero
domni ALEXANDRI pp IIII Anno quinto

Bulle fehlt, keine Seide erhalten.
Rand oben Mitte: Innovetur ad instar
J. vic. daneben links: ♁ ad instar
se. re. Alex pp IIII pred. nri
A tergo oben Mitte: Cartusiani

2910

P.— Paris Arch. nat.
L. 253 cap. 223 1259 Nov. 26

Alex. IIII priori domus de Vallevi-
ridi Parisien. Cartusien Ord.

Religiosam vitam eligentibus
Dat. Anagnie p. m. magistri
Jordani SRE notarii et vicecan-
cellarii VI kl. Dec. a° 5°.

Bulle fehlt. Seide erhalten.
Auf dem Rand oben:
fiat ad instar J vic
und : ♁ ad instar se. re. Alex.
pp. IIII pred. nri

vicecancellarius

Vergl. Von der Apost. Kanzlei, p. 78

2911

Madrid Arch.-Histor. Nacional
Coruña Monferro E 3
P.— 1259 Novembris 27

Alexander IIII . . abbi et conv.
mon. Montis ferri Cisterc.
Compostellan. dioc.
Cum sicut asserentis
Anagnie V kl. Dec. a° 5° ?
Bulle fehlt. Seide erhalten.
In plica rechts f. romien

2912

Instr. mon. F. Om. c. 106 1259 Dec. 5
P. 17721
Alex. IIII .. mag. et fratribus ord. Predic.
Inspirationis divine gratie
Anagnie non. Decembris a° 5°
Bulla an Seidenfäden.
In plica rechts : pro g. m. B. p. m.
A tergo : predicatorum

Bernardus Parm. cf. 1259
Jan. 31
Scriptor : Benjaminus subdia-
conus Parmensis
1259 februarii 18 cap. 5413

2913 (recto)

Genova Archivio di Stato
Abazia di S. Stefano 1523

1259 Decembris 18

Alexander IIII Fredentio abbati
monasterii Sci Stephani Janu-
en. OSB
 Licet e a que
Anagnie XV Kl. Januar. a° 5°
 Bulle liegt bei. Seide erhalten

In plica rechts ber

Inserirt Urkunde Ottoboni S. Adria-
ni diaconi card. 1259 Dec. 12
Zeugen: Mag. Mattheus de Salerno
dei gpe capell. Johannes Leca-
corvus can. Heneentin. et mag.
Uctilio de Comite prepos. S. Laurem-
tii Mediolanen. Capellani cardi-
nalis subdiaci. Actum Anagnie

Erste Zeile frei
gestreckte Ligaturen verso

2913 (verso)

Johanne Lecacorvo steht in
der Bulle. mithin ist der Nomi-
natio Lecacorvus.

2914

Paris Archives Nationales
 J 687 n. 94 bis
Breite 29.1 Rand links 1.6 rechts 7.6
Höhe 21.2 Rand oben 3.9 plica 3.3
 Erste Linie für Gitterschr. und
Oberlängen / Je eine Unterlinie
P. vacat 1260 Januarii 3
Alexander IIII (Gitterschr.) Carmo
in xpo filio . . Regi Francie Illustri
Dat Anagnie II Non Januar. a° 6°
Bulle an feiner Seide
In plica rechts : . . D.
 Sub plica links : S
 Ro
 S
Rand oben Mitte : L
A tergo oben Mitte : Riganet
Ungemein zierliche kleine feine
 Schrift

2915

Poitiers Archives departem
La Trinité
P. —
 1260 Januarii 8
Alexander IIII .. decano .. ar-
chidiacono et magro Raomp-
nulfo Andree canonicis Engolis-
men.
Conquesta est nobis
Anagnie VI id. Jan. a° 6°
Bulle und Hanf fehlen
In plica rechts p. Ro
Kleines schon geschriebenes
 Mandat

Paris Archives Nationales
J 690 n. 132
Breite 31.2 Rand links 1.6 rechts 1.4
Höhe 22.8 Rand oben 4.4 plica 3.1
Erste Linie für Gitterschrift und Oberlängen / Je eine Seitenlinie
P. vacat 1260 Januarii 9
Alexander IIII (Gitterschrift) Car-
mo in xpo filio .. Regi Francie
Illustri
Ex parte tua
Dat Anagnie V Id Januarii
a° 6°
Bulle an Seide
In plica rechts: Ge Ra
A tergo oben Mitte: Rigonetus
Kleine gotische stumpfe Schrift

Paris Archives Nationales
J 689 n. 129³
Breite 36.4 Rand links 4.8 rechts 2.1
Höhe 25.7 Rand oben 6.3 plica 4.9
Erste Linie für Gitterschrift und Oberlängen / Je eine Seitenlinie
P. vacat 1260 Januarii 10
Alexander IIII (Gitterschrift) Carmo
in xpo filio . L. Illustri Regi
Francie
Solet annuere sedes
Dat Anagnie IIII Id Januarii / a° 6°
Bulle an feiner Seide
In plica rechts : R. Gual
Sub plica links : ... Ro
Rand oben Mitte : L ... verte

A tergo oben Mitte :
 Rigonet)
Sehr schöne feste kleine Schrift

Instr. Mon. F. Dom. c. 130 1260 Jan. 13
 P. 17757
Alex III .. mag. et fratribus ord. Predic.
Petitio vestra nobis —
Anagnie Id Januarii a° 6°
Bulle an Hanfschnur
In plica rechts: G. M.
A tergo: predicatorum

2919

Instr. mon. F. Om. c. 57 1260 Jan. 21

P. 17761

Alex III .. inquis. her. prov. in Lombar-
dia et Marchia Iannuen.
Olim contra nobilem.
Anagnie XII Kal. Febr. a° 6°
Bulle an Aufrehmer.
In plica rechts: de Curia
J. A.

2920

P. 17782 1260 Ianuarii 31
Paris Archives Nationales
J 447 n. 54
Breite 29.7 Rand links 1,2 rechts 1.3
Höhe 33.7 Randoben 4.8 plica 3.9
Erste Linie für Oberlängen
Je eine Seitenlinie
Dat Anagnie / II Kl Februarz a° 6°
Bulle an Hanf
In plica rechts: Jacobus de Mevania
A tergo oben Mitte: Rigonetus
Fehr deutliche Schrift

Alexander IIII Archiepis et Epis et
alijs ecclear Prelatis per Regnum
Francie constitutis
Ex parte Carissimi

2921

Firenze, R° Augusto Ricci
P. 17790 1260 Februarii 16
Alexander IIII fratri Mansue-
to de ordine Minorum ca-
pellano et penitenciario
nostro
Dilecti filii .. prior
Anagnie XIIII Kl. Marcii a° 6°.
Bulle und Hanf fehlen
In plica rechts: J. V.

2922

Instr. Misc. 1250-1275 cap. 16
R — 1260 Martii 5
Alex III .. archepo Caxellen
Intellecto quod olim
Anagnie III non. Martii a° 6°
Bulle und Hanf fehlen
In plica rechts: A de Varen (?)

2923

Instr. Mon. F. om. C 152 1260 Martii 6

P 17802

Alex. IV .. mag. prioribus et fratribus
ord. Pred.

Meritis religionis vestre

Anagnie II non. Martii a° 6°

Bulle an Seidenfäden

In plica rechts: Q. Jual
 pro. Lu. d

Sub plica links abgeklenscht : ..

In plica links: Rec Q de Set pnt.

de Set ausgestrichen und darüber:

P m

Auf der plica zwei Zusätze zum Text
1) patriarche archiepi epi legati et
subdelegati ac prelati etc.
2) vel in posterum concedendi

Duplicat

cap. 109

Bulle und Seide fehlen

In plica rechts: Anret.

A tergo : predicatorum

2924

Instr. Misc. 1250 - 1275 cap. 17

P. — 1260 Martii 7

Alex. III mag. Johanni de Frisinon.
subdiacono et capellano nostro

Cum te ad

Anagnie non. Martii a° 6°

Bulle und Hanf fehlen

In plica rechts : at p

2925

Archives Nationales Paris
L 253 n. 228 1260 Martii 15

Br. 29,4 hoch 23. Plica 2,5
oberer Rand 6,6 links 1,6
rechts 1,5

Alexander III .. Abbati et Con-
ventui Monasterij sancti Germani
de Pratis Parisien ordinis sancti Bene-
dicti ad Romā ecclam nullo medio-
pertinentis

Monasterij vestri ac
Dat Anagnie id Martij a° 6°

Bulle und Seide fehlen

In plica rechts: Iacobs de Menania

A tergo oben links
 Gaufridus dns pp penitenciar
 Gotifridus

Starr eckige Schrift – menbroy – mit
zierl. Ligaturen, mit 3 verschiedene
konten Strichanfängen

In 1. Zeile ein ver. Buchstabe

Erste Linie für Gitterschrift und
 Oberlängen

P. vacat

2926

Instr. Misc. 1250 -1275 cap. 18

P — 1260 febr. 14 – Mart. 31

Alex. III mag. Johanni de Frisinono
subdiacono et capellano nostro

Expecta in apostolice

Anagnie Martii a° 6°

Bulle und Hanf fehlen

fleckig und zerfressen

P. vacat

Archives Nationales Paris
L 253 n. 230 *1260 Aprilis 12*
Br. 33.2 hoch 24,8 Plica 3,6
oberer Rand 5.5 links 1.
rechts 0.8
Alexander IIII - - Archiepo Remen
et eius Suffraganeis ac dil. filijs
Vicarijs et Officialibus eorundem
Credens dudum felicis
Dat Anagnie ij Id Aprilis a° 6°
Bulle an Hanf
Sub plica links : Jn plica rechts : Ja. Nri

\overline{Z} $\overset{..}{Ro}$

Raud oben Mitte cor
cor

Ecke oben rechts : Ma
A tergo Ecke oben links : J
n oben Mitte R de
Eckige Schrift
mit einem betonten Buchstaben
Erste Linie für Oberlingen
Papstname im Text nicht in Gitterschr

Firenze Camaldoli
P. 17835 *1260 Aprilis 20*
Alexander IIII - . priori et con-
ventui Heremi Camaldulen.
Vestre meritis religionis
Anagnie XII kl. Maii a° 6°
Jn plica rechts . Ja. ar.
Sub plica links $\overset{ty}{Ro}$
Rand oben hulblinks ζ
Rand oben Mitte cor

Bayer. Haupt. Staatsarchiv
Weihenstephan fasc. 1
P. vacat . *1260 Aprilis 24*
Alexander IIII (roman. Maii) e. s. s.
Dei dil. filijs .. Abbati Monasterij
Sci Stephanj in Weihensteinen eius
que fribus tam pres. quam fut. relig.
uitam professis JN PPM
Religiosam uitam eligentibus
pacis conueniant AMEN M a— AMEN
R. Ego Alexander Cath. ecclie Eps SS M
2 presb. 2 epi 3 diaconi
Dat. Anagnie per manum Magri Jor-
danj sancte Roman Ecclie Notarij
et Vicecancellarij VIII kl. Maij Jnd.
Ia Jnc. dominice Anno M° CC° LX
pontif. uero domni ALEXANDRO (Git-
terschrift) pp. IIII Anno Sexto
Bulle an Seide
Ecke oben rechts : a und YB A.
A tergo Ecke oben links : A.
Gitterschrift kräftig mit mässig
grossen Oberlängen ; Unterlängen
nur angedeutet.
Kleine regelmässige Schrift

Instr. Mon. F. Dom. c. 4 *1260 Apr. 30*
P. 17845
Alex. IIII fratribus ord. Predic. inquisitori-
bus heretice prauitatis in terris subjec-
tis dominio carissimi in Christo filij
nri .. regis Francie illustris deputa-
tis ab aplica sede.
Super eo quod —
Anagnie ij kal. Maii a° 6°
Bulle an Hanfschnur
Jn plica rechts : 20 Anaje de Curia
A tergo : Predictorum

Instr. mon. F. dom. c. 55 1260 Aprilis 30

P. 17846

Alex. IIII .. episcopo Legionen.

Petitio dilectorum filiorum

Anagnie II Kal. Maii a° 6°

Ausfochener. Bulle fehlt.

In plica rechts: Jacobus de Meirania

 pro magistro Alexandro

In plica Mitte: ⸗ errato. In Text

scV ⸗ ipsa ⸗ etiam

A tergo: predicatorum

Paris Archives Nationales

 J 690 n 131

Breite 27.7 Rand links 1.3 rechts 1.3

Höhe 21.8 Rand oben 5.3 plica 3.3

Erste Linie für Gitterschr. und

Oberlängen / Je eine Seitenlinie

P. vacat **1260 aprilis 30**

Alexander IIII (Gitterschrift) Dilecte

in Xpo filie nobili mulieri Ali

Comitisse Burgundie Palatin.

 Deuotionis tue precibus

Dat Anagnie / II Kl. Maij a° 6°

Bulle an feiner Seide

 In plica rechts : Maths

A tergo oben Mitte : Humilibus Dej

Kleine regelm.

Schrift

Archivio di Stato Milano

Bolle e Brevi

 P. 17847 1260 Maii 4

Alexander IIII univ. xpi fide

libus de congregatione beate vir

ginis ac de societate seu scho

la fidelium Mediolanen. pre

sentibus et futuris

 De studio pie

Anagnie IIII non. Maii a° 6°

 Bulle und Seide fehlen

In plica rechts

 de Cur

Ecke oben links B R

Nîmes, Archives Départem.

G. 1319

P. — 1260 Maii 7

Alexander IIII .. preposito et ca

pitulo ecclie Nemausen. Ostendit

 Illa vobis libenter

Anagnie non. Maii a° 6°

Bulle und Seide fehlen

In plica rechts Bar

Rand oben links

 sub nomine dni ut

renouetur ad tactum ry

 ^

Durchgestrichen und überge

schrieben

2935

Madrid Arch. Histór. General
XX Sahagun 1545
P.— 1260 Maii 7
Alexander IIII . . abbi et conv.
monast. S. Facundi ad Roman
Eccliam nullo medio perti-
nentis OSB Legionen. dioc.
Desideriis vestris in
Anagnie non. Maii a° 6°
Bulleiner Süd fehlen
In plica rechts Maths cap
Sub plica links .:.
　　　　3 Ro Ligaturen
　1547　　　　gemischt
Duplicat ohne alle
　Notizen, nur Com
　putor rechnung wie
　oben

2936

Archives Nationales Paris
L 253 n. 231 1260 Maii 11
Br. 32. hoch 24.8 Plica 2.5
　obere Rand 6.1 links 1.6
rechts 1.7
　Alexander IIII . . Abbati et
Benedicti Floracen Aurelianen
dioc
　　　Ad audientiam nram
Dat Anagnie V Jd Junii a° 6°
Bulle an Hanf
　　　In plica rechts : Ay . oy
Sub plica links : ..
　　　　z Ro

Kleine weite Schrift
　mit einem betonten Buchstaben
Erste Linie für Oberlängen

P. vacat

2937

Firenze, Camaldoli
P. 17867 1260 Maii 20
Alexander IIII . . epo Aretin.
　Referentibus nobis dilectis
Anagnie XIII kl. Jun. a° 6°
　Bulle fehlt, Hanf erhalten
In plica rechts Maths. cap.
　　　　s Ja. met
Sub plica links ..
　　　　y Ro
Breite Seitenränder
die beiden ersten Linien unbe-
schrieben
　Prachtvolle Schrift

2938

Firenze, Camaldoli
P. 17868 1260 Maii 20
Alexander IIII . . priori Heremi
Camaldulen. ad Rom. Eccl.
nullo medio pertinentis Are-
tin. dioc.
　Petitis tuis nobis
Anagnie XIII kl. Junii a° 6°
　In plica rechts Maths cap
Sub pl. links (s Ja met
　　y Ro Bulle nebst Sei
Rand oben mitte de fehlen
　│ p tinere dicitur
　│ Rf M. a. corrige
daneben S

2939

Bayer. Haupt-Staatsarchiv
Kl. Roth a/Inn fasc. 5

P. 77871 1260 Maii 23

Alexander III. . . de Obenperch et
. . de Etel abbatibus Frisingen.
dioc. Dilecti filij . . Abbas
Anagnie X Kl. Junij anno Sexto

Bulle fehlt, Hanf erhalten
In plica rechts: G(?) de Wartini
A tergo Ecke oben links: A

Kleines Mandat 16.7 × 12.7
plica 4.2

Enge flotte Schrift
Erste Zeile beschrieben
Seitenlinie nur links

2940

Firenze, Badia Fiorentina
P.— 1260 Maii 28

Alexander III. . . abbi mon.
Sce Salvii ord. Vallis Um-
brose Florentin. dioc.
 Conquesti sunt nobis
Anagnie V Kl. Jun. a° 6°

Bulle und Hanf fehlen
In plica rechts Jac Romanus
Ecke oben rechts Ma
Oberste Linie beschrieben
Sub plica um liniirt
13. 4 hoch, wovon 1.6 plica
14.2 breit
Seitenränder 0.6 breit
12 Zeilen zierlichster Schrift

2941

Archives Nationales Paris
L 253 n. 235 1260 Junii 9

Br. 31.7 hoch 21.8 Plica 3.9
Obere Rand 4.9 links 1.3
rechts 1.3
 Alexander III. . . decano Kuefor-
den Ordenis dudum felicis
bei Anagnie V Jd Junij a° 60

Bulle an Hanf
 In plica rechts J. . a
 Sub plica links
Rand oben links : dupl
A tergo Ecke oben links :

Ganz kleine fette Schrift

 Mit einem betonten Buchstaben
Ohne freie erste Linie
Papstname im Text nicht in Gitter-
schrift

n n. 236, 237, 238, 239
 genau gleich, nur an andere
Empfänger

P. vacat

2942

Bayer. Haupt-Staatsarchiv
Steingaden fasc. 9

P. orcat 1260 Junii 9

Alexander III. . decanus eccle Cu-
tien.
 Conquesti sunt nobis
Anagnie V Jd. Junij anno Sexto

Ausgezeichnet geprägte Bulle an
Hanf
In plica rechts : p. Angl.
Ecke oben rechts : Ma

Sub plica ausradirter zweizeiliger
Bullenaufzug.

2943

Madrid Arch. Histór. Nacional
Dominicos Huesca 9 E
P.— Arabische Bezeichnung
Alexander IIII 1260 Junii 18
.. epo Cesaraugustan. et ..
sacriste et magistro Guillel
mo de Jerun canonico secu
laris ecclie de Tutela Tyra
zonen. diöc.
Querelam dilectorum filiorum
Anagnie XIIII Kl. Julii aº 6º
Bulle fehlt. Hanf erhalten.

Initiale nicht ganz schöner
In plica rechts R plaï

2944

Madrid Arch. Histór. Nacional
Dominicos Huesca 10 E
P.— 1260 Junii 18
Alexander IIII -- abbi et con
ventui monasterii de Bero
la Cistörc. Tyrasonen. diöc.
Querelam dilectorum filiorum
Anagnie XIIII Kl. Julii aº 6º
Bulle und Hanf fehlen
In plica rechts a a a

Hier ist die Initiale ganz
schöner. Cf. supra

2945

Bayer. Haupt- Staatsarchiv
Memmingen Hospital fasc. 1
P. oncat 1260 Junii 23
Alexander IIII (rom. Mai.) e. s. s. Dü
dil filijs .. Magro Hospitalis
in Sadin de Vrbe eiusque fribus
etc. In DPM
 Inter opera pietatis
prcis inueniunt AMEN a AMEN

R. Ego Alexander cath. ecclie epo SS M
2 presb. 2 epi 4 discon
Dat. Anagnie per manum Magri Jordani
sce Rom. ecclie Notrij et vicecancel
larij VIII Kl. Julij Ind. III Inc. dnice
auno Mº CCLX pont. uero dormi
ALEXANDRI pp. IIII anno Sexto

Bulle an seinen Seide
In plica rechts : at. für
Eine Seitenlinie, eine Linie für Gitter
schrift; für Oberlängen Reime.

Dünne, regelmäßige mittelgroße Gitter
schrift mit mittelgroßen Oberlängen
mit angedeuteten Verzierungen!
Sehr schöne kleine Schrift
Papstnamen im text in Gitterschrift

2946

Bayer. Haupt- Staatsarchiv
Kl. Steingaden fasc. 9
P. oncat. 1260 Junii 27
Alexander IIII (Gitterschrift) .. Prepo,
sito et Conuentui Monasterij de
Steingaden Premonstraten. ordinis
augustani. diöc.
 Cum a nobis
Anagnie V Kl. Julij Anno Sexto

Bulle an Seide
In plica links : Rº.

Erste Zeile frei. Seitenlinien.
Kleine sehr schöne Schrift
Dilectis' und Capitelanfänge betont

2947

Wilten I I
P. 17909 1260 Julii 1
Alexander IIII .. abbati mon.
Wiltinen. eiusque fratribus
Arm. etc. in ppm
 Religiosam vitam eligen.
 tibus
inveniant Amen ⸺ Amen
R Ego Alexander catholice
 ecclie eps SS (M)
2 presb. 2 epi 4 diac
Dat. Anagnie per manus
magri Jordani SRE vicec.
et notarii Kl. Julii indict. I
Inc. dce a° M. cc. lx pont.
vero domni ALLXAUDII pp IIII
anno sexto
In plica rechts hₜ ? lo ̃ bₜ

2948

Bayer. Haupt. Staatsarchiv
Kl. Schönthal fasc. 2
P. orcat 1260 Julii 5
Alexander IIII (Gitterschrift) .. Priori
et fratribus Heremitis Herene vallis
Spetiose ordinis sci Guillermi Ratis-
bonen. dioc.
 Meritis nostre religionis
Anagnie III non. julii anno sexto
 Bulle an Seide
 In plica rechts : Jo. S.
Sub plica links : ∴
 E F
 7
Rand oben Mitte : L und Epo
A tergo Ecke oben links J.
Oberer Rand breit. Erste Zeile mit
Seitenlinien

2949

Instr. mon. F. dom. c. 66 1260 Julii 5
 P. 17911
Alex. IIII mag. Raynerio de Viterbio
capellano nostro rectori patrimo
nii beati Petri in Tuscia
Bone memorie .. Suanen
Anagnie III non. Julii a° 6°
Bulle an Hanfschnur
In plica rechts : Ja. mr.
Sub plica links : TEₑ Jℱ
 7
A tergo : predicatorum

2950

Instr. misc. 1250 - 1275 cap. 19
 P. — 1260 Julii 13
Alex. IIII .. electo narbonen.
Lecta coram nobis
Anagnie III iv. Julii a° 6°
Bulle und Hauf fehlen
In plica rechts : R Plat

A tergo : | Epo Magalonen. |

2951

Instr. misc. 1250 - 1275 cap. 15

P. — 4260 Augusti 13

Alex. .. abbati et conventui mo-
nasterii de Palaziolis Cistercien.
ordinis Albanen. dioc.

Cum a nobis

Sublaci id. Augusti a° 6°

Bulle und Seide fehlen

In plica rechts: p.

Sub plica links: xv

A tergo: de Palaziolis

2952

Coblenz Staatsarchiv
Domcapitel

P. — 1260 Sept. 7

Alex. IIII capitulo Treverensi

Cum dilectus filius

Sublaci III id. Sept. a° 6°

Bulle an Seide

In plica rechts A. g.

In plica von links nach rechts

Rc Guill. I darunter

Rec b. p. g. as., rechts von
der Seite tangens ordinier.
Befehl, endlich ganz rechts
weiterer Kanzlei befehl

A tergo oben Mitte

homo † consimilis scripta

 est

2953

Instr. mon. F. dom. c 59 1260 oct. 7

 P. 17950

Alex. IV fratribus ord. Bede. inquisito-
ribus heretice pravitatis in Lombar-
dia et Marchia Jannen.

firmissime teneat prudentia

Anagnie non. Octobris a° sexto.

Bulle an Hanfschnur.

In plica rechts: de Curia

 Jac. Anag

A tergo: fratris Raynerii predica-
 torum

2954

Instr. mon. F. dom. c 87 1260 Oct. 9

 P. 17951 rep.
 15731

Alex. IIII fratribus Predicatoribus inqui-
sitoribus prav. heretice in Lombardia
et Marchia Jannen.

Cupientes ut inquisitionis

Anagnie III id. Octobris a° 6°

Bulle an Hanfschnur.

In plica links: BV de Curia

A tergo: predicatorum und von
anderer Hand: fratris Raynerii

2955

Coblenz Staatsarchiv
Domcapitel
P. — 1260 October 17
Alex. IIII capitulo Treveren.
Cum dilectus filius
Anagnie XVI Kl. Nov. a° 6°
Bulle an Seide hat aus
zinnen
In plica rechts: L. p. C vergl.
1260 Sept. 7 woselbst der Be-
fehl zur Ingrossierung hiphis
an den Schreiber L. p.
vom Distributor G. ar.

2956

Instr. Mon. F. Dom. c 89 1260 Nov. 17
P. 17966
Alex. IIII .. priori S. Martini de Gua-
zolongo Pisan: et .. preposito eccle-
sie de Casulis Wulterran. dioc.
Exhibita nobis dilectorum
Laterani XV Kl. Decembris a° 6°
Bulle an Hanfschnur.
In plica rechts: B. pu
pro maio Tho Anron
A tergo: predicatorum

2957

Instr. Mon. F. Dom. c. 24 1260 nov. 27
P. 17977
Alex. IV fratri Reinerio de Placentia
et aliis fratribus ord. Bed. inquisito-
ribus heretice pravitatis in provincia
Lombardie et marchia Janue.
Ad audientiam nostram. —
Laterani V Kl. decembris anno 6°
Bulle an Hanfschnur
In plica rechts: B. P.
In plica links: Ista non est con-
cessa; si videtur super hoc sit ali-
quid faciendum, novam petitionem
domino pape legendam L. fiat.
Rand oben halblinks:
fiat due consimiles de Curia
Rt G. y
A tergo: frater Reinerius predca-
torum

2958

Firenze, SS. Annunziata
di Firenze
P. 17980 1260 Decembris 1
Alexander IIII .. priori et fribus
Servorum sancte Marie Senen-
oshug.
prestre merito religionis
Laterani Kl. Dec. a° 6°
Bulle fehlt, Seide erhalten
In plica rechts: Lu. d
Sub plica links
Rand oben mitte L

Instr. mon. S. Dom. c. 104 1260 Dec. 2
P. 17984
Alex. IIII .. priori provinciali fratrum Pred.
in Lombardia.
Cum super negotio
Laterani III non. decembris a° 6°
Unterschrift. Bulle fehlt.
Rand nichts oben:
R/ quitto et fiant due de curia

Firenze Strozziane bigweciani
Notariat 1260 Decembris 4
Alexander IIII Donato nato quon-
dam magistri Guidonis hasi
de Florentia laico
Quia si ius
Lateran. ☩ non. dec. a° 6°
 Bulle an Seide
In plica rechts: C. La.
Ecke oben links] P. 17155
A tergo dizzem mittelgross oben

Quia si ius
Rursus ne contra tenorem
huius est quod
nulli ergo omnino
Si quis autem

ad predicta Officia
ad que primi expetis
y Mens

CXXXVIII cepto anno sesto

Archivio di Stato Milano
Bolle e Brevi
P.— 1260 Decembris 8
Alexander IIII .. priorissae et con-
ventui ecclie S. Marie in Ho-
pitali S. Laurentii extra por-
tam Ticinii O. S. Aug. Mediola-
nen. dioc.
Necessitatibus vestris benignus
Lateran. VI id. Dec. a° 6°
Bulle fehlt. Seide erhalten
Sub plica links

Firenze S. Donato in Pol.
verosa
P.— 1260. Decembris 15
Alexander IIII .. epo Fesulan
et .. abbi mon. sce Marie et
.. priori sci Salvatoris ord.
Camaldulen. Florentin.
Conqueste sunt nobis
Lateran. XVIII Kl. Jan. a° 6°
Bulle und Rauf fehlen
In plica rechts scriptor
Ecke oben rechts
13. 7 hoch, wovon 2. plica
16. 1 breit, 13 Zeilen Zwi-
schen Schrift.

Firenze, Camaldoli
 P. 17994 1260 Decembris 18
Alexander IIII . . priori de conventu Aretini Camaldulen.
ac univ. abbibus, abbatissis,
prioribus, priorissis, fratribus et
sororibus Camaldulen. ordinis
ad Roman. Eccl. nullo medio
pertinentibus
Devotionis vestre precibus
Lateran. XV Kl. Jan. a° 6°
 In plica rechts A b c
 Bulle und Seide fehlen
 Erste Linie frei
 Sub plica halb unliniirt

Firenze, Camaldoli
 P. 17995 1260 Decembris 22
Alexander IIII . . preposito
ecclie Fesulan.
Querelam dilectorum fili
 orum
Lateran. XI Kl. Jan. a° 7°
 Bulle fehlt, Hanf erhalten
In plica rechts . A . a .
 Sub plica links
Rand oben Mitte
Erste Linie beschrieben

Firenze, Camaldoli
 P. 17996 1260 Decembris 23
Alexander IIII . . plebano ple
bis de Biblena Aretin. dioc.
 Significarunt nobis dilecti
Lateran. X Kl. Januarii a° 7°
 Bulle fehlt, Hanf erhalten
In plica rechts . a . g .
 Sub plica links . . .

Rand oben Mitte cor und
Ecke oben rechts
 Oberste Linie beschrieben
Sub plica halb liniirt

Archivio di Stato Milano
 Bolle e Brevi Punkte
 P. 17997 1260 Decembris 23
Alexander IIII univ. archepisc
epis et dil. filiis . . abbatibus, p
oribus decan. prepos. archidiac.
archipresb. plebanis et aliis
eccles. prelatis ad quos littere
iste pervenerint
 De dilecti filii
Lateran. X Kl. Jan. a° 7°
Runde, regelmässige Bulle an Hanf
In plica links de Cur. und
Nepot. r. de Cur. in continenta
Rand oben Mitte duplicetur

2967

Genova Archivio di Stato
n. g. 1523

1260 Decembris 28

Alexander IIII capitulo ecclesie
Januen.
 Ea que iudicis . a° 7°
Lateran. V kl. Jan . a° 7°
 Bulle und Seide fehlen

Ohne Schreibernamen

Erste Zeile frei
Gestreckte Ligaturen

Grosse Urkunde . in der Mitte
glatt durchgeschnitten

2968

Carcassonne , Archives Départem.
H . 318

P. 18002 1261 Januarii 3

Alexander IIII mag . et fribus ord.
Jerm Predicatorum
 Pium est es
Lateran. III non . Jan . a° 7°
 Bulle fehlt. Seide erhalten
In plica rechts Bo Parmen. pro ac.

Erste Zeile frei
Seitenränder klein, Linien
Gestreckte Ligaturen
Sehr schöne Schrift.

2969

Toulouse, Archives Départem.
H. 23

P. — 1261 Januarii 3

Alexander IIII.. magro et fratribus
Hospitalis Jerosolimitan.
 Sacrosancte religionis
Lateran. III id. Jan . a° 7°
 Bulle und Seide fehlen
Ohne alle notizen
Gestreckte Ligaturen
Erste Zeile frei.

2970

Instr. Mon. F. Dom. c. 93 1261 Jan. 3
 P. 18002

Alex III .. mag. et fratribus ord. fr. Pred.
Pium est et -
Lateran. III non. Jan. a° 7°
In plica rechts Nemaus.
Bulle fehlt. Seidenfäden.
Lefranen, wasserfleckig
 f. 1265 maii 5

 1265 maii 31

2971

Instr. Mon. F. Dom. c. 158 1261 febr. 4
 P. 18026
Alex. IIII .. episcopo Constantien
Sua nobis dilecti
Laterani II non. februarii a° 7°
Bulle an Hanfschnur
In plica rechts : M. P.
Rand oben links : dupl
a tergo Predictorum

2972

Firenze, Vallombrosa
 P. 18057 1261 februarii 25
Alexander IIII .. abbi et con-
ventui mon. vallis Umbrose
ad Rom. Eccl. nullo medio
pertinentis Fesulan. dioc.
 Petitio vestra nobis
Lateran. V Kl. Martii a° 7°
 Bulle und Seide fehlen
In plica rechts Jo de Camp.
Sub plica links V
 B pm
Rand oben mitte

 Grau ungewöhnliches
 Kursformat
 54. 7 breit
 30. 1 hoch
 4. 6 plica

2973

Firenze, Vallombrosa
 P. 18052 1261 februarii 25
Alexander IIII . . Vulteran. electo
 Petitio dilectorum filiorum
Lateran. V Kl. Martii a° 7°
 Bulle und Hanf fehlen
In plica rechts f.
 Oberste Linie beschrieben
Sub plica halb unliniirt
 Prachtvolle feste runde
Schrift

2974

Firenze, Vallombrosa
 P. 18073 1261 Martii 23
Alexander IIII .. priori Sancti
Salvatoris Camuldulen.
Florentin.
 Intellecto dudum quod
Lateran. X Kl. Apr. a° 7°
 Bulle und Hanf fehlen
In plica rechts pl R
Rand oben mitte cor
 Oberste Linie frei
Sub plica unliniirt

2975

Bayer. Haupt- Staatsarchiv
Gars F. ad 1

P. 18088* 1261 Aprilis 8

Alexander III (etwas rasierte top. Mai)
e. s. s. dei dil. filijs .. preposito Mo-
nasterij in Gars eiusque fratribus tam
present. quam futuris regul. vitam
professis IN PEM

Religiosam vitam eligentibus
pacis inveniant AMEN bene AMEN

R. Ego Alexander cath. ecclie eps M
2. pbri. 2 epi 2 diaconi

Dat. Laterani, per manum Magri Jordani
sancte Romane ecclie Notarij et Vice-
cancellarij VJ Jd. Aprilis Ind. II Incarn.
dominice Anno Mills. cc lxj pontif.
vero domni ALEXANDRJ pp IIII anno
septimo

Bulle an Seide
In plica rechts : .. a a a
Jede hübliche Gitterschrift mit kleinen
Oberlängen und kleinen Unterlängen, für
Oberlängen keine Linie.
Je zwei Seitenlinien

2976

Instr. mon. F. Dm. c. 33 1261 Apr. 10
P. 18089 rep.

Alex. III .. mag. et universis prioribus
ac vices priorum gerentibus ord. pre-
dicatorum Predic.

Licet ad hoc.
Laterani III iV. aprilis anno 7°
Bulle an Seidenfäden.

Sub plica links : ..
J Matheus Cap N. Riet

Oben und Mitte : Innovetur prout
in cedula . von anderen Hand.
Petitur renovari

2977

Instr. mon. F. Dm. c. 75 1261 Apr. 10
P 18090

Alex. IV .. mag. et fratribus ord. Predic.
Cum a nobis —
Laterani III iV. aprilis anno 7°
Seidenfäden. Bulle fehlt.
In plica rechts : g. me

2978

Barcelona Corona de Aragón
Leg. 14° u. 7°
P. — 1261 Aprilis 12

Alexander IIII .. abbati Sci
Petri de Gallicantu Gerunden.
.. priori Sci Michaelis de Fal-
lis Barchinonen. dioc. et Petro
Arberti canonico Barchinonen.
Cum olim in
Laterani II iV. Apr. a° 7°
Bulle fehlt. Hanf erhalten
In plica rechts Jo. dic
Sub plica links Bp u

Nîmes Archives départem.
G. 1319

P. — 1261 Mai 7

Alexander III .. abb. Sendraca
et .. priori S. Baudilii OSB
Nemausen. dioc.
 Cum nobis dilectus
Viterbii non. Maii a° 7°
 Bulle und Hanf fehlen
 In plica rechts Rob. Je

Archivio di Stato Milano
Bolle e Brevi
 Unbullirtes feierl. Privileg

Alexander III d. in xpo filiabus
abbatisse mon. S. M. et S. Apoli-
naris extra Portam Romanam
Mediolanen. eiusque etc. in ppm.
 Religiosam vitam eligentibus
inveniunt Amen et Amen
 R Ego Alexander catholice
 Ecclie Epo SS M
Unbullirt, ohne plica, im
Text unterwartet.
Das Datum ganz ausradirt.

Karlsruhe gr. Bad. Gen. Landesarch.
Select der Papsturk. Cap. 254
fehlt in der letzten Zeile XXXX — (1261?)
 des Papstes
Alexander III abbat monast
rii de Godesowe eiusque ...
 in ppm.
Religiosam vitam eligentibus
Amen Amen Amen
(R) Ego Alexander etc. (M)
Drei Reihen (unvollendet) von
Unterschriften
Datum, plica, Besiegelung
fehlen
Rund oben halblinks und halb
 rechts auscultetur
Über der vorletzten Textkeile
 unten durchgeschnitten
 Unvollendetes Original

1897

Nachfolger Urban IV hat dem
eine neue Urkunde ausge-
fertigt.
Die unvollendte fällt also
in die letzten Lebenstage
Alexanders IV. Die Bezeich-
nung „Fragment" auf
dem Karlsruher Urstücklag
ist darum falsch
Unterschriften:
2 Priester, 2 Bischöfe
1 Diakon
Auf der neuen von Urban
 2. 2. 3.

2982

Firenze, S. Donato in Pol.
versa

P. — 1261 Octobris 10

Urbanus IIII Peregrine suc
centrici mon . sci Cerbanii
Cist . ord . Lucan. dioc.
Attendentes dudum dilecta
apud Urbemveterem II id.
octobr. a° 1°

Bulle und Hanffaden

Sub plica links m p

Ecke oben links duplic

2983

Firenze, S. Ambrogio di
Firenze

P. — 1261 Octobris 26

Urbanus IIII . . abbatisse et
conventui mon . sancti Am
brosii extra muros civitatis
Florentin. OSB

Ut eo libentius
Viterbii VII. kl. nov. a° 1°
Bulle und Seide fehlen
In plica rechts . G . m.
oberste Zeile frei
Sub plica ganz liniirt

Brüchtige und Schrift

2984

Public Record Office London
Papal Bulls bundle 33 n. 3
P. 18 148 1261 Novembris 12
Urbanus IIII regi Anglorum illustri
Pre ceteris rebus
Viterbii II id. nov. a° 1°
Bulle an Hanf
in plica rechts p.Bo.
In plica links
Rx Symon . Reat
I pro ser proven (?)
Ecke oben links .L.
rechts

2985

Paris Archives Nationales
J 685 n. 54
Breite 32.7 Rand links $1.5 rechts 1.6
Höhe 23.5 Rand oben 5. plica 9. 6
Ohne erste freie Linie / Je eine
Seitenlinie
P. 18155 1261 Novembris 20
Urbanus IIII (Maj) Carmo in xpo
filio . . Regi Francie Illustri
Et si firmi
dat Viterbij XII kl decembr /
a° 1°
Bulle an feiner Seide
In plica rechts : F
Sub plica links : B fm

Ecke oben links : Rx
fette kleine strumpfe Schrift

Ŗ

Paris Archives nationales
J 684 n. 40
Breite 32. Rand links 1.5 rechts 1.5
Höhe 25.3 Rand oben 5. plica 2.2
Ohne erste freie Linie / Je eine
Seitenlinie
P. 18156 1261 Novembris 21
Vrbanus IIII (Mj) Carmo in xpo
filio . . Regi Francie Jllustri
 Personam tuam fili
Dat Viterbij XI Kl decembᵣ a° 1°
Bulle an feiner Seide
In plica rechts : F
 Sub plica links : Bᵖm
Ecke oben links : R

 veste

A tergo oben Mitte große Schrift
mit dickem Stab !

[sept] Cap. LXI.

Ŗ

Kleine schöne fette Schrift

2987

Archives nationales Paris
L 254 n. 1 1261 Novembris 21
Br. 29.2 hoch 22.5 plica 2.1
 oberer Rand 6.2 links 1.4
rechts 1.4
 Urbanus IIII (Gitterschrift
Initiale verziert) Carissimo in xpo
filio . . Regi Francie Jllustri
Dat Viterbij XI Kl decembᵣ a° 1°
Bulle an feiner Seide : Jac
 In plica rechts : A Romanus
A tergo oben Mitte : de ---
 pro Rege
Kleine sehr schöne Schrift, mit
geordneten Ligaturen, mit zwei betonten
Unterlängen
Erste Linie für Gitterschrift und
 Oberlängen

 P. vacat

2988

Paris Archives nationales
 J 447 n. 58
Breite 21.5 Rand links 1. rechts 1.
Höhe 17.3 Rand oben 3.9 plica 3.
Erste Linie über Oberlängen
Je eine Seitenlinie
P. vacat 1261 Novembris 24
Vrbanus IIII .. Archiepo Tyren
Devotionis tue precibus
Dat Viterbij | VIII Kl decembᵣ a° 1°
Bulle an dickem Hanf
A tergo oben Mitte : Archiepus Tyren
Schriftvolle kleine Schrift

2989

Barcelona Corona de Aragón
P. — Leg. 15° h= 1°
1261 Novembris 26
Urbanus IIII . . Epo Cesar-
augustano.
Pervenit ad audentiam
Viterbii VI Kl. Dec. a° 1°
Bulle an Hanf
In plica rechts Jacobs de Me
urina
Sub plica links Bpn

Ecke oben rechts bo

2990

Marseille Archives Départem.
H. O. J. 6
P. — _1261 Novembris 29_
Urbanus IIII .. magistro et fratri-
bus domus Militie Templi Jeros
Justis petentium desideriis
Viterbii III Kl. Dec. a° 1°
Bulle fehlt, Seide erhalten
In plica rechts al p
Erste Zeile frei, Seitenlinien
Zierliche Schrift
Schöne gestreckte Ligaturen

2991

Karlsruhe Gr Bad Gen Landesarchiv
Selek der Papsturk. cap. 200
P. — _1261 Decembris 2_
Urbanus IIII abbati monaste-
rii de Goddesowe eiusque in-
li perp.
Religiosam vitam eligentibus
Capitels anfänge betont
Amen Amen Amen
(R) Ego Urbanus (M)
Drei Reihen (2. 2. 3) hintereinander
M. Viterbii per manum magistri
Jordani SRE notarii et vice
cancellarii IIII non- Dec. a° 1°
Bulle an Seide
Ecke oben rechts bo

2992

Arch. Arcis
Arm. IX Caps. 7 cap. 3 21/51
P. 18180 _1261 Dec. 7_
Urb. IIII .. cancellario eccle Dui
colnien.
Dilecti filii Rogeri
Viterbii VII id. Dec. a° 1°
Bulle an Hanffschnur
A tergo oben Mitte !
Acontistus

2993

Paris Archives Nationales
J 447 n. 60
Breite 22.5 Rand links 1.3 rechts 1.3
Höhe 16.6 Rand oben 3.5 plica 3.2
Erste Linie über Oberlängen /
Je eine Seitenlinie
P. vacat 1261 Decembris 12
Vrbanus IIII Egidio Archiepo Tyren
In multis sed
Dat Viterbij / II Jd Decembr a° 1°
Bulle an Hanf
In plica links : B. fit
Rand oben Mitte : L
A tergo Ecke oben links : |
Mitte : .. Archiepo Tyren
Eilige kleine Schrift

2994

⟨datum⟩

Paris Archives Nationales
J 457 n. 2
Breite 24.2 Rand links 1.3 rechts 1.3
Höhe 19.1 Rand oben 3.9 plica 2.8
Erste Linie für Gitterschr. und
betonten Buchstaben / Je 1 Seitenl.
P. vacat 1261 Decembris 12
Vrbanus IIII (Gitterschr) Egidio
Archiepo Tyren
Denotionis tue probata
Dat / Viterbij II Jd Decembr a° 1°
Bulle an feiner Seide
In plica links : B. fit
Sub plica links : B pm
A tergo oben Mitte : F
Archiepo Tyren
Etwas flüchtige, aber klare Schrift

2995

Paris Archives Nationales
J. 457 n. 2 bis
Breite 27. Rand links 1.6 rechts 1.6
Höhe 21. Rand oben 4.3 plica 2.7
Erste Linie für Gitterschr. und Oberlängen /
Je eine Seitenlinie
P. vacat 1261 Decembris 12
Vrbanus IIII (Gitterschr) Egidio Ar-
chiepo Tyren
Denotionis tue probata
Dat Viterbij II Jd Decembr /
a° 1°
Bulle an feiner Seide
In plica rechts : F. a.
A tergo oben Mitte : Archiepo Tyren
Deutliche weite Schrift

2996

Napoli Curia Eccles. vol. 4°
P. 18186 1261 Decembris 13
Vrbanus IIII [ohne Punkte]
preceptoribus et fribus Hoospit.
Sce Marie Theuton. presentes
litteras inspecturis
Canonica constitutione cavetur
Viterbii II. Dec. a° 1°
Bulle und Hanf fehlen
plica abgeschnitten

2997

Bayer. Hpt. Staatsarchiv
Freising Hochstift fasc. 9

P. 18189 1261 Decembris 18

Vrbanus IIII . . de Tyrhaupt Augusten
et . . de Schiven . frisingen. dioc.
Abbatibus
Ex parte venerabilis
Viterbij XV Kl. Januarii Anno Primo

Bulle an dickem Hanf
In plica rechts : Jo. S.

40 Zeiliges Mandat G. 3 × 15.7
 plica 2.9

Verhältnismässig breite Ränder,
dickeres Mandat.

2998 (recto)

Datum R.

Paris Archives Nationales
 J 685 n. 60
Breite 44.8 Rand links 1.9 rechts 1.8
Höhe 30.9 Rand oben 6.5 plica 2.1
Thut erste freie Linie / Je eine
Luftenlinie

P. 18190 1261 Decembris 20
Vrbanus IIII (Maj) nobili viro
Philippo primogenito Carni
in Xpo filij nostri . . Regis Fran
cie Jllustris
 Exulta proles Regia
Dat/ Viterbij XIII Kl Januar,
a° 1°
Bulle an Seide vate
In plica rechts : F
Sub plica links : ,, B Pm

2998 (verso)

a tergo oben Mitte :
 G. de Harecourt pro Rege

 [pi] Cap° XX VIII

Kleine fette sehr schöne Schrift

2999

Archives Nationales Paris
L 254 n. 2 1261 Decembris 21
Br. 23.2 hoch 17. Plica 3.5
 oberer Rand 3.7 links 1.3
rechts 1.1
 Vrbanus IIII . . Abbati f[ü]
Benedti Floriacen Aurelianen dioc
Dat Viterbij XII Kl Januar a° 1°
Bulle an dickem Hanf
 In plica rechts : . J . S
Sub plica links : 5
 BPm
Ecke oben rechts : So
Unruhige getrennte Schrift
Mit einem betonten Buchstaben
Erste Linie für Oberlingen

 P. 18194

Paris Archives Nationales
J 431 n. 34
Breite 57.2 Rand links 2.1 rechts 2.1
Höhe 41.5 Rand oben 6.7 plica 3
Erste Linie für Oberlängen / Je
eine Seitenlinie
P. vacat 1261 Decembris 23
Vrbanus IIII . . priori fratrum
Predicatorum Parisien
Pre cunctis vre
Dat Viterbij X Kl Jannar /
anno 1°
Bulle an Hanf
In plica rechts: Jac Romanus
A tergo oben Mitte:
. G. de Herecourt pro Rege
Kleine prachtvolle Schrift

Archives nationales Paris
L 254 n. 3 1261 Decembris 23
Br. 34.9 hoch 24.9 Plica 2.4
oberer Rand 5.5 links 1.8
rechts 1.8
Vrbanus IIII . . Abbti Monas
terij sancti Dionisij in Francia Pa-
risien dioc Cum sicut ex
dat Viterbij X Kl Jannar a° 1°
Bulle an Hanf
In plica rechts: Jac Romanus
Sehr feine kleine Schrift
mit einem betonten Buchstaben
Erste freie Linie zwecklos

cf. P. 18193

Paris Archives Nationales
J 686 n. 79
Breite 37.3 Rand links 1.6 rechts 1.6
Höhe 29.4 Rand oben 7.5 plica 3.3
Erste Linie für Gitterschr und
Kleine Oberlängen / Je eine
Seitenlinie
P. 18196 1261 Decembris 27
Vrbanus IIII (Gitterschr) Cum
in Xpo filio . . Jllustri Regi
Francor
Serenitatis Regie nota
dat Viterbij VI Kl Jannar /
a° 1°
Bulle an seiner seide
In plica rechts: Jac Ment
A tergo oben mitte: pro Rege zzz

Archives nationales Paris
L 254 n. 4 1262 Januarii 13
Br. 23.8 hoch 18.8 Plica 3.4
oberer Rand 4.1 links 1.2
rechts 1.3
Vrbanus IIII . . Abbti Monas
terij sancti Dionisij in Francia
Parisien dioc ad Romanam
ecclam nullo medio pertinentis
ordinis sancti Benedicti
Religio tua meretur
Dat Viterbij Jd Jannar a° 1°
Bulle an dickem Hanf
In plica rechts: D. p.
Sehr nachlässige Schrift
Ohne jeden betonten Buchstaben
Erste Linie für Oberlängen

P. 18216

3004

Archives Nationales Paris
L 254 n. 5 1262 Januarii 13
Br. 24. hoch 18.5 Plica 2.2
oberer Rand 3.5 links 1.2
rechts 1.1
Urbanus IIII (Gitterschrift,
Initiale verziert) . . abbati et
Conventui Monasterij sancti
Dyonisij in Francia Parisiens dioc
ad Romanam Ecclesiam nullo medio
pertinentis ordinis sancti Benedicti
Dat Viterbij Id Januarr a° 10
 Sacrosancta Romana Ecclesia

Bulle an feiner Seide
 In plica links : B. 8.
Rand oben mitte :
 Ecke oben rechts : bo
A tergo oben mitte : g. Talliao

Kleine regelm. Schrift, mit gestreck.
ligaturen, mit 4 verzierten Satz-
anfängen
 In 1. Zeile 1 verz. Buchstabe

Erste Linie für Gitterschrift und
 Oberlängen

P. 18215

3005

beati Dyonisii
Archives nationales Paris
L 254 n. 6 1262 Januarii 13
Br. 24.5 hoch 20.5 Plica 3.1
oberer Rand 3.5 links 1.
rechts 1.3
Urbanus IIII (Gitterschrift,
Initiale verziert) . . Abbati et
Conventui Monasterij beati Dyo-
nisij in Francia ad Romanam Ecclesiam
nullo medio pertinentis ordinis
sancti Benedicti Parisiens dioc
Dat Viterbij Id Januarr a° 10
 Cum a nobis

Bulle an Seide
 In plica links : . B. 8.
Rand oben mitte :
 Ecke oben rechts :

A tergo oben mitte : g. Talliao

Kleine fette Schrift mit gestreck.
Ligaturen, mit vier verzierten
Satzanfängen

In 1. Zeile 1 verz. Buchstabe
Erste Linie für Gitterschrift und
 Oberlängen

P. vacat

3006

Instr. mon. F. dom. c. 73 1262 Jan. 13
P. 18213
Urb. IIII . . msg. , prioribus et universis
fratribus ord. Predic.
Qui ex apostolici
Viterbii iv. Januarii a° 10
Bulle an Seidenfäden.
In plica rechts : A. S. porter (?)
Sub plica links : . .
 Bf
 A. Sete Potentiane

3007

Archives Nationales Paris
L 254 n. 7 1262 Januarii 18
Br. 29. hoch 22.4 Plica 3.1
oberer Rand 5.2 links 1.2
rechts 1.2
Urbanus IIII (minuscules)
dil. in xpo filiabus . . Abbatisse
et Conventui monasterij de Tanar.
chijs Cisterciens ordinis Ninionien
dioc
 Cum a nobis
Dat Viterbij XV Kl februarr a° 10
Bulle und Seide fehlen
 In plica rechts : g. di Mote
Sub plica links : . .
 Bf
 Ecke oben rechts : bo

Sehr eckige unschöne Schrift mit
gestreck. Ligaturen , mit 4 verzierten
Satzanfängen
 In 1. Zeile 1 verz. Buchstabe
Erste Linie für Papstnamen

P. vacat

3008

Madrid Arch. Histor. Nacional
Huesca Santa Cristina C 176

P. — *vicecancellarius*
1262 Januarii 20

Urbanus IIII : abbi monast. S.
Marie de Gloria eiusque fribus
etc. in ppm

Religiosam vitam eligentibus
veniant Amen. A. A.
(R.) Ego Vrb. C. D. Epo es (M)
2 presb. 2 epi 4 diac.
Dat. Viterbii p. m. magri Jordani
SRE notarii et vicecancellarii
XIII Kl. febr. ind. ... Inc. Dce
anno m. CC. l. XI pont. vero domni
VRBANI pp IIII anno primo
Bulle fehlt. Seide erhalten.
In plica rechts nur Ecke oben
rechts unleserlich

3009

Archives Nationales Paris
L 254 n. 8 1262 Januarii 20

Br. 24.8 hoch 18.2 Plica 1.7
oberer Rand 5.1 links 1.3
rechts 1.3
Urbanus IIII (Übeleitung
von Gitterschr in Minuskel). . Ab-
bati et conventui monasterij sci
Dionisij in Francia ad Romanam
ecclesiam nullo medio pertinentis ordi-
nis sancti Benedicti Parisien dioc
Devotionis vestre precibus
Dat Viterbij XIII Kl februarij a° 1°

Bulle an Seide
In plica rechts : . p. . . .
Rand oben Mitte : vor
Ecke oben rechts : $\frac{k}{60}$

Kleine ungenaue Schrift, mit
gestreck. Ligaturen, mit 3 var
Satzanfängen

In 1. Zeile 1 var. Buchstabe
Erste Linie für Papstname nur
überlängen

P. 18219

3010

Archives Nationales Paris
L 254 n. 8 bis 1262 Januarii 20

Br. 25.8 hoch 19.5 Plica 2.8
oberer Rand 5.2 links 1.2
rechts 1.3
Urbanus IIII (Übergangsschrift
Minuskel). . Abbati e Conventui
monasterij sancti Dyonisij in
Francia ad Roman Ecclesiam nullo
medio pertinentis ordinis sancti
Benedicti Parisien dioc
Devotionis vestre precibus
Dat Viterbij XIII Kl Februarij a° 1°

Bulle an feiner Seide
In plica rechts : A. G.
A tergo oben Mitte : Sancty Dyonisius

Kleine fette Schrift, mit gestreck.
Ligaturen, mit 3 versierten Satz-
anfängen.
In 1. Zeile 1 var Buchstabe
Erste Linie für Papstname nur
untere Überlängen

P. 18219

3011

Archives Nationales Paris
L 254 n. 9 1262 Januarii 21

Br. 28.f hoch 21.4 Plica 3
oberer Rand 4.4 links 1.1
rechts 1.2
Urbanus IIII (Gitterschrift
Initiale versiert). . Abbati Cis-
tercij eiusque coabbatibus e Con-
ventibus Vniuersis Cisterciensis
ordinis
Cum a nobis
Dat Viterbij XII Kl februarij a° 1°

Bulle fehlt. Seide erhalten.
In plica rechts : P. B
Sub plica links : Jac. mut.
Ecke oben rechts : a
A tergo Ecke oben links : J
" oben Mitte : Cists ord
Kleine fette Schrift, mit gestr.
Ligaturen, mit vier # versierten
Satzanfängen
In 1. Zeile 1 var Buchstabe
Erste Linie für Gitterschrift

P. vacat

3012

Madrid Arch. histór. nacional
Dominicos Huesca. 11 G
P. — 1262 Januarii 28
Vrbanus IIII .. abbi et conuen
tui monast. de Berola Cisto.
Tyrasonen. dioc.
Querelam dilectorum filiorum
Viterbii V Kl. febr. aº 1º
Bulle an Hanf
In plica rechts J. A.
Rand oben Mitte cor
Ecke oben rechts Rp

3013

Madrid Arch. Histór. Nacional
Dominicos Huesca 12 G
P. — 1262 Januarii 28
Vrbanus IIII .. epo Cesaraugus
tan. et .. decano Tyrasonen.
ac .. sacriste secularis ecclie
Tutelan. Tyrasonen. dioc.
Querelam dilectorum filiorum
Viterbii V kl. febr. aº 1º
Bulle und Hanf fehlen
In plica rechts J. A.
Ecke oben rechts Rp

3014

Bayer. Haupt. Staatsarchiv
Kl. Vleon fasc. 5
P. 18223 1262 Januarii 31
Vrbanus IIII .. abbati monasterij
de Roth Frisingen. dioc.
Dilecti filij .. abbas
Viterbij VI kl. februarii anno Primo

Bulle an dickem Hanf
An plica rechts: Schreibername
Ecke oben rechti: bo
A tergo Ecke oben links:)

Kleines mandat 45.8 × 40.9
 ~~16.0~~ × ~~41.4~~
 plica ~~4.4~~ 0.6

Erste Zeile beschrieben.
Nur links Leitwörmel
Leicht nach links neigende Schrift.

3015

Archives nationales Paris
L 254 u.10 1262 Februarii 6
Br. 52.7 hoch 22 Plica 3.1
 oberer Rand 4.9 links 1.9
rechts 1.7
 Vrbanus IIII (Übergangsschrift)
.. magro Z fratribus militie Templi
Jerlimiten
 Cunctis denocium diuino
dat Vitabij VIII JD Februarij aº 1º
Bulle an feiner Seide
A tergo oben mitte : C

Starr eckige, aber deutliche Schrift,
mit geratr. Ligaturen, mit 3 ver-
zierten Vokaufangen

In 1. Zeile zwei verz. Buchstaben
Erste Linie für Papstnamen und
 Oberlängen
Papstname im Text u Gitterschrift

P. vacat

3016

Archives Nationales Paris
L 254 n. 10 bis — **1262 Februarii 6**
Br. 33.2 hoch 22 Plica 2.3
oberer Rand 5.6 links 1.5
rechts 1.5
Urbanus IIII (Übergangsschrift)
wie n. 10
Bulle an Seide
Schöne klare feste Schrift
Ohne erste freie Linie
Papstname im Text in Gitterschrift

P. vacat

3017

Archives Nationales Paris
L 254 n. 11 — **1262 Februarii 13**
Br. 28.7 hoch 22.8 Plica 3.8
oberer Rand 4.4 links 1.
rechts 1.
Urbanus IIII - - Preposito
ecctie Ambianen
Ad notam noueris
Dat Viterbij Jd Februarii a° 1°
Bulle an Hauf
In plica rechts : Jat Ja..
Sub plica links : - -
Rx f
A tergo oben mitte grosses +
weite runde offene Schrift
mit einem betonten Buchstaben
Erste Linie für Oberlängen

P. vacat

3018

Archives Nationales Paris
L 254 n. 13 — **1262 Februarii 20**
Br. 23 hoch 18.7 Plica 2.5
oberer Rand 4.7 links 1.4
rechts 1.4
Urbanus IIII (Übergangsschrift)
uniuersis Ministris et fratribus
ordinis sancte Trinitatis et Capti
uorum
Volet annuere sedes
Dat Viterbij X Kl Marcij a° 1°
Bulle und Seide fehlen
In plica rechts : .g. Sabin.
Rand oben mitte :
Rx Jac B fiat una
A tergo oben mitte :
Soe Trinitatis Ceptinox
Eckige Schrift, mit gebr. Ligaturen
(mit einer Ausnahme), mit vier
verzierten Satzanfängen
In 1. Zeile 1 vers. Buchstabe
Erste Linie für Papstname und
untere Oberlängen

P. vacat fiat una

3019

Instr. misc. 1250-1275 csp. 20 n. 95
P — 1262 Febr. 23
Urb. IIII .. abbti monasterii sete
Marie Farphen quod situm est ä loco
qui dicitur etc.
Cum pro ecclesiis
R unterschrift M
2 presb. 1 epus 4 diar
Vterbii per manum mag Iordani SR.
E. viccancellarii et notarii IIII Kl.
Martii ind V Inc. dom. a° M°CC°LXI
Pont. vero domni VVRANI pp IIII a° 1°
Bulle und Seide fehlen

3020

Archives Nationales Paris
L 254 n.14 1262 februarii 27

Br. 22.9 hoch 18.6 Plica 2.1
oberer Rand 4.2 links 0.8
rechts 0.7
Urbanus IIII .. Priori Sci Ma.
gloriosi Parisien
Ad audientiam nostram
Dat Viterbij III kl martij a° 1°

Bulle an Hanf
In plica rechts: a. d.
Sub plica links: --

Ecke oben rechts: bo
A tergo oben mitte:
Consepes de Ass

Sehr kleine enge Schrift

Mit einem betonten Buchstaben
Erste Linie für Oberlängen

P. vacat

3021

Bayer. Haupt- Staatsarchiv
Regensburg St. Emmeram fasc. 9
P. 78237 1262 Martii 1

Urbanus IIII .. abbati Monasterij
Prumiensis Ratisponen. dioc.
Conquesti sunt nobis
Viterbij kl. Martij anno Primo

Bulle an Hanf
In plica rechts: report
A tergo oben Ecke links: R

Erste Zeile beschrieben, ohne Zeilen
linien
fette, leicht nach links geneigte
ungelenke Schrift
Kleines Mandat 15.2 × 13
plica: 1.6

3022

Archives Nationales Paris
L 254 n.15 1262 Martii 11

Br. 27.6 hoch 22.8 Plica 4
oberer Rand 5.4 links und
rechts ohne erkennbare Linien 1.2, 1.
Urbanus IIII (Übergangsschrift)
.. Abbati et Conventui Monasterij
sancti Germani de Pratis Parisien
ad Romanam Ecclesiam nullo medio
pertinentis ordinis sancti Benedicti
Cum a nobis
Dat Viterbij V id Martij a° 1°

Bulle fehlt, Seide erhalten
Rand oben mitte:
Renovetur
R+ Jac B
non po... ista
a tergo oben Mitte : Scus Germani
umgekehrt links :
R. Roman Jac Alex
Schöne feste Schrift, mit gestreckten
Ligaturen, mit 4 betonten Verlängerungen

In 1. Zeile ein betonter Buchstabe
Erste Linie für Repetnamen und untere
Oberlängen

P. vacat Renovetur

3023

Archives Nationales Paris
L 254 n.16 1262 Martii 12

Br. 25.1 hoch 18.7 Plica 2.6
oberer Rand 4.9 links 1.1
rechts 1.
Urbanus IIII .. Abbati Sci Germ.
nesse Parisien
Sua nobis dilecti
Dat Viterbij III id Martij a° 1°

Bulle fehlt. Hanf erhalten
In plica rechts: Jacob de menania
R+ Jacob duplicetur
A tergo oben mitte: Sos Germanus

Kleine klare Schrift

Mit einem leicht betonten Buchstaben
Erste Linie für Oberlängen

P. vacat duplicetur

Firenze, Cestello
P.— 1262 Martii 13
Urbanus IIII . . abbi et conven.
sui mon. de Septimo Cist.
ord. florentin. dioc.
 Cum a nobis
Viterbii III id. Martii a° 1°
 Bulle fehlt, Seide erhalten
Sub plica links B.p
 Ecke oben rechts +

Archives Nationales Paris
L254 n.17 1262 Martii 15
Br. 26.3 hoch 22.9 Plica 2.9
 oberer Rand 4.4 links 0.8
rechts 0.7
 Urbanus IIII . . Decans ecclie
Huefonsten
 Pervenit ad audientiam
Dat Viterbij id martij a° 1°
Bulle an Hanf
 In plica rechts : Aud. T.
A tergo oben mitte : G. Talhat.
 " mitte :
iste littere constant III ß libr II sol. mi-
 nus

Kleine klare Schrift
 mit 1 betonten Buchstaben
Erste Linie für Oberlängen

Taxen P. 18278

Archives Nationales Paris
L254 n.18 1262 Martii 16
Br. 28.9 hoch 22.1 Plica 2.9
 oberer Rand 5.2 links 1.4
rechts 1.4
 Urbanus IIII (Übergangsschrift)
° Priori z fratribus Hospitalis
Jerlimitani in Francia
 Cum a nobis
Dat Viterbij XVIj kl aprilis a° 1°
Bulle und Seide ausgerissen
 Sub plica links : ..
Ecke oben rechts : bo
A tergo Ecke oben links : ⌉
 " oben mitte grosses +
Nachlässige kleine fette Schrift, mit ge-
streckten Ligaturen, mit + verzierten
Schwänzen
 In 1. Zeile 1 var. Buchstabe
Erste Linie für Aspirierme und Ober-
 längen

P. vacat

Archivio di Stato Milano
Bolle e Brevi
P. 18256 1262 Martii 23
Urbanus IIII . . priori provincia
li fratr. O.Ped. in Lombardia
Licet ex omnibus
Viterbii X kl. aprilis a° 1°
Bulle und Hanf fehlen
In plica rechts 0
 Sub plica links :
Rx O. Land et semitte mich
ad tranendum . / P. Read.
Rand oben Innovetur

3028

Firenze, S. Croce di Firenze
de Curia 1262 Martii 23
Urbanus IIII .. ministro provin-
ciali fratrum ord. Minorum in
administratione Tuscie
Licet ex omnibus
Viterbii X kl. Apr. a° 1°
Bulle an Hanf
In plica rechts Jac Jud
— de Cur

P.—

3029

Archives Nationales Paris
L 254 n. 19 1262 Martii 23
Br. 20.9 hoch 17.1 Plica 2.2
oberer Rand 3.6 links 0.9
rechts 0.8
Urbanus IIII Archiepis c Epis ad
quos littere iste pervenerint
Dat Viterbij X Kl Aprilis a° 1°
Sicut dilecti filij
Bulle an Hanf
In plica rechts : Ja. Ro.
Ecke oben rechts : a
Nachlässige schlechte Schrift
Ohne jeden betonten Buchstaben
Erste Linie für Oberlängen

Datum : P.× 18256a
Aprilis

3030

Archives Nationales Paris
L 254 n. 20 1262 Martii 23
Br. 32.9 hoch 22.9 Plica 2.3
oberer Rand 5.5 links 1.5
rechts 1.5
Urbanus IIII (Gitterschrift, dm Fä..
la anstehd .. Matro c fratribus do-
mus Hospitalis beate Marie Lau-
dunen.
Exigentibus nestre devotionis
Dat Viterbij X Kl Aprilis a° 1°
Bulle und Seide fehlen
In plica rechts : . f. a.
A tergo oben Mitte :
Ancherus nepos pape
Sehr weite geschwungene runde Schrift
mit gestr. Ligaturen, mit vier
betonten Satzanfänger
In 1. Zeile 1 betonter Buchstabe
Erste Linie für Gitterschrift und Ober-
längen

Ancherus nepos pp.

P. vacat

3031

Archives Nationales Paris
L 254 n. 20 bis 1262 Martii 23
Br. 35.2 hoch 23.9 Plica 2.8
oberer Rand 5.8 links 1.9
rechts 1.8
Urbanus IIII (Gitterschrift, Zu
Seite) ausgespart)
Alles wie in n. 20
Bulle fehlt, Seide erhalten
A tergo oben Mitte :
Ancherus nepos pape

Ancherus nepos papae

P. vacat

Archives Nationales Paris
L 254 n. 21 **1262 Martii 23**

Br. 30. hoch 22.4 Plica 2.4
oberer Rand 4.9 links 1.4
rechts 1.4
Urbanus IIII (Gitterschrift Initiale
ausgespart) .. Decano C Capitulo
Laudunen
Devotionis vestre precibus
Dat Viterbij X Kl Aprilis a° 10

Bulle und Seide fehlen
A tergo oben Mitte :
Ancherus nepos pape

Kleine ordentliche Schrift mit gert.
Ligaturen mit 2 betonten Satz-
anfängen
In 1. Zeile 2 betonte Buchstaben
Erste Linie für Gitterschrift und
Oberlängen

P. vacat

Ancherus nepos papae

Instr. Mon. F. Dom. c. 92 4262 Mart 23
P. 18256

Urb. IIII . priori provinciali fratrum
ord. Predic. in Lombardia.
Licet ex omnibus –
Viterbii X Kl. Aprilis a° 1°
Bulle an Hanfschnur
Sub plica links :
Matts cap Pacis de Curia
Rand oben links :
Innocentius .– petent
.... de Cur. M

Bayer. Haupt- Staatsarchiv
Regensburg St. Emmeram fasc. 9
P. 78261 4262 Martii 30
Urbanus IIII .. Abbati de Bruninigen
Ratisponen. dioc.
Pium esse dinoscitur
Viterbij III Kl. Aprilis Anno Primo

Bulle an starker Hanf.
In plica rechts ! -f- R
Ecke oben rechts : bo

Unterlängen Schlus-m und n :
Kleine, schöne, klare Schrift

Archives Nationales
J 447 n. 55
Breite 45.8 Rand links 0.9 rechts 1.2
Höhe 32.2 Rand oben 5.1 plica 3.5
Erste Linie über Oberlängen /
Je eine Titulinie
P. vacat **1262 Aprilis 18**
Urbanus IIII . . Priori Provincia-
li fratrum Predicator in Francia
Clemat instanter ad
Dat Viterbij XIII Kl Maij a° 10
Bulle an Hanf
A tergo oben Mitte : Pro terra Soa
priori provinciali
÷ fidelib pie Alamanniam
constitutis

Archives nationales Paris
L254 n. 22 **1262 Aprilis 18**

Br. 53. hoch 35.2 Plica 4.
obere Rand 5.2 links 2.4
rechts 2.1

Urbanus III . . Magro ordinis
fratrum predicatorum
Clamat instanter ad
Dat (ohne Viterbij) XIIII kl. maij a° 1°

Bulle fehlt. Hanf erhalten
In plica rechts :. J. a.
pro curia

Alles Andere fehlt

Sehr Kleine Schrift

Mit einem betonten Buchstaben

Erste frei Linie zwecklos

Viterbij fehlt

De Curia

Datum **P. vacat**

Archives nationales Paris
L254 n. 22 bis **1262 Aprilis 18**

Br. 46.8 hoch 36.9 Plica 2.5
obere Rand 6.3 links 1.
rechts 1.1

Urbanus III . . . Priori Provin-
ciali fratrum Predicatorum in Francia
Clamat instanter ad
Dat Viterbij XIIII kl maij a° 1°

Bulle fehlt. Hanf erhalten
In plica rechts : pro Curia
Dat 3 aut

A tergo oben mitte :
pro terra sancta

Kleine klare Schrift

Mit einem betonten Buchstaben

Erste frei Linie zwecklos

P. vacat De Curia

Barcelona Corona de Aragón
Drei Punkte Leg. 150 n. 2°
1262 Aprilis 22
Urbanus III . . Epo Cesarau-
gustan.
Dilecti filii . . . magister
Viterbii X kl. Maii a° 1°
Bulle an Hanf
In plica rechts c. p.
Sub plica links
B. f.
Rand oben mitte
Ecke oben rechts
P.—

Staatsarchiv Wien Klosterneub.
P. 18284 **1262 Aprilis 26**
Urbanus III . . epo Pragen.
Dilecti filii . . prepositus
Viterbii II kl. maii a° 1°
Runde schöne Bulle an Hanf
In plica rechts de cur

3040

innovetur

Archives Nationales Paris
L 254 n. 24 1262 Aprilis 27

Br. 29.2 hoch 21.6 Plica 3.
oberer Rand 5.2 links 1
rechts 1.2

Urbanus III (Gitterschrift, Initiale variiert.) .. Abbati et Conventui Monasterij sancti Germani de Pratis Parisien ad Romanam eccliam nullo medio pertinentis

dat. Viterbij V kl. Maij a° 1°
meritis vestre religionis

Bulle und Seide fehlen

In plica rechts: Jacobs de Me=
umia
Rand oben Mitte: petizstum innovari

A tergo oben Mitte: S° Germanus

Bitte sehr schöne kleine Schrift, mit geschr. Ligaturen, mit 4 variierten Satzanfängen

In n Zeile 1 variierter Buchstabe

Erste Linie für Gitterschrift und
Oberlängen

P. vacat petunt istam
innovari

3041

Archives Nationales Paris
L 254 n. 24 bis 1262 Aprilis 27

Br. 26.4 hoch 18.2 Plica 3.
oberer Rand 4.6 links 1.4
rechts 1.4

Urbanus III
wie in n. 24

Bulle und Seide fehlen
Rand oben Mitte !
R Ja dupplr. n.

A tergo oben Mitte: S° Germanus

Ganz kleine eilige Schrift, mit geschr.
Ligaturen (mit einer Ausnahme)

mit 3 variierten Satzanfängen
In 1. Zeile 1 var. Buchstabe

Erste Linie für Gitterschrift und
Oberlängen

iurisdicionem P. vacat

dupliceter

3042

Madrid Arch. Histór. Nacional
Poblet E n. 95
1262 Aprilis 29

P. —

Urbanus III .. epo Ylerden.

Significarunt nobis carissimus

Viterbii III kl. Maii a° 1°

Bulle fehlt. Hanf erhalten

In plica links !)

3043

Paris Archives Nationales
J. 447 n. 59

Breite 30.7 Rand links 2. rechts 2.
Höhe 22.4 Rand oben 5.9 plica 3.6

Erste Linie für Oberlängen /
Je eine Seitenlinie

P. vacat 1262 Maii 3

Urbanus III . . Archiepo Tyren
dat Viterbij / V Non Maij a° 1°

Bulle an Hanf

A tergo oben Mitte:
Bollandus de Senis
Prachtvolle feste Schrift

Archives nationales Paris
L 254 n. 27 **1262 Maii 8**
Br. 30.5 hoch 22.6 Plica 2.7
 oberer Rand 5.7 links 1.2
rechts 1.6
Urbanus IIII (Gitterschrift, In
teile undeutlich) . . Preceptori et
fratribus domus militie Templi
in Aquitania
Dat Viterbij VIII Jd Maij a° 1°
Bulle an feiner Seide
 In plica rechts, unterseitlich
a tergo oben Mitte : frater Lambertus
Kleine regelm. Schrift, mit gestr.
Ligaturen u. mit 4 verzierten
Satzanfängen
In erster Zeile 1 verz. Buchstabe
Erste Linie für Gitterschrift und
 untere Oberlängen

P. vacat

Archives nationales Paris
L 254 n. 26 **1262 Maii 9**
Br. 31.2 hoch 22.8 Plica 3.7
 oberer Rand 5.4 links 1.5
rechts 1.4
Urbanus IIII (Gitterschrift mit
Oberlängen) .. Abbati et Conventui
 Monasterij sancti Germani
de Pratis Parisien ordinis sancti Bene
dicti ad Romam ecclesiam nullo medio
pertinentis
Dat Viterbij VII Jd Maij a° 1°
Bulle und Seide fehlen
 Rand oben Mitte : ad instar
a tergo oben Mitte :
 Sctus Germanus)
Kleine regelm. Schrift, mit gestr.
Ligaturen, mit 5 verzierten Satz
anfängen
 In 1. Zeile 1 verz. Buchstabe
Erste Linie für Gitterschrift und
 Oberlängen
Papstname in Textlin Gitterschr.

ad instar **P. vacat**

Madrid Arch. Histór. nacional
Moreruela 12 E
 P. 18311 **1262 Maii 11**
Urbanus IIII .. abbati Cisterci
eiusque coabbatibus et conven
tibus universis Cisto
Devotionis augmentum tibi
Viterbii V id. Maii a° 1°
Bulle und Seide fehlen
In plica rechts Jac

Kleine, sehr schwungvolle
runde Schrift.

Neapoli Curia Eccles. vol. 40
p. ~ **1262 Maii 11**
Urbanus IIII . . magro et fri
bus Sancte Marie Theutonico
rum in Prussia
 Ex parte vestra
Viterbii V id. Maii a° 1°
Bulle und Seide fehlen
In plica rechts)

3048

Poitiers Archives départem.
St. Hilaire

P. —
\qquad 1262 Maii 11

Urbanus IIII .. abbi sci Johan
nis Monasterii Novi Pictaven.
OSB

Paterna consideratione pen.
santes

Viterbii V iN. Maii a° 1°
Bulle nur Hanf fehlen
In plica links ſl
Erste Zeile beschrieben
Rand oben cor
Sub plica links S.
(B) — RR

3049

Poitiers Archives départem.
St. Hilaire

Datum
\qquad 1262 Maii 11

Urbanus IIII .. decano et capi.
tuls ecclie sci Ilarii Pictaven.
Paterna consideratione pensantes
Viterbii ſl V iN. Maii a° 1°
Bulle nur Seide fehlen
In plica links ſl
Sub plica links
\qquad BR

Erste Zeile frei

Datum

3050

Instr. misc. 1250 – 1275 cap. 21

P. —
\qquad 1262 Maii 11

Urb. IIII Johanni Perüncto nepoti et
vicario in Campania et Maritima
magistri Iohannis Ecclesie Romane
vicecancellarii et notarii earun
dem Campanie et Maritimeque rec
toris.

Gravis et enormis
Viterbii V iN. Maii a° 1°
Bulle nur Hanf fehlen
In plica rechts a · S · potent
\qquad de curia

a · Ste Potentiane ?

3051

Madrid Arch. Histór. Nacional
Dominicos de S. Pablo Burgen. 32 E

P. —
\qquad pro Cur
\qquad 1262 Maii 15

Urbanus .. priori provinciali
fr̄m Predicatorum in Ispania
Volentes omnes crucesignatos
Viterbii iN. Maii a° 1°
Bulle fehlt. Seide erhalten
In plica rechts Jo de Camp
\qquad pro Cur

Rechts und links kleine Ränder

3052

Madrid Arch. Histór. Nacional
Segovia Huertos 1. 1
P. — 1262 Maii 15
Vrbanus IIII -- epo Segobiensem.
Ad audientiam nostram
Viterbii id. Maii aº 1º
Bulle an Hanf
In plica rechts Bernardus pm̅
Sub plica links --
 S. f

Sehr schmale Ränder links und
rechts. Kleine plica
Schöne Schrift.

3053

Paris Arch. Nat.
J 445 cap. 1 1262 Maii 15
sub IIII -- priori provinciali
fratrum Pred. in Francia
Cum predicationem Crucis
Viterbii id. Maii aº 1º
Bulle an Hanf
In plica rechts: Jac Ind
Sub plica links Bnς
R Anselmus de Curia
 Jaō mut

 cap. 22 XVI Kl. Aug. aº 3º
In plica rechts . a . a . a .
 pro cur̅a

3054

4 In e. modrem
Paris Archives Nationales
 J 445 n. 1
Breite 28.3 Rand links 0.9 rechts 1.
Höhe 23.3 Rand oben 3.9 plica 2.2
Erste Linie für Oberlängen!
Ohne Seitenlinien
cf. P. 18318 1262 Maii 15
Vrbanus IIII .. Priori provinciali
fratrum Praedicatoꝝ in Francia
 Cum predicationem Crucis
Dat. Viterbij Jd Maij / aº 1º
Bulle an Hanf
In plica rechts: Jaō --
Sub plica links : R Anselm̅ de Curia
 Jaō mut
a tergo 4 In e. modrem
und: pro terra Sca
Klare weite Schrift

3055

Archives Nationales Paris
L 254 n. 32 1262 Maii 15
Br. 29.1 hoch 22.4 Plica 2.9
 oberer Rand 4.5 links 1.3
rechts 1.2
Vrbanus IIII .. archidiacon de
Pontius in ecclia ambianen et
Mag̅ro Gerardo de Goignelu cano
nico Remen. Parisius commoran
tibus Sua nobis dilecti
Dat Viterbij Jd maij aº 1º
Bulle an Hanf
 In plica rechts: S. de tigesco (?
a tergo oben mitte: P. de mauro
Kleine feste Schrift
Mit einem betonten Buchstaben
Erste freie Linie zwecklos
P. × 18325

de curia

Paris Archives Nationales
J 447 n. 62

Breite 2?.? Rand links 0.9 rechts 0.8
Höhe 19.3 Rand oben 3.5 plica 2.9
Erste Linie für Oberlängen, je
eine Seitenlinie

P. 18318 **1262 Maii 15**

Urbanus IIII .. Priori provinciali
fratrum Predicatorum in Francia
Cum predicationem crucis
Dat Viterbij ?d Maij / a° 1°
Bulle an Hanf
In plica rechts / Jac ...
 de Cur
Sub plica links : R? Ben Fci de Curia
 Jac amit

A tergo oben rechts : pro terra sca
und d. e. m.

Archives Nationales Paris
L 254 n. 28 **1263 Maii 15**

Br. 24.9 hoch 20.4 Plica 3.8
oberer Rand 4.2 links und
rechts ohne Seitenlinien 0.3, 0.7
 Urbanus IIII .. magro ordinis
fratrum Predicatorum
 Cum tibi super
Dat Viterbij ?d maij a° 1°
Bulle fehlt, Hanf erhalten
 In plica rechts unleserlich
In plica halblinks
 R? Rom de Curia
 ac Mut
 A tergo oben Mitte : pro terra sca
darunter Kanzleibemerkung über weitere
Ausfertigungen
Ganz kleine fette Schrift
Mit 1 betonten Buchstaben
Ohne erste freie Linie

de curia cf. P. 18321

Archives Nationales Paris
L 254 n. 29 **1262 Maii 15**

Br. 27.2 hoch 18.2 Plica 3.
 oberer Rand 4.9 links 0.9
rechts 0.9
 Urbanus IIII .. Priori Provinciali
fratrum Predicatorum in Francia
 Cum tibi super
Dat Viterbij ?d maij a° 1°
Bulle fehlt, Hanf erhalten
 In plica rechts : Jacob de menana
 de Cur
A tergo oben Mitte : pro terra sancta
Ohne jeden betonten Buchstaben
Erste freie Linie zwecklos
Zwischen Text und Plica 1.9 frei
 Raum
Schöne kleine Schrift

de curia cf. P. 18321

Archives Nationales Paris
L 254 n. 29 bis **1262 Maii 15**

Br. 27.9 hoch 19. Plica 3.3
 oberer Rand 4.9 links 1.5
rechts 1.5
 Urbanus IIII
 wie in n. 29
Bulle fehlt, Hanf erhalten
 In plica links : B. fci
A tergo oben Mitte : pro terra sca
Sehr schöne kleine Schrift
 mit einem betonten Buchstaben
Erste freie Linie zwecklos

cf. P. 18321 _de curia_

Archives Nationales Paris
L 254 n. 30 **1262 Maii 15**
Br. 25.7 hoch 18.6 Plica 2.6
 oberer Rand 3.7 links 1.1
rechts 1.2
 Urbanus IIII (Gitterschrift. Dei-
liebe verziert) . . Magro ordinis
fratrum Predicatorum
 Volentes omnes crucesignatos
Dat Viterbij Id Maij a° 1°

Bulle fehlt. Seide erhalten
 In plica rechts: Th. S. de
 cur
In plica halblinks:
 R̊ pas per. de Curia
A tergo oben mitte: pro Terra Sča
Darunter : In e. modum – – – –
Frei Zeilen

Weite regelm. Schrift mit gestreck.
Ligaturen, mit 3 verzierten Sch̄-
anfängen.

In 1. Teile 4 ver. Buchstabe
Erste Linie für Gitterschrift und
 Oberlängen
de Curia P. vacat
I. e. modum

Archives Nationales Paris
L 254 n. 31 **1262 Maii 15**
Br. 54.5 hoch F 40.8 Plica 3.8
 oberer Rand 6.2 links 1.9
rechts 1.8
 Urbanus IIII . . Priori fratrum
Predicatorum provinciali in
 Francia
Dat Viterbij Orta est nobis Id Maij a° 1°

Bulle fehlt, Hanf erhalten
 In plica rechts : ber
Rand oben mitte 2 mal : gon
A tergo oben mitte :
 ⊕ – Ꝑo ⊕
 de Curia
A tergo vier angeordnete Kreuzliche
 merkungen

Kleine enge Schrift
mit drei betonten Schanfängen
Erste freie Linie zwecklos .
hanclat **de Curia**
 P. vacat

Paris Archives Nationales
 J 447 n 57
Breite 20.9 Rand links 0.6 rechts 0.7
Höhe 15.1 Rand oben 3. plica 2.5
Erste Linie für Gitterschr und .
Oberlängen / ohne Seitenlinien
P. vacat **1262 Maii 18**
Urbanus IIII (Gitterschr) Vniuersis
Predicatoribus verbi crucis
pro terre sče Subsidio ac executori-
bus eiusdem crucis
 Volentes labores uros
Dat Viterbij Id Maij a° 1°
Bulle an feiner Seide
Kleine flüchtige Schrift .

Marseille Archives départem.
H. o. m. 21
P. — **1262 Maii 18**
Vrbanus IIII . . priori et fratri-
bus Hospit. Ieros. de prioratu
Sancti Egidii
 Devotionis vestre precibus
Viterbii XV kl Iunii a° 1°
Bulle fehlt, Seide erhalten
In plica rechts mich
Sub plica links. B̈g
Erste Zeile frei
Gestreckte Ligaturen

Paris Archives Nationales
J 447 n. 56
Breite 32.2 Rand links 1.7 rechts 1.9
Höhe 21.2 Rand oben 5. plica 3.2
Erste Linie über den Oberlängen /
Je eine Seitenlinie
P. vacat 1262 Maii 21
Urbanus IIII · · Priori Provinciali
fratrum Predicatorum in Francia
 Cum predicationem Crucis
Dat Viterbij XII Kl Junij / aᵒ 1ᵒ
Bulle an Hanf
In plica links · ... de Cur
Kleine flüchtige Schrift
 de Curia cf. P. 18329/30

Paris Archives Nationales.
J 447 n. 63
Breite 26.4 Rand links 1.3 rechts 1.3
Höhe 19.8 Rand oben 3.5 plica 3.7
Erste Linie hoch über Oberlängen
Je eine Seitenlinie
P. vacat 1262 Maii 21
Urbanus IIII · · Priori provinci
ali fratrum poedicatorum in Francia
 Cum predicationem crucis
Dat Viterbij / XII Kl Junij aᵒ 1ᵒ
Bulle an Hanf
In plica rechts : de Cur ben
A tergo oben Mitte : pro Terra Sᵗᵃ
Sehr zierliche zarte Schrift
 de Curia cf. P. 18329/30

Archives Nationales Paris
L 254 n. 33 1262 Maii 21
Br. 27.9 hoch 21.9 Plica 3.4
oberer Rand 3.5 links 1.2
rechts 1.2
 Urbanus IIII · · Magro or
dinis fratrum Predicatorum
Dat Viterbij XII Kl Junij aᵒ 1ᵒ Cum terra sancta
Bulle fehlt, Hanf erhalten
 Alles Andere fehlt
Mit einem betonten Buchstaben
Erste freie Linie fehlt
 cf. P. 18331

P. 18335 Paris Arch. Nat.
J. 445 cap. 2 1262 Maii 23
Urb IIII ·· priori provinciali
fratrum Predic. in Francia
 Discretioni tue de
Viterbii X Kl. Junii aᵒ 1ᵒ
Bulle an Hanf
In plica links : B Fr ᵒ
Sub plica links Bug :
 R̴ Gerard p de Curia
 Dat mit · M·

 Michael de Tholosa ?

3068

de Curia S. e. modum

Paris Archives Nationales
J 445 n. 3
Breite 21.5 Rand links 1.3 rechts 1.3
Höhe 15.4 Rand oben 2.9 plica 2.4
Erste Linie über den Oberlängen /
Je eine Seitenlinie
P. vacat 1262 Maii 23
Urbanus IIII .. Priori provinciali
fratrum Predicator₂ in Francia
Discretioni tue de
Dat Viterbij ᵡ ꝁl Junij / aº 1º
Bulle au Hauf
In plica links : B. Jac
Sub plica links . R꜀ Gerard . p.
Jac Mut
Daneben : de Curia
verte

3069

A tergo oben Mitte :
Pro Terra Sancta
Darunter : Jn e. modum priori
Provinciali Predictor₂ in Anglia
Kleine sehr schöne Schrift

3070

Archives Nationales Paris
L 254 n. 34 1262 Maii 23
Nov. 22.2 hoch 15.3 Plica 3
oberer Rand 3.7 links 0.9
rechts 0.9
Urbanus IIII .. Magro Ordinis
fratrum Predicatorum
Discretioni tue de
Dat Viterbij ᵡ ꝁl Junij aº 1º
Bulle und Hauf fehlen
Jn plica rechts : . a. s.
Jn plica halblinks
R꜀ Rom de Curia
Jac Mut
A tergo oben mitte :
pro terra Sca
Darunter : Jn e. modum (eine Zeile)
Kleine gezogene Schrift
Mit einem betonten Buchstaben
Erste Linie für Oberlängen
de Curia cf. P. 18335
S. e. modum

3071

P. - Paris Arch. nat.
L 254 cap. 35 1262 Maii 23
Urb IIII .. priori provinciali
fratrum Predic. in Francia
Volumus et presentium
Viterbii ᵡ Kal Junii aº 1º
nachgetragen; andere Tinte
Jn pl rechts : de Curia
Sub plica (Bug) R꜀ Anselm
de Curia Jac Mut
Rand oben mitte
defectiva est in data ; videatis
si potest corrigi vel ᵭ
gratis
wird wohl zu ergänzen sein : vel
gratis rescribatur

Archives Nationales Paris
L 254 n. 35 1262 Maii 23

Br. 26.6 hoch 18.5 Plica 2.8
oberer Rand 3.4 links 0.9
rechts 0.9
Urbanus IIII .. Priori Prouinciali
fratrum Predicatorum in Francia
Volumus et presentium
Dat Viterbij X Kl Junij a° 1°

Bulle und Hanf fehlen
In plica rechts: de Curia
Rand oben Mitte:
defectina ē in dat̄ videatis si potest
corrigi vel ā
Im Datum ist: Viterbij X Kl
Junij mit anderer Tinte nachgetragen

A tergo oben Mitte: pro Terra sancta
Darunter drei Zeilen über frühere
Ausfertigungen

Kleine regelm. Schrift, mit einem
betonten Buchstaben

Ohne erste freie Zeile

Datum ! P. vacat

S. e. modum

Statsarchio Wien Chronol.
P. — 1262 Maii 26
Urbanus IIII Wlodiclao ca
pellano nostro preposito ecclie
Wissegraden. nato quondam
Henrici ducis Sclosie Pragen.
dioc.
Apostolice sedis benignitas
Viterbii VII Kl. Junii a° 1°
Bulle fehlt. Seide erhalten
In plica rechts ✠ totis parmen.
Sub plica links .S.

R⁂

Archives Nationales Paris
L 254 n. 36 1262 Junii 1

Br. 28.2 hoch 18.8 Plica 2.1
oberer Rand 3.8 links 0.8
rechts 0.7
Urbanus IIII -- Priori Prouinciali
fratrum Predicatorum in Francia
Cum terra sancta
Dat Viterbij Kl Junij a° 1°

Bulle und Hanf fehlen
A tergo oben Mitte: pro Terra sca

Sehr liederliche Schrift,

Ohne jeden betonten Buchstaben
Erste freie Linie zwecklos

P. vacat

Archives Nationales Paris
L 254 n. 37 1262 Junii 5

Br. 28.4 hoch 23. Plica 3.3
oberer Rand 4.1 links 1.3
rechts 1.1
Urbanus IIII . . Magro ordinis
fratrum Predicatorum
Cum predicationem Crucis
Dat Viterbij Non Junij a° 1°

Bulle und Hanf fehlen
In plica rechts: Th. S.
A tergo oben Mitte: pro Terra sca
Darunter zwei Zeilen über andere
Ausfertigungen In e. modum
Links oben und unten kleine
Bemerkungen

Sehr schöne regelm. Schrift
mit einem betonten Buchstaben
Erste Linie für Oberlängen

cf. P. 18352

S. e. modum

3076

Archives Nationales Paris
L 254 n. 38 1262 Junii 9

Br. 22.3 hoch 15. Plica 2.4
oberer Rand 3.8 links 0.6
rechts 0.6

Urbanus IIII C Gitterschrift, Ini-
tiale nuanciert und ganz verkratzt

.. Magro ordinis fratrum Predicatorum
Volentes labores tuos
Dat Viterbij V Jd Junij a° 1°

Bulle und Schnur fehlen
In plica rechts: p.o Cur
M p. Astiutz?

In plica halblinks:
R/ l. pa de Curia
Jac mut

Fehr kleine unordentliche Schrift

Ohne jede gestreckte Ligatur

Mit 3 betonten Schriftanfängern
In 1. Zeile 1 betonter Buchstabe

Erste Linie für Oberlängen

groses Durcheinander

de Curia cf. P. 18357

3077

Archives Nationales Paris
L 254 n. 39 1262 Junii 11

Br. 23.5 hoch 17.9 Plica 2.7
oberer Rand 4.2 links 0.7
rechts 0.9

Urbanus IIII .. Magro or-
dinis fratrum Predicatorum
Cum predicationem Crucis
Dat Viterbij II Jd Junij a° 1°

Bulle und Hanf fehlen
In plica rechts: P. Re
de Cur

In plica halblinks:
R/ Rom de Curia
Dat mut

A tergo oben Mitte: pro terra sca
darunter 2 Zeilen: In e. modum

Kleine regelmäßige Schrift

Mit einem betonten Buchstaben

Erste Zeile für Oberlängen

P. vacat de Curia

I. e. modum

3078

Archives Nationales Paris
L 254 n. 40 1262 Junii 11

Br. 24.4 hoch 18.3 Plica 2.6
oberer Rand 4.5 links 0.9
rechts 1.

Urbanus IIII .. Magistro ordinis
fratrum Predicatorum
Cum predicationem crucis
Dat Viterbij II Jd Junij a° 1°

Bulle fehlt, Hanf erhalten
In plica rechts: P. Re
de cur

In plica halblinks:
R/ pax de p. de Cur
Dat mut

A tergo oben Mitte: pro terra sca
darunter zwei Zeilen: In e. modum

Fehr kleine Schrift

Mit einem betonten Buchstaben

Erste Linie für Oberlängen

de Curia

I. e. modum P. vacat

cf. sub data:
1261 iun. 17

3079

Instr. Mon. T. Dom. c. 22 1262 Junii 11

P. 18357

Urb. IIII .. generali ac ceteris prioribus
et fratribus heremitis ord. s. a.

felicis recordationis Alexander
Viterbii III iv. Junii anno 1°

Bulle an Hanfschnur

In plica links: s.
Ober Rand Mitte: R/ p. fiat execu-
toria . I.

A tergo: predicatorum

3080

de Curia [Datum]

Paris Archives Nationales
J. 447 n. 61
Breite 23.5 Rand links 1.1 rechts 1.3
Höhe 15. Rand oben 3. plica 2.5
Erste Linie hoch über Oberlängen.
Je eine Textulinie

P. vacat 1262 Junii 17

Urbanus III . . Priori Provinciæ
li fratrum Predicator in Fran-
cia
 Cum nos predicationem
Dat/ Viterbij XV kl. Julij a° 1°
Bulle an dickem Hanf
In plica links: G. V. de Cur
A tergo oben Mitte: pro terra scā
Fette kleine schöne Schrift

3081

P. — Paris Arch. Nat.
J. 254 cap. 41 1262 Junii 17
Urb III . . . mag. ord. fratrum Ped.
Cum nos predicationem
Viterbii XV kl. Julii a° 1°
Bulle und Hanf fehlen
In plica links: V. V. de Curia
A tergo: pro terra Sancta

 cap. 40 eidem.
Cum predicationem crucis
Viterbii III id. Junii a° 1°
Bulle fehlt, Hanf vorhanden
In pl. rechts: P. Ro
 de Cur
In pl. links: Rf pax de p de turia
 Jac Mut

3082

 Archives Nationales Paris
L 254 n. 41 1262 Junii 17
Br. 22.8 hoch 16.4 plica 2.7
 oberer Rand 3. 8 links 1.1
rechts 1.2
 Urbanus III . . . — Magro ord.
nis fratrum Predicatorum
Dat Viterbij XV kl. Julij a° 1°
 Cum nos predicationem
Bulle und Hanf fehlen
 In plica links : C. V. de Cur
A tergo oben Mitte: pro terra sca
Fette weite Schrift
 Ohne jeden betonten Buchstaben
Erste freie Linie zwecklos

 de Curia P. vacat

3083

Coblenz Staatsarchiv
St. Florin Coblenz
P. — 1262 Junii 22
Urb. III . . cantori et scolast.
co ecclesiæ S. Stephani Mo-
guntin.
Ad audientiam nostram
Viterbii X kl. Julii a° 1°
Bulle an Hanf
Sub plica links Ꝟ ꝶ
Ecke oben rechts ƀ

3084

Madrid Arch. Histor. Nacional
Santo Sepulcro E 13
P. — 1262 Iunii 22
Vrbanus IIII · · priori et fratribus
dominici Sepulcri Ierosoli-
mitani. Osthus.
 Pro re delectabili
Viterbii X Kl. Iulii aº 1º
Bulle fehlt. Seide erhalten

Schmale Ränder rechts und
links

3085

Archives Nationales Paris
L 254 n. 42 1262 Iunii 22
Br. 27.5 hoch 18.6 Plica 2.5
 oberer Rand 4. 5 links und
rechts ohne Seitenlinien 0, 5, 0.6
 Vrbanus IIII · · Magro Ordinis
 fratrum Predicatorum
 volumus et presentium
Dat Viterbij X Kl. Iuly aº 1º
Bulle und Hanf fehlen
 In plica rechts :. a. s.
Schöne kleine etwas eckige Schrift
ohne jeden betonten Buchstaben
Erste Linie für Oberlängen

P. vacat

3086

Madrid. Arch. Histor. Nacional
Santo Sepulcro E 12
P. — 1262 Iunii 30
Vrbanus IIII · · priori et fratribus
dominici Sepulcri Ierosolimi-
tani. Osthus. per yspaniam con-
stitutis
Et si quelibet
Viterbii X Kl. Iulii aº 1º
Bulle fehlt. Seide erhalten
 In plica rechts Scriptor

fingerbreite Ränder rechts
und links

3087

de Curia

Paris Archives Nationales
 J 457 n. 3
Breite 39.5 Rand links 1.5 rechts 1.4
Höhe 29. Rand oben 5.6 plica 3.2
Erste Linie für die höheren Ober-
längen / Je eine Seitenlinie

P. vacat 1262 Iulii 4

Vrbanus IIII · · · Archiepo Brac-
arensi c. . Epo Vlixbonen
 Clamat instruter ad
Dat Viterbij IIII non Iuly aº 1º
Bulle an Hanf
 In plica rechts : Bnardj parm de Cur
Rx Jta a 7 fiunt in mo
ad alios judices
A tergo oben Mitte : pro terra sca
Sehr fette kleine Schrift

3088

P. — Paris Arch. nat.
J 451 cap. 3 **1262 Julii 4**
Urb. III .. archepo Bracaren. et
.. epo Ulisbonen.
Clamat instanter ad
Viterbii IIII non. Julii a° 1°
Bulle an Hanf.
In plica rechts de Cur
 Bernardf parm
 der
Daneben R/ Jar a et statim in
curia?
erno (?) ad alios indices

↑

Vide numerum praec.

3089

Madrid Arch. Histor. Nacional
Domi nicos de S. Pablo Burgos 33 €
P. — **1262 Julii 5**
Vrbanus III .. — decano — archi-
diacono de Medina et .. cantori
Salamantin.
Significarunt nobis dilecti
Viterbii III non. Julii a° 1°
Bulle fehlt. Hanf erhalten
In plica rechts pia ₧
Ecke oben rechts bo

 x wohl pax
 cf. 1262 Jun. 17

3090

Coblenz Stadtsarchiv
Domcapitel
 P. — 1262 Julii 7
Urb. III .. cancellario Tul-
lensi
Sua nobis dilecti
Viterbii non. Julii a° 1°
Bulle an Hanf
In plica rechts p
 Alex. ₧
Sub plica links . .
 B p
Ecke oben rechts : be

3091

Paris Archives nationales
 J. 451 n. 4.
Breite 36. 8 Rand links 1.4 rechts 1.6
Höhe 29. 1 Rand oben 5.1 plica 3.1
Erste Linie für Oberlängen / Je
eine Seitenlinie
cf. P. 18375 **1262 Julii 7**
Vrbanus III .. Archiepo Nithrovien
et .. Epo Asloen
 Clamat instanter ad
Dat. Viterbij non. Julij a° 1°
Bulle an Hanf
 In plica rechts : br̄
A tergo oben mitte : pro terra sca
Flotte runde stumpfe Schrift

3092

Archives Nationales Paris
L254 n. 43 1262 Julii 7
Br. 30.5 hoch 21.4 plica 2.6
oberer Rand 4.5 links 1.
rechts 1.
Urbanus III . . abbati de
Ferrariis Senonem dioc
Ad mram noueris
Dat Viterbij non Julij a° 1°

Bulle an Hanf
In plica rechts :. a. S.
Sub plica links :
R̄ J̄

Ecke oben rechts : ḡp

A tergo Ecke oben links : R
" Oben Mitte : T

Schöne kleine etwas eckige Schrift
mit einem betonten Buchstaben
Erste Linie für Oberlängen

P. vacat

3093

Instr. mon. F. dom. C. V. 1262 Julii 7
P. 18377
Mt. III .. epo Reatin.

felicis recordationis Alexander

Viterbii non. Julii a° 1°

Bulle an Hanfschnur

A tergo : predicatorum

3094

Archives Nationales Paris
L254 n. 44 1262 Julii 10
Br. — hoch — plica —
oberer Rand — links —
rechts —
Urbanus IIII (Gitterschrift)
Inytale voirevi .. Magro et pri
bribz militie Templi Jerlimitan
denotionis tue merita
Dat Viterbij II Jd Julij a° 1°
Bulle an feiner Seide
In plica rechts : Jac romanus
A tergo oben mitte :
pntz Lambertus T
Sehr schöne kleine Schrift, mit
gestreckten Ligaturen mit
4 betonten Sat anfängen
In 1. Zeile 1 betonter Buchstabe
Erste Linie für Gitterschrift

P. vacat

3095

Archivio di Stato Milano
Bolle e Brevi Clausa
P. 18383 1262 Julii 21
Urbanus
Alexander III fri Raynerio Pla
centin. O Bed. inquisitori here
tice prav. in Lombardia et Mar
chia Januen.

Cum super quibusdam
Viterbii XII kl. Augusti a° 1°
Bulle und Hanf fehlen
Rand oben links :
Ego Jo ya. Card. P legntur
tota domino, et si placet, bul
letur clausa et remittatur
nobis

3096

Archives Nationales Paris
L 254 n. 45 1262 Julii 21

Br. 26.5 hoch 17.4 Plica 3.
 oberer Rand 4.5 links 1.4
rechts 1.4

Urbanus IIII Prior Fratrum
torum . . . Ministro Minorum
fratrum . Provincialibus Francie
 Cum dilectus filius
Dat Viterbij XII kl Aug a° 1°

 Bulle und Hanf fehlen.
 Sn plica rechts : . S
A tergo oben Mitte :
 pro terra Sca

Ganz kleine runde Schrift

Mit einem betonten Buchstaben

Erste Linie für Oberlängen

__P. vacat__

3097

Archives Nationales Paris.
L 254 n. 46 1262 Julii 23

Br. 53.4 hoch 37.5 Plica 4.6
 oberer Rand 7.1 links 2.2
rechts

Urbanus IIII . . — Prioribus fra
trum Predicatorum Parisien
 Pre cunctis nre
Dat Viterbij X kl Aug. a° 1°

 Bulle fehlt. Hanf erhalten
 Sub plica links : V
 B J

A tergo oben Mitte :
 Ad petitionem Regis Francie

Weite schwungvolle Schrift

 mit einem betonten Buchstab

Erste Linie für Oberlängen

__P. vacat__

__ad petitionem Regis Fr.__

3098

Instr. Mon. F. Dom. c. 2 1262 Sept. 12
 P -

Urb. III .. priori et fratribus or. Pred.
S. Marie ad Gradus Viterbien.
Vestri ordinis preclara
Viterbii II id. Septembris a° 1°
Bulle an Seidenfäden
A tergo! Predicatorum

3099

Archives Nationales Paris
L 255 n. 48 1262 Octobris 4

Br. 25.4 hoch 18.2 Plica 2.6
 oberer Rand 4.3 links 1.2
rechts 1.

 Urbanus IIII Gitterschrift Im
Siele ausgefüllt . . Decano ?
Capitulo Laudun
 Justis petentium desideriis
Dat apud Montemflascon III non
octobre a° 2°

 Bulle und Seide ausgerissen

 Ohne jede Bemerkung

A tergo oben Mitte :
 Decano et Capto Laudun

Kleine regelm. Schrift, mit beson
 ders gestreckten Ligaturen, mit
vier betonten Satzanfängen

In 1 Zeile 1 betonter Buchstabe

Erste Linie für Gitterschrift und
 einige Oberlängen

__P. vacat__

Archives Nationales Paris
L 255 n. 49 **1262 Octobris 7**
Br. 31.7 hoch 22.2 Plica 4.4
oberer Rand 4.9 links 1.3
rechts 1.2
Vrbanus IIII (Gitterschrift, im
teile ausgespart) — decanio ?
Capitulo Laudunensi
Cum non sit
Dat apud Montemflasconm () non
octobris a° 2°

Bulle und Seide fehlen
Rundoben Mitte: cor

A tergo oben Mitte:
dns Ancherus cardinalis

kleine ruuhige Schrift, mit gestr.
Ligaturen, mit zwei betonten
Schaufängen

In 1. Zeile 1 betonter Anchstabe

Erste Linie für Gitterschrift

Ancherus cardinalis

P. vacat

Paris Archives Nationales
J 447 n. 68
Breite 25.6 Rand links 1.2 rechts 1.3
Höhe 18.3 Rand oben 4.8 plica 3.7
Zwei freie Linien über Oberlängen
Je eine Seitenlinie
P. vacat **1262 Octobris 25**
Vrbanus IIII (ohne Punkte) Archi-
epo Tyren
In nra constitutus
Dat apud Vrbemueterem VIII kl
Nouembris / a° 2°
Bulle an Hanf
In plica rechts: S. p
A tergo oben Mitte: pro terra sca

Punkte

Datum

Paris Archives Nationales
J 447 n. 68
Breite 15.8 Rand links 1. rechts 1.1
Höhe 15.8 Rand oben 3.6 plica 4.3
P. vacat **1262 Octobris 25**
Vrbanus IIII . — Archieps Tyren
In nra constitutus
Dat / apud Vrbemueterem
VIII kl Nouembr a° 2°
Bulle an Hanf
In plica rechts: S. pu
Rand oben links: duplicetur
A tergo oben Mitte: pro terra sca
Sehr schöne kleine Schrift

duplicetur

Paris Archives Nationales
J 447 n. 69
Breite 27. Rand links 1.1 rechts 1.3
Höhe 19.3 Rand oben 3.7 plica 3.5
Erste Linie für Gitterschr und
kleine Oberlängen) Je 1 Seitenlinie
P. vacat **1262 Octobris 25**
Vrbanus IIII (Gitterschr) — — Archi-
epo Tyren
Pacis tue quectates
Dat apud Vrbemueterem VIII kl
Nouembr a° 2°
Bulle an feiner Seide
In plica rechts: d pm
A tergo oben Mitte: pro terra sca
kleine schöne Schrift
Vier betonte Schaufänge

3104

Paris Archives Nationales
J 448 n. 72
Breite 32.5 Rand links 1.4 rechts 1.4
Höhe 25.4 Rand oben 5.1 plica 3.1
Erste Linie für Gitterschr. und Kleine Oberlängen / Je eine Seitenlinie
P. vacat 1262 Octobris 26
Urbanus IIII (Gitterschr.) . . Archiepo Tyren
 Licet moderamen quod
Dat apud Urbemveterem VII Kl
Novembr a° 2°
Bulle an feiner Seide
In plica rechts: Bernard parm
A tergo oben Mitte : pro Terra sancta
Sehr fette Kleine regelm. Schrift

3105

Paris Archives Nationales
J 448 n. 74
Breite 22.3 Rand links 0.8 rechts 0.8
Höhe 17.2 Rand oben 3.6 plica 3.8
Erste Linie über Oberlängen / Je eine Seitenlinie
P. vacat 1262 Octobris 28
Urbanus IIII . . Archiepo Tyren
 Cupientes quod in
Dat apud Urbemveterem V Kl
Novembr / a° 2°
Bulle an dickem Hanf
In plica rechts : B. p̄u
Rand oben Mitte : c̄r
A tergo oben Mitte: pro Terra sa̅
Prachtvolle mittelgr. fette Schr.

3106

Bayer: Haupt. Staatsarchiv
Indelsdorf. F. 4
P. 78424 1262 Novembris 4
Urbanus IIII .. Decano eccle Sanct.
Mauricij Augusten.
 Ad audienciam nostram
apud Urbemveterem II Non.
 Novembris Anno Secundo
Bulle an Hanf
In plica rechts : p. lat
Sub plica links : ..
 ꝰt
 ꝯ
Ecke oben rechts :
a tergo Ecke oben links : L
Mittelgroße Seitenränder
Weite Linienabstände

3107

Firense. S. donato in Pol
 verosa
P. — 1262 decembris 8
Urbanus IIII dil. in xpo filie
Peregrine succentrici non.
sci Cerboni Cistorr. Lucan.
dioc.
Attendentes dudum dilecte
Apud Urbemveterem VI iđ.
Dec. a° 2°
Bulle und Hanf fehlen
In plica rechts Jar Za̅
 Oberste Zeile frei
 Sub plica frei

3108

Stift Rein
P. — __1262 Decembris 21__
Vrbanus IIII .. abbati et con-
ventui monasterii de R....
Run Cisterciensis ordinis Sal-
geburgensis diocesis

 Iustis petentium desideriis
Apud Vrbemveterem XII Kl.
Ianuarii a° 2°
Bulle an Seide
In plica rechts · a - s.
Sub plica links J (Feder-
probe ?)
Seitenränder; __zwei__ Zeilen
unbeschrieben

3109

Madrid Arch. histor. Nacional
Dominicos de S. Pablo Burgos. 35 E
 P. — __1263 Ianuarii 2__
Vrbanus IIII -- decano -- cantori
et .. archidiacono de Medina
Salamantin.
Dilecti filii .. prior
Ap. Vrbemveterem IIII non.
Ian. a° 2°
Bulle fehlt. Schnur erhalten
Ecke oben rechts fo

3110 (recto)

__duplicetur__
Paris Archives nationales R....
 J 452 n. 5
Breite 42.3 Rand links 1.5 rechts 1.6
Höhe 29.2 Rand oben 4.5 plica 3.3.
Ohne erste freie Linie / Je eine
Seitenlinie
P. 18461 __1263 Ianuarii 9__
Vrbanus IIII - . . Archiepo Tyren.
 Clamante instanter ad
Dat apud Vrbemveterem V Id.
Ianuarii a° 2°
Bulle an Hanf verte
In plica rechts: Jac. Mut.
Sub plica links: n. g. s. pro p. vrc
 de p. u. R.. B. de Aquino
Ecke oben links : R.. mut du
A tergo oben mitte : pro terra ha

3110 (verso)

Schlank schwungvoll groß mit
dicken Strich

fette kleine deutliche Schrift

Archives Nationales Paris
L 255 n. 50 1263 Januarii 9
Br. 28.2 hoch 19.5 Plica 3.9
oberer Rand 4.8 links 1.
rechts 1.1
Urbanus IIII (Gitterschrift im
Siele ausgespart) fil. filijs (...
ohne Punkte) universitati Parisien
Scientiarum fontem irriguum
dat apud Urbemveterem V id
Januarij a° 2°
Bulle an feiner Seide

Ohne jede Bemerkung

A tergo oben Mitte: Magr Lauren
tius pro Universitate Parisien

Kleine schöne Schrift mit mehreren
gezr. Ligaturen, mit zwei ver-
zierten Satzanfängen

In 1. Zeile 2 verz. Buchstaben
Erste Linie für Papstnamen

P. × 18464 Punkte

Archives Nationales Paris
L 255 n. 51 1263 Januarii 9
Br. 23.5 hoch 18.7 Plica 2.7
oberer Rand 4.7 links 1.2
rechts 1.1
Urbanus IIII - - Priori de Cardi-
neto Parisien
Scientiarum fontem irriguum
dat apud Urbemveterem V id
Januarij a° 2°

Bulle an Hanf
In plica rechts: d pu
A tergo oben Mitte:
Magr Laurentius pro Universi.
tate Parisien

Enge kleine eckige Schrift
Mit einem betonten Buchstaben
Erste freie Linie zwecklos

P. 18457

Archives Nationales Paris
L 255 n. 51 bis 1263 Januarii 9
Br. 25.2 hoch 17.1 Plica 2.9
oberer Rand 4.3 links 0.9
rechts 0.8
Urbanus IIII - - Priori de Car-
dineto Parisien
Scientiarum fontem irriguum
dat apud Urbemveterem V id
Januarij a° 2°

Bulle an Hanf
In plica rechts : d pu.
In plica halbrechts : predicta +
freut pro positum - entspricht der
Correctur im Texte
Rand oben Mitte : corr
Ecke oben links : dupl

A tergo oben Mitte :
Magr Laurentius f Universitate Par

Kleine sehr schöne Schrift
Mit einem betonten Buchstaben
Erste freie Linie zwecklos

P. 18457 Duplicetur
 Corrector

Toulouse, archives Départem.
St. Sernin

P. - 1263 Januarii 13

Urbanus IIII Arnaldo abbati
ecclesie Sti Saturnini Tholo-
san. ad Roman. ecclesiam nullo
medio pertinentis ording.
Cum pro confirmatione
Apud Urbemveterem id. Jan.
a° 2°
Bulle an Hanf
In plica rechts name
Sub plica links ..
 nio
Erste Zeile frei
Kleine sehr schöne Schrift

3115

Toulouse, Archives Départem.
St. Sernin

P. — 1263 Januarii 13

Vrbanus IIII .. priori et capitulo
ecclie Sci Saturnini. Tholosan.
ad Roman. Eccliam nullo medio
pertinentis Ordug.
 Recte tunc ecclesiarum
Apud vrbemveterem id. Januarii a°20
Bulle an Hanf
In plica rechts: Jac Jac
Sub plica links
 m p
 J

Erste Zeile frei
Sehr schöne feine kleine Schrift

3116

Nice Archives Départem.
H. 837
P. — 1263 Januarii 17

Vrbanus IIII .. epo Regen.
 Abbas et conventus
Apud vrbemveterem XVI
Kl. februarii a°20
Bulle fehlt. Dicke Hanfschnur
erhalten
In plica rechts Schreiber
Ecke oben rechts Ja
Kleines, sehr schön geschrie-
benes Mandat
Erste Zeile beschrieben
Ohne Seitenlinien winzige
Ränder

3117

Archives Nationales Paris
L 255 n. 52 1263 Januarii 19
Br. 28.7 hoch 19.6 Plica 3.
oberer Rand 3.2 links 0.8
rechts 0.7
 Vrbanus IIII (maiusculae)
vniuersis Magris et Scolaribus
Parisien non decet nos
Dat apud Vrbemveterem XIIII kl
Febr. a°2°
Bulle an feiner Seide
 In plica rechts : Ja . nat
A tergo oben Mitte :
 Magr Laurentius.
Offene eckige Schrift, mit gestreck-
Ligaturen (mit einer Ausnahme)
mit 3 verzierten Satzanfängen
In 1. Zeile 1 verz. Buchstabe
Erste Linie für Papstnamen und
 Subeltingen
Papstname in Text u Gitterschrift
 P. × 18471

3118

Archives Nationales Paris
L 255 n. 52bis 1263 Januarii 19
Bor. 27.1 hoch 24.2 Plica 2.8
oberer Rand 5.6 links 1.
rechts 1.4
 Vrbanus IIII (Gitterschrift. Ou-
tinie verziert) vniuersis Magris
et Scolaribus Parisien
 non decet nos
Dat apud Vrbemveterem XIIII kl
Febr. a°2°
Bulle an feiner Seide
 In plica rechts : p la de mandat
 dur sur
A tergo oben Mitte :
 Magr Laurentius vniuersitate Pa-
 risien
Mehr regelm. Schrift, mit gestreck.
Ligaturen mit vier verzierten
Satzanfängen
In 1. Zeile 1 verz. Buchstabe
Erste Linie für Gitterschrift und
 Subeltingen
 P. × 18471

3119

Archives Nationales Paris
L 255 n. 53 1263 Januarii 27
Br. 29.2 hoch 20.9 Plica 2.2
oberer Rand 5.3 links 1.4
rechts 1.3
Urbanus IIII .. Archidiacon
Pictavien in Scotia Carnoten
Ex parte Dilectorum
Dat apud Vrbemueterem ꝓ Kl
Februarÿ a° 2°

Bulle an dickem Hanf
In plica rechts: Ger. p.

Sub plica links: ꝓ p

A tergo oben mitte:
Mgr Laurentius p vinausritte
Par

Sehr schöne regelmäßige Schrift
mit einem betonten Buchstaben
Ohne erste freie Linie
 P. x 18479

3120

Archives Nationales Paris
L 256 n. 62 1263 februarii 4
Nov. 28. hoch 19. Plica 2.5
oberen Rand 4.7 links 1.2
rechts 1.3
Urbanus IIII C Gitterschrift, Ini-
tiale ausgespart . Magistro
e fratribus Hospitalis sancti An-
tonii Vienneñ
 Exigentibus vestre denotionis
Dat apud Vrbemueterem ꝓ Non
Februarÿ a° 3°

Bulle an feiner Seide
 In plica rechts: Jac Romanus
Sub plica links:
 Jo Sal
A tergo oben mitte: Petrus de Anagnia

Kleine zierliche Schrift, mit gezir-
ten Ligaturen, mit vier betonten
Satzanfängen
In 1. Zeile 1 vers. Buchstabe
Erste Linie für Gitterschrift
 P. vacat

3121

Madrid Arch. Histór. Nacional
Dominicos de S. Pablo Burgos 34 C
 P. 18488 1263 februarii 9
Vrbanus IIII .. magro et fratribus
ord. Predic.
 Cum a nobis
Apud Vrbemueterem � febr.
a° 2°
Bulle fehlt. Seide erhalten
In plica rechts Jac Romanus

Zwei Ausfertigungen, die
in allem gleich sind

3122

Firenze, Dompiazio
 P. - 1263 februarii 13
Vrbanus IIII .. abbi et couen.
sui Mon. sancti Michaelis
discalciatorum OSB Pisan.
dioc.
 Devotionis vestre precibus
Apud Vrbemueterem �
febr. a° 2°
 Bulle und Seide fehlen
In plica rechts ꝓ B oT F
 Sub plica links ..
 ꝓ p

 Ben p

3123

Paris Archives Nationales
J 445 n. 6
Breite 31.2 Rand links 1.2 rechts 1.2
Höhe 22.2 Rand oben 4.3 plica 3.3
Erste Linie für Oberlängen / Je
eine Seitenlinie

P. vacat 1263 februarii 19
Vrbanus IIII Egidio Archiepo Tyren
Cum predicationem crucis
Dat apud Vrbemveterem xj Kl
Martij / aº 2º
Bulle an Hanf
In plica rechts : R - C.
A tergo oben Mitte : pro Terra Sca
Kleine prachtvolle Schrift

3124 (recto)

duplicetur
Paris Archives Nationales
J 457 n. 6
Breite 30.7 Rand links 1.5 rechts 1.2
Höhe 15, Rand oben 4.7 plica 3,8
Erste Linie über den Oberlängen
Je eine Seitenlinie
P. vacat 1263 februarii 19
Vrbanus IIII Egidio Archiepo
Tyren
Cum predicationem crucis
Dat apud Vrbemveterem / XI
Kl Martij aº 20
Bulle an Hanf
In plica rechts : Jo Vit
Sub plica links : .·3 verte
de pu Ro A. de Synisio

3124 (verso)

Rand oben halblinks : du
 " " halbrechts : por
A tergo oben Mitte :
 pro Terra Sca
Fete Silvia mittelgrosse deutliche
Schrift.

3125

P. — Paris Arch. nat.
J 445 cap. 5 1263 Martii 9
Vrb IIII Egidio archiepo Tyren.
Volumus et presentium
apud Vrbemveterem VII id. Mar
tii aº 2º
Bulle an Hanf
In plica links B Fu
Sub plica links --
 " Ang Bad Jan R B.
 de Fusca
Rand oben links : du

3126

duplicetur

Paris Archives Nationales
J 445 n. 5

Breite 26.9 Rand links 1.4 rechts 4.4
Höhe 43.8 Rand oben 3.1 plica 2.7
Erste Linie über den Oberlängen /
Je eine Seitenlinie

P. vacat 1263 Martii 9

Vrbanus IIII Egidio Archiepo Tyren
Volumus et presentium
Dat apud Vrbemueterem vij Jd
Martij / a° 2°
Bulle an Hanf
In plica links : B. fio . p.
Sub plica links -- und
de pu Rf B. de Fusca
Ecke oben links : du
A tergo oben Mitte : pro Terra Sca
Sehr kleine prachtvolle Schrift

3127 (recto)

duplicetur

Paris Archives Nationales
J 447 n. 70³

Breite 23.5 Rand links 0.7 rechts 1.
Höhe 16.7 Rand oben 3.3 plica 2.3
Erste Linie für Gitterschr. und
Oberlängen / Je eine Seitenlinie

P. vacat 1263 Martii 10

Vrbanus IIII (Gitterschr.) Vniuersis
Predicatoribus verbi crucis pro ter
re sancte subsidio ac executori
bus negotij eiusdem crucis
Volentes labores uros
Dat apud Vrbemueterem vj Jd
Martij a° 2°
Bulle an feiner Seide
In plica rechts : Pant / links : . y.
Sub plica links : p. lata . G.S.
Rand oben links : du (verte

3127 (verso)

A tergo oben Mitte.
pro terra Sca
Weite flüssige mittelgr. Schrift

3128

Paris Archives Nationales
J 447 n. 65

Breite 22.1 Rand links 1.1 rechts 1.
Höhe 17.8 Rand oben 3.2 plica 2.9
Erste Linie über Oberlängen /
Je eine Seitenlinie

P. vacat 1263 Martii 10

Vrbanus IIII Egidio Archiepo Tyren
Cum predicationem Crucis
Dat apud Vrbemueterem / vj kl
Aprilis a° 2°
Bulle an Hanf
In plica rechts : . p. Bo
A tergo oben Mitte : pro terra Sca
Zierliche schöne Schrift

3129

duplicetur

Paris Archives Nationales
J 447 n. 70³

Breite 24.7 Rand links 0.7 rechts 0.8
Höhe 18.3 Rand oben 3. plica 2.7
Erste Linie für Gitterschr. und
Kleine Oberlängen / Je 1 Seitenlinie

P. vacat 1263 Martii 10
Vrbanus IIII etc. ut in n. 70
Dat apud Vrbemueterem / VI
Id a° 2°
 Bulle an Seide
In plica rechts : Paul links:.p.
 pro Matth
Sub plica links : Paul pro socio. G. S.
 p. lata. G. S.
Rand oben links: du
A tergo oben Mitte : pro terra Sca
Eilige runde Schrift

3130

Paris Archives Nationales
J 447 n. 70³

Breite 24.8 Rand links 0.7 rechts 1.1
Höhe 20.2 Rand oben 3.9 plica 3.4
Erste Linie für Gitterschr und
Oberlängen / Je eine Seitenlinie

P. vacat 1263 Martii 10
Vrbanus IIII etc. ut in n. 70
Dat apud Vrbemueterem / VI
Id Martij a° 2°
 Bulle an feiner Seide
In plica rechts : Paul/links :.p.
Sub plica links : p. lata . G. S.
Rand oben links: du
A tergo oben Mitte : pro terra Sca
Kleine regelm. Schrift

3131

Paris Archives Nationales
duplicetur J 447 n. 70ᶜ
Breite 23.8 Rand links 1.1 rechts 1.1
Höhe 17.4 Rand oben 3.7 plica 3.7
Erste Linie für Gitterschr und Ober-
längen / Je eine Seitenlinie

P. vacat 1263 Martii 10
Vrbanus IIII (Gitterschr) etc. ut in
n. 70
Dat apud Vrbemueterem / VI Id
Martij a° 2°
 Bulle an feiner Seide
In plica rechts : Paul /links :.p.
 pro. Matth
Sub plica links : Paul pro socio G. S.
 p. lata . G. S.
Rand oben links: du
A tergo oben Mitte : pro terra Sca
Kleine etwas fettige Schrift

3132

Paris Archives Nationales
J 447 n. 70ᵉ

Breite 25.5 Rand links 1.3 rechts 1.2
Höhe 20. Rand oben 3.9 plica 2.7
Erste Linie für Gitterschr und ober
längen / Je eine Seitenlinie
P. vacat 1263 Martii 10
Vrbanus IIII (Gitterschr) ut in n. 70
 Dat apud Vrbemueterem VI Id
Martij a° 2°
 Bulle an feiner Seide
In plica rechts : p. lata
A tergo oben Mitte : pro terra Sca
Weite fette deutliche Schrift

duplicetur

Paris Archives Nationales Datum

J. 447 n. 70 c

Breite 25. Rand links 1.1 rechts 1.4
Höhe 20. Rand oben 4.2 plica 3
Erste Linie für Gitterschr / Je eine
Seitenlinie

P. vacat 1263 Martii 10

Vrbanus IIII (Gitterschr) etc. ut in n. 70
Dat, apud Vrbemueterem VI Jd.
Martij a° 2°

 Bulle an feiner Seide.

On plica rechts: Andreas Sy links: p.
Sub plica links: d. pu Rt G. de Monte
Rand oben links: du
A tergo oben Mitte: pro terra sca

Paris Archives Nationales

J 447 n. 70 d

Breite 24.9 Rand links 1.1 rechts 1.
Höhe 18.7 Rand oben 3.3 plica 2.3
Erste Linie für Gitterschr und Ober-
längen / Je eine Seitenlinie

P. vacat 1263 Martii 10

Vrbanus IIII (Gitterschr) ut in n. 70
Dat apud Vrbemueterem VI Jd
~~und~~ Martij a° 2°

 Bulle an feiner Seide

Du plica rechts: p. Lata
A tergo oben Mitte: pro terra sca
Breite fette uuhlürnige Schrift

Paris Archives Nationales

J 447 n. 70 e

Breite 27. Rand links 1.2 rechts 1.3
Höhe 19.7 Rand oben 3.9 plica 2.9
Erste Linie über Gitterschr und Ober-
längen / Je eine Seitenlinie

P. vacat 1263 Martii 10

Vrbanus IIII (Gitterschr) ut in n. 70
Dat apud Vrbemueterem VI N Mar-
tij a° 2°

 Bulle an feiner Seide
Du plica links: S und: p.

 Sub plica links: p. Lata
Rand oben links: du
A tergo oben Mitte: pro terra sca
Weite schöne feste Schrift

Paris Archives Nationales

J 447 n. 70 g

Breite 24.1 Rand links 1.1 rechts 1.1
Höhe 20. Rand oben 3.4 plica 2.6
Erste Linie für Gitterschr und
Oberlängen / Je eine Seitenlinie

P. vacat 1263 Martii 10

Vrbanus IIII (Gitterschr) etc. ut in n. 70
Dat apud Vrbemueterem VI Jd.
Martij a° 2°

 Bulle an feiner Seide
Du plica rechts: p. Lata
A tergo oben Mitte: pro terra sca
fette etwas uuhlürnige Schrift

3137

Paris Archives nationales

J 447 n. 70^(bis)

Breite 26.7 Rand links 1.9 rechts 1.6.
Höhe 20.7 Rand oben 5. plica 2.4
Erste Linie für Gitterschr. und Ober
längen / Je eine Seitenlinie
P. vacat 1263 Martii 10
Urbanus IIII (Gitterschr.) etc. ut in n. 70
Dat apud Urbem veterem VI Jd
Martij a° 2°
 Bulle an feiner Seide
In plica rechts : p. lata
A tergo oben Mitte : pro terra sca
Regelm. fette Schrift

3138

Arch. Arcis
Arm. IX caps. 2 cap. 13
P. — 1263 Martii 13
Urb. IIII .. epo Anagnin
Causam quam dilectus
apud Urbem veterem III id. Mar
tii a° 2°
Bulle an Hanf
In pl. rechts : L. B.
 Löcher und Risse

3139

Napoli Curia Eccles. vol. 4°
P. 18503 1263 Martii 23
Urbanus IIII [ohne P.] archiepi
et epis et d.f. abb. prior. dec.
archid. archipr. praep. et aliis
eccl. prelatis ad quos l. i. pervi.
Querelam gravem recepimus
Apud Urbem veterem X kl.
[April]is a° 2°
 Bulle und Seide fehlen
In plica rechts G. lucius
Sub plica links de numeramus
gestrichen G. S. G ? dann
~~Dom ? l.~~ ?
~~Dom~~ Ry l. de . G.
Rand oben links fiat cum
addit. presentibus post trien.

3140

Firenze, Camaldoli
P. 18506 1263 Martii 28
Urbanus IIII [ohne Punkte] con
ventui mon. sancti Petri
ad Vincula ad Rom. Eccl.
nullo m. pert. OSB Ravenn
dioc.
 Licet cunctarum ecclesiarum
apud Urbem veterem V kl.
Aprilis a° 2°
 Bulle und Hanf fehlen
In plica rechts δ pα
Sub plica links
 a??
Rand oben Mitte ̃ obr und obr
Sub plica fast ganz liniert

3141

Neapoli Curia Scales. Vol. 4°

P. 18507 1263 Martii 28

Urbanus III [ohne P.] archepis et epi
ac d. f. abbibus prior. dec. archi
diac. prepos. archipreab. et aliis
ecclrum prelatis ad quos litt-
re iste pervenerint
 Cum dilectis filiis
Apud Vrbemveterem v Kl. Apr.
 a° 2°
Bulle und Seide fehlen
plica abgeschnitten
 Rand oben links du M, dann
fiel einen additione presenti-
bus post tres M.
 Dann mitte Depic Sane

3142

Archives Nationales Paris
L255 n. 54 1263 Martii 28

Br. 31.6 hoch 22.8 Plica 4.3
oberer Rand 5.6 links 1.5
rechts 1.2
 Vrbanus IIII (Gitterschrift, ini-
tiale verziert) — — Preceptori
et fratribus militie Templi in
Aquitania
 mentis nostre sacre
Dat apud Vrbemveterem v Kl
aprilis a° 2°

Bulle an feiner Seide
 in plica rechts : g. co
Sub plica links : ...
 ĐP
 2

A tergo oben mitte : T

Ganz kleine sehr regelm. Schrift
mit sextae Ligaturen, mit 4
verzierten Schäftungen
 In 1. Zeile 1 verz. Buchstabe
Erste Linie für Gitterschrift

P. vacat

3143 (recto)

Paris Archives Nationales
 J 447 n. 71
Breite 65. Randlinks 1.7 rechts 1.7
Höhe 42.5 Randoben 5.1 plica 3.2
Erste Linie für Oberlängen / Je
eine Seitenlinie
P. 18510 1263 Martii 29
Vrbanus IIII Vniuersis Archiepis
ç Epis ac dil filiis fratribus Predica
torq ç Minorq ordinum ceterisque
executoribus per diuersa xpiana
Regna mundi ad crucis negoti
um pro terre sce subuentione
a sede Aplica deputatis ç in
posterum deputandis
 Cum negotium crucis
Dat apud Vrbemveterem iiii Kl

314·3 (verso)

Aprilis a° 2°
Bulle an Hanf
In plica rechts : ~2~ a.
Sub plica link : T
 g·s.
 y

A tergo oben mitte :
 pro terra Sca
Prachtvolle feste kleine Schrift

3144

Paris Archives Nationales
J 447 n. 71a
Breite 58.6 Rand links 1.9 rechts 1.7
Höhe 43.2 Rand oben 5. plica 3.4
Erste Linie für Oberlängen / Je
eine Seitenlinie
P. 18570 1263 Martii 29
Vrbanus IIII etc. ut in n. 71
Dat apud Vrbemueterem / IIII Kl
Aprilis a° 2°
Bulle fehlt Hanf erhalten
Ju plica rechts : Ag . CO.
Ju plica links : . p.
Sub plica links: g. S. Sy . R
Rand oben links: du
A tergo oben mitte: pro terra Sca
Jette kleine stumpfe Schrift

3145

Paris Archives Nationales
J 447 n. 71b
Breite 54.9 Rand links 1.2 rechts 1.3
Höhe 43.2 Rand oben 5.1 plica 2.9
Erste Linie über den Oberlängen
Je eine Seitenlinie
P. vacat 1263 Martii 29
Vrbanus IIII Egidio Archiepo Tyren
Cum predecessorum cruces
Dat apud Vrbemueterem IIII Kl Aprilis
a° 2°
Bulle an Hanf
Ju plica rechts : . 2. a.
Ju plica links : . p.
Rand oben halbrechts : car. uel G
A tergo oben mitte g terra Sca
Jeste regelm. Schrift

3146

Paris Archives Nationales
J 447 n. 71c
Breite 50.2 Rand links 1.6 rechts 1.7
Höhe 40.3 Rand oben 5.5 plica 2.8
Erste Linie über den Oberlängen /
Je eine Seitenlinie
P. 18570 1263 Martii 29
Vrbanus IIII etc. ut in n. 71
~~Dat Coloniam IIII Kl Aprilis~~
Dat apud Vrbemueterem / IIII Kl
Aprilis a° 2°
Bulle an Hanf
Ju plica rechts : . S. R .
A tergo oben mitte : pro terra Sca
Schöne kleine Flotte Schrift

3147

Archives Nationales
J 447 n. 71d
Breite 58.9 Rand links 1.5 rechts 1.3
Höhe 48.8 Rand oben 5.3 plica 5.
Erste Linie für Oberlängen / Je
eine Seitenlinie
P. 18570 1263 Martii 29
Vrbanus IIII ut in n. 71
Dat apud Vrbemueterem IIII Kl
Aprilis a° 2°
Bulle an Hanf
Ju plica rechts : . 2. a.
Sub plica ~~rechts~~ links : X
g. S. L. P
A tergo oben mitte : pro terra Sca
Sehr regelm. feste kleine Schrift

Paris Archives Nationales
J 447 n. 71 C
Breite 58.8 Rand links 2.1 rechts 2.1
Höhe 39.2 Rand oben 4.7 plica 3.5
Erste Linie für Oberlängen / Je
eine Seitenlinie
P. 18570 1263 Martii 29
Vrbanus IIII etc. ut in n. 71
Dat apud Vrbemueterem IIII Kl
Aprilis a° 2°
In plica rechts: Ay. m.
Bulle an Hanf
A tergo oben Mitte: pro terra sca
Kleine feste stumpfe Schrift

Paris Archives Nationales
J 447 n. 71 F
Breite 67. Rand links 2.4 rechts 2.5
Höhe 44.3 Rand oben 5.5 plica 3.7
Erste Linie hoch über Oberlängen
Je eine Seiten linie
P. 18570 1263 Martii 29
Vrbanus IIII etc. ut in n. 71
Dat apud Vrbemueterem / IIII Kl
Aprilis a° 2°
Bulle an Hanf
In plica links: J. S.
A tergo oben Mitte: pro terra sca
Kleine sehr regelm. Schrift

Paris Archives Nationales
J 447 n. 71 E
Breite 56.3 Rand links 2.1 rechts 2.2
Höhe 43.1 Rand oben 6.8 plica 3
Erste Linie über Oberlängen /
Je eine Seitenlinie
P. 18570 1263 Martii 29
Vrbanus IIII etc. ut in n. 71
Dat apud Vrbemueterem IIII Kl
Aprilis / a° 2°
Bulle an Hanf
In plica rechts: Jac Romanus
A tergo oben Mitte: pro terra sca
Sehr kleine prachtvolle Schrift

Paris Archives Nationales
J 447 n. 71 G
Breite 58.7 Rand links 2.4 rechts 2.1
Höhe 46.7 Rand oben 6.4 plica 3.4
Ohne obere freie Linie / Je eine
Seitenlinie
P. vacat 1263 Martii 29
Vrbanus IIII etc. ut in n. 71
Dat apud Vrbemueterem IIII Kl
Aprilis a° 20
Bulle an Hanf
In plica rechts: Jac Mnt
Sub plica links: ×
 Ro. E. x. de sco dat G. S
und Sca. J. S
A tergo oben Mitte: pro terra sca
Mittelgr. ganz prachtvolle Schrift

3152

Bayer. Haupt- Staatsarchiv
Bamberg proc. 795

P. 73514ª 1263 Aprilis 10

Vrbanus IIII .. Abbati et Conuen
tui Monasterii Ebracen. Cister
cien. ordinis Herbipolen. dioc.
 Cum a nobis
Apud Vrbemueterem IIII Jd. Aprilis
. Anno Secundo

Bulle an feiner Seide
 In plica rechts : Ger. p.
Sub plica links :
 m. p.

Ecke oben rechts
 A tergo Ecke oben links : |

Erste Zeile beschrieben, Seitenlinien

3153

Stift Rein
P. 18573 1263 Aprilis 10

Vrbanus IIII .. abbati et con.
uentui monasterii de Runa
Cistercien. ordinis Salzebur.
gen. diocesis
 Cum a nobis
Apud vrbemueterem IIII id.
Aprilis aº 2º
Bulle an Seide
In plica rechts a
 Ger p
Sub plica links
 m p
 2

Ecke oben rechts
Seitenlinien oberste Zeile
beschrieben Ligat. gemacht.

3154

Grazer Landesarchio n. 805
P. 18577 1263 Aprilis 13

Vrbanus IIII .. preposito et con.
uentui Ecclesie Seouien ord.
Sang. Salzeburgen. dioc.
 Cum a nobis
Apud vrbemueterem id apri
lio aº 2º
Bulle an Seide
In plica rechts Jo S.
Seitenlinien. oberste Zeile
unbeschrieben
Gestreckte Ligaturen

3155

Paris Archives Nationales
 J 448 n. 73
Breite 29.1 Rand links 1.4 rechts 1.2
Höhe 19.7 Rand oben 3.9 plica 2.6
Erste Linie für Initiale / Je eine
Seitenlinie

P. vacat 1263 Aprilis 22

Vrbanus IIII Egidio Archiepo Tyren
 Cum predicationem crucis
Dat apud Vrbem ueterem / X Kl
Maij aº 2º
 Bulle an Hanf
A tergo oben Mitte :
 pro Terra Scā
Unruhige fette Schrift

3156

Paris Archives Nationales
J 445 n. 11
Breite 26.6 Rand links 0.8 rechts 0.8
Höhe 9. Rand oben 3.2 plica 2.6
Erste Linie für Oberlängen / Je eine Seitenlinie
P. vacat 1263 Aprilis 24
Vrbanus IIII Egidio Archiepo Tyren
 Cum terra sca
Dat apud Vrbemueterem / VIII
Kl Maij a° 2°
Bulle an Hanf
In plica rechts : B Messy
A tergo oben Mitte : pro terra sca
Kleine sehr schöne Schrift

3157

Paris Archives Nationales
J 448 n. 75
Breite 26.8 Rand links 1.2 rechts 1.2
Höhe 21. Rand oben 4.3 plica 2.7
Erste Linie für Oberlängen / Je eine Seitenlinie
P. vacat 1263 Aprilis 24
Vrbanus IIII Egidio Archiepo Tyren
 Cum predicationem cincis
Dat apud Vrbemueterem VIII Kl
Maij / a° 2°
Bulle an Hanf
In plica rechts : G. de Sigestro
... sub plica links :
? mit g. s. d
 A tergo oben Mitte :
pro Terra sca
Regelm. fette Schrift

3158

Paris Archives Nationales
J 448 n. 77
Breite 28.5 Rand links 1.4 rechts 1.4
Höhe 18.3 Rand oben 3.5 plica 2.8
Erste Linie für Gitterschr und Oberlängen / Je eine Seitenlinie
P. vacat 1263 Aprilis 24
Vrbanus IIII (Gitterschr) Egidio Archiepo Tyren
 Volentes omnes co messignatos
Dat apud Vrbem ueterem VIII Kl Maij a° 2°
 Bulle an feiner Seide
In plica rechts : Math cap
A tergo oben Mitte : pro Terra sca
dünne regelm. kleine Schrift

3159

Paris Archives Nationales
J 445 n. 13
Breite 26. Rand links 0.8 rechts 0.8
Höhe 20. Rand oben 3.9 plica 2.7
Erste Linie frei / Je 1 Seitenlinie
P. vacat
Vrbanus IIII -- Egidio -- Archiepo
Tyren 1263 Aprilis 25
Cum pro Terre
Dat apud Vrbemueterem VII
Kl Maij / a° 2°
Bulle fehlt Hanf erhalten
In plica links fl und — g
A tergo oben Mitte :
 pro terra sca

3160

Paris Archives Nationales
J 448 n. 80
Breite 57.6 Rand links 1.3 rechts 1.3
Höhe 38.5 Rand oben 6. plica 3.8
Ohne erste Linie für Oberlängen /
Je eine Seitenlinie
P. vacat 1263 aprilis 25
Urbanus IIII Egidio Archiepo Tyren
de summis celorum
Dat apud Urbem veterem VII Kl
Maii aº 2º
Bulle an Hanf
In plica rechts : at . p.
In plica links : . p.
Sub plica links : ꝯ
de pu Rẽ sr p men
a tergo oben Mitte : pro terra scã
Kleine sehr schöne Schrift

3161

Paris Archives Nationales
J 445 n. 8c
Breite 23.1 Rand links 1.3 rechts 1.5
Höhe 23.6 Rand oben 4. plica 2.7
Erste Linie für Oberlängen / Je eine
Seitenlinie
P. vacat 1263 aprilis 27
Urbanus IIII etc. ut in n. 8³
V Kl. Maii aº 2º
Bulle an Hanf
In plica rechts : Jac Romanus
A tergo oben Mitte :
pro terra Sancta
Kleine prachtvolle schwungvolle
Schrift

3162

Paris Archives Nationales
J 445 n. 8c
Breite 35.3 Rand links 1.5 rechts 1.7
Höhe 24.8 Rand oben 4. plica 3.7
Erste Linie für Oberlängen / Je
eine Seitenlinie
P. vacat 1263 aprilis 27
Urbanus IIII Universis Archiepis
Patriarchis Archiepis et Epis ac dil
filiis Electis etc ut in n. 8³
Bulle an Hanf V Kl. Maii aº 2º
In plica rechts : R. C.
A tergo oben Mitte : pro terra scã
Prachtvolle kleine schwungvolle
Schrift

3163 (recto)

Paris Archives Nationales
J 445 n. 8c
Breite 35.2 Rand links 1.8 rechts 1.9
Höhe 26.8 Rand oben 4.9 plica X.
Erste Linie für Oberlängen / Je eine
Seitenlinie
P. vacat 1263 aprilis 27
Urbanus IIII Universis Patriarchis
Archiepis et Epis ac dil filiis Electis
Abbatibus Prioribus Capitulis Conven
tibus et Collegiis scī Benedicti vel
cuiuslibet alterius ordinis necnon de
canis archidiaconis Prepositis Ar
chipresbit'ris et aliis eccliar Prelatis et
Rectoribus ac Receptoribus seu admi
nistratoribus domorum Hospitalis et
Templi ac scē Marie Theotonicorum
exemptis et non exemptis ad quos

3163 (verso)

littere iste pervenerint

Cum venerabilem fratrem .

Dat apud Vrbemueterem v Kl Maij

a° 2°

Bulle an Hanf

Ju plica rechts : R. C.

A tergo : pro terra Sancta

Kleine prachtvolle Schrift

3164

Paris Archives Nationales

J 445 n. 12

Breite 21.2 Rand links 0.6 rechts 0.6

Höhe 16.3 Rand oben 3.3 plica 3.5

Erste Linie für Oberlängen / Je

eine Seitenlinie

P. vacat 1263 Aprilis 27

Vrbanus III Egidio Archiep̄o Tyren̄

Fraternitati tue de

Dat apud Vrbemueterem v Kl

Maij / a° 2°

Bulle an Hanf

Ju plica rechts : A. S.

Ju plica links : . p.

Rand oben links : Du

Sehr schöne kleine Schrift

duplicetur

3165

Paris Archives Nationales

J 445 n. 14

Breite 20.5 Rand links 0.9 rechts 1.

Höhe 5.3 Rand oben 3.5 plica 2.2

Ohne freie erste Linie / Je eine

Seitenlinie

P. vacat 1263 Aprilis 27

Vrbanus III Egidio Archiep̄o Tyren̄

Ut commissum tibi

Dat apud Vrbem ueterem v Kl

Maij / a° 2°

Bulle an Hanf

Ju plica rechts : ger̄ p

A tergo oben Mitte : pro terra Sc̄a

Sehr schöne kleine Schrift

3166

Archives Nationales

J 447 n. 64

Breite 24.7 Rand links 1.4 rechts 1.3

Höhe 16.8 Rand oben 3.6 plica 2.7

Ohne alle freien Linien

P. vacat 1263 Aprilis 27

Vrbanus IIII Egidio Archiep̄o

Tyren̄

Cum predicationem Crucis

Dat apud Vrbemueterem v

Kl Maij / a° 2°

Bulle an Hanf

Ju plica rechts : . S. links : . p.

Sub plica links : G. S. S.

p Ro pro J̄z

A tergo oben Mitte : pro terra Sc̄a

3167

Paris Archives Nationales
P. vacat J 447 n. 66
Breite 24.7 Rand links 1.4 rechts 1.4
Höhe 20. Rand oben 3.3 plica 3
Erste Linie über den Oberlängen
Je eine Seitenlinie
~~Cum pro~~ 1263 Aprilis 27
Vrbanus IIII Egidio Archiepo Tyren
 Cum predicationem Crucis
Dat apud Vrbemueterem / V kl
Maij a° 2°
 Bulle an Hanf
In plica links: B. fu
A tergo oben Mitte: pro Terra Sca
Kleine sehr schöne Schrift

3168

Paris Archives Nationales
 J 447 n. 67
Breite 27.6 Rand links 1. rechts 1.
Höhe 19.3 Rand oben 3.8 plica 3.2
Erste Linie über Oberlängen / Je
eine Seitenlinie
P. vacat 1263 Aprilis 27
Vrbanus IIII Egidio Archiepo Tyren
 Cum predicationem Crucis
Dat apud Vrbemueterem / V kl
Maij a° 2°
 Bulle an Hanf
In plica rechts : B. Meff
A tergo oben Mitte : pro Terra Sca
Kleine zierliche Schrift

3169

[Datum]
Paris Archives Nationales
 J 448 n. 76 bis
Breite 25.7 Rand links 1.2 rechts 1.3
Höhe 20. Rand oben 4.9 plica 3.1
Ohne erste Linie / Je eine
Seitenlinie
P. vacat 1263 Aprilis 27
Vrbanus IIII Egidio Archiepo Tyren
 Cum predicationem Crucis
Dat / apud Vrbemueterem V kl
Maij a° 2°
 Bulle an Hanf
In plica rechts : Ger p
A tergo oben Mitte :
 pro Terra Sca
Kleine sehr schöne Schrift

3170

duplicetur
Paris Archives Nationales
 J 445 n. 7
Breite 18.7 Rand links 0.9 rechts 0.9
Höhe 14.2 Rand oben 3.4 plica 2.
Erste Linie für Oberlängen / Je eine
Seitenlinie
P. vacat 1263 Aprilis 28
Vrbanus IIII Egidio Archiepo Tyren
 Cum predicationem crucis
Dat / apud Vrbemueterem IIII kl
Maij a° 2° Prachtvolle schwungvolle Schrift
 Bulle an Hanf
In plica rechts : d pu
In plica links : . p.
sub plica links : g . S . Ra . C
Rand oben
rechts : du A tergo oben Mitte :
 pro Terra Sca

3171

Paris Archives nationales
J 445 n. 9

Breite 31.9 Rand links 2.1 rechts 1.4
Höhe 22.4 Rand oben 4.4 plica 2.4
Erste Linie für Oberlängen / Je eine
Seitenlinie

P. vacat 1263 Aprilis 28

Urbanus IIII Archiepis et Epis ac dil
filijs ceteris eccliaz prelatis per Reg-
num Francie recnon Cameracen
Tullen Leodien meten y Virdunen
Civitates y dioceses constitutis

Dat apud Vrbemveterem IIIJ Non
Maij / a° 2°

Bulle an Hauf

In plica rechts : R. C.

A tergo oben Mitte : pro terra sancta

Prachtvolle schwungvolle Schrift

3172

Paris Archives nationales
J 445 n. 9c

Breite 27.6 Rand links 0.8 rechts 1.
Höhe 21.6 Rand oben 3.6 plica 2.9
Erste Linie für Oberlängen / Je eine
Seitenlinie

P. vacat 1263 Aprilis 28

Urbanus IIII omniversis Archiepis et
Epis per Regnum Francie recnon pa
Cameracen Tullen Leodien meten
y Virdunen civitates y dioc consti
tutis ad quos littere iste pvenerint

Cum nos negotium

Dat apud Vrbemveterem / M IIIJ Non
Maij a° 2°

Bulle an Hauf

In plica rechts :

A tergo oben Mitte : pro terra Sancta

Schwungvolle
schöne Schrift

3173

Paris Archives nationales
J 448 n. 76

Breite 20.2 Rand links 1 rechts 1
Höhe 15.3 Rand oben 3.4 plica 2.6
Erste Linie hoch über Oberlängen für
Oberteile / Je eine Seitenlinie

P vacat 1263 Maii 8

Urbanus IIII Egidio Archiepo Tyren

Ut commissum tibi

Dat apud Vrbemveterem / VIIJ Jd
Maij a° 2°

Bulle an Hauf

In plica rechts : Ger

A tergo oben Mitte : pro terra sta

Kleine sehr schöne Schrift

3174

Firenze, S. Croce di Firenze
De Curia 1263 Maii 15

Urbanus IIII .. ministro et capi
tulo generali ordinis fratrum
Minorum

Spiritus domini replens

Apud Vrbemveterem iv. Mai
anno 2°

Bulle und Hauf fehlen

In plica rechts de Cur
An. M

Oberste Linie frei
Sub plica fast ganz liniirt
Mässig breite Seitenränder

A tergo oben Mitte
de Cur

3175

Napoli Curia Eccles. vol. 4°
p. — 1263 Maii 15
Urbanus III Guillermo patri-
arche Jerosolimitan. apli-
ce sedis legato
Volentes vrm Jerosolimitan.
Apud vrbemveterem idus Maii
a° 2°
Bulle und Hanf fehlen
~~Plica abgeschnitten~~
In plica rechts Neput R
Sub plica links Ja aue
 2/ Ano(mi-
 num)
dnm f. R. g. S.
 3
Rand oben mitte zwei Bemerk-
gen darunter R petg seri-
betur alii eristi formam. B

3176

Paris Archives Nationales.
 J 445 n. 10
Breite 33.5 Rand links 1.4 rechts 1.3
Höhe 24.4 Rand oben 4.3 plica 2.7
Erste Linie frei / Je eine Seitenlinie
P. vacat 1263 Maii 15
Urbanus III – . Magro generali
ceterisque fratriby ordinis sancte
Trinitatis et Captivorum
 Ad hoc ordo
dat apud Vrbem veterem Jd
Maij / a° 2°
Bulle an Hanf
In plica rechts : d pū
A tergo oben mitte : pro terra soa
Kleine sehr schöne Schrift

3177

Napoli Curia Eccles. vol. 4°.
p. — 1263 Maii 23
Urbanus III [ohne Punkte] fra-
bus Clericis Hospitalis See
Marie Theutonicorum predi-
cantibus verbum Crucis in sub-
sidium Lyvonie Curonie et
Pruscie ad quos litt. iste perv.
 Pro fidei negotio
Apud vrbemveterem x kl.
Iunii a° 2°
Bulle und Hanf fehlen
~~In plica rechts~~ ait A. de Jo

3178

Arch. Arcis
Arm. XIII caps. 6 cap. 27
p. — 1263 Maii 31
Urb. III .. epo Anagnin.
Intelleximus quod tu
Apud vrbemveterem II kl.
Iunii a° 2°
Bulle an Hanf
In pli rechts : Ba P men

3179

Marseille Archives Départem.
H. S. C. A. 1
P.— 1263 Iunii 1
Vrbanus IIII dil. in xpo filiabus
.. abbatisse et conventui mo-
nialium inclusarum S. Marie
de Roqueta Arelaten. ord. S.
Damiani
 cum a nobis
Apud Vrbemveterem Kl. Iun.
a° 2°
Bulle, plica und Seide fehlen
Sub plica links ..
 Ja Ane
 2p
A tergo Ecke oben links]
Mittelmässige Schrift, ziemliche
Ligaturen
Schmale Seitenränder

3180

Marseille Archives Départem.
H. S. C. A. 1
P.— 1263 Iunii 1
Vrbanus IIII dil. in xpo filiabus
.. abbatisse et conventui mo-
nialium inclusarum mon.
S. Marie de Roqueta Arelaten.
ord. S. Damiani
 Meritis vestre religionis
Apud Vrbemveterem Kl. Iun.
a° 2°
Bulle fehlt, Seidenfäden erhalten
In plica rechts j. jo
Sub plica links ..
 Ja. Ane
 2p
A tergo oben links Ecke J
Schmale Seitenränder
mittelmässige Schrift, ziemli-
che Ligaturen

3181

Marseille Archives Départem.
H. S. C. A. 1
P.— 1263 Iunii 1
Vrbanus IIII dil. in xpo filiabus
.. abbatisse et conventui
monialium inclusarum
mon. Sancte Marie de Rosquета
Arelaten. ord. S. Damiani
 Devotionis vestre precibus
Apud Vrbemveterem Kl. Iun.
a° 2°
Bulle und Seide ausgerissen
In plica rechts . j. P
Sub plica links
 Ja Ane
 2p 2p
Ecke oben rechts Hp
Gestreckte Ligaturen

3182

Madrid Arch. Histor. Nacional
Santo Sepulcro C 19
 vice cancellarius
P.— 1263 Iunii 6
Vrbanus IIII .. priori et capitulo
ecclie dominici Sepulcri Jero-
solimitan. Ordinis
Ecclesiam dominici Sepulcri
Apud Vrbemveterem VIII id.
Iunii a° 2°
Bulle fehlt. Seide erhalten
In plica rechts B. Mess.
Rand oben Mitte eigenhändig
fiat consimilis pro ecclia de
coll Somener ? dioc. m
A tergo oben Mitte klein
 cap cxxv

– 236 –

3183

Firenze, Badia Fiorentina
P.— 1263 Iunii 9
Urbanus IIII .. abbi mon. de
sco Salus Florentin. dioc.
Dilecti filii .. abbas
Apud Vrbemveterem VId Iunii
anno 2°
Bulle und Hanf fehlen
In plica rechts Dat —
Winzige Seitenränder
10.8 hoch 7.8 plica
15.6 breit.
Prächtige winzige Schrift

3184

Paris Archives Nationales
J 445 n. 15
Breite 38.2 Rand links 1.3 rechts 1.3
Höhe 29.4 Rand oben 4.8 plica 3.6
Zwei Linien über Oberlängen / Je
eine Seitenlinie
P. vacat 1263 Iunii 11
Urbanus IIII . . Archiepo Re
men et eius Suffraganeis
Venerabilis fr nr
dat apud Vrbemveterem /
III Id Iunij a° 2o
Bulle an Hanf
In plica rechts : B. C
A tergo oben Mitte : pro terra sca
Kleine schöne Schrift

3185

Paris Archives Nationales
J 445 n. 16
Breite 37.7 Rand links 1.1 rechts 1.1
Höhe 28.3 Rand oben 3.5 plica 3.1
Erste Linie über Oberlängen / Je
eine Seitenlinie
P. vacat 1263 Iunii 11
Urbanus IIII dil. filiis . Electo Lugdunen
et ven. fratribus Suffraganeis ecclie
Lugdunen
Venerabilis frater nr
dat apud Vrbemveterem III Id
Iunij (a° 2o
Bulle an Hanf
In plica rechts : paul
A tergo oben Mitte: pro terra sca
Kleine regelm. Schrift

3186

Octauo

Paris Archives Nationales
J 448 n. 79
Breite 35.4 Rand links 1. rechts 1.1
Höhe 24.8 Rand oben 4.8 plica 3.2
Erste Linie für Oberlängen / Je
eine Seitenlinie
P. vacat 1263 Iunii 11
Urbanus IIII Nob viro Alfonso comi
ti Pictauen J Tholosan
Venerabilis frater nr
dat / apud Vrbemveterem III Id
Iunij a° 2o
Bulle an dickem Hanf
In plica links :
Sub plica links: jã ano
A tergo oben Mitte :
pro Terra sca
mit fünf Correcturen

3187

Archives Nationales Paris
L 255 n. 55 1263 Iunii 12
Bor. 65.2 hoch 45. Plica 3.3
oberer Rand 5.9 links 1.8
rechts 1.6
Urbanus IIII universis Archi
epis 7 Epis ac dil. filijs patribus
Predicatox et Minorx ordinum
ceterisque executoribus per diver
sa Regna mundi ad lividis ne
gotium pro terre sce subventione
a sede aplica deputatis c in po-
sterum deputandis
Cum negotium Crucis
dat apud Urbemueterem 7
Id Iunij a° 2°
Bulle und Brief fehlen
In plica rechts : Th. S.
A tergo oben Mitte : pro Terra sca
Kleine regelm - Schrift
Init einem betonten Buchstaben
Erste Linie für Oberlingen
 P. vacat

duplicetur
Paris Archives Nationales
 J 445 n. 4
Breite 35.2 Rand links 1.6 rechts 1.4
Höhe 25. 1 Rand oben 4.5 plica 3.3
Erste Linie über den Oberlingen / Je
eine Seitenlinie
P. vacat 1263 Iunii 13
Urbanus IIII Universis Archiepis 7
Epis 7 dil filijs abbatibx prioribx de
cani Archidiacon necnon prioribx Pre
dicatox Ministris Custodibus seu
Guardinis Minorx ordinum ceteris.
que personis eccliasticis secularibx ad
religiosis p Regnum Francie 7 p Came
racen Tullen Leodien Metem 7 Virdu
nen Civitates et dioc ad crucis
negotium 7 ad colligenda subsidia pe
cuniaria pro terre sancte subsidii a

sede aplica deputatis et in posterum
deputandis
 Et ei ad
dat apud Urbemueterem Id Iu
nij / a° 2°
Bulle an Brief
Sub plica links :
Ecke oben links : du
A tergo oben Mitte : pro Terra sca

Paris Archives Nationales
 J 457 n. 7
Breite 37.4 Rand links 1.2 rechts 1.2
Höhe 30. 8 Rand oben 5.3 plica 2.7
Erste Linie für höher Oberlingen /
Je eine Seitenlinie
P vacat 1263 Iunii 13
Urbanus IIII Universis Archiepis 7
Epis ac dil filijs Abbatibx Prioribx Deca
nis Archidiaconis nec non Prioribx
Predicatox Ministris Custodibx seu
Guardianis Minorx ordinum cete
risque personis eccliasticis seculari
bus ud religiosis per Regnum Fran
ci 7 per Cameracen Tullen Leodien
Metem 7 Virdunen Civitates c dioc
ad Crucis negotium 7 ad colligend

subsidia pecuniaria pro terre
sancte subsidio a sede aplica
deputatis 7 in posterum deputan-
dis

Et si ad
Dat apud Vrbemueterem Jd
Junij a° 2°
Bulle an Hanf
In plica rechts : · a · S.
Sub plica links : ···
Mut g. S.

a tergo oben Mitte : pro Terra sca
Sehr flüssige schöne mittelgr. Schr.

Arch. Arcis
Ann. XIII cap. 7 cap. 1
P. — 1263 Junii B
Urb. VIII magistro Gregorio de Na-
poli subdiacono et capellano
nostro.
Cum .. potestas .. prior
Apud Vrbemueterem W.
Junii a° 2°
Bulle mit Hanf ausgerissen
Ohne jedes Zeichen

3191

Marseille Archives Départem.
H. O. T. 6
P. — 1263 Junii 29
Vrbanus IIII archepis et epis
et abbatibus, prioribus, decanis,
archidiaconis et aliis ecclesiarum
prelatis ad quos littere iste per-
venerint
 Religiosos viros fratres
Apud Vrbemueterem III Kl.
 Julii a° 2°
Bulle fehlt, Seide erhalten
In plica links J. V.
Gestreckte Ligaturen.
Sehr hohe Oberlängen, kleine
Buchstaben

3192

Paris Archives Nationales R
 J 448 n. 78
Breite 20. Rand links 0 rechts 0.7
Höhe 12.8 Rand oben 1.7 plica 2.8
Ohne Linie oben / Je eine Leitkulr
P. vacat 1263 Julii 6
Vrbanus IIII .. Archiepo Tyren
 Cum nos quasdam
Dat apud Vrbemueterem / T bri
Julij a° 2°
 Bulle an Hanf
In plica rechts : nycol cap
Ecke oben links R
a tergo schlank schwungvoll
 R cap c. xl
 darüber : Senen
nachlässige kleine Schrift

3193

Marseille Archives départem.
H. O. J. 6
P. — 1263 Julii 8
Urbanus IIII archepis et epis et
abbatibus, prioribus et aliis ecclesi-
arum prelatis ad quos littere iste
pervenerint
 Si diligenter attenditis
Apud Vrbemveterem VIII iđ. Julii
a° 2°
Bulle fehlt, Seide erhalten
In plica rechts Jo. S.
 Alexander, Lucius, Vrbanus
 und Celestinus werden ge-
 nannt
Sehr schöne, regelmäßige Schrift
Gestreckte Ligaturen

3194

Archives nationales Paris
L 255 n. 56 1263 Julii 8
Br. 33.7 hoch 23.5 Plica 4.2
 oberer Rand 5.2 links 1.3
 rechts 1.1
Urbanus IIII (Gitterschrift Ini-
tiale verziert) Archiepis 2 Epis
et dil. filijs Archidiaconis ad quos
littere iste pervenerint
 Cum dilecti filij
Dat apud Vrbemveterem VIII iđ.
Julij a° 2°

Bulle an feiner Seide : P. de Jč
 Su plica rechts : P. de Jč
A tergo oben Mitte :
 frater Lambertus
Kleine, runde weite Schrift, mit
gestreckten Ligaturen (mit einer
Ausnahme) mit zwei verzierten
 Satzanfängen
In 1. Zeile 1 vers. Buchstabe
Erste Linie für Gitterschrift und
 Oberlängen
Papstname in rot in Gitterschrift

P. vacat

3195 (recto)

Firenze, S. Annunziata
 di Firenze
P.18597 1263 Julii 25
Urbanus IIII univ. prioribus
et fribus Servorum Sancte
Marie or. S. Aug.
 Inducunt nos opera
Apud Vrbemveterem VIII se
Aug. a° 2°
 Bulle fehlt, Seide erhalten
In plica rechts B p m
Sub plica links ..
 Odo de Castro Ja kñ C
 Radulfi 29
 Tusculanus eps. Jhs. S. G. S
Ecke oben links R druben
duplici

3195 (verso)

Rand oben Mitte :
Dns Tusculan. dicit, quod le-
gens istam dns ei mandavit
vit michi, quod fieren ein
sie fieri
 Darunter :
fiat ad instar
 Rt Ja Rt li

A tergo kräftig mittelgross

 (Joph) Cap° CLXXXXII
 R

Kräftige und schmutzvolle
runde Schrift

3196

Arch. Arcis
arm. XIII caps. 6 cap. 37
P. — 1263 Aug. 10
Urb. IIII .. epo Anagnin.
Intellecto nuper quod
apud urbemveterem IIII it.
Aug. a° 2¹
Bulle an Hanf
In pl. rechts: de Curia
 a · S.
Sub pl. links: Sy. R. G. S.
Ganz violett.

3197

Archives Nationales Paris
L 255 n. 57 1263 Augusti 13
Br. 30.4 hoch 20.6 Plica 3.8
oberer Rand 4.7 Bd links 13
rechts 1.2
Urbanus IIII .. Priori fratrum
Predicator Parisien.
Dat apud Vrbemveterem Id Aug
olim tibi ad
a° 2°
Bulle und Hanf fehlen
In plica rechts : a.a.
Sub plica links : ?
Ja. Aut
4
Rand oben Mitte : Nomine Reg Fran
ci ut in alia
Kleine schöne gestreckte Schrift
mit einem betonten Buchstaben
Erste freie Linie merklos
Nomine regis Franciē
P. vacat

3198

Barcelona Corona de Aragón
(1262 oct. 18- Leg. 15° n. 3°
1263 sept. 3) 1261 – 1262
Vrbanus IIII .. Epo Barchinen.
nen. et fratri Reynundo de
Penna forti OPred. ca
pellan. et penitentiario nostro
Ad nostram novestis
Apud Vrbemveterem X kl.
a° 2°
Bulle an Hanf
In plica rechts Gca p

3199

duplicetur de Curia
Paris Archives Nationales
445 n. 24
Breite 67.6 Rand links 2.5 rechts 2.5
Höhe 57.4 Rand oben 5.4 plica 5.5
Erste Linie über Oberlängen) Je
zwei Seitenlinien
P. vacat 1263 Septembris 6
Vrbanus IIII nob viro Alfonso Comiti
Pictavien et Tholosan
Vocem terrois audivimus.
dat apud Vrbemveterem VIII Id
Septembr / a° 3°
Bulle an Hanf
In plica rechts : R. C.
de Curia
Rand oben Mitte : dupp et scribat
a tergo oben Mitte : alteri
Pro terra sancta
Kleine lose Schrift

3200

Archives Nationales Paris
L 256 n. 58 *1263 Septembris 13*
Br. 27.7 hoch 18. Plica 2.7
oberer Rand 4.7 links 1.2
rechts 1.3
Urbanus IIII — — Drniomen et
— Sulviorgen decanis —
Livor edax interdum
Dat apud Vrbemveterem J0 Sep-
tembr a° 3°
Bulle und Hanf ausgerissen
In plica rechts : S
F · A

Kleine weite Schrift
Mit einem betonten Buchstaben
Erste freie Linie Tacklos

P. vacat

3201

Poitiers Archives départem.
St. Hilaire
Actum P. — *1263 Septembris 14*
Urbanus IIII ad futur. rei m.
Qui ex ore
Actum apud Vrbemveterem
|| XIII Al . oct. a° 3°
Bulle und Seide ausgerissen
Enthält Sentenz über unmit.
selbre Unterstellung der Kir-
che gegen den Bischof von
Poitiers
Ohne Scriptor

3202

Poitiers Archives départ.
St. Hilaire
P. — *1263 Sept. 19*
Urbanus IIII .. Thesaurario .. de-
cano et canonicis ecclie Sci
Ylarii Sictaven. tam presen-
tibus quam futuris in ppm
El si universe
Amen Amen Amen
R. Ego Urbanus catholice ecclie
eps ss m
6 preb. 5 epi 7 diac.
Dat. apud Vrbemveterem per ma-
nus Michaelis de Tholosa SRE
vicecancellarii XIIII Al. novembr
ind. VII J. d. a° m·CC·LXIII°
pont. vero domni VRBANI pp IIII
anno tercio
Bulle fehlt. Seide erhalten.
Papstunterschrift ganz verschied.
vom Duplicat. auch Monogramm

3203

Poitiers Archives départem .
St. Hilaire
P. — *1263 Sept. 19*
Urbanus IIII wie in beiden an-
deren

Papstunterschrift und Mono-
gramm in allen dreien verschie-
den.

in plica rechts
Jacobus de Mutina

3204

Poitiers Archives départem.
St. Hilaire
R. — 1263 Septembris 11
Vrbanus iiii .. thesaurario .. de
cano et canonicis ecclie sci Hi-
larii Pictaven. tam presentibus
quam futuris in ppm
Et dic universe
Amen Amen Amen
R. Ego Vrbanus catholice
 Ecclie Eps M
6 presb. 5 epi 7 diac.
Dat. apud Vrbemveterem per ma-
num Magri Michaelis de Tholosa
SRE vicecancellarii XVI X XIII E
kl. Nov. ind. VIa I. D. anno ... cc.
LXIIIº p. vero domni VRBANI pp iiii
aº 3º
Bulle fehlt Seide erhalten
Rand oben mitte R. dar B resm H5 ...
Fax. ... mm

3205 (recto)

Paris Archives Nationales
 J 457 n. 8
Breite 72.1 Rand links 4.3 rechts 4.3
Höhe 56. Rand oben 7. plica 3.6
Erste Linie für Oberlängen !
Je zwei Seitenlinien
cf. P.18670 1263 Octobris 3
Vrbanus iiii . Waltero Epo Wigor-
nien.
Inter occupationes multiplices
Dat apud Vrbemveterem V
Non Octobr. / aº 3º
Bulle an Hanf
In plica rechts : . S . (Vacat)
Sub plica links : Ja anc̄
 29
 Gras. I. S. amor a . d ji

3205 (verso)

Ecke oben links : R.
A tergo oben mitte : pro terra sc̄a
. Kleine ganz prachtvolle Schrift

3206

Paris Archives Nationales
 J 457 n. 8 bis
Breite 53.1 Rand links 1.6 rechts 2.4
Höhe 43.2 Rand oben 4.7 plica 3.3
Erste Linie über den Oberlängen
Je zwei Seitenlinien
cf. P.18670 1263 Octobris 3
Vrbanus iiii . . Epo Menevien
Inter occupationes multiplices
Dat apud Vrbemveterem V Non
Octobr. / aº 3º
Bulle an Hanf
sub plica links : R̄o
A tergo oben mitte : pro terra sc̄a
Sehr kleine enge schöne Schrift

Paris Archives nationales
 J 457 n. 8 ter.
Breite 59.2 Rand links 1.6 rechts 1.6
Höhe 47. Rand oben 4.2 plica 3.5
 Erste Linie über den Oberlängen
Je zwei Seitenlinien
cf P. 18670 1263 Octobris 3
Vrbanus III . . Epō Meneuen
 Inter occupationes multiplices
Dat apud Vrbemueterem V non
Octobr / aº 3º
 Bulle an Hanf
In plica links : Rō
A tergo oben Mitte : pro terra sca .
Kleine fette deutliche Schrift

Paris Archives Nationales
 J 457 n. 8 quater
Breite 72.9 Rand links 3.8 rechts 3.9
Höhe 52. Rand oben 6.2 plica 3.7
Erste Linie für Oberlängen / Je
zwei Seitenlinien
cf P. 18669 1263 Octobris 3
Vrbanus III . . Epō Sanctiandree
 Inter occupationes multiplices
Dat apud Vrbemueterem V non
Octobr / aº 3º
 Bulle an Hanf
In plica rechts : Ay. M.
A tergo oben Mitte : pro terra sca
Kleine sehr fette strumpfe Schr.

Paris Archives Nationales
 J 445 n. 25
Breite 55.6 Rand links 4.6 rechts 1.5
Höhe 41.1 Rand oben 6. plica 4.
Erste Linie über Oberlängen / Je
eine Seitenlinie
 1263 Octobris 4
Vrbanus III . . Epō Sancti Andree
 De summis celorum
Dat apud Vrbemueterem IIII non
Octobr / aº 3º
 Bulle an Hanf
Sub plica links :
 g. S. A. de 1tᵃ
A tergo oben Mitte : pro Terra Sca
Unten rechts : Andreas de Jh III
fette grosse Schrift
 cf P. 18673 — 18675

Paris Archives Nationales
 J 445 n. 26 ter
Breite 52.2 Rand links 1.7 rechts 1.5
Höhe 37.2 Rand oben 5.4 plica 3.8
Erste Linie über den Oberlängen /
Je eine Seitenlinie
 1263 Octobris 4
Vrbanus III . . Epō Menenen
 De summis celorum
Dat apud Vrbemueterem / IIII
non Octobr aº 3º
 Bulle an Hanf
In plica rechts : F. d
A tergo oben Mitte : pro terra sca
Kleine fette regelm. Schrift
 cf P. 18673 — 18675

3211

Paris Archives Nationales
J 445 n. 26 quater

Breite 53. Rand links 4.6 rechts 1.4
Höhe 41. 8 Rand oben 4.3 plica 5.5
Erste Linie für Oberlingen / Je
eine Seitenlinie

1263 Octobris 4

Urbanus IIII . . . Epo Menevien
De summis celorum
dat apud Urbem veterem IIII Non
Octobr a° 3 cf. P. 18573 –
Bulle an Hanf 18675
In plica rechts : And. G.
Sub plica links : ⁝

Jac. Mut. G. S.
.3.

A tergo oben Mitte : pro terra sca
Ecke unten rechts : Jac Mut ᛤ

3212 (recto)

Paris Archives Nationales
J 445 n. 26 quinquies

Breite 54. Rand links 1.7 rechts 1.7
Höhe 41. Rand oben 6.1 plica 3.3
Erste Linie über den Oberlingen
Je eine Seitenlinie

1263 Octobris 4

Urbanus IIII Waltero Wigornien
Epo
De summis celorum
Dat / apud Urbemveterem IIII
Non Octobr a° 3° cf. P. 18673 –
Bulle an Hanf 18675
In plica rechts : – J. G.
Sub plica links : ⁝

p. Ra IIII S. Riger A. S. duas
.3.

Ecke oben links! ℞ Vute

3212 (verso)

A tergo oben Mitte :
pro Terra Sancta
Ecke unten rechts:
Andreas de Sg
Weite Zeile ungemein regelmässige
Schrift.

3213

Paris Archives Nationales
J 457 n. 9

Breite 55.8 Rand links 1.9 rechts 2.3
Höhe 41.1 Rand oben 6. plica 4.1
Erste Linie über Oberlingen / Je
eine Seitenlinie

1263 Octobris 4

Urbanus IIII . . . Epo Sancti Andree
De summis celoy
Dat apud Urbemveterem IIII Non
Non Octobr / a° 3°
Bulle an dickem Hanf
In plica rechts : A. de Jc
Sub plica links : ⁝
A tergo oben Mitte : pro Terra sca
Sehr schöne kräftige Schrift

cf. P. 18673 – 18675

3214

Arch. arcis
Arm. XV capo. 3 cap. 75
P. — 1263 Oct. 10
Urb. IIII .. epo Anagnin.
Dilectus filius Stephanus
Apud urbemveterem VI id. oct.
a° 3°

 Bulle an Hanfschnur
In pl. rechts: . L. p
Sub pl. links: ..
 Ja ano
 4

3215

Archives nationales Paris
L 256 n. 59 1263 Octobris 11
Br. 31.4 hoch 22.7 Plica 3.6
oberer Rand 5.3 links 1.6
rechts 1.6
‖ Urbanus IIII (mit sehr feinen
Arabesken .. Abbati et Conventui
Monasterij sancti Germani de
Pratis Parisien ad Romani ecclesiam
nullo medio pertinentis ordinis
sancti Benedicti
Cum a nobis
Dat. apud urbemveterem V Id.
Octobr. a° 3°

 Bulle und Seide fehlen

 Ohne alle Bemerkungen

Fette runde Schrift, mit gestr. Liga-
turen [symbols] mit 4 vasen
[symbols] zum teil aufragen

Erste Zeile ein visierter Buchstabe

Erste Linie für Papstnamen

Papstname im Text in Gitterschrift

 P. vacat

3216

 (Datum)

Archives nationales Paris
 J. 451 n. 10
Breite 27.1 Rand links 1.2 rechts 1.2
Höhe 18.7 Rand oben x. plica 3.1
Erste Linie für Gitterschr und
Oberlängen / Je eine Seitenlinie
P. vacat 1263 Octobris 15
Urbanus IIII (Gitterschr.) .. Epo Me-
nenen
 Volentes omnes crucesignatos
Dat / apud urbemveterem Id oc-
tobr. a° 3°
Bulle an feiner Seide
In plica rechts : . f. a.
A tergo oben mitte : pro terra sca

3217

Paris Archives nationales
 J 451 n. 10 (bis)
Breite 28.3 Rand links 1.3 rechts 1.5
Höhe 19.2 Rand oben 3.9 plica 3.4
Erste Linie für Oberlängen (und Gitterschr.) Je
eine Seitenlinie
P. vacat 1263 Octobris 15
Urbanus IIII (Gitterschr.) .. Epo Me-
nenen
 Volentes omnes crucesignatos
Dat. apud urbemveterem Id octo-
br. / a° 3°
Bulle an feiner Seide (verte)
In plica rechts : . F. g. parent
Sub plica links : ..
 Ja mit G. S. ‖
A tergo oben mitte : pro terra sca
fette mittelgr. regelm. Schrift
Ligaturen gemischt

3218

Paris Archives Nationales
J 457 n. 10 (ter)
Breite 20.7 Rand links 1.3 rechts 1.2
Höhe 20 Rand oben 3.7 plica 2.4
Erste Linie über den Oberlängen
Je eine Seitenlinie

P. vacat 1263 Octobris 15

Vrbanus IIII Archiepis ↄ Epis ac dil
filijs ceteris ecclesiarꝫ prelatis per
Walliam constitutis

Terram sanctam quam
Dat apud Vrbemveterem Jd Octob.
Oꝭ 1 a° 3°
Bulle an Hanf
In plica rechts : G. A.
A tergo oben Mitte : pro terra sca
Kleine flüssige schöne Schrift

3219

Paris Archives Nationales
J 457 n. 10 (quater)
Breite 21. Rand links 1.4 rechts 1.8
Höhe 21.9 Rand oben 3.9 plica 2.8
Erste Linie über Oberlängen / Links
Zwei Seitenlinien, rechts eine

P. vacat 1263 Octobris 15

Vrbanus IIII Archiepis ↄ Epis ac
dil filijs ceteris ecclesiarꝫ prelatis per
Walliam constitutis

Terram sanctam quam
Dat apud Vrbemveterem Jd
Octobꝫ 1 a° 3°
Bulle an Hanf
In plica rechts : . E. G. parenth
Sub plica links : Jac Mut. G. S. II
A tergo oben Mitte : pro terra sca
Große kleine schöne Schrift

3220 (recto)

Datum

Archives Nationales Paris
J 445 n. 26
Breite 30. Rand links 7.3 rechts 1.2
Höhe 23.6 Rand oben 4.1 plica 3
Erste Linie über den Oberlängen /
Je eine Seitenlinie

J. P. 18691 1263 Octobris 23

Vrbanus IIII Archiepis et Epis ac
dil filijs ceteris ecclesiarꝫ prelatis per
Regnum Scotie constitutis

Terram sanctum quam
Dat apud Vrbemveterem x Kl No
vembꝭ 1 a° 3°
x Kl Nov. mit schwärzerer Tinte
nachgetragen
Bulle an Hanf
In plica rechts : . A de Fr
Sub plica links : ꝫ

3220 (verso)

A tergo oben Mitte
pro terra sca
Kleine ungemein regelmäßige
Schrift

[Datum]

Paris Archives Nationales
J 448 n. 82

Breite 20.3 Randlinks 1.4 rechts 1.4
Höhe 22.9 Rand oben 3.9 plica 2.5
Erste Linie hoch über Oberlängen /
Je eine Seitenlinie

cf. P. 18689 1263 Octobris 23

Vrbanus IIII . . Archiepis et Epis
ac Dil filijs cleris ecclear prelatis
per Regnum Scotie constitutis
Terram sanctam quam
Dat apud Vrbem neterem X Kl
Nonembr / a° 3°

X Kl non. nachgetragen

Bulle an dickem Hanf
In plica rechts : Jat Romanus
Sub plica links : d. de it G. S.
Sehr schöne Schrift
3

Paris Archives Nationales
J 448 n. 83

Breite 29. Randlinks 1.4 rechts 1.4
Höhe 20.5 Rand oben 3.5 plica 3.1
Erste Linie für Gitterschr und
Oberlängen / Je eine Seitenlinie

cf. P. 18690 1263 Octobris 23

Vrbanus IIII . . . Epo Sancti An-
dree
Volentes omnes mecsignatos
Dat apud Vrbem neterem IX Kl
Nonembre a° 3°
Bulle an Seide
In plica rechts : A. de Jc
A tergo oben mitte : pro terra sca
Kleine sehr regelm. fette Schrift
Viel variierte Buchstaben

Paris Archives Nationales
J 448 n. 84

Breite 24.7 Randlinks 1.2 rechts 1.5
Höhe 17.6 Rand oben 3.6 plica 2.7
Erste Linie für Gitterschr und
Oberlängen / Je eine Seitenlinie

P. vacat 1263 Octobris 23

Vrbanus IIII (Gitterschr) Vniuersis
predicatoribus nerbi crucis pro
terre sancte subsidio ac execu
toribus negotij eiusdem crucis
Volentes labores uros
Dat apud Vrbem neterem X Kl
Nonembre a° 3°
Bulle an feiner Seide
In plica rechts : A. Synitz
Sub plica links : Jat Jud g. S. II
3

Paris Archives Nationales
J 448 n. 84 bis

Breite 25.8 Randlinks 1.2 rechts 1.2
Höhe 19. 3 Rand oben 3.7 plica 2.6
Erste Linie über Oberlängen, für
Gitterschr / Je eine Seitenlinie

P. vacat 1263 Octobris 23

Vrbanus IIII ut in n. 84
Dat apud Vrbem neterem VIJ
Kl Nonembr / a° 3°
Bulle an Seide
In plica links : J. S.
A tergo oben Mitte : pro terra sca
Kleine feste Schrift

Datum

Paris Archives Nationales
J. 448 n. 84 ter
Breite 25. Rand links 1.1 rechts 1.
Höhe 19.7 Rund oben 3.7 plica 2.7
Erste Linie für Gitterschr. und
Kleine Oberlängen / Je 1 Seitenlinie
P. vacat 1263 Octobris 23
Urbanus IIII etc. ut in n. 84
Dat / apud Vrbemueterem VIII
Kl Nouembr a° 3°
Bulle an Seide
In plica links : J. V
A tergo oben links :
pro Terra sca
Kleine sehr schöne Schrift

Paris Archives Nationales
J. 457 n. 11
Breite 24.5 Rand links 2. rechts 2.1
Höhe 23.8 Rund oben 4.5 plica 3.1
Erste Linie für Gitterschr und Ober
längen / Je eine Seitenlinie / Sehr
weite Zeilenabstände
Puniert 1263 Octobris 23
Urbanus IIII (Gitterschr). . Epō
Sanctiandree J. P. 18690
Volentes omnes Ccrucesignatos
Dat apud Vrbemueterem X Kl
Nouembr Ja° 3°
Bulle an feiner Seide recte
In plica rechts : Jō. Romanus
Sub plica links : ?
 x. dt iñ J. S.
 3

A tergo oben Mitte :
pro Terra sca
Sehr schöne fette feste Schrift

Paris Archives Nationales
J. 457 n. 12
Breite 48.1 Rand links 1.1 rechts 1.
Höhe 43.2 Rund oben 4.9 plica 3.3
Erste Linie über Oberlängen /
Je eine Seitenlinie .
P. vacat 1263 Octobris 23
Urbanus IIII Vniuersis Archiepis
7 Epis ac dil filijs fratribz Predi
catoz et Minoz ordinum ceteri
squo executoribz per diuersas
piana Regna mundi ad crucis
negotium pes pro Terre scē fudend
subuentione a sede aplica deputatis
et in posterum deputandis
Cum negotium crucis
Dat apud Vrbemueterem X Kl

3227 (verso)

Novembr̄ a° 3°

Bulle an Hanf

In plica rechts : d

A tergo oben Mitte : pro terra ṡcā

Sehr schöne kleine sehr regelm. Schr

3228

Paris Archives Nationales

J 457 n. 12

Breite 60. Rand links 2.5 rechts 3.

Höhe 46.6 Rand oben 7.8 plica 4.6

Erste Linie schneidet die Oberlängen

Je eine Seitenlinie

P. vacat 1263 Octobris 23

Vrbanus ꜰꝰ etc. ut in n. 12

Dat apud Vrbem̄ veterem

Novembr̄ / a° 3°

Bulle an Hanf

In plica rechts : G. Vit

Sub plica links : X

Jo gat G.S. Jac Gaut

A tergo oben Mitte : pro Terra ṡcā

Ecke unten rechts : Jac Gaut /

Kleine fette stumpfe Schrift

3229

Paris Archives Nationales

J 457 n. 12 ter

Breite 59. Rand links 2.2 rechts 2.2

Höhe 47.7 Rand oben 5.9 plica 4.9

Erste Linie für die höheren Ober-

längen / Je eine Seitenlinie

P. vacat 1263 Octobris 23

Vrbanus ꜰꝰ etc. ut in n. 12

Dat apud Vrbem̄ veterem / X kl.

Novembr̄ a° 3°

Bulle an Hanf

In plica rechts : d p u

Sub plica links : T

a.a.a. G.S.

A tergo oben Mitte : pro Terra ṡcā

Sehr kleine ungemein regelm. Schr

3230

Paris Archives Nationales

J 457 n. 13

Breite 24.8 Rand links 0.9 rechts 0.9

Höhe 19.6 Rand oben 4.2 plica 2.5

Erste Linie für Gottesschr. und

kleine Oberlängen / Je 1 Seitenlinie

P. vacat 1263 Octobris 23

Vrbanus ꜰꝰ (Gottesschr) Vniversis

Predicatoribus urbi Crucis pro terra

Sancte subsidio ac executoribus

negotij eiusdem Crucis

Volentes labores nestros

Dat apud Vrbem̄ veterem VIII kl.

Novembr̄ / a° 3°

Bulle an feiner Seide

In plica links : p. V.

A tergo oben Mitte : pro terra ṡcā

Sehr schöne schwungvolle Schrift

3231

Bayer. Haupt. Staatsarchiv
Oberelchingen Fasc. 1

P. 18706ᵃ 1263 Novembris 8

Vrbanus IIII dil. in xpo filiabus pri-
orisse et sororibus Monasterij de
Medilingen ordinis sancti Augustini
secundum institut. fram predica-
torum viuentibus Auguster. dioc:
 Cum dilectis filijs
apud vrbemueterem VI jd. Nouem-
bris anno Tertio

Bulle an Hanf
 In plica rechts : a. d.
In plica links : Pu.
Ecke oben links : Pu.

Sub plica links :

Ganz kleines Mandat

Duplicat : Bulle an Hanf
In plica rechts : G. de Sigestro

Sehr feine zierliche Schrift.

3232

Bayer. Haupt. Staatsarchiv
Oberelchingen Fasc. 1

P. 18707ᵃ 1263 Novembris 8

Vrbanus IIII ... Magistro generali et
... priori prouinciali fratrum pre-
dicatorum in Alamania
 Dilecte in xpo
apud vrbemueterem VI jd. No-
uembris anno Tertio

Bulle an dicker Hanfschnur
In plica rechts : d. pa
Ecke oben links : Dus
Rand oben nach rechts : cor

Sub plica links : Jn Am

B pa S

3233

Paris Archives Nationales
 J 457 n. 14

Breite 57.6 Rand links 1.7 rechts 1.9
Höhe 40 Rand oben 4.7 plica 3.7
Erste Linie für Oberlängen /
Je eine Seitenlinie

P. 18712 1263 Novembris 13

Vrbanus IIII etc nt in n. 12
 Dat apud Vrbemueterem jd
Nouembr aᵒ 3ᵒ
Bulle an Hanf
In plica rechts : R. C.
Sub plica links : g. s.

A tergo oben Mitte : pro terra sca
Kleine fette deutliche Schrift

3234

Paris Archives Nationales
 J 451 n. 14 bis

Breite 58.5 Rand links 1.7 rechts 1.9
Höhe 45 Rand oben 5.2 plica 4.1
Erste Linie für Oberlängen
Je eine Seitenlinie

P. 18712 1263 Novembris 13

Vrbanus IIII Archiepis L Epis
ac dil filijs etc. nt in n. 12
 Dat apud Vrbemueterem jd
Nouembr / aᵒ 3ᵒ
Bulle an dickem Hanf
In plica rechts : Jo Sal
A tergo oben Mitte : pro terra sca
Sehr kleine fette Schrift

Paris Archives Nationales
J 457 n. 14 ter
Breite 61.4 Rand links 1.7 rechts 1.6
Höhe 45.1 Rand oben 5.2 plica 4.8
Erste Linie für Oberlängen /
Je eine Seitenlinie
P. 18712 1263 novembris 13
Vrbanus IIII etc ut in n. 12
Dat apud Vrbemueterem Id
Nonembr a° 3°
Bulle an Hanf
In plica rechts: Jo Sal
Sub plica links: X
 a p 9. S. M. C
 :3
A tergo oben Mitte: pro terra scā
Kleine fette deutliche Schrift

Arch. Arcis
Arm. XIV cap. 8 cap. 45
P. 18715 1263 novembris 19
Vrb. IIII magistro Alberto notario
nostro
Nuper nobis quandam
apud Vrbemueterem XIII Kl.
Decembris a° tertio
Bulle an Hanfschnur
Ohne alle Notizen

Zu Beginn bei Aufzählung
mehrerer Artikel schwize
Capitelszeichen

Paris Archives Nationales
J 448 u. 86
Breite 60.8 Rand links 2.3 rechts 2.3
Höhe 48.6 Rand oben 6.6 plica 2.4
Erste Linie für Oberlängen / Je
eine Seitenlinie
P. vacat 1263 Novembris 29
Vrbanus IIII .. Epo Sancti Andree
Inter occupationes multiplices
Dat apud Vrbem ueterem III Kl
Decembr / a° 3°
Bulle an Hanf
In plica links: ʃ
 x x
 Sub plica links: Jo Anag
A tergo: pro terra scā G. B.
 :3
Kleine fette Schrift

Paris Archives Nationales
J 448 . n. 81
Breite 39.5 Rand links 1.2 rechts 1.2
Höhe 30.8 Rand oben 3.9 plica 2.7
Erste Linie hoch über Oberlängen /
Je eine Seitenlinie
P. vacat 1264 Januarii 7
Vrbanus IIII .. Archiepo Tyren
et dil filio Nob viro Johanni de
Valengenis dno Cayphe
Dilectus filius frater
Dat apud Vrbemueterem VII Id
Januar / a° 3°
Bulle an Hanf
In plica rechts: G. Saon. de Cur
Kleine unruhige Schrift

de Curia

3239

Napoli Curia Eccles. Vol. 40
p. —
_____ 1264 Ianuarii 9
Urbanus IIII .. archiepo Tarentin.
Sub religionis habitu
Apud Urbemveterem V id.
Ian. a° 3°
Bulle und Druck fehlen
In plica rechts F.
Ecke oben rechts ...
A tergo Ecke oben links g

3240

Archivio di Stato Milano
Bolle e Brevi
P. 18779 1264 Ianuarii 13
Urbanus IIII ad certitudinem
presentium et memoriam fu-
turorum
Dudum felicis recordationis
Actum apud Urbemveterem
id. Ianuarii a° 3°
Bulle und Seide fehlen
In plica rechts N. g. potent

3241

Intr. ... F. Dom. c. 131 1264 Ian. 13
P. 18779
Urbanus IIII ad certitudinem presentium
et memoriam futurorum
Dudum felicis recordationis
apud Urbemveterem id. Ianuarii a° 3°
Bulle an Seidenfäden
In plica rechts: Gibertus p
Sub plica links:
:
v
Ja Sal
. M.
A tergo: frater Troianus

Michael de Tholosa
Vicecancellarius

3242 (recto)

Paris Archives Nationales
J 445 n. 18 c
Breite 35. Rand links 1.4 rechts 1.4
Höhe 28.2 Rand oben 5.7 plica 3.8
Erste Linie für Oberlängen / Je eine
Linienlinie
P. vacat 1264 Ianuarii 21
Urbanus IIII Universis Patriarchis
Archiepis ? Epis ac dil filijs Electis
abbatibz Prioribz Capitulis Conventibz
et Collegijs Sancti Benedicti nec non cu
cuislibet alterius ordinis necnon de
cuis archidiaconis Prepositis Archi-
pbris et alijs ecclie Prelatis et Rec-
toribus ac Preceptoribus seu admini-
stratoribus domos Hospitalis ? Templi
ac Sancte Marie Theotonicorum exemp...

3242 (verso)

tis et non exemptis ad quos litteras
iste pervenerint
Cum negotium Terre
Dat apud Vrbemueterem / xiiij Kl
Febr a° 3°
Bulle an Hauf
In plica rechts : · a · a · a ·
Sub plica links : ·
 Jo Sal
 G
A tergo oben Mitte : pro Terra Sta
Zierliche Zette Kleine Schrift

3243

Paris Archives Nationales
 J 445 n. 18 b
Breite 35.2 Rand links 2.1 rechts 1.8
Höhe 29.3 Rand oben 6.1 plica 3.1
Erste Linie für Oberlingen / Je
eine Seitenlinie
P. vacat 1264 Januarii 21
Vrbanus etc ut in n. 18
Dat apud Vrbemueterem xiiij Kl
Febr a° 3°
Bulle an Hauf
An plica rechts : · a · a · a ·
Sub plica links : ·
 Jo Sal
 G
A tergo oben Mitte : pro Terra Sta
Zette Kleine prächtige Schrift.

3244 (recto)

Paris Archives Nationales
 J 445 n. 26 bis
Breite 34.5 Rand links 1.4 rechts 1.7
Höhe 28.6 Rand oben 6. plica 3.2
Erste Linie für Oberlingen / Je
eine Seitenlinie
P. vacat 1264 Januarii 21
Vrbanus IIII Vniuersis Patriar
chis Archiepis et Epis ac dil filiis
Electis Abbatib3 Prioritb3 Capitulis
Conuentib3 y Collegiis sancti Benedicti
uel cuiuslibet alterius ordinis necnon
Decanis Archidiaconis Prepositis Ar
chipbris et aliis eccliar prelatis ac
Rectoribus ac preceptoribus seu admi
nistratoribus domox Hospitalis et Templi
ac sancte Marie Theotonicox ex
emptis y non exemptis ad quos

3244 (verso)

quos litteras iste pervenerint
Cum negotium Terre
Dat qp apud Vrbemueterem xiiij Kl
Febr / a° 3°
Bulle an Hauf
In plica rechts : · a · a · a ·
Sub plica links : ·
 Jo Sal
 · G
A tergo oben Mitte
 pro Terra Sancta
Kleine sehr schöne Schrift

3245

Archives Nationales Paris
L 256 n. 60 1264 Januarii 21
Br. 35.9 hoch 29.5 Plica 3.7
oberer Rand 7.1 links 1.6
rechts 1.5
 Urbanus IIII vniuersis Patriar-
chis, Archiepis z Epis ac dil. filijs
 Electis Abbatibus Prioribus Capitu-
lis Conuentibus z Collegijs sancti
Benedicti vel cuiuslibet alterius ordi-
nis necnon Decanis Archidiaconis
Prepositis Archipbris z alijs ecclie
Prelatis et Rectoribus ac Preceptori-
bus seu Administratoribus domorum
Hospitalis z Templi ac sancte Marie
Theotonicorum exemptis et non exem-
tis ad quos littere iste peruenerint
 Cum negotium Terre
Dat apud Vrbemueterem xij kl
Febr. a° 3°
 P. vacat
Bulle an Hanf
 Die plica rechts viel auseinanda:
 a a a
Sub plica links: Jo.? Sal
 Jo. Sal
A tergo oben Mitte: pro Terra sca
Kleine fette Schrift mit einem be-
sondern Buchstaben
Erste Linie für Oberlängen

3246

Paris Archives Nationales
 J 457 n. 15³
Breite 43.2 Rand links 1.8 rechts 1.9
Höhe 32.5 Rand oben 6 plica 4
Erste Linie für Oberlängen/
Je eine Seitenlinie
P. vacat 1264 Januarii 25
Vrbanus IIII etc. ut in n. 12
Dat. apud Vrbem ueterem VIII
kl Februarij / a° 3°
Bulle an dickem Hanf
In plica rechts: R. C.
A tergo oben Mitte: pro terra sca
Kleine stumpfe Schrift

3247

Paris Archives Nationales
 J 445 n. 4³
Breite 36.3 Rand links 1. rechts 1.2
Höhe 27.1 Rand oben 5.2 plica 2.6
Erste Linie über den Oberlängen/
Je eine Seitenlinie
P. vacat 1264 Januarii 26
Vrbanus IIII etc. ut in n. 4
Dat apud Vrbemueterem / VIJ kl
Februarij a° 3°
Bulle an Hanf
In plica rechts: F. R
Sub plica links:
A tergo oben Mitte: pro terre sca
Kleine schöne Schrift

3248 (recto)

Paris Archives Nationales
 J 445 n. 17
Breite 33,2 Rand links 1.3 rechts 1.3
Höhe 23.9 Rand oben 4.5 plica 2.6
Erste Linie über Oberlängen / Je
eine Seitenlinie
P. 18789 1264 Januarii 26
Vrbanus IIII Vniuersis Archiepis
Epis ac dil filijs Abbatib Prioub
Decanis Archidiaconis necnon Priori
bz Predicato Ministris seu Guardianis
Minoz ordinum ceterisque personis
ecclasticis vel religiosis per omnia
xpiana Regna mundi et prouincias
ad crucis negotium et ad colligenda
subsidia pecuniaria pro terre sce
subsidio a sede aplica deputatis

et in paterum deputandis
 Et si ad
Dat apud Vrbemueterem VII kl
Februar / a° 3°
 Bulle fehlt Hanf erhalten
In plica rechts : d fu
a tergo oben Mitte :
 pro terra sancta
Kleine schöne Schrift

Paris Archives nationales
 J. 445 n. 17³
Breite 39.5 Rand links 1.5 rechts 1.4
Höhe 24.5 Rand oben 4.4 plica 3.1
P. 18788 1264 Ianuarii 26
Vrbanus IIII ut in n. 17
 Dat apud Vrbemueterem VII
kl Februar / a° 3°
 Bulle fehlt Hanf erhalten
In plica rechts :. S. R
Vnb plica links :
 A tergo oben Mitte :
 p tra sca
Kleine schöne Schrift

Paris Archives nationales
 J. 445 n. 17³
Breite 34.6 Rand links 4.5 rechts 1.4
Höhe 27.3 Rand oben 4.3 plica 3.2
Erste Linie über Oberlängen / Je
eine Seitenlinie
P. 18788 1264 Ianuarii 26
Vrbanus IIII E. Archiepo Tyren
et dil filio Nob viro Johi de Valen
tinis domino Cayphe
 Cum nos diuersa
Dat apud Vrbemueterem VII kl
Februar a° 3°
 Bulle an Hanf
In plica rechts : Jac Romanus
A tergo oben Mitte : pro terra sca
Kleine schöne Schrift

Paris Archives nationales
 J. 457 n. 15ᵈ
Breite 43.9 Rand links 1.7 rechts 1.8
Höhe 33. Rand oben 5.4 plica 4.6
Erste Linie über den Oberlängen
Je eine Seitenlinie
P. vacat 1264 Ianuarii 26
Vrbanus IIII etc ut in n. 12
Dat apud Vrbemueterem VII kl
Februar / a° 3°
 Bulle an Hanf
In plica rechts : R . C
A tergo oben Mitte : pro terra sca
Kleine fette strumpfe Schrift

3252

Paris Archives Nationales
J 445 n. 4⁶

Breite 38.1 Rand links 1.4 rechts 1.3
Höhe 26.1 Rand oben 5.6 plica 3.3
Ohne freie erste Linie / Je eine
Seitenlinie

P. vacat <u>1264 Januarii 26</u>

Vrbanus IIII <u>ut in n. 4</u>
Dat apud Vrbemueterem / VII kl
Febr a° 3°
Bulle fehlt Hanf erhalten
In plica rechts : Jac. Mut
A tergo oben Mitte : pro terra scā
Fette ungemein regelmässige schöne
Schrift

3253

Paris Archives Nationales
J 457 n. 15³

Breite 41. Rand links 1.4 rechts 1.6
Höhe 29.9 Rand oben 5.4 plica 4.6
Erste Linie für Oberlängen / Je
eine Seitenlinie

P. vacat <u>1264 Januarii 26</u>

Vrbanus IIII <u>etc. ut in n. 12</u>
Dat apud Vrbemueterem. VII
kl Februar / a° 3°
Bulle an Hanf
In plica rechts : Rp R. C
A tergo oben Mitte : pro terra scā
Schwungvolle fette Schrift

3254

Paris Archives Nationales
J 457 n. 15⁴

Breite 36.8 Rand links 1.2 rechts 1.3
Höhe 29. Rand oben 4.5 plica 2.7
Ohne erste freie Linie / Je eine
Seitenlinie

P. vacat <u>1264 Januarii 26</u>

Vrbanus IIII etc. ut in n. 10
Dat apud † Vrbemueterem VII kl.
Februar / a° 3°
Bulle an Hanf
In plica rechts : a . a . a
A tergo oben Mitte : pro terra scā
Sehr regelm. feine kleine Schrift

3255

Paris Archives Nationales
J 457 n. 15⁵

Breite 39.1 Rand links 1.2 rechts 1.4
Höhe 26. Rand oben 4.6 plica 3.
Erste Linie über den Oberlängen
Je eine Seitenlinie

P. vacat <u>1264 Januarii 26</u>

Vrbanus IIII <u>etc. ut in n. 12</u>
Dat apud Vrbemueterem / VII
kl Februar a° 3°
Bulle an Hanf
In plica rechts : J. B
Sub plica links : Jo Jal
A tergo oben Mitte : pro terra scā
Runde regelm. Schrift

3256

Paris Archives Nationales
J 457 n. 15[16]
Breite 39.5 Rand links 1.4 rechts 1.4
Höhe 28.4 Rand oben 5.2 plica 2.6
Erste Linie über den Oberlängen
Je eine Seitenlinie
P. vacat 1264 Januarii 26
Vrbanus IIII etc. ut in n. 12
Dat apud Vrbemueterem
VII Kl. Februarii / aº 3º
Bulle an Hauf
In plica rechts: J. Cu
A tergo oben mitte: pro terra sca
Schöne klare weite Schrift

3257

Paris Archives Nationales
J 457 n. 15[D]
Breite 40. Rand links 1.4 rechts 1.8
Höhe 31.5 Rand oben 6 plica 3
Erste Linie für Oberlängen / Je
eine Seitenlinie
P. vacat 1264 Januarii 26
Vrbanus IIII etc ut in n. 12
Dat apud Vrbemueterem
VII Kl. Februarii /aº 3º
Bulle an Hauf
In plica rechts: a. a. a.
Sub plica links: Jo Sal
A tergo oben mitte:
pro terra sca
Kleine enge deutliche Schrift

3258

Paris Archives Nationales
J 457 n. 15[E]
Breite 38.1 Rand links 1.4 rechts 1.4
Höhe 26.2 Rand oben 4.9 plica 3.
Ohne erste freie Linie / Je
eine Seitenlinie
P. vacat 1264 Januarii 26
Vrbanus IIII etc ut in n. 12
Dat apud Vrbem ueterem / VII
Kl. Februarii aº 3º
Bulle fehlt Haufehalten
In plica rechts: Jac kuut
A tergo oben mitte: pro Terra sca
Fette kleine klare Schrift

3259

Paris Archives Nationales
J 451 n. 15[D]
Breite 38.1 Rand links 1.2 rechts 1.1
Höhe 26. Rand oben 5.1 plica 2.9
Erste Linie für Oberlängen /
Je eine Seitenlinie
P. vacat 1264 Januarii 26
Vrbanus IIII etc. ut in n. 12
Dat apud Vrbemueterem VII
Kl. Februarii / aº 3º
Bulle an Hauf
In plica rechts: B. Meß
A tergo oben mitte: pro terra sca
Sehr schöne zusammenhängend.
Schrift

3260

⟨Datum⟩

Paris Archives Nationales
J 457 n. 15^{40}
Breite 38.2 Rand links 1.7 rechts 1.7
Höhe 25.9 Rand oben 5.4 plica 2.4
Erste Linie über den Oberlängen
Je eine Seitenlinie
P. vacat 1264 Januarii 26
Vrbanus IIII etc. ut in n. 12
Dat. apud Vrbemueterem VII Kl
Februarii a° 3°
Bulle an Hanf
In plica rechts: · F · P ·
A tergo oben Mitte:
pro terra Sca
Kleine deutliche Schrift

3261

Paris Archives Nationales
J 457 n. 15^{41}
Breite 37. Rand links 1.1 rechts 1.2
Höhe 24.3 Rand oben 4.6 plica 3.
Erste Linie für Oberlängen
Je eine Seitenlinie
P. vacat 1264 Januarii 26
Vrbanus IIII etc. ut in n. 12
Dat apud Vrbem ueterem VII Kl
Februarii a° 3°
Bulle an Hanf
In plica rechts: B. Meff
A tergo oben Mitte: pro terra Sca
Prächtige feste Schrift

3262

Paris Archives Nationales
J 457 n. 15^{42}
Breite 39.8 Rand links 1.4 rechts 1.4
Höhe 26.5 Rand oben 4.5 plica 2.6
Erste Linie über den Oberlängen
Je eine Seitenlinie
P. vacat 1264 Januarii 26
Vrbanus IIII etc. ut in n. 12
Dat apud Vrbem ueterem VII
Kl Februarii a° 3°
Bulle an Hanf
In plica rechts: J. Cu
A tergo oben Mitte: pro terra Sca
Schöne etwas spitze Schrift

3263

Paris Archives Nationales
J 457 n. 15^{43}
Breite 38.7 Rand links 1.5 rechts 1.5
Höhe 24.3 Rand oben 6 plica 2.8
Erste Linie für Oberlängen
Je eine Seitenlinie
P. vacat 1264 Januarii 26
Vrbanus IIII etc. ut in n. 12
Dat apud Vrbem ueterem VII
Kl Februarii a° 3°
Bulle an Hanf
In plica rechts: · a · a · a ·
A tergo oben Mitte: pro terra Sca
Schöne etwas spitze Schrift

3264

Paris Archives Nationales
J 457 n. 15^{14}

Breite 33,4 Rand links 1,1 rechts 1,1
Höhe 24,6 Rand oben 4,3 plica 2,8
Erste Linie für Oberlängen
Je eine Seitenlinie
P. vacat _1264 Januarii 26_
Vrbanus IIII etc. ut in n. 12
Dat apud Vrbemneterem VII kl
Februarij a° 3°
Bulle an Hanf
In plica rechts: Mich
A tergo oben Mitte: pro terra sca
Unschöne kleine fette Schrift

3265

(Datum)

Paris Archives Nationales.
J 451 n. 15^{15}

Breite 34,8 Rand links 1,2 rechts 1,2
Höhe 24,9 Rand oben 4,6 plica 3
Erste Linie für Oberlängen
Je eine Seitenlinie
P. vacat _1264 Januarii 26_
Vrbanus IIII etc ut in n. 12
Dat/apud Vrbemneterem VII
kl Februarij a° 3°
Bulle an Hanf
In plica rechts: Mich
A tergo oben Mitte:.
pro terra sca
Ganz kleine fette Schrift.

3266

Paris Archives Nationales
J 457 n. 15^{16}

Breite 38,2 Rand li. 1,4 rechts 1,4
Höhe 27,2 Rand oben 4,5 plica 2
Ohne erste freie Linie / Je
eine Seitenlinie
P. vacat _1264 Januarii 26_
Vrbanus IIII etc. ut in n. 12
Dat apud Vrbemneterem VII
kl Februarij a° 3°
Bulle an Hanf
In plica rechts: J Gu
A tergo oben Mitte: pro terra sca
Eilige spitze Schrift

3267

Paris Archives Nationales
J 457 n. 15^{17}

Breite 34,1 Rand links 1,4 rechts 1,4
Höhe 24,6 Rand oben 4,3 plica 3,1
Erste Linie über Oberlängen
Je eine Seitenlinie
P. vacat _1264 Januarii 26_
Vrbanus IIII etc. ut in n. 12
Dat apud Vrbemneterem VII
kl Februarij a° 3°
In plica rechts: . S. p u
A tergo oben Mitte:
pro terra sca
Kleine sehr schöne feste Schrift

(Datum)

Paris Archives Nationales
J. 457 n. 15[19]
Breite 37.7 Rand links 1.4 rechts 1.5
Höhe 26.8 Rand oben 5.2 plica 3
Ohne erste freie Linie
Je eine Seitenlinie
P. vacat 1264 Januarii 26
Vrbanus IIII etc. ut in n. 12
 Dat/ apud Vrbemueterem
VII kl Februar/ a° 3°
 Bulle an Hanf
In plica rechts ! Jac Mut
A tergo oben Mitte: pro terra sca
Fette kleine breite Schrift

Paris Archives Nationales
J 457 n. 15[20]
Breite 31.9 Rand links 1. rechts 0.9
Höhe 24.8 Rand oben 4.8 plica 3
 Erste Linie für Oberlängen
Je eine Seitenlinie
P. vacat 1264 Januarii 26
Vrbanus IIII etc. ut in n. 12
 Dat apud Vrbemueterem VII
kl februar/ a° 3°
 Bulle an Hanf
In plica rechts : B. Mess
A tergo oben Mitte: pro terra sca
Sehr schöne kleine Schrift

Paris Archives Nationales
J 457 n. 15[21]
Breite 35.2 Rand links 1.2 rechts 1.2
Höhe 27. Rand oben 4.7 plica 2.7
Erste Linie über Oberlängen
Je eine Seitenlinie
P. vacat 1264 Januarii 26
Vrbanus IIII etc. ut in n. 12
 Dat apud Vrbemueterem
VII kl Februar/ a° 3°
 Bulle an Hanf
In plica rechts ! · F · R · :
A tergo oben Mitte: pro terra sca
Kleine fette stumpfe Schrift

Paris Archives Nationales
J 457 n. 15[23]
Breite 38.3 Rand links 1.4 rechts 1.3
Höhe 26.7 Rand oben 5.6 plica 3.2
Ohne erste freie Linie / Je
eine Seitenlinie
P. vacat 1264 Januarii 26
Vrbanus IIII etc. ut in n. 12
Dat apud Vrbemueterem VII
kl Februar/ a° 3°
 Bulle an Hanf
In plica rechts ! Jac Mut
A tergo oben Mitte !
 pro terra sca

3272

Archives Nationales Paris

L 256 n. 61 1264 Januarii 26

Br. 39.6 hoch 26.5 plica 2.7
oberer Rand 5.9 links 1.3
rechts 1.3

Urbanus IIII universis Archiep.
et Epis. ac dil. filiis Abbatibus Prioribus Decanis Archidiaconis nec non
Prioribus Predicatorum Minorum Custodibus seu Guardianis Minorum
ordinum ceterisque personis ecclesiasticis vel religiosis p. omnia
per regna mundi et provincias
ad Crucis negotium et ad colligenda
subsidia pecuniaria pro terre sancte
subsidio a sede aplica deputatis
et in posterum deputandis
Et si ad
Dat apud Urbemveterem VII kl
Februarii a° 3°

Bulle fehlt. Hanf erhalten
In plica rechts : . f. R.
Sub plica links :

A tergo oben Mitte : pro fra sca
Ingenui schöne kleine Schrift
eng ineinander geschoben
Ein zur leicht betonter Buchstabe

Erste freie Linie zwecklos

P. 18789

3273

Archives Nationales Paris

L 256 n. 63 1264 Februarii 4

Br. 30.3 hoch 23.3 plica 3.3
oberer Rand 5.1 links 1.3
rechts 1.4

Urbanus IIII . . Priori Sce Petri
de Calce Suessionen.
dilecta in Xpo
Dat apud Urbemveterem T non
Februarii a° 3°

Bulle und Hanf fehlen
In plica rechts : . P. B.
Sub plica links . . .
Ecke oben rechts : . P.

Nichtzeilige kleine Schrift
mit einem betonten Buchstaben
Erste freie Linie zwecklos

P. vacat

3274

P. 18801 ad instar

Archives Nationales Paris

L 256 n. 64 1264 Februarii 17

Br. 31.4 hoch 26.2 plica 3.6
oberer Rand 5.8 links 1.6
rechts 1.4

Urbanus IIII (Maiusculae)
dilectis in Xpo filiabus . . Abbatisse et Sororibus Monasterii Sce
Marie Suessionen ordinis sancti
Benedicti
Ea que ad
Dat apud Urbemveterem XIII kl
marcii a° 3°

Bulle und Seide fehlen
In plica rechts : Th Percett
Rand oben Mitte :
Renovata ad instar et app. sub
butt (?)
A tergo oben Mitte längere abgekürzte Bemerkung

Eckige weite Schrift, mit gestreckten Ligaturen (mit einer Ausnahme)
mit 4 betonten Satzanfängen
In 1. Zeile 1 betonter Buchstabe

Erste Linie für Papstname nur
untere Oberlängen

Papstname im Text (Lucius)
in Gitterschrift

3275

Grande Archivio di Napoli
Curia ecclesiastica

1264 Februarii 20

Urbanus IIII mag. et fratribus domus
Hosp. S. M. Theoton. Jerosolim.
Reducentes ad sedule
Apud Urbemveterem X kal. Martii a° 3°
Sub plica links v
Cosmas

Ecke oben rechts Rx
Rand oben Mitte : bof
links : dom. l. f. fieri
a tergo

DCC XXX III

3276

Paris Archives Nationales
J 445 n. 20
Breite 30.4 Rand links 7.6 rechts 1.4
Höhe 24. 2 Rand oben 4.9 plica 3.3
Erste Linie für Oberlängen 1
Je eine Leitenlinie

P. vacat 1264 Februarii 20

Vrbanus IIII .. Archiepo Tyren
et dil filio Nob viro Johanni de
Valentinis dno Cayphe
 Cum nos vnivisis
Dat apud Vrbemueterem X kl
Martij / a° 3°
Bulle an Hanf
Qu plica rechts : Mich
Sub plica links : ..
A tergo oben Mitte : pro terra Sca

3277

Arch. Arcis
Arm. XIII capo. 4 cap. 5
P. (18810) 1264 febr. 27
Vrb. IIII .. epo Anagnin.
Cum homines regni
Apud Vrbemueterem IIII kl.
Martii a° tercis
Bulle an Hanfschnur
In plica rechts : B. Men.
 Jenr violett.
Wroe deke oben links :
 R

3278

Montpellier, ville de Montp.
E. V Lonnet 2793

P. – 1264 Martii 21

Vrbanus IIII consulibus et com-
muni Montispesulan.
 Honorem vestrum decus
apud Vrbemueterem XII kl. Apr.
a° 3°
Bulle an Hanf
In plica rechts 1 6 S
 y curia

Erste Zeile frei
Leitenlinien, ziemlich breiten

3279 (recto)

Stratharchiv bien Chronol.
P. – 1264 Martii 23
Vrbanus IIII .. priorine mon.
See Marie Anne de Roncodove,
ye de Supramonte eiusque
sribus etc. in ppm
 Relègiosam vitam eligentibus
 Amen — amen
R. Ego Vrbanus catholice Ecclie
 Ep. ss m
6 presb. 5 epi 6 diño.
Apud Vrbemueterem p. m. ma-
gistri Michaelis de Tholosa
SRE vicecancellair X kl. Apr.
ind. VII I. Inice a° m°. CC. LXIII
p. v. domni VRBANI pp. IIII a° 3°
Bulle und Seide liegen bei (vide)
Rand oben Con prio. ordi. Aug.

3279 (verso)

Ecke oben rechts a / bo

(be) ?

3280

Archives Nationales Paris
L 256 n. 65 1264 Aprilis 3
Br. 24.6 hoch 21.5 Plica 3
oberer Rand 4.8 links 1.
rechts 0.9
Vrbanus IIII .. Abbati sanct..
lupi Trecen..
 ad audientiam noram
Dat apud Vrbemueterem II non.
Aprilis a° 3°

Bulle an Hanf
 In plica rechts: C
Sub plica links: B · Fol.
 Ecke oben rechts: bo
A tergo Ecke oben links: B
 oben Mitte: + petrm de Anagn..

Kleine eckige Schrift
 Ohne jeden betonten Buchstaben
Erste Linie zwecklos

P. vacat

3281

Bayer. Haupt- Staatsarchiv
Raitenhaslach fasc. 16

P. vacat 1264 Aprilis 4
Vrbanus IIII .. abbati monasterij sce
Marie in Raitenhaslach Cyster.
tien. ordinis Salzeburgen. dioc.
 Exhibita nobis tua
Apud Vrbemueterem II non. Aprilis
anno tertio

Bulle an starkem Hanf
 In plica rechts: Jo. · Mar.
 Sub plica links: ?
 B. Ju

Erste Zeile frei Seitenlinien
Kleine eckige Schrift

3282

Stift Admont

P. — 1264 Aprilis 12
Vrbanus IIII .. abbati et conuen
tui monasterii Admonten. OSB
Salzeburgen. diocesis
 Cum a nobis
Apud Vrbemueterem II non.
Aprilis a° 3°
 Bulle an Seide
In plica rechts p. B.
Sub plica links ..?
Seitenlinien. Drei Zeilen un
beschrieben
wenige Ligaturen nicht ge.
streckt.

P. 18890 Paris Arch. Nat.
J 697 cap. 27 1264 Maii 3
Urb. IIII. Lud. illustri regi
Francorum
Ab illis xpianissimis
Apud Vrbemveterem V non.
Maii aº 3º
Bulle an dünner Hanfschnur
Ecke oben links eigenhändig
R. Bonaventura fiat cito
et secrete quia non audeo
hec committere cuilibet.
cras mane habeam eas
et nullus videat M
über die Senatoria
Nobis des Karl
von Anjou

Napoli Curia Eccles. Vol. 4º
P. —
 1264 Maii 10
Vrbanus IIII. — archiepº Drontin...
Sub religionis habitu
Apud Vrbemveterem VI id.
Maii aº 3º
Bulle und Hanf fehlen
— Plica abgeschnitten
Sub plica links : 3
 B. fm (zu 3)
Ecke oben rechts: fp
A tergo Ecke
oben links ⌐

Bayer. Haupt-Staatsarchiv
Reitenhaslach fasc. 16
P. 18907 1264 Maii 11
Vrbanus IIII. — preposito ecclie
Salzeburgen.
 Ad audientiam nostram
apud Vrbemveterem V id. Maii
anno Tertio
 Bulle an starkem Hanf
In plica rechts : B. P.
Sub plica links :
 B. Su
 Jo Gal
 Ecke oben rechts: fp
Erste Zeile frei, Seitenlinien

Archives Nationales Paris
L 256 — 57 n. 66 1264 Maii 13
Br. 57,4 hoch × 5.2 Plica 3.8
 oberer Rand 6.7 links 2.1
rechts 2.2
 Vrbanus IIII (Erster reicher
zierter Papstname, viele
 arabesken, am
Rand 19 cm lang. Alle Capitelsan
fänge auch reich verziert (erste Zeile
in Gitterschrift) Ad futuram rei mem
 Audientia ecclia
Dat apud Vrbemveterem III id.
Maii aº 3º
Bulle und Seide fehlen
 In plica rechts : B. a. de tur
A tergo oben mitte
 schlank schmal 3.8
mit kleinem Kopfe
Fette Rhre Schrift
Erste Linie für Papst
name und gitter
 schrift
de Curia //// P. vacat
Arabesken

3287

Archives Nationales Paris
L 256 n. 66 bis 1264 Maii 13

Br. 54.5. Hoch 42.9 Plica 3.9
oberer Rand 6.7 links 2.3
rechts 2.2

Urbanus IIII (ungemein zier-
liche umfangreiche Arabesken für
unseren Textstamme, für A in Ad und
für alle Capitelanfänge. Auf dem
Rande 18.5 lang) ep eps Lereus
zenorum deiz Ad jur. rei mem.
(Gitterschrift)

Dudum in Ecclia
Dat apud Urbemveterem IIJ JD
maij a° 3°

Bulle und Seide fehlen
In plica rechts: Jacobs de Nut
de Cur
Erste Linie für Textstamme
und Gitterschrift

__Arabesken__ __P. vacat__

__de Curia__

3288

Bayer. Haupt. Staatsarchiv
oberaedeeingen fasc. 2.

P. 18943 1264 Junii 5

Urbanus IIII (Minuscalae) e. s. s. dei
dil. in xpo filiabus.. priorisse ecclie
see Marie de Medellingen eiusq᷒
sororibus tam pres. quam fut. regul᷒
in unum professis (Gitterschrift) IN FFM
Religiosam vitam eligentibus
inveniant AMEN a — e AMEN

R. Ego Urb. cath. ecclie eps ✠ M

5 presb. 5 epi. 6 diac

Dat. apud Urbem veterem per manum
Magri Michaelis de Tholosa see Romane
Ecclie Vicecancellarij Non. Junij Ind.
VII Incarn. dominice Anno M·CC·LXIIII
pontif. vero domni URBANI pp. IIII
Anno Tertio

Schreiu grosse Bulle an feiner Seide
Rand oben mitte: Coe pri ord. see
Aug

Je nur Seitenlinien

3289

Bayer. Haupt. Staatsarchiv
Kl. Rautenhaslach fasc. 16

P. 18955. 1264 Junii 24

Urbanus IIII (nur Maj.) e. s. s. dei
dil. filiis.. Abbati Monasterij see
Marie in Reytenhaselae eiusq᷒
fratribus tam pres. quam futuris
regularem vitam professis M FFM
Religiosam vitam eligentibus
pacis inveniant AMEN a — e AMEN

R. Ego Urbanus cath. ecclie eps ✠ M
4 presb. 5 epi. 6 diaconi
Dat. apud Urbemveterem per ma-
num Magri Michaelis de Tholosa
sancte Romane Ecclie Vicecancellarij
VII Kl. Julij Ind. VII Incarn. domi-
nice Anno M·CC·LXIIII (64) pontif.
vero domni VRBANI pp. IIII anno
Tertio
Bulle an Seide
In plica rechts: Jac. Nar.
Rand oben mitte: Coe priv. Cisterciens.
ordinis. Jac. Nar

Dicke mittelgrosse Gitterschrift mit
mittelhohen Oberlängen und ganz
kleinen Unterlängen

3290

Graz Landesarchiv n. 832
P. — 1264 Julii 9

Urbanus IIII Wernhero de Sanc-
to Georgio presbitero rectori
ecclesie de Piber Salzeburgen.
diocesis

Hijs que fiunt
Apud Urbemveterem VII id.
Julii a° 3°

Bulle an Seide
In plica rechts A. J. Potent.
Sub plica links
B. Su

Rand oben mitte ober und
Ecke oben rechts see
Rand oben links . L. 2.

3291

Graz Landesarchiv n. 833

P. —　　1264 Iulii 9

Vrbanus IIII .. epo Olomucen.
Hijs que fiunt
Apud Vrbemveterem vii id.
Iulii a° 3°
Hanf erhalten. Bulle liegt bei
In plica rechts R. I. Polent
Sub plica links ˙˙˙˙
　　　　B. Iu
Rand oben links . L . 2 . , mitte
cor . Ecke oben rechts

3292

Staatsarchiv Wien Chronol.

P. —　　1264 Iulii 14

Vrbanus IIII .. epo Patavien.
Petitio dilectorum filiorum
Apud Vrbemveterem ii id.
Iulii a° 3°
Bulle an Hanf
In plica rechts An . O
Sub plica links .˙.
　　　　　　Iac me
Ecke oben rechts ct

3293

de Curia
Paris Archives Nationales
　　　　J 445 n. 22
Breite 29.7 Randlinks 1.3 rechts 0.9
Höhe 24.5 Randoben 4.7 plica 3.
Ohne erste freie Linie / Seiten-
Seitenlinie

P. vacat　　1264 Iulii 17

Vrbanus IIII . . Archiepo Tyren
Dilectus filius Jod frater
Dat apud Vrbemveterem / XVI kl Aug
　　　　　　a° 3°
In plica rechts : . a . a . a .
　　　　　　pro Curia
Ecke oben links : R
A tergo oben Mitte : frater J pro
terra sancta
Feine kleine sehr regelm. Schrift

3294

Staatsarchiv Wien Chronol.

P. 18987　　1264 Iulii 17

Vrbanus IIII carmo in xpo fi.
lio Regi Boemie illustri
[ohne Punkte]
Celsitudinem regiam in
Apud Vrbemveterem XVI kl.
Aug. a° 3°
Bulle an Hanf, Seidenfäden aber
variert nur ausgespart.
In plica rechts　　　　h
　　　　　　　Ger p
Sub plica links Iac me
Rand oben mitte off
Oberste Zeile beschrieben
Prachtvolle weite schwung-
volle Schrift

3295

Paris Archives Nationales.
J 445 n. 21
Breite 24.7 Rand links 1.1 rechts 1.1
Höhe 19.5 Rand oben 4.7 plica 2.5
Erste Linie über Oberlängen /
Je eine Seitenlinie
P. vacat 1264 Julii 27
Urbanus IIII . . Archiepo Tyren
Ad audientiam nostram
Dat apud Urbemveterem / VI
Kl Aug a° 3°
Bulle an Hanf
In plica rechts: a Ver
Sub plica links --
Regelm. schöne Schrift

3296

Paris Archives Nationales
J 445 n. 23
Breite 28.9 Rand links 0.9 rechts 1.1
Höhe 17.4 Rand oben 3.7 plica 2.4
Erste Linie über den Oberlängen
/ Je eine Seitenlinie
P. vacat 1264 Julii 27
Urbanus IIII - - Archiepo Tyren
Ad audientiam nostram
Dat apud Urbemveterem VI Kl
Aug / a° 3°
Bulle an Hanf
In plica rechts: a. Ver
Sub plica links: - -
A tergo oben Mitte: pro terra sca
Fette sehr regelm. Schrift

3297

Arch. Arcis
Arm. XIII caps. 6 cap. 40
P. —
1264 Aug. 1
Urb. IIII .. epo Anagnin et
nicolao de Anagnia/nostro capellano
nepoti felicis recordationis
G. pape predecessoris nostri
olim executionem sententiae
apud Urbemveterem Kl.
Aug. a° 3°
Bulle an Hanf.
In pl. links de curia

3298 (recto)

Paris Archives Nationales
J 431 n. 35
Breite 53.9 Rand links 1.1 rechts 1.2
Höhe 44.5 Rand oben 5.9 plica 3.2
Erste Linie für Oberlängen / Je eine
Seitenlinie
P. vacat 1264 Augusti 2
Urbanus IIII fratrib ordinis Predicatoz
inquisitoribus heretice pravitatis
in Comitatibus Pictavie ac Tholose
7 quibuscumque locis sine terris
dominio dil. filij A. Pictavien 7
Tholosan Comitis mediate vel imme
diate subiectis ubique intra vel ex
tra Regnum Francie constitutis civi
tate Avinionen dumtaxat excepta
deputatis auctoritate aplica 7 in

3298 (verso)

posterum deputandis
Pre cunctis nre
Dat apud Vrbemueterem III non
Augusti / anno 3°
Bulle fehlt. Hanf erhalten
In plica rechts: B · P
Kleine regelm. Schrift

3299 (recto)

Joh. Gaet. cardinalis ! ! !
Paris Archives Nationales
J 431 n. 35 bis
Breite 59.4 Rand links 2. rechts 1.9.
Höhe 49.5 Rand oben 6. plica 4.3
Oberste Linie für Oberlängen / Je
eine Seitenlinie

P. vacat 1264 Augusti 2

Vrbanus IIII fratribus ordinis Predi-
catorq3 inquisitoribus heretice pra-
uitatis in Comitatibus Pictauie
et Tholose et quibuscuinque locis
siue terris dominio dil filij A.
Pictauieñ et Tholosan Comitis
mediate uel immediate subiect3
ubique infra uel extra Regnum Fran-
cie constitutis ciuitate Auinionen
duntaxat excepta deputatis
auctoritate aplice et in posterum

3299 (verso)

deputandis
Pre cunctis nre
Dat apud Vrbemueterem III non
Aug / a° 3°
Bulle fehlt, Hanf erhalten
In plica links: J. V. de Curia
Rand oben links :
Ego Jo - Ga - Card. ſ bullientur
ſ remittitur nobis ſ duplicetur
Triplicetur (duplicetur durch
Unterstreichen getilgt)
sws kleine zierliche Schrift

cf. Aus Kanzlei und Kam-
mer Seite 185 186 187
188

3300

Paris archives nationales
J 431 n. 35 ter
Breite 59. Rand links 2.3 rechts 2.2
Höhe 48.5 Rand oben 5.7 plica 3.8
Triplicat vm n. 35
Bulle an Hanf.
In plica links : J. V de Curia
Feine zierliche Schrift

Vrbanus IIII
III non Aug. a° 3°

P. vacat 1264 Augusti 2

3301

Clausa

Paris Archives Nationales
J 457 n. 16
Breite 35.3 Rand links 0.6 rechts -1.
Höhe 28.4 Rand oben 4.8 unten 5.1
Erste Linie für Oberlängen / Je
eine Seitenlinie
P. vacat **1264 Augusti 5**
Vrbanus IIII . . Archiepo Tyren
executori negotij Crucis in Regno
Francie
Letati sumus in
Dat apud Vrbemueterem non
Augusti / aᵒ 3ᵒ
dünne feine
Schrift

3302

!!!!!!

Paris Archives Nationales
J 431 n. 36
Breite 48. Rand links 1.3 rechts 1.3
Höhe 33. Rand oben 5.4 plica 3.7
Erste Linie unbenutzt / Je eine
Seitenlinie
P. vacat **1264 Augusti 9**
Vrbanus IIII -- Priori fratrum
Predicatorum Parisien
Pre cunctis nre
Dat apud Vrbem ueterem / V
Id Aug anno 3ᵒ
Bulle an Hanf
In plica rechts: S. R
Rand oben links :
Ego Jo. qa. Cardį J bulletur
remittatur nobis y duplicetur
cf. Aus Kanzlei u. Kammer, pp. 185-188

3303

Archives Nationales
J 431 n. 36 bis
Breite 42.8 Rand links 1. rechts 1.
Höhe 29.5 Rand oben 3.7 plica 3.7
Erste Linie für Oberlängen / Je
eine Seitenlinie
P. vacat 1264 Augusti 9
Vrbanus IIII -- Priori fratrum
Predicatorum Parisien
Pre cunctis nre
Dat apud Vrbem ueterem V
Id Aug aᵒ 3ᵒ
Bulle an Hanf
In plica rechts: dat Jmr
de Curia

3304

Paris Archives Nationales
J 448 n. 85
Breite 22.6 Rand links 1.2 rechts 1.3
Höhe 16.2 Rand oben 3.6 plica 2.3
Erste Linie über den Oberlängen
Je eine Seitenlinie
P. vacat **1264 Septembris 5**
Vrbanus IIII . - Archiepo Tyren
executori negotij crucis in partibus
Gallicanis
Olim dum adhuc
Dat apud Vrbem ueterem / non
Septembr aᵒ 4ᵒ
Bulle an Hanf
In plica rechts: A. Ver
A tergo oben Mitte : Alexander
de Vernlis
Fette kleine sehr regelm. Schrift

3305

Paris Archives Nationales
J 45 n. 17

Breite 32. Rand links 1.6 rechts 1.6
Höhe 23.8 Rand oben 3.1 plica 2.6
Erste Linie über den Oberlängen
Je eine Linealinie

P. vacat __1264 Septembris 5__

Vrbanus IIII . . . Archiepo Tyren
executori negotij crucis in par
tibus Gallicanis

 Auia ordinem Militie
Dat apud Vrbem veterem / V
Jd Septembr a° 4°

Bulle an Hanf
A tergo oben Mitte: Helyas de
Poyleyo
Kleine schöne weite Schrift

3306

Bayer. Haupt. Staatsarchio
Obermedlingen Fasc. 1
 Dat. vergessen

Vrbanus IIII dil. in xpo filiabus .. pri
rrisse et Conuentui Monasterij in
Medingen Augusten. ordinis Sanctis
Augustini secundum institutta fra
trum predicatorum viuentibus
 Cum a nobis

Bulle und Seide fehlen
In plica rechts: Iacobs de menania
Sub plica links: Böpm

Rand oben Mitte: ~~Copt~~
Ecke oben rechts: ~~Co~~

Vrbanus in Übergangsschrift
Schmale Seitenränder

3307

Bayer. Haupt. Staatsarchio
Heilig Geistspital München

? 1260 dann == Datum vergessen

Vrbanus IIII (romm. Mai.) e. s. s. dei
dil. filijo . . Magistro Hospitalis sci
Spiritus de Casto morticu. Euisque
fribus etc. IN RPM.
 Religionum utrum diligentibus
pacis inueniant AMEN Amen AMEN

. R. Ego Vrbanus cath. ecclie Ep. ✠ M.
 2 post. capi 7 diaconi

Bulle an feiner Seide
 In plica rechts: ~~gia~~ Ger.p.

Schöne kleine Gitterschrift mit hohen
 Oberlängen, ausgedrückte Unterlängen
Feste, sehr schöne, ~~gotische~~ mittel.
Grosse Schrift.

3308

Arch. Arcis
Arm. IX cap. 1 cap. 49
 P. — 1265 Martii 15

Clem IIII S. tit. Sce Cecilie pres
bitero cardinali aplice sedis le
gato
 Retulit coram nobis
 Perusii iv. Martii a° 1°
In pl. rechts: B p m
Sub pl. links: . .

 Jar me
Rand oben Ecke links R+
Oneben: | duplica. M. |
Rand oben Mitte: pro abbe Cist...
A tergo oben Mitte: Ypo. Portuen.

3309

Marseille Archives Départem.
H. O. M. 21
P. — 1265 Martii 19
Clemens IIII S. tit. S. Cecilie
presbitero cardinali aplice se-
dis legato
Felicis recordationis Urbanus
Perusii XIIII Kl. Apr. a° 1°
Bulle und Hanf fehlen
 Sub plica links jät mte
Brachtvolle, nuova, kleine
Schrift
Erste Zeile beschrieben

3310

Archives Nationales Paris
L 258 n. 2 1265 Martii 19
Br. 36.5 hoch 28.7 Plica 2.9
oberer Rand 5.8 links 1.6
rechts 1.6
Clemens IIII S. tt. Sce Ceci-
lie pbro Cardinali aplice sedis Le-
gato
Dat. Felicis recordationis Urbanus
Perusii XIIII Kl. Aprilis a° 1°
Bulle fehlt, Hanf erhalten
 In plica rechts: N5 petenti
Sub plica links:
A tergo oben rechte grosses +
Fette klare breite Schrift
Mit einem betonten Buchstaben
Erste Linie für Oberlängen
Papstname im Text nicht in
 Gitterschrift
P. vacat

Papstnamen

3311

Instr. mon. F. Dom. C. 107 1265 Martii 28
P. 19080
Clem. IIII .. archidiacono Pergamen.
multorum detestando presumptio
Perusii V Kl. Aprilis a° 1°
Bulle an Hanfschnur.
In plica rechts: Nycol cap.
 de Curia
A tergo: frater Tilmannus

3312

Staatsarchiv Wien Chronol.
P. 19093 1265 Aprilis 16
Clemens IIII -- preposito, Erbo-
ni et Kalhoho canonicis eccle-
sie Ratisponen.
Transmissa nobis venerabilis
Perusii XVI Kl. Maii a° 1°
Bulle an Hanf
In plica rechts f. A
Sub plica links G
 ...

3313

Firenze, S. Croce di Firenze
P. 19095 **1265 Aprilis 17**
Clemens IIII univ. xpi fideli
bus presentes litteras inspec
turis

Splendor paterne glorie
Perusii XV kl. maii aº 1º

Bulle und Seide fehlen
In plica rechts Tar Seu

Sub plica links Tar Me

Für die Oberlängen der ersten
Zeile ist eine Linie in doppel
tem Abstande gezogen worden,
die natürlich unbeschrieben
Nur Umbug unliniert

3314

Archives Nationales Paris
L 258 n. 3 **1265 Aprilis 17**
Br. 32.5 hoch 23.2 Plica 3.
oberer Rand 4.9 links 1.4
rechts 1.3
Clemens IIII Archiepis c Epis
ad quos littere iste pervenerint
En parte dilectorum
Dat Perusii XV kl maii aº 10

Bulle an Hanf

A tergo oben Mitte unleserlich

Sehr schöne kleine Schrift

mit einem betonten Buchstaben

Erste freie Linie zwecklos

Papstname im Text nicht in
Gitterschrift

Papstname

P. vacat

3315

Archives Nationales Paris
L 258 n. 4 **1265 Aprilis 19**
Br. 21.9 hoch 15.6 Plica 3.3
oberer Rand 2.5 links 0.8
rechts 0.8
Clemens IIII (Gitterschrift
Initiale versal) dilectis in xpo
filiabus .. Abbatisse z Conventui
monasterij de Fauarcheto Cister
cien ordinis Noviomen diõc
Cum a nobis
Dat Perusij XIII kl maij aº 10

Bulle fehlt, Seide erhalten
Sub plica links : J.B

Rand oben Mitte : SOR

Kleine Zette regelm Schrift, mit
gestreckten Listuren, mit 4 ver
zierten Satzanfängen
In 1. Zeile 1 ver. Buchstabe

Erste Linie für Gitterschrift und
Oberlängen

P. vacat

3316

Instr. Mon. F. Dom. c. — **1265 Apr. 23**
P. 19102
Clem. IIII .. mag. el fratribus ord. Pred. apud
Montem Pessulanum Convenientibus
in capitulo generali
Splendor paterne glorie.
Perusii VIIII kal. maii aº 10
In plica links : · Ro de Curia
Bulle an Hanfschnur
Photo Bulle

3317

Paris Archives Nationales
 J 449 n. 123 bis
Erste Linie über Oberlängen
Je eine Seitenlinie
P. vacat 1265 Aprilis 27
Clemens IIII Egidio Archiepo
Tyren
 Cum predicatio Crucis
Dat Perusij V Kl Maij /
a° 1°
 Bulle an Hanf
In plica rechts : Str (?)
A tergo oben Mitte : pro Terra Sta
Ganz kleine ungepflegte Schrift

3318

Paris Archives Nationales
 J 449 n. 126
Breite 25.9 Randlinks 1.3 rechts 1.3
Höhe 18.7 Rand oben 3.3 plica 2.
Erste Linie über Oberlängen / Je
eine Seitenlinie
P. 19113 1265 Aprilis 27
Clemens IIII . . Archiepo Tyren
 Felicis recordationis Vrbanus
Dat Perusij V Kl Mij / a° 1°
Bulle an Hanf
In plica rechts : Jac Romanus
Sub plica links : S
A tergo oben Mitte : pro Terra Sta
Prachtvolle kleine feste Schrift

3319

Paris Archives Nationales bis
 J 449 n. 126
Breite 25.3 Randlinks 1.3 rechts 1.3
Höhe 19.6 Rand oben 3.5 plica 2.2
 Erste Linie über Oberlängen /
Je eine Seitenlinie
P. 19113 1265 Aprilis 27
Clemens IIII . . Archiepo Tyren
Felicis recordationis Vrbanus
Dat Perusij V Kl. Maij / a° 1°
Bulle an Hanf
In plica rechts : Jac Romanus
A tergo oben Mitte : pro Terra Sta
Prachtvolle kleine feste Schrift

3320

Paris Archives Nationales
 J 449 n. 126 ter
Breite 24.9 Randlinks 1.4 rechts 1.3
Höhe 17.7 Rand oben 3.4 plica 2.3
Erste Linie über Oberlängen / Je
eine Seitenlinie
P. 19113 1265 Aprilis 27
Clemens IIII . . Archiepo Tyren
Felicis recordationis Vrbanus
Dat. Perusij V Kl Maij / a° 1°
Bulle an Hanf
In plica rechts : Jac Romanus
Prachtvolle kleine feste Schrift
Sub plica links : S

3321

Paris Archives Nationales
 J 449 n. 126 (Quater)
Breite 25.7 Rand links 1.3 rechts 1.3
Höhe 18. Rand oben 3.5 plica 2.1
Erste Linie über Oberlängen / Je
eine Seitenlinie
P. 19113 1265 Aprilis 27
Clemens IIII . . Archiepo Tiren
Felicis recordationis Vrbanus
dat Perusij V kl Maij / a° 1°
Bulle an Hanf
In plica rechts : Jac̄ Romanus
Sub plica links : ?
A tergo oben Mitte : pro Terra S̄c̄ā
Prachtvolle feste Kleine Schrift

3322

Paris Archives Nationales
 J 449 n. 126 E
Breite 23.9 Rand links 1.3 rechts 1.2
Höhe 18.2 Rand oben 3.6 plica 2.1
Erste Linie über Oberlängen / Je
eine Seitenlinie
P. 19113 1265 Aprilis 27
Clemens IIII . . Archiepo Tiren
Felicis recordationis Vrbanus
dat Perusij V kl Maij / a° 1°
Bulle an Hanf
In plica rechts : Jac̄ Romanus
Sub plica links : ?
A tergo oben Mitte : pro Terra S̄c̄ā
Prachtvolle kleine feste Schrift

3323

Paris Archives Nationales
 J 449 n. 126 C
Breite 25.1 Rand links 1.2 rechts 1.2
Höhe 19.3 Rand oben 3.6 plica 2.4
Erste Linie über Oberlängen / Je
eine Seitenlinie
P. 19113 1265 Aprilis 27
Clemens IIII . . Archiepo Tiren
Felicis recordationis Vrbanus
dat Perusij V kl Maij / a° 1°
Bulle an Hanf
In plica rechts : Jac̄ Romanus
Sub plica links : ?
A tergo oben Mitte : pro Terra S̄c̄ā
Prachtvolle Kleine feste Schrift

3324

Paris Archives Nationales
 J 449 n. 126 F
Breite 24. Rand links 1.1 rechts 1.2
Höhe 20.1 Rand oben 3.7 plica 2.4
Ohne erste freie Linie / Je eine
Seitenlinie
P. 19113 1265 Aprilis 27
Clemens IIII . . Archiepo Tiren
Felicis recordationis Vrbanus
dat Perusij V kl Maij / a° 1°
Bulle an Hanf
In plica rechts : Jac̄ Romanus
Sub plica links : ?
A tergo oben Mitte : pro Terra S̄c̄ā
Prachtvolle feste Kleine Schrift

3325

Paris Archives Nationales
 J 449 n. 130
Breite 28.5 Randlinks 1.4 rechts 1.4
Höhe 19.4 Randoben 4.8 plica 3.4
Erste Linie für Oberlängen / je
eine Seitenlinie
P. vacat 1265 Aprilis 27
Clemens IIII Egidio Archiepo Tyren
 Cum predicatio Crucis
Dat Perusij V Kl Maij / a° 1°
Bulle an Hanf
In plica rechts : B. pu
A tergo oben Mitte : pro Terra Sca
Sehr schöne kleine feste Schrift

3326 (recto)

Paris Archives Nationales
 J 450 n. 136
Breite 38.3 Randlinks 1.5 rechts 1.4
Höhe 31.6 Rand oben 6, plica 3.7
Erste Linie für Oberlängen / je
eine Seitenlinie
P. vacat 1265 Aprilis 27
Clemens IIII Vniuersis Archiepis
z Epis ac Dil filijs Abbatib3 Prioni
b3 Decanis Archidiacronis necnon
Prioribus Predicatorum Ministris
Custodibus seu Guardianis Minor3
ordinum ceterisque personis ecclia
stricis uel religiosis per omnia
xpiana Regna mundi 7 prouincia
ad Crucis negotium z ad colligand
subsidia pecuniaria pro Terre

3326 (verso)

Sancte subsidio a Sede aplica
deputatis z in posterum depu
tandis
 Et si ad
Dat Perusij V Kl Maij / a° 1°
Bulle an Hanf
In plica rechts : Rec. f.
A tergo oben Mitte :
 pro Terra Sca
fette undeutliche Schrift

3327

Paris Archives Nationales
 J 450 n. 140
Breite 23.7 Randlinks 1. rechts 1.1
Höhe 15.8 Rand oben 3, plica 2.8
Erste Linie über Oberlängen /
je eine Seitenlinie
P. vacat 1265 Aprilis 27
Clemens IIII Egidio Archiepo Tyren
 Cum predicatio Crucis
Dat Perusij V Kl Maij / a° 1°
Bulle an Hanf
In plica rechts : . F . R .
A tergo oben Mitte : pro Terra sca
kleine deutliche Schrift

Initium

Paris Archives Nationales
 J 450 n. 141
Breite 20. Rand links 1. rechts 1
Höhe 15.4 Rand oben 3.1 plica 3.5
Erste Linie über Oberlängen / Je
eine Seitenlinie
P. vacat 1265 Aprilis 27
Clemens IIII Egidio Archiepo Tyren
 Cum predicationem crucis
Dat Perusij V Kl Maij a° 1°
Bulle an Hanf
In plica rechts : S. Meß
 A tergo oben Mitte : pro terra sca
Sehr schöne feste kleine Schrift

Paris Archives Nationales
 J 450 n. 148
Breite 21. Rand links 0,9 rechts 0,9
Höhe 15.9 Rand oben 3 plica 3.
Ohne erste freie Linie / Je eine
Seitenlinie
P. vacat 1265 Aprilis 27
Clemens IIII Egidio Archiepo Tyren
 Ut commissum tibi
Dat Perusij V Kl Maij a° 1°
Bulle an Hanf
In plica links : B. V.
Sub plica links : Maths Cap
A tergo oben Mitte : pro terra sca
Schöne kleine Schrift

Initium

Paris Archives Nationales
 J 450 n 146
Breite 20.1 Rand links 1. rechts 1.
Höhe 18. Rand oben 3.8 plica 2.7
Erste Linie über Oberlängen /
Je eine Seitenlinie
P. vacat 1265 Aprilis 27
Clemens IIII Egidio Archiepo Tyren
 Cum predicationem crucis
Dat Perusij V Kl Maij E a° 1°
Bulle an Hanf
In plica rechts : B Meß
 §
sub plica links : Mathis cap
A tergo oben Mitte : pro terra sca
Prachtvolle kleine feste Schrift

Initium

Paris Archives Nationales
 J 450 n. 147
Breite 20.9 Rand links 0.9 rechts 1.1
Höhe 17. Rand oben 3.3 plica 2.1
Erste Linie über Oberlängen /
Je eine Seitenlinie
P. vacat 1265 Aprilis 27
Clemens IIII Egidio Archiepo Tyren
 Cum predicationem crucis
Dat Perusij V Kl Maij / a° 1°
In plica links : B. V
Sub plica links :
 Mathis Cap Am . Ste Sy
Dicke kleine Schrift

3332

Paris Archives Nationales
J 452 n. 1

Breite 40.3 Rand links 4.4 rechts 1.5
Höhe 30.2 Rand oben 4.3 plica 3.1
Erste Linie über den Oberlängen
Je zwei Aderbögen Seitenlinien
P. vacat _1265 Aprilis 27_
Clemens IIII etc. ut in J 452 n. 12
Dat Perusij/ V Kl Maij a° 1°
Et si ad
Bulle an Hanf
In plica rechts: n. Vivian
A tergo oben Mitte: pro terra sca
Weite schwungvolle etwas spitze
Schrift

3333

Paris Archives Nationales
J 452 n. 1³

Breite 37.3 Rand links 1.3 rechts 2
Höhe 29. Rand oben 6.1 plica 2.8
Erste Linie für Oberlängen
Je eine Seitenlinie
P. vacat _1265 Aprilis 27_
Clemens IIII etc. ut in J 452 n. 12
Dat Perusij V Kl Maij/ a° 1°
Bulle an Hanf
In plica rechts: An (?).
A tergo oben Mitte: pro terra sca
Kleine fette stumpfe Schrift

3334

Paris Archives Nationales
J 452 n. 1³

Breite 38.7 Rand links 1.7 rechts 1.4
Höhe 29.2 Rand oben 3.3 plica 3.1
Erste Linie über den Oberlängen
Je eine Seitenlinie
P. vacat _1265 Aprilis 27_
Clemens IIII etc. ut in J 452 n. 12
Dat Perusij V Kl Maij/ a° 1°
Bulle an Hanf
In plica rechts: n. Vivian
A tergo oben Mitte: pro terra sca
Weite dünne schwungvolle Schr.

3335

Paris Archives Nationales
J 452 n. 1³

Breite 39.3 Rand links 1.5 rechts 1.5
Höhe 30.4 Rand oben 3.3 plica 5
Erste Linie über Oberlängen
Je eine Seitenlinie
P. vacat _1265 Aprilis 27_
Clemens IIII etc. ut in J 452 n. 12
Dat Perusij/ V Kl Maij a° 1°
Bulle an Hanf
In plica rechts: n. Vivian
A tergo oben Mitte: pro terra sca
Weite dünne schwungvolle Schrift

Paris Archives Nationales
J 452 n. 1$^5$
Breite 37.1 Rand links 1.4 rechts 1.5
Höhe 31.3 Rand oben 4.7 plica 2.9
Ohne erste freie Linie / Je eine
Titelinie
P. vacat 1265 Aprilis 27
Clemens IIII etc. ut in J 451 n. 12
Dat Perusij V Kt. Maij a° 10
Bulle an Hanf
In plica rechts : Ger. p.
A tergo oben Mitte : pro terra sta
Fette gedrungene Klare Schrift

Paris Archives Nationales
J 452 n. 1$^6$
Breite 36.2 Rand links 1.6 rechts 1.5
Höhe 30. Rand oben 3.3 plica 2.4
Erste Linie über den Oberlingen
Je eine Titellinie
P. vacat 1265 Aprilis 27
Clemens IIII etc. ut in J 451 n. 12
Dat Perusij / V Kt. Maij a° 10
Bulle an Hanf
In plica rechts : N. Vinian
A tergo oben Mitte : pro terra sta
Schwungvolle leichte schöne Schrift

Paris Archives Nationales
J 452 n. 1$^7$
Breite 38.9 Rand links 1.3 rechts 1.3
Höhe 29. Rand oben 5.9 plica 3.5
Erste Linie für Oberlingen
Je eine Titellinie
P. vacat 1265 Aprilis 27
Clemens IIII etc. ut in J 451 n. 12
Dat Perusij V Kt. Maij a° 10
Bulle an Hanf
In plica rechts : Ber. J.
A tergo oben Mitte : pro terra sta
Fette etwas unruhige Schrift

Paris Archives Nationales
J 452 n. 1$^8$
Breite 36.7 Rand links 1.6 rechts 1.8
Höhe 30.4 Rand oben 5.8 plica 3.
Erste Linie für Oberlingen
Je eine Titellinie
P. vacat 1265 Aprilis 27
Clemens IIII etc. ut in J 451 n. 12
Dat Perusij V Kt. Maij a° 10
Bulle an Hanf
In plica rechts : Ber. F
A tergo oben Mitte : pro terra sta
Kleine unordentliche fette Schrift

Paris Archives Nationales
J 452 n. 1ᵇ

Breite 39.7 Rand links 1.4 rechts 7.5
Höhe 26 Rand oben 5.2 plica 2.9
Ohne erste freie Linie / Je eine
Seitenlinie
 P. vacat 1265 Aprilis 27
Clemens IIII etc. ut in J 457 n. 12
Dat Perusij ▽ ꝛ Maij / a⁰ 1⁰
Bulle an Hanf
In plica rechts : F
A tergo oben mitte : pro terra sca
Kleine fette blasse Schrift

Paris Archives Nationales
J 452 n. 1ᶜᶜ

Breite 42.3 Rand links 1.8 rechts 1.6
Höhe 29.7 Rand oben 4.1 plica 3.x
Erste Linie über Oberlängen / Je
eine Seitenlinie
 P. vacat 1265 Aprilis 27
Clemens IIII etc. ut in J 457 n. 12
Dat Perusij / ▽ ꝛ Maij a⁰ 1⁰
Bulle an Hanf
In plica rechts : N. Viviän
A tergo oben mitte : pro terra sca
Weite spitze schwungvolle Schrift

Paris Archives Nationales
J 452 n. 1ᵈ

Breite 47.7 Rand links 1.6 rechts 1.4
Höhe 30.3 Rand oben 3.2 plica 2.9
Erste Linie über den Oberlängen
Je eine Seitenlinie
 P. vacat 1265 Aprilis 27
Clemens IIII etc. ut in J 457 n. 12
Dat Perusij / ▽ ꝛ Maij a⁰ 1⁰
Bulle an Hanf
In plica rechts : N. Viviän
A tergo oben mitte : pro terra sca

Paris Archives Nationales
J 452 n. 1ᵉ

Breite 36.8 Rand links 1.5 rechts 1.4
Höhe 29.3 Rand oben 4.3 plica 3.1
Ohne erste freie Linie / Rechts
~~eine plus~~ zwei links eine Seiten-
linie
 P. vacat 1265 Aprilis 27
Clemens IIII etc. ut in J 457 n. 12
Dat Perusij ▽ ꝛ Maij / a⁰ 1⁰
Bulle an Hanf
In plica rechts : Gir. p.
A tergo oben mitte : pro terra Sca
Sehr schöne schwungvolle Schr.

3344

Paris Archives Nationales
 J 452 n. 1 [13]

Breite 37.7 Rand links 1.7 rechts 1.7
Höhe 29.5 Rand oben 5. plica 4.4
Ohne erste freie Linie / Je eine
Seitenlinie

P. vacat 1265 aprilis 27

Clemens IIII etc. ut in J. 451 n. 12
Dat Perusij V kl Maij / a° 1°
Bulle an Hanf
In plica rechts : F
A tergo oben Mitte : pro terra sca
Kleine strumpfe fette Schrift

3345

Paris Archives Nationales
 J 452 n. 1 [13]

Breite 36.3 Rand links 1.3 rechts 1.1
Höhe 30. Rand oben .5. plica 2.5
Erste Linie für Oberlängen / Je
eine Seitenlinie

P. vacat 1265 aprilis 27

Clemens IIII etc. ut in J 451 n. 12
Dat Perusij V kl Maij a° 1°
Bulle an Hanf
In plica rechts : Ber. F.
A tergo oben Mitte : pro terra sca
Fette enge Schrift

3346

Paris Archives Nationales
 J 452 n. 1 [15]

Breite 35.9 Rand links 1.4 rechts 1.5
Höhe 28.4 Rand oben 4.5 plica 3.1
Ohne erste freie Linie / Je eine
Seitenlinie

P. vacat 1265 aprilis 27

Clemens IIII etc ut in J 451 n. 12
Dat Perusij V kl Maij / a° 1°
Bulle an Hanf
In plica rechts : Ger. P
A tergo oben Mitte : pro terra sca
Schöne fette Schrift

3347

Paris Archives Nationales
 J 452 n. 1 [16]

Breite 38.8 Rand links 1.3 rechts 1.3
Höhe 29.7 Rand oben 5.9 plica 3.9
Erste Linie für Oberlängen /
Je eine Seitenlinie

P. vacat 1265 aprilis 27

Clemens IIII etc. ut in J 451 n. 12
Dat Perusij V kl Maij a° 1°
Bulle und Hanf ausgerissen
In plica rechts : Ber. F
A tergo oben Mitte : pro terra sca
Fette kleine nachlässige Schrift

3348

Paris Archives Nationales
J 452 n. 1

Breite 37.5 Rand links 1.4 rechts 1.3
Höhe 29.1 Rand oben 3.6 plica 2.2
Erste Linie über den Oberlängen
Je eine Seitenlinie
P. vacat 1265 Aprilis 27
Clemens III etc. ut in J 451 n. 12
Dat Perusij V Kl Maij aº 1º
Bulle un Hanf
In plica rechts: N. Vinian
A tergo oben Mitte: pro terra Sca
Schwungvolle schöne dünne Schr.

3349

Paris Archives Nationales
J 452 n. 1
Breite 39.8 Rand links 1.4 rechts 1.5
Höhe 29.7 Rand oben 5.2 plica 3.1
Ohne erste freie Linie / Je eine
Seitenlinie
P. vacat 1265 Aprilis 27
Clemens III etc. ut in J 451 n. 12
Dat / Perusij V Kl Maij aº 1º
Bulle un Hanf
In plica rechts: Ger o p.
A tergo oben Mitte: pro terra Sca
Feste schöne Schrift

3350

Paris Archives Nationales
J 452 n. 1
Breite 39. Rand links 1.4 rechts 1.6
Höhe 29.4 Rand oben 6.1 plica 3.8
Erste Linie für die höheren Ober-
längen / Je eine Seitenlinie
P. vacat 1265 Aprilis 27
Clemens III etc. ut in J 451 n. 12
Dat Perusij V Kl Maij aº 1º
Bulle un Hanf
In plica rechts: Ber. F.
A tergo oben Mitte: pro terra Sca
fette wohllinige Schrift

3351

Paris Archives Nationales
J 452 n. 1
Breite 32.7 Rand links 1.1 rechts 1.2
Höhe 25.9 Rand oben 4.5 plica 2.7
Ohne erste freie Linie / Je eine
Seitenlinie
P. vacat 1265 Aprilis 27
Clemens III etc. ut in J 451 n. 12
Dat Perusij V Kl Maij / aº 1º
Bulle un Hanf
In plica rechts: F
A tergo oben Mitte: pro terra Sca
Kleine fette blasse Schrift

3352

Paris Archives Nationales

J 452 n. 1^(a)

Breite 33.2 Rand links 1.2 rechts 1.3

Höhe 28.3 Rand oben 4.7 plica 3

Ohne erste freie Linie / Je eine

Seitenlinie

P. vacat 1265 Aprilis 27

Clemens IIII etc ut in J 452 n. 12

Dat Perusij V Kl Maij / a° 1°

Bulle an Hanf

In plica rechts : F

A tergo oben Mitte : pro terra sca

Kleine fette stumpfe Schrift

3353

Paris Archives Nationales

J 452 n. 2

Breite 24 Rand links 1.5 rechts 1.7

Höhe 16.2 Rand oben 4.2 plica 3.2

Erste Linie über Obelängen / Je

eine Seitenlinie

P. vacat 1265 Aprilis 27

Clemens IIII Egidio Archiepo Tyren

Cum predicatio crucis

Dat Perusij V Kl Maij / a° 1°

Bulle an Hanf

In plica rechts : A. Sen ..

Rand oben Mitte : at (tende) +

A tergo oben Mitte : pro terra sca

flotte kleine Schrift

3354

Paris Archives Nationales

J 452 n. 3

Breite 21. Rand links 0.9 rechts 1.1

Höhe 17.1 Rand oben 3.3 plica 3.2

Erste Linie hoch über den Obelängen

Je eine Seitenlinie

P. vacat 1265 Aprilis 27

Clemens IIII Egidio Archiepo Tyren

Ut commissum tibi

Dat Perusij V Kl Maij / a° 1°

Bulle an Hanf

In plica links : B. V.

A tergo oben Mitte : pro terra sca

Fette kleine gedrängte Schrift

3355

(Quinturn)

Paris Archives Nationales

J 452 n. 4

Breite 21.5 Rand links 0.9 rechts 1.

Höhe 18.5 Rand oben 3.5 plica 2.6

Erste Linie über Obelängen

Je eine Seitenlinie 1265 Aprilis 27

Cum predictionem crucis stb

predicatio

Dat Perusij V Kl Maij a° 1°

Bulle an Hanf

In plica links : B. V.

A tergo oben Mitte : pro terra sca

Fette klare Schrift

Clemens IIII

P. vacat

Paris Archives Nationales
J 452 n. 6
Breite 23.5 Rand links 0.9 rechts 0.8
Höhe 16.5 Rand oben 3.3 plica 3.5
Erste Linie über Oberlängen
Je eine Seitenlinie
P. vacat 1265 Aprilis 27
Clemens IIII Egidio Archiepo Tyren
Cum predicatio Crucis
Dat Perusij V Id Maij a° 1°
Bulle an Hanf
In plica rechts : fr...
Sub plica links : g mathis cap
Kleine deutsche Schrift

Paris Archives Nationales
J 452 n. 5
Breite 26. Rand links 1. rechts 1.
Höhe 20c Rand oben 4.2 plica 2.5
Erste Linie für Oberlängen
Je eine Seitenlinie
P. 19113 1265 Aprilis 27
Clemens IIII . . . Archiepo Tyren
Felicis recordationis Vrbanus
Dat Perusij V Id Maij / a° 1°
Bulle an Hanf
In plica rechts : . B. p.
Sub plica links : S
 g mathis cap Jac Rō X
A tergo oben mitte : pro Terra sca
Fette grosse schöne Schrift

Paris Archives Nationales
J 452 n. 7
Breite 27.5 Rand links 1.2 rechts 1.2
Höhe 20. Rand oben 3.5 plica 2.8
Erste Linie über den Oberlängen
Je eine Linie zutvärts
P. vacat 1265 Aprilis 27
Clemens IIII Egidio Archiepo Tyren
Cum predicatio Crucis omnis
Dat Perusij V Id Maij a° 1°
Bulle an Hanf
In plica rechts : p. Bō /
A tergo oben mitte : pro Terra sca
Schöne kleine Schrift

Paris Archives Nationales
J 452 n. 8
Breite 23.8 Rand links 1.3 rechts 1.1
Höhe 16.9 Rand oben 3.2 plica 2.5
Erste Linie über den Oberlängen
Je eine Seitenlinie
P. vacat 1265 Aprilis 27
Clemens IIII Egidio Archi
epo Tyren
Cum predicatio crucis
Dat Perusij V Id Maij a° 1°
Bulle an Hanf
In plica rechts : p. Bō
A tergo oben mitte : pro Terra sca
Flüssige kleine deutliche Schrift

3360

Paris Archives Nationales
J 452 n. 8 bis

Breite 28,7 Rand links 1.3 rechts 1.2
Höhe 20. Rand oben 3.9 plica 3.5
Erste Linie über den Oberlingen
Je eine Seitenlinie

P. vacat **1265 Aprilis 27**

Clemens IIII Egidio Archiepo Tyren
Cum predicatio crucis
Dat Perusij V Kl Maij a° 1°
Bulle an Hanf
In plica rechts : O ..
A tergo oben mitte : pro terra sca
Eilige kleine fette Schrift

3361

Archives Nationales Paris
L 258 n. 7 **1265 Aprilis 27**

Br. 20.6 hoch 15.9 Plica 2.1
oberer Rand 3.4 links 0.9
rechts 1.2
Clemens IIII .. Archiepo Tyren
Ad audientiam nram
Dat Perusij V Kl Maij a° 1°.
Bulle an Hanf
In plica links : B. V
Sub plica links abgeklatscht !
Math cap. an or Sy sca
A tergo oben mitte : pro terra sca
Kleine fette Schrift
Mit einem betonten Buchstaben
Erste freie Linie zwecklos

P. vacat

3362

Paris Archives Nationales
J 449 n. 723

Breite 31.1 Rand links 1.6 rechts 1.4
Höhe 19.6 Rand oben 4.3 plica 2.9
Erste Linie über Gitterschr und Ober-
lingen / Je eine Seitenlinie
P. vacat 1265 Aprilis 28
Clemens IIII (Gitterschr) Egidio Archi-
epo Tyren
Volentes omnes concessignatos
Dat Perusij IIII Kl Maij / a° 1°
In plica links : B. fu
Bulle an feiner Seide
Weite regelm. Schrift
Vier betonte Initialen
A tergo oben mitte : pro terra sca

3363

Paris Archives Nationales
J 449 n. 123 ter

Breite 30.9 Rand links 1.5 rechts 1.5
Höhe 20.6 Rand oben 4.1 plica 2.7
Erste Linie für Gitterschr und zwei
betonte Initialen, aber über Oberlin-
gen / Je eine Seitenlinie
P. vacat 1265 Aprilis 28
Clemens IIII (Gitterschr) Egidio
Archiepo Tyren
Volentes omnes concessignatos
Dat Perusij IIII Kl Maij / a° 1°
Bulle an Seide
In plica links : B. xxx B. fu
Sub plica links : ..
Math Cap P. Rom
A tergo oben mitte : pro Terra sca
Eilige unruhige Schrift

3364

(Initium)

Paris. Archives Nationales
J 449 n. 128
Breite 23.8 Rand links 1. rechts 1.1
Höhe 74.9 Rand oben 3.2 plica 2.4
Erste Linie über den Oberlängen /
Je eine Leitenlinie
P. vacat 1265 Aprilis 28
Clemens IIII Egidio Archiepo Tyren
 Cum predicationem Crucis
Dat Perusij III Kl Maij a° 1°
 Bulle an Hanf
A tergo oben Mitte: pro terra sca
Sehr schöne kleine Schrift

Im Initium muss es heissen:
predicatio statt predicationem,
diero Cum ... tibi sit commissa

3365

Paris Archives Nationales
J 449 n. 129
Erste Linie über Oberlängen
Je eine Leitenlinie
P. vacat 1265 Aprilis 28
Clemens IIII Egidio Archiepo
Tyren
 Ut commissum tibi
Dat Perusij III Kl Maij / a° 1°
Bulle an Hanf
In plica links: B. fic
Sub plica links:
 G Maths cur and Sy
A tergo oben Mitte: pro terra sca
Zwar kleine unregelm. Schrift

3366

Paris Archives Nationales
J 450 n. 133
Breite 33.4 Rand links 1.3 rechts 1.3
Höhe 26.9 Rand oben 4.2 plica 2.8
Erste Linie für Oberlängen /
Je eine Leitenlinie
P. 19115 1265 Aprilis 28
Clemens IIII Egidio Archiepo Tyren
et Dil filio Nos viro Johi de Valen
zenis domino Cayphe
 Cum sedes aplica
Dat Perusij III Kl Maij / a° 1°
Bulle an Hanf
In plica rechts: J. B
Sub plica links: J. S.
A tergo oben Mitte: pro terra sca
Ungemein schöne kleine Schrift

3367 (recto)

Paris Archives Nationales
J 450 n. 135
Breite 26.4 Rand links 1.7 rechts 1.4
Höhe 23.3 Rand oben 3.8 plica 2.2
Erste Linie für Oberlängen /
Je eine Leiten Linie
P. vacat 1265 Aprilis 28
Clemens IIII Archiepis z Epis y dil
filijs ceteris Ecclex Prelatis per
Regnum Francie nec non Camera
cen Tullen Leodien Meten ac
Virdunen Civitates / dioc con
stitutis
 Terram sanctam quam
Dat Perusij III Kl Maij a° 1°
Bulle an Hanf
In plica rechts: . a. S.
 verte

3367 (verso)

Sub plica links: ⌐ Mathes Cap

A tergo oben Mitte: pro terra scā

Kleine deutliche Schrift

3368

(Datum) (Iustium falsch)

Paris Archives Nationales

J 452 n. 9

Breite 26.4 Rand links 1.5 rechts 1.1

Höhe 16.4 Rand oben 3.4 plica 2.4

Erste Linie über den Oberlängen

Je eine Seitenlinie

P. vacat 1265 Aprilis 28

Clemens IIII . . Archiepo Tyren

Cum predicationem crucis

Dat/ Perusij m̄ ⁇ Maij a° 1°

Bulle an Hanf

In plica rechts: . A. S.

A tergo oben Mitte: pro terra scā

Ganz kleine fahrige Schrift

3369

⌐ Iustium falsch

Paris Archives Nationales

J 452 n. 9 bis

Breite 24.7 Rand links 1.4 rechts 1.3

Höhe 18.1 Rand oben 3.6 plica 3.2

Erste Linie für höhere Oberlängen

Je eine Seitenlinie

P. vacat 1265 Aprilis 28

Clemens IIII Egidio Archiepo Tyren

Cum predicationem crucis statt

praedicatio

Dat Perusij m̄ ⁇ Maij a° 1°

Bulle an Hanf

In plica rechts: . A. S.

Sub plica links: ⌐ Mathes Cap

A tergo oben Mitte: pro terra scā

Kleine fette stumpfe Schrift

3370

Paris Archives Nationales

J 452 n. 10

Breite 20.9 Rand links 1.2 rechts 1.1

Höhe 15.6 Rand oben 3.4 plica 3

Erste Linie über Oberlängen /

Je eine Seitenlinie

P. vacat 1265 Aprilis 28

Clemens IIII Egidio Archiepo Tyren

Ut commissum tibi

Dat Perusij m̄ Kl Maij /a° 1°

Bulle an Hanf

In plica links: B. fri (sic?)

A tergo oben Mitte: pro terra scā

Nachlässige eilige kleine Schrift

Paris Archives Nationales
　　　　　J 452 n. 11
Breite 28.5 Randlinks 1.3 rechts 1.2
Höhe 21.1 Rand oben 4. plica 2.8
　Erste Linie über den Oberlängen
Je eine Seitenlinie
P. vacat　　4265 Aprilis 28
Clemens III Carmo in xpo filio
Lud Jllustri Regi Francor$
　Cum nos ad
Dat Perusij iij Kl Maij / a° 1°
Bulle an Hanf
In plica rechts : p. Ro
Sub plica links : --
A tergo oben Mitte : pro terra Sca

Paris Archives Nationales
　　　　　J 452 n. 12
Breite 33.6 Randlinks 1.3 rechts 1.3
Höhe 26.9 Rand oben 4.3 plica 2.9
　Erste Linie für Oberlängen /
Je eine Seitenlinie
P. 19115　　　1265 Aprilis 28
Clemens III Egidio Anchiepo Tyren
et dil filis Nob viro Joho de Valen
genis domino Cayphe
　　Cum sedes aplica
Dat Perusij iij Kl Maij / a° 1°
　Bulle an Hanf
In plica rechts : J. B.
Sub plica links : S.
A tergo oben Mitte : pro Terra Sca
Sehr schöne kleine feste Schrift

(Datum)
Paris Archives Nationales
　　　　　J 452 h. 12 bis
Breite 38.2 Randlinks 1.1 rechts 1.
Höhe 27. Rand oben 3.7 plica 3.1
　Ohne erste freie Linie / Je eine
Seitenlinie
P. 19115　　　4265 Aprilis 28
Clemens III Egidio Anchiepo Tyren
et dil filio Nob viro Joho de Valen
genis dño Cayphe
　Cum sedes aplica
Dat / Perusij iij Kl Maij a° 1°
Perusij iij Kl Maij ist nachgetragen
Bulle an Hanf
In plica rechts : And, B.
A tergo oben Mitte : pro terra Sca
Kleine feste weite Schrift

Paris Archives Nationales
　　　　　J 450 n. 131 bis
Breite 12.4 Randlinks 1.4 rechts 1.3
Höhe 14.3 Randoben 2.4 plica 2.7
Erste Linie über Oberlängen
Je eine Seitenlinie
P. vacat 4265 Aprilis 29
Clemens III Egidio Anchiepo Tyren
　Personam tuam honorare
Dat Perusij iij Kl Maij a° 1°
　Bulle an Hanf
In plica rechts : R Maths lig
A tergo oben Mitte : pro terra Sca
Kleine dünne Schrift

3375

Paris Archives Nationales
J 452 n. 13
Breite 29.7 Rand links 1.3 rechts 1.2
Höhe 20.8 Rand oben 5.3 plica 2.5
Erste Linie über den Oberlängen
Je eine Seitenlinie
P. vacat 1265 Aprilis 29
Clemens IIII · · Archiepō Tyren
Ad audientiam nram
Dat Perusij / IIII Kl Maij aº 1º
Bulle an Hanf
In plica rechts: Alex · p
Lichte dünne sehr schöne Schrift

3376

Paris Archives Nationales
J 450 n. 138
Breite 26.2 Rand links 0.9 rechts 0.9
Höhe 18.6 Rand oben 3.6 plica 3
Erste Linie über Oberlängen /
Je eine Seitenlinie
P. vacat 1265 Aprilis 30
Clemens IIII Egidio Archiepō Tyren
Cum predictis Crucis
Dat / Perusij IIII Kl Maij aº 1º
Bulle an Hanf
In plica rechts : · F · B ·
A tergo oben Mitte : pro terra scā
Ganz kleine regelm. Schrift

3377

Paris Archives Nationales
J 450 n. 139
Breite 28.1 Rand links 1. rechts 1.1
Höhe 18.3 Rand oben 3.6 plica 2.1
Ohne erste freie Linie / Je eine
Seitenlinie
P. vacat 1265 Aprilis 30
Clemens IIII Egidio Archiepō Tyren
Cum pro tione
Dat Perusij IIII Kl Maij / aº 1º
Bulle an Hanf
In plica rechts : a · a · a
A tergo oben Mitte : pro terra scā
Ganz kleine dünne zierliche Schrift

3378

Paris Archives Nationales
J 452 n. 14
Breite 25.8 Rand links 1.1 rechts 1.2
Höhe 18.9 Rand oben 3.6 plica 2.9
Erste Linie über den Oberlängen
Je eine Seitenlinie
P. vacat 1265 Aprilis 30
Clemens IIII · · Archiepō Tyren et
dil filis Nobili Viro Johi de Valen-
cenis domino Cayphe
Cum felicis recordationis
Dat / Perusij IIII Kl Maij aº 1º
Bulle an Hanf
In plica rechts : p. Ro
Sub plica links : --
A tergo oben Mitte : pro Terra scā
Kleine sehr schöne Schrift

3379

Paris Archives Nationales
J 452 n. 15
Breite 27.3 Rand links 1.2 rechts 1.2
Höhe 20.5 Rand oben 4.1 plica 2.3
Erste Linie über den Oberlängen
Je eine Seitenlinie
P. vacat 1265 Aprilis 30
Clemens IIII Egidio Archiepo Tyren
Cum pro Terre
Dat Perusij ʃ ʃʃ kl Maij aº 1º
Bulle an Hanf
In plica rechts : F · R ·
Sub plica links : ʃ
A tergo obere Mitte : pro Terra ʃca
Ganz kleine fette stumpfe Schrift

3380

Archives Nationales Paris
L 258 n. 8 1265 Aprilis 30
Br. 23. hoch 17.2 plica 2.4
obere Rand 4.4 links 1.
rechts 1.1
Clemens IIII Egidio Arch Edroch
Cum predicatis crucis
Dat Perusij ʃʃ kl Maij aº 1º
Bulle an Hanf
In plica rechts : · a a a.
A tergo oben Mitte :
pro terra ʃca
Kleine enge Schrift
Mit einem betonten Buchstaben
Erste Linie für Oberlängen

P. vacat

3381

Archives Nationales Paris
L 258 n. 9 1265 Aprilis 30
Br. 20 hoch 14,2 Plica 2.6
obere Rand 4.2 links 0.7
rechts 0.9
Clemens IIII Archiepis et
Epis ad quos littere iste pervenerint
Sicut dilecti filij
Dat Perusij ʃʃ kl Maij dº 1º
Bulle an Hanf
In plica rechts : · g · J.
A tergo oben Mitte : Antonius
Kleine nachlässige Schrift
Mit einem betonten Buchstaben
Erste Linie für Oberlängen

P. vacat

3382

Name und Punkte !!!!
Paris Archives Nationales
J 449 n. 130 bis
Erste Linie über den Oberlängen
Je eine Seitenlinie
P. vacat 1265 Maii 1
Clemens IIII -- Egidio Ar-
chiepo Tyren
Cum predicatio crucis
Dat Perusij Kl Maij / aº 1º
Bulle an Hanf
In plica rechts : A. Synitz
A tergo oben Mitte : pro terra ʃca
Kleine lesbare Schrift

Paris Archives Nationales
J 452 n. 16
Breite 27' Rand links 1.5 rechts 1.7
Höhe 19.7 Rand oben 4. plica 4.
Erste Linie über den Oberlängen
Je eine Seitenlinie
P. vacat 1265 Maii 1
Clemens IIII Egidio Archiepo Tyren
Cum predicatio Crucis
Dat Perusij 26 Maij a° 1°
Bulle an Hanf
In plica rechts: A. Sy...
Sub plica links: ..
g Maths Mar Cap p. Ro
a tergo oben mitte: foo tena Sca
Kleine deutliche Schrift

P. 19120 Paris Arch. Nat.
J 695 cap. 176 bis 1265 Maii 1
Clem IIII Ludovico regi Fran
corum illustri
Regalis excellentie zelum
Perusii Kl Maii a° 1°
Bulle an Seid
In plica rechts Jo vac oben
Vat (Vic!)
Sub plica links ..:
g Maths Cap Jac Joat
Rand oben links: Duplica non
obstante quod non est bullata M
A tergo Rex Francie
Drunter: Corrigatur indulgen
tes ubi dicitur iniungentes. Item
ubi dicitur domanii ponatur do-
minii vete

Die erste Correctur ist aus
geführt, die zweite nicht;
es ist domanii stehen ge.
blieben.

Paris Archives Nationales
J 160 A n. 11
Breite 32.5 Rand links 1.8 rechts 1.8
Höhe 22.5 Rand oben 3. plica 3.1
Erste Linie für Maj und Oberlän
gen/ Je eine Seitenlinie
P. vacat 1265 Maii 4
Clemens IIII (häuflich verz. Maj.)
... priori et Conventui Prioratus
Sancti Mauricij Silvanecten or
dinis Sancti Augustini
Consideratione Rerum in
Dat Perusij IIII Non Maij / a° 1°
Bulle an Seide
In plica rechts: N. B. Ho...
Sub plica links: Jac Alex
g Mathi Cap A. G. aube fram
Vdinus

3385 (verso)

A tergo oben Mitte:
 Rex Francie
Kleine fette stumpfe Schrift

3386

Archives Nationales Paris
L 258 n. 10 1265 Maii 4
Br. 30.8 hoch 23.5 Plica 3.4
 oberer Rand 6.1 links 1.1
rechts 1.2
 Clemens IIII .. Cartusie ac
alijs Prioribus et fratribus Vniuer-
sis Cartusien ordinis
 Speciali gratia et
Dat Perusij IIII non Maij aº 1º

Bulle fehlt, Seide erhalten
 In plica rechts: · A· Vet
A tergo oben Mitte: Cartusium

Kleine regelmässige Schrift, mit
gestreckten Ligaturen, mit ver-
betonten Satzanfängen

 In 1. Zeile ein betonter Buchstabe
Iste Linie für Gitterschrift

 P. 19126

3387

Archives Nationales Paris
L 258 n. 11 1265 Maii 4
Br. 29.8 hoch 18.8 Plica 3.2
 oberer Rand 5. links 1.4
rechts 1.7
 Clemens IIII (Gitterschrift,
ganz schwarze Initiale) . Cartu-
 sie ac
alijs Prioratibus et fratribus vni-
uersis Cartusien ordinis
 Speciali gratia et
Dat Perusij IIII non Maij aº 1º
Bulle fehlt, Seide erhalten
 In plica rechts: ber
Sub plica links: ..
A tergo oben Mitte:
 Heremita not ß Cartusia
Schöne kleine Schrift, mit gestr.
Ligaturen, mit drei betonten Satz-
anfängen
 In 1. Zeile kein betonter Buchstabe

 P. 19126

3388

Archives Nationales Paris
L 258 n. 11 bis 1265 Maii 4
Br. 25 hoch 18.7 Plica 4.1
 oberer Rand 4.6 links 1.1
rechts 1.1
 Clemens IIII
 wie in n. 11

Alle Einzelheiten genau die
 gleichen

 P. 19126

3389

Archives Nationales · Paris
L 258 n. 12 1265 Maii 5
Br. 23.2, hoch 18.1 Plica 2.4
obere Rand 4.4 links 0.8
rechts 0.9
Clemens IIII .. Abbati
sancte Genovefe Parisien̄
Sua nobis .. Abbas
Dat Perusij II non Maij a° 1°
Bulle fehlt, Hauf erhalten
Sub plica links : 5 In plica rechts : pč
Iač Alex
A tergo oben Mitte : de Pedemonte
Kleine fette Schrift
Ohne jeden betonten Buchstaben
erste Linie für Oberlängen

P. vacat

3390

Archives Nationales Paris
L 258 n. 13 1265 Maii 5
Br. 29.6 hoch 22.7 Plica 1.8
obere Rand 5.9 links 1.3
rechts 1.3
Clemens IIII (Gitterschrift, Ini-
tiale ausgespart) .. Magro et fratri-
bus Hospitalis sancti Johis Jerlimitan
Solet annuere sedes
Dat Perusij II non maij a° 1°
Bulle an Seide
In plica rechts : g de Segestro
Sub plica links : ..
Iač Alex
Rand oben Mitte : of
Ecke oben rechts : Sfr
A tergo Ecke oben links : Y
" oben Mitte grosses +
Sehr weite schöne Schrift, mit gestr.
Ligaturen, mit 4 betonten Lateinanfängen
In 1. Zeile 1 betonter Buchstabe
Erste Linie für Gitterschrift und Oberlängen

P. vacat

3391

Instr. mon. T. dom. c. — 1265 Maii 5
P. —
Clem. IV .. mag. et fratr. ord. Praed.
Pium est et —
Perusii II non. Maii a° 1°
Bulle und Seide fehlen.
In plica rechts : Iač Mut
A tergo : Praedicatorum

Hohl cassirt maii 31
vergl. 1265
P. 19467.
1265 Jan. 3
vergl.

3392

Archives Nationales Paris
L 258 n. 14 1265 Maii 6
Br. 32.1 hoch 22.2 Plica 2.7
obere Rand 4.2 links 1.4
rechts 1.4
Clemens IIII (Gitterschrift, Ini-
tiale variiert) Universis xpi fide-
libus per Regnum Francie consti-
tutis Quoniam ut ait
Dat Perusij II non Maij a° 1°
Bulle fehlt, Seide erhalten B. fieč
In plica links : ..
Sub plica links : ..
Iač Alex
A tergo oben Mitte : Cartusie
Kleine regelm. Schrift, mit gestr.
Ligaturen (mit einer Ausnahme)
mit zwei variierten Lateinanfängen
In 1. Zeile 2 variierte Buchstaben
Erste Linie für Gitterschrift

P. vacat

Archives Nationales Paris
L 258 n. 15 1265 Maii 6
Br. 30.7 hoch 21.1 plica —
oberer Rand 5 links 1.4
rechts 1.4
Clemens IIII. . Priori (et dioni
sij in Francia Ranisten dioc
Sua nobis dilecti
Dat Perusij ij non Maij a°10

Plica ganz abgerissen (Hanf)
links : 5

Ecke oben links : duplt
a tergo oben Mitte :
de Pedemonte

Kleine sehr schöne Schrift

Mit einem betonten Buchstaben
Ohne erste freie Linie

P. vacat

duplicetur

Archives Nationales Paris
L 258 n. 16 1265 Maii 6
Br. 38. hoch 23.2 plica 4.1
oberer Rand 4.6 links 1.5
rechts 1.5
Clemens IIII (Gitterschrift, Ini-
tiale verziert) . . Priori ij patribus domus
vallis viridis prope civitatem Pari-
sien Cartusien ordinis
Desiderijs vestris in
Dat Perusij ij non Maij a°10

Bulle fehlt, Seide erhalten
In plica links : B. fio
Sub plica links : 5

a tergo oben Mitte : Jac Alex
Cartusie

Kleine regelm. Schrift, mit gestr
Ligaturen (mit drei Ausnahmen)
mit drei verzierten Satzanfängen

In 1. Zeile 1 verz. Buchstabe
Erste Linie für Gitterschrift

P. vacat

Paris Archives Nationales
J 792 n. 23
Breite 23.2 Rand links 1.2 rechts 1.2.
Höhe 17.8 Rand oben 3.6 plica 2.6
Erste Linie für Oberlängen / Je eine
Seitenlinie
P. vacat 1265 Maii 7
Clemens IIII Nob viro . . Comiti
Tholosan ij Pictauien

Preces que iustitiam
Dat Perusij non Maij / a° 1°
Bulle an Hanf
A tergo oben Mitte : fres de
Monte Carmeli M
Kleine sehr zierliche und schöne
Schrift.
Ohne jede Kanzleibemerkung

Paris Archives Nationales
J 450 n. 138
Breite 43.4 Rand links 0.8 rechts 0.8
Höhe 26.2 Rand oben 4.3 plica 3.4
Erste Linie über Oberlängen / Je
eine Seitenlinie
P. vacat 1265 Maii 7
Clemens IIII Egidio Archiepo Tyren
Inter occupationes multiplices
Dat Perusij non Maij a°10
Bulle an Hanf
In plica rechts : . A. Ver.
A tergo oben Mitte : pro feria Jta
Ganz prachtvolle kleine feste
Schrift

Paris Archives Nationales
J 450 n. 142

Breite 28.7 Rand links 1.7 rechts 1.9

Höhe 23. Rand oben 4.1 plica 3

Erste Linie über Oberlängen

Je eine Seitenlinie

P. vacat 1265 Maii 7

Clemens IIII Egidio Archiepo

Tyren

 Cum predicatis crucis

Dat Perusij non Maij / a° 1°

Bulle an Hanf

A tergo oben Mitte: pro terra sca

Kleine enge fette Schrift

 Text verschieden von 140, 141

146 (142/147)

Archives Nationales Paris
L 258 n. 17 1265 Maii 7

Br. 28.8 hoch 20.8 Plica 3.2
 oberer Rand 4.8 links 1.7
rechts 1.6

 Clemens IIII (Gitterschrift, Im
 Siele verziert) .. abbati et Conventui
Monasterij sci Mauri de Fossatis or-
dinis sancti Benedicti Parisien
 dioc

 Cum a nobis

Dat Perusij non Maij a° 1°

Bulle fehlt. Seide erhalten
 In plica rechts : m. p
Sub plica links : --

A tergo oben Mitte : Donum Regis

Sehr ungeschickte, unachtsame
Schrift, mit großen Ligaturen,
mit 4 betonten Satzanfängen

In 1. Zeile 1 betonter Buchstabe

Erste Linie für Gitterschrift

 P. vacat

Archives Nationales Paris
L 258 n. 18 1265 Maii 8

Br. 30 hoch 23.6 Plica 2.9
 oberer Rand 4.6 links 1.6
rechts 1.6

 Clemens IIII Cartusie ac uni-
uersis Prioribus et fratribus Cartu-
sien ordinis

 Religionis nestre meretur
Dat Perusij VIII Id Maij a° 1°

Bulle fehlt. Seide erhalten
 In plica rechts : St. Sd. potent9
Sub plica links : S c

A tergo oben Mitte : Cartusie

Kleine regelmäßige Schrift mit
gestreckten Ligaturen mit vier
betonten Satzanfängen

In 1. Zeile 1 betonter Buchstabe

Erste Linie für Gitterschrift und
 Oberlängen

Papstname in Text in Gitterschrift

 P. 19134

Madrid. Arch. Histor. Nacional
dominicos de S. Pablo Burgos 40 E
P. 19137 1265 Maii 9

Clemens IIII -- magro -- prioribus
et fribus universis ord. fratrum
Predic.

In quibusdam locis

Perusii VII id. Maii a° 1°

Bulle fehlt. Seide erhalten.

In plica rechts m p
Sub plica links ..

3401

Archives Nationales Paris

L 258 u. 19 **1265 Maii 9**

Br. 27.3 hoch 18.6 Plica 3.4
oberer Rand 5. links 1.3
rechts 1.3

Clemens IIII (Gitterschrift
Initiale versiert) .. venter Prioribus
et fratribus venuensis ordinis fra-
trum Predicatorum

In quibusdam locis
dat Perusii VII Jd Maii a° 1°

Bulle an stärkerer Seide
In plica rechts : Jo. S.
Sub plica links : ...

A tergo oben mitte:
Predicatores

Mittelgrosse regelm. Schrift, mit
gestr. Ligaturen (mit zwei Ausnahmen)
mit vier versierten
Satzanfängen

In 1. Zeile 1 vers. Buchstabe

Erste Linie für Gitterschrift

P. 19137

3402

Archives Nationales Paris

L 258 u. 20, **1265 Maii 10**

Br. 27.3 hoch 20. Plica 3.
oberer Rand 4.4 . links u. 6
rechts 1.5

Clemens IIII (Gitterschrift,
Initiale versiert) .. magro et
fratribus Hospitalis sancti Johannis
Jerlimitan

Solet annuere sedes
dat Perusii VI Jd Maii a° 1°

Bulle und Seide ausgerissen
In plica rechts : N. S. potent)
(N de ?)
Sub plica links: ..

Jat Alex
Ecke oben rechts : O
Rand oben mitte : cor
a tergo oben mitte grösser +
" Ecke oben links : y

weite, sehr schöne kleine
Schrift, mit gestreckten Ligaturen,
mit 4 versierten Satzanfängen

In 1. Zeile ein betonter Buchstabe

Erste Linie für Gitterschrift und
Oberlängen

P. vacat

3403

Archives Nationales Paris

L 258 u. 21 **1265 Maii 11**

Br. 30. hoch 22.9 Plica 3.1
oberer Rand 5.5 links 1.5
rechts 1.5

Clemens IIII (Gitterschrift,
Initiale ausgespart) .. Abbati et
Conventui Monasterij Ste Ger-
mani de Pratis Parisien ad Ro-
mam Ecclesiam nullo medio perti-
nentis ordinis sancti Benedicti
Volentes ponam et
dat Perusii V Jd Maii a° 1°

Bulle und Seide fehlen
In plica rechts : .D.
In plica zwei lange Zeilen : Innoue-
tur istud privilegium etc.

A tergo oben mitte : de Pedemonte

Sehr schöne kleine Schrift, mit nur
vereinzelten gestr. Ligaturen, mit
drei betonten Satzanfän-
gen. In 1. Zeile 1 betonte Buchstabe

Erste Linie für Gitterschrift und
Oberlängen

Innovetur **P. vacat**

3404

Archives Nationales Paris

L 258 n. 21 bis **1265 Maii 11**

Br. 36.5 hoch 25.9 Plica 3.3
oberer Rand 5.5 links 2.2
rechts 1.9

Clemens IIII (versierte ma-
iusculae) . . Abbati et Conventui
Monasterij Sti Germani de Pratis
Parisien etc

wie in u. 21

Bulle fehlt. Seide erhalten
In plica rechts unterschied
Sub plica links : ...

Jat Alex

Auf der plica darunter :
N mathis Cap. J.

Ecke oben links : darpa du. p.

A tergo Ecke oben links : B
" oben mitte :
de Pedemonte

weite regelm. Schrift, mit sehr ge-
streckten Ligaturen, mit drei
versierten Satzanfängen
In 1. Zeile 1 vers. Buchstabe

Erste Linie für Papstname

dupliciter **P. vacat**

Instr. Mos. F. tom. c. 80 1265 Maii 11

P. 19144

Clem. IIII .. mag. et univ. prioribus
ac vices priorum gerentibus ord.
fratrum Predic.

Licet ad hoc.

Perusii V id. maii anno 1°

Seidenfäden. Bulle fehlt.

In plica links: A...

Sub plica links: ..

 2 maths cap

Ecke oben links: - duo N₃

A tergo: Predicatorum

f. 1265 Januar Michael de Tholosa
1265 Junii 5 vicecancellarius

Paris Archives Nationales
 J 452 n. 17

Breite 22.7 Rand links 1.5 rechts 1.6
Höhe 16.2 Rand oben 4.1 plica 2.3
Erste Linie für Gitterschrift / Je
eine Seitenlinie

P. vacat 1265 Maii 15

Clemens IIII (Gitterschr) etc. ut in n. 19

 Plures labores nos

Dat Perusij Id Maij / a° 1°

 Bulle an feiner Seide

In plica rechts: A. Synit (?)

A tergo oben mitte: pro terra sca

Etwas nachlässige kleine Schrift

Paris Archives Nationales
 J 452 n. 18

Breite 56.8 Rand links 1.5 rechts 1.5
Höhe 47.8 Rand oben 7.4 plica 5.1
Erste Linie für höhere Oberlängen
Je eine Seitenlinie

P. vacat 1265 Maii 15

Clemens IIII etc. ut in J 452 n. 12

 Cum felicis recordationis

Dat Perusij Id Maij a° 1°

Bulle an Hanf

In plica rechts: S. R.

Sub plica links: X

A tergo oben mitte: pro terra sca

Spitze dünne enge Schrift

Archives Nationales Paris
L 258 n. 22 1265 Maii 15

Br. 33.1 hoch 21.3 plica 3.4
 oberer Rand 5.6 links 1.5
rechts 1.5

 Clemens IIII (Gitterschrift
Initiale verziert) .. Abbati et Con-
ventui Monasterii sancti germani
de Pratis Parisien ad Romanã ecclesiã
nullo medio pertinentis ordinis sancti
Benedicti

 Cum a nobis
Dat Perusij Id maij a° 1°

Bulle fehlt, Seide erhalten
 In plica rechts: A. f u (?)
Sub plica links: ..

A tergo oben mitte: de Redemonte

Kleine sehr schwungvolle Schrift, mit
schön gestreckten Kopf turren, mit
vier verzierten Satzanfängen.
 In 1. Zeile 1 vers. Buchstabe.

Erste Linie für Gitterschrift und
 untere Oberlängen

P. vacat

Archives Nationales Paris
L258 n. 22 bis 1265 Maii 15

Br. 29.7 hoch 21.1 Plica 2.8
oberen Rand 4.7 links 1.1
rechts 1.2
 Clemens IIII (Gitterschrift
Initiale verziert) -- Abbati et con-
ventui monasterii sancti Ger-
mani de Pratis Parisien. ad
Romam ecclesiam nullo medio
pertinentis etc.
 wie in n. 22

Bulle fehlt, Seide erhalten
 In plica links ! R O
Sub plica links ! Sat' Alex
Auf der plica darunter: Minth cap
 Ecke oben links : du . P.
Rand oben mitte : cor

A tergo Ecke oben links : B
 oben mitte : de Pedemonte

Kleine fette regelm. Schrift, mit
gestr. Ligaturen, mit viel verzier-
ten Schwänzchen

In 1. Zeile 1 vers. Buchstabe

Erste Linie für Gitterschrift

duplicetur P. vacat

Coblenz Staatsarchiv --
Himmerode
P. -- 1265 Maii 18
Clemens IIII .. abbati et con-
ventui monasterii de Claustro
ordinis Cisterzien. Treverensis
diocesis
Cum a nobis
Perusii XV Kl. Junii a° 1°
Bulle an Seide
In plica rechts Jo Anagi
In plica links XXIII
Sub plica links --- Drunter auf
dem Bug sehr flüchtig = Maths
pro:
ep. Jo anag.
Mehrere Verbesserungen.

Duplicat

Gleichlautend ohne Verbesserung

gen, ohne Notiz auf dem
Bug; in plica links XV s.

Paris Archives Nationales
 J 450 n. 149
Breite 25.6 Rand links 1. rechts 0.8
Höhe 17.2 Rand oben 2.9 plica 2.9
Erste Linie für Oberlängen / Je
eine Leiterlinie
P. vacat 1265 Maii 18
Clemens IIII .. Archiepo Tyren
Ad audientiam nostram
Dat Perusii XV Kl Junii a° 1°
Bulle an dickem Hanf
In plica rechts : A . S.
A tergo oben mitte : pro tura Jra
Sehr schöne kleine Schrift

3412

Archives nationales Paris
L 258 n. 23 **1265 Maii 18**

Br. 32.3 hoch 22.3 Plica 3.3
oberer Rand 5.3 links 1.5
rechts 1.4

Clemens IIII (Gitterschrift
Initiale verziert) . . Preceptori et
fratribus domus militie Templi
Merito incongruum censeri
Dat Perusij XV Kl Junij a° 1°

Bulle und Seide ausgerissen
In plica rechts : Ja. S
Sub plica links: --?

A tergo oben mitte : Helyas de Payllio

Kleine regelmäßige Schrift, mit ge-
streckten Ligaturen (mit zwei Ausnah-
men) mit 4 betonten Satzanfängen

In 1. Zeile zwei betonte Buchstaben

Erste Linie für Gitterschrift und Ober-
längen

P. vacat

3413

Archives nationales Paris
L 258 n. 24 **1265 Maii 18**

Br. 32.7 hoch 25.5 Plica 3.
oberer Rand 5.8 links 1.4
rechts 1.3

Clemens IIII (Gitterschrift. Ini-
tiale verziert) . . Magro et fratribus
Hospitalis sancti Johis Jerlimitan
Merito incongruum censeri
Dat Perusij XV Kl Junij a° 1°

Bulle an stärkerer Seide
In plica rechts : . A. g.

A tergo oben mitte : Angelerius

Sehr schöne feste Schrift, mit gestr.
Ligaturen, mit vier verzierten Satz-
anfängen
In 1. Zeile 1 verz. Buchstabe
Erste Linie für Gitterschrift und Oberlängen

P. vacat

3414

Poitiers Archives départem.
Ordre de Malte
P. —

 1265 Maii 25

Clemens IIII archepis et epis
ad quos lit. iste pervenerint
Querela dilectorum filiorum
Perusij VIII Kl. Junii a° [1°]
Bulle fehlt, Seide erhalten
In plica rechts B Welf
Erste Zeile beschrieben
Seitenlinien kleine Ränder
Ligaturen gemischt.
Sehr schöne kleine Schrift mit
schwungvollen Längen

3415

Toulouse, Archives départem.
H. 24
P. —

 1265 Maii 25

Clemens IIII archepis et epis ad
quos littere iste pervenerint
Querela dilectorum filiorum
Perusii VIII Kl. Junii a° 1°
Bulle fehlt, Seide erhalten
In plica rechts pro nïa Rog
Ja. var
In plica links Rf Jaõ renovetur
sub dat. II Kl. febr. 6.
Drunter : pro preceptore et frati-
bus domus militie Templi Jerosol.
Sub plica links ..
mathc Cap . B. Mon
VT g. Par. VI
drunter B fus ?

Archives Nationales Paris
L 258 n. 25 1265 Maii 25

Br. 29.6 hoch 22.1 Plica 4
oberer Rand 6.1 links 0.8
rechts 0.8
 Clemens IIII (Gitterschrift, Initiale
ausgespart) Archiepis et Epis
ad quos littere iste pervenerint
 Querela dilectorum filiorum
Dat Perusij VIII kl Junij a° 1°

Bulle und Seide fehlen
 In plica rechts: B. mess)
Sub plica links : . .

Zarte kleine regelm. Schrift, mit gestr.
Ligaturen (mit einer Ausnahme)
mit 2 betonten Satzanfängen

Erste Linie für Gitterschrift und
 Oberlängen

 P· vacat

Archives Nationales Paris
L 258 n. 26 1265 Maii 25

Br. 39.3 hoch 26.8 Plica 3.
oberer Rand 6.2 links 1.5
rechts 1.5
 Clemens IIII (Gitterschrift, die
Linie mit schönen Arabesken verziert)
Archiepis et Epis ac Dil filijs Abbatibus
Prioribus Decanis Archidiaconis et
alijs ecclesie prelatis ad quos littere
iste pervenerint
 Ii discrimina que
Dat Perusij VIII kl Junij a° 1°

Bulle an Seide
 In plica rechts : · a. S.
Sub plica links : S
 . . .

Kleine regelm. Schrift, mit gestr. Liga-
turen (mit zwei Ausnahmen) mit
einem verzierten Satzanfang

In 1. Zeile ein ver. Buchstabe

Erste Linie für Gitterschrift und
 Oberlängen

 P· vacat

Marseille Archives Départem.
H · O · m · 21
P ·— 1265 Maii 27

Clemens IIII . . magro et pa-
tribus Hospitalis Jerosolim .

 Quieti vestre providere

Perusii VI kl . Junii a° 1°

Bulle und Seide ausgerissen

In plica rechts Monkis . . .

Sub plica links S

Erste Zeile frei

Gestreckte schwungvolle Ligat.

Archives Nationales Paris
L 258 n. 27 1265 Maii 27

Br. 40.4 hoch 31.9 Plica 3.6
oberer Rand 6.5 links 1.5
rechts 1.2
 Clemens IIII (Gitterschrift,
Initiale ausgespart) Archiepis et Epis
ac Dil filijs abbatibus Prioribus Decanis
archidiaconis 7 alijs Ecclie Prelatis
ad quos littere iste pervenerint
 Ii diligenter attenditis
Dat Perusij VI kl Junij a° 1°

Bulle fehlt, Seide erhalten
 In plica rechts : Ja. vo
Sub plica links :
 Darunter auf der plica :
 7 Matty matty
A tergo oben Mitte : ┼

Klare eckige Schrift , mit gestr. Liga-
turen (mit mehreren Ausnahmen)
mit fünf betonten Satzanfängen

In 1. Zeile 2 betonte Buchstaben
Erste Linie für Gitterschrift und Ober-
 längen

Papstname im Text nicht in Gitterschr.
Schreibfehler
religiosi P· vacat

3420

Archives Nationales Paris

L 258 n. 28 1265 Maii 27

Br. 29.6 hoch 22.5 Plica 2.8
oberer Rand 5.7 links 1.3
rechts 1.6

Clemens IIII (Gitterschrift, Initiale ausgespart) Archiepis et Epis
ac dil. filiis Abbatibus Prioribus decanis archidiaconis et aliis ecclesiarum
Prelatis ad quos littere iste pervenerint
Pervenit ad nos
Dat Perusij VI kl Junij a° 1°

Bulle an Seide
 Sub plica links : - -
 Rand oben Mitte : ☩

A tergo oben Mitte : ☩

Kleine schwungvolle
 Schrift, mit gestr. Ligaturen,
mit zwei betonten Satzanfängen

In 1. Zeile ein betonter Buchstabe

Erste Linie für Gitterschrift und
 untere Oberlängen

Papstname im Text in Gitterschrift

__P. vacat__

3421

Archives Nationales Paris

L 258 n. 29 1265 Maii 27

Br. 30.5 hoch 26.2 Plica 4.5
oberer Rand 6.7 links 1.3
rechts 1.4

Clemens IIII (Gitterschrift, Initiale ausgespart) .. Magistro et fratribus Hospitalis Jerusolimitani
 Quanto per gratiam
Dat Perusij VI kl Junij a° 1°

Bulle und Seide fehlen
 In plica rechts : Rec. J.
Sub plica links : .?
 A tergo
 oben Mitte grosses +

Fette kleine nachlässige und undeutliche Schrift, mit
glatt. Anf;[?] mit 3 betonten
 Satzanfängen
In 1. Zeile 2 betonte Buchstaben

Erste Linie für Gitterschrift und
 Oberlängen

Papstname im Text (Eugenius)
 in Gitterschrift

__P. vacat__

3422

Archives Nationales Paris

L 258 n. 30 1265 Maii 27

Br. 29.3 hoch 22.5 Plica 5.
oberer Rand 5.2 links 1.3
rechts 1.4

Clemens IIII (Gitterschrift,
Initiale versiert) Archiepis et Epis
et dil. filiis Abbatibus Prioribus Deca
nis Archidiaconis et aliis ecclesiarum
Prelatis ad quos littere iste pervenerint
 Cum a religiosorum
Dat Perusij VI kl Junij a° 1°

Bulle an Seide
 In plica rechts : B. pu
A tergo oben Mitte grösseres + pu

Fette Regeln. Schrift, mit wenigen
gestr. Ligaturen, mit einem
versierten Satzanfang

In 1. Zeile 1 vers. Buchstabe

Erste Linie für Gitterschrift und
 Oberlängen

__P. vacat__

3423

Poitiers Archives départ.
Ordre de Malte

P. — 1265 Maii 27
Clemens IIII archiepis et epis
et d.f. abb. prior. dec. archid.
et aliis eccl. prel. ad quos l. i. pers.
Cum a religiosorum
Perusii || VI kl. Junii a° 1°
Bulle fehlt. Seide erhalten
In plica rechts B f

__Datum__

3424

Archives Nationales Paris
L 258 n. 31 1265 Maii 28

Br. N 28.8 hoch 21.4 Plica 4.
oberer Rand 5.6 links 1.3
rechts 1.1
 Clemens IIII (Gitterschrift,
Initiale versiert).. Magro et fr.
Tribus domus Militie Templi
Jerlimitan.
Dat Perusij V Kl Junij a° 1°

Bulle an Seide
 In plica rechts: Jo. S.
Sub plica links: ..

A tergo oben mitte: Helyas de Poyllieu
mit gestr. Ligaturen (mit einer
Ausnahme) mit 4 verz. Satzaufzügen

In 1. Zeile 1 verz. Buchstabe

Erste Linie für Gitterschrift mit einige
 Oberlängen
Klare feste Schrift

P. vacat

3425

Archives Nationales Paris
L 258 n. 32 1265 Maii 28

Br. 28.1 hoch 21.8 Plica 4. 4
oberer Rand 5.6 links 1.3
rechts 1.2
 Clemens IIII (Gitterschrift, Initiale versiert).. Magro T fratribus
domus Militie Templi Jerlimitan.
Dat Perusij V Kl Junij a° 1°

Bulle an Seide
 In plica rechts: Jo. S.
Sub plica links: ..

A tergo oben mitte: Poyllieu
 Helyas de

Klare feste Schrift, mit gestreckten
 Ligaturen, mit 4 verzierten
 Satzaufzügen

In 1. Zeile 1 verz. Buchstabe

Erste Linie für Gitterschrift mit
 Oberlängen

P. vacat

3426

Toulouse, Archives Départem.
 H. 24

P. — 1265 Maii 29

Clemens IIII archepis et epis
ac abbat. prior. decan. archid.
archipresb. et aliis ecclesiarum
prelatis ad quos littere iste per-
venerint
 Paci et quieti
Perusii IIII Kl. Junii a° 1°
Rund. Bulle an Seide
In plica links B. 8.
Sub plica links ...

feste schöne runde Schrift.

3427

Archives Nationales Paris
L 258 n. 33 1265 Maii 29

Br. 33.4 hoch 24.3 Plica 3.1
oberer Rand 5.2 links 1.9
rechts 1.9
 Clemens IIII (Gitterschrift,
Initiale reich mit zierlichen
Arabesken) Archepis T Epis T
fil. filijs Abbatibus Prioribus
decanis Archidiaconis Archipbris
et alijs eccliar. Prelatis ad quos
littere iste pervenerint
 P dci et quieti
Dat Perusij IIII Kl Junij a° 1°

Bulle an Seide
 In plica rechts: Bo p mer
Sub plica links: S

A tergo oben mitte:
 Helyas de Poyllieu
Sehr schöne feste runde Schrift,
mit gestreckten Ligaturen, mit
mit 4 varierten Satzaufzügen

In 1. Zeile 1 var. Buchstabe

Erste Linie für Gitterschrift mit
 Oberlängen
Arabesken P. vacat

3428

Archives Nationales Paris

L 258 n. 35 1265 Maii 29

Br. 26.4 hoch 21.5 Plica 3.7
oberer Rand 6.3 links 1.
rechts 1.1
Clemens IIII (Gitterschrift.
Initiale verziert) .. Preceptori ⁊
fratribus domus Militie Templi
in Francia. Cum a nobis
Dat Perusij III Kl Junij a° 1°

Bulle an Seide
In plica mitte längere von B
gezeichnete Bemerkung über die
Ausfertigung anderer Stücke.
Darunter: R℟ Iac B.
A tergo oben mitte: ✝
Helyas de Poylleio
Texte sehr regelm. Schrift, mit gestr.
Ligaturen, mit 4 obesisten Sch
aufängen.
In 1. Zeile 1 verz. Buchstabe

Erste Linie für Gitterschrift und
überlängen

P. vacat

3429

Marseille Archives Départem.
H. O. T. 6
P. — 1265 Maii 29
Clemens IIII .. preceptori et fratri-
bus domus Militie Templi.
Jerosolimitan.
Cum a nobis (sic)
Perusii III Kl. Junii a° 1°
Bulle an Seide
In plica rechts . paul 9
Gestreckte Ligaturen
Sehr regelmäßige, schwungvolle
schöne Schrift

3430

Archives Nationales Paris

L 258 n. 36 1265 Maii 31

Br. 30.4 hoch 22.1 Plica 3.4
oberer Rand 5.4 links 1.1
rechts 1.2
Clemens IIII (Gitterschrift
Initiale ausgespart) Archiepo et
Epo, ac dil. filiis Abbatibus priori-
bus decanis. Archidiaconis et aliis
eccliaz prelatis ad quos littere
iste pervenerint Pervenit ad nos
Dat Perusij III Kl Junij a° 1°

Bulle an schlechter Seide
In plica rechts: B. P.
Sub plica links : a a
A tergo oben mitte : Poylleio
Helyas de Poylleio
Text. regelm. Schrift, mit gestreckt.
Ligaturen, mit 2 betonten
Sch aufängen.
In 1. Zeile 1 betonter Buchstabe

Erste Linie für Gitterschrift und
überlängen

Expositurne ein Teil in
Gitterschrift.

P. vacat

3431

Archives Nationales Paris

L 258 n. 37 1265 Maii 31

Br. 25. hoch 13.9 Plica 2.4
oberer Rand 4.3 links 1.5
rechts 1.4
Clemens IIII wie in n. 37 bis

Bulle an Seide
A tergo oben mitte ✝

Kleine regelm. Schrift, mit ge-
streckten Ligaturen, mit den
betonten Sch aufängen.
In 1. Zeile 1 verz. Buchstabe

Erste freie Linie fehlt

P. vacat

3432

Archives Nationales Paris
L 258 n. 37 bis 1265 Maii 31
Br. 25.6 hoch 16.3 Plica 28
oberer Rand 4.5 links 1.5
rechts 1.3
Clemens IIII (Gitterschrift,
Initiale verziert) .. Magro et
fratribus domus Hospitalis Jeru-
limitan
Devotionis vee mentru
dat Perusij V Kl Junij a° 1°
Bulle an Seide
Sub plica rechts : Aba
plica links : /
A tergo oben mitte grosses +
Kleine fette regelm. Schrift, mit
gestr. Ligaturen , mit viel ver-
zierten Schwänzen
In 1. Zeile 1 verz. Buchstabe
Erste Linie für Gitterschrift und
 Oberlängen

P. 19165

3433

Instr. mon. F. Dom. c. 140 1265 Maii 31
 P. 19167
Clem. IV .. mag. et fratribus ord. fratrum
Bertie.
Pium est et. —
Perusii V Kal. Junii anno 1°
Seerenfieden. Bulle fehlt.
in plica halbrechts : J. Ro
 „ „ rechts : J. B
Unter dem Bug links abgekleatrabt:
 Maths Cap. Sac ... M
Links obere Rand : Barthol de visit.
 Cigeti ... m
 a

J. 1241 Jan. 3
1265 mai 5
 Michael de Tholosa
 vicecancellarius

3434

Marseille Archives Département.
H. S. C. a. 2
P. — 1265 Junii 2
Clemens IIII .. epo Magalonen.
Dilecte in xpo
Perusii IIII Non. Jun. a° 1°
Bulle und Hauf fehlen
In plica links . B. V.
Sub plica links ...
Kleine regelmänige kräftige
Schrift

3435

Paris Archives Nationales
 J 450 n. 134
Breite 26.6 Rand links 1.6 rechts 1.2
Höhe 18.6 Rand oben 3.6 plica 4.
Erste Linie für Oberlängen / Je
eine Leitenlinie
P. vacat 1265 Junii 2
Clemens IIII .. Archiepo Tyren
Ut Commissum Libi
dat Perusij IIII Non Junij a° 1°
Bulle an Hauf
In plica rechts : p. lata
Sub plica links : S
 Jat Alex
flotte kleine weite Schrift

Der Text ist verschieden von n. 131ten

3436

drus Alben

Paris Archives Nationales
J 450 n. 145
Breite 19.8 Rund links 1. rechts 1.1
Höhe 12.9 Rund oben 3.3 plica 3.2
Ohne erste freie Linie / Je eine
Seitenlinie
P. vacat 1265 Junii 2
Clemens IIII . . Archiepo Tyren.
Ut communius tibi ... mandatur
mus, das er keine Dispensen vom
Kreuzzuge gebe
Dat. Perusij III non Junij / aº 1º
Bulle an Hanf
In plica rechts : lata de mandato
dni Alben
Sub plica links : Jac Alex
Sehr schöne kleine Schrift

3437

Paris Archives Nationales
J 450 n. 150
Breite 37.1 Rund links 1.8 rechts 1.9
Höhe 23.9 Rand oben 3.5 plica 3,2
Erste Linie für Oberlängen / Je
eine Seitenlinie
P. vacat 1265 Junii 2
Clemens IIII Nob viro . . . Pictavien et Tholosan
Nobilitatis tue vestre multiplicità
Dat Perusij III Non Junij
Bulle an Hanf aº 1º
Ohne alle Notizen
Prachtvolle kleine feste Schrift

3438

Paris Archives Nationales
J 452 n. 19
Breite 23.4 Rund links 1. rechts 0.9
Höhe 16. Rund oben 2.7 plica 2.1
Erste Linie für Gitterschr und
Oberlängen / Je eine Seitenlinie
P. vacat 1265 Junii 3
Clemens IIII (Gitterschr) Vniuersis
Predicatoribus uerbi Crucis pro terra
Sca Subsidio ac executoribus negotij
eiusdem Crucis
Volentes labores uros
Dat Perusij III Non Junij / aº 1º
Bulle an feiner Seide
In plica rechts : . A. S.
A tergo oben Mitte : pro terra sca
Weite spitzes sehr schöne Schrift

3439

Archives Nationales Paris
L 258 n. 38 1265 Junii 3
Br. 75.5 hoch 56. plica 2.9
oberer Rand 6.7 links 2.3
rechts 2.5
Clemens IIII (Maiusculae
der erste Name mit reichen
Arabesken von großer Feinheit
verziert. Capitels anfänge ebenfalls
.. Magro Prioribus et fratribus vni-
uersis ordinis Predicatorum
Virtute conspicuos sacri
Dat Perusij III non Junij aº 1º
Bulle fehlt. Seide erhalten
A tergo oben Mitte :
Predicator Parisiensium quod
metit (?) ei vice cancellarius
Sehr schöne kleine Schrift, mit vielen
gestreckten ligaturen
Erste Linie für Papstnamen
und unter Oberlängen
vicecancellarius
Arabesken

P. 19175

3440

Carcassonne, Archives Départ.
H. 318

P. 19175 1265 Junii 3
Clemens IIII .. magistro, prioribus
et fratribus universis ord. Predic.
Virtute conspicuos sacri
Perusii III non. Jun. a° 1°
Bulle fehlt, Seide erhalten

Ohne alle Notizen

Grosses Queerformat
Kleine Zeilenabstände
Ausserordentlich kleine, aber feste
und sehr schöne Schrift.

3441

Graz Landesarchiv h. 844
P. 19175-18077 1265 Junii 3
Clemens IIII .. magro, priori-
bus et fribus univ. Ord Bed.
Virtute conspicuos sacri
Perusii III non. Junii a° 1°
Bulle und Seide ausgerissen
In plica rechts dar M.

3442

Napoli Curia Eccles. Vol. 4°
P. 19175 1265 Junii 3
Clemens IIII .. magro prioribus
et fribus universis ord. Predicat.
Virtute Conspicuos sacri
Perusii III non. Junii a° 1°
Bulle fehlt. Einzelne Seidenfä-
den erhalten
In plica rechts a. G.

Prachtvoll geschriebene grosse
Urkunde
...volle schöne ziemlich enge
Zeichren.

3443

Intr. mon. F. dom. c. 5 1265 Junii 3
P. 19175 reg. 18077
Clem. IIII .. mag. fabr prioribus et fra-
tribus ord. Pred.
Virtute conspicuos sacri.
Perusii III non. Junii a° 1°
Seidenfäden. Bulle fehlt.
In plica rechts: J. A
A tergo: predicatorum
R cap (XXVIIII (?)

Rand oben links längere halbradirte
Notizen
In plica rechts eine längere spätere
Processnotiz. verte

3444

Graz Landesarchiv n. 844ª
P. 19179 1265 Iunii 6
Clemens III .. epo Olomucen
Pervenit ad audientiam
Perusii VIII iD. Iunii aᵒ1ᵒ
Bulle an Hanf
In plica links
Sub plica
links Jar Alex.
Ecke oben rechts c/o
Seitenlinien. Erste Zeile un
beschrieben

3445

Firense, SS. Annunzia
ta di Firense
P. 19184 1265 Iunii 8
Clemens III (ohne Punkle) Jen
vasis prioribus et fribus Ser
vorum Sancte Marie Oskug.
Inducunt nos opera
Perusii VI iD. Jun. aᵒ1ᵒ
Bulle fehlt Seide erhalten
In plica rechts N. Vuisen
Sub plica links Jar Alex
Rand oben Mitte ausculle
tur cum originali · N
und cor

3446

Graz Landesarchiv n. 845ª
P. — 1265 Iunii 8
Clemens III .. epo Olomucen
Sub religionis habitu
Perusii VI iD. Iunii aᵒ1ᵒ
Bulle an Hanf
In plica links
Sub plica links B ..
Seitenlinien. Erste Zeile un
beschrieben

3447

Marseille Archives Départem.
H. O.T. 6
P. — 1265 Iunii 8
Clemens III archepis et epis et
archidiaconis ad quos littere
iste pervenerint
Cum dilecti filii
Perusii VI iD. Iunii aᵒ1ᵒ
Bulle fehlt, Seide erhalten
In plica rechts G. Ju
Sub plica links c
Erste Zeile frei. Seitenlinien
Die cl- ligatur hat zwei formen
eine runde und eine eckige

Archives Nationales Paris
L 258 n. 40 1265 Junii 8
Br. 35.5 hoch 23.7 Plica 3.6
oberer Rand 5.8 links 1.3
rechts 1.3
Clemens IIII (Gitterschrift
Initiale ausgespart) - - Archiep
7 Epis r Dil. filijs Archidiaconis
ad quos littere iste pervenerint
Dat Remisij VI Id Junij a° 1°
Bulle an Seide
In plica rechts: F. A.
Sub plica links: - - -
Bpu A d'Ast
Darunter auf der
Plica: J. Py Rx aedo' J. G.
Ry L. G. J. G.
A tergo oben Mitte: Helyas de Poglleis
Sehr regelm. feste Schrift, mit gestr.
Ligaturen, mit 1 betonten Schau-
In 1. Zeile 1 betonter Buchstabe
Erste Linie für Gitterschrift und
Überlängen
Papstnamen im Text in
Gitterschrift

P. vacat

Archives Nationales Paris
L 258 n. 40 bis 1265 Junii 8
Br. 34.2 hoch 26.2 Plica 3.1
oberer Rand 7. links 1.3
rechts 1.4
Clemens IIII (Gitterschrift, Ini-
tiale verziert) . . Archiep et
Epis et Dil. filijs Archidiaconis
ad quos littere iste pervenerint
wie n. 40 P. vacat
Bulle an Seide
In plica rechts: G. T. . . .
Sub plica links: 5
Iar ales
Darunter auf der plica: 5 Matty at
Ecke oben rechts: fiant IIII or
Rand oben halbrechts:
ascultetur cum provinciali M.
app at iuster et in provinciali
A tergo oben Mitte T
Helyas de Poglleis
Maior Anibaldus 7 frids Vic°Bem
XX · vy sol. minus m°? S
Kleine regelm. Schrift etc wie in
ascultetur cum provinciali n. 40
vicecancellarius n.

Archives Nationales Paris
L 258 n. 40 ter 1265 Junii 8
Br. 32 hoch 23.3 Plica 2.8
oberer Rand 7.3 links 1.9
rechts 2.
Clemens IIII (Gitterschrift
Initiale ausgespart)
wie in n. 40
Bulle und Seide ausgerissen
In plica rechts: G. a. . . .
Sub plica links:
A tergo oben Mitte:
Helyas de Poglleis
Ecke kleine regelm. Schrift, mit
gestr. Ligaturen etc wie in n. 40

P. vacat

Archives Nationales Paris
L 258 n. 41 1265 Junii 8
Br. 30.5 hoch 20.3 Plica 3.6
oberer Rand 6. links 1.7
rechts 1.7
Clemens IIII (Gitterschrift. Ini-
tiale verziert) Archiep et Epis r
Dil. filijs Archidiaconis ad quos
littere iste pervenerint
Dat Remisij VI Id Junij a° 1°
Bulle und Seide fehlen
In plica rechts: aba
Sub plica links: . . .
A tergo oben Mitte : Frat Bernardus Clem
bo
Kleine regelm. Schrift, mit gestr.
Ligaturen, mit einem verzierten
Schauzug
In 1. Zeile ein verz. Buchstabe
Erste Linie für Gitterschrift und
Überlängen
Papstnamen im Text in Gitterschrift

P. vacat

3452

Graz Landesarchiv n. 846
P. — 1265 Junii 13
Clemens IIII .. preposito eccle-
sie Sancti Vigilii Frisacen.
Salzeburgen. diocesis
Sua nobis dilecti
Perusii iV. Junii a° 1°
Bulle an Hanf
In plica rechts G. M
Sub plica links .. Jac Alex.
Ecke oben rechts bo
Seitenlinien.
Oberste Zeile beschrieben

3453

Graz Landesarchiv n. 847
P. — 1265 Junii 13
Clemens IIII .. epo Olomucen.
et .. preposito eccle. Sci Vir-
gilii Frisacen. Salzeburgen.
diocesis
Conquesti sunt nobis
Perusii iV. Junii a° 1°
Bulle an Hanf
In plica rechts l. anagni.
Jura Kleines Mandat
Schmale Seitenränder
12. 8 hoch 15. 4 breit.

3454

Graz Landesarchiv n. 848
P. — 1265 Junii 13
Clemens IIII .. epo Frisingen.
Sua nobis Rodolphus
Perusii iV. Junii a° 1°
Bulle an Hanf
In plica rechts G. M
Sub plica links ..
 Jac Alex.
Ecke oben rechts bo
Seitenlinien

3455

Marseille Archives Départem.
H. O. M. 21
P. — 1265 Junii 13
Clemens IIII .. magro et fribus
Domus Hospitalis Jerosolim.
Devotionis vestre promeretur
Perusii [iV.] Junii a° 1°
Bulle und Seide fehlen
In plica rechts Abas
Sub plica links !
Erste Zeile frei
Gestreckte Ligaturen

3456

Firenze, S. Croce di Firenze
P. (19209) 1265 Iunii 15
Clemens IIII .. ministro genera-
li et fribus ordinis Minorum
Exigentibus vestre devotionis
Perusii XVII kl. Iulii a° 1°
Bulle fehlt, Seide erhalten
In plica rechts. Ce. Ra.
feste Schrift leicht nach
links geneigt

3457

Carcassonne, Archives départem.
H. 463
P. - 1265 Iunii 15
Clemens IIII .. magro et fratribus
ordinis Predicatorum
Exigentibus vestre devotionis
Perusii XVII kl. Iulii a°1°
Bulle fehlt, Seide erhalten
Ohne alle Notizen
Erste Zeile beschrieben
Sehr schöne, fest regelmässige
Schrift
Gestreckte Ligaturen

3458

Marseille Archives Départem.
H. P.a.9
P. 19209 1265 Iunii 15
Clemens IIII .. magro et fra-
tribus Ord. Predic.
Exigentibus vestra devotionis
Perusii XVII kl. Iulii a°1°
Bulle an Seide
Ohne alle Notizen
Kräftige, schöne Schrift
Gestreckte Ligaturen

3459

Marseille Archives Départem.
H. P.a.9
P. 19210 1265 Iunii 15
Clemens IIII .. magro et fribus
Ord. Predicatorum
Exigentibus vestre devotionis
Perusii XVII kl. Iulii a°1°
Bulle an Seide
Ohne alle Notizen
Kräftige regelmässige und
schöne Schrift
Gestreckte Ligaturen

3460

Madrid Arch. Histór. Nacional
Palencia San Pablo B. 14
P. 19209 1265 Iunii 15
Clemens IIII -- mgro et fribus
O. Pred.
 Exigentibus vestre devotionis
Pernnii XVII Kl. Iulii aº 1º
Bulle fehlt. Seide erhalten
In plica rechts G. de Assisio
Sub plica links

Ziemlich breite Ränder
breite plica
Schlechte Schrift.
 Prima facie scheint es
eine Bulle von Clemens V
zu sein
Ligaturen gestreckt.

3461

Madrid Arch. Histór. Nacional
Dominicos de S. Pablo Burgos 41 E
P. 19210 1265 Iunii 15
Clemens IIII -- mgro et fribus
O. Pred.
Exigentibus vestre devotionis
Pernnii XVII Kl. Iulii aº 1º
Bulle fehlt. Seide erhalten.
In plica rechts B. p
Sub plica links

3462

Madrid Arch. Histór. Nacional
Dominicos de S. Pablo Burgos 42 E
P. 19210 1265 Iunii 15
Clemens IIII -- mgr. et fribus O. Pred.
 Exigentibus vestre devotionis
Pernnii XVII Kl. Iulii aº 1º
Bulle fehlt. Seide erhalten
Sub plica links ---
Rand oben links
 fünt due "CJ

Duplicat siehe oben. Die eine
kostete 4, die andere 3 gr.
Siehe Sub plica links

3463

Madrid Arch. Histór. Nacional
Dominicos de S. Pablo Burgos 43 E
 Zwei Ausfertigungen
P. 19210 verschiedene Taxe
 1265 Iunii 15
Clemens IIII -- mag. et fribus O. Pred.
 Exigentibus vestre devotionis
Pernnii XVII Kl. Iulii aº 1º
 Verschieden von der andern
 mit gleichem Institium und
 gleichem Datum
 Bulle fehlt. Seide erhalten
Sub plica links --
 und --

3464

Instr. Mon. F. Dom. C. 6 1265 Jun. 15

P. 19209

Clem. IV .. ung. et fratribus ord. Praed.
Exigentibus vestre devotionis
Perusii XVII Kal. Julii a° 1°
Bulle fehlt. Seide vorhanden.
In plica rechts: Jo Vit
 pro d̄c̄o
In plica links: pro fratribus Predica-
 toribus de Viterbio
A tergo : Predicatorum

3465

Napoli Curia Eccles. Vol. 4°
P. _ 1265 Junii 16
Clemens IIII .. magro et fribus
ordinis Predicatorum
Exigentibus vestre devotionis
Perusii XVI Kl. Julii a° 1°
Bulle und Seide fehlen
In plica rechts f. a.
Sub plica rechts ..

3466

Instr. Mon. F. Dom. C. 82 1265 Jun. 16

P. 19210

Clem. IIII .. mag. et fratribus ord. Praed.
Exigentibus vestre devotionis
Perusii XVII Kal. Julii a° 1°
Seidenfäden. Bulle fehlt.
In plica rechts: b. a.
Sub plica links : ?
A tergo : Predicatorum

 Duplicat

————————
auch C. 82
Seidenfäden. Bulle fehlt.
In plica rechts: b. a.
Links nicht sub plica : ?
A tergo : Predicatorum

3467

Graz Landesarchiv n. 849
P. _ 1265 Junii 17
Clemens IIII .. preposito et capi-
tulo Secovien. OStaug.
Cum a nobis
Perusii XV Kl. Julii a° 1°
Bulle an Seide
Sub plica links sä blä
mit f et ... cap Jo Sim
Ecke oben links . du.
Mitte Rand gof
Seitenlinien . Oberste Zeile
unbeschrieben
Ligaturen gemischt

Paris Archives Nationales
 J 449 n. 124
Erste Linie über Oberlängen
Je eine Seitenlinie
P. vacat 1265 Junii 17
Clemens IIII C Archiepo Tyren
Gratias agimus gratiaſ
Dat Perusij XV Kl Julij aº1º
 Bulle fehlt Hanf erhalten
In plica rechts : Jat Romanus
Sub plica links : - - - -
A tergo oben mitte : pro terra ſta
Prachtvolle kleine Schrift

Paris Archives Nationales
 J 450 n. 137
Breite 36.4 Rand links 1.7 rechts 1.7
Höhe 25. Rand oben 4.9 plica 3.5
Erste Linie für Oberlängen / Je
eine Seitenlinie
P. vacat 1265 Junii 17
Clemens IIII Carmo in xpo filio .. Jl.
lustri Regi Navarre, Campanie ac
Brie Comiti Palatin
 Gaudemus in domino
Dat Perusij XV Kl Julij / aº 1º
Bulle an Hanf
 In plica rechts : . S. Guerle
Sub plica links : .:.
 Jat Alex
 Maths Cap B Meſſ iiij

A tergo oben mitte :
 pro terra ſta
Kleine sehr regelm. spitze Schrift

Paris Archives Nationales
 J 452 n. 20
Breite 32.9 Rand links 0.8 rechts 0.8
Höhe 22.9 Rand oben 4.5 plica 3.4
Erste Linie für die Oberlängen /
Je eine Seitenlinie
P. vacat 1265 Junii 17
Clemens IIII .. Archiepo Auxitan
 Gaudemus in domino
Dat Perusij XV Kl Julij / aº1º
Bulle an Hanf
In plica rechts : B. Meſſ
Sub plica links : .S.
A tergo oben mitte : pro terra ſta
Kleine sehr schöne feste Schrift

Instr. Mon. F. dom. c. 40 1265 Iun. 20

P. 19216

Clem. IIII .. mag. et fratribus ord. fra-
trum Predic.

Quidam temere sentientes
~~später nachgetragen~~
Dt. Perusii XII Kal. Iulii aº 1º

Seidenfäden. Bulle fehlt.

In plica rechts: Johan p̄ m

In plica links und Mitte verschiedene
reichere Rev.
Sub plica: I. G. Rᵗ Io S. II
 Rᵗ Pant II J. Ar.

Rᵗ Vinci

Bp̄m Rᵗ Io de Capis duas et Sy. Ro.
 duas alias.

Rand oben links: friut IIII or M̄
friut due M friut IIII or sub eadem
friut II M date M.
a tergo : predi⟩ friut IIII or M / verte
cetorum

Michael de Tholosa vicekanzler
1163 Ian. 9 bis 1268 Iun. 22

3472

Graz Landesarchiv h. 850
P. 19216 1265 Iunii 20
Clemens IIII magro et fribus
Ordinum Predicatorum
 Quidam temere sentientes
Perusii XII Kl. Iulii aº 1º
Bulle und Seide fehlen
In plica rechts bᵗ
Sub plica links ...
Seitenlinien. Oberste Zeile
unbeschrieben
Gestreckte Ligaturen

3473

Madrid Arch. histór. Nacional
Dominico de S. Pablo Burgos 39€
 P. 19216 1265 Iunii 20
Clemens IIII .. magro et fribus ordi-
nis fratrum Predic.
Quidam temere sentientes
Perusii XII Kl. Iulii aº 1º
Bulle fehlt. Seide abhanden
In plica rechts bᵗ
Sub plica links - - -

3474

P. 19216

Neapel Curia Eccles. Vol. 40
Besiegelung? 1265 Iunii 20
Clemens IIII .. Generali minis-
tro et fribus universis ord. frum
Minorum
Quidam temere sentientes
Perusii XII Kl. Iulii a° 1°
Bulle und ~~Seide~~ fehlen
Side of duplicat
Ganze schwere Urkunde
Aber alles gestreckte Ligatu-
ren
In plica rechts Name

3475

Neapel Curia Eccles. Vol. 40
P. 19216 1265 Iunii 20
Clemens IIII .. magro et fribus
ord. Praedicatorum
Quidam temere sentientes
Perusii XII Kl. Iulii a° 1°
Bulle fehlt. Ebenso Seide erhalten
In plica rechts Jar Jar

3476

Graz Landes archiv n. 857
 1265 Iunii 22
Clemens IIII .. abbi mon. sci
Pauli in Lavant et .. praeposito
ecli sci Bartholomei Frisacen.
Salzeburgen. diocesis
Dilecti filii .. praeposito
Perusii X Kl. Iulii a° 1°
Bulle an Hanf
In plica links ∫
Ecke oben rechts Bo
Leitenlinien. Oberste Zeile und
schilden
 12. 3 X 14. 9

3477

Paris Archives Nationales
 J 449 n. 125
Erste Linie über Oberlängen
Je eine Seitenlinie
P. vacat 1265 Iunii 22
Clemens IIII .. R. Achiepo Tyren
Ut communem tibi
Dat Perusii / X Kl. Julii a° 1°
Bulle an Hanf
In plica rechts : . p. Ro
Sub plica links : ..
 Jar Alex
 X Matth car
A tergo oben Mitte : pro teva Sta
Sehr regelm. Kleine Schrift

3478

Paris Archives nationales
J 449 n. 127
Erste Linie über Oberlängen
Je eine Seitenlinie
P. vacat 1265 Iunii 22
Clemens IIII · E. Archiepo Tyren
In desiderijs nris
Dat Perusij / X Kl Julij a° 10
Bulle an Hanf
In plica rechts : p. Bo
Sub plica links : --
Jac Alex
y Maths cap
A tergo oben Mitte :
pro terra sca
Kleine regelm. Schrift

3479

Paris Archives nationales
J 450 n. 131 ter
Breite 23.6 Rand links 1.1 rechts 1.1
Höhe 17. 7 Rand oben 3 5 plica 2. 4
Erste Linie für Oberlängen 1
Je eine Seitenlinie
P. vacat. 1265 Iunii 22
Clemens IIII E. Archiepo Tyren
Vt communium tibi
Dat Perusij X Kl Julij / a° 10
Bulle an Hanf
In plica rechts : B. Ju
A tergo oben Mitte : pro terra sca
Sehr schöne enge kleine Schrift

Der Text ist verschieden von n. 134

3480

Paris Archives nationales
J 450 n. 132
Breite 21.7 Rand links 1.9 rechts 1.8
Höhe 22.5 Rand oben 3.5 plica 4.3
Erste Linie über den Oberlängen /
Je eine Seitenlinie
P. vacat 1265 Iunii 22
Clemens IIII E. Archiepo Tyren
In desiderijs nris
Dat Perusij / X Kl Julij a° 10
Bulle fehlt, der Hanf erhalten
In plica rechts : Maths Cap
Sub plica links : S Maths Cap
A tergo oben Mitte : pro terra sca
Sehr schöne dünne spitze Schrift mit
schwungvollen Rundungen

3481

Actum

Paris Archives nationales
J 450 n. 143
Breite 20.2 Rand links 1.7 rechts 1.7
Höhe 22. 3 Rand oben 4.9 plica 3.3
Erste Linie über Oberlängen / Je
eine Seitenlinie
P. vacat 1265 Iunii 22
Clemens IIII · E. Archiepo Tyren
Ut commissum tibi
Dat / Perusij X Kl Julij a° 1°
Perusij X ist nachgetragen
Bulle an Hanf
In plica rechts : p. Ro
Sub plica links : Jac alex
A tergo oben Mitte : pro terra sca
Sehr schöne kleine Schrift

3482

Paris Archives Nationales

J 452 n. 21

Breite 28.9 Rand links 1.2 rechts 1.1

Höhe 20.8 Rand oben 3.9 plica 3.7

Erste Linie über den Oberlängen

Je eine Seitenlinie

__P. vacat__ __1265 Junii 22__

~~Clemens IIII .. Egidio~~

Clemens IIII . . E. Archiepo Tyren

Ut commissum tibi

Dat Perusij X kl. Julij / a° 1°

Bulle an Hanf

In plica rechts : p. Ro

Sub plica links : Jac̄ Alex

⇒ Maths cap̄ Nipul Tres

Rand oben Mitte : cor

3483

Paris Archives Nationales

J 452 n. 22

Breite 31.7 Rand links 1.5 rechts 1.7

Höhe 23. 5 Rand oben 4.4 plica 4.2

Erste Linie über den Oberlängen

Je eine Seitenlinie

__P. vacat__ __1265 Junii 22__

Clemens IIII . E. Archiepo Tyren

In desiderijs nris

Dat Perusij / X kl. Julij a° 1°

Bulle an Hanf

In plica rechts : p. Ro

Sub plica links : Jac̄ Alex

⇒ Maths cap̄ Jac̄ Ro

A tergo oben Mitte : pro terra sc̄a

Weite prachtvolle feste Schrift

3484

Instr. mon. F. dom. c. 7 1265 Jun. 22

P. 19222

Clem. IIII .. mag. et prioribus universis

ac eorum vicem gerentibus ord. frat.

Pred.

Celestis amor patrie

Perusii X kl. Julii a° 1°

Seidenfäden. Bulle fehlt.

In plica rechts : J. B.

Sub plica links : ..

A tergo : predicatorum

3485

Instr. mon. F. dom. c. 155 1265 Junii 22

P 19225

Clem. IIII .. mag. et fratribus ord. Pred.

Cum a nobis

Perusii X kal. Julii a° 1°

Bulle fehlt. Seidenfäden.

In plica rechts :]

 J. B

In plica links : visa

Sub plica links : f S

unter dem Bug : R . Jac̄ Nicol F

 Maths cap̄ IIII

A tergo predicatorum (?)

3486

Archives Nationales Paris
L 258 n. 44 1265 Junii 25
Br. 35,1 hoch 26,3 Plica 2,8
oberer Rand 5,6 links 1,3
rechts 1,5
 Clemens IIII .. Archiepo
Bituricen et eius Suffraganeis
 Sua nobis dilecti
Dat Perusij VII Kl Julij a° 1°

Bulle an Hanf
 In plica rechts : J. B.
A tergo oben Mitte : A. de Vileta

Sehr zierliche offene Schrift

mit einem betonten Buchstaben
Erste Linie für Oberlingen

P. 19233

3487

Archives Nationales Paris
L 258 n. 45 1265 Junii 25
Br. 37,7 hoch 28 Plica 3,9
oberer Rand 5,6 links 1,8
rechts 1,7
 Clemens IIII .. Archiepo Se
nonen et eius suffraganeis
 Sua nobis dilecti
Dat Perusij VII Kl Julij a° 1°

Bulle an Hanf
 In plica rechts : Jo Vic
Sub plica links : . . .
 Fiat alex
Darunter auf der plica : ½ Mathi
Rand oben links : Rc . Mathee Cap
 " " Mitte : fiat ad alios
 sub simili forma
Ecke oben rechts : do cor

A tergo 3 Bemerkungen über an
 dere Ausfertigungen

Kleine regeln. Schrift

 Mit einem betonten Buchstaben
Erste freie Linie zwecklos

cf. P. 19233 Mathee

3488

Marseille Archives Départem.
H. O.T. 6
P. — 1265 Junii 26
Urbanus IIII .. preceptori et fra
tribus domus Militie Templi
in Provincia
 Solet annuere sedes
Viterbii VI Kl. Julii a° 1°
Bulle fehlt, Seide erhalten
In plica rechts P. Rc
Ecke oben rechts do
Schwungvolle Schrift, schöne
gestreckte Ligaturen
Erste Zeile frei, Seitenlinien

3489

Madrid Arch. Histor. Nacional
Dominicos de S. Pablo Burgos 386
 P. 19235 1265 Junii 27
Clemens IIII .. magro et prior
bus provincialibus ord. Bed.
Exigentibus vestre devotionis
Perusii V Kl. Julii a° 1°
Bulle fehlt. Seide erhalten
In plica rechts Ja S.
Sub plica links .!.

3490

...eille Archives Départem.
H. P. A. 9
P. 19235 1265 Iunii 27
Clemens IIII .. magro et prioribus provincialibus Ord. Præd.
Exigentibus vestre devotionis
Perusii V Kl. Iulii a° 1°
Bulle an Seide
Ohne alle Notizen
Sehr kräftige, schöne und regelmäßige Schrift
Gestreckte Ligaturen

3491

Instrum. mon. F. Dom. cap. 154 1265 Iun. 27
P. 19235
Photo

Clem. IV .. mag. et prioribus provincieli bus ord. Præd.
Exigentibus vestre devotionis —
Perusii V Kal. Iul. a° 1°
Seidenfäden. Bulle fehlt.
In plica links : ſ
über die ganze plica ausgestrichen du Vermerke, zwei verblichen.
Bpn Rt Io de Se (?) et fac III or
Bpn Rt Sy. et Rom et fac (?) IIII or

cap. 14
Seidenfäden. Bulle fehlt.
In plica rechts : Io S.
Sub plica links : .ſ
A tergo : Fredericomim Duplicat

Michael de Tolosa
vicecancellarius

3492

Instrum. mon. f. Dornen. cap. 154 1265 Iunii 27
Clem. IV .. mag. et prioribus provincia ord. Prædic. — Exigentibus vestre devotionis — Perusii V Kal. Iulii a° primo
— Seide — Bulle fehlt. In plica links A oder N
Sub plica links : .ſ daneben auf derunten Rt 9 Rt a. n.
 Iac aleX Rt Bonus concess duas Maths fr d
 Rt P. Lato duas Maths
 Maths II. daneben Bp m

Rt Io S. et fac mor In plica : Rt Iac etc. Bp m Rt Io S. et fac
daneben Bp m Rt Sy. Rom. et far IIII or. mor
Rund oben links : da p oor P. 19235
 fiant II M fiant III or sub eadem data N Rt mit grossen
 fiant due M fiant IIII or M Rosures daneben

3493

Arch. dép. de la Gironde Bord.
H - 11 - 7
P. — 1265 Iunii 30
Clemens IIII .. abbati et conventui monasterii Silve maioris OSB Burdegalen. dioc.
Quieti vestre consulere
Perusii II kl. Iulii a° 1°
Bulle und Seide fehlen
In plica rechts . . S.

3494

Marseille Archives départem.
H. o. m. 22
P. — 1265 Iulii 5
Clemens IIII .. preposito ecclie
Arelaten
Sub religionis habitu
Apud Urbemveterem III non.
Iulii a° 1°
Bulle fehlt, Auf erhalten
Erste Zeile frei

3495

Graz Landesarchiv n. 853
P. — 1265 Iulii 8
Clemens IIII .. Olomucen. et
.. Gurcen. episcopis
Sua nobis dilecti
Perusii VIII id. Iulii a° 1°
Bulle an Hanf
In plica rechts G. de Af...
Sub plica links
Seitenlinien . oberste Zeile
unterschrieben

3496

Graz Landesarchiv n. 854
P. — 1265 Iulii 8
Clemens IIII .. abbi mon. Sci
Pauli in Leuend et .. preposito ecclie Sci Virgilii in Fröa
co Salzeburgen. diocesis
Sua nobis dilecti
Perusii VIII id. Iulii a° 1°
Bulle an Hanf
In plica links ß
Sub plica links ..

3497

Graz Landesarchiv n. 855
 P. 19255 *1265 Iulii 11*
Clemens IIII carissimo in
xpo filio... Regi Bvemie il
lustri
 Pijs mentis apud
Perusii V id. Iulii aº 1º
 Bulle an Hanf
 In plica links ℞

Sub plica links Jac. Alex
Seitenlinien

3498

Arch. Avis.
Arm. XII cap. 4 cap. 16
 P. 19280 *1265 Iulii 21*
Clemens IIII ... generali et proui.
Kl. ver. My. [cilibus minis-
tris ac universis patribus ordi-
nis fratrum Minorum
 Virtute conspicuos mori
Perusii XII Kl. Aug. aº 1º
Bulle und Seide ausgerissen.
Alle Schwanzfänge mit vacierten
Kl. Maj. Buchstaben versehen
A tergo oben Mitte: Minorum

3499

Marseille Archives Départem.
H. S. C. a. 2
P. — *1265 Iulii 29*
Clemens IIII univ. xpi fidelibus
per Arelaten., Avinionen. et
Nemausen. civitates et dioce-
ses constitutis
 Quoniam ut ait
 Perusii IIII Kl. Aug. aº 1º
Bulle fehlt, Seide erhalten
In plica rechts Jac Mut
Sub plica links ..
 B. fn
darunter: Ma... vsp. B. S. v.
Ecke oben links: du p
Ecke oben rechts xl. quing
 (xl dies ad quing.)
Kräftige schöne Schrift und Liga-
turen.

3500

Marseille Archives Départem.
H. S. C. a. 2
P. — *1265 Iulii 29*
Clemens IIII univ. xpi fideli-
bus per Arelaten., Avinionen.
et Nemausen. civitates et dio-
ceses constitutis
 Quoniam ut ait
 Perusii IIII Kl. Aug. aº 1º
Bulle und Seide fehlen
In plica rechts Jac mut
Sub plica links ..
 B. fn
Ecke oben rechts - C- Quing
Sehr schöne kräftige Schrift
Erste Zeile beschrieben
Schöne Ligaturen
 (centum dies ad quing.

3501

Marseille Archives Départem.
H. S. C. Q. 2
P. — 1265 Julii 29
Clemens IIII univ. xpi fidelibus
presentes literas inspecturis
Vite perennis gloria
Perusii IIII kl. Aug. a° 1°
Bulle, Seide, plica fehlen.
Auf dem Reste derselben rechts
I at mut.
Sub plica links ..
Ecke oben rechts Numerus der Bulle
C. in IIII festis dne nre et in festis
scorg francisci et Clare et p oct.
assumpt. et nativit. Quinque.
Kräftige, schöne Schrift
Gestreckte Ligaturen

3502

Nimes, Archives départem.
G. 13 19
P. — 1265 Augusti 5
Clemens IIII — preposito et ca
pitulo ecclie — Nemausen.
ostesg.
Devotionis augmentum vobis
Perusii IIII non. Aug. a° 1°
Bulle und Seide ausgeschnitten
In plica rechts I at mut
sub plica links ..
 B. fi ?
 B. fu

Punkte

3503

Nimes, Archives départem.
G. 13 19
P. — 1265 Augusti 5
Clemens IIII .. preposito et ca
pitulo Nemausen. ostesg.
Devotionis augmentum vobis
Perusii non. Aug. a° 1°
 Bulle und Seide ausgeschnitten

Prachtvolle Schrift

Ohne alle Notizen

3504

Nimes, Archives départem.
G. 13 19
P. — 1265 Augusti 5
Clemens IIII .. . preposito et ca
pitulo Nemausen. ostesg.
Devotionis augmentum vobis
Perusii non. Aug. a° 1°
Bulle fehlt, Seide erhalten
In plica rechts I at mut.
sub plica links ..
 R. fu (fi ?)
Rand oben mitte fac maü a
ascultetur cum litteris. m

Marseille Archives Départem.
H. O. T. 6
P.— 1265 Septembris 1
Clemens IIII . . magistro et fra-
tribus Militie Templi Teros.
Quieti vestre providere
Asisii Kl. Sept. a° 1°
Bulle und Seide fehlen
In plica rechts m. p.
Sub plica links --
Ecke oben links a. p.
 Alexander und Urbanus
 werden genannt
Fahrige, ungeübte, ganz unre-
gelmäßige Schrift

Bayr. Haupt - Staatsarchiv
 Ritterorden N. 18
P. orcat 1265 Septembris 4
Clemens IIII (Gitterschrift) . . Magro
et fratribus Hospitalis Jerosolimithn.
 Meritis vestre sacre
Asisij II non. Septembris Anno Primo

Bulle an feiner Seide
 Zwischen den Aufhirungslöchern
 in plica : . M.

Sehr schöne, aufrechte Schrift mit
gleich grossen Ober- und Unterlän-
gen, die gestreckten Ligaturen sind
bald eng, bald weit

Im Text die Namen Alexandrj et
Urbanj in Gitterschrift

Marseille Archives Départem.
H. O. T. 6
P.— 1265 Septembris 4
Clemens IIII archepis et epis ac
archidiaconis et decanis ad
quos littere iste pervenerint
 Quanto dilecti filii
Asisii II non. Sept. a° 1°
Bulle fehlt, Seide erhalten
In plica rechts . D.
Sub plica links
Schöne kleine Schrift mit hohen
Längen.

Bayr. Haupt - Staatsarchiv
 Ritterorden N. 19
P. orcat . 1265 Septembris 8
Clemens IIII . . Magro et fratribus Ho-
spitalis sci Johannis Jerosolimithn.
 Eo uobis quilibet
Asisij II Jr. Septembris Anno Primo

Bulle an feiner Seide
 In plica rechts : m. Chj

Rand oben links :
 finit due Rf Paul . S.

Sehr schöne regelmässige Schrift mit
gleichmässigen Ober- und Unterlängen
die gestreckten Ligaturen sind von
einander abweichend.

Die beiden ersten Zeilen unterschieben

3509

Toulouse, Archives Départem.
H. 24

P. — 1265 Septembris 8

Clemens IIII .. magro et fribus
Hospitalis S. Johnn. Jerosolim.
Eo vobis quilibet
Assisii VI iđ. Sept. a° 1°
Bulle an Seide
In plica rechts J. de Enrasti
Sub plica links ..

Sehr schöne runde Schrift.

3510

Marseille Archives Départem.
H. O. J. 6

P. — 1265 Septembris 8

Clemens IIII .. magistro et fribus
Militie Templi Jerosolim. etc
in Provincia
Eo nobis quilibet
Assisii VI iđ. Sept. a° 1°
Bulle fehlt, Seide erhalten
In plica rechts . V.
Sub plica rechts links - - -
Gestreckte schöne Ligaturen
Innocentius und Alexander
werden genannt
Sehr schöne Schrift

3511

Paris Archives Nationales
 J 450 n. 144
Breite 49.3 Rand links 1.9 rechts 1.9
Höhe 40.4 Rand oben 5.5 plica 3.4
Erste Linie für Oberbügen / Je
eine Seitenlinie
P. vacat 1265 Septembr. 11
Clemens IIII .. Archiepo Tyren
Amara est potio
Dat Perusii VII Jđ Septembr / a° 1°
Bulle an Hanf
In plica rechts : R . C
 de cur
Kleine deutliche Schrift

3512

P. — Paris Arch. Nat.
J 391 cap. 5 1265 Sept. 13
 Clausa
Die Schnitte treffen
die Schrift nicht
Rechte untere Ecke
ausgeschnitten
Clem IIII A comiti Pictaven.
et Tholosan.
Et temporis qualitas
Perusii idus Sept. a° 1°

3513

Public Record Office London
Papal Bulls bundle 10 n° 1
P. 19342 1265 Septembris 13
Clemens IIII O. S. Adriani diac card.
apostolice sedis legato
Gravi dintius regnum
 Perusii id. Sept. a° I°
 Bulle an Hanf
 In plica rechts G de S. i. zeresto
 de Cur

Sub plica links : darunter
 Mathe cap $\frac{X}{}$ Ber penn detur
 Rand oben links
 dñ P. de Cur
 (duas P. de curia, oder duplica
 P. de Curia

3514

Public Record Office London
Papal Bulls bundle 10 n° 2
P. 19339 1265 Septembris 13
Clemens IIII O. S. Adriani diac.
card. apostolice sedis legato
Per nobilem virum
 Perusii id. Sept. a° I°
 Bulle fehlt, Hanf erhalten
 In plica rechts de Cur
 A de Stynath
Sub plica unten links
 Mathi cap Ben. fer de Cur
de curia et fac scribi eam
Rand oben links
 dñ p. de Cur.
(duas p. de Curia oder duplica
 P. de Curia

3515

Public Record Office London
Papal Bulls bundle 10 n° 6
P. 19343 1265 Septembris 13
Clemens IIII O. S. Adriani diac.
Card. apostolice sedis legato
 Per nobilem virum
Perusii id. Sept. a° I°
Bulle fehlt Hanf erhalten
In plica rechts: G. de Vercell
Sub plica links unten
Maths cap aud. de Levania
 de cur et fac scribi eam
Rand oben links dñ P. de Cur

3516

Public Record Office London
 Papal Bulls bundle 10 n° 8
 Corrector
P. 19341 1265 Septembris 13
Clemens IIII de primogenito ... regis
Anglie illustris
Gravi dintius regnum
Perusii id. Sept. a° I°
Bulle an Hanf
In plica links O Laud
" " rechts de Curia
Darunter klein, ausgestrichen
Age itaque fili pro civibus cum mansuetudine
tamen debita, quod fasti qualitas exigit Re
Dieselbe von fili bis Res im Text auf Rasur
Rand oben links dñ p. de Cur
Sub plica ganz unten : Math cap
Ba Parm de Curia
fac eam scribi
 2069

3517

Public Record Office London
Papal Bulls bundle 10 n° 14
P. 19338ᵃ 1265 Septembris 13
Clemens IIII O. S. Adriani diac.
card. apostolice sedis legato
 Per nobilem virum
 Perusii id. Sept. a° I°
 Bulle an Hanf
In plica rechts de Cur
 Ar. M.
Sub plica links primo unten
Maths Cap̄ Ben̄ de Curia
et per bonum scriptorem
Ecke oben links Rf Clar.

3518

Public Record Office London
Papal Bulls bundle 10 n° 16
 P. 19340 1265 Septembris 13
Clemens IIII ad futuram rei memoriam
 Olim in minori
Perusii id. Sept. a° I°
 Bulle an Seide
In plica rechts Ab a
 de Curia
Sub plica links ganz unten
Maths cap̄ And de Lavania
et fac scribi per bonum
scriptorem de Curia
Ecke oben links Rf du. M.
 et de Cur M

3519

Archivio di Stato Milano
Bolle e Brevi
 P. — 1265 Septembris 26
Clemens IIII fribus O Bed. inqui-
sitoribus her. prav. in Lombardia
et Marchia Janaen. deputatis auct̄
nolte aplica et in posterum depu-
trandis
 Licet ex omnibus
Perusii VI kl. Octobris a° I°
 Bulle fehlt, Hanf erhalten
In plica rechts de Curia
In plica links O Lrud aut
Rf n. pro anno in continenti et...
Rand oben links Ego Jo Ga Card
§ bulletur et remittatur nobis.
Daneben später Inscription befer...

3520

Toulouse Archives départem.
 H. 24
 P. — 1265 Septembr. 30
Clemens IIII archiepis et epis ac
ecclesiarum prelatis ad quos
littere iste pervenerint
 Eis praecipue ac
Perusii II kl. Octobr. a° I°
 Bulle an Seide
Rand oben links . du. M
 vergliche Duplicat

Sehr schöne runde Schrift

3521

Toulouse, Archives Départem.
H. 24

P. — 1265 Septembr. 30

Clemens IIII archiepis et epis
ac ecclesiarum prelatis ad
quos littere iste pervenerint
 Eis precipue ac
Perusii II kl. Octobris a° 1°
Dünne Bulle au Seide
In plica rechts Aba ...
Sub plica links / ..

Gestreckte Ligaturen

3522

Public Record Office London
 Papal Bulls bundle 10 n. 3
 P. 19382 1265 Octobris 4
Clemens IV .. regi Anglie illustri
Benedictus dominus qui
Perusii IV non. Oct. a° 1°
 Bulle an Hanf
 In plica rechts a a a
 pro Curia

3523

Madrid Arch. Histor. Nacional
Dominicos de S. Pablo Burgos 37 G
 P. 19398 1265 Octobris 11
Clemens IIII .. magro xx ac prio
ribus et universis fratribus ordi-
nis Predic.
 Loca sanctorum omnium
Perusii V id. Octobris a° 1°
Bulle fehlt. Seide erhalten
In plica rechts An g
Sub plica links ..

3524

Instr. mon. T. Dom. c.76. 1265 Oct. 11
 P. 19398

Clem. IIII .. mag. ac prioribus et uni
versis fratribus ord. Predic.
Loca sanctorum omnium.
Perusii V id. octobris a° 1°
Seidenfäden. Bulle fehlt.
In plica rechts: Jo. Ar.
Sub plica links: .. f. a.
 R/ G. m. III f. a.
 R/ . . . quatuor Nich
 R/ D. g. Bobinus
 J. a. quatuor Nich procancellarius
 R/ XII
 Nich Vic R/ Gilbertus per
 quinque Nich
Oben links:
duplica B. In plica teilweise Befehle
 halb verblasst.
a tergo: predicatorum

35 25

Instrum. mon. F. Domen. cap. 76 1265 ~~Septembris 27~~ Octobris 11

Clem. IV .. mag. ac prioribus et univ. fratribus ord. Pred. — Loca
sanctorum omnium — Perusii V id. octobr. aᵒ primo — Bulle
fehlt. — Seide. In plica rechts ta Aₙ
Obere Ecke links: duplicia B. In plica links: R .. B. f.. Alfar-
dius et Iar Alex. alias duas

Sub plica links: R g . m . IIII f . a .
 R C Rasmy quatuor mich P. 193 ~~98~~ 98
 R D . G. / Bolinus
 R A quatuor mich R gilbert f quinque
 mich

35 26

Instr. mon. F. Dom. c 132 1265 Oct. 11
 P. 19398

Clem. IV .. mag. ac prioribus et univ. fra-
tribus ord. Pred.

Loca sanctorum omnium

Perusii V id. oct. aᵒ 1ᵒ

Bulle fehlt. Seidenfäden

Letzte Zeile ganz sub plica

In plica rechts : . A. g.

Sub plica links : ..

A tergo : predicatorum

35 27

Marseille Archives départem.
H. P. a. 9
P. 19399 1265 Octobris 11
Clemens IV [ohne Punkte] ma-
gistro ac prioribus et universis
fratribus ord Pred.

Loca sanctorum omnium
Perusii V id. oct. aᵒ 1ᵒ
Bulle und Seide fehlen
In plica rechts g. Saon
Sub plica links ..
Etwas unruhige Schrift
Hübsche Ligaturen

3528

Instr. mon. F. Dom. c 12 1265 Oct. 18
P. 19406 rep. 18253

Clem. IIII .. priori provinciali fratrum
ord. Praed. in Lombardia
Licet ex omnibus
Perusii XV Kal. nov. a° 1°
Hanfschnur. Bulle fehlt.
In plica rechts : J. de Atin (?)
 de Cur.
Letzte Zeile ganz sub plica
A tergo : predicatorum

3529

Marseille Archives Départem.
H. O. T. 6
P. — 1265 Octobris 23
Clemens IIII .. magistro et fra-
tribus domus Militiae Templi
Jerosolimitan.
Quia proni sunt
Perusii X Kal. nov. a° 1°
Bulle und Hanf fehlen
In plica recht Johng p m
Sub plica links :.

3530

Bayer. Haupt- Staatsarchiv
Ritterorden n. 21
P. vacat 1265 Octobris 24
Clemens IIII . . . Magro et fratribus Hos-
pitalis sancti Johannis Jerosolimitan
 desiderijs nestris in
Perusij VIII Kl. novembris Anno
Primo
Bulle mit Seide ausgerissen
Ohne jegliche Kanzleibemerkung.

Dieser Umstand in Verbindung mit der
Tatsache der Ausreissung der Besie-
gelung lässt es wahrscheinlich erschei-
nen, dass hier eine von der Kanzlei
selbst cassierte Ausfertigung vorliegt.

Die Schrift ist von besonderer Schönheit
und Regelmässigkeit

3531

de Curia

Paris Archives Nationales
 J 452 n. 24
Breite 69.2 Rand links 2 2 rechts 2.
Höhe 57.6 Rand oben 6.2 plica 3.7
 Erste Linie über den Oberlängen
Je eine Titenlinie
P. 19430 1265 Novembris 2
Clemens IIII S. tt sce Cecilie pbro
Cardinali aplicae sedis Legato
De venenoso genere
Dat Perusij III non Novembr,
a° 1°
Bulle an Hanf
In plica rechts: de Cur
 T. A.
A tergo oben Mitte : de Curia

Mgr Petrus de Latyeca

3532

Paris Arch. nat.
J 452^B Cap. 24 1265 Nov. 2
Clem IIII Perusii IIII non. Nov.
 a° 1°
Rand oben links
 dn. de Cur. M.

3533

Public Record Office London
Papal Bulls bundle 10 n. 17
P. 19436 1265 Novembris 4
Clemens IIII .. priori ecclesie ~~sancte~~ de
Heveiinglaid einsque fratribus
religiosam vitam eligentibus
Amen Amen Amen
R Ego Clemens cath. eccte eps ss (M)
2 presb 5 epi 5 diac Michaelis
Dat. Perusii per manum magistri de
Tholosa SRE vicecancellarii II non. Nov.
M CC LXV° a° 1°
 Bulle an Seide
Rand oben Mitte g. T
cum privil. Ord. S. Aug.
 ascultatum
 Ehre rechts oben bo

3534

Firenze, S. Chiara di Cortona
P. 19454 1265 Novembris 20
Clemens IIII ~~Johel~~ ~~PuRRAR~~ ..
univ. abbatissis et conven-
tibus sororum inclusarum
monasteriorum ordinis
sancte Clare
 Quanto studiosius devota
Perusii XII kl. Decembris a° 1°
 Bulle fehlt, Seide erhalten
In plica rechts de ratione preferit
 Adez . p .
Sub plica links...
 Breite plica, breiter obe-
rer Rand, breite Seitenrän-
der
 27

3535

Instr. mon. et dom. C. 43 1265 Nov. 20
 P 19455
Clem. IIII mag. prioribus et universis fratribus
ord. Predic.
Ad consequendam gloriam -
Perusii XII kl. Dec. a° 1°
Bulle fehlt. Seidenfäden
In plica rechts: p. lira [B. letra] Photo
In plica links: B - - - - 9
 R al p II as
 et duas
 R Jac Viro III es
 P
Sub plica links: pro duabus. g. f. p. a.
 R P. A. II f. A. vicecancellarius
 B pm
vorstehendes auf grosser Rasur, so viele andere
Befehle stunden.
Unter dem Bug: R. B pm. ex parte magri
 Bernardi scrii iu Mich.
R dj de monte Mich
R Gerardine de Mantina duas Mich
Rand oben links: duplica B fiant VI M
duas M duas B a tergo : predica-
 torum

35 36

Instr. Mon. f. domiciu. 43 *1265 Novembris 20*

Clem. IV mag. prioribus et univ. fratribus ord Pred. - Ad conse.
quendum gloriam — Perusii XII kal. decembris a° primo
leude — Bulle fehlt. In plica rechts B Lata g
Sub plica links: · · · · feiner! pro duobus G. S. P. A.

 Rf B. A. II f. A.
Rf B. pu et parte mag" Bernardi *Scpm*
* Laon III nuch*
Rf g. de Monten nuch *Oben links : duplici B fini V. M*
Rf Guardone de multina ducas
 du M du M
In plica links : B — — — —
* R al I III II et Anag I* *P. 19455*

* Rf Jac Vincenc III J M (monogramm)*

35 37

Firenze, Pistoia
P. — 1265 Novembris 21
Clemens IV . . archidiacon.
Pistorien.
Sic insanit in.
Perusii XI kl. Dec. a° 1°
* Bulle fehlt, Hanf erhalten*
In plica rechts Bcy- p.
Sub plica links Jac
* M*
Rand oben Mitte
* Jac*
* Kleine Seitenränder*
Ganz kleine plica
Q Tergo Ecke oben links R

35 38

Bayer. Haupt. Staatsarchiv
* Aibling fasc. 42*
P. 19460 1265 Novembris 22
Clemens IV . . Abbati et Conventui
Monsterij de Schirenordinis sanc
ti Benedicti Frisingen. dioc.
* Ad religiosorum locorum*
Perusij X kl. decembr. anno Primo

Bulle an feiner Seide
In plica rechts : Jac mut.
Sub plica links : · · ·
* Jac*
* m (Jac. mut)*

Rand oben Mitte : Jac
* Ecke oben rechts JJ*
Q tergo Ecke oben links : p
Sehr schöne kleine Schrift.
ligaturen in verschiedener form
gemacht : et et t usw.

3539

Bayer. Haupt- Staatsarchiv
Kl. Scheyern Jasc. 2

P. 79467 1265 Novembris 26

Clemens IIII .. Epo Frisingen. et
dil. filio .. Electo Ratisbon.
Vita nobis dilecta
Perusii VI Kl. Decembris anno primo

Bulle an dünnem Hanf
In plica rechts: An. M
 Sub plica links: S

Rx R. C. Ja nicht
Rand oben links: du. M
 niedrige, fette, eckige Schrift

3540

Staatsarchiv Wien Chronol.

P. — 1265 Novembris 27

Clemens IIII .. epo et .. preposito Pragen.
Ad nostram noveritis
Perusii V Kl. Dec. a° 1°
Bulle an Hanf.
Ganz winzige plica, die noch
dazu die letzte Zeile deckt.

3541

Graz Landesarchiv n. 860

P. — 1265 Novembris 29

Clemens IIII Wlodislao elec-
to Salzeburgen.
Considerantes multiplicas
et
Perusii III Kl. Dec. a° 1°
Bulle an Hanf
Ohne alle Notizen

3542

Staatsarchiv Wien Chronol.

P. — 1265 Novembris 29

Clemens IIII W. Salzeburgen.
electo.
De benivola cordis
Perusii III Kl. Dec. a° 1°
Bulle an Hanf
In plica rechts F. R.
 pro persona notarii

„ Magister Johannes de
Capua notarius noster"

„ Jacobus de Neapoli fami-
liaris et procurator eiusdem
notarii."

3543

Avignon. Archevêché d'Avignon

P. 19477 **1265 Nov. 30**

Clemens IIII B. epo Avinionen.

Divini cultus numinis

Perusii II. Kl. Dec. a° 1°
 Bulle und Hanf fehlen
In plica rechts: dat. par
Sub plica links ...

A tergo oben Mitte sehr schön
gross

Cap CLXXVII

3544

Paris Archives Nationales
 J 452 n. 23

Breite 19.2 Rand links 1.9 rechts 1.8
Höhe 13. Rand oben 3.3 plica 2.7
 Erste Linie über den Oberlängen
Je einfl Leitenlinie
P. vacat **1265 Decembris 6**
Clemens IIII . . Archiepo Tyren
 Cum terra sca
Dat Perusii VIII Idus decembr a° 1°
 Bulle an Hanf
Grosse sehr schöne feste Schrift

3545

Paris Archives Nationales
 J 452 n. 23 (bis)

Breite 21.1 Rand links 1.8 rechts 1.2
Höhe 14.9 Rand oben 3.8 plica 2.2
Erste Linie über den Oberlängen
Je eine Leitenlinie
P. vacat **1265 Decembris 6**
Clemens IIII . . Archiepo Tyren
 Cum terra sca
Dat Perusii VII Id decembr /a° 1°
 Bulle an Hanf
A tergo oben Mitte: fr Guithardus
 de Curia
Kräftige kleine sehr schöne Schrift

 de Curia

3546

Instr. Mon. T. dom. c. 47 **1266 Jan. 13.**
 P. 19522 17536
Clem. IIII fratr. ord. Prat. inquisit. heret. prav.
in Lombardia et Marchia Januen. auct.
apost. deputatis et in posterum deputan-
dis.
 ne inquisitionis negotium
dat. Perusii IV Januarii a° 1°

 Bleibulle fehlt. Seide fehlt.

In plica rechts: Jo. de Camp.
 de Curia
Sub plica links: R/ Jac. Rom.
II de Curia J. g.
Oben Rand links: Ego Jo. g. car.
s, legatur domino et bulletur, si
placet. Et remittatur nobis bullata
et duplicetur fiant due de Cur. IIJ.
 — due de Cur. IIJ
A tergo: Predicatorum

 vicecancellarius

3547

Toulouse, archives Départem.
H. 24

P. — 1266 Januarii 23

Clemens IIII .. magro et fratribus
Hospitalis sci Johannis Jerosolim
Volentes promovan et
Vitubii X Kl. febr. a° 2)
Bulle fehlt, Seide erhalten
In plica rechts g. de ...

Zerbrochen Ligaturen
Erste Zeile frei.

3548

· Stratsarchiv zu Chronol.
P. — 1266 Januarii 23
Clemens IIII archiepis et epis ac
abb. prior. dec. archidiac. et aliis
eccl. prelatis ad quos l. iste perv.
Cum dilectis filiis
Perusii X Kl. febr. a° 1°
Bulle an Hanf
In plica rechts (scriptor
Sub plica links
R/ Palm Reat Mich

3549

Stratsarchiv zu Chronol.
P. — 1266 Januarii 28
Clemens IIII . . epo Pragen.
Significavit nobis dilectus
Perusii V id. febr. a° 1°
Bulle an Hanf
In plica rechts Mich
Sub plica links g

3550

Kulsruhe gr. Bad. Gen Landesar.
Selecf der Papsturk. cap. 261ª
P. — 1266 Januarii 29
Clemens IIII .. magistro et fratribus
Hospitalis Jerosolimitan tam pre-
sentibus ... in perp
Xpiane fidei religio
Lenitt betonte Capitelanfänge
Papstnamen in Zitterschrift
Amen Amen Amen
(R) Ego Clemens etc. (M)
drei Reihen (2. 4. 5) Unterschriften
des Perusii per manum magistri
Michaelis SRE viceeancel-
larii IIII Kl. febr. ... a° 1°
Bulle an Seide (Ecke oben rechts
Rand oben mitte (ä
 paul
duplicetur privilegium hospitli
trum siens in bulleta verte

3551

Paris Archives Nationales
J 160 A n. 10
Breite 23.6 Rand links 1.5 rechts 1.6
Höhe 19.9 Rand oben 1.8 plica 3.6
Erste Linie für Gitterschr. und
Oberlängen / Je eine Seitenlinie
P. vacat 1266 Februarii 5
Clemens IIII (Gitterschr.) . . Priori
7 fratribus Sancti Mauricii Silua-
rectm ordinis Sci Augustini
Loca dicata deo
Dat Perusij / Non Februarij a° 1°
Bulle an Seide
A tergo oben Mitte : fr Phm
Kleine stumpfe feste Schrift

3552

Paris Archives Nationales
J 683 n. 11
Breite 41.8 Rand links 2.5 rechts 2.5
Höhe 28.3 Rand oben 5.4 plica 4.3
Erste Linie für Gitterschr. und Ober-
längen / Je eine Seitenlinie
P. vacat (Gitterschr.) 1266 Februarii 5
Clemens IIII (Nob Viro Philippo pri-
mogenito Caroli in xpo filij . . Re-
gis Francorum Illustris
Inter ceteras sublimes
Dat Perusij Non Februar. a° 1°
Bulle an sehr feiner Seide
In plica rechts : Jac Mut
Sub plica links ! S
F m
Sehr schöne feste kleine Schrift
vier betonte Initialen

3553

Staatsarchiv Wien Chronol.
P. 19539 1266 Februarii 9
Clemens IIII Carolo in xpo
filio . . Boemie Regi ill.
Pro favore regio
Perusii V id. febr. a° 1°
Bulle an Hanf
In plica rechts . S.
Sub plica links . S.
Jac
m
Rx . n . Reat. miok.

3554

Archives Nationales Paris
L 258 n. 1 1265/66
Br. 23.5 hoch 18.5 Plica 3.4
oberer Rand 5. links 1.2
rechts 1.3
Clemens IIII (Gitterschrift In 1.
linie verziert) . . Magro et fratribus
Hospitalis Sci Antonij Viennen dioc
Exigentibus vre devotionis
Dat Perusij — — — a° 1°
Bulle an Seide
In plica rechts : B pu
Kleine regelmässige Schrift, mit
gestreckten Oberlängen, mit 4 ver-
zierten Initialanfängen
In 1. Zeile ein verz. Buchstabe
Erste Linie für Gitterschrift und
untere Oberlängen
Grosse Wasserflecken

3555

Instr. misc. F. Ann. c. 18 1266 Febr. 26

P. 19559 P. 19559

Clem. IIII .. priori fratrum ord. Praed.
Parisien.

Precunctis nostre mentis

Perusii IIII Kal. Martii a° s(ecundo)
 abgeschnitten
Bulle und Hanfschnur fehlen.

Bug und rechte Ecke bis 6. Zeile excl.
auf 2 cm. abgeschnitten

A tergo : frater Florasius

3556

Arch. Arcis

Arm. XIII cap. 6 cap. 39

P. — 1266 Febr. 27

Clem. IIII .. epo Anagnin. et
Nicolao felicis recordationis
Gregorii ppe predecessoris nostri
nepoti capellano nostro

Cum (?) dudum inter

 III Kl. Martii a° 2°

Bulle an Hanf.

In pl. rechts : Gebh p de Cun.
 Löcher, grüca violett

3557

Instr. misc. 1250 . 1275 cap. 42

P. — 1266 Martii 13

Clem. IIII archepis et epis ac electis,
abbatibus etc. ad quos litt. ipse perv.

Cum dilecti filii

Perusii III id. Martii a° 2°

Bulle und Hanf ausgerissen

In plica rechts : de Curia

A tergo : Littere procuratoris ma=
gistri Alberti [de Parma]

3558

Instr. ~~Kon.~~ Kon. F. d. c. 159 1266 Mrd. 21

P. 19585

Clem. IV .. archepo Brachaien. et epis
per regnum Portugalie constitutis
ad quos littere iste pervenerint
De meritorum excellentia —
Perusii XII Kal. Aprilis a° 2°
Bulle an Hanfschnur
In plica rechts : f. a.
Sub plica links : R ... g. comes
 f. a.
A tergo : predicatorum

3559

Madrid Arch. Histor. Nacional
Dominicos de S. Pablo Burgos. 44€
P. — 1266 Aprilis 6
Clemens IIII .. epo Burgen.
Dilecti filii fratres
Perusii IIII id. Apr. a° 2°
Bulle fehlt. Hanf erhalten
In plica rechts Jac̄ Mut

Sub plica links G.

3560

Instr. mon. F. dom. c. 5 1266 Apr. 17
P. 19609
Clem. IIII .. priori provinciali et fra-
tribus Francie ord. Pred.
Circa ea debemus.
Perusii XV kal. Maii a° [secundo]
Rechts plica ausgerissen
Bulle an Seidenfäden ..

3561

Avignon Archives Départem.
G. Evêché de Cavaillon

P. — 1266 Maii 11

Clemens IIII .. epo Nemausen.
Auxelam dilectorum filiorum
Viterbii V id. Maii a° 2°
Bulle fehlt, Hanf erhalten
In plica rechts .R·C.
Sub plica links Je. S.
Certe Leute frei.

3562

Avignon Archives Départem.
G. Evêché de Cavaillon

P. — 1266 Maii 11

Clemens IIII nob. viro .. Pictavie
ac Tholose comiti
Super hiis que
Viterbii V id. Maii a° 2°
Bulle und Hanf fehlen
Plica fehlt.
Sub plica links ..
 G. M.

Ecke oben links duplica B.
Rand oben mitte tota

3563

Bayer. Haupt. Staatsarchiv
St. Emmeram fasc. 10

P. 19632 1266 Maii 13

Clemens IIII .. abbati Monasterij
in Ebersperg Frisingen. dioc.
Venerabilis fratris nostri
Viterbij III Jd. Maij anno Secundo

Bulle und Hanf fehlen
In plica rechts: J. S.
Sub plica links:
Jac Alex
Mich

A tergo Ecke oben links: p

Erste Zeile frei. Je zwei Seitenlinien

Duplicat

3564

Bayer. Haupt. Staatsarchiv
St. Emmeram fasc. 10

P. 19632 1266 Maii 13

Clemens IIII .. abbati Monasterij
in Ebersperg Frisingen. dioc.
Venerabilis fratris nostri
Viterbij III Jd. Maij anno Secundo

Bulle an starkem Hanf
In plica rechts: J. S.
Sub plica links:
Jac alex
Mich

Oed Rand oben links: du. N.
Ecke oben rechts: 60
a tergo Ecke oben links: p

Erste Zeile frei; Je zwei Seitenlinien

Duplicat

3565

Bayer. Haupt. Staatsarchiv
St. Emmeram fasc. 10

P. 19638 1266 Maii 15

Clemens IIII (roman. Mii. reich ver.
ziert) Friderico Abbatj Monasterij
sci Emmerammi Ratisponen. ordi-
nis sci Benedicti
devotionis tue precibus
Viterbij Jd. Maij anno Secundo

Bulle an feiner Seide
In plica rechts: J. S.
Sub plica links:
Jac alex
Rand oben links: du. N.

Erste Zeile frei; je zwei Seitenlinien
Ecke oben links: p

Duplicat

3566

Bayer. Haupt. Staatsarchiv
Regensburg St. Emmeram Fasc. 10

P. 19638 1266 Maii 15

Clemens IIII (rom. Mii.) Friderico Ab-
bati Monasterij sci Emmerammi Ratis-
ponen. ordinis sci Benedicti
devotionis tue precibus
Viterbij Jd. Maij anno Secundo

Bulle an Seide
In plica rechts: J. S.
Sub plica links:
Jac alex Duplicat

A tergo Ecke oben links: p

A tergo Mitte ziemlich tief
ohne script und
ohne Haken in der canda

In der ersten Zeile D(ilecto) und F(riderico)
sehr stark betont und verziert wie die
Papstname; desgleichen drei Capitelan-
fänge. Überlängen der ersten Zeile hoch
und f mit Aufbau. — Schöne weit
Schrift. Unterlängen J. Gestreckte Liga-
turen etwas verschnörkelt etc. — Erste Zei-
le frei. Zwei Randlinien

3567

Arch. Arcis

Arm. XIII cap. 6. cap. 36

P. 19645 1266 Maii 20

Clem. IIII .. epo et Bartholomeo

dicto Testa canonico Anagnin.

 Gravem ad nos

 Viterbii XIII Kl. Iunii aᵒ 2ᵒ

Bulle an Hanf (dünn)

In pl. rechts: a. g.

A tergo Procurator

3568

Arch. Arcis

Arm. XIII cap. 6 cap. 1

P. — 1266 Maii 22

Clem. IIII nobilibus viris baro-

nibus, potestatibus etc per

Campaniam et Maritimam

constitutis

 Ex parte dilecti

Viterbii XI Kl. Iunii aᵒ 2ᵒ

Bulle fehlt Hanf (dünn)

In pl. rechts: Vitalis

Sub pl. links: ...

 g. m.

A tergo Procurator

3569

Bayer. Hauptst. Staatsarchiv

 Kl. Roth fasc. 5

P. vacat 1266 Maii 28

Clemens IIII .. Abbati Monasterij

Servensis ordinis sancti Benedicti

Salceburgen.

 Sua nobis dilectus

Viterbij V kl. Junij anno Secundo

Bulle an Hanf

In plica rechts: J. de Anniis

Sub plica links: .

 g. m.

Ecke oben rechts: bo

 a tergo Ecke oben links: y

Erste Zeile frei, Literlinien

3570

Madrid Arch. Histor. Nacional

San Marcos de Leon N: 30

P. — 1266 Maii 28

Clemens IIII .. thesaurario eccle

sie Legionen.

Conquesti sunt nobis

Viterbii V kl. Iunii aᵒ 2ᵒ

Bulle und Hanf fehlen

In plica rechts i – n.

Ecke oben rechts bo

Ohne jeden Rand rechts und

links

3571

Avignon Archives Départem.
g. Évêché de Cavaillon

P. — 1266 Junii 9

Clemens IIII . . epo Cavallicen.
Tuis instruter exigentibus
Viterbii V id. Jun. a⁰ 2⁰
[...] unterer Theil abgerissen

3572 (recto)

Bayer. Haupt- Staatsarchiv
St. Emmeram Fasc. 10

P. 19685 1266 Junii 9

Clemens IIII . e. s. l. dei [...] filijo . . . Abb.
[...] Monasterii sci Emmerami Ratis-
ponen. eiusque fratribus pres. quam
futuris regularem vitam professis
IN PP̄M
 Religiosam vitam eligentibus
preis universum AMEN · A [...] AMEN

R. Ego Clemens cath. ecclie epo ss. M
2 presb. 4 epi 4 diaconi

Dat. Viterbij per manum Magistri Mi-
chaelis sancte Romane ecclie viceca[...]
cellarij V id. Junij ind. VIIII Inc. domi-
nice Anno M. CC LX VI Pontif. uero
domni Clementis (Gitterschrift) pp. IIII Anno
Secundo
 Bulle an Seide
Rand oben halblinks. : coe privilegium
ord. sci Benedicti fac Romanus
Mitto : (Porrectus) In audientiam [...]
datam positum
Ecke oben rechts : a
 Deputinum roman. Mai. Schöne

3572 (verso)

Kräftige Gitterschrift mit [...] Ober-
längen und kleinen Nebelängen
Text in fester, [...] schöner kleiner
Schrift
Je zwei Seitenlinien

3573

Marseille Archives Départem.
H. S 3.

P. — 1266 Junii 10
Clemens IIII . . abbati Cistercii
et ceteris abbatibus ac monachis
Cistercien. ordinis
 Cum ante facies
Viterbii IIII id. Junii a⁰ 2⁰
Bulle und Seide fehlen
In plica rechts. a. d. K
Sub plica links :.
A tergo : P. de Ass Franco-
nis Vallium

3574

Firenze, Badia di Coltibuo

P. — 1266 Iunii 22

Clemens IIII . . . abbi mon. de ...

Eugenio Senen. dioc.

Conquesti sunt nobis

Viterbii x kl. Iulii a° 2°

Bulle und Hanf fehlen

Entsprechende Ränder und

plica.

Ecke oben rechts ∞

11. 8 hoch, plica 1.8

14. 8 breit

außerordentlich schöne fei

ze und schwungvolle Schrift

3575

P. — Paris Arch. Nat.

J 695 ap. 175ᵉ 1266 Iulii 15

Clem IIII .. S. Dionisii in Francia

et .. S Germani de Pratis Pari-

sien. monasterij abbatibus

Prelucida et precelsa

Viterbii id. Iulii a° 2°

Bulle an Hanf

Rand oben links radirt

fiant due N

Daneben

R̄ Io p̄r̄ fiant due et statim

et secrete P

3576

Taxe XVIII statt $\frac{\overline{VII}}{X}$

Paris Archives Nationales

 J 450 n. 157

Breite 76.5 Rand links 2·7 rechts 2.6

Höhe 49.3 Rand oben 4; 9 plica 3.6

Erste Linie über den Oberlängen

Je zwei Seitenlinien

P. vacat 1266 Iulii 29

Clemens IIII . J. tt S. Cecilie pbro

Cardinali aplice sedis Legato

Cum predicationem crucis

Dat Viterbij IIII kl Augusti / a° 2°

Bulle fehlt Hanf erhalten

In plica rechts : R . C

Sub plica links : XVIII !!!!

A tergo oben mitte : pro Terra sancta

Kleine flotte Schrift

3577

Paris Archives Nationales

P. 19776 J 684 n. 21

Breite 37.2 Rand links 2·3 rechts 2·4

Höhe 23.8 Rand oben 4.9 plica 2.7

Erste Linie über den Oberlängen

Je eine Seitenlinie

P. 19776 1266 Iulii 31

Clemens IIII Carmo in xpo filio

Ludouico Regi Francorum Illustri

A felicis recordationis

Dat Viterbij / II kl Aug a° 2°

Bulle an Hanf

Kleine weite etwas verschnörkelte

Schrift

3578

Firenze, R° Acquisto ~~Pini~~
P.— 1266 Septembris 1

Clemens IIII .. epo Vrbevetan.
Exhibita nobis dilectorum
Viterbii Kl. Sept. a° 2°
Bulle und Hanf fehlen
In plica rechts : P. G.
Sub plica links :
Ecke oben rechts do
Prachtvolle runde Schrift

Eingestellt 1306 Sept. 1

3579

Brit. Mus. Add. Chart. 26.045
P. 19821 1266 Septembris 24

Clemens IIII .. archipresbitero et
Capitulo ecclesie Nidrosien.
Cum a nobis
dat. Viterbii VIII kl. Octobris
a° 2°
Bulle an Seide
In plica links B. V.
Sub plica links ...

3580

Madrid Arch. Histor. Nacional
Orense Celanova 2 €
P.— 1266 Septembris 27

Clemens IIII .. archidiacono
de Vivario in ecclia Mindonen.
Significarunt nobis dilecti
Viterbii V kl. Octobris a° 2°
Bulle an Hanf
In plica recht G. G.
δ
Sub plica links Gr
w a
Rand oben linke cpp und an
der verblasste kleine Notizen

3581

Bayer. Haupt- Staatsarchiv
Bamberg fasc. 27
P. 19856ᵃ 1266 Octobris 21

Clemens IIII .. Epo Bambergen.
Cum annuum censum
Viterbii XII Kl. novembris anno
Secundo
Bulle an Hanf
In plica rechts : J. de Asisio
Sub plica links :
g. m.
Kleine regelmässige Schrift, leicht
nach links geneigt
Erste Zeile frei, Seitenlinien

3582

Marseille Archives Départem
H. O. M. 21

P. — 1266 Octobris 25

Clemens IIII.. magro et fribus
Hospitali sancti Johannis Je-
rosolimitani

Quanto sollicitius pro
Viterbii VIII kl. nov. a° 2°

Bulle fehlt, Seide erhalten

Sub plica links — — — ⁵ —
 u. Vivian.

Rand oben links Ċ͞R und
duo Ṁ

Erste Zeile frei

Gestreckte Ligaturen

3583

Marseille Archives Départem
H. O. M. 21

P. — 1266 Octobris 25

Clemens IIII... magro et fra-
tribus Hosp. S. Johannis Jerosol.

Quanto sollicitis (sic) pro
Viterbii VIII kl. nov. a° 2°

Bulle und Seide fehlen

In plica rechts Name

Sub plica links — . ⁵ . —
 Siehe Duplicat

fehler

3584

Coblenz Staatsarchiv
Domcapitel

P. — 1266 novembris 6

Clemens IIII magistro Laurentio notario nostro scolastico
Treverensi

Desideriis tuis in
Viterbii VIII kl. nov. a° 2°

Bulle und Seide fehlen

In plica rechts
 pro persona mgri L. von
anderer Hand! S

 Ger. p

3585

Nîmes, Archives Departem.
H. 109

P. — 1266 Decembris 6

Clemens IIII.. abbi monasterii
Praemonstren. etc. in ppm

Cum universis sancte
inveniunt Amen Amen
R. Ego Clemens catholice
 Ecclie Eps SS M

3 presb 4 epi 7 diac.

Viterbii p. m. magri michaelis
sancte R. ecclie viceconc. VIII
id. dec. Ind. X Inc. dnice anno
M. CC. LXVI. pont. vero domni
CLEMENS IIII pp. IIII a° secundo

Bulle fehlt, Seide erhalten

Gestreckte Ligaturen

3586

Nimes, Archives départem.
H.110

P. — 1266 Decembris 6

Clemens IIII
........ abbi et conven...
mon. Kalmodien. Nemausen. dio
Meretur vestre devotionis
Viterbii VIII id. dec. a° 2°
Bulle an Seide
In plica rechts G. G.

Sub plica links ..

Gestreckte Liga ℞
Turm
Sehr schöne Schrift

3587

Napoli Curia Eccles. vol. x°
P. — 1266 Decembris 8
Clemens IIII Adree de Ducent°
subdiacono et capellano nro
cuonico Capuan.
Pervenit ad audientiam
Viterbii II id. dec. a° 2°
Bulle und Hanf fehlen
In plica rechts G. M
Ecke oben rechts M Go (be?)

3588 (recto)

Paris Archives Nationales
J 435 n. 5
Breite 31.2 Rand links 2.1 rechts 1.8
Höhe 26.9 Rand oben 7.6 plica 4
Erste Linie für Maj. und kleine Ober
längen / Je eine Seitenlinie
P. vacat 1267 Januarii 10
Clemens (Maj) IIII dil filio Nob
viro Fernando Carmogg in xpo
filiorum nrogg.. Castelle ac Legio
nis et Dil in xpo filie Nob muli
eri Blance Franc Regum Illustri
um natis
 Attenta sedis aplice
Dat Viterbii IIII Id Januagg / a° 2
Bulle an Seide
In plica rechts : B. Jac
 verte

3588 (verso)

Clemens reich verziert, ebenso
6 Capitelsanfänge
Schöne kleine Schrift

3589

Firenze, S. Apollonia

P.— __1267 Ianuarii 18__

Clemens IIII . . abbatisse et
Conventui monasterii de
Fonte Domini Fesulan. dioc.
OSAug.

Iustis petentium deside-
riis

Viterbii XV Kl. febr. a° 2°

Bulle und Seide fehlen
In plica rechts Ge · Ra ·
Sub plica links: ⳨

Rand oben Mitte: N. Viniani

Cor . . vel ⳨
Ecke oben rechts pe
A tergo Ecke oben links B

3590

Firenze, S. Appollonia di
Firenze

P.— __1267 Ianuarii 18__

Clemens IIII . . abbatisse et con-
ventui mon. de Fonte Domi-
ni OSAug. Fesulan. dioc.

Solet annuere sedes
Viterbii XV Kl. febr. a° 2°

Bulle und Seide fehlen
In plica rechts Ge · Ra ·
Sub plica links . .
⳨

Sub plica unliniert

3591

Firenze, S. Appollinaria di
Firenze

__Fehler__ | P.— __1267 Ianuarii 18__

Clemens IIII . . abbatisse et con-
ventui monasterio [Fehler]
de Podio Crucis OSAug. Fe-
sulan. dioc.

Religionis intuitu sub
Viterbii XV Kl febr. a° 2°

Bulle und Seide fehlen
In plica rechts Ge · Ra
Sub plica links . .
⳨

Oben zwei Zeilen unbeschrieben

3592

Marseille Archives Départem
H. O. M. 22

P.— __1267 Ianuarii 20__

Clemens IIII univ . archepis
et epis et . . abbatibus, priori-
bus et aliis eccles. prelatis
ad quos littere iste pervener.

Dilecti filii . . magister
Viterbii XIII Kl. febr. a° 3°

Bulle (vernietet) an Hanf
In plica rechts Jo de . . .
In plica links R. Jac renove-
tur sub dat. II Kl. febr. 6
Sub plica links und Bpu
R. an . S.

3593

Nice Archives Départem.
H. 1328
P. — 1267 Januarii 30
Clemens IIII archipis et epis et
abbatibus, prioribus, decanis,
archidiaconis, prepositis archi-
presbiteris et aliis eccl. prelatis
rectoribus quoque clericis ac per-
sonis eccles. ad quos littere pre-
sentes pervenerint
 Rem in oculis
Viterbii III Kl. febr. aº 3º
Bulle und Hauf fehlen
In plica rechts pᵗ R
Sub plica links ...

3594

Instr. mon. F.ffbm. c. 58 1267 febr. 6
 P. 19935
Clem. IIII... mag. et prioribus provincialibus
ow. Pred.
Affectu sincero etc.
Viterbii VIII ir. februarii anno 2º
Bulle an Seidenfäden
In plica rechts : D. Cum
Sub plica links : X
 I. G. d. Vinian
 Bpu
Bpu Ry Ber . et fac I et d. pu I.
 Ry dominus I. g
Vides abgeklatscht.
Rand oben links der M sind dies M
 " " rechts cor
 incancellarius

3595 (recto)

Bayer . Haupt . Staatsarchiv
 Fürstenfeld Kl. N. 4
P. 19948 ? 1267 Februarii 15
Clemens III (rom. mai). e. s. s. Dei
dil. filiis (ohne Punkte und zwischen-
räume) Abbati Monasterij de Fürsten-
welt eiusque fratribus tam pres. quam
futuris regularem vitam professis
IoN PPM (f und s mit dreistöckigen
Oberlängen. Die anderen Oberlängen sehr
klein; Unterlängen kaum angedeutet)
 Religiosam vitam eligentibus
preis in nevimt ABbt Amen ANEN

 R. Ego Clemens cath. ecclie eps M

3 presb. 4 epi 7 diaconi
Dat. Viterbij pu manum Magri Michae-
lis sce Romni. ecclie vicecancellarij XV
Kl. Martij Ind. X Incarn. dominice anno
Mllº. CC. LXVI pont. uero domnj CLEMEN
TIS pp. IIII anno Tertio

Bulle an Seide
Je zwei Leerlinien. Linie für Gitter-
schrift, aber keine für Oberlängen.
Capitelanfänge betont.
Die letzten fünf Zeilen mit wesentlich

3595 (verso)

kleinerer Tinte geschrieben. Reportzeile
mit schwarzer Tinte. Auditorenunter-
schriften mit einer Ausnahme mit
ganz blasser Tinte geschrieben
Rand oben Mitte : auscultetur —
(Portetur) in auditorium pro datum
positum — cor — Gilbertus f —
Ecke oben rechts : pa

3596

Poitiers Archives départem..
 Ordre de malte
P.—
 1267 Martii 11
Clemens IIII archepis et epis ac
d.f. aliis ecclarum prelatis ad
quos litt. iste pervenerint
 Eis precipue ac
Viterbii V id. Martii a° 3°
Bulle fehlt, Seide erhalten
In plica rechts:
Sub plica links .. nur:
... Irineo
Erste Zeile frei
ad instar Alex. Innoc. et Alex.
IIII

3597

Bayer. Haupt. Staatsarchiv
 Kl. Seeon Fasc. 5
P. 19966 1267 Martii 15
Clemens IIII .. decano ecclie de
Snatzse Salseburgen. dioc.
 Conquestus est nobis
Viterbii Id. Martii anno Tertio

Bulle am Hanf
 Au plica rechts : p. c. h.
Ecke oben rechts : ld nicht aus
 gestrichen
 a tergo. Ecke oben links : J

Kleines Mandat 17.5 12.8
 plica 1.00
10 Zeilen
 die beiden ersten Zeilen frei

3598

Marseille Archives Départ.
H. O. M. 22
P.— 1267 Martii 15
Clemens IIII .. priori et pa.
tribus Hospitalis Ierosol.
apud sedem apostolicam
Viterbii id. Martii a° 3°
Bulle und Seide fehlen
In plica rechts ...
Erste Zeile frei
Gestreckte Ligaturen

3599

Toulouse, Archives départem..
H. 24
P.— 1267 Martii 18
Clemens IIII .. priori ... Aman..
cii Ruthenen. ...
Querela dilectorum filiorum
Viterbii XV kl. Apr. a° 3°
Bulle fehlt, Hanf erhalten
In plica links O. ...
Ecke oben rechts ...

Toulouse, Archives départem.
H. 24

P. — 1267 Aprilis 9

Clemens IIII .. magro et fribus
Hospitalis Jerosolim.
 Cum olim felicis
Viterbii V id. Apr. a° 3.
 Bulle fehlt, Seide erhalten
 In plica rechts a. d. v.
 Erste Zeile frei
 Elegante Ligaturen
 feine runde elegante Schrift

Barcelona Corona de Aragón
 Leg. 150 n. 6°
P. — 1267 Aprilis 11
Clemens IIII nobili mulieri
Constantie nate quondam Pe-
tride Monte Cathano Ilerden.
dioc.
 Petitionis tue seriem
Viterbii III id. Apr. a° 3°
 Bulle fehlt. Seide erhalten
 In plica rechts Jac Romanus

Barcelona Corona de Aragón
 Leg. 15° n. 6°
P. — 1267 Aprilis 11
Clemens IIII archiepo Tarra
Chonen. et .. Epo Magalonen.
Seriem petitionis dilecte
Viterbii III id. Apr. a° 3°
Bulle an Hanf
In plica rechts gibt? p
Sub plica links J

Oben links Rand dup. M.

 Viceromollinus

Montpellier, ville de Montp.
 E. V Louvet 2248

P. — 1267 Aprilis 29

Clemens IIII univ. xpi fidelibus
per Magalonen. Nemausen. et Be-
terren civitates et dioc. constitutis
 Quoniam ut ait
Viterbii III kl. Maii a° 3°
 Bulle an Seide
 In plica rechts D. g
 Sub pl. links ..

 g

Rund oben rechts pro fractura Bontis
mod. xg

3604 (recto)

(Hanf und Seide)

Paris Archives Nationales
J 450 n. 153 bis
Breite 34.6 Rand links 1.4 rechts 1.4
Höhe 24.3 Rand oben 4.7 plica 3.4
Erste Linie für Gitterschr und
Oberlängen / Je eine Seitenlinie

P. 19996 1267 Maii 5
Clemens IIII (Gitterschr) Carmo in
xpo filio -- Regi Francor Illustri
In spiritu pietatis
Dat Viterbij III non Maij a° 3°
Bulle an Hanf
In plica links: P K B. Jac
. J. J statim (annum et statim)
Rand oben links: Rx und:
no obst quod ē am filo fiat
oa cū serico (verte)
A tergo oben mitte: pro Terra Sca

3604 (verso)

Sehr schlank und schmal:

Scps Cap° X X X IIII

Schiffausstattung als am filo
serico, und mit Hanf besiegelt

3605 (recto)

Paris Archives Nationales
J 450 n. 153
Breite 36.2 Rand links 1.6 rechts 1.3
Höhe 26.5 Rand oben 4.9 plica 2.9
Erste Linie für Gitterschr und Ober-
längen / Je eine Seitenlinie
P. 19996 1267 Maii 5
Clemens IIII (Gitterschr.) Carmo in
xpo filio .. Regi Francor Illustri
In spiritu pietatis
Dat Viterbij / III non Maij a° 3°
Bulle an feiner Seide
In plica rechts: P. G
 de Cur
Ecke oben links: Rx und per
A Tergo oben mitte:
 Rex Franc (verte)

3605 (verso)

Groß schlank etwas steif:

Scps Cap° X X X V

Sehr schöne kleine feste Schrift

3606 (recto)

P. 19996 Paris Arch. Nat.
J 450 cap. 153 bis 1267 Maii 5
Clem III .. regi Francorum illustri
In spiritu pietatis
Viterbii III non. Maii aˇ 3ˇ
Bulle an Hanf, obschon C für
Seide verziert war
In plica links N
daneben Rx B Iaˇ · I. et statim
Sub plica links ...
 n.v.
Rand oben links Rx
daneben durchstrichen
nˇ obst quod ē cˇ filo fiat cˇ serico
A tergo cap° xxx IIII
 vide

3607

Paris Archives Nationales
 J 450 n. 154
Breite 33.9 Rand links 1.1 rechts 1.3
Höhe 21.4 Rand oben 5.3 plica 3.6
Erste Linie für Oberlängen / Je
eine Seitenlinie
P. 19996 1267 Maii 5
Clemens IIII (Gitterschr) Carmo in
xpo filio .. Regi Francor Illustri
.. In spiritu pietatis
Dat Viterbij III Non Maij aˇ 3ˇ
Bulle an Seide
In plica links : ſ
 Sub plica links : ...
 n.v.
Kleine unschöne Schrift

3606 (verso)

cap. 153
gleicher Text, nur ist die Bewilli-
gung der Einnahmen verschieden
 Bulle an Seide
A tergo R xxx V

Die Neuausfertigung von
cap. 153 bis sub filo serico
liegt sub cap. 154
 ohne Registraturzeichen
Weitere Bewilligungen J. 452
capp. 25¹ bis 28⁴ hierselbst
Befehle : Rx Iaˇ Mut et statim
remittas michi oder
et remittatur michi statim
 usw.

3608

Statim remittas michi
Paris Archives Nationales
 J 452 n. 25ᵈ
Breite 38.3 Rand links 3.1 rechts 2.6
Höhe 30.2 Rand oben 6.5 plica 3.1
 Erste Linie für Maj und Oberlän-
gen / Je zwei Leitenlinien
P. 19996 1267 Maii 5
Clemens IIII (verz. Maj) Carmo in
xpo filio .. Regi Francor Illustri
 In spiritu pietatis
Dat Viterbij III Non Maij aˇ 3ˇ
 Bulle an Seide
 In plica rechts: Ger. ß
 In plica links : Rx Ger ß Z sta-
tim remittas michi
Ecke oben links : Rx
A tergo oben Mitte : pro terra Sˇa
 Enge schöne Schrift

3609

de curia

Paris Archives Nationales
J 452 n. 25²
Breite 41.5 Rand links 2.2 rechts 2.4
Höhe 31.5 Rand oben 6.3 plica 4.2
Erste Linie für Maj und kleine Oberlängen / Je zwei Seitenlinien
P. 19996 1267 Maii 5
Clemens IIII (ves. Maj) Carmo in
xpo filio - Regi Francorum Jllustri
Ju spiritu pietatis
Dat Viterbij III Non Maij / a° 3°
Bulle an Seide
In plica links: Johes de Pona
de Cur
A tergo oben Mitte: pro Terra sta
Fette sehr feste schöne Schrift

3610

Paris Archives Nationales
J 452 n. 25 bis
Breite 44. Rand links 2.5 rechts 2.6
Höhe 29.9 Rand oben 5.3 plica 3.6
Ohne erste freie Linie / Mit je
einer Seitenlinie
P. 19996 1267 Maii 5
Clemens IIII (Gitterschr) Carmo in
xpo filio - Regi Francorum Jllus-
tri
Ju spiritu pietatis
Dat Viterbij III Non Maij / a° 3°
Bulle an Seide
A tergo oben Mitte: pro Terra sta
Kleine fette stumpfe Schrift

3611

de curia statim remittas mihi

Paris Archives Nationales
J 452 n. 25 ter
Breite 37. Rand links 1.4 rechts 1.3
Höhe 25.5 Rand oben 5. plica 3.6
Erste Linie für Gitterschr, aber über
den Oberlängen / Je eine Seitenlinie
P. 19996 1267 Maii 5
Clemens IIII (Gitterschr) Carmo in xpo
filio - Regi Francorum Jllustri
Ju spiritu pietatis
Dat Viterbij III Non Maij a° 3°
Bulle an Seide
In plica rechts: P. G.
de Cur
In plica links: Rf Johannes z statim
remittas mihi
Kleine fette deutliche Schrift

3612 (recto)

de curia statim remittas mihi

Paris Archives Nationales
J 452 n. 25 quater
Breite 45.6 Rand links 2.9 rechts 2.4
Höhe 28.7 Rand oben 4.6 plica 3
Erste Linie für Gitterschr und
kleinere Oberlängen / Je zwei Seitenlinien
P. 19996 1267 Maii 5
Clemens (Gitterschr) Carmo in
xpo filio - Regi Francorum st
Jllustri
Ju spiritu pietatis
Dat Viterbij / III Non Maij a° 3°
Bulle an Seide
In plica rechts: R. C. curte
de Cur
In plica links: Rf Dat krul z
statim remittas mihi / Rf h. Reat
z remittatio mihi statim

3612 (verso)

Sub plica links : V
n. V.
Ecke oben links : Rt
a tergo oben Mitte : pro terra s̄ta
Kleine fette klare Schrift

3613

de Curia

Paris Archives Nationales
J 450 n. 152
Breite 50.3 Rand links 1.6 rechts 2,
Höhe 39.7 Rand oben 7. plica 5.3
Erste Linie für Oberlingen / Je
eine Seitenlinie
P. 19996 1267 Maii 6
Clemens IIII . S. H̄ sanctæ Ceciliæ
phrō Cardinali aplice sedis Legato
Ju spiritu pietatis
Dat Viterbij / II hō Maij a° 3°
Bulle an Hanf
Ju plica rechts : pt R
de Curia
Sub plica links : V
n. V.
A tergo oben Mitte : pro Terra s̄ta

3614 (recto)

Paris Archives Nationales
J 450 n. 152 bis
Breite 42.2 Rand links 1.6 rechts 1.6
Höhe 28.7 Rand oben 4.4 plica 4.5
Erste Linie für Oberlingen /
Je eine Seitenlinie
P vacat 1267 Maii 6
Clemens IIII . S. H̄ sanctæ Ce
cilie phrō Cardin aplice sedis Le
gato
Ju spiritu pietatis
Dat Viterbij II hō Maij a° 3°
Bulle an Hanf
Ju plica rechts : B. pu
de Cur
Rf O. Srud / Ju plica links :
Rf g. Aŋ. P j statim nur

3614 (verso)

ein weiterer Befehl
Sub plica links : V
n. V
Ecke oben links : Rf
a tergo oben Mitte :
pro terra s̄ta
Kleine fette deutliche Schrift

P.— Paris Arch. nat.
J 458 cap. 285 1267 Maii 7
Clem III S. tit. S. Ceciliae presb.
card. aplice sedis legato
In spiritu pietatis
Viterbii non Maii a° 3°
Bulle au Hanf
In plica rechts Gilbertus p de
 Cur

Sub plica links ꝩ
 h. ꝩ
In plica links
R/ Leo G et statim remittas michi
R/ Gilberte et statim remitte michi
Ecke oben links. R/

Ähnliche Notizen auf manchen
anderen Bullen dieses Cartons

Marseille Archives départem.
B 366
P.— 1267 Maii 18
Clemens III nob. viro Philippo
primogenito cui in xpo filii
nostri Balduini Constantinopolitani. imperatoris illustris
 Sedes aplica gratiarum
Bulle au Seide XV Kl. Iun. a° 3°
In plica rechts Jacobus de Mutina
Schwungvolle, weite, kleine
Schrift mit schönen Schnörkeln
und Längen.
Pergament, Bulle und Seide
ausgezeichnet erhalten

Marseille Archives départem.
B 366
P.— 1267 Maii 18
Clemens III nob. viro Philippo
primogenito cui in xpo filii
nostri Balduini Constantinopolitani. imperatoris illustris
 Sedes apostolica gratiarum
Viterbii XV Kl. Iunii a° 3°
Bulle au Seide
In plica rechts Jacobus Mut.
Alles ausgezeichnet erhalten

Arch. Arcis
Arm. IX capo. 2 cap. 11
P.— 1267 maii 25
Clem. III .. epo Anagnin.
Conspicientes hactenus Lundonem
Viterbii VIII Kl. Iunii a° 3°
Bulle au Hanf, abgefallen und
wieder angeknüpft.
In pl. rechts: P. Romanus
 de Cur

3619

Marseille Archives départem
B 366
P. — 1267 Maii 29
Clemens III ad perp. rei mem.
[Carissimi in xpo]
Viterbii III Kl. Iunii a° 3°
Bulle an Seide, prachtvoll er
halten.
In plica rechts Iacobus de Mutina
Ausgezeichnet schöne kleine
Schrift; großes Pergament
Fleckig und auf beiden Seiten
Löcher

3620

Marseille Archives départem.
B 366
P. — 1267 Maii 29
Clemens III ad perp. rei mem.
Carissimi in xpo
[Apud Viterbii Viterbii] ?
[III] Kl. Iunii a° 3°
Bulle an Seide
In plica rechts [] de Mutina
Sehr große schwungvoll geschrie
bene Bulle. Enge, etwas fette und
runde Schrift.
Sehr beschädigt und fleckig

3621

Napoli Perg. Farn. Bolle n. 9
P. — 1267 Iunii 22
Clemens III - - epo Balneoregen
Sua nobis dilectus
Viterbii X Kl. Iulii a° 3°
Bulle und Hanf fehlen
In plica rechts S · R
Sub plica links G
 ≈ mio

3622 (recto)

Instr. mon. F. Dom. c. 70 1267 Iun. 30
 P. 20060
Clem. III .. mag. et fratribus ord. Pred.
meritis vestre religionis
Viterbii II Kl. Iulii a° 3°
Bulle an Seidenfäden.
In plica rechts: Gibertus p
In plica links: R. Io Viter. I. G. quat.
R. Io f. II I. G. beides durchstrichen
Mitte: Bpm R. Io de Capis
Sub plica: I. G. p cc vie cancellar
 Bpm R. Da et Iac III or [Bei ausge
loscht und drüber: al p)
Ecke oben links: R.
Rand oben: finit due M.
 finit III or sub eadem data M
·casa · finit III or M
 finit III or M verte

3622 (verso)

a tergo : Predicatorum

℞ cap° LXXVIII°

3623 (recto)

P. 20064ˣ Paris Arch. nat.

L 261 cap. 98 1267 Julii 6

Clem III fratribus Ord. inquisi-

toribus heretice pravitatis in Bi-

suntin. Gebennen., Lausanen.,

Sedunen., Tullen., Meten., Vir-

dunen. civitatibus et dioc. suis

deputatis auct. aplica et in pos-

terum deputandis

Pre cunctis nostre

Viterbii II non. Julii a° 3°

Bulle fehlt. Hanf erhalten

In plica rechts : Jac̄

In plica links : Dat. ap. urbem

Veterem II Kl. Julii anno tercio

CCXXV | Ecke oben links steht :

Innovetur [sub
rub. II]

3623 (verso)

Sub plica links Bng :

H. Pad. J. de Setia

℞ h Vant. et remitte michi

ad tacendum

J. Reat

3624

Instr. Mon. F. Dom. c. 89 1267 Julii 7

P. 20069

Consurgit in nobis

Bulle an dicken Seidenfäden

In plica links : O. Laud.

Daneben confirmationis et inhibi-

tionis

Ecke links oben : ℞

Sub plica links ▽

J mir

a tergo : ℞ cap° LV°

3625

P. — Paris Arch. nat.
L 261 cap. 99 1267 Julii 8
Clem. IV .. priori provinciali fra-
trum ordinis Predicatorum in
Francia
Precunctis nostre mentis
Viterbii 8 id. Julii a° 3°
Bulle fehlt; Hanf erhalten
In plica rechts: B. tomes
 de Curia
Rand oben ganz links eigenhändig:
Ego Jo. Ga. card[?] ß bulletur
iniuncta nob. Moneter alia man[?]
fiunt tres de curia gratis B.
Sub plica Ang: R. N. Vivian I
g. de Curia facit unam
R. Jo.S. J.G. binas de Curia

3626

Public Record Office London
Papal Bulls bundle 10 n. 5
 P. 20 080 1267 Julii 15
Clemens IV. U. S. Adriani diac.
card. ap. sedis legato
Ex parte carissime
Viterbii id. Julii a° 3°
 Bulle an Hanf
In plica rechts Jac Mut
Sub plica links - - - -
 = M. C.
Eck oben links R
Rand Mitte corr
A tergo
 cap° L III°

3627

Instr. Mon. F. dom. C 25 1267 Julii 15
 P. 20082
Clem. IV archepo Terraconen. et suf.
frganeis eius
Dampnabili perfidia iudeorum.
Viterbii id. Julii a° 3°
Bulle an Hanfschnur
Sub plica links γ (γ oder ▽)

A tergo: fr. Paulus xp̄nus
Einige Löcher im Texte.

3628

Instr. Mon. F. dom cap. 136 1267 Jul. 15
 P. 20081
Clem. IV regi Aragonum
Dampnabili perfidia iudeorum
Viterbii id. Julii a° tercio
Bulle an Hanfschnur
In plica rechts : untersclich
Sub plica links: ▽
A tergo: fr. Paulus xp̄nus

3629

Madrid Arch. Histor. nacional
Armentiera n. 2 P. —
Schreibfehler vicecancellarius
1267 Julii 25
Clemens IIII.. abbati mon. S. Jo-
hannis de Podio eiusque fratri-
bus etc. in ppm
Religiosum vitam eligentibus
inveniant Amen a. a.
(CR.) Ego Clemens C. 9. eps ss. (M)
3 presb. 4 epi 4 diac.
Dat. Viterbii p. m. Hael(s)
SRE vicecancellarii VIII kl. aug
ind. X Inc. D. a° M. CC....m pont
vero domni Clementis
Bulle fehlt. Seide erhalten
Rand oben links (coe p ord. scib
weiter rechts p coe ord. soi Ben
A. de Syria (?)
a tergo 1267

3630

Instr. mon. F. tom. c. 28 1267 Juli 29
P. 20095
Clem. IIII fratribus Predic. et Minorum
ordinum inquisitoribus he. pravit.
auctoritate Sedis aplice deputatis
aut imposterum deputandis
Turbeto corde audivimus.
Viterbii II kl. Augusti a° 3°
nachgetragen
Bulle an Hanfschnur
In plica rechts : de Curia
L. G.
A tergo : xpi nus photo Bulle
Bulle ganz verwittert und brüchig. Haf
schnur frisch und gut. Bruch der Bulle
läßt die grauen Fäden bis oben hin
sehen

3631

Arch. Arcis
Arm. IX cap 1 cap. 48
P. — 1267 Julii 29
Clem. III .. epo Anagnin.
Ecce dilectum filium
Viterbii III kl. Aug. a° 3°
Bulle an Hanf
In plica rechts : dat 3 at
Sub plica links : F m . c.
A tergo oben Mitte
Cabinianum

3632

Marseille Archives Départem
H. O. n. 22 1267 Augusti 12
P. —
Clemens IIII archepis et epis
et abb. prior. dec. archid. pe-
pos. archipresb. et aliis eccles.
prelatis ad quos littere iste per-
Querelam gravem recepimus
Viterbii II id. Augusti a° 3°
Bulle fehlt Seide erhalten
In plica rechts Jac̄ mut
Sub plica links v
p. y. e
Rand oben Mitte : ita cum
correctionibus novis et cor-
cens ad quing
Erste Seite beschrieben

3633

Instr. misc. 1250-1275. cap. 45
P. — 1267 Augusti 20
Clem. IIII .. epo Magalonen.
Que provide peraguntur
Viterbii XIII kal. Sept. a° 3°
Bulle und Seide fehlen
In plica rechts: J. G.
Sub plica links: ---
= m.c.

Rand oben links: 2.2.
. tota .
Rand oben rechts: + supp (Loch)

Ecke rechts oben: /80
A tergo :. Villa magna .

3634

Arch. Arcis
Arm. IX caps. 2 cap. 12
P. — 1267 Aug. 25
Clem. IIII .. epo Anagnin.
Dilecti filii nobiles
Viterbii VIII kl. Sept. a° 3°
Bulle an Hanf
Inpl. rechts : M. C.
Sub plica links : - - - -
M.C

M C mit einem Haken dazwischen.
wahrscheinlich unbeabsichtigt.

36 35

Marseille Archives dipartem.
H. St. Paul de Marseille 1
P. — 1267 Augusti 31
Clemens IIII .. ministro generali ac prioribus et fratribus universis ordinis eremitarum
sancte Marie Matris Christi
sub regula beati Augustini
viventibus
Devotionis vestre precibus
Viterbii II kl. Sept. a° 3°
Bulle und Seide ausgeschnitten
In plica rechts p. R
pro magro Palmerio
Sub plica links ..
Gestreckte Ligaturen
Kleine deutliche feine Schrift

36 36

Public Record Office London
Papal Bulls bundle 13 n. 3
P. — 1267 Octobris 27
Clemens IIII U. S. Adriani diac.
card. apostolice sedis legato
Significaunt nobis .. prior
Viterbii VI kel. Nov. a° 3°
In plica rechts Sy Ro
Sub plica links -
J. G.
ganz unten n R daneben
... te ri J. G.
Rand oben links
. dn. M

Bulle und Hanf fehlen.

3637

Public Record Office London
Papal Bulls bundle 13 n. 4
P - 1267 Octobris 27
Clemens IIII -- priori et conventui
ecie S. Trinitatis Londoniens OS Aug.
Justis petentium desideriis
Viterbii VI kel. Nov. a° 3°
In plica rechts Jac. Mut
Sub plica links G
 = M.C.
Edce oben rechts ba
Bulle und Seide fehlen

3638

P. - Paris Arch. Nat.
L 261 cap. 102 1267 Nov. 22
Clem III .. mag. et fratr. domus
militie Templi Jerosolimitani
Desideriis desiderantes vos
Viterbii X kal. Dec. a° 3°
Bulle au Seide
In plica rechts : F de Atin.
Sub plica links :
 // J ic
Links oben Rand figut den M
 fava
Mitte : ascultetai . M -
 durchstrichene Hand
Sub plica links distributor :
Rf Jo S. pro te et J. M. Bpm

3639

Napoli Curia Eccles. fol. 4
P. 20197 1267 Decembris 4
Clemens IIII .. archepo Tranen.
Petulerunt ad audientiam
Viterbii II non. Dec. a° 3°
Bulle und Hanf fehlen
In plica rechts A . J.
Sub plica links .!

Prachtvolle kleine Schrift

3640

Marseille Archives Départem.
H. Trinitaires de Marseille 1
P. - 1267 Decembris 10
Clemens IIII .. maiori ministro
et fratribus totius ordinis Sancte
Trinitatis et Captivorum
Solet annuere sedes
Viterbii IIII id. Dec. a° 3°
Bulle au Seide
In plica rechts Name
Sub plica links ..
Ligaturen gemischt
Deutliche kleine Schrift

3641

Instr. misc. ~~1250~~ 1275 Cap. 52

P. — 1267 Dec. 10

Clem. IV .. epo Mrgalonen.

Ea que a

Viterbii III Id. Dec. a° 3°

Bulle und Seide fehlen

In plica links: O. Laud

über den pl. links: - - - -

Sub pl. links: g⁵ Iar Romanus

Rund oben . 2. z. und

asculfetur und

R⁄ Alex y innovetur ad instar

Ecke rechts oben: ~~Jo~~

(ascultata Paulus) a paul

A tergo oben: Ex illa magna

of. 1256 Ian. 28 c. 8

of. 1275 Iunii 9 c. 79

3642

Public Record Office London

Papal Bulls bundle 13 m. 2

P. — 1267 Decembris 13

Clemens IIII U. S. Adriani diac.

card. apostolice sedis legato

Significarunt nobis .. prior

Viterbii id. Dec. a° 3°

In plica rechts B. pm

Sub plica links --

Bulle und Hanf fehlen

3643

Statsarchiv Wien Chronol.

P. 20186 1267 Decembris 17

Clemens IIII nob. viro .. duci

Carinthie

Ab hiis tua

Viterbii XVI Kl. Ian. a° 3°

Bulle an Hanf

In plica rechts . A . S.

Sub plica links - - -

f S Iao Romanus

B. pm

Ecke oben links duplica B

und oor

3644

Instr. Mon. + Dom. c139 1267 Dec. 20

P. 20193

Clem. IV ., mag. et fratr. O. Prd. Photo

meritis vestre religionis —

Viterbii XIII Kal. Ian. a° 3°

Bulle fehlt. Seide vorhanden.

In plica rechts: G. de Appo

Sub plica links: - - -

oben links: R⁄

Oben halblinks durchstrichen:

fiant . due . M.

fiant . IIII⁰ʳ . M.

Sub plica links durchstrichen:

B pm R⁄ d. p ire (?) f. de A. et fac

duas et Iao Und aliis duas

Auf Bug nicht durchstrichen:

B pm R⁄ a aa de L. et fac IIII⁰ʳ

von anderer Hand ist et per d

A tergo: predicatorum

R cap⁰ C⁰ XLVII

cancellarius

3645

Instr. mon. F. Mu. Cap. 98 1267 Dec. 22

P. 20197

Clem IV .. generali ministro et fratribus
ordinis fratrum Minorum
Quo vos in —
Viterbii XI Kal. Ianuarii a° tercio
Bulle an Seidenfäden.
In plica rechts : R̄w̄s R·C.
Sub plica links : ·'·

Oberer Rand : dieß ... finußt IIII or M

A tergo : predicatorum
vicenuellarius

3646

Statsarchiv Wien Böhm. Archiv
P. 20229 1268 Ianuarii 20

Clemens IIII carmo in xpo filio..
Regi Boemie illustri
In hui magnificentia
Viterbii XIII Kl. februarii a° 3 ·
Bulle an Seide
In plica rechts B. Comes
Sub plica links V̄

Bpu

Ecke oben links 14 und /////

« der M »

Rand oben mitte Rex
A tergo oben mitte
schlank kräftig
schnell

[Duplicat] In plica
links Ro, sub
plica links F. alles
andere fehlt gänslich

139

Caf cXX
VIIII

3647

Statsarchiv Wien Böhm - Archiv
P. 20246 1268 Ianuarii 26

Clemens IIII carissimo in xpo fi
lio . Regi Boemie illustri
Ad extollendum fidei
Viterbii XI Kl. feb. a° 3°
Bulle an Seide
In plica rechts B. pm
Sub plica links abgeklatscht

B pm

Ecke oben links 14 und

daneben Smrtz //////

Rand oben mitte Rex

A tergo mittelgros
schlank kräftig

Caf CXL

3648

Wien Statsarchiv Böhm. Archiv
P. 20252 1268 Ianuarii 31

Clemens IIII .. magistro et fribus
Hospitalis sancte Marie Theu
tonicorum in Pruscia
Cum a nobis
Viterbii XI Kl. februarii a° 3°
Bulle an Seide
In plica rechts L. G

Ligaturen gemischt.
oberste Zeile unterschrieben

3649

Bayer. Haupt. Staatsarchiv
Würzburg n. 3066

P. rect ✠ 1268. Februarii 21

Clemens IIII . . praepos to ecclie de
Truckelhusen Herbipolen. dioc
Significarunt nobis dilecti
Viterbij X Kl. Marcij a° Quarto

Bulle an dünnem Hanf
In plica rechts : BO. p men

Sub plica links : qS Jac. Romanus

Ecke oben rechts : t̄t̄

Niedrige fette Schrift; geschwungene
Ober- und Unterlängen

3650

Marseille Archives Départem.
H. S. C. a. 2
P. 20291 1268 Martii 15

Clemens IIII dil . in Xpo filiabus
univ. abbatissis et sororibus mo-
nasteriorum OS Clare
Inducunt nos devotionis
Viterbii id. Martii a° 4°
Bulle fehlt Seide erhalten
In plica rechts B p m (ns?)
Sub plica links ..
Rand oben links findb. xo . ng
Nach links liegende schöne
Schrift
Ligaturen gemischt

3651

Bayer. Haupt. Staatsarchiv
Kaisheim n. 146

P. 20333 1268 Maii 2

Clemens IIII (Gitterschrift) . . Abbati
et Conventui monasterij Cesarien
Cistercien. ordinis Augustin. dioc
Cum a nobis
Viterbij VI Non. Maij anno Quarto

Bulle an feiner Seide
✠ In plica rechts : p. Bo oder Ro

Prachtvolle, zierliche, runde Schrift
mit langen Unterlängen

Ziemlich breite Seitenränder

3652

Staatsarchiv Wien Chronol.
P. — 1268 Martii 5
Clemens IIII . . archiepisco-
po Salzeburgen.
Licet infra certum
Viterbii III non. Martii a° 4°
Bulle an Hanf
In plica rechts Sng Ro
Sub plica links ..
 qS Jac Romanus
 B p m

Rand oben links das m

Arch. Archis
Arm. II cap. V cap. 4
P. 20331 1268 Maii 2
Clem IV fratri Guillermo de Tu-
ningo ordinis Predicatorum
Hoste pacis abolim
Viterbii VI non. Maii a° 4°
Bulle an dünnen Hanfschnur
In pl. rechts: Jac Romanus

Sehr klein und undeutlich

P. 20355 Paris Arch. nat.
L 262 cap. 114 1268 Maii 23
Clem III .. abbati et conventui
mon. S. dionisii in Francia ad
Romanam Ecclesiam nullo
medio pertinentis OSB Pari-
sien. dioc.
Licet is de
Viterbii X Kl. Junii a° 4°
Bulle an Seide
In plica rechts al pu
Ecke oben links duplica B.
Sub plica links: Bpm Ry Ale
de I00 G

Instr. mon. F. Dom. c. 115 1268 Maii 30
P. 20364
Clem III .. mag. fratrum ord. Pred.
Petitio tua nobis.
Viterbii III Kal. Junii a° 4°
Bulle an Seidenfäden
In plica rechts: Jo. S.
Sub plica links: . . .
Jac Romanus
Rand oben: - du - m. tota
darüber andere Hand: tota
Mitte: ascultetur M.
A tergo: predicatorum
Die Schrift plica bedeckt 1½ Zeile

Brit. mus. Add. Chart. 6306
P. - 1268 Junii 1
Clemens III .. decano et capi-
tulo ecclesie S. Andree Wai-
macien.
Justis petentium desi-
deriis
Dat. Viterbii Kl. Junii a° 4°
Bulle an Seidenfäden
In plica rechts pa
Sub plica links --
A tergo:
Confirmatio super Eccle-
sia in Beintersheim

3657

Archivio di Stato Milano
Bolle e Brevi ricevuta
Copie P. — 1268 Junii 5
Clemens III priori et fratribus heremitis in Lombardia constitutis fratri Bosorent. etc . in ppm
Religiosorum ritum eligentibus
R. Ego Clemens etc.
4 proob. 3 epi 5 diac.
Viterbii p . m . major Michaelis de Tholosa SRE viccann̄
Non. Junii ind. XI a° 4°

 inscribot duplicat

3658

Instr. Misc. 1250 - 1275 cap. 44
 R 20372 1268 Jun. 5
Clem. III [ministro loch] generali et aliis ministris de fratribus ord. Min.
 Quia plerumque in
Viterbii non. Junii a° 4°
Bulle und Seide augerissen
In plica rechts : Jo J.
 pro dco
Sub plica links : darunter
Loch drum . os et G III V asis
 Bpn R4 B de Afin et fiant IIIor
viccant R Johanne et for duas
michael de
Tholosa [Ecke oben links
Verschiedene Hinwl R4 - du M
A tergo Predicatorum und Scpt xxx

3659 (recto)

Joh. Gaet cardinalis duplica
Paris Archives nationales
 J 192 n. 22
Breite 37, 2 Rand links 1.5 rechts 1.4
Höhe 26.6 Rand oben 4.8 plica 4.2
Erste Linie für linize Obulüngen
Je eine Seikalinie rechts und links
P. vacat 1268 Junii 20
 Clemens III nob viro . . Comiti Pictaviēn y Tholosān
 De sincerissima devotione
 Dat Viterbij XII Rl Julij / a° 4°
 Bulle an Hanf
 In plica rechts : J. Seluad
 Sub plica links : e. Jñ Romanus
 Rand oben links : duplica D
 Rand oben Mitte : de mañ dñi Jo
 Gaytan Card verte

3659 (verso)

A tergo Ecke oben links]
A tergo oben Mitte :
 Bonaspes de Ass
Sehr kleine prachtvolle gwañ
Schiff

3660

Instr. mon. F. Dom. c. 47 1268 Jun. 21
P. 20398

Clem. IV .. epo Albanen. apost. sedis
legato.
Significabit nobis dilectus
Viterbii 11 kal. Julii a° 4°
Kupferstecher und Bulle fehlen.
In plica rechts: Alex. Bo.
Sub plica links: ..
A tergo: predicatorum

3661

Firenze, S. Croce di Firenze
P. 20408 1268 Julii 6

Clemens IIII .. generali et pro-
vincialibus ministris univer-
sis fibus ord. frum Minor.
 Lecta nobis vestra
Viterbii 11 non. Jul: a° 4°
 Bulle fehlt, Seide erhalten
In plica rechts F. de Ати
 Sub plica links
Oberste Linie frei
 Sub plica unliniiert

3662

Instr. mon. F. Dom. c. 133 1268 Julii 6
p 20408

Clem. IV .. magistro et fratribus ordinis Prel.
Lecta nobis vestra —
Viterbii 11 non. Julii a° 4°
Bulle an Seidenfäden.
In plica rechts: Jy. Ro
Sub plica links:
 96 Jac. Romanus
Rand oben Mitte: de man dni vic.
Rand oben links: fiant 11 ut ist steht
et alii sex fratri Rinaldo (?) si null
in quibus scribatur Minoribus
si null übergeschrieben
In plica längere Notiz Rinaldo
vidit

A tergo: Predicatorum
Innenseite scpt cap' 1.17

3663

Instr. misc. 1250-1275 cap. 47
P. — 1268 Augusti 1

Clem. IIII mag. Willermo Folquini ca-
pellano nostro canonico narbonen.
 Ex parte carissimi
Viterbii kal. Augusti a° 4°
Bulle und Hanf fehlen
In plica rechts: Jac. Alexii
Sub plica links: X
In plica links: ⚜ (: J M)

Rand oben links: . du. M.
A tergo : Necapolis
 Michael de Tolose
 vicecancellarius

3664 (recto)

Paris Archives Nationales Ṛ̣
 J 435 n. 5 bis
Breite 40.4 Rand links 2.4 rechts 2.3
Höhe 28.8 Rand oben 5.4 plica 3.9
Keine Linie für sehr hohe Oberlängen
Je eine Seitenlinie

p. vacat **1268 Augusti 10**

Clemens IIII nob viro Ferrando
Carissimorum in Xpo filiorum nostr
.. Castelle ac Legionis et dilecte in
Xpo filie nobili mulieri Blanch.. Fran
core Regum Illustrium natis.
Regalis prosapia generis
Dat Viterbii IIII Jd Aug / aᵒ 4ᵒ
Bulle an sehr feiner Seide
In plica rechts: dat Mut
 verte

3664 (verso)

A tergo oben Mitte mittelgross

Ṛ Cap VIIII

Schöne mittelgrosse gerade
Schrift

3665

Arch. Avis
Ann. IX cps. exp.
 P. – 1268 Sept. 13
Clem. IIII magistro Willermo
Fulquini capellano nro cano-
nico Narbonen.
Super gravaminibus que
Viterbii iv. Sept. aᵒ 4ᵒ
Bulle an Hanf
In pl. rechts: dat Nicol
Sub pl. links: ...
In pl. halblinks:
 Ṛ dat Jud

Rand oben links: fiat tres. M
A tergo oben: + Neapolis +

3666

Instr. Misc. 1250–1275 cap. 48
 P. – 1268 Sept. 13
Clem. IIII mag. Willermo Fulquini
capellano nostro canonico Narbonen.
Super gravaminibus que
Viterbii iv. Septembris aᵒ 4ᵒ
Bulle und Hanf fehlen
In plica rechts: D (aˀ) Cum
Sub plica links:
 dat Alexii
In plica links: Ṛ (...) J. Mut
(J.M.) darunter ein Monogramm
Ecke oben links: |Ẹ . dcr . m
A tergo: Ṛ̣ cap LXIII
 michael de Tholosa
 vicecancellarius

3667

Bayer. Haupt- Staatsarchiv
Prüfening Fasc. 12

P. 20464 1268 Septembris 24

Clemens IIII .. abbati Monasterij
de Prvel Ratisponen. dioc.
Pervenit ad audientiam
Viterbij VIII Kl. Octobris anno
Quarto

Bulle an Hanf
In plica rechts: P. Th. . .
 Sub plica links:
 Jac. alexij

Erste Zeite frei Seitenlinien
Kleine flüssige Schrift

3668

Instr. Mon. F. dom. C. 34 1268 Sept. 24

 P. 20463

Clem. IIII .. episcopo Asten.
Inundans malitia perversorum.
Viterbii VIII Kl. Octobris a° 4°
Bulle an Hanfschnur
In plica rechts: Al. p.
Sub plica links: --
 Jac. Alexii

Rand oben links : - du. M
Ecke rechts oben : X
A tergo: previsatorum
 vice cancellarius

3669

Paris Archives Nationales
 J 435 n. 4
Breite 28.2 Rand links 1.8 rechts 1.8
Höhe 9.4 Rand oben 5.2 plica 3.5
Erste Linie für Oberlängen / Je eine
Seitenlinie
P. vacat IIII 1268 Octobris 9
Clemens (Gitterschrift) Dilecte in
Xpo filie Blance nate carissimi in
Xpo filij nostri .. Regis Francie Illus-
tris
 Attendentes quod si
Dat Viterbij VII Jd Octobr. / a° 4°
 Bulle an feiner Seide
In plica rechts: Jo Amago
Vier verzierte Buchstaben
Regelm. schöne Schrift

3670

Barcelona Corona de Aragón
 P. — Leg. 15° n. 7°
 1268 Octobris 29
Clemens IIII .. archidiacono
de Riparcuria in ecclia Ilea-
den.
Sua nobis dilecti
Viterbii III Kl. Nov. a° 4°
Bulle fehlt. Hanf erhalten
In plica rechts R. C.
Sub plica links ?
 B fic (fu)

Rand oben Mitte
de mandato dni Cardinalis
Ecke oben rechts X

3671

Firenze, Badia fiorentina
P. — 1268 Octobris 31
Clemens IIII .. archipresbitero
ecclesie Fesulan.
Dilecti filii .. abbas
Viterbii x Kl. nov. a° 4°
Bulle und Hanf fehlen
In plica scriptor
Oberste Zeile beschrieben.
Sub plica unliniert
H. 8 hoch 17. 8 breit
2. 5 plica

3672

Instr. misc. 1250-1275 cap. 50
P. — 1268 nov. 5.
Clem. IIII mag. Guillelmo Folgui-
ni capellano nostro canonico narbonen.
Pro negotio quod
Viterbii non. novembris a° 4°
Bulle und Hanf fehlen
In plica rechts: de Curia
 D. Cur.

3673

Instr. misc. 1250-1275 cap. 51
P. — 1268 nov. 13
Clem. IIII mag. Guillelmo Folguini
capellano nostro canonico Narbon.
Super gravaminibus que
Viterbii id. novembris a° 4°
Bulle und Hanf angerissen
In plica rechts: Ber
 de Curia

3674

Bulla blanca
Paris Archives Nationales
J 448 n. 94
Breite 46. Randlinks 2.9 rechts 2.7
Höhe 30.9 Randoben 5.7 plica 3.7
Erste Linie über den Oberlängen
Je eine Zutenlinie
P. vacat 1272 Martii 4
Gregorius X Dil filijs abbatibus no-
bilibus viris Erardo de Valeri, Re-
naldo de Bari, Gerardo de Marbais
& eorum in hac parte consortibus
Inter occupationes multiplices
Dat Viterbij IIII non Martij / a° 1°
Bulle fehlt Hanf erhalten
In plica rechts: P. G.
 de Cur
Kleine fette Schrift

3675

P.— Paris Arch.-Nat.
J 448 Cap. 94 1272 Martii 4
Greg electus (X) Erardo de Valen
Renardo de Bari, Gerardo de Mar
bais et eorum in hac parte consor-
tibus
Inter occupationes multiplices
Nec miremini
Dat. Viterbii IIII non Martii
suscepti a° I°
Bruch erhalten Bulle fehlt.
In plica rechts P G
 de Cur

3676 (recto)

Paris Archives Nationales Bulla
J 448 n. 96 blanca
Breite 30.8 Rand links 1.6 rechts 1.4
Höhe 21.7 Rand oben 4.6 plica 3.4
Erste Linie für Oberlängen / Je
eine Seitenlinie
P. vacat 1272 Martii 4
Gregorius X Electus Eps v. s. d ven
fratribus. Archieps et Epis per Regnum
Francie constitutis ad quos littere
iste pervenerint
 Clamante instanter ad
Nec miremini quod bulla non expri
mens nomen nrm etc usque in
finem Dat Viterbii IIII Non Martii /
a°I° suscepti a nobis Aplatus of-
ficij anno primo
 Bulle an Bruch vacat

3676 (verso)

In plica rechts : P. Ro
Kleine fette sehr regelmässige Schrift

3677

Stautsarchiv Wien Chronol.
P. (20525) 1272 Martii 31
Gregorius X. — archeps Sal
zeburgen. et epis ac abb.,
prior. dec. archidiac. prepos.
et aliis eccl. prel. per Salse
burgen. prov. constitutis
Salvator noster in
Laterum. II Kl. Apr. a° I°
Bulle fehlt. Bruch erhalten
Rand oben links cor ascultis
tur; Mitte ascult, rechts
paut

3678

Barcelona Corona de Aragón
P.— Leg. 15⁰ n. 8⁰
~~Gregorius X~~ 1272 Aprilis 12
Gregorius X .. archidiacono
de Riparouria in ecclia Gler
den.
Sua nobis dilecti
Lateran. V ii aprilis a⁰ 1⁰
Bulle fehlt. Hanf erhalten
In plica links Rō
Sub plica links p̔. Romanus

3679

P.— Paris Arch. Nat.
J 348 cap. 7 1272 Maii 1
Greg X magistro Gerardo de Ram
pelione archidiacono Senonen.
capellano S. tit. S. Cecilie
presbiteri cardinalis
Exposuisti nobis quod
Laterani Kl Maii a⁰ 1⁰
Bulle an Seide
Sub plica links
Sub plica links Bug al p

Rand oben links dupt . 7.
Rf altde et facias duas

Hieraus geht hervor, das zwei unbe-
schriebene Pergament blätter an den
Alberten gegeben werden zusammen
mit der nota.

3680

P.— Paris Arch. Nat.
J 348 cap. 7 bis 1272 Maii 1
Greg X magistro Gerardo de Ram
pelione archidiacono Senonen.
capellano S. tit. S. Cecilie
presbiteri cardinalis
Exposuisti nobis quod
Laterani Kl Maii a⁰ 1⁰
Bulle an Seide
In plica rechts al pm

Albertus Parmensis
of. Duplicat

3681

P.— Paris Arch. Nat.
J 348 cap. 7 ter 1272 Maii 1
Greg X .. abbati et .. priori
monasterii S. Dyonisii in
Francia Parisien. dioc.
Exposuit nobis dilectus
Laterani Kl Maii a⁰ 1⁰
Sub plica links . . .
Sub plica links Bug
 al p

Rand oben links dupt. 7
und Rf Alberte facias fieri duas
 Duplicat nicht erhalten.
 Dieselbe Verhältnis wie
 auf den vorhergehenden
 Duplicaten.

3682

Archives Nationales Paris
L 263 n. 1 1272 Maii 7

Br. 33.2 hoch 23.6 Plica 2.3
oberer Rand 6. links 2.2
rechts 2.2
Gregorius X (Gitterschrift
Initiale ausgespart) . . Priori
et fratribus Hospitalis Jerlimitan
in Francia
Solet annuere sedes
Dat Laterani non Maij a° 1°

Bulle und Seide ausgerissen
In plica rechts : R.c.

A tergo Ecke oben links : y .

Fette kleine regelm. Schrift, mit
gestr. Ligaturen, mit drei beton=
ten Satz aufängen

In 1. Zeile 1 betonter Buchstabe

Erste Linie für Gitterschrift und
Oberlängen

P. vacat

3683

Archives Nationales Paris
L 263 n. 2 bis 1272 Maii 20

Br. 33.3 hoch 22.6 Plica 3.3
oberer Rand 6.9 links 1.8
rechts 1.8
Gregorius X (Gitterschrift
Initiale ausgespart)
wie n. 2

Bulle an Seide
In plica rechts: P.g.
Sub plica links : . .

a tergo obenmitte . Petrus Fortialis
pro T

Schöne regelm. Schrift,
mit gestr. Ligaturen, mit vier betonten
Satz aufängen

In 1. Zeile ein betonter Buchstabe

Erste Linie für Gitterschrift und unteren
Oberlängen

P. vacat

3684

Archives Nationales Paris
L 263 n. 2 1272 Maii 21

Br. 28.2 hoch 18.9 Plica 3.7
oberer Rand 4.8 links 1.1
rechts 1.3
Gregorius X (Gitterschrift
Initiale ausgespart) . Magro
et fratribus domus militie Templi
Jerlimitan
Cum a nobis
Dat Laterani XII kl Junij a° 1°

Bulle und Seide ausgerissen
In plica rechts : J.g
A tergo oben mitte :

Petrus Fortialis pro T

Schöne runde Schrift, mit gestreck.
Ligaturen, mit 4 betonten Satz
aufängen
In 1. Zeile 1 betonter Buchst.

Erste Linie für Gitterschrift und
untere Oberlängen

3685

Marseille Archives Départem.
H. o.J. 7
P. — 1272 Maii 21
Gregorius X . . magistro et fra=
tribus domus militie Templi
Jerosolimitan.

Cum a nobis
Laterani XII kl. Junii a° 1°
Bulle an Seide
In plica rechts .B. pusin9
pro p. Ro
Sub plica links ..

reiche wohlproportionierte
Schrift. Schöne Ligaturen

3686

Coblenz Staatsarchiv.
St. Mathias

P. —　　1272 Maii 30

Gregorius X .. abbati et con-
ventui monasterii Sancti Eu-
charii ord. S. Benedicti Treve-
rensis dioceris

　Cum a nobis

Laterani II kl. Iunii a° 1°

Bulle und Seide fehlen.

In plica rechts Nepul

Sub plica links p̄ Romanus

Ecke oben rechts b̄s

3687

Archives Nationales Paris
L263 n. 4　　1272 Maii 31

Br. 27 hoch 19.7　klein 3.
oberer Rand 5.13　links 1.3
rechts 1.5

Gregorius X (Gitterschrift zum
Teil ausgespart) .. Magro et fratribus
domus Militie Templi Jerosolimitan

Att Lateran cum a nobis
Att Lateran II kl Junii a° 1°

Bulle und Seide ausgenommen
Sub plica links : .-

A tergo oben Mitte :　[Petrus Fortialis]

Regelm. feste Schrift
mit Zeilen. Ligaturen
mit 4 betonten Satzanfängen

In 1. Zeile 1 betonter Buchstabe

Erste Linie für Gitterschrift und Oberlä-
　　　　　　gen

P. 20558

3688

Public Record Office London
Papal Bulls bundle 16 n. 8
P. 20558　　1272 Maii 31

Gregorius X̄　.. magistro et fratribus
domus Militie Templi Jerosolimitan

　Cum a nobis

Lateran. II kl. Junii a° 1°

　Bulle an Seide

In plica rechts　P. G.

Sub plica links　..

　　　　p. g. g. s. III

Rand oben links
　triplicatum　J. viᶜ

3689

Marseille Archives Départem.
Gr S. J. A. 24
P. —　　1272 Iunii 24

Gregorius X̄ .. preposito ec
Clerie Insulan. Cavallicen.
dioc.

　Sua nobis dilecti

Laterani VIII kl. Iulii a° 1°

Bulle an Hanf

In plica rechts　St. s. mᵃ

Sub plica links　..

　　　p. Romanus

Rand oben Mitte : Rebulleta
vic.

Ecke oben rechts　b̄s

Sehr schöne regelmässige Schrift

3690

de Curia

Paris Archives Nationales
J 448 n. 97
Breite 29.1 Rand links 1.4 rechts 1.8
Höhe 21.8 Rand oben 4.8 plica 2.7
Erste Linie für Oberlängen / Je
eine Seitenlinie

P. vacat 1272 Julii 6

Gregorius X . . Carmo in xpo
filio . . Regi Francox Jllustri
 Ad recipiendum pro
Dat apud Vrbemueterem II Non
Julij / a° 10
 Bulle an Hanf
 In plica rechts : i . a .
 de Cur
A tergo oben Mitte :
 de Cur und : Patriarcha Jerlotan
Kräftige, sehr regelm. Schrift

3691

Archives Nationales Paris
L 263 n. 5 1272 Julii 6

Br. 27.2 hoch 20.6 Plica 3.
oberer Rand 5. 8 links 1.3
rechts 1.3
 Gregorius X (Gitterschrift,
Initiale ausgespart) . . Abbati ¿ tov
uentui Mouasterij Fossatou ordinis
sancti Benedicti Parisien diue
 Solet auunere sedes
Dat apud vrbemueterem II Nou
Julij a° 10

 Bulle fehlt, Seide erhalten
 In plica rechts : Jat: Romanus
Sub plica links : Jac Romanus

 Rand oben Mitte cor
Ecke oben rechts : co

A tergo Ecke oben links :]
 " Mitte oben :
 R de Aquila

Kleine gute Schrift, mit gestr. Liga-
turen, mit vier betonten Schau-
fängen. In 1. Zeile 1 betonter Buchstabe
Erste Linie für Gitterschrift und Ober-
 längen
P. vacat

3692

Archives Nationales Paris
L 263 n. 6 1272 Julii 10

Br. 22.8 hoch 17.3 Plica 2.3
oberer Rand 3.8 links 0.6
rechts 0.6
 Gregorius X . . Archidiacono
Ebroicen
 Sua nobis dilecti
Dat apud Vrbemueterem II Jd
Julij a° 10

Bulle fehlt, Hanf erhalten
 In plica rechts : Johes m
a tergo oben mitte :
 Guitts capitis ferri

Regelmässige offene Schrift
mit einem betonten Buchstaben
Erste Linie für Oberlängen

 P. vacat

3693

Archives Nationales Paris
L 263 n. 7 1272 Julii 14

Br. 30. hoch 18.6 Plica 2.4
oberer Rand 3.9 links 1.4
rechts 1.3
 Gregorius X . . Priori uechi
Mouastei de Campis Parisien
 Ad audientiam nostram
Dat apud Vrbemueterem II Jd
Julij a° 10

Bulle an Hanf
 In plica rechts : S. B
Sub plica links : - -
A tergo oben mitte : Petrus Fortiat
 pro C
breite unruhige Schrift
Ohne jeden betonten Buchstaben
Ohne erste freie Linie

 P. vacat

3694

Archives Nationales Paris
L 263 n. 8 1272 Julii 21

Bor. 28.7 hoch 19.5 Plica 2.8
oberer Rand 5.6 links 2.
rechts 1.7
　　Gregorius X .. Priori de Calce
7 .. decim ecclie sancti Clodoaldi
Suessionen 2 Duicen dioc
　　Sua nobis dilecti
Dat apud Vrbemueterem XII Kl
　　Augusti a° 1°

Bulle an Hanf
　　In plica rechts: G. aly
Ohne allen sonstigen Bemerkungen
Sehr fette regelm. Schrift

　　Mit einem betonten Buchstaben
Erste freie Linie zwecklos

　　P. vacat

3695

Archives Nationales Paris
L 263 n. 9 1272 Julii 26

Bor. 28.2 hoch 18.9 Plica 2.7
obere Rand 5.2 links 1.7
rechts 1.7
　　Gregorius X (C. Gitterschrift, Ini=
tiale ausgespart) .. Priori et Conuen=
tui Monasterii sancti Martini de
Campis Parisien Cluniacen ordinis
　　Solet annuere sedes
Dat apud Vrbemueterem VII Kl
　　Aug a° 1°

Bulle an feiner Seide
　　In plica rechts: J. J.
Sub plica links : ..
　　Ecke oben rechts: 80

A tergo oben Mitte: Bonaspes de Ass.

Schöne sehr regelm. Schrift, mit gestr.
Ligaturen, mit vier betonten Schr.
anfängen
　　In 1. Zeile 1 betonter Buchstabe
Erste Linie für Gitterschrift und
　　untere Oberlängen

　　P. vacat

3696

Archives Nationales Paris
L 263 n. 10 1272 Julii 27

Bor. 48.6 hoch 37.2 Plica 3.6
obere Rand 8.5 links 2.7
rechts 2.7
　　Gregorius X Carissimo in
xpo filio .. Ph .. Illustri Regi Fran
corum
　　In libro superne
Dat apud Vrbemueterem VII Kl
Aug al 1°

Bulle und Hanf fehlen
　　In plica rechts: Gui. Bob
A tergo oben Mitte:
　　Johes de Furton
　　　　　✝
Prachtvolle fette Schrift mittelgroß
Mit einem betonten Buchstaben
Je zwei Seitenlinien und zwei freie
Linien über dem Text. Die zweite
für Oberlängen

　　P. vacat

3697 (recto)

Papstnamen _Auslassungen_

Archives Nationales Paris
L 263 n. 11 1272 Julii 29

Bor. 36.7 hoch 26.7 Plica 3.2
oberer Rand 6.8 links 2.1
rechts 1.9
　　Gregorius X .. Priori et
Conuentui Domus vallis viridis
prope Ciuitatem Parisien Carte=
sien ordinis
　　olim felicis recordationis
Dat apud vrbem ueterem III Kl
Aug a° 1°

Bulle fehlt. Seide erhalten
　　In plica rechts: Jac. Romanus
Sub plica links : '
　　Jac Romanus
　　　　8　　P. vacat
A tergo oben Mitte:
　　Heremita not. pro Cartusia
Kleine fette Schrift, mit gestr. Li=
gaturen, mit vier betonten Schr.
anfängen
In 1. Zeile 1 betonter Buchstabe
Erste Linie für Oberlängen
　　Papstname im Text nicht in Gitterschr.
"Verum quia in eisdem lit... 1
scribentis errorem dictiones aliquae
　　　　　　　　verte

3697 (verso)

fuerunt omine, videlicet salutem
et apostolicam benedictionem, vos
dubitantes ne occasione talis erroris
etc.

3698

Archives Nationales Paris
L 263 n. 12 1272 Julii 31
Br. 30.4 hoch 21.8 Plica 2.6
oberer Rand 6.2 links 1.8
rechts 1.7
 Gregorius X (. Gitterschrift,
Initiale ausgespart) . priori
Cartusie ac ceteris Prioribus .
Cartusiensis ordinis
 devotionis vestre precibus
Dat apud Urbemveterem T Kl
Aug a° 10

Bulle fehlt, Seide erhalten
 In plica rechts: Jac Romanus

A tergo oben mitte:
 Heremita not. pro Cartusia

Kleine rute schöne Schrift mit gestr.
Ligaturen, mit drei betonten Wort-
anfängen
 In 1. Zeile 1 betonter Buchstabe

Erste Linie für Gitterschrift und Ober-
 längen

 P. vacat

3699

Archives Nationales Paris
L 263 n. 13 1272 Julii 31
Br. 24.4 hoch 14.2 Plica 3.2
oberer Rand 2.9 links 0.6
rechts 0.8
 Gregorius X . . Abbati Maio-
ris Monasterij Turonen 7. . Prio-
ri Prioratus Ste Marie de Campis
Parisien ad Monasterium ipsum
immediate spectantis eorumque
Conventibus ordinis Sci Benedicti
 Cum sicut ex
Dat apud Urbemveterem T Kl
Aug a° 10

Bulle fehlt, Hanf erhalten
 In plica rechts: N. bobois
Sub plica links: S
 Ecke oben links: Jo S.
A tergo oben mitte:
 Heremita notarius
 pro Cartusia P. vacat

Sehr unordentliche Ausstattung
der Kl. Urkunde

3700

Archives Nationales Paris
L 263 n. 14 1272 Augusti 1
Br. 30 hoch 21.2 Plica 2.7
oberer Rand 6.6 links 1.7
rechts 1.8
 Gregorius X (. Gitterschrift, Ini-
tiale ausgespart) . . Prioribus et
fratribus Cartusiensis ordinis
 meritis vestre religionis
Dat apud Urbemveterem Kl. Aug.
 a° 10
Bulle und Seide fehlen
 In plica rechts: Jac Romanus
Sub plica links: . .
 Darunter auf der plica: Apa G. B.
Ecke oben links: Dupt

A tergo oben mitte:
 Heremita not pro Cartusia

Kleine fette regelm. Schrift mit
gestr. Ligaturen, mit 4 betonten
Wortanfängen
 In 1. Zeile 1 betonter Buchstabe
Erste Linie für Gitterschrift und Ober-
 längen

duplicetur P. vacat

3701

Archives Nationales Paris

L263 n. 14 bis __1272 Augusti 1__

Br. 30,1 hoch 21.5 Plica 2.7
oberer Rand 6.5 links 1.6
rechts 1.7

Gregorius X . . Prioribus
etc. wie in
__n. 14__

Bulle fehlt, Seide erhalten
In plica rechts: Jac Romanus
Sub plica links : . .

A tergo wie n. 14
Sbeiss Schiff usw.

P. vacat

3702

triplicetur vicecanc.

Archives Nationales Paris

L263 n. 14 ter __1272 Augusti 1__

Br. 29.6 hoch 20.5 Plica 3.5
oberer Rand 5.9 links 1.9
rechts 1.6

Gregorius X Prioribus (ohne
Punkte)
wie in n. 14

Bulle fehlt, Seide erhalten
In plica rechts: Jac Alex
Sub plica links : . --
Jac Romanus
Darunter auf der plica :
Jac Ro. G. S. m
Ecke oben links :
Triplicety Vce
A tergo sehr oben links : B
" oben mitte : de neapoli

Fette regelm. Schrift, mit gestr.
Ligaturen, mit 3 bet. Schauzügen
In 1. Zeile 1 betonter Buchstabe
Erste Linie für Gitterschrift und
unteren Oberlängen

P. vacat

3703

Napoli Curia Eccles. Vol. 3°
P. - __1272 Augusti 13__

Gregorius X visellis monasterii
Sce Marie de qualto ad Roman
Ecliam nullo medio pertinentis
OSB Beneventan. dioc.
Monasterio Sancte Marie
Apud Vrbemveterem iĩ. Aug.
a° 1°

Bulle und Hanf fehlen
In plica rechts . S.
Sub plica links : demetrius

Ecke oben links R
Rand oben mitte dnus symō man
dan ex parte dni nri litt. fieri

3704

Napoli Curia Eccles. Vol. 4°
P. - __1272 Augusti 18__

Gregorius X .. priori et convẽ
tui mon. Sce Marie de quẽl
do ad Roman. Eccl. n. m. per
O.S.B. Beneventan. dioc.
Cum a nobis
Apud Vrbemveterem XV kl.
Sept. a° 1°
Bulle und Seide fehlen
In plica rechts R. C.

3705

Nrpoli Curia Eccles. Vol. 4°
P. —
 1272 Augusti 18
Gregorius X .. epo Salpitan
 Sub religionis habitu
Apud Vrbemveterem xv kl.
 Sept. a° 1°
Bulle und Hanf fehlen
In plica rechts ven. Clu
Sub plica links ?
 Demetrius

3706

Montpellier, ville de Montp.
E. F Louvet 2249

P. 20594 1272 Augusti 25
Gregorius X .. Priulo consulibus +
universitati Montispesulan.
Adaperiat Dominus suorum
Apud Vrbemveterem VIII kl. Sept.
 a° 1°
Bulle (sehr leicht) an Hanf
 In plica rechts Jac. Mut.
 de Curia

A tergo oben Mitte de Camera

De mercatura cum
 Saracenis

Erste Zeile beschrieben
zierliche kleine Schrift

 Cf. 1272 Dec. 31

3707

Firenze, Badia Fiorentina
.P. — 1272 Septembris 13
Gregorius X .. abbi mon. Ste
Marie de Gregnano ordinis Valli
Vmbrose Pistorien. dioc.
Significarunt nobis .. abbas
Apud Vrbemveterem iV. Sept.
anno 1°
Bulle fehlt, Hanf erhalten
In plica rechts B. pusin
Rand oben Mitte oo
 Oberste Linie unbenutzt
Sub plica unliniirt
plica deckt letzte Zeile
 Seitenränder wingig klein

3708

Bayer. Haupt. Staatsarchiv
Regensburg St. Emmeram fasc. 12
P. 20605 1272 Septembris 22
Gregorius X .. abbti monasterij de
Inferiori altha Patavien. dioc.
 Conquesti sunt nobis
Apud Vrbemveterem X kl. Octobris
anno primo

Bulle an starkem Hanf
In plica rechts : N Sebe .. ?

Erste Zeile beschrieben. Seitenlinie
nur links
Grau Kleines Mäuerch +o 15.1 x 10
 plica 1.1

Kleine würdige, leicht nach links
geneigte Schrift.

3709

Bayer. Hrupt. Staatsarchiv
St. Emmeram fasc. 12

P. 20608 1272 Septembris 27

Gregorius X (c. Gitterschrift) .. Abbati
et Conventui Monsterij sancti
Emmeranni Ratisponen. ordinis
sancti Benedicti
 Cum a nobis
Dat. apud Urbemveterem V kl.
Octobris Anno Primo

Bulle an feiner Seide
In plica rechts : Aba sub ?
 Sub plica links : --
Rand oben halblinks : Dupl. G. vic.

Duplicat

3710

Bayer. Hrupt. Staatsarchiv
St. Emmeram fasc. 12

 1272 Septembris 27

Gregorius X (c. Gitterschrift) .. Abbati
et Conventuij Monsterij sancti
Emmeranni Ratisponen. ordinis
sancti Benedicti
 Cum a nobis
Apud Urbemveterem V kl. Octobris
 Anno Primo

Bulle an feiner Seide
 An plica rechts. Jacoby de menania
Sub plica links : --

Schöne, zusammenhängende Schrift

Duplicat

3711

Public Record Office London
Papal Bulls bundle 16 n. 9
P. 20615 1272 Octobris 1
Gregorius X .. Westmonasterii et --
de Waltham abbatibus London. dioc.
 Ut clerici carissimi
Apud Urbemveterem kl. Oct. a° 1°
 Bulle an Hanf ?
In plica rechts de Osim ?
sub plica links ----
 Demetrius
 Weiter unten Jac. Ovist. J.

 Rand oben links dupl. J. vic.

3712

Bayer. Hrupt. Staatsarchiv
Regensburg St. Emmeram fasc. 12

P. 20617 1272 Octobris 7

Gregorius X .. Abbati Monsterij sci
Petri Salzeburgen.
 Conquesti sunt nobis
Apud Urbemveterem non. Octobris
anno Primo

Bulle an mitteldickem Hanf
In plica rechts : Ven . Clu

Erste Zeile frei. Seitenlinien
Kleine feste regelmässige Schrift

Ganz kleines Mandat 13 x 8.2
 plica 1.4

3713

Neapel Annis Eccles. Vol. 3°
P. – 1272 Octobris 7
Gregorius X – – priori et conventui
monast. Sce Marie de Gualdo ad
Rom. Eccl. nullo med. pertinen.
tis OSB Beneventan. dioc.
 Cum a nobis
Apud Urbemveterem non. Oct.
a° 1°
Bulle und Seide fehlen
In plica rechts Jac Romanus
Sub plica links demetrius
Ecke oben rechts 60

 Zehn Jahre früher waren
 Bulle und Seide
 noch vorhanden, wie
 ich mir angemerkt hatte

3714

Archivio di Stato Milano
Bolle e Brevi vicecancell.
Copie 1272 Octobris 7
Gregorius X priori eccles. S. M.
de Frigionaria ciusque frib.
etc. in perpm
Religiosam vitam eligentibus
R. Ego etc.
2 presb. 2 epi 6 diac.
Apud Urbemveterem p. m. ma-
gistri Jannoni dec. ecov. sce
vice concellarii non octobri
a° 1°
 P. 20619

3715

Instr. Misc. 1250 – 1275 cap. 61
 P. 20621 1272 Oct. 8
Greg. X Guidoni de Gena canoni-
co Mutinen. familiari nostro
Volentes omnia que
Apud Urbem veterem VIII id. octo-
bris a° 1°
Bulle und Hanf fehlen
In plica rechts : B pusin.
 de Curia
A tergo Ecke oben links : p

3716

Archives Nationales Paris
L 263 n. 15 1272 Octobris 18
Br. 27. hoch 18.5 Plica 2.8
oben Rand 4.6 links 1.1
rechts 1.2
Gregorius X (Gitterschrift, Zwi-
sche ausgespart) Dilectis in Xpo
filiabus – – Abbatisse et Conventui
Monasterij de Fanarchijs Cister-
tien ordinis Noviornen dioc.
 Cum a nobis
Dat apud Urbemveterem XV kl
Novembre a° 1°
Bulle fehlt, Seide erhalten
 In plica rechts : Jac Alexij
Sub plica links : ..
 J 2
A tergo oben huke unleserlich
kleine fette unordentliche Schrift
mit gestr. Ligaturen, mit vie-
len betonten Satzaufängen
In 1. Zeile 1 betonte Buchstabe
erste Linie für Gitterschrift und
 untere Oberlängen
 P. vacat

3717

Bayer. Haupt. Staatsarchiv
Regensburg St. Emmeram Fasc. 12
P. 20635 1272 Octobris 28
Gregorius X (Gitterschrift) .. Abbati
et Conventui Monasterij sancti
Emmerammi Ratisponen ordinis
sancti Benedicti
 Cum a nobis
Apud Urbemveterem V Kl Novem-
bris anno Primo

Bulle an Seide
In plica rechts: Johes p͞m
Sub plica links : ..
 U͞e
Unruhige kleine Schrift. Steife Ober-
längen. Unterlängen J. Am Wort-
ende m = m
In der 1. Zeile D͞h͞l) stark betont

3718

Marseille Archives Départem.
H. S. S. 7 (Saint Sauveur)
P.— 1272 Novembris 3
Gregorius X Berengario Capelle-
rio et Pontio []ini canonicis
Avinionen.
 Sua nobis dilecte
Apud Urbemveterem III non.
nov. a°10
Bulle fehlt, Hanf erhalten
In plica rechts m . de Rocca
Sub plica links ..
Ecke oben rechts de
Zwei oberste Zeilen frei
Kräftige Schrift.

3719

Napoli Monast. Soppr. Vol. 2°
P.— 1272 Novembris 29
Gregorius X .: archepo Capuan
 Lecta nobis dilectorum
Apud Urbemveterem III Kl.
 Dec. a°1°
Bulle und Hanf fehlen
In plica rechts Repät R
Sub plica links X Sy Vei g. S.
Rand oben Mitte dupl G. V.
Ecke oben rechts S͞o͞o

 In plica links in liederlicher
 Schrift: P/ apud arcem ceccan. XXI
 mens. april. prime ind. Nil.

X V; darunter in plica aversa

3720

Public Record Office London
Papal Bulls bundle 16 n. 5
 Clausa
P. 20643 1272 Novembris 22
Gregorius X Eduardo -- regis
Anglie primogenito
 Felici ad nos
Apud Urbemveterem X. kel. De-
cembris a° 1°
 Bulle an Hanf
 Ränder mässig gross.

3721 (recto)

Archives Nationales Paris.

L 263 n. 16 1272 December 1
P. vacat
Br. 61.3 hoch 77. Plica 2.
oberer Rand 10.1 links 3.5
rechts 3.4

Gregorius X (zweite vorletzte
Minuskulae Z; das Andere in Gotter-
schrift) dej (ohne die Dei Zeichen) Dilectis
filijs Magistro Religiose Militie Templi
quod Jerliuis situm est eiusque fratri-
bus ... professis IN RPM
 Omne datum optimum
consequentur AMEN a e AMEN
R [go Gregorius catholice ecclie Epo. M
 [E in ego hat keinen Doppelstrich
+ [+ presb. 2 epi 5 diac
 [4 Zeile frei 2 Zeile frei
Dat apud Vrbemueterem per manum
magri Janonis Leccacorii sande Ro
mane ecclie Vicecancallarij Kl December
Judicitione 2 Incarnationis dnice
Anno m. cc. lxxy. Pontificatus vero
domni GREGORIJ pp X Anno primo

Bulle und Seide fehlen
Sub plica links: Rx J C. F. Atius
 verte

3721 (verso)

Rand oben halblinks:
 Privilegium Templi Jerlinitan sump
tum de prouinciali Cancellarie. paur
 Paul
Darunter: Dupl + vic
 Rechts darüber:
 ↓
dann ascultet Demetrius dann paur
dann: In aud pro dat quia non est ab.
Ecke oben rechts: bo, darunter: a
 paul

a tergo oben linke:
 fr. Jacobus procur. Templi

Prachtvolle feste Schrift mit betonten
Capitelsanfängen

Vergl. in der Apost. Kanzlei, pag. 80

duplicetur

3722 (recto)

P- Paris Arch. Nat.
L 263 cap. 16 1272 Dec. 1
Greg. X. Magistro religiose mi
litie Templi quod Jerosolimis
situm est eiusque fratribus
Omne datum optimum
Dat. apud Vrbemueterem per
manum magistri Janoni Lec
cacorvi SRE vicecancellarii
Kl. Dec. aᵒ 1ᵒ
Bulle und Seide fehlen
Sub plica (Bug) links:
Rx J. C. f. Atin
Auf dem oberen Rande:
priuilegium Templi Jerosoli
mitani sumptum de provin
ciali cancellarie paur.
darunter alia manu
Dupl. J. vic Janonus

3722 (verso)

weiter rechts: Demetrius,
dann: paur
dann: ascultetur
dann: in aud post dat
quia no e absoluen
Ecke rechts: bo
 a
 paur

3723

Madrid Arch. Histor. Nacional
P. — Poblet E n. 78
__1272 Decembris 4__
Gregorius X – – abbi et conv. mon.
Populeti Cisto Terraconen. dioc
Cum a nobis
Apud Vrbemveterem II non. Dec.
a° 1°
Bulle fehlt. Seide erhalten
In plica rechts Jac alexii
Sub plica links – –
Jac

3724 (recto)

Napoli Curia Eccles. Vol. 3
viceruncellarius
P. — __1272 Decembris 5__
Gregorius X – – priori monas.
terii Sancte Marie de Galdo
eiusque fribus etc. in ppm
Religiosam vitam eligentibus
veniant Amen a. a.
(R) Ego Gregorius c. e. epo (m)
presb. 2 epi 7 diac.
Apud Vrbemveterem p. m. mgri
Jauani Leccacorui SRE vice
cancellarii non. Dec. ind. II J.
dce a° in. cc L XXII pa a° 1°
Bulle und Seide fehlen
plica abgeschnitten
Rand oben Mitte Commune pri
vilegium OSB. und de pu pro gra
tia und In aut pt bat und Ponetur
data

3724 (verso)

ascultetur
Ecke oben rechts bo
α
paul.

3725

Marseille Archives départem.
H. S. C. a. 3
P. — __1272 Decembris 9__
Gregorius X . . epo Carpento
raten.
Significarunt nobis dilecti
Apud Vrbemveterem V id.
Decembr. a° 1°
Bulle und Hanf fehlen
In plica rechts Aud. B.
Sub plica links ..
Jac
Rand oben Mitte Cor

3726

Archives Départem. Marseille
H. S. C. Q. 3
P. — 1272 Decembris 9
Gregorius X . . . epo Carpento-
ratem.
 Pervenit ad audientiam
Apud Vrbemveterem V iď.
Dec. a° 1°
Bulle und Hanf fehlen
In plica rechts And · S.
Ecke oben rechts ko
Sub plica links

3727

Montpellier, ville de Montp.
E V Louvois 22 57
P. — 1272 Decembris 9
Gregorius X consulibus, consili-
et communi Montispesulani.
De bone voluntatis
Lugdun. V iď. Dec. a° 2°
Bulle an Hanf

Ohne jegliche Notiz
Erste Zeile frei

3728

Archives Nationales Paris
L 263 n. 17 1272 Decembris 12
Br. 30. hoch 22.2 Plica 2.5
oberer Rand 5.2 links 1.5
rechts 1.4
 Gregorius X (Gitterschrift,
Initiale ausgespart) .. Abbati
7 Conventui Monasterij Clunia-
cen̄ ad Roman̄ ecclesiam nullome-
dio pertinentis Matisconen̄ dioc̄
 Indempnitati vestre Monasterij
Dat apud Vrbemveterem V iď
Decembr. a° 1°

Bulle an feiner Seide
 In plica rechts : F. aug
A tergo oben Mitte :
 Bonaspes de Ass)
Kleine eilige Schrift, mit gestr. Li-
gaturen, mit 3 betonten Satzanfängen.
In 1. Zeile 1 betonter Buchstabe
Erste Linie für Gitterschrift und un-
 tere Oberlängen
cf. P. X 20649 — 20651

3729

Archives Nationales Paris
L 263 n. 18 1272 Decembris 12
Br. 31.8 hoch 23.2 Plica 3.7
oberer Rand 5.7 links 2,
rechts 2.
 Gregorius X (Gitterschrift,
Initiale ausgespart) .. Abbati
Monasterij Cluniacen̄ ad Roman̄
ecclesiam nullo medio pertinentis
Matisconen̄ dioc̄
 Exigentibus tue devotionis
Dat apud Vrbemveterem V iď
Decembr. a° 1°

Bulle an sehr feiner Seide
 In plica rechts abgerieben
Sub plica links : - - -

Fette regelmäßige Schrift, mitgestr.
Ligaturen, mit 4 betonten Satz-
anfängen
 In 1. Zeile 1 betonter Buchstabe
Erste Linie für Gitterschrift und
 untere Oberlängen
Je zwei Seitenlinien
 cf. P. X 20649 — 20651

P. 20649ᵃ⁻⁵¹ˣ Graz Stadtarchiv
St. Alban Urk. n. 26 1272 Dec. 12
Greg. X .. abbati et conventui
monasterii Cluniacen. ad
Roman. ecclesiam nullo me-
dio pertinentis Matisconen.
dioc.
Indempnitati vestre mo-
nasterii
Apud urbemveterem II id
Dec. a° 1°
Bulle und Seide ausgerissen
In plica rechts D
Sub plica links J g· (Monogr.)
Ang durchstochen abgeklatscht

R꜀ Io Vic g J. Atin II
Rand oben: dupl̃i . J. Atin. Dann
bulleta auscultetur cum illa
...... rechts bo

Staatsarchiv Wien Chronol.
P. — 1272 Decembris 13
Gregorius X .. priorisse mon.
S. M. de Minnebach eiusque
sororibus etc. in ppm
Religiosam vitam eligentibus
Amen a Amen
(R.) Ego Gregorius catholice
 ecclie eps ss. (M)
4 pbri. 2 epi 3 diac
Apud urbemveterem p. m. ma-
gistri Iauonis Leonardi SRE
vicecanc. id. dec. ind. I Ino
Dnice a° M·CC·L XXII p. v. domni
GREGORII pp X a° primo
Bulle fehlt Seide erhalten
Rand oben SRE piis. ord S. Aug.
und auscultetur und Ecke bo
 prut

Archives Nationales Paris
L 263 n. ꝓ 920 1272 Decembris 19
Br. 30.5 hoch 23.2 Plica 4.1
oberer Rand 5.1 links 1.4
rechts 1.3
 Gregorius X (Gitterschrift Ini
sind verziert) dilectis in Xpo filia
bus .. Abbatisse et Conventui mo
nasterij libere Abbatie iuxta
Bellum locum Cisterciem ordinis
Noviomen dioc
 Cum a nobis
Dat apud Urbemveterem XIIII kl
Ianuar. a° 1°

Bulle an feiner Seide
 In plica rechts : . . a. S.
Sub plica links : . .

Rand oben rechts : ꝓ P. vacat
 ꝓ
 a tergo oben Mitte :
 Summi Regis
weite offene etwas eckige Schrift,
mit gestr. Ligaturen (mit zwei Aus
nahmen), mit 4 betonten Text
anfängen
 vale

In 1. Zeile 1 betonter Buchstabe
Erste Linie für Gitterschrift und
 Oberlängen

3733

Montpellier ville de Montp.
2. F. Londres 2794

P. — _1272 Decembris 31_

Gregorius X populo Montis Pesulani
de fidelitate ac
Apud Urbemveterem II kl. Jan. a° 1°
Bulle an Hanf

A tergo oben : _de Camera_

Credentialia für den Collector
eusrum etc. May. Adegerius
de Parma scriptor noster ca-
nonicus Parmen.

Doppelte Seitenlinien

cf. 1272 Augusti 25

3734

Bayer. Hauptstaatsarchiv
St. Emmeram fasc. 12

P. 20665 1273 Januarii 9

Gregorius X (Gitterschrift) : Abbati
et Conventui Monasterij sancti
Emmeranni Ratisponen. ordinis
sancti Benedicti
Devotionis vestre precibus
Apud Urbemveterem V Jd. Januarij
alij anno primo

Bulle an Seide
In plica links : f. N. scrin
Haupt oben halblinks : dupl. F.
Mitte : fox , Ecke rechts 80

Sub plica links : 5

Jm

Duplicat

3735

Bayer. Hauptstaatsarchiv
St. Emmeram fasc. 12

P. 20665 1273 Januarii 9

Gregorius X (Gitter ähnlich Gitter-
schrift) : Abbati et Conventui Mo-
nasterij sancti Emmeranni
Ratisponen. ordinis sancti Benedicti
Devotionis vestre precibus
Apud Urbemveterem V Jd. Januarij
anno primo

Bulle an grüner Seide
In plica links : Angls
Sub plica links : 5

Breite Ränder überall

Duplicat

3736

Public Record Office London
Papal Bulls bundle 16 n. 4

Clausa

R 20664 1273 Januarii 9

Gregorius X A. regine Anglie illustri
Sicut alie nostre

Apud Urbemveterem Vid. Jan. a° 1°

Bulle an Hanf

Oben ziemlich, unten rechts
breiter Rand, an den Seiten
drei Finger breit.

3737

Staatsarchiv Wien Chronol.

P.— 1273 Januarii 13

Gregorius .. magro et fribus
domus ord. militie Sci Iaco.
bi in Ispania

Solet annuere sedis

Apud Urbemveterem id. Ian.
a° 1°

Bulle an Seide

In plica . 9. T.

Sub plica links - -

R̸ C Wirt J. Atin.

R̸ F. Atin. M

Rand oben Mitte

juxit tres F. oïc.

3738

Archives Nationales Paris

L 263 n. 21 1273 Januarii 18

Br. 39,5 hoch 29,2 Plica 4,2
oberer Rand 6,7 links 2,1
rechts 2,1

Gregorius X (gitterschrift
Initiale ausgespart) -- abbati
conventui Monasterij Cluniacen
ad Romam eccliam nullo medio
pertinentis Matisconen dioc

licet in concessis

Dat apud Urbemveterem XV Kl.
Februarii a° 1°

Bulle an Seide

A tergo oben mitte:

Bonaspes de An

Ohne alle Bemerkungen
Fette regelm. Schrift, mit gestr. Liga-
turen, mit 3 betonten Schraubfingern
In 1. Zeile 1 betonter Oberstrich
Erste Linie für Gitterschrift und unter
Obenlängen
Papstnamen im Text nicht in Gitterschr.

Je zwei Seitenlinien P.×20673

3739

Bayer. Haupt- Staatsarchiv
Indersdorf fasc. 5

P. 20675 1273 Januarii 23

Gregorius X. . scolastico ecclie
Augusten.

Ad audientiam nostram
apud Urbemveterem X Kl. Febr.
arij anno Primo

Bulle an dickem Hanf
In plica rechts: M. P
Sub plica links: M. P

M. P

Rand oben nach rechts : cor
Ecke oben rechts : bo
A tergo Ecke oben links : y

Aussergewöhnlich kräftige Linien
mit sehr breiten Griffel gezogen

Schlechte zitterige Schrift, am Schluss
zusammengedrängt

3740

Marseille Archives Départem.
H. S. d. C. a. 3

1273 februarii 20

Gregorius X
Abbatis ... dil. in xpo filiabus
.. abbatisse et conventui mon
beate Marie de Rochetta ord
Vasch. Damiani Arelaten. d

Solet annuere sedes

Apud Urbemveterem X Kl.
Martii a° 1°

Bulle fehlt Seide erhalten

In plica rechts . i. a.

Sub plica links ..

JA
a

Ecke oben rechts bo

Gestreckte Ligaturen

Schöne kräftige Schrift

Marseille Archives Départem.
H. S. C. A. 3
P. — 1273 februarii 20
Gregorius X dil. in xpo filiabus
.. abbatisse et conventui mon.
beate Marie de Rochetta ord.
sancti Damiani Arelaten.
 Sacrosancta Rom. Ecclesia
Apud Urbemveterem X Kl.
Martii a° 1°
Bulle an Seide
In plica rechts Ven. Ola
Sub plica links ...
Unschlüssige Schrift
Künstliche Ligaturen.

Marseille Archives Départem.
H. S. C. A. 3
P. — 1273 februarii 20
Gregorius X dil. in xpo filiabus
.. abbatisse et conv. monast.
beate Marie de Rochetta ord. S.
Damiani Arelaten.
 Devotionis vestre precibus
Apud Urbemveterem X Kl.
Martii a° 1°
 Bulle und Seide fehlen
In plica rechts Anuie
Sub plica links ...
Rand oben Mitte

3743

Marseille Archives Départem.
H. S. C. A. 3
P. — 1273 februarii 20
Gregorius X .. epo Magalonen.
 Sub religionis habitu
Apud Urbemveterem X Kl.
Martii a° 1°
Bulle und Hanf ausgerissen
In plica rechts .. z. a.
Sub plica links S.

3744

Bayer. Haupt-Staatsarchiv
 Bamberg fasc. 196
? P. 20679ˣ 1273 Februarii 22
Gregorius X (Gitterschrift) .. Abb.
ti et Conventui Monasterij Ebra-
cen. Cistercien. ordinis Herbipo-
len. dioc.
 Solet annuere sedes
Apud Urbemveterem VIII Kl. Martij
 Anno Primo

Bulle an feiner Seide
 In plica rechts: Palmerius
Sub plica links: ..., darunter ein
Monogramm X Kreuz unter einer
radirt Recipe - Bemerkung

A tergo Ecke oben links: R

Kleine schöne Schrift mit stark
verschnörkelten schlingenweiten
Ober- und Unterlängen

3745

Public Record Office London
Papal Bulls bundle 16 n. 14
P 20 682 1273 Martii 1 Actum
Gregorius X ad certitudinem
presentium et memoriam futurorum
Quondam Henrici de
Actum apud Urbemveterem
in palatio nostro Kal. Martii aº 1º
 Bulle an Seide
 In plica rechts P
 de Cur

3746

Bayer. Haupt. Staatsarchiv
 Herrenchiemsee fasc. 6
P 20.683ª 1273 Martii 5
Gregorius X .. Abbati sci Petri
Salzeburgen. ordinis sci Benedict
 Conquesti sunt nobis
Apud Urbemveterem III non. Martij
 anno Primo

Bulle an starkem Hanf
 In plica rechts : . 5.

Gnus kleines Mandat: 16.5 × 11.3
 plica 2.0

Ungemein zierliche, feste blaue
Schrift. Ober- und Unterlängen
in gleicher grösse

3747

 duplicetur vicecanc.
Archives Nationales Paris
L 263₂.22 1273 Martii 21
Br. 52.2 hoch 36.9 plica 4.9
oberer Rand 10. links 2.5
rechts 2.3
 Gregorius X Carissimo in
xpo. filio Ph. Regi Francorum
Illustri Plenum adhibere te
dat apud Urbemveterem XV kl
Aprilis aº 1º

Bulle und Hanf fehlen
 In plica rechts : Jac mut
Sub plica links : . . .
 v
Darunter auf | |
 du plica : | + | P. vacat
Rf Jac mut. F. Atin |_|
 Rand oben mitte : Dupl. F. vic
A tergo oben mitte : G. de Castro nell

Prachtvolle feste Schrift
 mit einem betonten Buchstaben
Erste Linie für Oberlängen

Vergl. Von der Apost. Kanzlei, pag. 79

3748

P.— Paris Arch. Nat.
L 263 cap. 22 1273 Martii 21
Greg X Ph. regi Francorum
Plenum adhibere te
Apud Urbemveterem XV kl. Apr.
aº 1º
Bulle und Hanf fehlen
In plica rechts : Jac mut
Rand oben links : Dupl. F. vic
Sub plica links :
 v
Sub plica links (Bug) f. Rf Jac
mut. F. Atin

263 cap. 14 ter : triplicetur vic
L. 264 cap. 42 ter : fiant viginti vic
Sub plica (Bug) Herstellung der
 selben 5 scriptoren

3749 (recto)

Paris Archives Nationales

Datum

J 448 n. 95

Breite 32. Rand links 1.9 rechts 2.1

Höhe 22.8 Rand oben 5.1 plica 3.5

Erste Linie für Oberlängen / Je

eine Seitenlinie

P. vacat 1273 Martii 23

Gregorius X Carmo in ... filio

· Illustri Regi Francie

· Serenitatis Regie petitio

Dat apud Vrbemueterem X Kl

· Apelis / a° 1°

Bulle au Hauf

In plica rechts: paul

Sub plica links: ...

duplicetur F. Atin

verte

3749 (verso)

Rund oben halblinks:

dupt F. V.

Rechts radirte J. e. m.

Feste prachtvolle fette Schrift

3750

duplicetur

Paris Archives Nationales

Datum

J 448 n. 95 bis

Breite 29.1 Rand links 1.3 rechts 1.3

Höhe 20.5 Rand oben 3.9 Plica 4.4

Erste Linie über den Oberlängen

Je eine Seitenlinie

P. vacat 1273 Martii 23

Gregorius X ut in n. 95

Dat apud Vrbemueterem 1

X Kl Apelis a° 1°

Bulle au Hauf

In plica rechts: G. aly

Sub plica links: ---

A tergo oben Mitte:

Marcus de Cumis pro Rege Franc°

duppl

V. G.

fette kleine Schrift

3751 (recto)

Paris Archives Nationales Rꝑ

J 683 n 2

Breite 27.9 Rand links 1.7 rechts 1.9

Höhe 20. Rand oben 5.7 plica 3.6

Erste Linie für Gitterschr und

Oberlängen / Je eine Seitenlinie

P. vacat 1273 Martii 23

Gregorius X (Gitterschr) Carmo in

xpo filio · Phi· Illustri Regi Francie

Celsitudinis tue merita

Dat apud Vrbemueterem X Kt Apri

lis a° 1°

Bulle au feiner Seide

In plica rechts: · d.

Ecke oben links: Rꝑ verte

A tergo oben Mitte:

Marcus de Cumis pro Rege Francie

- 389 -

3751 (verso)

darunter mit sehr dickem
Strich
℞ cap⁰ cˣ L V ij

Prachtvolle feste Schrift

3752 (recto)

Paris Archives Nationales
J 685 n. 42
Breite 31.6 Rand links 2.1 rechts 2.1
Höhe 22. Rand oben 4.6 plica 4.2
Erste Linie für Gitterschr und
Oberlängen / Je eine Seitenlinie
P. vacat 1270 Martii 23
Gregorius X (Gitterschr) Carmo in
Xpo filio · Phy · Regi Francie Illustri
Quia proni sunt
Dat apud Vrbem veterem X Kl
Aprilis / aº 1º
 Bulle an Seide
In plica links : O. Laud
 F. g.
Sub plica links : ∴
Ecke oben links : ℞ vat

3752 (verso)

A tergo oben Mitte :
Marcus de Cunio pro Rege Francᵉ
Sehr schöne regelm. fette Schrift

3753 (recto)

Paris Archives Nationales
J 686 n. 77
Breite 33.6 Rand links 2. rechts 2.1
Höhe 24.7 Rand oben 6.4 plica 3.2
Erste Linie für Gitterschr und Ober-
längen / Je eine Seitenlinie
P. vacat 1270 Martii 23
Gregorius X (Gitterschr) Carmo
in xpo filio Phy Illustri Regi
Francie
 Cum in te
Dat apud Vrbem veterem / X Kl
Aprilis aº 1º
 Bulle an Seide
 In plica rechts : Paul
Sub plica links : ∴∴
 Ja vat

3753 (verso)

Rand oben links: ~~consta~~
consul ⌐ teg quod pk ti
no

A tergo oben Mitte:
Marcus de Cumis
 pro Rege Francie

Sehr schöne feste fette Schrift

3754 (recto)

ascultata innovata

duplicetur
Paris Archives Nationales
 J 689 n. 129⁴
Breite 33.8 Rand links 2.1 rechts 2.2
Höhe 25.6 Rand oben 5.4 plica 4.8
Erste Linie für Gitterschr. und klei-
nere Oberlängen / Je 1 Seitenlinie
P. vacat 1273 Martii 23
Gregorius X (Gitterschrift) Carmo
in xpo filio . Phy. Illustri Regi
Francie
 Solet annuere sedes
Dat apud Urbemueterem X kl
Aprilis / a° 1°
 Bulle an Seide
 In plica rechts : Paul.
 Sub plica links : .E.
 G verte

3754 (verso)

Sub plica links :
R. O. Laud F Any
 F Any

Rand oben links : dupl F. V.
Rand oben Mitte : Jnnovata
ad iecto quodam temperamento
 Daneben :
 ascult ⌐ videat tempera.
mentum

Sehr schöne fette kleine Schrift

3755 (recto)

Paris Archives Nationales
 J 690 n. 132²
Breite 31.6 Rand links 1.3 rechts 1.1
Höhe 22.8 Rand oben 3.6 plica 2.4
 Erste Linie über den Oberlängen
Je eine Seitenlinie
P. vacat 1273 Martii 23
Gregorius X .. Sancti Dyonisij
in Francia Parisien dioc . et ..
Sci Germani de Batis iuxta Pa-
risius Monasterior abbatibus
 Habet in nobis
Dat apud Urbemueterem X kl
Aprilis a° 1°
 Bulle an Hanf
 In plica rechts : b. a
Sub plica links : - - - - verte

a tergo oben Mitte:
 Mag Magr Laurentius
Kleine Zettel struppe Schrift

duplicetur inovata

Paris Archives Nationales
 J 690 n. 132⁴
Breite 38.4 Rand links 2.2 rechts 2.4
Höhe 23.5 Rand oben 6.5 plica 4.4
Erste Linie für Gitterschrift und
Oberlängen / Je eine Leitlinie
P. vacat 1273 Martii 23
Gregorius X (in Mitte vac. Gitter-
schrift) Carmo in xpo filio Phi. Jl-
lustri Regi Francie
 habet in nobis
Dat apud Vrbemueterem X Kl Apri-
lis / a⁰ 1⁰
 Bulle an feiner Seide
 In plica rechts: Raul
Sub plica links:⁵
 Gr² vete

Randoben links: dupt F. V.
daneben: Innovato
A tergo oben Mitte:
 Marcus de Cunio pro
 Rege Franc
feste breite Sehr schöne Schrift

duplicetur

Paris Archives Nationales
 J 690 n. 132⁵
Breite 35.8 Rand links 2. rechts 2.4
Höhe 27.3 Rand oben 5.2 plica 3.1
Erste Linie für Oberlängen /
Je eine Leitlinie
P. vacat 1273 Martii 23
Gregorius X .. Sco Dyonisij in
Francia Parisien dioc̄ et .. Sancti
Germani de Pratis iuxta Parisius
Monasterioꝝ abbatibus
 Habet in nobis
Dat apud Vrbemueterem X Kl
Aprilis / a⁰ 1⁰ vete
 Bulle an Hanf
 In plica rechts: paul
Sub plica links:⁵
 ꝉ F ali

Rand oben links: duplex. V.
A tergo oben Mitte:
Marcus de Cumis pro Rege
Franc
Teste kleine fette sehr schöne
Schrift

Paris Archives Nationales
J 690 n. 132 c
Breite 31.7 Randlinks 1.2 rechts 1.2
Höhe 22. Rand oben 3.8 plica 3.2
Erste Linie für Gitterschr und
kleines Oberlängen / Je 1 Seitenlinie
P. vacat 1273 Martii 23
Gregorius X (Gitterschrift) Carmo
in xpo filio Phil. Illustri Regi
Francie
habet in nobis
Dat apud Urbemveterem X Kl.
Aprilis a° 1°
Bulle an feiner Seide
In plica rechts: C. a.
Sub plica links: - - - s
fette kleine stumpfe Schrift

P. — Paris Arch. Nat.
J 695 cap. 175. f 1273 Martii 23.
Greg. X .. S. Dyonisii in Francia
parisien. dioc. et S. Germani
de Batis iuxta Parisius mona-
steriorum abbatibus
Cum sicut ex
Apud Urbemveterem X Kl.
Aprilis a° 1°
Bulle an Hanf
In plica rechts p? Cum
Sub plica links p.!
" " Bug ausgestrichen
J. atim
Rand oben links: Kr und
Rx Franc Dann Mitte
Rescribatur sub (hodierna dta)
et h n cassetur (hic non notatur) verte

A tergo Procurator reg
R sept cap. CXLVIIII

3760

Archives Nationales Paris

L 263 n. 23 1273 Martii 23

Br. 30.7 hoch 19.5 Plica 4.6
oberer Rand 6.3 links 2.4
rechts 2.2

Gregorius X Archiepis et Epis
ac Dil. filijs decanis Archidiaconis
officialibus ac vniuersis eccliax
Prelatis per Regnum Francie constitutis

Ex parte carissimi

Dat apud Vrbemueterem X Kl aprilis
a° 1°

Bulle an Hanf links
In plica ~~rechts~~: R O. Laud
Sub plica links : ..

A tergo oben mitte :
Marcus de Cumis pro.
Rege Francie

Grosse sehr schöne feste Schrift

Mit einem verzierten Buchstaben

Erste Linie für Oberlängen

P. vacat

3761 (recto)

ascultetur innovata

Paris Archives Nationales

J 585 n. 51

Breite 28.7 Rand links 1.5 rechts 1.5
Höhe 21.2 Rand oben 4.5 plica 3.3
Erste Linie für Oberlängen / Je
eine Seitenlinie

P. vacat 1273 Martii 24

Gregorius X Carmo in xpo filio
Phi. Illustri Regi Francie

Et si desideremus

Dat apud Vrbemueterem. VIII Kl
Aprilis/ a° 1°

Bulle an Hanf

In plica rechts : Paul

Sub plica links : Ja

Rand oben mitte : Innovata
remoto de sententiis hominum
vnd .ascultetur

3761 (verso)

A tergo oben mitte :
Marcus de Cumis pro Rege
Franc
Alle Kleine sehr schöne Schrift

3762

Archives Nationales Paris

L 263 n. 24 1273 Martii 28.

Br. 24.5 hoch 17.9 Plica 2.6
oberer Rand 4.1 links 1.3
rechts 1.3

Gregorius X (Gitterschrift
Initiale ausgespart) -- Priori
et Conuentui Monasterij See Ma
tinj de Campis Parisien Cluniacen ordinis

Cum a notis

Dat apud Vrbemueterem V Kl
Aprilis a° 2° P. vacat

Bulle an feiner Seide
In plica rechts: nep...
Sub plica links : ..

Ecke oben rechts : Go Jus
A tergo Ecke oben links J
„ oben mitte : Jes
Enge kleine ~~feste~~ Schrift | n. Baldnini |
mit gestr. Ligaturen
mit 4 betonten Unterschlingen
In 1. Zeile 1 betonter Buchstabe p. 6
Erste freie Linie fehlt

Bayer. Haupt- Staatsarchiv
Heilig Geistspitze München

P. vacat 1273 Martii 29

Gregorius X - - Rectori et fribus
Hospitalis sci Spiritus de Mo-
naco Frisingen. dioc.
 Cum a nobis
Apud Vrbemueterem III kl. Apri-
lis anno Secundo

Gutgeprägte Bulle zu feiner Seide
In plica rechts: Rc (?) Ro
Sub plica links: S

Jene kleine und dünne Schrift
mit großen Ober- und Unterlän-
gen. Fällt sehr aus dem gewöhn-
lichen Schriftbild heraus

Bayer. Haupt- Staatsarchiv
München Chorstift Fasc. 1.

P. 20705 1273 Martii 29

Gregorius X (Gitterschrift) .. Epo Fri-
singen.
 Cum a nobis
Apud Vrbemueterem III kl. Aprilis
 anno Secundo

Bulle an sehr feiner Seide
In plica rechts:
Sub plica links: Jac Jac und
 mus unten: R m. de Rocc
 F. atin.

Rand oben links: dupt f. v.
Rand oben mitte: by R
Ecke oben rechts: by

Sehr schwungvolle schöne Schrift
Schmale Schriftzüge

Paris Archives Nationales
 J 684 n. 31
Breite 29.2 Rand links 1.6 rechts 1.8
Höhe 21.7 Rand oben 5.4 plica 3.2
 Erste Linie für Gitterschr. und Ober-
längen / je eine Seitenlinie
P. vacat 1273 Martii 30
Gregorius X (Gitterschr.) Carmo in
xpo filio Ph. Regi Francorum
Jllustri
 Progenitorum tuorum memoriam
Dat apud Vrbem ueterem / III kl
Aprilis a° 2°
 Bulle an feiner Seide
 In plica rechts : · δ
 Sub plica links : ...S
 verte

A tergo oben mitte:
Marcus de Camis pro Rege
 Francorum
Sehr schöne kleine regelm. Schrift

(Datum)

Paris Archives Nationales
 J 690 n. 132 C³
Breite 30.2 Rand links 1.4 rechts 1.3
Höhe 19.9 Rand oben 4.2 plica 3.8
Zwei freie Linien über den Oberlängen
Je eine Seitenlinie
P. vacat 1273 Martii 31
Gregorius X ... abbati Monasterij
Sancti Dyonisij in Francia Pari-
siensi dioc
 Cum sicut ex
Dat apud Vrbemueterem 7 Kl.
Aprilis / a° 2°
 Bulle an Hanf
In plica rechts: J. Aly
 Sub plica links: ---
A tergo oben Mitte: Marcus de Cumis
 pro Rege Franc

(Datum) dupliceter

Paris Archives Nationales
 J 690 n. 132 F
Breite 36.2 Rand links 2.1 rechts 1.9
Höhe 25.3 Rand oben 5.7 links 4.6
Erste Linie für Oberlängen
Je eine Seitenlinie
P. vacat 1273 Martii 31
Gregorius X ... abbati Monaste-
rij Sancti Dzonisij in Francia
Parisien dioc
 Cum sicut ex
Dat apud Vrbemueterem 7 Kl Apre-
lis / a° 2°
 Bulle an Hanf
In plica rechts: Paul Vite
Sub plica links: ...
 Fatin

Rand oben links: Dupt F...
A tergo oben Mitte:
Marc de Cumis pro Rege Fra

Kleine fette stumpfe Schrift

Public Record Office London
 Papal Bulls bundle 16 n. 25
 P. 20712 1273 Aprilis 1
Gregorius X Ad perp. rei memoriam
Nephandum scelus sceleste
 Actum in palatio nostro
Urbeveter. kal. Aprilis a° 2°
 Bulle an Seide

 Duplicat n. 26
 Triplicat n. 29

3769

Archives Nationales Paris
L 263 n. 26 1273 Aprilis 19

Br. 47.7 hoch 30.5 Plica 3.8
oberer Rand 6.8 links 2.9
rechts 2.6
Gregorius X . . Priori fratrum
ordinis Predicatorum Parisien
Precunctis nre mentis
Dat apud Vrbemveterem XIII Kl
Maij a° 2°

Bulle fehlt. Hanf erhalten
In plica links : O. Laud
Sub plica links :

Rand oben rechts : cor
A tergo oben Mitte :
Magr Laurek ḟ Rege Francie Illustri

Prachtvolle feste Schrift
mit einem betonten Buchstaben

Erste Linie für Oberlängen

P. vacat

3770

Paris Archives Nationales
J 448 n. 100
Breite 48.6 Rand links 3. rechts 2.9
Höhe 31.5 Rand oben 7.3 plica 4.7
Erste Linie über den Oberlängen
Je eine Seitenlinie

P. vacat 1273 Aprilis 19
Gregorius X . . Priori fratrum
ordinis Predicator Parisien
Precunctis (sic) nre mentis
Dat apud Vrbemveterem XIII
Kl Maij a° 2°
Bulle an Hanf
In plica rechts : h. Roman
Sub plica links
Jo. ḟm
Rand oben Mitte : Mittatur duo Johi
A tergo : Magr Laurentius pro Rege Francie
illustri

3771 (recto)

Paris Archives Nationales Rt
J 683 n. 3
Breite 33.9 Rand links 1.3 rechts 2.
Höhe 25.6 Rand oben 4.8 plica 2.9
Erste Linie für Gitterschr. und Ober-
längen / Je eine Seitenlinie
P. 20719 1273 Aprilis 19
Gregorius X (Gitterschr) Carmo in Xpo
filio . . Regi Francie Illustri
Inter ceteras sublimes
Dat apud Vrbemveterem XIII Kl
Maij / a° 20
Bulle an feiner Seide
In plica rechts : paul
Sub plica links :
Jo ḟm
Ecke oben der links : Rt
vacat

3771 (verso)

Schlank schön mittelgroß mit
dickem Strich
R cap° VII
darüber : Mare de Cura pro
Reg Franc
Fette weite schöne Schrift
mit 4 betonten Buchstaben

3772

de Curia

Archives Nationales Paris.
L 263 n. 27 1273 Aprilis 20

Br. 6 ? hoch 45.2 Plica 3.
oben Rand 7.1 links 2.8
rechts 2.3
 Gregorius X fratribus ordinis
Predicatorum Inquisitoribus here-
tice pravitatis in Regno Francie
deputatis auctoritate aplica et in
posterum deputandis
 Pre cunctis nre
dat apud Vrbemueterem XII Kl
Maij a° 2°

Bulle fehlt, Hanf erhalten.
 In plica rechts : . F. R
 – de. curia.

A tergo oben mitte : Predicator

Kleine regelm. Schrift

Mit einem betinten Bruchstücken
Erste freie Linie zwecklos

 Je zwei Seitenlinien

 P. 20720

3773 (recto)

videat eam Dnus R

Paris Archives Nationales
 J 686 n. 71
Breite 27.7 Rand links 1. rechts 1.7
Höhe 19.9 Rand oben 4.6 plica 2.2
 Erste Linie für Gitterschr und
Oberlängen / Je eine Seitenlinie
P. vacat 1273 Aprilis 20
Gregorius X (Gitterschr) Carmo
in xpo filio . . Regi Francor
Illustri
 Illa filialis denotio
dat apud Vrbemueterem XII
Kl Maij / a° 2°
 Bulle an feiner Seide
In plica rechts : Paul
Sub plica links : Jo pm
 rate

3773 (verso)

Ecke oben links : R
Rand oben mitte : videat eam
dns y
A tergo oben mitte :
Marcus de Curiis pro Rege Francie
darunter schwungvoll schön

 R cap . VIIJ

fette stumpfe regelm. Schrift

3774

P. – Paris Arch. nat.
J 697 cap. 34 1273 Aprilis 29

Schnitte gehen
nicht in die
Schrift

greg X . . regi Francie
illustri
His que dilecti
apud Vrbemueterem
III Kl. Maii a° 2°

3775

Archives Nationales Paris
L 263 n. 28 1273 Maii 1

Br. 22.8 hoch 17.7 Plica 2.9
 oberer Rand 4. links 1.3
rechts 1.3
 Gregorius X C Gitterschrift
Initiale ausgespart) . . Maiori
ministro et fratribus domus de Cer
uo frigido ordinis sce Trinitatis
et Captiuorum Meldeñ dioc
 Solet annuere sedes
Dat apud Vrbemueterem Kl Maij
 a° 2°
Bulle und Seide fehlen
 In plica rechts : bñ auc
Sub plica links : - -
 Ecke oben rechts : bo
A tergo oben Mitte : P. de Sooles

Schöne regelm. Schrift, mit gestr.
Ligaturen, mit vier betonten Satz.
 anfängen
In 1. Zeile 1 betonter Buchstabe
Erste Linie für Gitterschrift

 P. vacat

3776

Madrid Arch. Histór. Nacional
Navarra Leire 14 E
 P. - 1273 Maii 6
Gregorius X .. Toletan. et ..
Terraconen. archiepis
Sua nobis dilecti
Ap. Vrbemueterem II non Maii
a° 2°
Bulle und Hanf fehlen
In plica rechts . A. G
Sub plica links
 xxxv. Ro

Kleine, prachtvolle, runde Schrift
ziemlich geschlossen, mässige
Wortabstände, deutliche Ober-
und Unterlängen ohne viele
Schnörkel. Sehr wenige Abkür-
zungen

3777

Madrid Arch. Histór. Nacional
Navarra Leire 16 E
 P. - 1273 Maii 6
Gregorius X .. illustri regi Na
varre
Ille sincerus dilectionis
Apud Vrbemueterem II non.
Maii a° 2°
Bulle fehlt. Hanf erhalten.
In plica rechts . S.
Sub plica links xl
 Jy darunter
unten f. Atin Rt Paut Reat.
Rand oben links ///
 dupt vic
Rand oben Mitte gtr und
darus R card. mau. ut in at
darunter suppt Dat et hoc vi
deatur in ista quod et in prima

3778

Archives Nationales Paris
L 263 n. 29 1273 Maii 7

Br. 22.1 hoch 22. Plica 3.9
 oberer Rand 4.9 links 1.5
rechts 1.8
 Gregorius X (weite Gitterschr.
Initiale ausgespart) . . Minis
tro et fratribus domus ordinis
sce Trinitatis et Captiuorum
Parisien
 Cum a nobis
Dat apud Vrbemueterem non
 Maij a° 2°

Bulle an Seide
 In plica rechts : B. pusin
Sub plica links : - - Jo pm
Ecke oben rechts : bo
 A tergo oben Mitte : Ph de Sooles

Weite schöne Schrift, mit gestr. Liga-
turen mit 4 betonten Satzanfän-
gen. In 1. Zeile 1 betonter Buchstabe
Erste Linie für Gitterschrift und
 untere Oberlängen

 P. vacat

Stratsarchiv Wien Chronol.
P. — 1273 Maii 7
Gregorius X Frederico Sal-
ceburgen. archepo
Rationis oculis intuentes
Apud Urbemveterem non
Maii a° 2°
Bulle an Hanf
In plica rechts Jo parm
Sub plica links v
 Jo pm
à tergo oben Mitte
dick klein R cap **π

Archives Nationales Paris
L 263 n. 30 1273 Maii 15
Br. 27.7 hoch 20. Plica 3.4
obere Rand 4.8 links 1.9
rechts 1.7
 Gregorius X .. Abbati Mo-
nasterij sancti Dionisij in Fran-
cia ad Romanam Ecclesiam nullo
medio pertinentis ordinis sancti
Benedicti Parisien dioc
 Exhibita nobis tua
dat apud Urbemveterem Jd
Maij a° 2°

Bulle an Hanf
 In plica links : O. Laud
Sub plica links : S
 à tergo oben Mitte : g. Talhot

Mittelgrosse sehr schöne Schrift

Mit einem betonten Anfangsstab
Erste Linie für Oberlängen

 P. vacat

Stratsarchiv Wien Klosternrk
P. 21731 1273 Maii 15
Gregorius X dil. in xpo filiabus
.. magistre monast. de Dokzan
eiusque etc. in ppm
Poenitentibus virginibus que
Amen a Amen
R. Ego Gregorius catholice eccle
 epo SS m
2 presb. 1 epo 4 diac
Apud Urbemveterem p.m. magri
Jannoni Leccarovi SRE vi-
cecancellarii iv Maii ind.
prima Dat. dnice anno mi. cc.
LXXIII p. v. domni GR. ppe a° 2°
Bulle an Seide

Rand oben links coe priv. ow.
 sci Aug. paul.
Mitte : absolut und
Dat. aud. pt Dat. apposita
Ecke oben rechts fo
 paul

Madrid Arch. Histor. Nacional
Orden de la Merced n. 6
Abschrift vicecancellarius
 P. — 1273 Maii 21
Gregorius X mag. domus S.
Marie de Mercede Captivorum
eiusque fratribus etc. in ppm
Religionem vitam eligentibus
invenitit Amen
 Ego Gregorius C. S. S. S.
2 presb. 1 epo 3 diac
Dat. apud Urbemveterem p.m.
magri Johis Joannonis Lecca-
corvi SRE viceno XII kl. Iu-
nii ind. I a° 1273 p. a° 2°

Barcelona Catedral (tom. 1
Privilegiorum pontificium
Abschrift vicecancellarius
P. — 1273 Maii 21
Gregorius [. .] dil. filiis magnifice
domus S. Marie de Mercede Capti-
vorum eiusque fratribus tam prae-
sentibus etc. in ppm
Religiosam etc.
2 presb. 1 ep. 3 diac.
Ap. Vrbeveteri p. m. magri Anno-
ni Leccavovi SRE. viccancell.
XII Kl. Iunii ind. 1ª I.d. aº 1273
pont. aº 2º

Staatsarchiv Wien Klosterneub.
P. 20737 1273 Maii 23
Gregorius X . . magistro monast.
Cholesworicen. eiusque sorori-
bus etc. in ppm
Religiosam vitam eligentibus
Amen a Amen
R. Ego gregorius catholice ecclie
eps ss M
2 presb. 1 eps 4 diac.
Apud Vrbemveterem p. m. magri
Ianoni Leccavovi SRE vice
cancellarii X Kl. Iunii ind. dei
prima Anno D. aº M. CC. LXXII
p. v. dmni GREG. pp. X aº secundo

Bulle an Seide
In plica Mitte . S .

Rand oben links cõe p̃ ord. Pre-
monstrat. dnm : p . . . d. R[. .]ndis
O. Land. dnm : In and pot
dat
Ecke oben rechts p̄nuẽ

Paris Archives Nationales
 J 448 n. 99
Breite 33,8 Rand links 2.5 rechts 2.3
Höhe 23. Rand oben 5.9 plica 3.7
 Erste Linie über den Oberlängen
Je eine Seitenlinie
P. vacat 1273 Novembris 20
Gregorius X . . Abbati Monaste-
rij Sancti dionisij in Francia ad
Romam ecclam nullo medio per-
tinentis
 Intelleximus quod nonnulli
Dat Lugdun XII Kl. Decembr I
aº 2º
 Bulle an Hanf
Ecke oben links : ohne
R. Zeichen a tergo

de Curia
Paris Archives Nationales
 J 448 n. 98
Breite 40. Rand links 1.3 rechts 1.2
Höhe 24,2 Rand oben 5.2 plica 4.3
 Erste Linie hoch über Oberlängen
Je eine Seitenlinie
P. vacat 1273 Novembris 20
Gregorius X . . abbati monasterij
Sancti dionisij in Francia ad Ro-
mam Ecclam nullo medio perti-
nentis
 Per alias nostras
Dat Lugdun XII Kl. Decembr I
aº 2º
 Bulle an Hanf F. R
In plica rechts I de curia
Kleine fette Schrift

3787

Paris Archives Nationales
J 448 n. 98 bis
Breite 42.3 Rand links 3.1 rechts 2.8
Höhe 30. Rand oben 7.1 plica 4.3
Erste Linie für Oberlängen / Je
eine Seitenlinie
P. vacat 1273 Novembris 20
Gregorius X ut in n. 98
Dat Lugdun XII Kl Decembr
/ a° 2°
Bulle an Hanf

3788

Paris Archives Nationales
J 448 n. 99 bis
Breite 35.6 Rand links 2.1 rechts 2.
Höhe 23.5 Rand oben 6.1 plica 4.4
Erste Linie über den Oberlängen
Je eine Seitenlinie
P. vacat 1273 Novembris 20
Gregorius X .. Abbati Monasterij
Sancti Dionisij in Francia ad Ro-
man ecclam nullo medio pertinentis
Intelleximus quod nonnulli
Dat Lugdun / XII Kl Decembr a° 2°
Bulle an Hanf
In plica rechts: Palmerius
Fette etwas flüchtige Schrift

3789

Paris Archives Nationales
J 448 n. 98 ter
Breite 40.5 Rand links 1.9 rechts 2.
Höhe 31.6 Rand oben 6.9 plica 5.8
Erste Linie für Oberlängen / Je
eine Seitenlinie Anschrift wie in
Cum sicut de n.98 quater
Dat Lugdun VIII Kl Decembr/
a° 2° P. vacat 1273 Novembris 23
Gregorius X
Bulle an Hanf
In plica rechts: Reput R
de Cur

Ecke oben links: R
a tergo Rein
R - Zeichen
unruhige häßliche Schrift
P. vacat de Curia

3790

Paris Archives Nationales
J 448 n. 98 quater
Breite 40.4 Rand links 2.5 rechts 2.3
Höhe 33.4 Rand oben 8. plica 4.2
Erste Linie für Oberlängen/
Je eine Seitenlinie
P. vacat 1273 Novembris 23
Gregorius X .. Abbati sancti Dio
nisij in Francia ad Romam Eclam
nullo medio pertinentis
Cum sicut de
Dat Lugdun VIII Kl Decembr /a°2°
Bulle an Hanf
In plica rechts: fra Romanus
Ecke oben links: R
ohne R Zeichen; a tergo
Kleine fette sehr regelm - Schrift

3791

Montpellier ville de Montp.
E.V. Louvet 2250
Clausae

P. — 1273 Decembris 1

Gregorius X civibus et populo Mon.
dispersulem.
 Non est preter
Lugdun. Kl. dec. a° 2°
Bulle am Hanf

3792

Brit. Mus. Harl. Chart. 43. A. 43
 P. — 1274 Februarii 23

Gregorius X .. priori et conven
tui monasterii de OS.
Aug. Conventren. dioc.
 Cum a nobis
Dat. Lugduni . VII Kl. Martii
a° 2°
Bulle und Seide fehlen
In plica rechts Jac Menami

3793

Archives Nationales Paris
L 263 n. 31 1274 Martii 1

Br. 28.1 hoch 20. Plica 2.4
obere Rand 4. links 1.2
rechts 1.2
 Gregorius X fratribus Predicato
rum H & Minorum ordinum inqui
sitoribus heretice pravitatis aucto-
ritate sedis aplice deputatis c in
posterum deputandis
 Turbato corde audivimus
Dat Lugdun. Kl. martij a° 2°

Bulle fehlt, Hanf erhalten
 In plica rechts: Nicor (?)
 de Curia
Ohne sonstige Bemerkungen
Kleine fette regelm. Schrift

Ohne jeden betonten Buchstaben

Erste Linie für Oberlängen
 de Curia

 P. 20798

3794

Archives Nationales Paris
L 263 n. 31 bis 1274 Martii 1

Br. 36.6 hoch 26. Plica 4.7
obere Rand 5.7 links 1.7
rechts 1.7
 Gregorius X
 wie in 31

Bulle fehlt, Hanf erhalten
 In plica rechts: F. (?)
Sub plica links: S atim
A tergo oben Mitte: predicator

Sehr schöne weite Schrift
 mit 1 betonten Buchstaben

Erste Linie für Oberlängen

 P. 20718

Firenze

Abschrift

P. 20800 1274 Martii 7

Gregorius X priorisse mon. se
Agnetis de Burgo Si Lauren
tii de Muscello eiusque soror.
etc. in ppm

Religiosam vitam eligen.
Dat. Lugdun. p. m. magistri
Simonis Luccacanoi S.R.E. vice
cancellarii non. Martii ind.
2° Inc. D. a° 1273 p. a° 2°

Archives Nationales Paris

L 263 n. 33 1274 Martii 8
P. —

Br. 16,3 hoch 11. Plica 1,4
oberer Rand 2,1 links und
rechts ohne Seitenlinien winzige Rän
Gregorius X .. Priori b. et d.
Marie inter muros 7 Fossata Au
relianen.
Conqueste sunt nobis
Dat. Lugdun. VIII Id. Martij a° 2°

Bulle an Hanf

In plica rechts verdeckt
A tergo oben mitte :
A. de Romanis

Ganz kleine Schrift (11 Zeilen)

Ohne jeden betonten Buchstaben

Erste Linie für Oberlängen

Staatsarchiv Wien Chronol.
P. 20816 1274 Aprilis 22
Gregorius X .. decano Aquile
gen.
Ad nostram noveris
Lugdun. X Kl. Maii a° 3°
Bulle und Hanf fehlen
In plica rechts a g ?
Rund oben mitte cor at g.
cor.
Ecke oben rechts ß
Sub plica links --

m̄p

Seitenlinien, oberste Reihe
unbeschrieben
Ganz ungewöhnliche Schrift

Staatsarchiv Wien Chronol.
P. — 1274 Aprilis 22
Gregorius X .. priore et conven.
tui domus sce Marie in Vre
nung ad Rom. Ecclesiam nullomo
dio pertinentis Cart.Ord. Aquile
gen. dioc.
Solet annuere sedes
Lugdun. X Kl. Maii a° 3°
Bulle an Seide
In plica rechts a.
Sub plica links --

m̄p

Rund oben für Ecke oben rechts
ß

Brit. Mus. Harl. Chart. III. A. 25
P. 20826 1274 Maii 11
Gregorius X .. abbati Cisterci=
ensque coabbatibus et conuen=
tibus universis Cisterciēn=
ordinis
Cum a nobis
Dat. Lugduni V. id. Maii a° 3°
Bulle an Seide
In plica rechts f. At f
Sub plica links ..

Die plica deckt die letzte
Zeile

Public Record Office London
Papal Bulls bundle 16 n. 20
P. 20828 1274 Maii 15
Gregorius X E. regi Anglie illustri
Et si a
Lugdun. id. Maii a° 3°
Bulle an dünner Hanfschnur
In plica rechts Jac Romanus de
Cur

Public Record Office London
Papal Bulls bundle 16 n. 17
Clausa
(Gregor X) 1274 Maii 18
Ohne Salutatio etc. Incipit absolute:
Preter multa que
Lugdunen. XV. kl. Junii a° 3°
Bulle an Hanf
War wohl eine Einlage in die im Text
erwähnten litterae patentes. Hatte
jedoch gesonderte Adresse auf der Aussen=
seite.
An den König von England; soll sich nicht
auf Turniere in Frankreich einlassen

Arch. Dép. de la Gironde Bord.
H - 11 - 5
P. - 1274 Junii 5
Gregorius X .. abbati et conuen=
tui monesterii Silve Maioris
OSB Burdegalen. dioc.
Cum a nobis
Lugdun. non. Junii a° 3°
In plica links . O. Lond
Sub plica links ..

3803

Bagee · Haupt · Stratsarchiv
Ke. Bergen foic. 2

P. vacat 1274 Junii 13

Gregorius Pt . . Plebano ecclie de
Peter
Conqueste sunt nobis
Lugdure. Jd. junij anno Tercio

Bulle an Hanf
In plica rechts : c. me...

Kleines Mandat : 44.4 × 11.1
 plica 1.7

3804

Instr. Mon. F. Dm. c. 3 1274 Julii 31
Fondo Domen. 1090 20876
Greg. XXR s. Angeli diacono card.
Sue nobis dilecti —
Lugdure π Kal. Augusti. anno III°
Bulle an dünner Hanfschnur
In plica rechts : c. Ani
Sub plica links : - -
Oben Rand rechts : fiat sub anno
dat in and. e
2da non capietur
A tergo : predicatorum
l (aufrancus)
J. P. 20934 - 20936 vonneur
eine : Sua nobis dilecti
1274 octobris 1
J. 1275 Apr. 1. P. 2404

P. 20876

3805

Initium

Paris Archives Nationales
J 449 n. 106
Breite 42.6 Rand links 4.5 rechts 4.4
Höhe 26. Rand oben 5.4 plica 4.4
Erste Linie über Oberlängen
Ohne Leitenlinien
P. vacat 1274 Julii 31
Gregorius X Carmo in xpo filio
. . Regi Francor Jllustri
Ad excellencie tuam (Sic)
Dat Lugdurn / π Kl Aug a° 3°
Bulle an Hanf
Regelm. Schrift
Im Initium ist ein Wort aus-
gefallen

3806

Paris Archives Nationales
J 449 n. 107
Breite 60.2 Rand links 2.3 rechts 2.2
Höhe 43.3 Rand oben 9.6 plica 5.7
Erste Linie für Oberlängen / Je
eine Leitenlinie
P. vacat 1274 Augusti 1
Gregorius X S. Pt sancte Cecilie
pbro Cardinali aptice sedis Legato
Recenz etatie Sacrosancte
Dat Lugdurn Kl Aug a° 3°
Bulle fehlt Hanf erhalten
Jährige unschöne Schrift

3807

de Curia

Paris Archives Nationales
 J 449 n. 103
Breite 75.2 Rand links 2.7 rechts 2.7
Höhe 48.7 Rand oben 5.5 plica 5.3
 Erste Linie über Oberlingen /
Je zwei Seitenlinien
J.P.20884 1274 Augusti 1
Gregorius X Carmo in Xpo filio
 .. Regi Francor Jllustri
 Novum genus salutis
 Dat Lugdun Kl Augusti a° 3°
 Bulle an Hanf
 In plica rechts: R . C .
 de Cur
Rand oben mitte: L de Cur
Sehr regelm. schwungvolle Schrift

3808

Paris Archives Nationales
 J 449 n. 104
Breite 46.9 Rand links 1.7 rechts 2.4
Höhe 35.2 Rand oben 6. plica 3.9
 Erste Linie über Oberlingen /
Je eine Seitenlinie
P. vacat 1274 Augusti 1
Gregorius X .S. tt Sancte Cecilie
pbro Cardinali aptice sedis legato
 Recens ecctie sacros ste
 Dat Lugdun Kl Aug a° 3°
 Bulle an Hanf
 In plica rechts: p. Bo
Schöne kleine feste Schrift

3809

Public Record Office London
 Papal Bulls bundle 16 n. 18
 P. 20903 1274 Augusti 18
Gregorius X Lewellino principi
Wallie
 Cum a nobis
 Lugdun XV kl. Sept. a° 3°
 Bulle an Seide
 In plica links O. Land.
 Sub plica links $\frac{V}{c\,th}$

 Rand oben Mitte
 in Land
 Ecke oben rechts Bo

3810

de Curia

Archives Nationales
 J 449 n. 105
Breite 39.8 Rand links 1.9 rechts 2.1
Höhe 29.5 Rand oben 5.2 plica 5.1
Erste Linie für Oberlingen / Je
eine Seitenlinie
P. vacat 1274 Augusti 19
Gregorius X .S. tt sce Cecilie pbro
Cardinali aptice sedis legato
 Cum te ad
 Dat Lugdun/ XIIII kl Septembr
a° 3°
 Bulle an Hanf
 In plica rechts: d. g
 de Curia
 Rand oben halblinks L d Cur
Regelm. schwungvolle Schrift

3811

Firenze, Castello
P. 20905 1274 Augusti 20
Gregorius X .. abbi Cistercii
eiusque coabbatibus et conver
tibus universis Cisterc.
Meritis vestre sacre
Lugdun. XIII Kl. Sept. aº 3º
Bulle und Seide fehlen
die 2 obersten Zeilen frei
Sub plica frei ganze limini
In plica rechts J. aiy

3812

Graz Landesarchiv. n. 1014
P. — 1274 Septembris 4
Gregorius X .. priori Cartusie
et universis prioribus et fr
tribus ord. Cartusien.
Meritis vestre sacre
Lugduni II non. Sept. aº 3º
Bulle an Seide
In plica rechts p. G.
Sub plica links --
Seitenlinien. Oberste Zeile
unbeschrieben
Gestreckte Ligaturen

3813

Poitiers Archives départem.
Ordre de Malte
P. — 1274 Sept. 13
Gregorius X .. magro et fra
tribus domus Militie Templi Je
rosolimitan.
Licet in concessis
Dat Lugdun. id Sept. aº 3º
Bulle und Seide fehlen
In plica rechts f. any
rumhige Schrift. Kleine kräftig

Datum

3814

de Curia
Paris Archives nationales
J 449 n. 107
Breite 84.6 Rand links 1.3 rechts 1.2
Höfe 23. 2 Rand oben 5.1 plica 5.5
Erste Linie für Oberlängen /
Je eine Seitenlinie
P. vacat 1274 Septembris 21
Gregorius X Carmo in xpo filio
.. Regi Francor Illustri
Jn terre Sancte
Dat Lugdun XI Kl Octobr /aº3º
Bulle an Hauf
In plica rechts : Jo Sal
de Cur
In plica Ecke oben links RX
Rand oben Mitte : B und L

3815

de Curia per bonum
scriptorem

Paris Archives Nationales
J 449 n. 152
Breite 42.1 Rand links 1.6 rechts 1.6
Höhe 32. Rand oben 5. plica 4.5
Erste Linie für Oberlängen /
Je eine Seitenlinie
P. 20940 1274 Octobris 12
Gregorius X . S. tt sanctae Caeciliae
ptro Cardinali aplice sedis Legato
 Primum dilē [gentie tue]
Dat Lugdun / IIII Id Octobr aº 3º
Bulle an Hanf
In plica rechts: ba
 de tur
Rand oben Mitte: ℟ de Cur L pe
bonū scriptorem
Schöne regelm. Schrift

3816

Neapoli Curia Eccles. vol. 5º
P. 20946 1274 Octobris 19
Gregorius X .. magro et fribus
Hospitalis S Marie Theut. Jeros
Ipsa nos cogit
Lugdun. XIIII kl. nov. aº 3º
Bulle und Seide fehlen
In plica rechts Jo pgam
Sub plica links ...
 ℟ de pu . IIII .
 fratin
 ℟ o. Roca. IIII
 ℟ pant . . . etc.

3817

Marseille Archives Départem
H. OM. 22.
P. — 1274 Octobris 23
Gregorius X .. magro et fribus
Hospitalis Jerosolim.
 Ipsa nos cogit
Lugdun. X kl. nov. aº 3º
Bulle fehlt, Seide erhalten
In plica rechts n. p.
Erste Zeile pei

3818

Marseille Archives Départem
H. OM. 22
P. — 1274 Octobris 23
Gregorius X .. magro et
patribus Hospitalis Jerosol.
 Ipsa nos cogit
Lugdun. X kl. nov. aº 3º
Bulle und Seide fehlen
In plica rechts lo
Sub plica links

3819

Toulouse, Archives Départem.
H. 25

P. — 1274 Octobris 23

Gregorius X ... magro et frat-
bus Hospitalis Jerosolim.
 Ipsa nos cogit
Lugdun. X ke. nov. a° [~~X~~] (3°)
Bulle fehlt, Seide erhalten
... plica links
Erste Zeile überschrieben

3820

Marseille Archives Départem.
G. V. V. a. 28

P. — 1275 Januarii 30

Gregorius X Jmmerio archiepo
et capitulo Aquen.
 Cum a nobis
Lugdun. III kl. febr. a° 3°
Bulle an Seide
In plica p. G
Sub plica links
 D. Rom...
Daneben Jo deut p
Rand oben links ... und L
Ecke oben rechts bo
Rand oben Mitte ausradiert
und ...
 Nachlässige Schrift
 Gestreckte Ligaturen

3821

Paris Archives Nationales
 J 435 n. 6 bis
Breite 53.3 Rand links 3.2 rechts 3.4
Höhe 37.6 Rand oben 7.2 plica 5.8
Erste Zeile für Gitterschrift und kleine
Oberlängen / Je zwei Seitenlinien

P. vacat 1275 februarii 20

Gregorius X Carmo in xpo filio Phi-
lippo Regi Francor... et Carme in
xpo filie Blance Regine navarre
Illustribus
 Rigori iuris non
Dat Lugduni X kl. Martij a° 3°
 Bulle an Seide
In plica rechts: Jacob. de Mutina
Sehr stattliche schöne Schrift.

3822

Bayer. Haupt. Staatsarchiv
 Ebersberg F. 3

P. vacat 1275 Martij 4

Gregorius X (Gitterschrift Übung)
... Abbati et Conventui Mo-
nasterij in Hebersperch ordinis
sci Benedicti frisingen. dioc.
 Solet annuere Sedes
Lugdun. III non. Martij a° tertio
Bulle an feiner Seide
In plica rechts Schreibername
Ecke oben rechts : bo ...
Erste Zeile frei
Mittelbreite Seitenränder
Sehr schöne leicht nach links geneig-
 te Schrift
m, n und Abkürzung by am
Wortschluss mit ... nach links

3823

Düsseldorf Staatsarchiv
Stift Essen Cap. 67
P. — 1275 Martii 14
Gregorius X .. abbatisse et
Capitulo secularis ecclesie
Asinden. ad Romanam
Ecclesiam nullo medio per-
tinentis Colonien. dioc.
 Solet annuere sedes
Lugdun. X iiii. Martii 230
Bulle an Seide
In plica rechts ʃb
Sub plica link --
Ecke oben rechts ʃb
 Bullenanfang 1¼ Zeilen
 sub plica nenadril

3824 (recto)

Instr.
Eccl. Mon. F. dom. cap. 2
P. 2007 1275 Martii 23
Gregorius X dilectis in Christo fili-
Mny. vasius erga M. D. fill-
bus .. priorisse monasterii beate
Marie de Pmlians eiusque soror-
bus tam presentibus quam futuris
regularem vitam professis in ppm
 Religiosam vitam eligentibus
... precis inveniunt Amen a. a.
 (R) Ego Greg. Cath. Eccl. eps (M)
I 3 presb. II 5 epi III 5 diac.
Dat. Lugdun. per manum magri
Lefranci archidiaconi Paga-
men. sce Roman ecclie Vice
cancellarii X Kl. Aprilis indic-

3824 (verso)

tione III Incarnationis domi-
nice Anno ti. CC LXXIII ponti-
ficatus vero domni GREGORII pp
X anno tercio
Bleibulle hängt an feinem
Schnur
 Ecke oben rechts : ʃb
A tergo oben Mitte: predicatorum

3825

Bayer. Haupt- Staatsarchiv
Metten Fasc. 4
P. 21013 1275 Aprilis 1
GREGORIUS(Maiasculae) e. s. s. dei dil.
filius .. Abbati monasterii de Metten
eiusque fidus tam pres. quam fut. regal.
vitam professis (Gitterschrift, breit, dick)
pm
 Religiosam vitam eligentibus
inveniunt AMEN a. c AMEN
 R Ego Greg. Cath. ecclie eps A M
2 presb. 4 epi 3 diac.
Dat. Lugduni per manum Magri Lanpranci
Archidiaconi Pagamen. sancte Roman
ecclie Vice cancellarii Kl. Aprilis Indictione
III Incarn. dominice anno m. CC. LXXV.
 Pont. vero domni GREGORII pp Anno
Quarto
Bulle fehlt. Seide erhalten
Rand oben Mitte: In dut pt dat
 and.

3826

Instr. mon. F. Dom. c. 15 1275 Apr. 1
Fondo Domen. 112 P. 21014
Greg. x R. S. Angeli diac. card.
Jus nobis dilecti
Lugduni kal. Aprilis a° 4°
Bulle au Hanfschnur
In plica rechts: M. de Rocca
A tergo: predictorum
 (pro corpore Clementis)

 cf. 1274 Julii 31
 p. 20876.

3827

Madrid Arch. Histór. Nacional
 Poblet N. 79
Abschrift vicecancellarius
P. 21020 1275 Aprilis 5
Gregorius X univ. abbatibus
ac abbatissis et conventibus Cist.
tam presentibus etc. in ppm
In vestitu deaurato
Nulli ergo etc.
Siquis autem etc. incursurus
(R) Ego Gregorius etc. (M)
2 presb. 2 epo 5 diac.
Dat. Lugdun. p. m. magri Lau
franci archid. Pergamen. SRE
vicecancellarii non. April. ind
III Dur. D. a° 1275 pont. a° quarto

3828

Madrid Arch Histór. Nacional
Zaragoza Bernela 13 €
Abschrift vicecancellarius
P. 21020 1275 Aprilis 5
Gregorius X universis abbatibus
Abbatissis et conventibus Cistod.
tam presentibus quam fut. in ppm
In vestitu deaurato
Lugdun. p. m. magri Laufranci
archidiac. Pergamen. SRE vice
non. Apr. ind. III a ind etc. 1275
a° 4°

3829

Instr. misc. 1250-1275 c. 79 150
150 148 p. — 1275 Junii 9
Greg. X .. epo Magalonen.
Ea que a
Bellioadri V id. Junii a° 4°
Bulle und Seide fehlen
In plica Mitte: renovetur
Sub plica links: - - - -
 ag (Monogramm)
Ecke oben links: A
Ecke oben rechts: pcut a (ascultate paulus)

A tergo: P. de Montepetroso
A tergo Ecke oben links: y

 cf. 1267 Dec. 10 c. 52

3830

Instr. misc. 1250-1275 cap. 30 150
P. — 1275 Junii 9

Greg. X .. archepo Narbonen. et suffr. gnecis eius.

Cum sicut venerabili

Bellicadri v id. Julii a° 4°

Bulle und Hanf fehlen.

In plica rechts: Leo

Daneben links: Renovetur mutatis mutandis si per dominum papam sententia ferretur

Sub plica links:
 ag (Monogramm)

Ecke oben links: Conservationis
Ecke oben rechts: paut (asculptatum paulus)

A tergo: P. de Monte petroso

3831

P. — Paris Arch. Nat.

J 391 cap. 7 1275 Junii 22
 Clausa

Die Schnüre treffen die Schrift nicht

Greg. X .. regi Francorum illustri

Cum ballivi clare

Bellicadri X kl. Julii a° 4°

3832

Public Record Office London
 Papal Bulls bundle 16 u. 27
 P. 21 052 1275 Julii 15

Gregorius X .. archiepo Cantuarien.

Et si coniunctio

Bellicadii id. Julii a° 4°

 Bulle und Hanf fehlen

 In plica rechts Leo

 Sub plica links v̄
 a g

 a tergo oben Mitte

 R si̇pt

 XXX VIII

3833

 Paris Arch. Nat.

J 448 cap. 96

Nec miremini

 in bullandis litteris ante sue consecrationis munus modum huiusmodi obser-vare

 Dagegen

J 448 cap. 94

Nec miremini

 in bullandis litteris ante consecrationis et sue dictionis munus modum huiusmodi observare.

 Gregorii X

3834

Paris Archives Nationales
J 448 n. 88
Breite 44.9 Rand links 3.5 rechts 3.9
Höhe 31.5 Rand oben 6.9 Plica 4.2
Erste Linie für Oberlängen 1
Je eine Seitenlinie
P. vacat 1276 februarii 25
Innocentius V Carmo in xpo
filio .. Regi Francor. Illustri
Per dilectos filios
Dat Laterani VI Id. Martij 1
a° 1°
Bulle an Hanf
In plica rechts: Leo
de Cur
Feste fette sehr regelm. Schrift
de Curia

3835

Paris Archives Nationales
J 351 n. 1
Breit 61.3 Loch x 0.2
Schrift 28.6 x 55.5 Oberste Linie
unbeschrieben / Zwei enge Seitenlinien
P. vacat 1276 februarii 25
Innocentius V Cmo in xpo filio
.. Regi Francie Illustri / Funda-
mentum aliud ponere / Dat La-
terani VI Kal Marcij anno primo
Bulle und Hanf fehlen
In plica rechts . Jo. \overline{m}
a tergo: Innoc V. de Crea Toc
sua
Darunter X
Jette Kleine aufeinander liegende
Buchstaben

3836

Instr. Misc. 996-1249 c. 50
1276
P $\frac{}{V}$ Mart. 23
Innoc V S. tit. S. Cecilie presb. card.
aplice sedis legato
Attendens sollicite felicis
Laterani X Kal. Aprilis a° 1°
Bulle und Hanf ausgerissen
In plica rechts: Jac Romanus
Links oben: Rx dup p. Vic
Mitte oben: Cor.
Photo
vice cancellarius
Petrus Peregrossus
Instr. Misc. 56

3837

Coblenz Staatsarchiv
Himmerode
P. ~ 1276 Martij 29
Inn. V .. scolastico ecclesie
Sancti Symeonis Treverensis
Conquesti sunt nobis
Laterani III Kl. Aprilis a° 1°
Bulle an Hanfschnur
In plica rechts . S.

3838

Coblenz Statsarchiv
Himmerode
P. — 1276 Martii 29
Inn. V ,, scolastico ecclesie
Sancti Symeonis Treverensis
Dilectorum filiorum .. abbatis
Laterani III Kl. Aprilis a° 1°
Bulle fehlt. Hanf erhalten
In plica links : O. Laur.

3839

Archives nationales Paris
L 265 n. 1 1276 Martii 30
Br. 27.1 hoch 18.9 Plica 3.5
oberer Rand 5.1 links 1.2
rechts 1.1
Innocentius V (Gitterschrift
Initiale ausgespart) .. Magro et
fratribus domus Militie Templi
Jerusolimit[...]
 Solet annuere sedes
Dat Laterän III Kl Aprilis a° 1°

Bulle und Seide ausgerissen
Sub In plica rechts : p. Ro.
Sub plica links : ..

A tergo oben mitte : B de Guarci[no]

Sehr zierliche, feste Schrift, mit gestän-
digstoren, mit 4 betonten Sat-
anfängen
In 1. Zeile 1 betonter Buchstabe
Erste Linie für Gitterschrift

P. vacat

3840

Arch. Avis 3714
Arm. XIII. cap. 6 cap. 45
P. — 1274 [Martii] 31
 1276
Innocentius V ad perp. r. m.
Moribus ab initio
Lateran. II Kl. lis a° 1°
Bulle fehlt. Grobe Seidenfäden
In pl. links : O. Laur.
 Löcher, violett.

 Könnte vielleicht zum
Jahre 1276 gehören
 (Innocentius V)

O. Laur. kommt vor von 1265—1291
mithin Innocenz V

3841

Madrit Arch. Histor. nacional
Zaragoza Rueda 28 €
P. — 1276 Aprilis 9
Innocentius V .. abbi et con-
ventui monast. de Rota Cist.
Ord. Cesaraugustan. dioc.
 Cum a nobis
Laterun. V Id. Aprilis a° 1°
Bulle fehlt. Seide erhalten
In plica rechts B' Gamoren.
Sub plica links ..)
 p. Borg

Prächtige Schrift

3842

Madrid Arch. Histór. Nacional

Zaragoza Rueda 26 E

vicecancellarius 1276 Aprilis 11

P. —

Innocentius V . . sacriste secu-

laris ecclie Jacten. Oscen. dioc.

Significavit~ sunt~ nobis dilecti

Lateran. III iď. Aprilis a° 1°

Bulle fehlt. Hanf erhalten

In plica rechts B° Gamoren.

Sub plica links unten J. Atin

Rand oben links ✗ . p. vic

Prächtige Schrift

3843

Archives Nationales Paris

L 265 n. 2 1276 Aprilis 13

Br. 29.7 hoch 18.9 Plica 2.9

oberer Rand 6.4 links 1.6

rechts 1.6

℈ Innocentius V (Gitterschrift

Initiale ausgesparet) . . Magro

et fratribus Hospitalis sancti Johis

Jerlimitan. Cum a nobis

dat Lateran. id. Aprilis a° 1°

Bulle an Seide

In plica rechts ! Vg. Ro

Sub plica links : . –

A tergo oben mitte : R de Aquila+

Kleine sehr regelm. Schrift, mit

gest. Ligaturen, mit + beton-

ten Satzanfängen.

In 1. Zeile 1 betonter Buchstabe

Erste Zeile für Gitterschrift und
 überlängen
P. vacat

3844

Marseille Archives Départem.

H. O. M. 22

P. — 1276 Aprilis 13

Innocentius V epo Listricen.

Sua nobis .. prior

Lateran. iď. Apr. a° 1°

Bulle an Hanf

In plica rechts Jo Sal

Sub plica links ..g
 p. Rom.
Rand oben ✗r

3845

Toulouse, Archives Départem.

H. 25 26

P. — 1276 Aprilis 13

Innocentius V . . magro et

fratribus Hospitalis sancti

Johannis Jerosolim.

Cum a nobis

Lateran. iď. apr. a° 1°

Bulle an Seide

In plica rechts Vg Ro .

Sub plica links ..

Coblenz Staatsarchiv
St. Mathias
P. — 1276 Aprilis 22
Innocentius V .. abbati et
conventui Sancti Mathie ex-
tra muros Treveren. ordinis
Sancti Benedicti
 Cum a nobis
Lateran. X kl. Maii a° 1°
Seide fehlt; Bulle liegt bei
In plica rechts . δ
Sub plica links ·· p. Toni
Rand oben Mitte / Coff Ecke
oben rechts fo /
 wohl = Romanus)

Madrid Arch. Histor. Nacional
Dominicos de S. Pablo Burgos 48C
 P. — 1276 Maii 17
Innocentius V magro Petro Sar-
acen. archidiacono vallis
Posite in ecclia Burgen.
Sua nobis dilecti
Lateran. XVI kl. Iunii a° 1°
Bulle fehlt. Hanf erhalten
In plica rechts Veru Clu
Sub plica links ··· g
 p. Rom...
Dem unter
 Pt f. Reat
 j . ann

Duplicat 49 C An pl. r. f. R
Sub plica links X frau
 regul
Rand oben Mitte Renovetur et in
aud. J cfor

Archives Nationales Paris
L 265 n.1 1276 Octobris 1
Br. 15.8 hoch 11.2 Plica 2.2
oberer Rand 1.8 links 0.4
rechts 0.4
 Johannes XXI . . Priori Sce
Columbe Senonen
 Conquesti sunt nobis
Dat Viterbii kl Octobr. a° 1°
Bulle und Hanf fehlen
 In plica rechts unleserlich
Ganz kleine regelm. Schrift, enge
 Zeilen, ohne jeden be-
sonten Buchstaben
Erste freie Linie nicht erkennbar
 P. vacat

Archives Nationales Paris
L 265 n.2 1276 Octobris 1
Br. 27. 8 hoch 21.2. Plica 3.5.
oberer Rand 5.6 links 1.4
rechts 1.6
 Johannes XXI (Gitterschrift
Initiale ausgespart) · · abbati
et Conventui Monasterij Fusi
nacen Cisturcien ordinis Laudu-
nen diece
 Solet annuere sedes
Dat Viterbii kl Octobr. a° 1°
Bulle fehlt. Seidenreste erhalten
 In plica rechts : P. atur
Sub plica links : — —
 Iac Romanus
A tergo oben Mitte: Heremita
Regelm. lockere Schrift, mit gestr.
Ligaturen, mit vier betonten
Schaufingen
 In 1. Zeile 1 betonter Buchstabe
Erste Linie für Gitterschrift und
 unteren Oberlängen
Je zwei Zeilenlinien P. vacat

P(etrus) vicecancellarius

3850

Archives Nationales Paris
L 265 n. 3 1276 Octobris 1

Br. 26.7 hoch 17.2 Plica 2.7
oberer Rand 5.1 links 1.6
rechts 1.5
 Johannes XXI (Gitterschrift
Initiale ausgespart) .. Priori et
fratribus Hospitalis Sti Johis
Jerlimitani in Provincia
 Cum a nobis
Dat Viterbij Kl Octobris a° 1°

Bulle fehlt, Seidenreste erhalten P. vacat
 In plica rechts : Leo
Sub plica links : - -
 Darunter auf der plica abgeklatscht
 Rf 4 Viviani
 F. atin . 8.
Rand oben links : R F fient quin.
 → que. P. vie ←
A tergo oben Mitte : R. de Aquila
Sehr schöne kleine Schrift, mit
gestr. Ligaturen, mit viel betonten
Satzanfängen
In 1. Zeile 1 betonter Buchstabe
Erste Linie für Gitterschr. und Oberlängen
Vergl. von der Apost. Kanzlei, pag. 80

3851

Archives Nationales Paris
L 265 n. 3 bis 1276 Octobris 1

Br. 26.6 hoch 21.4 Plica 3.
oberer Rand 6. links 1.7
rechts 1.8
 Johannes XXI (Gitterschrift,
Initiale ausgespart) - - Magro
et fratribus Hospitalis sancti Jo-
his Jerlimitani
 Cum a nobis
 wie in n. 3

Bulle an grober Seide
 Regelm. ebenere Schrift
In plica rechts : F. atin
 Sub plica links : - -
A tergo oben Mitte : R de Aquila

 P. vacat

3852

Archives Nationales Paris
L 265 n. 3 ter 1276 Octobris 1

Br. 25. hoch 19.2 Plica 3.2
oberer Rand 5.4 links 1.9
rechts 1.7
 Johannes XXI
 wie in n. 3

Bulle fehlt, Seidenreste erhalten
 In plica rechts : p. G.
Sub plica links ; - -
 A tergo oben Mitte : R de Aquila

Sehr schöne feste kleine Schrift, mit
schwungvollen gestr. Ligaturen,
mit drei betonten Satzanfängen
 In 1. Zeile 1 betonter Buchstabe
Erste Linie für Gitterschrift

 P. vacat

3853

Karlsruhe Gr. Bad. Gen.-Landesar.
Select der Papsturk. cap. 274
 P. - 1276 Octobris 1
Johannes XXI .. abbati Cister-
cii eiusque coabbatibus et con-
ventibus universis Cisterciensis
ordinis
 Cum a nobis
Dat. Viterbii Kl. Octobris a° 1°
Bulle an grober Seide
In plica rechts . 8.
Sub plica links ..

3854

Public Record Office London
Papal Bulls bundle 24 nr. 1
P 21159 ~~regr~~ 1276 Octobris 7

Johannes XXI regi Anglie illustri

Divi eterna legis

Viterbii non oct a° I°

Bulle am Hanf

In plica rechts . d. cur
links daneben mehrere in e. m. - Befehle
links daneben R Guido Septe pro pecunia
Jac. Ro vos faciatis . II. et Galganus . I.

In plica links weitere in e. m. -
Befehle.

Rand oben Mitte cor suppl dat.

(Die Worte non. Octobr. sind
später nachgetragen.

3855

Archives Nationales Paris
L 265 n. 14 1276 Octobris 7

Br. 25.2 hoch 17. Plica 3.
oberer Rand 3.9 links 1.
rechts 0.9

Johannes XXI (Gitterschrift
ersten teile ausgespart) .. abbati et
Conventui Monasterij Vallis clare
Cisterciem ordinis Laudunen
dioc

Cum a nobis
Dat Viterbij non Octobr a° 1°

Bulle und Seide fehlen β. J. Saon
In plica rechts: ~~Guido~~ Saom ()
Sub plica links : - -
A tergo oben Mitte: J de Stratis

Runde lockere Schrift, mit gest.
Ligaturen (mit einer Ausnahme)
mit 4 betonten Satzanfängen
In 1. Zeile 1 betonter Buchstabe
Erste Linie für Gitterschrift und
Oberlängen

P. vacat

3856

Archives Nationales Paris
L 265 n. 5 1276 Octobris 7

Br. 34.4 hoch 30.9 Plica 4
oberer Rand 5.3 links 2.1
rechts 2.

Johannes XXI - - Magro et
fratribus Domus Milicie Templi
Jerlimitan

Cum a nobis
Dat Viterbij non Octobr a° 1°

Bulle an feiner Seide
In plica rechts: F. Atin
Sub plica links : - -
A tergo oben Mitte: B de Guaram

Runde lockere fette Schrift, mit gest.
Ligaturen, mit 4 betonten Satzan
fängen
In 1. Zeile 1 betonter Buchstabe
Erste Linie für Gitterschrift und
Oberlängen

mit je zwei Seitenlinien

P. vacat

3857

Bayer. Haupt. Staatsarchiv
Kl. Baumburg fasc. 4

P 21161 1276 Octobris 7

Johannes XXI .. Preposito ecclie
in Ostingen Salzeburgen. dioc
Conquesti sunt nobis
Viterbij non. Octobris Anno Primo

Bulle am Hanf
In plica rechts Jo. Vic

Kleine, sehr enge Schrift mit großen
Ober- und Unterlängen

Mandat : 18.7 x 43.3
pl. 2.9

Marseille Archives Départem
H. O.T.7
P.— 1276 Octobris 7
Johannes XXI .. magro et fratribus domus Militie Templi
Jerosolimitan.
 Cum a nobis
Viterbii non. Oct. a° 1°.
Bulle fehlt, Seide erhalten
In plica rechts f. any
Sub plica links —
Gezogene etwas fahrige und
fette Schrift

Marseille Archives Départem
H. O. m. 22
P.— 1276 Octobris 7
Johannes XXI — — epo Sista-
ricen.
 Pervenit ad audientiam
Viterbii non. nov. a° 1°
Bulle an Hanf
In plica links Ro
Sub plica links Jāē Romanus
 Erste Zeile frei
Sehr zierliche, schwungvolle
Schrift

Toulouse, Archives Départem.
H. 27

P.— 1276 Octobris 7
Johannes XXI .. Epo Sistaricen
 Pervenit ad audientiam
Viterbii non. nov. a° 1°
Bulle und Hanf fehlen
In plica rechts Les
Sub plica links —
Erste Zeile frei
Eckige Schrift.

Bayer. Hupt. Staatsarchiv
Kl. Baumberg fasc. 4
P. 21163* 1276 Octobris 11
Johannes XXI — — preposito et Con-
ventuj Monasterij in Baum-
burc per prepositum soliti gu-
bernii ad Roman. ecclam nullo
medio pertinentis ordinis sancti
Augustini Salzeburgen. dioc.
 Cum a nobis
Viterbij V id. Octobr. anno Primo
Bulle an dicker Seide
 In plica rechts : a de Sy
Sub plica links : —
Eche oben rechts : Jᵒᵉ Romanus

3862

Brit. Mus. Add. Chart. 1547
P.— 1276 Octobris 15
Johannes XXI .. abbati Clunia
cen. eiusque coabbatibus .. pri
oribus et conventibus universis
Cluniacen. ord.
Cum a nobis
Dat. Viterbii id. Oct. a° 1°
Bulle und Seide fehlen
In plica rechts f. atri

3863

Karlsruhe Gr. Bad. Gen. Landesar.
Select der Papsturk. np. 275
P. 21173 1276 Octobris 18
Johannes XXI .. preceptori
et fratribus Hospitalis S. Marie
Theutonicorum Ierosolimi
tan. in Alsatia et Burgundia
Cum a nobis
Viterbii XV kl. Novembris a° 1°
Bulle an grober Seide
In plica rechts a. B. Og.
Sub plica links — —
Jāc Romanus
Rand oben Mitte cor
Ecke oben rechts 60

3864

P.— Paris Arch. Nat.
J 697 cap. 38 1276 Octobris 19
Joh XXI .. regi francie illustri
Ad universalis ecclesie
Viterbii XIIII kl. nov. a° 1°
Bulle an Hanf
In plica rechts b. a.
Sub plica links x̄x̄
Jāc Romanus
a a Burg durchstri-
chen:
Rx u Equinal f atri
Rx /D/ Ecke oben links
f. atri ♰ f
Rand oben Mitte : cor
ut alia usque incrementum

3865

Archives Nationales Paris
L 265 n. 6 1276 Novembris 3
Br. 26·7 hoch 17·2 plica 3.
oberer Rand 4·6 links 1·5
rechts 1·4
Johannes XXI (Gitterschrift
Inchoat ausgespart) — — Abbati
et Conventui Monasterij sanc-
ti Germani de Pratis Parisien
ad Romanam ecclesiam nullo medio
Pertinentis ordinis Sci Benedicti
Cum a nobis
Dat Viterbij III Non novembre a° 1°

Bulle und Seide fehlen
In plica rechts : Nepot. R
Sub plica links : — —
Jāc Romanus
Ecke oben rechts : 60
A tergo Ecke oben links : B
" oben Mitte : de Pedemonte
Kleine feste regelm. Schrift, mit gesch.
Ligaturen, mit 4 betonten Schrau-
fängern.
In 1. Zeile mit 1 betonten Buchstaben
Erste Linie für Gitterschrift und
Oberlingen
P. vacat

Firenze, Cestello
P. — 1276 Novembris 5
Iohannes XXI .. abbati et con-
ventui mon. de Septimo Cist.
ordinis florentin. dioc.
 Cum a nobis
Viterbii non. Nov. a° 1°
 Bulle fehlt, Seide erhalten
In plica rechts M de Rocca
Sub plica links ..
 Rechte Zeile frei
Sub plica liniert
Schmale Seitenränder
 Flüchtige winkelgrosse kräf-
tige Schrift

Archives Nationales Paris
L 265 n. 7 1276 Novembris 13
Br. 27. hoch 18.3 Plica 2.4
oberer Rand 5.5 links 2.5
rechts 2.6
 Iohannes XXI (Gitterschrift
Initiale ausgespart) .. Priori et Con-
ventui Monasterij Vallis viridis
iuxta Parisius Cartusien ordinis
 Cum a nobis
Dat Viterbij Jd Novembr a° 1°

Bulle und Seide fehlen
 In plica rechts : Leo
Sub plica links : - - -
 Ecke oben rechts : do
A tergo oben mitte: p Cartusien

Kleine fette regeln. Schrift, mit
gestr. ligaturen, mit vier betonten
Schaufungen
 In 1. zeile 1 betonter Buchstabe
Erste Linie für Gitterschrift und Oberlängen

Instr. Misc. 1276 cap. 5
 P. 21141 ... 1276 Nov. 17
Joh. XXI Iacobo Ferentinat. Gaufri-
do Taurinen. epis et fratribus Ragnono
priori conventus Viterbien. ac Salvoslec
fri Lucan. ord. Praed.
In litteris quas.
Viterbii XV Kl. Decembr. a° 1°
Bulle und Hanf fehlen.
In plica rechts : P. Cornety
 de Curia
J. 1276 nov. 30
 cap. 15. Rt J. Potthast 21765
 1278 oct. 7.
Sbaralea, Bullarium III. 268 n° 32
setzt die griechischen Gesandtschafts-
bullen zu Johann XXI, Kefele, Con-
ciliengeschichte II (1867) 139 setzt
sie unter Innocens V
J. Potthast 21137 — die Lösungsfrist
Kaltenbrunner, MiÖG Seite 36 ff.

Napoli Curia Eccles. vol 5
P. 21184 1276 Novembris 17
Iohannes XXI .. magro et fribus
Hospitalis sancte Marie Theut.
Ieros.
 Cum a nobis
Viterbii XV Kl. Dec. a° 1°
 Bulle und Seide fehlen
plica abgeschnitten

3870

Instr. misc. 1276 cap. 6

P. 21139 1276 Nov. 30

Joh. XXI .. patriarche archepis et epis ac abbatibus ceterisque prelatis Grecorum

Grandis affectus quem

Viterbii II Kal. Dec. a° 1°
Bulle und Hanf fehlen

In plica rechts: Leo
 de Curia

Rand oben Mitte: cum serico dermuta lange notiz, vermuthlich Adresse, fast ganz radirt.

Vergl. Bemerkung zu 1276 Nov. 17.

3871

Instr. misc. 1276 cap. 8

P. — 1276 Nov. 30

Joh. XXI Jacobo Ferentinat et Gaufrido Taurinen. epis et fratribus Raynono priori conventus Viterbien et Salvo Lectori Lucan. ord. Pred.

Cum vos ad

Viterbii II Kal. Decembris a° 1°
Bulle und Hanf fehlen.

In plica rechts: p. benef.
 de Curia

Vergl. Bemerkung zu 1276 Nov. 17

3872

Instr. misc. 1276 cap. 7.

P. — 1276 Nov. 30

Joh. XXI archepis et epis et abbatibus prioribus etc. ad quos litt. iste perv.

Cum venerabiles fratres

Viterbii II Kal. decembris a° 1°

(Gesandtschaft an M. Paleologus imperator Grecorum)

Bulle und Hanf fehlen.

In plica recht: P. Benef. de
 Curia

Ecke oben links: ƻ f

Rand oben Mitte: Rx Sg. B. fiat sub nomine domini nostri de Curia per bonum scriptorem ad alios et antiqua non censetur.

Vergl. Bemerkung zu 1276 Nov. 17

3873

Instr. misc. 1316. 1317 cap. 15

P. — 1276 Nov. 30

Joh. XXI Jacobo Ferentinat. et Gaufredo Taurinen. epis et fratribus Raynono priori conventus Viterbien et Salvo Lectori Lucan. ord. Pred.

Cum vos ad

Viterbii II Kal. decembris a° 1°
Bulle <s>und</s> fehlt Hanf vorhanden.

In plica rechts: Ph. de
 Curia

Rand oben Mitte: Rx Sg. B. de Cur
 fiat sub nomine dni nri

Ecke oben links: ƶ f. (δ. d)

Vergl. Bemerkung zu 1276 Nov. 17

3874 (recto)

Nopoli Perg. Farn. Bolle n° 10°
P.—
 1276 Decembris 2
Johannes XXI .. epis ac dil. f.
electis abbibus prior. conventibus
Cistercien. et aliorum ordinum
ac prepos. archidiac. archpris
plebanis capitulis et aliis ecclesiarum
prelatis seu rectoribus ceterisque
personis ecclesiis exemptis et non
exemptis ac Hosp. Ieros. et Mili-
tie Templi magris preceptor. et
fribus necnon prioribus quarum
et fribus Bed.el Min. ordinum per An
con min. Marchiam et terras Tarfen.
monasterii constitutis
 Dum imbecillitatis humane
Viterbii IIII Non. Dec. a° 1°
 Bulle und Hanf fehlen
 In plica rechts B. Zamoren
 de Cur

3874 (verso)

Ecke oben links ⊄ f
A tergo Spuren von zwei ? ,
zer ovalen Siegeln

3875 (recto)

Paris Archives Nationales Rx
 J 448 n. 92
Breite 40.3 Randlinks 2.2 rechts 2.3.
Höhe 26.8 Randoben 7.9 plica 4.1
Erste Linie für Oberlängen 1
Je eine Seitenlinie
P. 21201 1276 Decembris 9
Johannes XXI Ven fratribus.
Archiepis et Epis ac aliis ecclia
& Prelatis per Regnum Francie
constitutis
 Considerantis ferventis Carismi..
Dat Viterbij V Id Decembr a°
Primo
 Bulle an Hanf
 In plica rechts : B. p usu
 Sub plica links : ⌣⌣⌣
 9 vacat

3875 (verso)

Sub plica links :
 Rx Reput F. a tin
Ecke oben links · I·
Ecke oben rechts Rx
A tergo halblinks : Reput ꝟ sol
A tergo oben Mitte schwungvoll
Mittelgroß Scrip R L XVIII
 cap

3876

Archives Nationales Paris
L 265 n. 8 1276 Decembris 9

Br. 24.6 hoch 19.2 Plica 5
oberer Rand 4.4 links 1.1
rechts 1.1
Johannes XXI (Gitterschrift
Initiale ausgespart) Dilectis in
xpo filiabus . . abbatisse et con-
ventui Monasterii de Favar-
chiis Cisterciensis ordinis Nivernen-
sis dioc.
Cum a nobis
Dat. Viterbii V Jd. Decembris a° 1°

Bulle und Seide fehlen J. Saxon
In plica rechts :
Sub plica links : p. — 9
P. Rom Chovel
A tergo oben mitte : P. de Choher (2)

fette kleine Schrift usw.

Erste Linie für Gitterschrift und
untere Obteilungen

P. vacat

3877

Archives Nationales Paris
L 265 n. 8 bis 1276 Decembris 9

Br. 26.2 hoch 19.2 Plica 2.5
oberer Rand 5.2 links 1.2
rechts 1.2
Johannes XXI (Gitterschrift
Initiale ausgespart)
wie in n. 8

Bulle und Seide fehlen
In plica rechts : J. Saxon
Sub plica links : — 9
p. Rom
A tergo oben mitte : P. de Choher

das Andere wie n. 8

P. vacat

3878

Public Record Office London
Papal Bulls bundle 24 n° 2
P. 21 203 1276 Decembris 13
Johannes XXI E. regi Anglie
illustri
Devotio gnam in
Viterbii id. Dec. a° I°
Bulle an Hanf
In plica rechts Sy Ro
pro dno S. Carb.

3879

Public Record Office London
Papal Bulls bundle 55 n. 1
P. 21 204 1276 Decembris 18
Johannes XXI . . regi Anglie
illustri
Cum censum ecclesie
Viterbii XV kl. Jan. a° 1°
Bulle fehlt, Hanf erhalten
In plica rechts : Jac. Romanus

3880

Paris Archives Nationales
J 448 n. 89

Breite 49.5 Rand links 2.9 rechts 2.8
Höhe 34,6 Rand oben 8. plica 5
Erste Linie für Oberlängen / Je
zwei Seitenlinien

P. vacat 1276 Decembris 31

Johannes XXI Dil filio S. H
Sancte Cecilie pbro Cardinali
aplice sedis Legato

Ex parte Carissimi

Dat Viterbij H Kl Januar / aº 1º
Bulle an Hanf
In plica rechts : Jac Romanus
Sub plica links : 9
Ecke oben links : a
Ecke oben rechts : 2½
Kleine fette prachtvolle Schrift

3881

Paris Archives Nationales
J 448 n. 89 bis

Breite 50. Rand links 4. rechts 3.8
Höhe 36.7 Rand oben 7 plica 5.1
Erste Linie für Oberlängen / Je
eine Seitenlinie

P. vacat 1276 Decembris 31

Johannes XXI etc. ut in n 89
Dat Viterbij H Kl Januar / aº 1º
Bulle an Hanf
Sub plica links : Leo und :
Rf Jac Ro F. Atin
Prachtvolle kleine fette Schrift des
Jac Romanus

3882

Paris Archives Nationales
J 448 n. 90

Breite 57.6 Rand links 2.9 rechts 3.2
Höhe 35.8 Rand oben 7.9 plica 4.7
Erste Linie für Oberlängen / Je
zwei linien zuhörst

P. vacat 1276 Decembris 31

Johannes XXI Dil filio S. H Sancte
Cecilie pbro cardinali aplice sedis
Legato

Carissimo in Xpo
Dat Viterbij H Kl Januar / aº 1º
Bulle fehlt Hanf erhalten
In plica rechts : Jac Romanus
Sub plica links : Leo und
Rf Jac Ro F. Atin
Ecke oben links

Prachtvolle fette kleine Schrift

3883

Paris Archives Nationales
J 448 n. 90 bis

Breite 47.8 Rand links 2.7 rechts 2.6
Höhe 35.8 Rand oben 7.1 plica 5.1
Erste Linie für Oberlängen / Je
zwei Seitenlinien

P. vacat 1276 Decembris 31

Johannes XXI etc. ut in n. 90
Dat Viterbij H Kl Januar aº 1º
Bulle fehlt Hanf erhalten
In plica rechts : Jac Romanus
Sub plica links 9 Rand oben
Ecke oben links : a Mitte : car
Ecke oben rechts : Rf
A tergo oben Mitte : +
Prachtvolle fette kleine Schrift

Düsseldorf Staatsarchiv
Siegburg Cap. 100
 1277 Januarii 3
Johannes XXI .. preposito ec
clesie Colonien.
 dilectorum filiorum .. abbatis
Viterbii III non. Januarii
p. n. a° 1°
 Bulle und Hanf fehlen
In plica rechts B. Zamoren.

 Ganz kleine, schön geschrie
bene Urkunde

Brit. Mus. Add. Chart. 1548
 P. 21216ˣ 1277 Januarii 18
Johannes XXI .. abbati S. Corne
lii de Compendio Suessionen.
dioc.
Ex parte dilecti
Dat. Viterbii XV Kal. febru
arii a° 1°
 Bulle und Hanf fehlen
In plica rechts Schreibernamen

3886

Paris Archives Nationales
 J 448 n 91
Breite 59.6 Randlinks 3.6 rechts 3.5
Höhe 41.5 Randoben 8.1 plica 4.9
Erste Linie für Oberlängen / Je
eine Seitenlinie
P. vacat 1277 Januarii 18
Johannes XXI Carmo in Xpo filio
.. Regi Francie Illustri
 Gregis divina credita
Dat Viterbij XV Kl Februarÿ / a°1°
Bulle an Hanf
In plica rechts : -1- a.
Ecke oben rechts : Kf
A tergo oben Mitte : Corinthum
Dicke fette regelm. Schrift

3887

Paris Archives Nationales
 J 448 n. 93
Breite 34.4 Randlinks 1.7 rechts 1.7
Höhe 21.6 Randoben 5.1 plica 3.6
Erste Linie für Oberlängen
Je eine Seitenlinie
P. vacat 1277 Januarii 23
Johannes XXI Magro Henrico
de Virzeliaco Capellano nro
Statum lugubrem sue
Dat Viterbij X Kl Februarÿ a°1°
Bulle an Hanf
In plica rechts : Ph
A tergo oben Mitte : Corinthum
Kleine sehr regelm. Schrift

3888

P.— Paris Arch. nat.
J 704 cap. 188 1277 Januarii 25
Clausa

Breite Ränder
Johannes XXI
-- regi Francie
illustri.

Habet in nobis
Viterbii VIII kl. Febr. a° 10

Bulle und Hanf fehlen
In plica rechts Jac Bopt
Sub plica links =v̄= S
Leo Lc

3889

Archivio di Stato Milano
Bolle e Brevi
P.21223× 1277 februarii 9
Johannes XXI. . . abbatisse et
conv. mon. S. M. foris Portam
Civitatis Papie OSB.
Cum a nobis
Viterbii V id. febr. a° 1°
Bulle an Seide
In plica rechts Jac Lar
Sub plica links Leo

3890

Archivio di Stato Milano
Bolle e Brevi
P.— 1277 februarii 15
Johannes XXI . . . abb. mon.
S. Salvatoris Papie.
Sub religionis habitu
Viterbii XV kl. Martii a° 1°
Bulle an Hanf
In plica rechts Jac Lar
Sub plica links Leo
Ecke oben rechts bo

3891

Archives Nationales Paris
L 265 n. 9 1277 Martii 5
Br. 33.7 hoch 22.7 Plica 2.8
oben Rand 7.1 links 2.2
rechts 2.11
Johannes XXI (Gitterschrift
Zentrale ausgespart) . . Priori
et Conventui Monasterii Vallis
Viridis Certusien ordinis Parisien
dioc Ea parte nostra
Act Viterbij III non. martij a° 1°

Bulle und Seide fehlen
In plica rechts : . S.
Sub plica links : L S
Leo
A tergo Ecke oben links : J
" oben Mitte : B. de Guarcino
Kleine sehr regelm. Schrift, mit
gestr. Ligaturen (mit einer Aus-
nahme), mit drei betonten Schauffzügen
In 1. Zeile 1 betonter Anfangsbuchstabe
Erste Linie für Gitterschrift

P. vacat

3892

Karlsruhe
Salem 4/50
P. — 1277 Martii 11
Iohannes XXI .. abbati mona-
sterii de Petri domo Constancien.
dioc.
Insinuarunt nobis dilecti
Viterbii V id. Martii a° 1°
Bulle und Hanf fehlen
In plica rechts pδ (monogr.)
Sub plica links .q [PS]
Rand oben mitte a... (oder?)
Ecke oben rechts bo

3893

Karlsruhe Gr. Bad. Gen. Landesar.
Select der Papsturk. cap. 276
P. — 1277 Martii 23
Iohannes XXI .. abbati et con-
ventui monasterii de Salem
Cistercien. ordinis Constantien.
dioc.
Ex parte vestra
Dat. Viterbii X kl. Aprilis a° 1°
Bulle an feiner Seide
In plica rechts .δ.
Sub plica links R/ Demetr. III

Rand oben ausgestrichene unleser-
liche Notiz

3894

Karlsruhe Gr. Bad. Gen. Landesar.
Select der Papsturk. cap. 277
P. — 1277 Aprilis 9
Iohannes XXI .. abbati mona-
sterii S. Vincentii Bisuntin.
Quia nonnulli sic
Viterbii V id. Aprilis a° 1°
Bulle an Hanf
In plica rechts [JGn]

Sub plica links .S.
 Leo

3895

Coblenz Staatsarchiv
Himmerode
P. — 1277 Aprilis 9
Iohannes XXI .. abbati et conven-
tui monasterii de Hymmen-
rode Cistercien. ordinis Treveren-
sis diocesis
Ex parte vestra
Viterbii V id. Aprilis a° 1°
Bulle und Seide ausgerissen
In plica rechts .δ.
Ecke oben rechts [N]

3896

Staatsarchiv Wien Chronol.
P.(21264) _1278 Januarii 15_
Nicolaus III. . archeps Salze-
burgen., epis et abbtibus ac
aliis eccliarum prelatis per
Salzeburgen. provinciam con-
stitutis
Immense Deus potentie
Rome apud Scm Petrum
XVIII Kl. febr. a° 1°
Bulle an Hanf
In plica rechts B Zamoreu
de Curia
Rand oben Mitte ...

Prachtvollste Schrift.

3897

Public Record Office London
Papal Bulls bundle 29 n 14
P. 21263 _1278 Januarii 15_
Nicolaus III - - regi Anglie illustri
Immense Deus potentie
Rome ap. S. Petrum XVIII Kl. Febr. a° 1°
Bulle an Hanf
In plica rechts
B Zamoreu
de Curia

3898

Archives Nationales Paris
L 266 n. 1 _1278 Januarii 18_
Br. 31.6 hoch 21.3 plica 4.2
oberer Rand 8.4 links 2.9
rechts 2.5
Nicolaus III (Gitterschrift
In titel ausgespart) .. Magro
et fratribus domus Militie Templi
Jerosolimitani
Cum a nobis
Dat Rom apud Scm Petrum XV Kl
Februarii a° 1°
Bulle und Seide ausgerissen
In plica rechts : Leo
Sub plica links : ..
A tergo oben Mitte: B de Querciu
Sehr schöne fette Schrift, mit gestr.
Ligaturen, mit vier betonten
Satzanfängen
In 1. Zeile 1 betontes Bruchstück
erste Linie für Gitterschrift und
Verlängerungen

P. vacat

3899

Marseille Archives Départm.
H. O. T. 7
P.— _1278 Januarii 18_
Nicolaus III . . magro et fribus
domus Militie Templi Jeros
Cum a nobis
Rome apud Scm Petrum XV
Kl. febr. a° 1°
Bulle fehlt, Seide erhalten
In plica rechts J. Auv
Sub plica links ..
Etwas gehackte und gezogene
Schrift.

3900

Wiesbaden Staatsarchiv
Rossdorf Höchst
P. — 1278 februarii 1
Nicolaus III .. mag. et fratribus
Hospitalis Sancti Antonii Vi-
ennen. dioc.
Cum a nobis
Rome apud Scm Petrum
Kl. febr. a° 1°
Bulle an Seide
In plica rechts f. Arm
Sub plica links : --

3901

Firenze, Volterra
P. — 1278 februarii 25
Nicolaus III [ohne Punkte] com-
muni Vulteran.
Cum a nobis
Rome apud Sanctum Petrum
V Kl. Martii a° 1°
Bulle fehlt, Seide erhalten
In plica rechts J

Sub plica links
 Erste Zeile frei
 Sub plica Hälfte frei

3902

Firenze, Pistoia
P. — 1278 Martii 15
Nicolaus III . . magistro et fra-
bus Hospitalis S. Bartholomei
de Prato Episcopi de Alpibus
Ord. Aug. Pistorien. dioc.
Cum a nobis
Rome apud Sanctum Petrum
id. Martii a° 1°
Bulle Nicolai III an Seide
mit Hanf
ist zu Klöben angehängt wor-
den, de sie vorgegangen war.
In plica rechts f. Arm
Sub plica links : --
Sehr ungewöhnliche Schrift
mit Abkürz. Zeichen : R

3903

Archives Nationales Paris
L 266 n. 2 1278 Aprilis 5
Br. 25.5 - hoch 19.2 Plica 3.
 oberer Rand 3.8 links 1.5
rechts 1.4
 Nicolaus III (Gitterschrift
Initiale ausgespart) .. Abbati et
Conventui monasterii Vallis beate
Marie Cisterciensis ordinis Pariam
dioc Cum a nobis
dat Rome apud Scm Petrum Non
Aprilis a° 1°

Bulle und Seide fehlen
 In plica rechts : cj . dis (-)
Sub plica links : --

Kleine fette Schrift, mit gestreckten
Ligaturen, mit 4 betonten Satz-
anfängen
 Mit 1 beh. Buchstaben in 1. Zeile
Erste Linie für Gitterschrift und
 oberlängen
 P. vacat

3904

Stratsarchiv Wien Chronol.
P. — 1278 Aprilis 25
Nicolaus III . . abbi et conv. mon
Milstaten. OSB Salzburgen. diöc
 Cum a nobis
Rome apud Scm Petrum VII kl.
Maii a° 1°
Bulle an Seide
Sub plica links n. Viviani
Ecke oben rechts, ro
Gestreckte Ligaturen
 Prächtige zierliche Schrift

3905

Archives Nationales Paris
L 266 n. 3 1278 Maii 7
Br. 25,6 hoch 19,3 Plica 3,8
 oberer Rand 4,4 links 1,1
rechts. 1
 Nicolaus III (Gitterschrift
Initiale ausgespart) . . magro et
fratribus Hospitalis sancti Johis
Jerlimitan
 Cum a nobis
Dat Rome apud Scm Petrum
non Maii a° 1°
Bulle an Seide
 In plica rechts v. de. g.
Sub plica links
 A tergo oben mitte: R de Aquila
Sehr schöne kleine fette Schrift usw.
Erste Linie für Gitterschrift mit
 unterer Oberlängen

P. vacat

3906

Stratsarchiv Wien Chronol.
P. — 1278 Maii 7
Nicolaus III . . decano ecclie
Ratisponen.
Venerabilis fratris nostri
Rome apud Scm Petrum
non. Maii a° 1°
Bulle an Hanf
In plica rechts Ge. Ra
Ecke oben rechts ro
Gnaz kleines brauntes mit
Schmalen Seitenrändern

3907

Stratsarchiv Wien Chronol
P. — 1278 Maii 7
Nicolaus III . . preposito ecclie
Ratesponen.
Conquestus est nobis
Rome apud Scm Petrum non
Maii a° 1°
Bull an Hanf
In plica rechts B. Ant ?
Stark ineinandergeschobene
schöne Schrift.
Rand oben mitte ro

3908

Archives Nationales Paris
L 266 n. 4 **1278 Julii 1**

Br. 27,4 hoch 24. plica 4.
oberer Rand 7,2 links 1.7
rechts 1.5
 Nicolaus III (Gitterschrift
Initiale ausgespart) . . Abbati
7 Conventui Monasterij sti Germa
ni de Pratis Parisien ad Romanam
ecclesiam nullo medio pertinentis
ordinis sti Benedicti
 Cum a nobis
Dat Viterbij Kl Julij a° 1°

Bulle und Seide fehlen
 In plica rechts : A. med
Sub plica links : ¨¨
 Sy. Ven **P vacat**
Ecke oben rechts : ffo
A tergo Ecke oben links : B
 oben Mitte : de Pedemonte
Tekke enge regeln. Schrift mit gestr
Ligaturen, mit 4 kl. Zeilanfängen
In 1. Zeile 1 betonter Buchstabe
Erste Linie für Gitterschr nur Oberlängen

3909

Bayer. Haupt – Staatsarchiv
Kl. Seeon fasc. 5

P. 21358 **1278 Julii 13**

Nicolaus III . . Abbati sci Petri Sal-
zeburgen.
 Conquesti sunt nobis
Viterbij III Id. Julij anno Primo

Bulle an starkem Hanf
In plica rechts : P. amicus
 Ecke oben rechts : BO
a tergo Ecke oben links . J

Jnnes kleines Mandat 14,7 × 8,0
 plica ffo 1.1

Zierliche saubere Schrift. Unterlängen
vielfach länger als die Oberlängen

3910

Public Record Office London
Papal Bulls bundle 29 n. 9
P. 21374 **1278 Augusti 1**
Nicolaus III . . regi Anglie illustri
 Dilecti filii frater
Viterbii Kl. Augusti a° 1°
 Bulle an Hanf
In plica rechts Jac. Unit
Sub plica links – – – Ric scps
 Sy Ven
Rand oben links . J.
Ecke oben rechts R
a tergo Mitte

3911

Public Record Office London
Papal Bulls bundle 29 n. 12
P. 21373 **1278 Augusti 1**
Nicolaus III . . regi Anglie illustri
 Dilecti filii frater
Viterbii Kl. Augusti a° 1°
 Bulle an Hanf
In plica rechts Jac. Unit
Sub plica links ≡
 Sy Ven.
Rand oben links J.
Ecke oben rechts R
a tergo oben Mitte

3912

Madrid Arch. histór Nacional
Zaragoza Mercenarios 1 E
P. — 1278 Augusti 5
Nicolaus III .. magro et fra-
tribus domus beate Marie de
Olivario de Mercede Captivorum
Oshug. Cesaraugustan. dioc.
Sacrosancta Romana Ecclesia
Viterbii non. Aug. a° 1°
Bulle an Seide
In plica rechts Jac hnit
Sub plica links .. Ven
 Sy Ven
Rand oben Mitte Ofst

3913

Public Record Office London
Papal Bulls bundle 29 n.13
P. 21 392 1278 Augusti 12
Nicolaus III .. Londonien et ..
Herefordan. epis ac magro Arditioni
capellano et nuntio nostro in Anglie
et fratri Johanni de Derlenton OSB
 Nuper tu fili
Viterbii II id. Aug. a° 1°
 Bulle an Hanf
In plica rechts Jac hnit
Sub plica links X
 Sy Ven
Rand oben links . J. rechts R X
 a tergo oben Mitte

3914

Archives Nationales Paris
L 266 n. 5 1278 Augusti 18
 P. —
Br. 33.7 hoch 23.9 Plica 3.9
oberer Rand 4.9 links 1.8
rechts 1.8
 Nicolaus III (Gitterschrift, Ini-
tiale ausgespart) .. Decan et Capi-
tulo Ecclie Parisien
 Ex parte vestra
Dat Viterbii XV Kl Septembr a° 1°

Bulle an schlechter grober Seide
 In plica rechts : F. atin
Sub plica links : ..
 Darunter auf der plica : F. atin
 R X lausrant
Ecke oben Rechts : bo
a tergo oben Mitte Philippus de pem
Teke schöne Schrift, fast ohne jeden Haar-
strich mit gestr. Ligaturen, mit
3 betonten Initanfängen
In 1. Zeile 1 bet. Buchstabe
erste Linie für Gitterschrift und an
 ihre Oberlängen
Je zwei Seitenlinien

3915

Archives Nationales Paris
L 266 n. 6 1278 Augusti 18
Br. 33.9 hoch 23.3 Plica 3.8
oberer Rand 6.3 links 1.9
rechts 1.9
 Nicolaus III (Gitterschrift, Ini-
tiale ausgespart) .. Decan et Ca-
pitulo Parisien
 Justis petentium desiderijs
Dat Viterbii XV Kl Septembr a° 1°

Bull an feiner Seide
 In plica rechts ! F. atin
Sub plica links : .. --
 a tergo oben Mitte ganz abgerieben
 P (hilippus de pemonte)

Schrift wie die n. 5 auch alles Andere
über dem Text jedoch zwei freie
Linien

 P. vacat

Paris Arch. Nat.
J 3 x 8 cap. 8 1278 Aug. 23
N° III Viterbii X Kl. Sept.
a° 1°

Bulle an Hanf
In plica rechts
 M. de Rocca
 φ cur.

 P. 21401

Paris Archives Nationales
 J 449 n. 109
Breite 30.5 Rand links 2.8 rechts 2.8
Höhe 23.6 Rand oben 5.3 plica 3.4
Erste Linie für Gitterschr. und
Oberlängen / Je eine Seitenlinie
P. vacat 1278 Septembris 13
Nicolaus III Carmo in χρο filio
Pho Regi Francop Illustri
Ut ... terre sancte
Dat Viterbij Jd Septembr a° 1°
Bulle an feiner Seide
In plica rechts : Sy. Ven.
Sub plica links : ...
A tergo oben Mitte
 Philippus
 de Pemonte

Paris Archives Nationales
 J 449 n. 110
Breite 38.7 Rand links 2.6 rechts 2.3
Höhe 26.4 Rand oben 8.9 plica 5.9
Zwei freie Linien über Oberlängen
Je eine Seitenlinie
P. vacat 1278 Septembris 13
Nicolaus III Archiepis et Epis per
Regnum Francie constitutis
Ut terre sancte
Dat Viterbij Jd Septembr a° 1°
Bulle an Hanf
In plica rechts : pa. de pan
Sub plica links : .'.
A tergo oben Mitte
 Philippus de Pemonte

Paris Archives Nationales
 J 449 n. 110 bis
Breite 26.7 Rand links 2.3 rechts 2.3
Höhe 20.4 Rand oben 5.6 plica 3.2
Erste Linie für Oberlängen / Je
eine Seitenlinie
P. vacat 1278 Septembris 13
Nicolaus III etc. ut in n. 110 ter
Dat Viterbij Jd Septembr / a° 1°
Bulle an Hanf
In plica links : O. Laud
A tergo oben Mitte
 Phs de Pemonte

Feine prachtvolle Schrift

3920 (recto)

Paris Archives Nationales
J 449 n. 110 ter

Breite 28.1 Rand links 2.6 rechts 2.9
Höhe 21. Rand oben 6.5 plica 4.4
Erste Linie für Oberlängen /
Je eine Zeilenlinie

P. vacat 1278 Septembris 13

Nicolaus III Universis Confessoribus
Religiosis et Secularibus ex potes-
tate ordinaria uel ex priuilegio
confessiones audientibus per Reg-
num Francie Constitutis

Ut Terre Sancte
Dat Viterbij / Jd Septembr̄ a° 1°
Bulle an Hanf
In plica rechts : f͂u
Sub plica links : Jy Ven
9

3920 (verso)

Darunter :
Rf O. Laud F. atin̄
Rand oben links : ·l· N F
Ecke oben rechts : Rf
A tergo oben Mitte :
Philippus
de Pemonte

Schlank mit dickem Strich

Rscps̄ c l xx
R cap

Schwungvolle schöne Schrift

3921

Paris Archives Nationales
J 449 n. 111

Erste Linie für kleine Oberlän-
gen / Je eine Zeilenlinie

P. vacat 1278 Septembris 13

Nicolaus III Archiepis et Epis
per Regnum Regnum Francie
constitutis

Sicut accepimus contingit
Dat Viterbij Jd Septembr̄
a° 1°
Bulle an Hanf
In plica rechts : B. Zamoren̄
Sub plica links : S
A tergo oben Mitte : Philippus
de Pemonte
Sehr schöne regelm. Schrift

3922 (recto)

Darum R

Paris Archives Nationales
J 449 n. 111 bis
Erste Linie für Oberlängen / Je
eine Zeilenlinie

P. vacat 1278 Septembris 13

Nicolaus III Uen fratrib3 Archi-
epis et Epis per Regnum Francie
constitutis

Sicut accepimus contingit
Dat / Viterbij Jd Septembr̄
a° 1°
Bulle an Hanf
In plica rechts : p
Sub plica links : 9 S (vaie
Jy Ven
cor
Rf Bēr Zamor
F. atin̄

3922 (verso)

Rand oben links : · J· und :
Δ F. und : oo͞r
Ecke oben rechts : R⸗
A tergo oben Mitte :

Philippus
de Pemonte

Mittelgross schlank mit
dickem ~~Feder~~ Strich :

[srpt] C L XVIIJ
[cap]

Kleine unruhige Schrift

3923

Firenze, S. Croce di Firenze
P. 21410 1278 Septembris 17
Nicolaus III . . archo presbt.
Raynerio de Montemagno
et Baldo canonicis ecclesie
Lucan
Sua nobis dilecti
Viterbii XV Kl. Oct. a° 1°
Bulle und Hanf fehlen
In plica rechts Nepul. B
Oberste Zeile beschrieben
Sub plica unliniirt
Breite Ränder, grosse plica

3924 (recto)

R⸗

Paris Archives Nationales
J 449 n. 112
Erste Linie für Oberlängen / Je
Zwei Leitenlinien
P. vacat 1278 Septembris 19
Nicolaus III . . Archiepis et
. . Epis et dil filijs alijs
ecclia χ Prelatis per Regnum
Francie constitutis
Ex parte Carissimi
Dat Viterbij / XIIJ Kl Octobr⸗
a° 1°
Bulle an Hanf (verte
In plica rechts : B. Zamoren
Sub plica links : Sij Ven und abg.
Abtsch̄t : R⸗ p⸗ g Verat .
F. Aim

3924 (verso)

Rand oben links : · Lc· und :
Δ F.
Ecke oben rechts : R⸗
A tergo oben Mitte :
Philippus de Pemonte

Schwungvoll mittelgross mit
dickem Strich :

[srpt] C L XVIIJ
[cap]

Sehr schöne feste Schrift

3925

Paris Archives Nationales
J 449 n. 112 bis
Erste Linie für Oberlängen/
Je eine Seitenlinie
P. vacat 1278 Septembris 19
Nicolaus III etc. ut in n. 112
Dat Viterbij XIII Kl Octobr/
a° 10
Bulle an Hanf
In plica rechts: p. V.
Sub plica links : ..
A tergo oben Mitte :
Philippus de Pedmonte
Kleine fette sehr schöne Schrift

3926

P. — Paris Arch. Nat.
J 683 cap. 18 bis 1278 Sept. 19
Nic III Phylippo regi Franco-
rum illustri
Precelsa tue magnitudinis
Viterbii XIII Kl. Oct. a° 10
Bulle an Seide
In plica rechts J. R.
Sub plica links --
Sub plica links Bug abgeklebt
R Sy Ren (Ben ?)
Atin
Rand oben f
und . r. und J. a
Ecke oben
rechts R a tergo C XXXVIII

3927

Paris Archives Nationales
J 449 n. 114
Zwei freie Linien über Oberlängen
Je eine Seitenlinie
P. vacat 1278 Septembris 20
Nicolaus III Universis magris
preceptoribus et fratribus Hos-
pitalis ści Johis Jerlimitanii
Milicie Templi et sancte
Marie Theotonicoz ordinum
Ura pre alijs
Dat Viterbij / XII Kl Octobr
a° 10
Bulle an Hanf
In plica rechts : G. aly
Sub plica links :
A tergo oben Mitte : Philippus de Pedmonte

3928 (recto)

R
Paris Archives Nationales
J 686 n. 72
Breite 29.3 Rand links 2, rechts 1.9
Höhe 21.8 Rand oben 5.6 plica 3.7
Erste Linie für Gitterschr und
kleinere Oberlängen/ Je ein
Seitenlinie
P. vacat 1278 Septembris 20
Nicolaus III (Gitterschr) Carmo
in xpo filio Philippo Regi Fran-
coz Illusti
Significasti nobis quod
Dat Viterbij XII Kl Octobr
a° 10
Bulle an sehr feiner Seide
In plica rechts : Sy Vin
Crete

3928 (verso)

Sub plica links : Sy Ven
9

F. Amo

Ecke oben links : · 2 ·
und : ⚔ F.

Ecke oben rechts : R̸

A tergo oben Mitte :

Philippus de Pomonte
Darunter schlank sehr var.
schnörkelt

C⸱X⸱C·L·V·II̸

fette gezogene gezogene
kleine Schrift

3929

Paris Archives Nationales
J 686 n. 72 bis

Breite 33.9 Rand links 2.6 rechts 2.6
Höhe 21.3 Rand oben 4.5 plica 4.
Erste Linie für Gitterschr. und
kleinere Oberlängen / Je 2 Seitenlinien
P. vacat 1278 Septembris 20

Nicolaus III (Gitterschr.) Carmo
in xpo filio Philippo Regi Fran-
corum Illustri
Significasti nobis / quod
Dat Viterbij XII Kl Octobris
a° 1°

Bulle an feiner Seide
In plica rechts : F. Amy

A tergo oben Mitte : Philippus de Po-
monte

3930

Paris Archives Nationales
J 686 n. 77²

Breite 39.7 Rand links 3.1 rechts 2.7
Höhe 29.6 Rand oben 7.3 plica 4.3
Erste Linie für Gitterschr. und ober-
längen / Je eine Seitenlinie
P. vacat 1278 Septembris 20

Nicolaus III (Gitterschr.) Carmo
in xpo filio Philippo Regi Fran-
corum Illustri
Cum in te
Dat Viterbij / XII Kl Octobris
a° 1°

Bulle an feiner Seide
In plica rechts : p benet

A tergo oben Mitte : Philippus de Pomonte
Fette sehr deutliche etwas steife Schrift

3931 (recto)

Datum

Paris Archives Nationales R̸
J 686 n. 77³

Breite 42.2 Rand links 3.4 rechts 3.4
Höhe 32.6 Rand oben 8.6 plica 5.6
Erste Linie für Gitterschr. und Ober-
längen / Je zwei Seitenlinien
P. vacat 1278 Septembris 20

Nicolaus III (Gitterschr.) Carmo
in xpo filio Philippo Regi Fran-
corum Illustri
Cum in te
Dat / Viterbij XII Kl Octobre a° 1°

Bulle an sehr feiner Seide
In plica rechts : Sy Ven
Sub plica links : Sy Ven
9

R̸ R. Beo F. Amy alles ab.
zeichnet verk

3931 (verso)

Ecke oben links : · v. und · F
Ecke oben rechts : R₄

a tergo oben Mitte :

Philippus de Pomonte

darunter schwach und zierlich

fette kleine sehr rgelm. Schrift

3932

Paris Archives Nationales
J 688 n. 112

Breite 31.2 Rand links 2.8 rechts 2.5
Höhe 27. Rand oben 7. plica 5.

Erste Linie für Gitterschrift und
kleinere Oberlängen / Je 1 Seitenlinie

P. vacat 1278 Septembris 20

Nicolaus III (Gitterschr) Dil̄ in xp̄o
filie nob Mulieri Blanche inte
clare memorie · L. Regis Francor
Pium arbitramur et

Dat Viterbij XII Kl̄s Octobr̄ / a° 1°

Bulle an Seide

In plica rechts : Jac̄ Mut

A tergo oben Mitte : Philippus de Pomonte
Kleine sehr fette ungemein schöne Schr.
Ecke oben links : &

3933

Paris Archives Nationales
J 688 n. 112 (bis)

Breite 37.4 Rand links 3.4 rechts 3.1
Höhe 26.4 Rand oben 7.2 plica 3.8

Erste Linie für Gitterschr und Ober-
längen / Mit je einer Seitenlinie

P. vacat 1278 Septembris 20

Nicolaus III (Gitterschr) Carme in
xp̄o filie Marie Regine Francor
Jllustri

Personam tuam denotione

Dat Viterbij XII Kl̄ Octobr̄ a° 1°

Bulle an Seide

In plica rechts : M de Rocca
Sub plica links : ...

Ecke oben links : a
Sehr fette kleine sehr schöne Schrift

3934 (recto)

Paris Archives Nationales
J 689 n. 129⁶

Breite 31.9 Rand links 2.5 rechts 2.4
Höhe 24.7 Rand oben 4.9 plica 3.7

Erste Linie für Gitterschr und
Oberlängen / Je eine Seitenlinie

P. vacat 1278 Septembris 20

Nicolaus III (Gitterschr) Carniss
in xp̄o filijs Phylippo Regi et Ma
rie Vxori eius Regine Francor
Jllustribus

Apertis petene gratie

Dat Viterbij XII Kl̄ Octobr̄ a° 1°

Bulle an feiner Seide

In plica rechts : Jac̄ Roc̄
Sub plica links : -- Jacob

A tergo oben Mitte!
Philippus de Pomonte

Sehr zarte kleine schöne Schrift.

Paris Archives Nationales

J 690 n. 132 (8)

Breite 33.7 Rand links 2.8 rechts. 2.6
Höhe 22.2 Rand oben 5.6 plica 3.9
Erste Zeile für Gitterschr. und Ober-
längen, je zwei Seitenlinien
P. vacat __1278 Septembris 20__
Nicolaus III (Gitterschrift) Carme
in xpo filie (Regine Marie) Francorum
Jelustri
Consuevit interdum sedes
Dat Viterbii / XII Kl. Octobris a° 1°
Bulla an Seide
In plica links : O. Land
 Sub plica links : --
A tergo oben Mitte : Phs de Pomonte

Prachtvolle feste
zette Schrift

3936

P.— Paris Arch. Nat.
J 691 cap. 135³ __1278 Sept. 20__
Nic III Philippo regi Franco-
rum illustri
Consuevit interdum sedes
Viterbii XII Kl. Octobris a° 1°
Bulle an Seide
In plica rechts G. Al
Sub plica links ..

 " " Bug ausgestrichen
 F. Atin
Ecke oben links I. rechts Rx
links 4 f
A tergo Procurator
 scpt CXLIII
 cap X

3937

P.— Paris Arch. Nat.
J 691 cap. 138² __1278 Sept. 20__
Nic III XII Kl. Oct. a° 1°
Sub plica links .?
 Sy Ven
 g
Sub plica links, Bug, durch-
strichen und abgekratzt
 Rx fulco
 J. Atin
Rand oben links . I. Rx J.
Rand oben rechts Rx
A tergo scpt CXL
 cap X

J 692 cap. 147² dieselben Noten
auf dem Bug. Ber Rx CXLIII

3938

P. — Paris Arch. nat.
J 697 cap. 39 <u>1278 Sept. 20</u>
Nic III XII ... Oct. a° 1°
In plica rechts Sy Ven.
Sub plica links ?

Sy Ven
9

Sub plica links Buy ausge-
strichen und abgeklatscht
Rx Bern Lamor
J Atin
Rand oben links . J.
und ... J
Ecke rechts Rx
A tergo CLXXI
sopi
cap

3939

Archives Nationales Paris
L 266 n.9 <u>1278 Septembris 20</u>
Br. 38. hoch 27. Plica 3.9
oberer Rand 7. links 1.9
rechts 2.2
Nicolaus III S. tt sancte Ci-
cilie pbro Cardinali aplice sedis
Legato
Significante olim sicut
dat Viterbij XII ... Octobr a° 1°
Bulle an dünnem Hanf
In plica rechts: B. Lamoren
Sub plica links: ?
A tergo oben Mitte: Philippus de Pamonte
Sehr sorgfältige grosse fette Schrift
mit einem betonten Buchstaben
<u>Je zwei Seitenlinien</u>

P. vacat

3940

Archives Nationales Paris
L 266 n.10 bis <u>1278 Septembris 22</u>
Br. 36.3 hoch 18.4 Plica 4.9
oberer Rand 7.5 links 2.2
rechts 2.1
Nicolaus III (Gitterschrift Ini-
tiale ausgespart) Matheo Abbati
usw. wie n. 10
Bulle an feiner Seide P. 21450
Sub plica links: Sy. Ven
Darunter auf der plica:
Rx Fulco F. Atin
Rand oben links: F
Rand oben Mitte: Ecke oben Rechts: Rx
A tergo oben Mitte: n. de S¹⁰ Victore
Darunter etwas angelenkt
stark betont 3.2 CCII
sopi
cap
Feste breite Schrift, mit
<u>3</u> betonten Satzanfängen
usw.
In servus servorum
haben die s zwei oberlängen
aufgesetzt

3941 (recto)

Paris Archives Nationales
J 585 n. 43
Breite 34.8 Rand links 2.6 rechts 2.5
Höhe 25.2 Rand oben 5.7 plica 5.1
<u>Erste Linie</u> für die geknoteten Oberlän-
gen, <u>weite</u> für Gitterschr und andere
Oberlängen / Je eine Seitenlinie
<u>P. vacat</u> <u>1278 Septembris 22</u>
Nicolaus III (Gitterschr) Carissimo in
xpo filio Philippo Regi Francor.
Illustri
Personam tuam devotione
dat Viterbij X Kl Octobr / a° 1°
Bulle an feiner Seide
In plica rechts . B. Pasin
Sub plica abgeklatscht! . --

verte

3941 (verso)

A tergo oben Mitte:

Philippus de Pomonte

Sehr feierliche fette große Schrift

3942

P. — Paris Arch. Nat.

J 685 cap. 43 bis 1278 Sept. 22

hic III Philippo regi Franco-
rum illustri

Personam tuam devotione

Viterbii × pat octobris a° 1°

Bulle an Seide

In plica rechts G. Ali

Sub plica links --
9

Rand oben links ·u]. ⌀ f

Sub plica links Dng abgeklatscht

Rf B pa f atin

Ecke oben rechts Rf

3943 (recto)

Rf

Paris Archives Nationales
J 686 n. 43 bis

Breite 33,9 Rand links 2.4 rechts 2.8
Höhe 21.7 Rand oben 6 plica 4.1

Erste Linie für Gitterschrift und
einige Oberlängen / Je zwei Lei-
tenlinien

P. vacat 1278 Septembris 22

Nicolaus III (Gitterschr) Carmo
in xpo filio Philippo Regi Fran-
corum Illustri

Personam tuam devotione
Dat Viterbii × pt Octobr / a° 1°
Bulle an feiner Seide
In plica rechts: G. aly
Sub plica links: --
9 vute

3943 (verso)

Sub plica links Alles abgeklatscht:

Rf Bi pa u F Ang

Rand oben links: ·l.

und ⌀ F

Ecke oben rechts: Rf

A tergo oben Mitte:

Philippus de Pomonte

Darunter schlank mit zierli-
chen Schnörkeln

C X L ij

Fette etwas nachlässige Schrift

3944

Paris Archives Nationales
J 688 n. 102
Breite 31.7 Rand links 2.8 rechts 2.8
Höhe 21.7 Rand oben 5. plica 3.5
Erste Linie nur für Gitterschrift
Je eine Lutenlinie
P. vacat 1278 Septembris 22
Nicolaus III (Gitterschr.) Carme in
xpo filie Marie Regine Fransorf
Jlluski
 Personam tuam devotione
Dat Viterbij X kl Octobr/ a°1°
Bulle in seide
In plica rechts : P. V.
Sub plica links : .5.
A tergo oben mitte : Philippus de Pomort
krumsivolle kleine fette Schrift

3945

Paris Archives Nationales
J 688 n. 110
Breite 34.2 Rand links 2.6 rechts 2.6
Höhe 25.6 Rand oben 6.5 plica 4.
 Erste Linie für Gitterschr. nur
Oberlängen/ Je eine Lutenlinie
P. vacat 1278 Septembris 22
Nicolaus III (Gitterschr.) Carme in
xpo filie Marie Regine Fransorf
Jlluski
 Persona tua devotione
Dat Viterbij / X kl Octobr. a°1°
Bulle an feiner Seide
In plica rechts : Jy Sei
Sub plica links : .5.
A tergo oben Mitte : Phylippus de Pom
Fette kleine sehr
regelm. Schrift

3946

Archives Nationales Paris
L 266 n. 10 1278 Septembris 22
Br. 33.4 hoch 28.9 Plica 3.4
oberer Rand 8.8 links 2.1
rechts 2.
 Nicolaus III (Gitterschrift,
Initiale verziert) Matheo Abbati
Monasterij sancti Dyonisij in
Francia ad Roman Ecclиam nullo
medio pertinentis ordinis sancti
Benedicti Parisien dioc
 Religionis zuadet honestas
Dat Viterbij X kl Octobr a°1°
Bulle an feiner Seide
 In plica rechts : -F.
Sub plica links : - - -
 A tergo oben mitte: N. de Sto Victore

Weite fette Schrift, mit gestr. Signaturen
mit 4 verzierten Satzanfängen
In 1. Zeile 1 verz. Buchstabe
Erste Linie für Gitterschrift und un-
tere Oberlängen
 P. 21450

3947

Archives Nationales Paris
L 266 n. 11 1278 Septembris 22
Br. 37.6 hoch 29.2 Plica 3.8
oberer Rand 7. links 2.4
rechts 2.2
 Nicolaus III . M. Abbati mo-
nasterij sti Dyonisij in Francia ad
Roman eccliam nullo medio per-
tinentis ordinis sancti Benedicti
Parisien dioc
 Geritur in affectu
Dat Viterbij X kl Octobr a° 1°
Bulle an Hanf
 In plica rechts : p. berief
Sub plica links : - - - -
 A tergo oben mitte : N de Sto Victore

Fette kleine Schrift
 Mit einem betonten Buchstaben
Erste Linie für Oberlängen
 P. vacat

3948

Madrid Arch. Histór. Nacional
Zamora Toro 3 E
P. — 1278 Septembris 24
Nicolaus III .. magro Ordi
nis fratrum Praedicat.
 Petitio tua nobis
Reate VIII Kl. octobris a° 1°
Bulle und Seide fehlen
In plica rechts N. Viviani
Sub plica links v̄

3949

Bull. gen. I cap. II 11
P. — 1278 Sept. 30
Nicolaus III Silvestro Rayne
xtr
gr. mittelgr. Gitt. geschweift, oben dick
 intendimus
pū Gasti militis de Viterbio
 Dignum reputamus et
Viterbii apud S. Franciscum
pridie Kalas. Octobr a° 1°
Rand rechts und plica abgeschn.
von einem neuen Schreiber, mit
allerlei Unregelmässigkeiten

Fehler

3950

Paris Archives Nationales
 J 449 n. 113
Zwei freie Linien über den
Oberlängen / Je eine Seitenlinie
P. vacat 1278 Octobris 3
Nicolaus III dil filio S. tt
sancte Cecilie pbro Cardinali
aplice sedis Legato
 Sicut ex parte
Dat Viterbij V non Octobr 1
a° 1°
Bulle an Hanf
In plica rechts : G. aly
Sub plica links :
A tergo oben Mitte : Philippus
Nachlässige kleine] de Pennonte
Schrift

3951 (recto)

R↗

Paris Archives Nationales
 J 449 n. 113 bis
Erste Linie über Oberlängen /
Je eine Seitenlinie
P. vacat 1278 Octobris 3
Nicolaus III dil filio S. tt
sancte Cecilie pbro Cardinali
aplice sedis Legato
 Sicut ex parte
Dat Viterbij V non Octobr a° 1°
Bulle an Hanf
In plica rechts : G. aly erste
Sub plica links abgeklatscht : g
 ---- Rand oben links :|
 g und : ◊ F / Mitte :
 F. Atin oii / Ecke oben rechts :
 R↗

3951 (verso)

A tergo oben mitte
Phylippus de Pemonte

Schlank groß mit dicken
Strich

(scō) CLXII
(cāp)

Regeln. etwas flüchtige
Schrift

3952 (recto)

Rx

Paris Archives Nationales
J 690 n. 132bis

Breite 45.5 Rand links 3.9 rechts 4.1
Höhe 37,6 Rand oben 8.8 plica 5.5
Erste Linie über den Oberlängen
Je zwei Seitenlinien

P. vacat 1278 Octobris 3

Nicolaus III . . Sancti Vyonisii
in Francia Parisien̄ dioc et . .
Sancti Germani de Pratis Parisiē
ū Monasteriorz abbatibus

Regie celsitudinis merita
Dat Viterbij v non Octob̄/a° 1°
Bulle an Hanf
In plica rechts : G aly
Sub plica links : ⸿ mō ⟨verte⟩

F. Atin

3952 (verso)

Rand oben links :. 2. mō ⸿ F
A tergo oben mitte 1
Phylippus
de Pomonte

(scō) C L.
(cāp)

3953 (recto)

Rx

Paris Archives Nationales
J 690 n. 132ter

Breite 43.5 Rand links 5.1 rechts 4.7
Höhe 33.9 Rand oben 8.9 plica 4.9
Erste Linie für Gitterschrift und
Oberlängen / Je zwei Seitenlinien

P. vacat. 1278 Octobris 3

Nicolaus III (Gitterschrift) Carmo
ū xp̄o filio Philippo Regi Fran-
corz̄ Illustri

Regie celsitudinis merita
Dat Viterbij v non Octob̄/a° 1°
Bulle an sehr feiner Seide
In plica rechts : G. aly
Sub plica links : ⸿
9 mō abge ⟨kratzt⟩

F. Atin Rx Jas M̄ul verte.

3953 (verso)

Rand oben links : . l. mit

N F

Ecke oben rechts : R

a tergo oben Mitte :

 Phylippus

 de Pomonte

3954

Paris Archives Nationales

 J. 690 n. 132⁹

Breite 39.3 Rand links 2.2 rechts 2.

Höhe 28.2 Rand oben 6.2 plica 3.7

 Erste Linie für Gitterschr. mit Ober-

länger / Je eine Textlinie

P. vacat <u>1278 Octobris 3</u>

Nicolaus III (Gitterschr.) Carmo in

xpo filio Philippo Regi Francorum

Jelustri

 Regie celsitudinis merita

Dat Viterbij V non Octobr / a° 1°

 Bulle an feiner Seide

In plica rechts : dat. Mut

A tergo oben Mitte :

 Philippus de Pomonte

fette sehr schöne Schrift

3955

Paris Archives Nationales

 J 690 n. 132¹⁰

Breite 46.2 Rand links 3. rechts 2.5

Höhe 34, Rand oben 7.5 plica

 Erste Linie über den Oberlängen

Je eine Textlinie

P. vacat <u>1278 Octobris 3</u>

Nicolaus III . . Sancti Dyonisij

in Francia Parisien dioc et . .

Sci Germani de Pratis Parisien

monasteriorum abbatibus

 Regie celsitudinis merita

Dat Viterbij V non Octobr / a° 1°

Bulle an Hanf

 In plica rechts : G. aly

 Sub plica links : V

a tergo oben Mitte :

 Philippus

 de Pomonte

3956

Archives Nationales Paris

L 266 n. 12 <u>1278 Novembris 15</u>

 P. 21484

Br. 30.8 hoch 22. Plica 3.2

oben Rand 6.8 links 1.8

rechts 2.6

 Nicolaus III (Gitterschrift

Initiale ausgespart) . . Abbati

et Conventui Monasterij sancti

Dionisij in Francia ad Romanam

ecclesiam nullo medio pertinentis

ordinis sci Benedicti Parisien dioc

 Ex parte vestra

Dat R. ap. S. P. XVIJ Kl. Dec. a° 1°

 Bulle an feiner Seide

 In plica rechts : . P. Ro

Sub plica links :

 Dat Roman

Darunter auf der plica :

 F. Atin

Rand oben links : dupl. F

 Ecke oben rechts : b

A tergo Ecke oben links : 6

 oben Mitte : Jam Jacobe

Schöne kleine Schrift, mit geschr. Ligaturen

mit 3 bel. Schranßigen. In 1. Zeile

1 bel. Buchstabe. Erste Linie für

 Gitterschrift

3957

Archives Nationales Paris

L 246 n. 12 bis __1278 Novembris 15__
 P. 21484
Br. 31.5 hoch 21 Plica 4.5
obere Rand 5.5 links 1.9
rechts 1.9
 Nicolaus III (Gitterschrift,
Initiale ausgespart) .. Abbati et
Conventui Monasterii sancti dio-
nisii in Francia ad Roman eccliam
nullo medio pertinentis ordinis
sancti Benedicti Parisien dioc
 Ex parte nra
Dat Rome apud Sem Petrum XVII
Kl Decembris a° 1°

Bulle au Seide
 In plica rechts : F . . .
Sub plica links : _ _
A tergo oben Mitte gelöscht
 ~ de Sto Victore darunter
 Jam Jacobe
Nachlässige fette Schrift, nov. nri
n. 12
 Je zwei Seitenlinien

Über dem Text zwei leere Linien

3958

Toulouse Archives Départem.
H. 28

P. — __1278 Novembris 19__

Nicolaus III .. epo Biterren
ad audientiam nostram
Rome apud Sem Petrum XIII
Kl. Dec. a° 1°
Bulle an Hanf
In plica rechts B p usiu
Subplica links ..
Grosse deutliche Schrift

3959

P. — Paris Arch. Nat.
J 391 cap. 1 __1278 Dec. 3__
 Clausa
Alle vier Ränder
sehr breit

Nic III .. regi Francie illustr
Querela gravis grandis
Rome apud S Petrum III non.
dec. a° 1°
A tergo rechts Mitte von unten
 Rand
nach oben pro b. c

3960 (recto)

de Curia

Paris Archives Nationales
 J 449 n. 108
Breite 76.5 Rand links 3.7 rechts 3.6
Höhe 52.1 Rand oben 71 plica 6.
Erste Linie für Oberlängen / je
zwei Seitenlinien
P. vacat __1278 Decembris 3__
Nicolaus III Nob Viris R Bur-
gundie e J Britanie ducibus
ac G Flandrie E Campanie ac
Brie P Alenzone z Carnoten R
Clarimonten T Barri R Altoba-
... R Nivernen R Drocen z
Montisfortis H Marchie z Engolisme
J Pontivi G Sto Pauli J Suessio-
nen J Donnimartini J Rociaci .
z J Sacricesaris Comitibus ac J

3960 (verso)

J Buticularis ǫ J Constabulario
Francie ǫ J de Cociaco G de Archepo
ǫ S. de nigella dominis ac R Cash.
deni ǫ G Thoartij vicecomitibus

Samaritanus patris eterni

Dat Rome / apud Sctm Petrum ꝯ
Nõ decembr̄ a°1°

Bulle an Hanf

In plica rechts: A. Mẽd
de cur

Ocke oben links : 2.

Fette regelm. Schrift

A tergo oben Mitte : eps Ambiannsis

3961

Stratsarchiv Wien Chronol.

Clausa 1278 Decembris 21

nicolaus ꝯ . . archepo Salge-
burgen.

Decet te prudenter

Rom. apud Scm Petrum
ꟙꟙ Kl. Jan. a°1°

Bulle und Hanf
liegen bei

P. –

3962

lecta in nota Viterbii
Archives Nationales Paris

L266 p.13 1278 Decembris 22
P. –

Br. 35.7 hoch 28.8 Plica 4.4
oberer Rand 7.1 links 1.6
rechts 1.4

Nicolaus ꝯ Matheo abbti
Monasterij sci Dyonisij in Francia
ad Roman ecclam nullo medio
pertinentis ordinis sci Benedicti
Parisien diöc

Significasti nobis quod
Dat Rõm apud Scm Petrum ꟙ Kl
Januarx a°1°

Bulle an Hanf
In plica rechts : F. B
Ecke oben rechts : J
Rand oben Mitte : lecta in nota Vitei
Ocke oben rechts : Rx lij
A tergo oben Mitte : F de Piperno
Darunter strik be.
hoch 2.8
Kleine sehr schöne Schr.
mit einem bet Buch.
Oben
Erste freie Linie zwecklos
CXIII (2)

3963

Instr. miur. F. dom. c. 123 1278 Dec. 30
P. –

nic. ꝯ univ potestatibus, capitaneis
et rectoribus etc. per Lombardie pro
vinciam constitutis
Illa vos credimus –
Rome ap. SP. ꟙ Kal. Dec. a° 2°
Bulle an Hanffaden.
In plica links : O. Saint.
Oben links : 2. , rechts P
Oben Mitte : de mandato dni
darunter Sffr
Sub plica links : ū
P. V.
9

Auf dem Bug durchstrichen :
Rx p an p an . F. an
Darunter : XVII Ꜧ daneben XVII
A tergo : inquisitores Lombardie
scripti CLXXXI
cap

de morte fratris Pagani Lombardi
inquisitoris hereticorum

3964

Archives Nationales Paris

L 267 n. 15 1279 Januarii 23

Br. 30.8 hoch 20.8 Plica 3.4
oberer Rand 5.7 links 2.4
rechts 2.2

Nicolaus III (Gitterschrift,
Initiale ausgespart) -- abbati et
conventui Cluniacen.
Cum a nobis
Dat Rom apud Sem Petrum X
Kl Februar a° 2°

Bulle an Seide P.× 21514
Sub plica links : --

Offene sehr fette nachlässige Schrift
mit großen Ligaturen, mit vier be-
sonderen Schraufungen
In 1. Zeile 1 bel. Buchstabe
Freie Linie über dem Text nicht
erkennbar ist aber von
Haaren, die Strich auf dem Rand zeigt

ad istas . Je zwei Seitenlinien
Papstnamen im Text nicht in
Gitterschrift

3965

Archives Nationales Paris

L 267 n. 15 bis 1279 Januarii 23

Br. 35. hoch 23.2 Plica 4.2
oberer Rand 5.8 links 2.5
rechts 2.4
Nicolaus III
wie in 4. 15

Bulle an Seide
In plica rechts : F. a...
Sub plica links : . .

Mit je zwei Seitenlinien

Papstname im Text in Gitterschr.

Erste Linie für Gitterschr. und
untere Oberlängen

P.× 21514

3966

Brit. Mus. Add. Chart. 1549
P. 21513-21 1279 Januarii 23
Nicolaus III .. abbati et conventui
monasterii Cluniacen.
Exigentibus vestre devotionis
Dat. Rome apud S. Petrum X
Kl. februarii a° 2°
Bulle und Seide fehlen
In plica rechts Fe

Sub plica links Jac Romanus
fr. Atrii
Re Jac Nyat
fr Afri Re Jac Smit X
Atrii g

Ecke oben links !
" " rechts !
a tergo. XPO LXXVII

Klein

3967

Madrid Arch. Histór. Nacional
Logroño S. Millan
Santa Maria de Suvota n 42
P. - 1279 februarii 5
Nicolaus III .. archidiaconus de
Nagera in ecclie Calagurritan.
Conquesti sunt nobis
Rome ap. S. Petrum non febr. a°
Bulle fehlt. Auch erhalten
In plica rechts g. Saon
Ecke oben rechts be

3968 (recto)

Madrid Acd. Histor: Nacional
Logroño S. Maria de Herrera.
Vicecancellarius
P. — 1279 Martii 7
Nicolaus III .. abbati monast.
S. Marie de Ferraria eiusque
fratribus etc. in ppm
Religiosam vitam eligentibus
inveniant Amen a. a.
(R) Ego Nicolaus Cath. Eccl. eps (M)
2 presb. 3 epi 5 diac.
dat. Rome ap. S. Petrum per ma-
num magistri Petri de Medio-
lano SRE vicecancellarii
non. martii ind. VII J. dec anno
M. CC. LXXVIII pont. vero domni
Nicolai pp III anno secundo
Bulle fehlt. Seide erhalten.
verte

3968 (verso)

Rand oben links: Privilegium
Commune ord. Cist. O. Laud.
Rand oben Mitte längere va
dick Bemerkung:
... det. ... ascultat.
Ecke oben rechts Go
pet

3969

Napoli Curia Eccles. Vol. 3°
P. — 1279 Martii 7
Nicolaus III .. eps Andren.
Conquesti sunt nobis
Rome apd. Sem Petrum non.
martii a° 2°
Bulle und Hanf fehlen

3970

Poitiers Archives départem.
Montierneuf
Rote Nachbildung
P. 21557ᵃ 1279 Martii 18
Nicolaus III Jvoni abbi Cluniacen.
eiusque successoribus etc in ppm
Iniuncti nobis a
R. M.
underschriften
2 presb. 3 epi s diac.
Rome apud S. Petrum p. m. magi
petri de Mediolan. SRE vicecan
cellarii XV kl. apilis ind. VII J.
dom. a° 1278 pont. 2°

3971

Inoth. Mon. F. dom. c. 132 1279 Martii 22

Cum a nobis P. 21555

Bulle an Seidenfäden

A tergo maioricarum mi

☐ RP Waldini ☐

3972

Nice Archives départem.

H. 1010

__1279 Aprilis 17__

Nicolaus III . . abbati et conven-
tui mon. S. Honorati Lirinen.
OSB Grassen. dioc.

Ex parte vestra

Rome apud Sem Petrum
XV Kl. Maii a° 2°

Bulle fehlt Seide erhalten

In plica rechts Ge. Ba

Sub plica links Jar Roman

Ecke oben rechts

Ligaturen gemischt

Erste Zeile frei. Vertenlinien

3973

Archives Nationales Paris
L 267 n. 16 __1279 Maii 12__

Br. 32,1 hoch 21.9 Plica 3.9
obere Rand 6.2 links ... 2.4
rechts 2.3

Nicolaus III (Gitterschrift
Initiale ausgespart). . Abbati et
Conventui Monasterii sancti Germa-
ni de Pratis Parisien ad Roman
ecclesiam nullo medio pertinentis or-
dinis sancti Benedicti

Devotionis vre precibus
Dat Rome apud Sem Petrum IIII
Jd Maii a° 2°

P. vacat

Bulle und Seide fehlen

In plica links : O. Laud
Sub plica links : Jar Roman

Rand oben mitte

A tergo Ecke oben links : B
n oben mitte übereinander : Guillien
Expit / Ferr / Par
Sehr sorgfältige fette Schrift, mit gestr.
Ligaturen, mit vir verzierten Schat
Schlaufungen. In 1. Zeile 1 verz. Buchstabe
Erste Linie für Gitterschr. und Oberlängen

3974

Archives Nationales Paris
L 267 n. 17 __1279 Maii 12__

Br. 33.2 hoch 21.8 Plica 4.2
obere Rand 6.1 links 1.6
rechts 1.8

Nicolaus III (Gitterschrift
Initiale ausgespart). . Abbati
et Conventui Monasterii sancti
Germani de Pratis Parisien ad
Roman ecclesiam nullo medio
pertinentis ordinis sancti Benedicti

Cum sicut ex
Dat Rome apud Sem Petrum
III Jd Maii a° 2°

P. vacat

Bulle und Seide fehlen

In plica rechts : Sy. Ro
Sub plica links : -

A tergo oben mitte : Guillo
Kleine weite sehr regelm Schrift Capiff
mit gestr. Ligaturen (mit Ferr
einer Ausnahme) mit 3 betonter par
Initie anfangen. In 1. Zeile ein
betonter Buchstabe
Erste Linie für Gitterschrift und
untere Oberlängen

3975

Archives Nationales Paris
L 267 n. 18 1279 Maii 12

Br. 40.4 hoch 30.4 Plica 4.9
oberer Rand 9.2 links 3.1
rechts 2.9
 Nicolaus III (Gitterschrift
Initiale ausgespart) .. Abbati
et Conventui Monasterij sancti
Germani de Pratis Parisius ad Ro
man ecclam nullo medio pertinentis
ordinis sancti Benedicti
 Ex parte ua
Dat Rome apud Scm Petrum III
Id Maij a° 20
 P. vacat
Bulle fehlt, Seide erhalten
 In plica links : · O. Laud.
Sub plica links : - - -
 Jac Roman
Rand oben Mitte ꝶ F
Ecke oben rechts : ba
 A tergo oben Mitte : Guillus
Zugemein sorgfältige ge rapide
ferte Schrift, zart gestri- ferri
chelter mit 3 verzierten Par
Satzanfängen, mit 1 verz. Buchstaben
in 1. Zeile. Erste Linie für Gitterschr.
 mit Oberlängen

3976

Statsarchiv kein Chronol.
P. 21585 1279 Maii 25
Nicolaus III Johanni episco-
po Jurcen.

Romani pontificis quem
Rome apud Sanctum Petrum
VIII Kl. Junii a° 20
Bulle an Hanf
In plica rechts pa. de pon.
Ecke oben links ꝗ F . C.
& rechts Rꝑ
Sub plica links X und Rꝑ
Phi F. Atin. LXXXXI
A tergo Mittelgross

3977

Paris Archives Nationales
 J 446 n. 33 bis
P. vacat 1279 Julii 3
Martinus IIII .. Archiepo Rotho.
magen

 Felicis recordationis Gregorius
Dat apud Montem flasconem V
Non Julij a° 2°
Bulle fehlt Hanf erhalten
In plica rechts : Maur de Cur
Erste Linie für Oberlängen, da
rüber eine zweite Linie / je
Zwei Seitenlinien

Sehr schöne grosse fette Schrift

3978

Firenze, S. Croce di firenze
P. — 1279 Augusti 14
Nicolaus III ad perp. rei mem.
 Exiit qui seminat
Lugduni XVIII Kl. Sept. a° 2°
 Bulle und Seide fehlen
In plica rechts Jₒ. Gen.
In plica Mitte
 est computata Leo
Rand oben Mitte ascultp
70.00 hoch 707.7 breit.
 4.4 plica
98 Zeilen zu ungefähr 63
Worten = 6174 Worte
Sehr regelmässige, schöne
kleine Schrift.

3979

Firenze, S. Croce di Firenze
P. 21630 1279 Augusti 25
Nicolaus III [ohne Punkte] uni-
versis xpi fidelibus ad quos
littere iste pervenerint
 Litteras felicis recordationis
Iunocii VIII Kl. Sept. a° 2°
 Bulle fehlt, Seide erhalten
In plica links Jač bocl
 Breite Ränder,
 breite Plica
 Eine Zeile frei
Sub Plica frei

3980

Archives Nationales Paris
L 267 u. 19 1279 Septembris 27
Br. 33.2 hoch 24.9 Plica 3.4
 oberer Rand 5.7 links 2.3
rechts 2.1
 Nicolaus III . . Archepo
Turonen
 Sub religionis habitu
Dat Viterbij V Kl octobᵣ a° 2°
 Bulle fehlt, Hanf erhalten
 In plica rechts : Sy. Ber
Sub plica links : ⁻c̄
Rand oben Mitte : concessa p. dm Jač Romau
Q Ecke oben rechts : ay
A tergo Ecke oben links : 6
 " oben Mitte : +
 [W. Waldini]
Schwungvolle
schöne Schrift mit einem betonten
 Buchstaben
Erste Linie für Oberlängen
 concessa per dominum
 P. vacat

3981

Archives Nationales Paris
L 267 u. 20 1279 Septembris 27
Br. 33, hoch 23.9 Plica 3.8
 oberer Rand 5.3 links 2.2
rechts 2.1
 Nicolaus III . . Archepo Ro-
thomagen
 Sub religionis habitu
Dat Viterbij V Kl octobᵣ a° 2°
 Bulle fehlt . Hanf erhalten
 In plica rechts : Sy. Ber
Sub plica links : ⁻s
 Jač Romau
Rand oben Mitte : concessa p dom
 Ecke oben rechts : ay
A tergo oben Mitte : +
 [W. Waldini]
Regelm. Kleine Schrift
mit einem betonten Buchstaben
Erste Linie für Oberlängen
 concessa per dominum

 P. vacat

3982

Toulouse, Archives départem.
H. 28
P. — 1279 Novembris 4
Nicolaus III .. abbati seculari
ecclesie Sancti Affrodisii Bi:
teren. dioc
 Ad audientiam nostram
Rome apud San Petrum II
non . Novembris a° 2°
 Bulle uud Hanf fehlen
In plica rechts hame
Sub plica links . .
 p. v.

Archives Nationales Paris
LL 67 n. 21 __1279 Novembris 13__

Br. 19.3 hoch 16.4 Plica 2.7
oberer Rand 3.1 links 1.4
rechts 1.3
 Nicolaus III .. Cantori
ecclie de Chableys Lingonen dioc
 Conquesti sunt nobis
Dat Rome apud Scm Petrm Jd
Novembre a° 2°

Bulle und Hanf fehlen
 In plica rechts : maur
Ecke oben rechts : ~~bo~~
A tergo oben Mitte : Hugo de Virdun
" Ecke oben links : R

Sehr fette kleine regelm Schrift ohne
jeden betonten Buchstaben
Erste freie Jd Linie zwecklos

P. vacat

Firenze, S. Croce di Firenze
P.— __1279 Novembris 20__
Nicolaus III . generali et
provincialibus ministris ac
custodibus et univ. fribus
ordinis frum Minorum
Litteras felicis recordationis
 Suriani XII kl. Dec. a° 2°
Bulle und Seide fehlen
~~In plica links scriptor~~
Sehr schöne mittelgrosse
Schrift der grossen Urkunde

__de curia__ __duplicetur__
 __Vicecancellarius__
Paris Archives Nationales
 J 449 n. 115
Erste Linie für Oberlängen/
Je eine Seitenlinie
P. vacat __1280 Martii 31__
Nicolaus III Carmo in xpo filio
- - Regi Francie Jllustri
Felicis recordationis Gregorius
Dat Rome apud Scm Petrm
II Kl Aprilis / a° 3°
 Bulle an Hanf
In plica rechts : p . benef
 de Cur
Sub plica links : g
In plica halblinks : R g. Aly
Reput de Cur
Rand oben links : 2. dann : dup vic
 vac

A tergo oben Mitte :
 Quitt
 Capitis
 feri
Regelm. fette kleine Schrift

3986

Taxae

Archives Nationales Paris
L 268 n. 22 1280 Aprilis 5

Br. 32.1 hoch 23. Plica 3.2
obere Rand 6.5 links 1.9
rechts 1.9
 Nicolaus III (Gitterschrift
Initiale ausgespart.) .. Abbati
et Conventui Monasterij sancti
Mauri Fossatensis ordinis sancti
Benedicti Parisien
 Cum a nobis
Dat Rome apud S. Petrum non
Aprilis aº 3º P. vacat.
Bulle und Seide fehlen
 In plica rechts : p. benet
darunter von Procurator : Johis
quattuor Turonen grossos 2 VIII
Turonen parvos
 Sub plica links : R. C.
 A tergo Ecke oben links : 6
 „ oben mitte : Jam Jacobe
fette kleine Schrift, mit gestr. Ligaturen
(mit einer Ausnahme) mit 4 betonten
Satzanfängen. In 1. Zeile 1 bet. Buchstb.
Erste Linie für Gitterschr. und untere
 Oberlängen

3987

Archives Nationales Paris
L 268 n. 23 1280 Junii 27

Br. 66, hoch 46.5 Plica 4.5
obere Rand 8.7 links 4.
rechts 4.1
 Nicolaus III Capitulo
ecclie Parisien
 Sollicitudinis apliceˉ Studium
Dat Viterbii V kl Julij aº 3º

Bulle an Hanf
 In plica rechts : Jac Mut
 de Curia
Ohne alle Bemerkungen

Mit einem betonten Buchstaben

Sehr sorgfältige, weite und schöne
 Schrift
Ohne erste freie Zeile

 de Curia
 P. vacat

3988

Madrid Arch. Histór. Nacional
 III Piedra 36 E
 P. — 1280 Julii 1
Nicolaus III .. sacriste secu-
laris ecclie Tutelan. Tyra-
sonen. dioc.
Sua nobis Thomasius
Tirasonen. kl. Julii aº 3º
Bulle fehlt. Hanf erhalten
In plica rechts M Romanus
Sub plica links
Rand oben mitte
Renouelh In Audi

3989

Archives Nationales Paris
L 268 n. 24 1280 Julii 15

Br. 30.9 hoch 22. Plica 3.7
obere Rand 5. links 2.1
rechts 1.8
 Nicolaus III .. Abbati et
Conventui Monasterij sci Victoris
Parisien ordinis sci Augustini
 Cum a nobis
Dat Viterbii Jd Julij aº 3º

Kulle an feiner Seide
 In plica rechts : Galgand
Sub plica links : ..
 Henr Rad
Ecke oben rechts : Ay

Kleine fette Schrift, mit gestr. Liga-
turen, mit 4 betonten Satzanfängen
 In 1. Zeile ein betonter Buchstabe

Erste Linie für Gitterschrift und
 untere Oberlängen

 P. vacat

3990

Arch. Arcis
Arm. IX cap. 5. cap. 2
P. 21744　　　　1281 Aprilis 29
Martinus IIII charissimo in X°
filio Carolo regi Siciliae illustri
senatori Urbis
　Pater futuri seculi
Dat. apud Urbemveterem
III Kl. Maii　a° 1°
　Bulle an feinen Seidenfäden
A tergo oben Mitte

scpt lo
cap

scdo

3991

Instr. misc. 1276 - Exp. 36
　P. —　　　　~~1281~~ 1281 Maii 3
Mart. IIII ven. fratribus ...
Imprimis (?)
Apud Urbemveterem V non.
Maii a° 1°
　Bulle und Hanf fehlen
Zerpressen und beschmiert.
In plica rechts : J. Laur.
Sub plica links : :
　　　　　　　　x

Rand oben links : Dupplicetur in
continenti sub pena iuramenti de
mandato d̅n̅i̅ dicti et (das Weitere ist aus-
gepressen und verschwunden)
　(vielleicht dupp et se (mittatur ...

3992

Madrid Arch. Histór. nacional
　　　　　　Poblet E u. 81
　P. —　　　　1281 Maii 15
Martinus IIII .. abbi et conv.
mon. de Populeto Cist.O. Ter-
raconen. diöc.
　Cum a nobis
Apud Urbem veterem iii. Maii
　　　　　　a° 1°
Bulle fehlt. Seide erhalten
In plica rechts Jac de Roo
Sub plica links − −
　　　　　H. Pad
Ecke oben rechts Jac

3993

Firenze , Badia Fiorentina
　P. —　　　　1281 Iunii 17
Martinus IIII .. plebano plebis
sci Pauli de Peri echo Pistori-
en. diöc.
　Dilectus filius .. prior
Apud Urbemveterem XV Kl.
Iulii a° 1°
　Bulle fehlt, Hanf erhalten
In plica rechts scriptor
　Sub plica links ..
|| Grosse Räume , grosse plica

3994

Toulouse, Archives Départem.
H. 29

P.— 1281 Junii 20

Martinus IIII . . archidiaconus
de Sco Castore in ecclesia aptien
 Ad audienciam nostram
Apud Urbem veterem XII Kl.
Julii a° 1°
 Bulle fehlt, Hanf erhalten
In plica rechts: G. Mar ?
Sub plica links: —
Ecke oben rechts: ad

3995

Bayer. Haupt. Staatsarchiv
Kl. Herrenbreun Fasc. 4

P. 27767^x 1281 Julii 1

Martinus IIII . . Preposito ecclie de
Leubach Augusten. dioc.
 Ad audienciam nostram
Apud Urbemveterem Kl. July Anno
Primo

Bulle an dünnem Hanf
In plica rechts: b. Ant (Ant)
A tergo Ecke oben links: a
Sub plica links: . .
 f. ann.

Enge mittelgrosse Schrift fliesst aus
breiter Feder

3996 (recto)

(Datum)

Paris Archives Nationales R
 J 683 n. 4
Breite 33,1 Rand links 3. rechts 2.9
Höhe 25.8 Rand oben 6.8 plica 5.2
 Erste Linie für Gitterschr und
kleinen Oberlängen) Je eine Seitenlinie
P. vacat 1281 Octobris 3
Martinus IIII (Gitterschr) Carmo in
Xpo filio Philippo Regi Francie
Jllustri
 Celsitudinis Regie gratificari
Dat/apud Urbemveterem Non
Octobr a° 1°
 Bulle an Seide
In plica rechts: Jac de Roce
A tergo oben mitte: verte
 J. de Sco Gorman

3996 (verso)

mittelgross stark verschnörkelt
mit dickem Strich:

Kleine sehr fette klare Schrift

Paris Archives Nationales
 J. 686 n. 64 bis

Breite 45.3 Rand links 3.6 rechts 3.6
Höhe 31.7 Rand oben 9.3 plica 5.1
 Erste Linie in Gitterschr. mit
Oberlängen / Je zwei Leitlinien

P. vacat 1281 Octobris 3

martinus IIII (Gitterschrift) Car
mo in χρο filio . . Regi Francie
Illustri
 Exemie caritatis gelus
 Dat apud Urbemueterem non
Octobr / a° 1°
 Bulle an Seide
In plica rechts : P. Gen.
Sub plica links : - - - -
 F. Aug ovate

A tergo oben mitte :
 J. de Sto Germano
darunter zierlich stark ver
schnörkelt

Sehr weite , sehr regelm.
fette Schrift

P. 21798 x : Paris Arch. Nat.
J 683 cap. 14 ter **1281 Okt. 7**
Mart IIII Philippo regi Francie
illustri
Grandia regie celsitudinis
apud Urbemueterem non . Oct.
 a° 1°
 Bulle an Seide
In plica rechts P. Benetj
Sub plica links --
 F. Atin
daneben abgekantscht Rf P. Gen
 Nept
Ecke oben links Ⱶ Nept
 Ⱶ = distribuat oder
 ähnlich
A tergo: ista duplicatur et fist si

milis pro regina ; darunter

Paris Archives Nationales
J 585 n. 44
Breite 38.3 Rand links 2.7 rechts 2.8
Höhe 26.5 Rand oben 6.6 plica 4.8
Erste Linie für Gitterschr. und
Oberlängen / Je eine Seitenlinie
P. vacat 1281 Octobris 7
Martinus IIII (Gitterschr.) Carmo in
xpo filio Phylippo Regi Francie
Illustri
Affluentis deuotionis affectus
Dat apud Vrbemueterem / Non
Octobr a° 1°
 Bulle an Seide
In plica rechts: P. de Eug
Sub plica links: .5. verte

A tergo oben Mitte:
J. de Sco Germano
Darunter sehr zierlich mit
feinen Schnörkeln:

Paris Archives Nationales
J 684 n. 23
Breite 32.3 Rand links 2.2 rechts 2.1
Höhe 26.8 Rand oben 5.7 plica 4.4
Erste Linie für Gitterschr und Ober-
längen / Je eine Seitenlinie
P. vacat 1281 Octobris 7
Martinus IIII (Gitterschr) Carmo
in xpo filio Phylippo Illustri
Regi Francie
Annuto maioris apud
Dat apud Vrbemueterem Non Oc-
tobr / a° 1°
 Bulle an Seide
 In plica rechts: G. aret
Sub plica links: Fi. Aug

Rand oben Mitte: cor
A tergo Mitte oben schon gezeich-
net mit dickerem Strich:

darüber:
J. de Sco Germano
Kleine fette weitgelagerte Schrift

4001 (recto)

℞

Paris Archives Nationales
J 684 n. 26

Breite 27.7 Rand links 1.6 rechts 1.8
Höhe 17.9 Rand oben 4.7 plica 4.2
Erste Linie über den Oberlängen
Je eine Seitenlinie

P. vacat 1281 Octobris 7

Martinus IIII. Carmo in xpo filio
Phylippo Regi Francie Jllustri
Redundat fili nobis
Dat apud Vrbemueterem / VII ...
Octobr. a° 1°
Bulle an Hanf
In plica rechts: P. G
Sub plica links: S̄
F. Any vale
A tergo oben Mitte: J. de Sto German

4001 (verso)

A tergo oben Mitte mittelgross
schwungvoll ℞ × LIII
cap

Kleine fette regelm. Schrift

4002 (recto)

℞

Paris Archives Nationales
J 685 n. 55

Breite 44.7 Rand links 3.1 rechts 3.
Höhe 32.4 Rand oben 8.5 plica 4.7
Erste Linie für Gitterschr. und
kleinere Oberlängen / Je eine
Seitenlinie

P. vacat 1281 Octobris 7

Martinus IIII (Gitterschr.) Carmo
in xpo filio . . Regi Francie
Jllustri
Dum sublimium excellentiam
Dat apud Vrbemueterem Non
Octobr. / a° 1°
Bulle an Seide
In plica rechts: P. Gen
Sub plica links: - - - -
F. Any vale

4002 (verso)

A tergo oben Mitte:
J. de Sto German
Darunter mit vielen kleinen
Schnörkeln
℞ × × × V°
cap

Sehr weite schwungvolle Schrift

Paris Archives Nationales R
J 686 n. 79ᶜ
Breite 42.1 Rand links 3. rechts 2.8
Höhe 30.7 Rand oben 8.3 plica 5.3
Erste Linie für Gitterschr und Ober-
längen / Je eine Seitenlinie
P. 21795 1281 Octobris 7
Martinus IIII (Gitterschr) Carmo
in xpo filio . Ph. Regi Francorum
Jllustri
Regalis providentie magnitudo
Dat apud Vrbemveterem non
octobr / aᵒ 1ᵒ
Bulle an feiner Seide
In plica rechts : P. Gen
Sub plica links : - - - - -
F. Amy verte

A tergo oben Mitte:
J de Sco Germano
Rund ziemlich mit feiner
Schnörkeln:

Sehr weite, sehr grosse, sehr fette
Schrift

Paris Archives Nationales R
J 686 n. 77ᶜ
Breite 37.2 Rand links 3 rechts 2.9
Höhe 24.5 Rand oben 6.6 plica
Erste Linie für Gitterschr. und Ober-
längen / Je eine Seitenlinie
P. vacat (Gitterschr) 1281 Octobris 7
Martinus IIII Carmo in xpo filio
Philippo Regi Francie Jllustri
Salutis Regie incrementum
Dat apud Vrbemveterem / non
Octobr aᵒ 1ᵒ
Bulle an Seide
In plica rechts : Leo
Sub plica links : -
a tergo oben Mitte schlank F. Amy
ziemlich ... XXXVIIII
(cap) darüber: J de Sco Germano

R
Paris Archives Nationales
J 688 n. 101
Breite 30. Rand links 2.7 rechts 2.3
Höhe 30.8 Rand oben 5.1 plica 2.7
Erste Linie für Gitterschr und Ober-
längen / Je eine Seitenlinie
P. vacat 1281 Octobris 7
Martinus IIII (Gitterschr) Carme
in xpo filie Marie Regine Fran-
cie Jllustri
Inter ceteras sedis
Dat apud Vrbemveterem non
Octobr aᵒ 1ᵒ
Bulle an Seide
In plica rechts : Leo
Sub plica links : -
F. Amy
verte

A tergo oben Mitte :
 J. de Sco Germāo

Mittelgross schlank mit vielen
kleinen Schnörkeln

Fette weite kleine Schrift

(Datum) R/

Paris Archives Nationales
 J 690 n. 132 ⅓
Breite 46.4 Rand links 3.7 rechts 3.5
Höhe 34.3 Rand oben 4. plica 4.
Erste Linie für Oberlängen /
Je eine Zeilenlinie
P. vacat 1281 Octobris 7
Martinus IIII . . . Sancti Dyoni-
sij in Francia Parisien diõc et
. . . Sancti Germani de Pratis iux
ta Parisius Monasteroꝝ abbā
tibus
 Exigit devotionis integritas
Dat/ apud Vrbemueterem non
Octobꝝ aº 1º (verte)
 Bulle an dickem Hanf
In plica links : O. Arad

Sub plica links : v̄
A tergo oben Mitte !
 J. de Sco Germāu
darunter schlank mit vielen
kleinen Schnörkeln :

R/

Paris Archives Nationale
 J 690 n. 132 ¼
Breite 44. Rand links 2.7 rechts 3.4
Höhe 32.9 Rand oben 7.6 plica 4.4
 Erste Linie für Gitterschr und klei
nere Oberlängen/ Je eine Zeilenlinie
P. 21798 1281 Octobris 7
Martinus IIII (Gitterschr) Carmo
in xpō filio Philippo Regi Fran
cie Illustri
 Exigit Regalis devotionis
Dat apud Vrbemueterem / non
Octobꝝ aº 1º
 Bulle an Seide
In plica rechts : Jac Romāu
Sub plica links : v̄
 (verte)

A tergo oben Mitte :

J. de sto Germān

[symbol] xlviiij

Kleine schöne flüssige Schrift

℞

Paris Archives de Nationales
J 689 n. 129⁰

Breite 37.3 Randlinks 2.9 rechts 2.8
Höhe 28.2 Randoben 7. plica 4.4
Erste Linie für Gitterschr nur
Oberlängen | Je eine Seitenlinie

P. vacat 1281 Octobris 10

Martinus IIII (Gitterschr) Carmo
in xpo filio Philippo Regi Fran-
cie Jllustri

Et si cunctis

Dat apud Vrbemueterem VJ [symbol]
Jd Octobris a° 10

Bulle an Seide

In plica rechts : Leo Crrate
Sub plica links : — — —
F. Ann

A tergo oben Mitte :

J. de sto Germān

Drunter schlank zierlich mit
vielen kleinen Schnörkeln :

[symbol] xliiij

Steife unschöne Schrift

P. — Paris Arch. Nat.
J 695 cap. 175² 1281 Oct. 15
Mart IIII is oct. a° 10

Bulle an Hanf
In plica rechts p de Eug
In plica links

po et as . M. de Rocca
Sub plica links ...

P. — Paris Arch. Nat.
J 695 cap. 175ᵃ 1281 Oct. 15
Mart IIII iĩ Oct. aº Iº
 Bulle an Hanf
In plica rechts J de Soo Ger-
 mano]
Sub plica links ... some
 abgekratzt und durchstrichen
 Rᵗ p Iᵗg Neput
Am oberen Rande ✠ Nept
a tergo J de Soo Germano

In plica rechts ...

Marseille Archives Départem
H. O. T. 7
P. — 1281 Octobris 23
Martinus IIII .. preposito ec-
clesie Vticen.
 Ad audientiam nostram
Apud Vrbem veterem X Kl.
novembris aº Iº
 Bulle an Hanf
In plica rechts a. de G.
Sub plica links ..

Barcelona Corona de Aragón
 Leg. 16º n. 7º
 P. — 1281 Decembris 13
Martinus IIII .. sacriste eccle-
sie Gerunden.
 Dilectorum filiorum .. precep-
toris
Apud vrbemveterem iĩ. Dec.
 aº Iº
 Bulle an Hanf
In plica rechts V. de G.

 Ganz kleines Mandat.

Madrid Arch. Histór. Nacional
 Poblet C n. 24
 P. — 1281 Decembris 18
Martinus IIII magro Raymun-
do de Bisulduno archidiacono
Tarantone et Raymundo de
Vallibus in Ylerden. ac Ray-
mundo Egidii in Vicen. ecclĩs
canonicis
 Cum olim sicut
Apud montem fliscon. XV Kl.
Jan. aº 2º
 Bulle fehlt. Hanf erhalten
In plica rechts f. Afin
Sub plica links ☰

P. (21825) Paris Arch. nat.
J 698 cap. 54 <u>1281 Dec. 23</u>
Mart IIII.. regi Francie illustri
Inter sollicitudines varias
Apud Urbemveterem X Kl.
 Jan. a° 1°
Bulle an Hanf
In plica links Jac Boet
Sub plica links Ang
Rx ambros J Atin. et fiat
Statim ex parte dni pape

P.— Paris Arch. nat.
J 678 cap. 57 <u>1281 Dec. 23</u>
 <u>Clausa</u>

Schrift geht nicht
bis an die Ein-
rierung. Breite
Ränder

Martinus IIII .. regi Francie
illustri — Quam sit nobis
Apud Urbemveterem X Kl.
Jan. a° 1°

Madrid Arch. Histór. Nacional
 Poblet E n: 59
 P.—
 <u>1282 Januarii 13</u>
Martinus IIII magro. Raymundo
de Bisulduno archidiacono Ta-
rantone in ecclia Ylerden. et
Raymundo de Vallibus Ylerden.
et Raymundo Egidii Vicen. Ca-
nonicis
Conquesti sunt nobis
Apud Urbemveterem III id. Jan.
 a° 2°
Bulle und Hanf fehlen
In plica rechts pen
Ecke oben rechts As
 Kleines mandat

Archives nationales Paris
L 269 n.2 <u>1282 Januarii 18</u>
Br. 30.9 hoch 22. Plica 3.8
 oberer Rand 6.7 links 1.7
rechts 1.5
 Martinus IIII (Gitterschrift
Initiale ausgespart) .. decano et
Capitulo ecclie Parisien
 Cum a nobis
sit apud Urbemveterem XV Kl.
 februarii a° 1°

Bulle an Seide
 In plica rechts : Jy. Sim
Sub plica links : —
 F. atin R̃ Lepvic
Ecke oben rechts : As F. atin

Sehr schöne kleine Schrift, mit gesth.
Ligaturen, mit t betonten Schaufuss
In 1. Zeile ein betonter Buchstabe
Erste Linie für untere Oberlängen

Dilec tis ganz unförmlich
 <u>P. vacat</u>

4018

Archives Nationales Paris

L 269 n. 3 1282 Januarii 18

Br. 31.4 hoch 20.3 Plica 3,
oberer Rand 5.9 links 1.8
rechts 1.8

Martinus IIII .. Epo Carnoten.
Cum iuxta scripture

Dat apud Urbemveterem XV Kl
Februar. a° 1°

Bulle fehlt, Hanf erhalten
In plica rechts: Sy. ven
Sub plica links: S
F. atin darunter
auf der plica: R. Jac. Rom Jac ba..
Ecke oben rechts: asa
A tergo oben mitte: Jam Jacobe
J. de va

Tur .VI.
Kleine sehr regelm. Schrift mit
einem betonten Buchstaben
Erste freie Linie zwecklos

P. vacat

Je zwei Seitenlinien

4019

Archives Nationales Paris

L 269 n. 4 1282 Januarii 18

Br. 27.3 hoch 23.7 Plica 3.
oberer Rand 5.7 links 1.4
rechts 1.5

Martinus IIII . decano
ecclie de Sancto Clodoaldo Pari-
sien dioc
Significarunt nobis dilecti

Dat apud Urbemveterem XV Kl
Februar. a° 1°

Bulle an Hanf
In plica rechts: Sy. ven
In plica links: R. g. Sagey
F. atin
Sub plica links: S
F. atin R lspruce
F atin
Rand oben mitte: R. F. B
Ecke oben rechts: asa
A tergo oben mitte: Jam Jacobe
Kleine fette regelm. Schrift
mit einem betonten Buchstaben
Erste freie Linie zwecklos

P. vacat

4020 (recto)

P. — Paris Arch. Nat.

L. 269 cap. 4 1282 Januarii 18

Mart. IIII .. decano ecclesie de S.
Clodoaldo Parisien. dioc.

Significaverunt nobis dilecti

Ap. Urbemveterem XV Kl. feb. a° 1°

Bulle an Hanf

In plica rechts Sy Ven

Sub plica links S
f. atin

Daneben abgeklatscht durchstrichen
R. Lafranc
J atin

In plica links R. g Sigen
J. atin

4020 (verso)

Rand oben mitte R. F. B
Ecke oben rechts Ven
A tergo mitte Jam Jacobi
darunter pro decan ecc sci
Marchi iuxta parisius
darunter datum non habuit
XII . . .

R. magr dom pel (?) Jo B

4021

Archives nationales Paris

L 269 n. 5　　　1282 Januarii 22

Br. 27.7　hoch 20.5　Plica 2.9
oberer Rand 5.4　links 1.4
rechts 1.3
　　Martinus IIII (Gitterschrift
Initiale ausgespart) . . Abbati
et conventui Monasterij sancti
Victoris Parisien ordinis sancti
Augustini
　　Devotionis ure precibus
üit apud Urbemveterem XI kl [...]
Februar̄ a° 1°　　P. 21842

Bulle an feiner Seide
　　In plica rechts : . F.
Sub plica links :　J. [...]

Rand oben Mitte : [...]
　A tergo oben Mitte : P. de Bixxena
A tergo Ecke oben links : J
Teils weite ordentliche　Schrift
mit gestr. ligaturen, mit drei
betonten Satzanfängen. In 1. Zeile
1 betonter Buchstabe
Erste freie Linie fehlt

4022

Public Record Office London
Papal Bulls bundle 28 n. 4
　　　　Clausa
P. 21844　　　1282 Januarii 28
Martinus IIII -- regi Anglie illustri
Agimus fili carissime
　Apud Urbemveterem V kl
februarii a° 1°
　　Bulle an Hanf

4023

Madrid Arch. Histór. Nacional
S. Esteban de Salamanca n. 21
　P. 21848　　1282 februarii 9
Martinus IIII .. epo Olomucen.
Exhibita nobis dilectorum
Apud Urbemveterem V id.
febr. a° 1°
Bulle fehlt. Seide Hanfschnüren
In plica rechts Jy. Röm
Sub plica links [...]

4024

Papstnamen

Archives nationales Paris

L 269 n. 6　　1282 Martii 7

Br. 52.7　hoch 34.9　Plica 5.5
oberer Rand 11.1　links 3.1
rechts 2.9
　　Martinus IIII Matheo
Abbati Monasterij sancti Dyo-
nisij in Francia ad Romanam
Ecclesiam nullo medio pertinen-
tis ordinis sancti Benedicti
Parisien diōc
　　Laudanda religio que
dat apud Urbemveterem non
Martij a° 1°　　P. 21866

Bulle an Seide
　　In plica rechts : P. Ro
Sub plica links : [...]
A tergo oben Mitte : N. de sco Victore
　　darunter zierlich
mit Schnörkeln 2.6 [...] CXXn°
Kleine regelm. Schrift
mit gestr. ligaturen
Erste Linie für Gotter-
schrift und untere Ober-
　　　längen
Papstnamen im Text nicht in Gitterschr.

4025

Archives Nationales Paris
L 269 n. 6 bis 1282 Martii 7
Br. 50 hoch 29. Plica 4
oberer Rand ~ links 3.6
rechts 3.3
 Martinus IIII
 wie n. 6
der grösser Theil des oberen
Randes ist abgeschnitten, so
dass nur noch ein kleines
Stückchen des grossen R+
a tergo sichtbar ist

Bulle an Seide.
 In plica rechts: p. benet
Sub plica links: ⫶
 J. me
Darunter auf
der plica: R+ ? P. Ro F. Atin

 P. 21866

Je 2 Seitenlinien

4026

Archives Nationales Paris
L 269 n. 7 1282 Martii 7
Br. 60.5 hoch 40.5 plica 5.4
oberer Rand 10.7 links 3.5
rechts 3.6
 Martinus IIII (Gitterschr.
Initiale versiert) Matheo Abbati
Monasterij sancti Dyonisij in
Francia ad Romanam ecclesiam nullo
medio pertinentis ordinis sancti
Benedicti Parisien. dioc.
 Et si cunctis
Dat apud Urbemveterem non.
 martij a° 1° P. 21865
Bulle an sehr schöner feiner Seide
 In plica rechts: a. med
Sub plica links: X
A tergo oben mitte: N. de Sto Victore
darunter fett und
verschnörkelt 3.1
Sehr sorgfältige fette
Schrift, mit gestr. Liga-
turen.
Erste Linie für Gitterschrift
 und Oberlängen.
Je zwei Seitenlinien Papstname
 im Text nicht
 in Gitterschr

4027

Archives Nationales Paris
L 269 n 7 bis 1282 Martii 7
 P. 21865
Br. 55.5 hoch 41.2 Plica 5.6
oberer Rand 9.6 links 4.3
rechts 3.8
 Martinus IIII
 wie n. 7
Bulle an feiner Seide
 In plica rechts: p. benet
Sub plica links: X
 J. me
 9
Rand oben
links: ⊿ Franc
Rand oben mitte: ...
Ecke oben rechts: R+

A tergo wie n. 7
 R-grösse 3.5

Je zwei Seitenlinien
Papstname im Text nicht in
 Gitterschrift.

4028

Graz Landesarchiv n. 1205
P. 21875 1282 Martii 31
Martinus IIII .. abbatisse et
conventui monasterii in
Gorze OSBen. Salzeburg-
gen. dioecesis
 Cum a nobis
Apud Urbemveterem II kl.
Aprilis a° 20
Bulle an Seide
In plica rechts Jacobus de
 Menania
Sub plica links .j. me.
Ecke oben rechts Atin
Gemischte Ligaturen

4029

Graz Landesarchiv h. 1206

P. 21876 **1282 Martii 31**

Martinus IIII .. abbatisse et
conventui monasterii in
Zone Ord Ben. Salzeburgen.
diocesis

Devotionis vestre precibus
Apud Urbemveterem ✝ Kl.
Aprilis a° 2°

Bulle an Seide

In plica rechts Jacobus de
 Menania

Sub plica links J. Me

Ecke oben rechts An

4030

Public Record Office London
Papal Bulls bundle 28 n. 8

P 21894 1282 Aprilis 27

Martinus IIII -- priori de Cruce.
Rois Londonien.

 Sua nobis dilecti

Ap. Urbemveterem V Kl. Maii a° 2°

 Bulle an Hanf

 In plica rechts Abia - - -

 Sub plica ganz unten - -
 f. Anm.

 Rand oben links y. Franco

4031

Firenze, Badia di Passi
 gnano

P. — **1282 Maii 15**

Martinus IIII .. priori de Casale,
.. de Podiobonizi et .. de Sco Ge
miniano ecclesiarum prepo si
tis Wultern. et Florentin. dioc.

 Exposuerunt nobis .. abbes

Apud Urbemveterem id. Maii
anno secundo

Bulle fehlt, Hanf erhalten
In plica rechts p. Vend
 16. 4 hoch. plica 2. 8
 20. 4 breit
 12 Zeilen Kleiner Schrift

4032

Public Record Office London
Papal Bulls bundle 28 n. 19

P. 21911 1282 Junii 4

Martinus IV -- priori de Conceroys
Londonien. dioc.

 Ex parte dilectorum

Apud Urbemveterem II non. Junii a° 2°

Bulle fehlt. Hanf erhalten

In plico rechts . p. Ro

Sub plica links - -
 J. Me

Rand oben ausgeschrieben
fiant due pro una quaque eccle
sia una

Ecke oben rechts an

4033

Marseille Archives Départem.
H. S. 3.
P. — 1282 Junii 5
Martinus IIII .. abbati et conven-
tui monasterii Silvecane
Cist. Aquen. diocesis
 Cum a nobis
Apud Vrbemveterem Non. Ju-
nii aº 2º
 Bulle an Seide
In plica rechts Nume
Sub plica links . .
 J me
A tergo P. de Ass. phi J

4034

Madrid Arch. Histór. Nacional
 Poblet C. z. vncat
 P. — 1282 Junii 5
Martinus IIII .. abti et conventu
mon. de Populeto Cist. O. Tarra-
conen. diöc.
 Cum a nobis
Apud Vrbemveterem Non. Jun.
 aº 2º
 Bulle und Seide fehlen
In plica rechts bñ pgium
Sub plica links j. me
Rand oben Mitte ofje
Ecke oben rechts afr

4035

Brit. Mus. Harl. Chart. 43. A. 45
 P. — 1282 Junii 8
Martinus IIII .. archidiacono
Leycestrie in ecclesia Lincol.
nen.
 Conquesti sunt nobis
Dat. apud Vrbemveterem
II N. Junii aº 2º
 Bulle und Hanf fehlen
In plica links P. Cand.

4036

Staatsarchiv Wien Chronol.
 P. — 1282 Junii 17
Martinus IIII . . archiepo Salze-
burgen.
 Ex suscepte seruitetis
Apud Vrbemveterem XV Kl.
Julii aº 2º
 Bulle an Hanf
In plica rechts P. Gen.
Sub plica links z vor XV Kl.
 Julii
Ecke oben links z.
Ecke oben rechts
A tergo kein
Rg Zeichen

4037 (recto)

Datum ℞

Paris Archives Nationales
J 446 n. 32 bis
Breite 64.x Rand links 4.3 rechts 4.1
Höhe 46.7 Rand oben 10.x plica 5.5
Erste Linie für Oberlängen / Je
Zwei Seitenlinien
P. vacat 1282 Junii 19
Martinus IIII Vniuersis suffrage-
neis et dil filiis Capitulo ecctie
Burdegalen
 Et si terre
dat / apud Vrbemueterem XIIIJ
Kl Februaxx a° 2°
Bulle an Hanf (verte)
In plica rechts: Alb . pa
Sub plica links : ͯͯ ℞ Raynald
 F. Atri
 Maga Raynald

4037 (verso)

Rand oben links : ℞ . l.
 △ frme
Rand oben Mitte : asca q rūp atb
Ecke oben rechts : ℞ b
A tergo oben Mitte nickelgroß
schwungvoll mit dickem Strich
 Scōe CXVIII anni Scdi
 cap

4038

Paris Archives Nationales
J 446 n. 33
Breite 68.6 Rand links 4.1 rechts 4.9
Höhe 47.4 Rand oben 8.7 plica 5.1
Erste Linie für Gitterschr und klei-
ne Oberlängen / Je zwei Seitenlinien
P. vacat 1282 Junii 19
Martinus IIII (Gitterschr) Carmo
in xpo filio Ph Regi Francorum
Jllustri
 Felicis recordationis Gregorius
dat apud Vrbemueterem / XIIIJ
Kl Julij a° 2°
 Bulle an feiner Seide
In plica rechts : Minr de Cur
Jede sehr regelmäßige große Schr

4039

Archives. Nationales Paris
L 270 n. ʺ 1282 Julii 3
Br. 73.6 hoch 50.7 Plica 5.6
oberer Rand 10.3 links 4.3
rechts 4
 Martinus IIII .. archiepo Rotho-
 maten
 Felicis recordationis Gregorius
dat apud montem flasem ͯ non
 Julij a° 2°
 Bulle an dünnerem Hanf
 In plica rechts : Q air
 Ohne jede weitere Bemerkung
 Sehr gepflegte feine Schrift
 Mit einem betonten Buchstaben
 Erste Linie für Oberlängen
 Ungemein stattliche Urkunde
Papstnamen P. vacat

Je zwei Seitenlinien
Papstname im Text nicht in Gitterschrift

4040

Bull. Gen. II cap. 92
P. — 1282 Aug. 1
Mart. IV magro Egidio de Castell
leto notario nro et .. preposito
ecclesie S. Audomari Morinen.
dioc.
Personam dilecti filii
Apud montemflasconem Kl.
Aug. a° 2°
Rand oben mitte Cof
A tergo oben " Jhs B. Card.
Bulle, Hauf, plica fehlen

43

4041

Instr. misc. 1276 1283 cap. 39
P. — 1282 Aug. 1
Mart. III mag. Egidio de Castelleto
notario nostro et .. preposito eccle
Sncti Audomari Morinen. dioe.
Personam dilecti filii
Apud montemflasconem Kal.
Augusti a° 2°
Bulle und Hauf fehlen

4042

Bull. Gen. II cap. 91
P. — 1282 Aug. 1
Martinus IV B. S. Nicolai in
Gith. mittelgroschon Carcere Tulliani
diacono cardinali
Personam tuam precipua
Apud montemflascon Kl. Aug.
a° 2°
Bulle und Seide fehlen
In pl. rechts! vacat

4043

Marseille Archives départem.
H. O. T. 7
P. — 1282 Augusti 30
Martinus III .. epo Tholosan.
Quia mundo posito
Apud Montemflasconem
II kl. Septembris a° 2°
Bulle fehlt, Hauf erhalten
In plica rechts J.
Sub plica links :.
Erste Zeile beschrieben
Unruhige Schrift

4044

Napoli Perg. Farn. Bolle n. 11
P. — 1282 Octobris 14
Martinus IIII .. archipbro ecclie
Vitebien
Ad audientiam nostram
apud montemflascon. II N.
Octobr. a°2°
Bulle und Hanf fehlen
In plica rechts Name
Sub plica links ..
 Jac Romanus
Rand oben Mitte
Ecke oben rechts an 2

4045

Brit. Mus. Add. Chart. 15. 775
P. — 1282 Novembris 5
Martinus IIII .. decano ecclesie
Cicestren
Ad audientiam nostram
Dat. apud Montem flascon.
Non. Novembris a° 2°
Bulle und Hanf fehlen
die letzte Zeile nur von der
plica ganz verdeckt
Sub plica links
 Jac Romun
Rand oben Mitte Coll daneben
ein anderes ausgestrichenes
Wort: fc....

4046

P. — Paris Arch. Nat.
J 699 ap 62 1282 Nov. 16
Mart III .. regi Francorum illustri
Dudum vacante monasterio
apud montemflasconem XVI kl.
Dec a° 2°
Bulle an Hanf
In plica rechts P. E
Sub plica links X auf dem
Bug durchstrichen
Rt L Pag...
 a de Sy (?)
Rand oben links .2. und
andr. vic
Ecke rechts

4047

Barcelona Corona de Aragón
 Leg. 160 n. 30
P. 21947 ad valvas
 1282 Novembris 18
Martinus IIII ad certitudinem
presentium et memoriam fu-
turorum
Longa retro series
Actum apud montemflascon
ante predictum Eccle-
siam Sancti Flaviani in festo
dedicationis Basilice principis
Apostolorum a° 2°
Bulle an Seide
In plica links Jac Boet
Sub plica links VI Labr
 a. de Sy.
Sehr grosse Bulle. Publications
notiz am Schluss des Textes

4048 (recto)

P.— Paris Arch. Nat.
J 699 cap. 61 bis 1283 Jan. 10
Mart IIII .. epo Cathalau-
nen.
Dudum in minori
Apud Vrbemveterem IIII
id Jan. a° 2°
Bulle an Hanf
In plica rechts P geñ
Sub pl. links ≡
 v
 x
 9
 aus dem
 Bug durch
 Strichen:

R̷ Thom p̷ar
 / Atrii Ecke oben
links: ⚮ Franc̄
 ⊥
 verte

4048 (verso)

Rand oben Mitte
 fiat cõp de but und
 at. de and
Ecke rechts R̷

A tergo Sept̄ CXVII anni Irdi
 R̷ cõp

fiat copia de bullato
attende de audientia

4049

Staatsarchiv Wien Chronol.
P.— 1283 Januarii 12
Martinus IIII .. priorissæ et
conventui monasterii Sanctæ
Crucis de Tulna Osdiug. se-
cundum institutam fratrum Pre-
dicatorum viventibus Pata-
vien. diœc.
Devotionis vestre precibus
Apud Vrbemveterem II id.
Januarii a° 2°
Bulle fehlt. Seide erhalten
In plica rechts Sy Beñ
Sub plica links --
 H. Pad.
Rand oben Sept
Ecke oben rechts
A tergo R̷ ... estimatur Mag
 B. de Fulg.
Ecke oben links a
Barth. de Fulg. sur procurator

4050

Staatsarchiv Wien Chronol.
P.— 1283 Januarii 13
Martinus IIII .. epo Ratis-
ponen.
Obvie malitiis pervasorum
Apud Vrbemveterem id.
Januarii a° 2°
Bulle fehlt. Hanf erhalten
In plica rechts Sy Beñ
Sub plica links ____ s
 h. Pad.
und R̷ ... Sept ? und R̷
Sy Veñ. F. atii.

4051

Firenze, S. Croce di Firenze

P. 21976 1283 Januarii 18

Martinus IIII .. generali et pro-
vincialibus ministris ac custo-
dibus universis ord. frum. min.
Exultantes in domino
Apud Vrbemveterem XV kl.
februarii a° 2°

Bulle und Seide fehlen
In plica rechts m. de Rocca
Sub plica links X
Breite plica, breite Rän-
der. Oberste Zeile frei
Sub plica unliniirt

 Dupliket Stidem
In plica rechts Rnldf

4052

Brit. Mus. Add. Mnsc. 12.780

P. — 1283 Januarii 19

Martinus IIII .. potestati, capi-
taneis, consilio et conventui
communi Januen.
Onus apostolice sollicitudinis
Dat. apud Vrbemveterem XIIII
kl. febr. a° 2°

Bulle und Hanf fehlen
In plica rechts P. Eug.
 de Cur

4053 (recto)

Paris Archives Nationales R×
 J. 446 n. 32
Breite 60. Rand links 3. rechts 2.7
Höhe 43. Rand oben 8.3 plica 5.4
Erste Linie für Oberlängen / Je
eine Seitenlinie

P. vacat 1283 Januarii 20

Martinus IIII . . Archiepo Bi-
turicen et eius suffraganeis
 Et si terre
Dat apud Vrbemveterem XIII kl.
Februarii a° 2°
Bulle an Hanf
In plica rechts ! venldf
Sub plica links : ÷ und : f
A tergo oben Mitte :
 Guido / darunter
 vate

4053 (verso)

groß schwungvoll mit dickem
Strich

(Scpt) CXVIII anni Sch

Rap°

Regelmäßige schöne Schrift

Archives nationales. Paris
L270 n. 12 1283 Ianuarii 20

Br. 57,6 hoch 46.7 Plica 4.5
oberer Rand 12, links 4.6
rechts 4.8
 Martinus IIII .. Archiep
Lugdunen. et eius suffraganeis
 Et ad terre
Dat. apud Vrbemveterem XIIII Kl
 Februar a° 2°

Bulle an dickem Hanf
 In plica rechts: all P
Sub plica links : =/x g

A tergo oben Mitte: Guido
 darunter schwungvoll
stark verschnörkelt 2.5 ̈sepr̈ CXVIII.
 Anni Sedi
Feste regelmässige Schrift capa
 Mit 1 behnten Buchstaben

Erste freie Zeile fehlt

 P. vacat

Barcelona Corona de Aragón
 Leg. 16° n.° vacat.
P. 21998 1283 Martii 21
Martinus IIII ad certitudinem
presentium et memoriam
futurorum
De insurgentis in
Actum apud Vrbemveterem
 in platea dicte Ma-
ioris Ecclesie XII Kl. Aprilis
a° 2°
Bulle fehlt. Seide erhalten
In plica rechts P. Gen
 d. Cur

Sententia privationis
Sehr grosse Bulle.
Am Schlusse des Textes
die Publicationsnotiz

Barcelona Corona de Aragón
 Leg. 16° u. 3°
P. 21998 In valvis
Martinus IIII 1283 Martii 21
ad certitudinem presentium et
memoriam futurorum
De insurgentis in
Actum apud Vrbemveterem
 in platea dicte Maioris
Ecclesie XII Kl. Aprilis a° 2°
Bulle an Seide
In plica rechts A. med
 Die Löcher für die Aufhef-
 tung zum Zwecke der
 publicatio sind auf den
 vier Rändern deutlich
 erkennbar
Sententia privationis contra
Petrum regem Aragonum

Sehr grosse Bulle
Am Schlusse des Textes der
Publicationsbefehl ad
valvas maioris Ecclesie

Archives Nationales Paris

L 270 n. 8 1283. Aprilis 13

Br. 36, hoch 27.7 Plica 3.8
oberer Rand 7, 2 links 2. 2
rechts 2.4
Martinus IIII (Gitterschrift
Initiale leicht verziert) . . Abbati et
Conventui Monasterij sancti Dyo-
nisij in Francia ad Roman Ecclam
nullo medio pertinentis ordinis sancti
Benedicti Parisien dioc
Sincere devotionis que
Dat apud Vrbemveterem Id
Aprilis a° 2° P. 21886

Bulle an Seide
In plica rechts : P. benet
Sub plica links :
J. mz?

9 R. fules F. Ati
Rand oben links :
J. 4 Franc Rand oben Mitte :
AT de
Ecke oben rechts : R.

Je zwei Seitenlinien Verte

A tergo oben Mitte :
N. de voo Victore
Drunter schwungvoll
mit Schnörkeln 2.4

Kleine regelm. Schrift
mit gestr. Ligaturen (mit
einer Ausnahme)

Erste Linie frei Gitter-
schrift und Oberlängen

4058

Archives Nationales Paris

L 269 n. 9 1283 Aprilis 13

Br. 45.3 hoch 36. 2 Plica 4.6
oberer Rand 10.7 links 3
rechts 3
Martinus IIII (Übergangs-
schrift, Initiale ausgespart) . . Ab-
bati z Conventui Monasterij
sancti Dyonisij in Francia. etc.
wie in n. 9 bis

Bulle an Seide
In plica rechts : Sy Vri.
Sub plica links : V

A tergo wie in n. 9 bis

P. vacat

Je zwei Seitenlinien

4059 (recto)

R.

Archives Nationales Paris
1283 . apr. 13
L 269 n. 9 bis
P.

Br. 46.8 hoch 34. 5 Plica 4. 4
oberer Rand 8. 4 links 2. 2
rechts 2.4
Martinus IIII (Meniusculae
Initiale ausgespart) . . Abbati
et Conventui Monasterij sancti
dyonisij in Francia ad Roman
Ecclam nullo medio pertinentis
ordinis sancti Benedicti Parisien
dioc.
Specialis dilectionis affectus
Dat Apud Vrbemveterem Id
Aprilis a° 2°

Bulle an Seide
In plica rechts : f
Sub plica links : V Bedy Ver
Fatin
Rand oben links : J. 4 Franc
Ecke oben rechts : R.

fette regelm. Schrift, mit vielen ge-
strackten Ligaturen Erste freie Linie fehlt Verte

4059 (verso)

Auf steys oben Mitte
N. de Sto Victore.
Darunter verschnörkelt 3.2

4060

Paris Archives Nationales
J 446 n. 34
Erste Linie für Oberlängen
Je eine Seitenlinie
P. vacat 1283 Aprilis 23
Martinus IIII fratri J. de Tur
no Thesaurario domus Mili
tie Templi Parisien
 Volumus et tibi
Dat apud Urbemveterem VIII
id Maii / a° 3°
Bulle ... auf Hanf ...
In plica rechts : . b . a .
Weite mittelgrosse kleine Schrift

4061

Archives Départem. Marseille
H. S. 3
P. — 1283 Maii 15
Martinus IIII .. abbati et con-
ventui monasterii de Silvaca
na Cist O. Aquen. dioc:
 Ex tenore vestre
Apud Urbemveterem id. Maii
a° 3°
Bulle an Seide
In plica rechts Sy Ven
Sub plica rechts ƀ pd
Rund oben Mitte ...
Ecke oben rechts ...
Zwei Seitenlinien
Kleine, fette schöne Schrift

4062

Marseille Archives Départem
H. S. 3
P. — 1283 Maii 15
Martinus IIII .. abbi et conven
tui monasterii de Silvacana
Cistoaguen. dioc.
 Iustis petentium desideriis
Apud Urbemveterem id.
 Maii a° 3°
Bulle an Seide
In plica rechts ... Sy ver
Sub plica links ƀ pd
Schöne fette Schrift, schwung-
volle gestreckte Ligaturen

4063

Marseille Archives Départem.
H. S. 3
P. — 1283 Maii 23
Martinus IIII .. abbati et con-
ventui monasterii de Silva-
cava Cistbci. Aquen. dioc.
Sacrosancta Romana Ecclia
Apud Vrbemveterem
X Kl. Iunii aº 3º
 Bulle und Seide fehlen
 In plica rechts p. benet
 Sub plica links h̄ p̄d
 Dicke schöne Schrift

4064

Staatsarchiv zu Klosterwrk
P. 22030ˣ 1283 Iunii 3
Martinus IIII .. priori et fratribus
domus dominici Sepulchri
in Zederak ad Ierosolimitan.
ecclam nullo medio perti-
nentis Osbug. Bagen. dioc.
 Cum a nobis
Apud vrbemveterem III non. Iunii
aº 3º
 Bulle an Seide
 In plica rechts J. sej
 Sub plica links ...
 Seitenlinien breiter Rand
 Zwei Zeilen oben frei

 Ligaturen gemischt

4065

P. — Paris Arch. Nat.
J 699 cap. 67 1283 Iunii 16
 Clause
 breite Ränder
 Schnitte gehen
 nicht in die Schrift
Mart IIII Philippo regi Franc.
orum illustri
 Ad notitiam regiam
Apud vrbemveterem XVI
 Kl Iulii aº 3º

4066

Papstnamen
Archives Nationales Paris
L 269 n. 10 1283 Iunii 19
 Br. 60.4 hoch 48.5 Plica 6.4
 oben Rand 9.5 links 3.4
 rechts 3.6
 Martinus IIII Carissimo
in Xͬͦ filio Ph. Regi Francorum
Illustri
 Felicis recordationis Gregorius
Dat apud Vrbemveterem XIII
 Kl Iulii aº 2º

 Bulle an Seide
 In plica rechts : Mnut
 ohne jede Bemerkung
 drei
 Mit einem betonten Buchstaben
 erste Linie für Gitterschrift und
 Oberlängen
 P. vacat
 Papstname im Text nicht in Gitterschr.
 Je zwei Seitenlinien

Archives Nationales Paris
L 270 n. 13 __1283 Julii 13__

Br. 62.6 hoch — Plica 4.3
oberer Rand — links 5
rechts 5.1 oberer Rand sehr beschnitten
 Martinus IIII (Gitterschrift,
sehr grosse Initiale, reich verziert) Petro
Abbati Monasterij Fossaten ordinis
sancti Benedicti Parisien diöc
 Dignum laude multiplici
Dat apud Urbemveterem III
Jd Julij a° 30

Bulle fehlt, Seide erhalten
 In plica rechts : Sy . Veii
Sub plica links : ⸗

Fette regelm. weite Schrift, mit gestr.
Ligaturen (mit mehreren Ausnahmen)

In ersten Teile eine ungeheuerliche
nur häßliche Ligatur, siehe oben
Erste Linie für Gitterschrift und Obslänge

 Sehr grosse Zeilenabstände

Je Seitenlinien P. vacat

Archives nationales Paris
L 270 n. 14 __1283 Julii 13__

Br. 48.8 hoch 30.5 Plica 5.3
oberer Rand 9.3 links 4.6
rechts 4.6 Raum verschwendung
 Martinus IIII Petro Abbati
Monasterij Fossaten ordinis sancti
Benedicti Parisien diöc
 Per grata devotionis
Dat apud Urbemveterem III Jd
Julij a° 30

-Bulle und Seide fehlen
 In plica rechts : P. Sug
 pro R. Pip
Sub plica links : V
à tergo oben mitte : Jam Jacobe pro
 dno Fossaten
Sehr weite regelm. fette Schrift mit
gestr. Ligaturen.
Sehr grosse Zeilenabstände
 Erste Linie für Gitterschrift und
 untere Obslängen

P. vacat
 grosse Ränder
Je zwei Seitenlinien verschwendung

Archives nationales Paris
L 270 n. 15 __1283 Julii 13__

Br. 61. hoch — Plica 6.9
oberer Rand — links 5.9
rechts 5.8 oberer Rand sehr beschnitten
 Martinus IIII Petro Abbati
Monasterij Fossaten ordinis sancti
Benedicti Parisien diöc
 Sincere devotionis integritas
Dat apud Urbemveterem III Jd Julij
 a° 30
Riesige verzierte Initiale, verzierte maj-
culae, sehr grosse Zeilenabstände
grosse Ränder, ungemein weite Schrift

Bulle und Seide ausgerissen
 In plica rechts : Galgan d
Sub plica links : V nebst R4 Be-
 Neput merkungen
à tergo Spuren des Registratur-R

 P. vacat

 Je zwei Seitenlinien

Barcelona Corona de Aragón
 P. — Leg. 16° n. 5°
 __1283 Augusti 29__
Martinus IIII Johanni tit. S.
Ceciliæ presb. cardinali
Cui regne transfert
Apud Urbemveterem IIII Kl.
Sept. a° 30
Bulle an Hanf
In plica rechts
 M. de Rocca pro Cur.

4071

Barcelona Corona de Aragón
 Leg. 16° 4. 6°
 P. — 1283 Septembris 1
Martinus IIII .. Regi Francie et
 Illustri
Dilecti filii Gerardus
apud Urbemveterem kl. Sep-
 tembris a° 3°
Bulle an Hanf
In plica rechts Maior

4072

Bayer. Haupt. Staatsarchiv
 Juttenbach N. 10
P. 22071* 1283 Octobris 24
Martinus IIII (Gitterschrift diinn,
klein, weit) .. Abbati et Conven-
tui monasterii de Weltenbach
ordinis sancti Benedicti Augusten-
dioc.
 Cum a nobis
Dat. apud Urbemveterem VI Id.
Novembris anno Tertio

Bulle fehlt, Seide erhalten.
In plica rechts: By. Roman
Sub plica links –
 nepul
Rand oben halbrechts OOr

Erste Zeile frei. Je zwei Schreibe-
nien.

4073

Brit. Mus. Harl. Chart. II. A. 26
 P. — 1283 Novembris 13
Martinus IIII .. abbati et conven-
tui monasterii Raufurge
Cist. O. Eboracen. dioc.
 Cum a nobis
Dat. apud Urbemveterem
 id. Nov. a° 3°
 Bulle an Seide
In plica rechts Jo Sal

4074

 P. — Paris Arch. Nat.
J 699 cap. 65 1284 Januarii 9
Mart IIII Clausa

 Breite Rän-
 der; die Schnitte
 gehen nicht in
 die Schrift

Mart IIII .. regi Francie ill.
Quanto personam regiam
apud Urbemveterem V id.
Jan. a° 3°

4075

P.— Paris Arch. Nat.

J 714 cap. 305 1284 Jan. 9

Mart. IIII F iÍ Jan. a° 3°

Bulle an Hanf

In plica rechts

M. de Rocca pro cur.

J 714 cap. 305ᵗ 1284 Maii 26

Mart. IIII VII Kl. Junii a° 4°

Bulle an Hanf

In plica rechts J. P.
 de cur
 . G.

Gratis!

4076

P.— Paris Arch. Nat.

J 594 cap. 29ᵍᵘᵃᵗᵉʳ 1284 Jan. 10

Mart. IIII .. regi Francie illustri

Dilecti filii magistri

Apud Urbemveterem IIII iÍ Jan.
 a° 3°

Bulle an Hanf

In plica rechts
 M. de Rocca pro cur

4077

Barcelona Corona de Aragón
 Leg. 16° n. 7°

P. 22093/94 1284 Januarii 10

Martinus IIII · J. tit. S. Ceciliae

presb. cardinali

In litteris apostolicis

Apud Urbemveterem IIII iÍ.

Januarii a° 3°

Bulle an Hanf

In plica rechts P. G.

4078

Bayer. Haupt- Staats archiv
 Oberschönefeld fasc. 8

P. vacat 1284 februarii 8

MARTINUS IIII Henrico priori et fra-
tribus domus dei in Heilsbrach ordinis
sancti Benedicti Augustan. dioc.
 Cum a nobis
Apud Urbemveterem VI Jd. febru-
 arii anno tertio

Bulle an Seide
In plica rechts Sym. T

Breite Seitenränder
Kräftige regelmässige Schrift
Kleine et und grosse St Ligaturen

4079

de Curia

Paris Archives Nationales
J 446 n. 36

Eine Linie für Gitterschr. und eine
geht mitten durch die Gitterschr.
Je zwei Seitenlinien

P. vacat 1284 Februarii 16

Martinus IIII Ad perp. rei mem.
(Maj Gitterschr.)
Pridem infrascriptas litteras
Dat apud Vrbemueterem XV
Kl Martij / aº 3º

Bulle au sehr feiner Seide
In plica links : O Laud
 de Cur

Ganz prachtvolle feste grosse
Schrift

Martinus reich verziert

4080

Archives Nationales Paris
L 270 n. 17 1284 Martii 7

Br. 49,5 hoch 35.6 Plica 5.3
oberer Rand 10.4 links 2.3
rechts 3.2
 Martinus IIII Vniuersis
magris et scolaribus Parisien
 ad statum vniuersitatis
Dat apud Vrbemueterem non
Martij aº 3º

Bulle au Hanf
 In plica rechts : . T . P
Sub plica links :
 Jac Roman
Darunter auf der plica :
 Rx Roma P
 Fr Atin
 A tergo oben mitte : Parisius
Sehr hohe Initiale. Sehr schöne feste
Schrift.
 Mit einem betonten Buchstaben

Grosse Raumverschwendung bei
plica und oben

P. 22112

4081

Bayer. Haupt. Staatsarchio
 Würzburg n. 3069

P. vacat 1284 Martii 15

Martinus (Gitterschrift) IIII . . Ab-
batione et Conuentui Monasterij
Sancte Agnetis Hutispolen.
ordinis Sancte Clare
 Sacrosancta Romana Ecclesia
Apud Vrbemueterem Jd. Marcij
anno Tertio.

Gutgeprägte Bulle au Seide
In plica rechts : P. borelli
Sub plica links : ——
 Jac Roman

Scharfe, fette Schrift

A tergo Ecke oben links : B

4082

Barcelona Corona de Aragón
 Leg. 16º n 10º
 vicecancellarius
 Duplicat in forma eius
P. 22131 1284 Maii 5
Martinus IIII Carolo regi Arago
num et Valentie illustri nato
Philippi regis Francie Illustris
Dudum propter iniustitias
se nouerit incursurum
(R) Ego Martinus C. S. Epo ss (M)
5 presb — epi 3 diac
Dat ap. Vrbemueterem p. m.
magri Petri de Mediolano SRE
vicecancellarii IIII non. Maii
ind. XII J. D. aº M. CC. LXXXIIII p.
vero Domni Martini pp IIII aº 4º
Bulle fehlt. Seide erhalten
 Ohne Notizen

4083 (recto)

Barcelona Corona de Aragón
P. 22131 Leg. 16° n. 9°.
 vicecancellarius
 1284 maii 5
Martinus IIII Carolo regi Arago
num illustri nato carmi in
xpo filii nri Philippi [in der
Abschrift (f. unten Phy)] Regis
Francie Illustris
 Dudum propter inustitias
lius se noverit incursurum
(R) Ego Martinus C. Z. Eps ss (M)
5 presb. — epi 3 diac
Dat. apud Vrbemveterem per
manum Magri Petri de Medio
lano SRE vicecancellarii III
non. maii ind. XII. I.Q. a° nii. CC.
LXXX IIII pont. vero domni martii
ni pp IIII a° 4°

4083 (verso)

Bulle an Seide
In plica rechts Jo Lauck

die Bulle war schon in forma
simplici geschrieben und
wurde dann in forma et
lemui ememeit.

4084

Barcelona Corona de Aragón
 Leg. 16° n. 9° bis
P. 22131 1284 maii 5
Martinus IIII Carolo regi Arago.
num illustri nato Phy. Regis
Francie Illustris
Dudum propter inustitias
Apud Vrbemveterem III non.
Maii a° 4°
Bulle, Seide, plica fehlen

Große Bulle

Vielleicht wurde die plica und
das Siegel schon in der Kanz
lei entfernt, da die Bulle
in forma solemni ergehen
sollte.

4085

Barcelona Corona de Aragón
 Leg. 16° n. 10° bis
P. 22131 1284 maii 5
Martinus IIII Carolo Regi Arago.
num et Valentie Illustri nato
Philippi Regis Francie Illustris
Dudum propter inustitias
Apud Vrbemveterem III non Maii
a° 4°
Bulle an Seide
In plica links Jac Boct

das eigentliche Original
wurde in feierlicher form
ausgestellt. Cf. supra

4086 (recto)

Paris Archives Nationales
 J 446 n. 37
Ohne jede obere freie Linie / Je
Frei Seitenlinien
P. vacat 1284 Maii 5
Martinus IIII Universis Archiepis
J Epis ac dil filijs Electis Abbatib;
Priorib; decanis Archidiaconis
Prepositis Archipbris et alijs eccli
ax Prelatis Capitulis Conventib;
et Collegijs Cistercien Cluniacen
Premonstraten sancti Benedicti
sancti Augustini Cartusien ga
Grandimonten et aliop ordinum
necnon Priorib; Hospitalis sancti
Johannis jerlimitan domorum mi
litie Templi et beate Marie Theo-

4086 (verso)

tonicorum Preceptoribus ceteris
que omnibus personis ecclastias
secularib; y regularib; exemptis
y non exemptis per Regnum
Francie constitutis
 Excessus detestabiles per
dat apud Urbemueterem III Non
Maij aº 4º
III Non Maij ist nachgetragen
 Bulle fehlt Hanf erhalten
In plica rechts: Alto p
A tergo oben Mitte: monitoria
super adiectione quarti anni
 und: de adiectione quarti
anni monitoria
kleine fette stumpfe Schrift

4087

executoria

Paris Archives Nationales
 J 446 n. 38
Erste Linie jed Oberlängen
Je eine Seitenlinie
P. vacat 1284 Maii 5
Martinus IIII Johanni tt sanc
te Cecilie pbro Cardinali apliee
sedis Legato
 Novit tua discretio
Dat apud Urbemueterem / III
Non Maij aº 4º
 Bulle an Hanf
In plica links: O. Land
A tergo oben Mitte: de Francia
 de adiectione quarti anni ex
ecutoria
Ganz prachtvolle grosse feste Schr.

4088

Bayer. Hupt.–Staatsarchiv
Aukhausen a. d. Wörnitz fasc. II
 728 [?] Maii 15
Martinus IIII .. Abbati et Conventui
Monasterij in Hausen ad Romanam
ecclesiam nullo medio pertinentis
ordinis sancti Benedicti Eysteten.
dioc.
 Justis petentium desiderijs
apud Urbemueterem Jd. Maij
anno quarto

 Bulle an Seide
In plica rechts A. de Cy
 Sub plica links: ~~ Roman
 Jac Roman
Rand oben Mitte
Etwas vernachlässigte Schrift

4089

Public Record Office London
Papal Bulls Bundle 29 n. 8
　　　　　Capitelzeichen
P. 22 143　　1284 Maii 26
Martinus III] E regi Anglie illustri
Venientes ad nos
① prima petitio tua: Quod
② Responsio　② Secunda petitio
　schwarze Kapitelzeichen
Apud Urbemveterem VII kl. Junii
a° 4°
Bulle an Hanf
Sub plica links ganz unten Rx

4090

Instr. misc. 1276 cap. 42
　　P. —　　　　　1284 Junii 17
Mart. III .. epo Spoletan
Per alias tibi
Apud Urbemveterem XV kal. Julii
a° 4°
Bulle und Hanf fehlen
In plica rechts:　de Curia
　　　　　　Jac̄ de Roc̄
unter dem Bug links unten und
abgeklatscht: Rx
De tergo :　.c.

91

4091

Madrid Arch. Histór. Nacional
Huesca Doc. Ecl. E 178
　P. —　　1284 Octobris 23
Martinus III .. priori de Li-
ert Ord Aug. Oscen. dioc.
Sua nobis Sanctius
Perusii X kl. Nov. a° 4°
Bulle und Hanf fehlen
In plica rechts　p G
Sub plica links
　　　　⸫
　　p. Romań
Ecke oben rechts An

4092

　　　Paris Arch. Nat.
J 714 cap. 305 3 1284 Oct. 30
　　P. —　　Clausa
[grid diagram]　Breite Rinder
　　　　Martinus III Phy
lippo regi Francorum
Ex parte regia
Perusii III kl. nov. a° 4°
　In plica rechts P. Eug.
　　　de Cur

Karlsruhe

P — 40/4 1285 Martii 13

Martinus IIII .. officiali Spiren.
Ex parte dilectarum
Perusii III id. Martii a° 4°
Bulle und Hanf fehlen
In plica rechts Bar
Sub plica links 5

f. Ann
Rand oben Mitte cor.
Ecke oben rechts R

Bull. Gen. I cap. 4 aprilis 11
P. — 1285 Martins

Honorius IIII electus eps. s. s. d.
Benedicto S. Nicolai in Carcere
Tulliano diac. cardinali
Que ad tui bulla blanca
Perusii III id Aprilis suscepti
a nobis aplatus officii a° 1°
Bulle und Hanf fehlen
Rechter Rand abgeschnitten
In pli. rechts: P (Rest fehlt

« nec miveris quod bulla non expri-
mens nomen nrm est appense prae-
sentibus que ante consecrationis et bene-
dictionis nre sollempnia transmit-
tur, quia hii qui fuerunt hactenus
in Romanum electi pontifices consueverunt
in bullandis literis ante sue consecrationis
munus modum huiusmodi observare

Firenze, Urbino
P. — Ante coronationem
1285 Aprilis 17

Honorius IIII electus eps. s. s. d.
d. filio .. plebano plebis de Aria
Camerinen. dioc.
Cum sicut ex
Nec miveris.
Perusii XV kl. Maii suscepti
a nobis apostolatus officii anno
primo.
Bulle und Hanf fehlen

Bulla blanca

Public Record Office London
Papal Bulls bundle 19 n. 3
ante coronationem
P. 22230 1285 Aprilis 20
Honorius IV electus eps etc - - regi
Anglie illustri
Accedentes ad apostolicam
Perusii XII kl. Maii suscepti a
nobis apostolatus officii a° 1°
Bulle an Hanf
Schriftseite leer
In plica rechts nr de Rocca
Sub plica links x/x
?
In ausgezeichneter Schrift und Erhaltung
grosse Urkunde, prächtige bulla blanca

4097

Public Record Office London
Papal Bulls bundle 18 n. 21
 Clausa

 ante coronationem
P. 22231 1285 Aprilis 25
Honorius IV electus .. regi
Anglie illustri
Sincere caritatis affectus
 Perusii VII kl. Maii suscepti
a nobis apostolatus officii a° 1°
 Bulle und Hanf fehlen

4098

Marseille Archives Départem.
H. 0. T. 7
P. — 1285 Julii 23
Honorius IIII .. preposito eccle-
sie Aurasicen.
Et si. quibuslibet
Tibur. X kl. Aug. a° 1°.
Bulle fehlt. Hanf erhalten
In plica rechts g. auy
Sub plica links ..s.
Schöne feste Schrift.

4099

Public Record Office London
Papal Bulls bundle 18 n. 26
P. 22274 1285 Julii 28
Honorius IIII .. regi Anglie
Licet nuper excellentie
Tibur. V kl. Augusti a° 1°
 Bulle fehlt. Hanf erhalten
 In plica rechts Main
Sub plica links --
 Jac. Romanus
A tergo Mitte oben, ohne script

4100

Archives Nationales Paris
L 272 n. 2 1285 Augusti 5
 Br. 35.6 hoch 25.2 Plica 3.6
 oberer Rand 8, links 2.2
rechts 2.2
 Honorius IIII (Gitterschrift Ini-
tiale ausgespart) .. Abbati et
Conventui Monasterii sancti
Dyonisii in Francia ad Romanam
ecclesiam nullo medio pertinentis
ordinis sancti Benedicti Parisien
 dioc
 Cum a nobis
Dat Tyburii non. Aug. a° 1°

 Bulle an feiner Seide
 In plica rechts : p. bonet
Sub plica links : --
 Jac. Roman
A tergo oben Mitte : N. de S˜t Victore
Sehr regelm. Kleine feste Schrift
Erste Linie für Gitterschrift und
 Überlängen
 Sehr grosser oberer Rand
 P. vacat

4101

Public Record Office London
Papal Bulls bundle 19 n. 5
Clausa

P. 22 277 1285 Augusti 5
Honorius IIIJ - - regi Anglie illustri
Missa nobis a
Tibur. non. Aug. a° 1°

Breite Ränder, herrliche Schrift

4102

Public Record Office London
Papal Bulls bundle 18 n. 25
Clausa

P. - 1285 Augusti 5
Honorius IIIJ - - regi Anglie illustri
Solita benignitate recepimus
Tibure non. Aug. a° 1°
Bulle und Hanf fehlen

4103

Madrid Arch. Histór. Nacional
San Marcos de Leon n. 31.
P. - 1285 Augusti 13
Honorius III Stephano Domi_
nici et Garsie Petri canoni_
cis Zamoren.
Conquestus est nobis
Tybur. iv. Augusti a° 1°
Bulle fehlt. Hanf erhalten
In plica rechts p. Anno
Ecke oben rechts AN

Rechts und links kleiner Rand

4104

Marseille Archives Départem
H. O.J. 7
P. - 1285 Augusti 13
Honorius III . . magistro et fratr.
domus Milicie Templi Jeros.
Cum a nobis
Tibur. iv. Aug. a° 1°
Bulle und Seide ausgeschnitten
In plica rechto f. Aug
Sub plica links - -
Ecke oben links E

feste, schöne Schrift

4105

Marseille Archives Départem.
H. O. T. 7
P. — 1285 Augusti 13
Honorius IIII . . magistro et fra-
tribus domus Militie Templi
Jerosolimitan.
 Cum a nobis
Tibur id. Aug. a° 1°
Bulle fehlt, Seide erhalten
In plica rechts f. Aug
Sub plica links . .
feste etwas gezogene Schrift
Gestreckte Signaturen

4106

Bayer. Haupt- Staatsarchiv
Regensburg dominicaner fasc 1c
P. 22287 12 85 Septembris 13
Honorius IIII . . Magro et fratribus or-
dinis Predicatorum
 Meritis vestre religionis
Tyburi id. Septembris anno Primo
Bulle und Seide ausgerissen
In plica rechts : Mar. Vall
Sub plica links : v
Neitgelegate flüssige kleine Schrift
Sehr breite Ränder überall

4107

Firenze, Rocchettini di Pistoia
P. — 1285 Septembris 13
Honorius IIII . . primicerio ecclie
Lucan.
 Sua nobis dilecti
Tibur. id Sept. a° 1°
Bulle Hanf und Plica fehlen
Sub plica links . .
Ecke oben rechts a N

4108

Instr. Mon. F. Dom. C. 11 1285 Sept. 13
 P. 22287
Hon. IIII . . mag. et fratribus ord. Pred.
Meritis vestre religionis —
Tibure id Sept. anno I°
Bulle an Seidenfäden.
In plica rechts : Jac Roman
Sub plica links : v ; Arm : R Neapot
frei Jac Boet ; R Dominice IIII Jac
Boet (beide durchstrichen)
Unten dem Hanf : R Henr. Ped f Aug
nicht durchstrichen
kaum oben links : Fiat littes pro fra-
bus Minoribus sub nomine dni nri P.
a tergo : Predicatorum

Vice Kanzler Peregrini
maj. Petrus . . de mediolano

Instr. misc. 1276-1285 cap. 28
P. 22290　　　1285 Sept. 17
Honorius IIII　ad perp. rei mem
mittelgross　　　gross fett eng.
rund

Dilectus filius nobilis
(R) Ego Honorius (M)
4 presb.　4 epi　2 diac
Dat. Tibure per manum magri
Petri de Mediolano SRE vice
cancellarii XV kle Oct. ind. XIIII
Inc. dom. anno M. CC. LXXXV pont.
vero dmni Honorii pp III a° 1°
[pp Helssen?] zittersdr.
Bulle und Seide fehlen.　verte
Ecke oben rechts: p̄ Correctp̄
oder Getm　　　(ganz klein)
A tergo [fr. G. Charnerii]

Alle Abschnitte mit blauen
und rothen Capitelzeichen
Foten

4110

Instr. misc. 1276-1285　cap. 29
P. 22291　Tibure 1285 Sept. 22
Honorius IV　ad perp. rei mem.
Klein fett　kl. dickere mänig angfg
Iustitia et pax
(R) Papstunterschrift (M)
4 ppresb.　4 epi　8 diac
Dat. Tibure per manum magri
Petri de Mediolano SRE. vice
cancellarii XV Kal. Oct. ind. XIIII
Incarn. dom. anno M. CC LXXXV
pont. vero d. Hon. pp III a° 1°
Blaue und rothe Capitelzei-
chen abwechselnd bei jedem
Abschnitt; doch ohne alinea
Ecke oben rechts: R̄　(m) LXXXXII
A tergo oben Mitte:　R̄

4111

Instr. Mon. F. Dom. cap. 160　1285 Oct. 1
Honorius IV .. magistro　P. 22299
et fratribus or. Predic.
Meritis vestre religionis —
Tibure Kal. Octobris anno primo
Bulle und Seidenfäden ausgerissen
In plica rechts: Sy. Ven.
Sub plica links: ꝉ
　　　　Iac. Romanus
　　　e
Unter dem Bug links:
R̄ Iac. Boll
　　　f. Amy
Ecke links oben: A. f.　a
Ecke rechts oben: R̄
A tergo: predicatorum
　　R̄ CCXXXVI°
　cap

4112

Madrid Arch. Histór. Nacional
Zamora Toro 6 E
P. 22299 1285 Octobris 1
Honorius III .. magro et fra-
tribus Ord Praedic.
Meritis vestre religionis
Tybure Kl. oct. aᵒ 1ᵒ
Bulle und Seide fehlen
In plica ~~rechts~~ links
 Jac. Boel !!!
Sub plica links ▽ . ..

A tergo unter dem Procurato-
rennamen steht
Registrata est
und eine verwischte Notiz
über ☓ libri und fahren
Cameral-
register !!!

4113

Archives nationales Paris
L 272 n. 3 1285 Octobris 22
Br. 74,5 hoch 55. Plica 5,1
obrer Rand 12,2 links 6,3
rechts 5,4
 Honorius III .. Abbati
monasterij sancti Remigij ord.
nis sancti Benedicti .. Archidia-
cono Wastinen. et magro Guil-
lermo de Castro Nantonis cano-
nico Senonen.
 Exhibita siquidem nobis
dat. Rome apud Sctam Sabinam
XI Kl. novembr. aᵒ 1ᵒ

Bulle fehlt, Hanf erhalten
 In plica rechts: P. Bo
Sub plica links: ☓
 ☓
 A tergo oben mitte: P. de Bea [che]
mit einem betonten Buchstaben

Kleine fette regelm. Schrift
Erste Linie für Überlänge
Je zwei Leitunglinien P. vacat

4114 (recto)

P. — Paris Arch. nat.
L. 272 cap. 3 bis 1285 Oct. 22
Hon III .. abbati mon. S. Remigii
OSB, .. archidiacono Wastinen.
et magistro Guillermo de Castro
Nantonis Senonen.
Exhibita siquidem nobis
Rome apud S. Sabinam
XI Kal. nov. aᵒ 1ᵒ
Bulle fehlt; Hanf erhalten
In plica rechts Jatganus
 pro magro N. de Curia
Sub plica links ☓
 ☓
 ☓
 Jac. Roman,
 " " Bny F. Atin

4114 (verso)

Rand oben mitte:
jus copia de bullata
Ecke rechts oben ~~jus~~
 a
 P. Jac. Atin

4115

copia de bullata

Archives nationales Paris

L 272 n. 3 bis 1285 Octobris 22

Br. 75.7 hoch 49 Plica 6
oberer Rand 11.3 links 205
rechts 4.9

Honorius IIII
wie in 4. 3

Bulle fehlt, Hanf erhalten
In plica rechts : Galgan9
pro magro N. de Curia
Sub plica links : × ×
× ×

Jac Roman
Fr Atin
Rand oben Mitte : fiat copia
de bullata
Ecke oben rechts : fo
a
P. Gen
a tergo oben Mitte : P. de Bruxella

Fette kleine Schrift
mit einem betonten Buchstaben
Erste Linie für Oberlängen

4116

Madrid Arch. Histór Nacional
Zamora Toro 5 E
P. 22333 1285 novembris 25
Honorius IIII .. magro et fra-
tribus ord Pred.
Ex parte vestra
Rome ap. S. Sabinam VII
Kl. Dec. aº 1º.
Bulle und Seide fehlen
In plica rechts J. Ven.
Sub plica links ₌

4117

Poitiers Archives départem.
Noaillé
P. — 1285 Dec. 5
Honorius IIII .. abbi et conv.
mon. Nobiliacen O S B. Pic-
Taven. diöc.
Solet annuere sedes
Rome apud Scm Sabinam
non. Decembris aº primo ?
Bulle fehlt, Seide erhalten
In plica rechts: P. Venel9
Sub plica links ₌
Jac. Roman
Erste Zeile frei.
Sub plica ohne Linien

4118

Archives nationales Paris
L 272 n. 4 1285 Decembris 13
Br. 37.1 hoch 24. Plica 4.6
oberer Rand 8 links und
rechts ohne Seitenlinien 204, 19
Martinus IIII Honorius IIII
(Gitterschrift, Initiale ausgespart)
.. decano et Capitulo Parisien.
Cum a nobis
Dat Rome apud Sctm Sabinam
Iº decembr̄ aº 1º
Bulle an Seide, gelbe Fäden sehr grob
In plica rechts: L. Pgrin
Sub plica links : ··
Ecke oben rechts : gm
A tergo oben Mitte :
I de vn pro N. de Sto Victore
Jacobo de Trebis ; Phylippo
de Romonte
Sehr schöne feste Schrift
Erste Linie für Gitterschrift und
untere Oberlängen

P. vacat

4119

Archives Nationales Paris

L 272 n. 5 1285 Decembris 13

Br. 28.6 hoch 21.1 Plica 3.7
oberer Rand 6 links und
rechts ohne Seitenlinien 1.3, 0.8
~~Nostrum~~ III Honorius IIII - -
Officiali Senonen.
 Significarunt nobis Dilecti
Dat. Rom. apud Sctm Sabinam
 Jd Decembr. a° 10

Bulle an Hanf
 In plica rechts: L. ƥ gam
Sub plica links: . . .

Sehr regelm. fette Schrift
 mit einem betonten Buchstaben

Erste Linie für Oberlängen

A tergo oben Mitte: J. de va pro
pho C. Jac. de Trebis

 P. vacat

4120

Archives Nationales Paris

L 272 n. 6 1285 Decembris 13

Br. 34.2 hoch 23.1 Plica 3.
oberer Rand 6 links 2.2
rechts 1.5
 Honorius IIII C. Querschrift
Initiale ausgespart .·. Decano et
Capitulo ecclie Parisien.
 Ex parte nra
Dat. Rome apud Sctm Sabinam
 Jd Decembr. a° 10

Bulle an Seide, gelbe Fäden gröber
 In plica rechts: L. ƥ gam
 Sub plica links: S.
 ~~A tergo~~ Ecke oben rechts: Asƥ
A tergo oben Mitte:
 J. de va pro N. de Sco Victore .
 Jacobo de Trebis et Phy.
 de pomonte
Ungemein gepflegte feste Schrift
mit gestr. Ligaturen (mit einer Aus-
nahme)
 Erste Linie für Querschrift
 und Oberlängen

 P. vacat

4121 (recto)

Firenze, Innocenti di Fi-
 renze
P.- 1285 Decembris 21
Honorius IIII [ohne Lücke ohne Punk-
te] rectori Hospit. Sce Marie ad
scum Gallum Florentin. eiusq.
fribus etc. Jn ƥ ƥ M
 Religiosam vitam eligentibus,
R. Ego Honorius catholice
 ecclie eps SS M.
3 presb. 4 epi 3 diac.
Rome apud Sanctum Sabinam
p. m. magistri Petri de Medio
lan. sancte Roman. ecclie vi
cecancellarii XII Kl. Januarii
ind. XIIII Incarnationis dominice
Anno M°. CC. LXXXV p. vero domni
HONORII pp IIII Anno primo
 verte

4121 (verso)

Rand oben Mitte: "registro"
sumptum est a . . . "Alea
cuius tenor de verbo ad ver
bum est in Regesto eius-
dem. Paul
 at assertionem
Ecke oben rechts paul
Bulle und Seide fehlen

4122

Instr. mon. F. Dom. c- 1285 Dec. 21

P. —

Hon. IIII .. mag. prioribus et fratribus
universis ord. Predic.

Virtute conspicuos sacri —

Rome apud S. Sabinam XII Kl. Dec.
anno 1°

Bulle an Seidenfäden

In plica rechts: Atto. p

Sub plica links 4

Jac Boet

4123

Firenze, S. Croce di Firenze
P. 22352 1286 Januarii 18

Honorius III . . ministro gen.
et fribus ord. Minorum
Ex parte vestra
Rome apud scam Sabinam
XV Kl. febr. a° 1°

Bulle und Seide fehlen

In plica links o - Laud.
Ecke oben links . L. p Jac et
fiant x L. Ecke oben rechts R
Sub plica links v̄ Jac boel Dun
alles ausgestrichen
R p. ben I Jac boel
R p. R II Jac boel
R no. ben II } Jac boel
R Jac Ro III
R v. p. IV Jac boel

A tergo gross schön
mit einigen Schnörkeln

(219)
S̄c̄p̄s̄ xvm
cop

4124

Firenze, S. Croce di Firenze
P. 22352 1286 Januarii 18

Honorius IIII . . . ministro ge
nerali et fratribus O Min.
Ex parte vestra
Rome apud Sanctam Sabin.
XV Kl. febr. a° 1°

Bulle und Seide fehlen

In plica rechts unleserlich

Sub plica links Jar boel

Eingestellt 1217 Jan. 18

4125

Bayer. Haupt. Staatsarchiv
Regensburg dominicaner fasc. 12

P. 22353 1286 Januarii 19

Honorius IIII . . Magro et fratribus
ordinis predictorum
Religionis favor sub
Rome apud Scam Sabinam XIIII Kl
februarij anno primo

Bulle fehlt. Seide erhalten
In plica rechts . pa de põn.
Sub plica links : v

Wohlgelungene schöne Schrift
Sehr breite Ränder überall

Zwei Seitenlinien

4126

Instr. mon. F. Dom. c. 17 1286 Jan. 11

P. 22353

Hon. IIII .. mag. et fratribus ord. Præd.

Religionis favor sub.

Rome ap. S. Sabinam XIIII Kal. fe-

bruarii aᵒ 1ᵒ

Bulle an Seidenfäden

In plica rechts : f. Any

Sub plica links : = unv. abge.

Rentrecht und durchstrichen :

Rᵧ h. Viviani unam Jy Ro duas.

H. Pad. unum Jac Boet

Rᵧ Jo Laur. III Jac. Boet

Rᵧ Jac. Anag. π Jac. Boet

A tergo : Prædicatorum

4127

Madrid Arch. Histór. Nacional.

Zamora Toro 4 E

P. 22353 1286 Januarii 19

Honorius IIII magro et fratri-

bus ordinis Prædicatorum

Religionis favor sub

Rome ap. S. Sabinam XIIII

Kl. febr . aᵒ 1ᵒ

Bulle und Seide fehlen

In plica rechts Jy J (Ro?)

Sub plica links =
v

4128

Bayer. Haupt. Staatsarchio
Kl. Niederbaiern fasc. 5

P. 22356ˣ 1286 Januarii 23

Honorius IIII .. Abbati monasterij
de Tegernsee Frisingen. diœc!
Ad audientiam nostram
Dat. Rome X Kl. Februarii anno
Primo

Bulle an dickem Hanf
In plica rechts : f anu
Sub plica links : m. Roc.

Ecke oben rechts au

Die schlecht geschriebene Urkunde
ist ohne Prüfung ausgegeben worden.
Im Datum fehlt die Ort Ortsbe-
zeichnung in Rom : apud sanctam
Sabinam

4129

Staatsarchio Wien Chronol.

P. — 1286 Januarii 23

Honorius IIII .. magistro et ..

priori provinciali Theotonie or-

dinis Prædic.

Apostolice sedis benignitas

Rome apud Scam Sabinam X

Kl. febr . aᵒ 1ᵒ

Bulle fehlt. Hanf erhalten
A dextra in plica per Leonard
Mitte a. med. ascult. et comput.
Sub plica X unv (ausgestrichen)
Rᵧ m. Roca II ≥ Jac boet
R. O. duad. I ≥ Jac boet
Rand oben Mitte : fiat similis
pro mon. pro quibus dicit frater
Raynon?

Staatsarchiv Wien Chronol.
P. — 1286 Januarii 23
Honorius IIII .. mag.ro et ..
priori provinciali Theotonie
ord. pred. Predic.

Apostolice sedis benignitas
Rome apud Sanctum Sabi-
nam X kl. febr. a° 1°

Bulle fehlt. Seide erhalten
In plica rechts
Sub plica links
Ecke oben links
Ecke oben rechts
A tergo oben
gross sehen CCCxxxx II
Signatum Cap.
sig

Staatsarchiv Wien Chronol.
P. — 1286 Januarii 23
Honorius IIII .. priorine et conv..
mon. Sancte Crucis in Tulna
O. Hung. Patavien. dioc

Apostolice sedis benignitas
Rome apud Scam Sabinam X
kl. febr. a° 1°

Bulle fehlt. Seide erhalten
In plica rechts X. Pergam.
Sub plica links X und R∠ Do
Laur. I∠. April (9)
Ecke oben links . l. X Iac
rechten
A tergo oben Mitte
gross Signatum
!!! !!!
Cap.

Staatsarchiv Wien Chronol.
P. — 1286 Januarii 23
Honorius IIII .. priorine et
conventui mon. Sancte Crucis
in Tulna O. Hung. Patavien. d.

Apostolice sedis benignitas
Bulle fehlt. Seide erhalten
In plica rechts J. Laur.
Sub plica links X
Rand oben Mitte:
ascult. et comp. pu o. Lrud.
X kl. febr. a° 1°

Marseille Archives Departem.
H. O. T. # 7
P. — 1286 Februarii 5
Honorius IIII .. epo Legionen.
Sua nobis dilecti
Rome apud Scam Sabinam
non. febr. a° 1°
Bulle fehlt, sehr dicker Hanf
erhalten
In plica rechts G. aly
Sub plica links
Ecke oben rechts m. Roc
Zwei Linien unbeschrieben

4134

Archives nationales Paris

L 272 n. 7 **1286 Februarii 7**

Br. 51.6 hoch 30.3 Plica 3.5
oberer Rand 10.4 links 3.8
rechts 3.4

Honorius IIII (minuscule
Initiale ausgespart) . . Abbati et
Conventui Monasterii sancti
Germani de Pratis Parisien.
ad Romanam ecclesiam nullo medio
pertinentis ordinis sancti Bene-
dicti

Cum sicut ex
Dat. Rome apud Sanctum Sabi-
nam VII Id. Februarii a° I°

Bulle fehlt Seide erhalten
In plica rechts : SE · S · O
Sub plica links : " "
m. R..
A tergo oben Mitte : Bernardus
Fabri pro
Qnus unscheinlich auseinan-
Auseinandergezogene Schrift auf weiten Zeilen

Grosse Raumverschwendung
P. vacat

4135 (recto)

Firenze, S. Croce di Firenze

P. 22372 **1286 Februarii 10**

Honorius IIII . . Generali mi-
nistro et fratribus ord. Minorum

Religionis favor sub
Rome apud Sanctum Sabinam
IIII Id. febr. a° I°

Bulle und Seide fehlen
In plica rechts a . med.
Ecke oben links . l. und
Δ Dat et firmat x l.
Ecke oben rechts R
Sub plica links in boel; dann
weiter unten durchstrichen
R Corams . j . Dat boel
R S. pn . j . Dat boel
R p. Nt . j . Dat boel
R pa pn . j . Dat boel boel

4135 (verso)

A tergo schön, verziert
fehlt mittelgross

Sopt cclviiii
Cap°

Ungeheure Pergamenten-
schwendung, reiche Ausstatt-
ung, sehr breite Zeilen

4136

Napoli Curia Eccl. Mon. Soppr.
vol. 20 P. 22372 **1286 februarii 10**

Honorius IIII .. generali mi-
nistro et fratribus Ord. Min.
Religionis favor sub
Rome ap. Sanctum Sabinam
IIII Id. febr. a° I°
Bulle und Seide fehlen
plica abgeschnitten

4137

Firenze, Archiv fiorentino
P.— __1286 februarii 18__

Honorius IIII . . priori Sancti
Frigdiani Lucan. Ostens. et
.. plebano ecclie sci Petri
de Monterotii. Lucan. dioc.

Exhibita nobis dilectorum
Rome apud Scam Sabinam
XII Kl. Martii a° 1°

 Bulle und Hanf fehlen
In plica rechts Jac Vit
 Sub plica links 9

Ecke oben links . L . m - Roc ?
 Rec ?
unten rechts ordinetf
Ecke oben rechts
A tergo oben Mitte [J...] CCLXXXXV

4138

Paris Archives Nationales
 J 449 n. 116
Erste Linie für Oberlängen,
Je eine Leitenlinie
__P. vacat__ __1286 februarii 18__

Honorius IIII Carmo in Xpo filio
Php Regi Francie. Illustri
 Dura nimis et
Dat Rome apud Scam Sabi
nam XII Kl Martij, a° 1°
 Bulle an Hanf
In plica rechts: att p
 de Cur
Kleine fette unschöne Schrift

__de Curia__

4139

Archives Nationales Paris
L 272 n. 8 __1286 februarii 20__

Br. 31.2 hoch 23. Plica 3.6
oberer Rand 7, 8 links 2.3
rechts 2.5
 Honorius IIII (C Gitterschrift,
Initiale ausgespart) .. Epo Pa-
risien
 Exigentibus tue devotionis
Dat Rome apud Scm Sabinam
 X Kl Martij a° 1°

Bulle an feiner Seide
 In plica rechts : Jac Roman

Ohne alle sonstigen Bemerkungen
Grosse Raumverschwendung, weite
Zeilenabstände

Fette sehr regelm. Schrift, gestr. Liga
turen
 Erste Linie für Gitterschrift und
 untere Oberlängen

__P. 22375__

4140 (recto)

Bullarium Generale ab Ale-
xandro III ad Clementem VI
 Tom. I (a tergo)
 cap. 2
P.— 1286 Martii 7
Honorius IIII Johanni nato nobilis
viri Pagenelli de Montemagno
canonico eccle Pisan.
Sedes aplice personarum
Rome apud Sanctum Sabinam
non. Martii a° p°
Bulle fehlt. Sehr feine helle Sei
denfäden erhalten
Rechter Rand abgeschnitten
Sub pl. links : m. Roc (Rec)
 9
auf dem Bug durchstrichen :

Rf. Pal . Jac . Boet
Ecke oben links : fact
 J.

A tergo oben Mitte :
Plebanus de Sta Felicitas

Bull . Gen . I cap. 3
 P. — 1286 Martii 7
Hon . IIII . . abbti mon . de Quieu
Pisan . dioc . et Oppidoni de Ces.
sello Canonico Lucan .
 Sedes . aplica personarum
Rome ap. S. Sabinam non. Martii a° p°
Bulle und Hanf fehlen
Plica abgeschnitten
Sub pl. links
 m Rea Roc

Darunter a. manu durchstrichen
Rf P. Ben . Jac Boet
Ecke oben links : ♃ fac
(i) tergo oben Mitte
plebanus de Sta filicita

4142

Public Record Office London
Papal Bulls bundle 51 n. 2
P. 22 393 1286 Martii 14
Honorius IIII . . cpō Herefordem
Dilectus filius nobilis
Rome ap. S. Sabinam
 II id. Martii a° 1°
 Bulle an Hanf
In plica rechts Galgan

4143 de Curia Papstname

Archives Nationales Paris
L 272 n. 9 1286 Aprilis 1
 Bm 59 , hoch 41.9 Plica 4.8
oberer Rand 13.2 links 5.4
rechts 4.9
 Honorius IIII (sehr reich
Verzierte sehr grosse Maiusculae)
Universis Canonicis ecclie Parisien
 Petitis ura notis
Dat Rome apud Scm Sabinam
 Kl ♃ Aprilis a° 1°
Bulle an Seide P. vacat
 In plica links . O. Rand
 de Curia
Sub plica links : 9
 Rand oben links : .I.
Grosse, fette sehr gepflegte breite
Schrift, mit gestr. Ligaturen

Erste Linie für Papstname mit oben
 längen
Grosse Raumverschwendung

Papstname im Text nicht in Gitter
Mit je 2 Seitenlinien schrift

4144

Archives nationales Paris
L 272 n. 9 bis **1286 Aprilis 1**

Br. hoch Plica
oberer Rand links
rechts
Honorius IIII
vide n. 9

in Allem genau gleich, nur
a tergo oben mitte: Parisien

P. vacat

4145 (recto)

Firenze, R° Acquisto
P. — **1286 Aprilis 20**
Honorius .. generali ceteris-
que prioribus et fribus ordinis
sancti Guillermi
Ordinis vestri meretur
Rome apud Sanctam Sabi-
nam XII Kl. Maii a° 1°
Bulle und Seide fehlen
In plica rechts ſ pat
Sub plica links .. in: Roũ Rec?
q
Quer unten, durchstrichen,
Strich abgeklatscht
Rx O. Landen. Jaũ boẽt
Ecke oben links .l. rechts Rx
Rand oben mitte
ascult p m. Roũ verte

4145 (verso)

A tergo oben mitte minkel
gross, zierlich etwas verschnde.
hell
⌢⌢⌢⌢⌢⌢⌢⌢

Sñpũ CCCC XXX III

cap

Ränder und plica breit, ach-
linie unbeschrieben, sub
plica unliniert

4146

P. 22420 Paris Arch. Nat.
L 272 cap. 12 bis 1286 Apr. 26
Hon. IIII .. abbati et conventui mo-
nasterii S. Dionisii in Francia
ad Rom. Eccl. nullo medio perti-
nentis OSB Parisien. dioc
Ad monasterium vestrum
Rome ap. S. Sabinam VII Kl
Maii a° 1°
Bulle an Seide
In pl. rechts N Viviani
Sub plica links: q
m. Rẽo
daneben durchstrichen abgeklatscht
Rx fa põn
Jaũ boẽt
Ecke oben links; .l. und: Δ Jaũ

4147

Archives Nationales Paris

L 272 n. 10 **1286 Aprilis 26**

Br. 34. hoch 25.5 Plica 5.4
oberer Rand 8.1 links 2.9
rechts 2.7

Honorius IIII Ma
ttes Abbti Monasterij sancti Dioni
sij in Francia ad Romanam ecclesiam
nullo medio pertinentis ordinis
sancti Benedicti Parisien. dioc.
Ut populus tue
Dat. Rome apud Sanctam Sabinam
VI Kl Maij a⁰ 1⁰

Bulle an Hanf Rae
In plica rechts : Jac de Reb.
Sub plica links : --
9

A tergo oben mitte : n. de sto Victore

Ungemein gepflegte fette Schrift
Mit einem betonten Buchstaben
Erste freie Linie zwecklos

P. 22419

4148

due sunt concesse

Archives Nationales Paris

L 272 n. 11 **1286 Aprilis 26**

Br. 37.7 hoch 26.6 Plica 2.8
oberer Rand 6.6 links 1.9
rechts 2.

Honorius IIII . . Abbti
Monasterij de Compendio ordinis
sancti Benedicti Suessionen. dioc
Et si quibus libet
Dat. Rome apud Sctam Sabinam
VI Kl maij a⁰ 1⁰

Viviani ?
Bulle an Hanf ↓
In plica rechts : n. damiani
Sub plica links : . . .

Rand oben links : .l. (1) Reo
Ecke oben rechts : ay (Sy ?)
Rand oben mitte : due sunt concesse
A tergo oben mitte : n. de sto Victore

Kleine sehr weite regelm. Schrift
Ohne jeden betonten Buchstaben

Erste Linie zwecklos
P. vacat

4149

Archives Nationales Paris

L 272 n. 12 **1286 Aprilis 26**

Br. 35. hoch 26.4 Plica 4.3
oberer Rand 7.3 links 1.9
rechts 1.9

Honorius IIII (sehr fette
schöne Gitterschrift, zierlich verziert)
. . Abbti et Conventui Monasterij
sti Dionisij in Francia ad Roman ecclam
am nullo medio pertinentis ordinis
sti Benedicti Parisien dioc
Ad monasterium vrum
Dat. Rome apud Sanctam Sabinam
VI Kl maij a⁰ 1⁰

Bulle an Seide
In plica rechts : pa de po
Sub plica links : V

Fette kleine enge Schrift, mit mehreren
festr. Ligaturen
Erste Linie für Gitterschrift und unten
Oberlängen
Ungemein hässliche obere Oberlängen

P. 22420

4150

Archives Nationales Paris

L 272 n. 12 bis **1286 Aprilis 26**

Br. 43.5 hoch 33.3 Plica 5.9
oberer Rand 8.8 links 2.12
rechts 2r. 4

Honorius IIII (Gitterschrift
zierlich ausgespart) . . Abbti et
Conventui Monasterij sancti Dio
nisij in Francia etc
wie in n. 12

Bulle an Seide
In plica rechts : n. Viviani
Sub plica links : 9
m. Reo
Bx pa pon
Jac boet
Rand oben links : .l. und ꝰ Jac
A tergo oben mitte : n. de sto Victore

Kleine runde offene Schrift
Erste Linie für Gitterschrift

P. 22420

Archives Nationales Paris

L 272 n. 13 __1286 Aprilis 26__

Bn 34.2 hoch 25.4 Plica 5.3
oben Rand 6.1 links 1.5
rechts 1.5

Honorius IIII . . . Abbati mo
nasterij sancti dionisij in Francia
ad Romam ecclesiam nullo medio
pertinentis ordinis sci Benedicti
Pauperem dive
 Sicut petitio tua
Dat Rome apud Scam Sabinam
VI Kl Maij a° 1°

Bulle an dickem Hanf
 In plica rechts: n. Vivianj
Sub plica links: m. Rec
 Rand Doben links : . l.
A tergo oben Mitte : n. de sco Victore
Sehr weite kleine runde Schrift
Mit einem leicht behenten Brotstehen

Erste Linie fleckloss
 P. 22421

Rx

Paris Archives Nationales
 J 585 n. 45
Breite 39.2 Rand links 3.6 rechts 3.1
Höhe 29.8 Rand oben 8.9 plica 5.1
Erste Linie für Gitterschr und klei
nere Oberlängen / Je 1 Leitenlinie
P. vacat __1286 Aprilis 27__
Honorius IIII (Gitterschr) Carmo in
xpo filio Phy Regi Francie Illustri
Celsitudini Regie libenter
Dat Rome apud Scam Sabinam
V Kl Maij / a° 1°
 Bulle an feiner Seide
In plica rechts : P. y
Sub plica links : m. Roc und
Rx F. R. Jac bod 9 vacte

Ecke oben links : ⊿ Jac und
L Ecke oben rechts : Rx

A tergo oben Mitte :
Guido de Nod (sio) boy
dermuter Schluck mit vielen
kleinen Schnörkeln :

R [xpi] CCCLXXj
 [ap]

Kleine werk fette Schrift

Paris Archives Nationales
 J 585 n. 45 bis
Breite 39.4 Rand links 3.2 rechts 3.6
Höhe 30. Rand oben 9.3 plica 4.2
Erste Linie für Gitterschr und
Oberlängen / Je eine Leitenlinie
P. vacat __1286 Aprilis 27__
Honorius IIII (Gitterschr) Carmo
in xpo filio Phy. Regi Francie
Illustri
 Celsitudini Regis Regie libenter
Dat Rome apud Scam Sabinam
V Kls Maij a° 1°
Bulle an Seide
In plica rechts : F. Rx
Sub plica rechts : - - - vacte

4153 (verso)

A tergo oben Mitte:
Guido de Boy
Kleine fette stumpfe Schrift

4154

Paris Archives Nationales
J 683 n. 5
Breite 42.1 Rand links 3.7 rechts 3.
Höhe 30.2 Rand oben 8.9 plica 3.4
Erste Linie für Gitterschr und
Kleinere Oberlängen / Rechts eine,
links zwei Seitenlinien
P. vacat 1286 Aprilis 27
Honorius IIII (Gitterschrift) Carmo
in Xpo filio . Phy. Regi Francie
Jllustri
Ob tuorum excellentium
Dat Rome apud scam Sabinam
V Kt Maij a° I°
Bulle an feiner Seide
Su plica rechts : Q . S...
Große sehr fette kleine Schrift

4155 (recto)

Rr
Archives Nationales Paris
J 683 n. 5 bis
Breite 47.7 Rand links 3.7 rechts 3.8
Höhe 28.3 Rand oben 6.9 plica 4.3
Erste Linie für Gitterschr und
Oberlängen / Je zwei Seitenlinien
P. vacat 1286 Aprilis 27
Honorius IIII (Gitterschr) Carmo
in xpo filio . Phy. Regi Francie
Jllustri
Ob tuorum excellentium
Dat Rome apud scam Sabinam
V Kt Maij / a° I°
Bulle an Seide
Su plica rechts : Jac Vit
Sub plica links : g~~~ verte
Rr domine
Jac Boal

4155 (verso)

Ecke oben links : Rr Jac . l
Ecke oben rechts : Rr
A tergo oben Mitte schlank
mit dickem Qu Strich :

CCC lxxv

Weite fette schöne Schrift

4156

P. — Paris Arch. Nat.

J 685 cap. 45 **1286 Apr. 27**

Hon IIII Phg regi Francie ill.

Celsitudini regie libenter

Rome apud Sabinam V

Kl. maii a° 1°

Bulle an Seide

In plica rechts P. G

Sub plica link ---

 m. Rev. daneben

 9

durchstrichen Rx J. R. Jac Boet

Ecke oben links Xp Jac . J.

 " " rechts Rx

A tergo scpt CCCLXXI

 cap

4157 (recto)

Rx

Paris Archives Nationales

 J 686 n 79 c

Breite 39.9 Rand links 3.5 rechts 3.4

Höhe 30.9 Rand oben 1.6 plica 5.2

Erste Linie für Gitterschr und klei-

ne Oberlängen / Je eine Seitenlinie

P. vacat 1286 Aprilis 27

Honorius IIII (Gitterschr) Carmo in

xpo filio Phg Regi Francie Illustri

Gaudemus in domino

Dat Rome apud Scam Sabinam

/ V Kl Maij a° 1°

Bulle an sehr feiner Seide

 In plica rechts : P. G

Sub plica link : m. Roc

 9 Rx F. R Jac boet

 vede

4157 (verso)

Ecke oben links : Xp Jac und : l

Ecke oben rechts : Rx

A tergo oben Mitte :

Guido de boy

 scpt CCCLXXII

 cap

Kleine sehr schöne fette Schrift

4158

Paris Archives Nationales

 J 686 n. 79 d

Breite 35.2 Rand links 2.8 rechts 2.4

Höhe 29.9 Rand oben 3.1 plica 4.8

Erste Linie für Gitterschr und

Oberlängen / mit je 2 Seitenlinien

P. vacat 1286 Aprilis 27

Honorius IIII (Gitterschr) Car-

mo in xpo filio Phg Regi Fran-

cie Jllustri

Gaudemus in domino

Dat Rom apud Scam Sabi-

nam V Kl Maij a° 1°

Bulle an Seide

In plica rechts : F. R

A tergo oben Mitte : Guido de boy

Kleine flotte Schrift

4159 (recto)

Rx

Paris Archives Nationales
J 690 n. 132 (15)
Breite 57.5 Rand links 4. rechts 4.7
Höhe 38.1 Rand oben 8. plica 8.7
Erste Linie für Gitterschr. und Ober-
längen / Je zwei Zeilenlinien
P. vacat 1286 Aprilis 27
Honorius IIII (Gitterschrift) Carmo
in xpo filio Philippo Regi Fran-
cie Jllustri
 Puritas devotionis et
Dat. Rome apud Sanctam
Sabinam V Kl Maij / a° 10
Bulle an Seide
In plica rechts : Jac Vith (vel
Sub plica links : ⹅ 9 und
Rx L. Pergamen Jac Boet

4159 (verso)

Rand oben links : ⹅ Jac
und : L.
Ecke oben rechts : Rx

A tergo oben Mitte schlank
und schön und vielen kleinen
Schnörkeln :

[Jpo] CCC l xxVI

Weite feste sehr schöne Schrift

4160

(Datum)

Paris Archives Nationales
J 690 n. 132 (20)
Breite 58.2 Rand links 5.8 rechts 5.8
Höhe 31.6 Rand oben 8. plica 5.5
Erste Linie für Gitterschr. und kleinen
Oberlängen / Je zwei Zeilenlinien
P. vacat 1286 Aprilis 27
Honorius IIII (Gitterschrift Initiale
mit goth. Stirnzeile eine Kirche ver-
ziert) Carmo in xpo filio Philippo
Regi Francie Jllustri
 Puritas devotionis et
Dat. Rome / apud Scam Sabinam
V Kls maij a° 10
Bulle an Seide, schöne fette Schrift
In plica rechts : L. Pgani
Sub plica links : ⹅

4161

Paris Archives Nationales
J 690 n. 132 (16)
Breite 46.5 Rand links 3.4 rechts 3.6
Höhe 33.8 Rand oben 8.9 plica 3.9
Erste Linie für Gitterschr. nur
Oberlängen / Je eine Zeilenlinie
P. vacat 1286 Aprilis 27
Honorius IIII (Gitterschr.) Carmo
in xpo filio Phy Regi Francie
Jllustri
 desiderijs Regijs gratificari
Dat. Rome apud Scam Sabinam
/ V Kl maij a° 10
Bulle an feiner Seide
In plica rechts : Jac Romm
A tergo oben Mitte : Guido de noel bog

4162

Paris Archives Nationales
J 690 n. 132 (17)
Breite 57. Rand links 4. rechts 2.6
Höhe 38.6 Rand oben 8.8 plica 5.8
Erste Linie für Oberlängen
Je eine Seitenlinie
P. vacat 1286 aprilis 27
Honorius IIII . . . Abbati Mona-
sterij Sancti Dyonisij in Francia
Paris iem dioc
Desiderij, Carissimi in
Dat Rome apud sctm Sabi-
num, V kl Maij a° 1°
Bulle am Hanf
In plica rechts: Reput̄ R
A tergo oben Mitte: J. de boy

4163

Paris Archives Nationales
J 690 n. 132 (8)
Breite 48.2 Rand links 4.7 rechts 4.6
Höhe 34.7 Rand oben 8. plica 3.8
Erste Linie für Oberlängen
Je eine Seitenlinie
P. vacat 1286 aprilis 27
Honorius IIII . . . Abbati monasterij
Sancti Dyonisij in Francia Paris
iem dioc
Puritas devotionis et
Dat Rome apud Sctm Sabinum
V kl Maij a° 1°
Bulle fehlt, Hanf erhalten
In plica rechts: A . Med
Sub plica links : $\frac{\equiv}{V}$
A tergo oben Mitte: J. de Sco Germun

4164

Paris Archives Nationales
J 690 n. 132 (19)
Breite 48.6 Rand links 4.7 rechts 4.8
Höhe 33.2 Rand oben 8.1 plica 3.3
Erste Linie für Oberlängen
Je eine Seitenlinie
P. vacat 1286 aprilis 27
Honorius IIII . . . Abbati Mona-
serij Sctm Dyonisij in Francia
Paris iem dioc
Puritas devotionis et
Dat Rome apud Sctm Sabinum
V kl Maij a° 1°
Bulle am Hanf
In plica rechts : A . Med
A tergo oben Mitte: Guido de boy
Selbe große schöne Schrift

4165

P.— Paris Arch. Nat.
J 690 cap. 132ᵃ 1286 Apr. 27
Hon IIII Philippo regie Francie
illustri
Puritas devotionis et
Rome apud S Sabinam
V kl. Maii a° 1°
Bulle an Seide
In plica rechts L. pgam̄
Sub plica links $\frac{\equiv}{V}$

In der Initiale eine sehr
zierliche gothische Kirchen-
ansicht eingezeichnet

4166

Paris Arch. Nat.
J 691 cap. 139³ <u>1286 Aprilis 27</u>
Hon. IIII V Kl. Maii a° 1°
In plica rechts P G
Sub plica links --

 m. Rec̄.
 g

" " "Burg ausgestrichen
R̄ Jac̄ Rōm Jac̄ Boel
Ecke oben links ⋈ Jac̄ 2.
 " " rechts ℞

A tergo procurator

 scr̄ CCCLXXIIII

 cap

4167

P. 22422 Paris Arch. Nat.
J 692 cap. 141ᵉ <u>1286 Aprilis 27</u>
Hon. IIII V Kl Maii a° 1°
In plica rechts P G
Sub plica links v̄

 m Roco nur

 Jac̄ boel
Ecke oben links ⋈ Jac̄
Rand oben Mitte
ascultata ē cū indulg et bn
 a. med
Darunter ausgestrichen
redditur clericis Regis Fran
cie, ne corrigatur sicut alia

4168 (recto)

 ℞
Paris Archives Nationales 8,
 J 689 n. 129
Breite 44.3 Rand links 4. rechts 3.6
Höhe 29. Rand oben 5.7 plica 4.9
 Erste Linie für Gitterschr über
lüngen/ je zwei Intenlinies
P. 22423 <u>1286 Aprilis 29</u>
Honorius IIII Carmo in Xpo filio
Phy Regi Francie Illustri. —
 Desideriis Regiis benigne …
Dat Rome apud Scm Sabinam
III Kl Maii / a° 1°
 Bulle an feiner Seide.
In plica rechts : Jac̄ Vit
Sub plica links : - - - nur
 g
R̄ H. Rad Jac̄ boel / aute

4168 (verso)

Ecke oben links : ⋈ Jac̄ 2.
Ecke oben rechts : 14.
 A tergo oben Mitte schön schwung
voll mit vielen kleinen Schnörkeln :

 CCC LXXVI

 cap feste mittelgrosse
 sehr schöne Schrift

4169 (recto)

Paris Archives Nationales ℞
J. 431 n. 37
Breite 55.5 Rand links 4.7 rechts 4.7
Höhe 39.9 Rand oben 9.7 plica 4.7
Erste Linie für Oberlängen / Je
2 Seitenlinien
P. vacat 1286 Aprilis 30
Honorius IIII Johanni tt sancte
Cecilie pbro Cardinali aplice
sedis legato
 Prosperum et felicem ____
Dat Rome apud Scam Sabinam
ij Kl Maij / aº 10
Bulle an Hanf
In plica rechts : A. Med
In plica links : soluit
Sub plica links : ≈
 m Reč verte

4169 (verso)

darunter auf dem Bug :
℞ p. Reat Jac bot
Ecke oben links : ⅂ Jac
und . 2 .
Ecke oben rechts : ℞
A tergo oben Mitte :
 Guido de boy
 ┃scpt⟩ C C C L X X X VIII
 ╏cap╏
 Ecke oben links : B
Weite fehlt Oben Schiff

4170

Paris Archives Nationales
J. 431 n. 37
Breite 56.7 Rand links 5.1 rechts 5.6
Höhe 43.8 Rand oben 9.7 plica 8.
Erste Linie für Oberlängen / Je
Zwei Seitenlinien
P. vacat 1286 Aprilis 30
Honorius IIII Johanni tt sancte
Cecilie pbro Cardinali aplice
sedis legato
 Prosperum et felicem
Dat Rome / apud Scam Sabinam
ij Kl Maij anno 1º
 Bulle an Hanf
In plica rechts : P. Reat
 Sub plica links ≈
A tergo oben Mitte : Guido de Boy

4171 (recto)

duplicetur / vice cancellarii
 bulletur
Paris Archives Nationales
J. 431 n. 38
Breite 42.1 Rand links 3. rechts 3.1
Höhe 34.7 Rand oben 8.7 plica 5.1
Erste Linie für Gitterschr. und kleine
Oberlängen / Je eine Seitenlinie
P. vacat 1286 Aprilis 30
Honorius IIII (cum. Initiale gt.
Sancto) Johanni tt sancte Cecilie
pbro Cardinali aplice sedis legato
 Dudum felicis recordationis
Dat Rome apud Scam Sabinam
ij Kl Maij aº 1º
 Bulle in Seide
In plica rechts : A. Med
Sub plica links : ʒ und
℞ O Landen verte
 Jac biol

4171 (verso)

Rand oben links : · l · davnebens
dup vro
Mitte : bulletur et dño re.
mittatur
Ecke oben rechts : R
A tergo oben Mitte :
· J · de Sco Germano
Fehlt grösse blaue Schrift

4172

P. — Paris Arch . Nat.
J 714 cap. 305 9b 1286 Aprilis 30
Hon ꟿ Johanni tit S. Cecilie
presb. card apl. sedis legato
Cupientes ut canonicus
Rome apud S Sabinam II
Kl. Maii aº 1º
Bulle an Hanf
Inplica rechts · A · Med ·
Sub plica links m̈ Roc
g
Sub plica links Bng R Sy T
Jač boet
Ecke oben rechts H Jač und · l ·
Mitte gor rechts R
A tergo [symbol] CCCLXXVIIII
Ja√

4173 (recto)

Firenze, Rº Acquisto Ma.
riotti
P. —
1286 Maii 5
Honorius ꟿ [ohne Punkte ohne
Lücke] priori generali ceterisque
prioribus et fribus Heremitis
Sci Guillermi tam presenti.
bus etc. Ih ppM
Religiosam vitam eligentib
R. Ego Honorius catholice
ecclie Eps ss m
5 presb. 5 epi 1 diav
Rome apud Scam Sabinam p ma
magistri Petri de Mediolano sancte
Roman. ecclie vicecancellarii ꟿ
non. Maii, Indict. XIIII Inca. Dnica
anno M. CC. LXXXVI p. nero donni
HONORII pp ꟿ aº primo verte

4173 (verso)

Schluss des Textes nur
zwei Mal amen
Aug Aug .
neben dritt letzter Text.
rechts auf dem linken Rand
v̈
m̈ Roc

4174

Public Record Office London
Papal Bulls bundle 19 n. 6
Clausa

P. 22 427 1286 Maii 5

Honorius IV -- regi Anglie
illustri

Exigit regalis ad

Rome apud S. Sabinam

III non. Maii a° 10

Bulle an Hanf

Breite Ränder

4175

Archives Nationales Paris
L 272 n. 16 1286 Maii 7

Br. 35.3 hoch 25.9 Plica 5.9
ober Rand 9.5 links 3.2
rechts 3.2

Honorius IIII (hohe Gitterschrift
Initiale ausgespart) Matheo Abbati
Monasterij sancti Dyonisij in Francia
ad Romam ecclesiam nullo modo per-
tinentis ordinis sancti Benedicti
Parisien dioc

Devotionis tue precibus

Dat Rome apud S. Sabinam
non Maij a° 10 P. 22430

Bulle an Seide

In plica rechts: Jac de ...

Sub plica links: g

Rand oben links: .l.

A tergo oben Mitte: N. de Sto Victore

Sehr weite selbe gepflegte Schrift

Erste Linie für Gitterschrift nur Ober-
längen

Sehr weite Zeilenabstände

4176

Archives Nationales Paris
L 272 n. 17. 1286 Maii 7

Br. 49.2 hoch 30 Plica 6.1
ober Rand 9.4 links 6
rechts 6.1

Honorius IIII Archiepis et
Epis per Regnum Francie consti-
tutis Ex parte Carissimi

Dat Rome apud S. Sabinam
non Maij a° 10 P. vacat

Bulle an Hanf

In plica rechts: P. Reat

Sub plica links: g

a) Ree

Darunter: Rf P. Sct Jac boel
Rand oben links: Jac 7.
Ecke oben rechts: Rf
A tergo Ecke oben links: B
oben Mitte:
verschnörkelt, breit schön 2.7

Mit je zwei Seitenlinien

4177

Staatsarchiv kein Böhm. Archiv
P. — 1286 Maii 7

Honorius IIII universis comi-
tibus, baronibus, magnatibus
et nobilibus per regnum Boemie
ac terras alias cum in ... filii
nri .. Regis Boemie illustris con-
stitutis

Audito nuper quod

Rome apud S. Sabinam
non. Maii a° 10

Bulle an Hanf

In plica rechts n. Viviani

Sub plica links V

nur Rf M. Rocca Jac bait?

Ecke oben links Jac nur

.l. Rand oben Mitte ben und cft

4178 (recto)

℞

Paris Archives Nationales
J 686 n. 73
Breite 40.5 Rand links 4, rechts 3.4
Höhe 29.5 Rand oben 10.5 plica 3.8
Erste Linie für Gitterschr. und
kleinere Oberlängen / Je 1 Seiten-
linie
P. vacat 1286 Maii 11
Honorius IIII (Gitterschr.) Carmo
in xpo filio Philippo Regi Fran-
cie Illustri
Significasti nobis quod
Dat Rome apud sanctam Sabi-
nam V Jd Maij a° 1°
Bulle an feiner Seide
In plica rechts: ✠ P. G.
vacat

4178 (verso)

Sub plica links: m̈ Roc
9
Daneben: ℞ Sy Ro Jan boel
Ecke oben links: ✠ Jan und
2. Ecke oben rechts: ℞
A tergo oben Mitte:
J. de Sco Germano
darunter schlank sehr ver-
schnörkelt: [Signatur] CCCLXXXXIII
℞ar
Weite stumpfe fette Schrift

4179 (recto)

Paris Archives Nationales
J 686 n. 73 bis
Breite 36.2 Rand links 2.2 rechts 2.5
Höhe 25.1 Rand oben 7.4 plica 4.2
Erste Linie für Gitterschr. und
kleinere Oberlängen / Je eine
Seitenlinie
P. vacat 1286 Maii 11
Honorius IIII (Gitterschr.) Carmo
in xpo filio Philippo Regi –
Francie Illustri
Significasti nobis quod
Dat Rome apud sanctam Sabi-
nam / V Jd Maij a° 1°
Bulle an Seide
In plica rechts: Sy. Ro
vacat

4179 (verso)

Sub plica links: - - -
A tergo oben Mitte:
J. de Sco Germano
Lose dünne deutliche Schrift

4180

Bayer. Haupt. Staatsarchiv
Bamberg 791

P. 22443^x 1286 Maii 15

Honorius III (ohne Punkte) Clero
Civitatis et dioc. Bambergen.
 Pastoralis officij summis
Rome apud ~~S. Petr.~~ Scam Sabinam
Id. Maij Anno Primus -

Bulle an Hanf.
In plica rechts: L. pgem

Sub plica links: $\overline{\overline{\overline{x}}}$
 m. Roc
 ~~Jac Bod~~ ?
Ecke oben links: ~~M~~ Df Jac
oben mitte: cor
 Ecke oben rechts: L
A tergo Ecke oben links: a

Sehr breite Ränder. Kleine strich ab
gerundete und verbundene Schrift mit
grossen ober- und Unterlängen.

 Vergl. Duplicat

4181

Bayer. Haupt. Staatsarchiv
Bamberg h. 193

P. 22443^x 1286 Maii 15

Honorius III Universis Vasallis Bam-
bergen. ecclie
 Pastoralis officij summis
Rome apud Sern ~~Petr~~ Sabinam Id.
Maij anno Primus

Sehr gut geprägte Bulle an dickem Hanf
In plica rechts: p. g.
 Sub plica links: $\overline{\overline{\overline{x}}}$
 m. Roc
 Rt p. gem
 Jac. Bod.
Ecke oben links: Df Jac.
Innenben: ·l·
 Ecke oben rechts: Rt
A tergo Ecke oben links: a

 Vergl. Duplicat

4182 (recto)

Datum

Paris. Archives Nationales
 J 449 n. 118
Erste Linie für Oberlängen /
Je eine Zwischenlinie
P. vacat 1286 Maii 21
Honorius III Ven fratrib' Uni-
uersis Archiepis et Epis ac Dilē
filijs Abbatib' Priorib' et alijs
Eccliaꝝ Prelatis per Regnum
Francie constitutis
 Ad audientiam aptatus
Dat/ Rome apud Sčam Sabi-
nam XII kl Junij aº 2º
Prachtvoll geprägte Bulle an
Hanf
In plica rechts: · a. Ned
Sub plica links: $\overline{\overline{v}}$
 g vate

4182 (verso)

Rand oben links: ·l·
Ecke oben rechts: Rt
A tergo oben mitte: Guido de Bog
Sehr schöne Jette regeln. Schin

4183

Paris Archives Nationales

J 449 n. 118 bis

Erste Linie für Überlängen
Je eine Seitenlinie

P. vacat **1286 Maii 21**

Honorius IIII etc ut in n. 118
Dat Rome apud Scam Sabi
nam XII kl Junii a° 20

Bulle an Hanf

In plica rechts : A. Med

Sub plica links :

A tergo oben Mitte : Guido de Boy

Herrliche fette mittelgr. Schrift

4184

Archives Nationales Paris

L 273 n. 18 **1286 Junii 5**

Br. 35.6 hoch 28.1 Plica 4.9
oberer Rand 9.5 links 2.1
rechts 2.3

Honorius IIII (Gitterschrift
Initiale ausgespart) . . Abbati
et Conventui Monasterij sancti
Germani de Pratis Parisien ad
Romam ecclam nullo medio per
tinentis ordinis sancti Benedicti
 Cum sicut ex
Dat Rome apud Scam Sabinam
non Junij a° 20 **P. vacat**

Bulle und Seide fehlen
 In plica rechts : Sy. Ro
Sub plica links : - -
 m. Reo
Ecke oben rechts : att
A tergo Ecke oben links : R
 " oben Mitte : Bernardus
Leichte weite Schrift Fabri pro
 rechts . m. g.
Erste Linie für Überlängen
 und Gitterschrift

4185

Archives Nationales Paris

L 273 n. 19 **1286 Junii 5**
 P. vacat
Br. 41.7 hoch 25.9 Plica 3.4
oberer Rand 8.7 links 3.1
rechts 3.8
 Honorius IIII (Gitterschrift
In tiale ausgespart) . . Abbati
et Conventui Monasterij sci Ger
mani de Pratis Parisien ad Ro
man ecclam nullo medio perti
nentis ordinis sci Benedicti
 Ex parte nra
Dat Rome apud Scam Sabinam
 non Junij a° 20

Bulle und Seide fehlen
 In plica rechts : Sy. Ro
Sub plica links : - - -
 m. Reo
Ecke oben rechts : att
A tergo oben Mitte : Bernardus
Leichte offene Schrift Fabri pro
Erste Linie für Gitter . m. g.
schrift und Überlängen

4186

Public Record Office London
Papal Bulls bundle 18 n. 19
 Clausa

P. 22 481 1286 Junii 17

Honorius IV E. regi Anglie illustri

Processit ex intime

Rome apud S. Sabinam XV kl.

Julii a° 20

Bulle an Hanf

4187

Firenze, S. Maria Nuova
P. — 1286 Junii 22
Honorius IIII . . priori secula-
ris ecclesie sancti Petri
Skeradii Florentin.

Significavit nobis Fulco
Rome apud Scam Sabi-
nam X Kl. Julii a° 2°
Bulle fehlt, durchgehalten
In plica recht f
Sub plica links ...

Ecke oben links . f. ... rechts ...
A tergo oben Mitte ...
verschnörkelt
klein

4188

napoli Curia Eccl. ...
vol. 2° P. — 1286 Julii 23
Honorius IIII . . magistro et fra-
tribus Hospitalis S. Marie Theo-
tonicorum Jerosolimitan.

Solet annuere sedes
Tiburi. X Kl. Aug. a° 1°
Bulle und Seide fehlen
In plica rechts f. Ant
Sub plica links . .

4189

Bull. gen. I cap. 5
P. — 1286 Augusti 12
Honorius IIII Benedicto dicto
mit kl. Schnörkeln m° com n
versiert
Gaitano de Anagnia nepoti
B. S. Nicolai in Carcere Tulliano
diaconi cardinalis canoni-
co Atrebaten.

Volentes personam tuam
Tibure I N. Augusti a° 2°
Bulle und Seide fehlen
Dica abgeschnitten
A tergo oben Mitte: Dns B. Card.

4190

Bull. gen. I cap. 6
P. — 1286 Augusti 13
Honorius IIII Benedicto dicto
M. mit kl. Schnörkeln
Gaitano de Anagnia nepoti B.
S. Nicolai in Carcere Tulliano
diaconi cardinalis canonico
Atrebaten. . .

Venerabilis frater noster
Tibure iv. Augusti a° 2°
Bulle fehlt. dünne Seide erhalten
In pl. rechts: P. gen. g
A tergo: Dns B. Card.

4191

Firenze , Monte Pulciano
P.– 1286 Octobris 11
Honorius IIII .. archipresbitero
plebis scē Marie de Monte Pulcian
Aretin dioc.
Conquestus est nobis
Rome apud Sanctam Sabinam
V id. oct. a° 2°
 Bulle und Hanf fehlen
In plica rechts Mato
Ecke oben rechts aŕ

Eingestellt unter 1217 oct. 11

4192

Marseille Archives départem.
H. o.m. 22
P.– 1286 Octobris 30
Honorius IIII .. priori scē Salva
toris de Monoascha
 Pium esse dinoscetur
Rome apud scēm Sabinam
III kl. nov. a° 2°
 Bulle an Hanf
In plica rechts J. Laur.
Sub plica links .:
Ziemlich schöne Schrift

4193

Archives Nationales Paris
L 273 n. 20 1286 Novembris 15
Br. 67.2 hoch 55. Plica 3.7
 oberer Rand 11.6 links 2.9
rechts 2.6
 Honorius IIII (Im Titel aus
gespart: das Andere in schönen run
den Mini.) • Priori Generali et
fratribus Heremitarum ordinis sanc
Ti Augustini
 Petitio nestra nobis
dat Rome apud scēm Sabinam
XVII kl decembr a°2°
 Bulle und Seide fehlen
 In plica rechts : N. Viniani
Randoben halblinks : · p.
 " " Mitte cor

Sehr regelm. weite Schrift
erste Linie für Papstnamen

 P. 22533

4194 (recto)

 ascultetur cum (prov.)
Archives Nationales Paris
L 273 n. 21 1286 Novembris 15
Br. 75.5 hoch 56. Plica 5.4
 oberer Rand 13.2 links 5.4
rechts 6.
 Honorius IIII (Im Titel ver
ziert. das Andere schöne runde Mini
mit Arabesken. — Priori Generali
et fratribus Heremitarum ordinis
sancti Augustini
 Petitio nrā nobis
dat Rome apud Scām Sabinam
XVII kl decembr a°2°
 Bulle und Seide fehlen P. 22534
 In plica rechts : O. Land
Sub plica links : :) ×
 ×
 O. Land.
Ecke oben links : 4 Jāt
nur · L. daneben : · p. (provin
Rand oben Mitte : ascultetr cum. —
Ecke oben rechts : Rf · a°.
 p. geñ
A tergo oben Mitte · frater Clemens
 verte

4194 (verso)

Sehr fette grobe schöne Schrift.

Erste Linie für Papstname
und Oberlängen

Mit je zwei Seitenlinien

4195

Archives Nationales Paris
L 273 n. 22 1286 Novembris 15

Br. 67.5 hoch 43.7 Plica 7.4
oberer Rand 10.7 links 4.7
rechts 4.5

Honorius IIII (Die Teile ausg.
spart; das Andere: schöne runde
minuskulae) . . Priori Generali
et fratribus Heremitax ordinis sanc-
ti Augustini

Meritis ure religionis
Dat. Rome apud Sanctam Sabi-
nam XVII kl decembr̄ a° 2°

Bulle und Seide fehlen.
In plica rechts : J. Lutary
Sub plica links : ✓
Rand oben ☓ | halblinks : . p.
Feste regelm. Schrift
Erste Linie für Papstnamen
und andere Oberlängen

Oberer Rand 10.7. P. 22535

Mit je zwei Seitenlinien

4196 (recto)

Archives Nationales Paris
L 273 n. 23 1286 Novembris 15

Br. 67.3 hoch 55.7 Plica 5.4
oberer Rand 14.2 links 4.7
rechts 4.7

Honorius Honorius IIII (Die
Teile ausgespart; das Andere reich mit
Arabesken verziert) . . Priori Genera-
li et fratribus Heremi Frum sancti
Augustini

Petitio ura nobis
Dat. Rome apud Scam Sabinam
XVII kl decembr̄ a° 2° P. vacat

Bulle und Seide fehlen.
In plica links : O. Laud
Sub plica links : 9 x
 x
 O. Laud
R̄ Ambros Tai boet
Ecke oben links : ✠ Jao .l.
Rand oben Mitte asculteta

Oberer Rand 14.2 !!!
Mit je zwei Seitenlinien verte

4196 (verso)

Ecke oben rechts : R̄ . a.
 p. Gen
A tergo Ecke oben links : B
 oben Mitte : frater Clemens

Registratur nicht erkennbar

Kräftige regelm. Schrift

Erste Linie für Papstnamen
und Oberlängen

4197

Archivio di Stato Milano
Bolle e Brevi
P. — 1286 Novembris 27
Honorius IIII .. preposito ecclie
sci Raymundi duodecim apo-
stolorum Placentin.
Tua nobis .. minister
Rom. apud Sctam Sabinam
V kl. decembr. a° 2°
Bulle und Hanf ausgerissen
In plica rechts Mar Vell.
Sub plica links ö. Laud.
Ecke oben rechts a vii

 Fälschlich unter Honorius III
 eingestellt.

4198

Archivio di Stato Milano
Bolle e Brevi
P. — 1286
Honorius Innocentius IIII .. archipresbi-
tero ecclie Papien.
Conquesti sunt nobis
Rom. apud Sctam Sabinam
V kl. decembris a° 2°
Bulle und Hanf fehlen
In plica rechts Mar Vell
Ecke oben rechts a vii

 Fälschlich sub Honorio III

4199

Bull. gen. I cap. 7
P. — 1286 Dec. 13
Honorius IIII Odoni nato nobis
 Kl. Gettembr.
lii viri Adenulphi Mathie de
Anagnia canonico eccle S.
Amati Duacen. Atrebaten.
diöc.
 Exigunt tue probitatis
Rome apud S. Sabinam iv.
decembris a° 2°
 Bulle und Seide ausgerissen
Inpl. rechts Sy. T.
A tergo oben mitte: Dus Ben. Cur.

4200

Instr. mon. F. dm. C. 147 1286 Dec. 18
 P. 22548
Hon. IIII .. priori provinciali Fraucie
ord. Predic.
Cum sicut dilecti
Rome ap. S. Sabinam XV kal.
 Ianuarii a° 2°
 Bulle an Hanfschnur
In Bulle plica links: ö. Laud.
Sub plica links: ...
 ö. Laud.
 9
Oben Ecke links: .l. , rechts R
mitte C vii
A tergo I Pred.

4201

Archivio di Stato Milano
Bolle e Brevi
P. — 1287 Ianuarii 28
Honorius IIII . . preposito ecclie
ste marie duodecim Apostolo-
rum Placentin.
Conquesti sunt nobis
Rome apud Scam Sabinam
V Bl. febr . a° 2°
Bulle und Hauf fehlen
In plica rechts G aly

4202

Archives Nationales Paris
L 273 n. 24 1287 Martii 7
Br. 36.5 hoch 29.2 plica 3.6
obven Rand 10. links 3.3
rechts 3.6 Honorius IIII
Initiale ausgespart) . . Abbati et
Conventui Monasterii sancti dionisii
sij in Francia ad Romam Ecclam
nullo medio pertinentis ordinis
sancti Benedicti Parisien dioc
 Cum a nobis
Dat Rome apud Scam Sabinam
non martij a° 2° P. vacat
Bulle XXX an Seide XXXXX
 In plica links : D. Laud
Sub plica links : --
 atto p
A tergo oben Mitte : N. de Sto Victore
Ausnahmsweise grosse sehr schöne
 Schrift. Oerste Linie für Gitterschrift
 und Oberlängen
Je zwei Seitenliniera

4203

Archives Nationales Paris
L 273 n. 25 1287 Martii 23
Br. 39.5 hoch 26. plica 4.8
obven Rand 9. links 3
rechts 2.7
 Honorius IIII (Gitterschrift
Initiale ausgespart) . . Abbati et
Conventui Monasterii sancti dyo-
nisij in Francia ad Romam Ecclam
nullo medio pertinentis ordinis sce-
te Benedicti Parisien dioc
 Cum sicut ex
Dat Rome apud Sanctam Sabinam
X Kl aprilis a° 2°

Bulle an Seide
 In plica rechts : P. benets
Sub plica links : --
 a tergo oben Mitte : N. de Sto Victore
Sehr regelm. feste Schrift
 Oerste Linie für Gitterschrift und
 P. vacat Oberlängen

Je zwei Seitenliniera

4204

Public Record Office London
Papal Bulls bundle 19 n. 9
 Regestum Camerae
P. 22596 1287 Aprilis 1
Honorius IIII — E — regi Anglie Illustri
Attendentes laudabile et
Rome apud S. Sabinam
Kl. Aprilis a° 2°
 Bulle an Seide
In plica rechts Galgan?
a tergo oben Mitte
 . L XX caşi
Rf in Regesto Came
magrm Jacobum de Viterbio

 Vorzüglich schöne und gleich-
 mässige Schrift.

4205

Public Record Office London
Papal Bulls bundle 30 n. 8
P. — 1288 Februarii 24
Nicolaus IIII .. regi Anglie illustri
Iudicii Dei abyssus
Lateran. VII kl. Martii a° 1°
Bulle an Hanf
In plica links: Jac boet
de cur
daneben R Cosmas I pro rege
Norguehie (sic) et cito
Alb p

4206

Arch. Arcis
Arm. C fsc. 29 cap. 3
1288 febr. 28
Nicolaus IIII Loffrido dicto Gaitano de Anagnia nepoti dil. f.
nri B. S. Nicolai in Carcere Tulliano
diaconi cardinalis canonico Ambianen.
Devotionis tue meritis
Bulle und Seide ausgeschnitten
In pl. recht: P. Gen. pro
nepote cards
Dat. Laterani, III Kl. martii
pont. nostri a. primo

4207

Quotr. Inc. 1277 1288-1298 a. 2
P. — 1288 Martii 8
Nic. IIII B. Sancti Nicolai in Carcere
Tulliano diacono card.
Considerantes in sinu
Laterani VIII id. Martii a° 1°
andere Tinte
Bulle und Seide fehlen
In plica rechts: Sy. Ro.
de Curia
Sub plica links: 9
Rund oben links: a.

4208

Bull. Gen. I cap. 9
P. — 1288 Martii 8
Nic. IIII B. S. Nic. in Carcere
Tulliano diacono cardinali
In agro domini
Laterani VIII id. Martii a° 1°
Bulle und knif ausgerissen
Sub pl. links: 9
Ecke oben links: d

4209

Archives nationales Paris

L 274 n. 1 **1288 Aprilis 12**

Br. 29.6 hoch 21. Plica 3.1
obere Rand 4.3 links 1.8
rechts 1.8

Nicolaus IIII (Gitterschrift
Initiale ausgespart) - - Magro et
fratribus Domus Militie Templi
Jerlimitani
 Cum sicut ex
dat Rome apud Scm Petrum II
Jd Aprilis a° 1°

Bulle an Seide

Fette eilige Schrift
 Erste Linie Gitterschrift und
 Oberlängen

Gnia wanaufleichig
 P. vacat

4210

Archivio di Stato Milano
 Bolle e Brevi
 P. 1288 Aprilis 17
Nicolaus III .. epo novariensis.
 Ex parte dilecti
Rome apud S. Petrum XV Kl.
Maii a° 1°

 Bulle und Hanf fehlen
In plica links Scriptor
Sub plica links alto p

Ecke oben links. 2., rechts
Rand " mitte
A tergo oben mitte XXInj.
ziemlich klein schlank

4211

Brit. Museum Harl. Chart. II. A. 27
 P. 1288 Aprilis 24
Nicolaus III.. abbati et conven
tui monasterii Clarevallis
Cistord. Lingonensis diöc.
Presentata nobis ex
Rome apud S. Petrum VIII
Kal. Maii a° 1°

Bulle an Hanf
In plica rechts Schreiber
Sub plica links

4212

Archives nationales Paris

L 274 n. 2 **1288 Aprilis 27**

Br. 84. hoch 22.9 Plica 3.6
obere Rand 6.4 links 2.7
rechts 2.5

Nicolaus IIII (Gitterschrift
Initiale Ausgespart) . . Abbati et
Conventui Monasterij sancti Vic
toris Parisien ordinis sancti augus
tini
 Solet annuere sedes
dat Rom apud Scm Petrum F Kl.
 Maij a° 1°

Bulle an Seide
 In plica S rechts : c. and
Sub plica links : --
 alto p
Ecke oben rechts
 Fette kleine enge Schrift ', mit gesta
Ligaturen
 Erste Linie ful Gitterschrift und
 Oberlängen
 P. vacat

Je zwei Linienlinien

4213

Public Record Office London
Papal Bulls bundle 30 n. 6
P. 22688 1288 Aprilis 28
Nicolaus IIIj . . regi Anglie
Illustri
 Honorem tuum fili
Rome apud S. Petrum IIIj kl. Maii
 a° 1°
 Bulle an Hanf
 In plica rechts f . R .
 de Curia

4214

Archivio di Stato Milano
Bolle e Brevi
P. — 1288 Maii 1
Nicolaus IIII . . abbi et conv.
monasterii de Cereto Cisterc. O.
Lauden. dioc.
 Cum a nobis
Rom. apud S. Petrum kl.
Maii a° 1°
Bulle und Seide fehlen
In plica rechts Jac boet
Sub plica links n. Viviani
Eine Ligatur et nicht gestreckt

4215

Madrid Arch. Histor. Nacional
 Huesca doc. eccl. 1° 68
 P. — 1288 Maii 2
Nicolaus .. Camerario et..
cantori ecclie Cesaraugustan.
ac magro Petro de Briva ca-
monico Ilerden.
Conquesti sunt nobis
Rome ap. S. Petrum non. Maii
a° 1°
Bulle und Hanf fehlen
In plica rechts Johan pom ?
Ecke oben rechts be

4216

Firenze, S. Croce di Firenze
 P. 22707 1288 Maii 14
Nicolaus IIII . . generali et pro-
vincialibus minis tris ac uni-
versis fribus ord. prum Minor.
 In vestri ordinis
Reate ◊ iñ. Maii a° 4°
 Bulle und Hanf fehlen
In plica rechts Jo. de Rocca
 Sub plica links V̄
weiter unten durchstrichen
 R̸ Thomas pa
 R̸ M. Rocc. IIII
 pro al. sub f. Ang

4217

Napoli Curia Eccles. Vol. 3°
P. — 1288 Maii 27
Nicolaus IIII. — magro et fribus
Hospitalis Stce Marie Theutonic.
comm. Ierosol.
 Solet annuere sedes
Reate VI Kl. Iunii a° 1°
Bulle und Seide fehlen

4218

Nîmes Archives départem.
G. 432

P. — 1288 Iunii 3

Nicolaus IIII. Guilelmo de Lau-
ro rectori ecclesiarum Sancte
Marie et S. Andree de Conge-
niis, quarum una dependet
ab alia Nemausen. dioc.
 Cum a nobis
Reate III non. Iun. a° 1°
Bulle fehlt, Seide erhalten
In plica rechts T. palub

Sub plica links
 alb. p

4219

Firenze, Badia di Passignano
 P. — 1288 Iunii 5
Nicolaus IIII. — abbati mon. de
Rufena Aretin. dioc.
 Conquesti sunt nobis
Reate non. Iunii a° 2°
 In plica rechts . f. R.
Ecke oben rechts Ja
 Bulle und Hanf fehlen
 14. 7 hoch
 3. 2 plica
 21. 0 breit

Kleine spitze schwung.
volle Schrift

4220

Archives nationales Paris
L 274 n. 3 1288 Iunii 8
Br. 20 hoch 12 plica 3
 obere Rand 3. 4 links 1. 1
rechts 1
 Nicolaus IIII. — Priori fri Egi-
dij de Publico Monte Leodien. dioc
 Dilectorum in xpo
Dat Reate VI Id. Iunij a° 1°

Bulle und Hanf fehlen
 In plica rechts : Coonnes
A tergo oben Mitte : p. de teo Victore

Kleine eilige Schrift
 Ohne jeden betonten Buchstaben
erste freie Linie rechts

 P. vacat

4221

Firenze, Comune di Firenze
P. — 1288 Iulii 1
Nicolaus IIII — epo Florentin
 Inundans malicia perversos
Reate Al. Iul. a° 2°
Bulle und Hanf fehlen
In plica rechts M. de Rocca
Sub plica links . . ²⁵
 reput

Ecke oben rechts
 J. de Penesth und ʃʃ

4222

Archives Nationales Paris
L 274 u. 5 1288 Iulii 28
Br. 58.5 Hoch 36.1 Plica 5.6
 obere Rand 9.6 links 4.5
rechts 4.2
 Nicolaus IIII (Gitterschrift
Initiale ausgespart) . . magro
et fratribus ordinis fratrum Predi-
catorum
 Dum sollicite considerationis
Dat Reate V kl aug a° 1°

Bulle und Seide fehlen
 In plica rechts : M. de Rocca
Sub plica links : Ξ
 Darunter : R₄ Alatri IIII
 F. Atri
fette kleine regelm. Schrift
 erste Linie für Gitterschrift und
 Oberlängen

 P. 22758

4223

Madrid Arch. Histór. Nacional.
Dominicos Palma 26 C
 P. 22758 1288 Iulii 28
Nicolaus IIII — magro et fribus
ord. frum Pred.
Dum sollicite considerationis
Reate V kl. Aug. a° 1°
Bulle fehlt. Seide erhalten
In plica rechts dominicus
Sub plica links Ξ
 V
gans unten :
Iterum R₄ Iaū ver IIII
 J. Ann

R₄ J. frate ʃʃ
 J. Ann

4224

Madrid Arch. Histór. Nacional.
Dominicos Huesca 17 C
 P. 22758 1288 Iulii 28
Nicolaus IIII — magro et fra-
tribus ord. fratrum Predic.
Dum sollicite considerationis
Reate V kl. Aug. a° 1°
Bulle fehlt. Seide erhalten
In plica rechts Iaū d'pis
A tergo oben linke breit und
klein Iapō l xxx viiii ?

 dap

4225

Madrid Arch. Histor. Nacional
Zamora Benavente 3 E
P. 22759 Registratur
 1288 Julii 28
Nicolaus IIII .. magro et fratribus ordinis fratrum Pred.
Inter cetera vobis
Reate V Kl. Aug. a° 10
Bulle nur Seid. fehlen
In plica rechts dominicus
Sub plica links v̄
A tergo ganz oben halbrechts
klein und breit

scripte cap° LXXXVIII

4226

Madrid Arch. Histor. Nacional
Dominicos S. Pablo Burgos 51 E
P. 22759 1288 Julii 28
Nicolaus .. magro et fribus
ord. frum Pred.
Inter cetera vobis
Reate V Kl. Aug. a° 1°
Bulle fehlt. Seidenhalten
In plica rechts dominicus
Sub plica links ≡

4227

Napoli Curia Eccles. Vol. III
P. 22759 1288 Julii 28
Nicolaus IIII .. magro et fribus
ord. fratr. Pred.
 Inter cetera vobis
Reate V Kl. Aug. a° 10
Bulle nur Seid. fehlen
plica abgeschnitten

4228

Instr. Miscell. F. Dom. C. 14 1288 Jul. 28
 P. 22758
Nic. IIII .. mag. et fratribus ord. fratrum
 Pred.
Drum sollicite considerationis
Reate V bal. Aug. anno 1°
Seidenfäden, Bulle fehlt.
In plica rechts: H. Par.
Sub plica links: ≡
 v̌

Unter dem Bug links:
 R/ M. de Adria IIII et non facias plures
 ~~E Aug~~ J. Aug

A tergo: die VIIII Septembris producta
per magistrum Petrum Aldegem
procuratorem

 Duplicat

C. 3 Bulle nur Seide fehlen
 In plica rechts: Nicol p m

4229

Archives Nationales Paris

L 274 n. 6 **1288 Augusti 7**

Br. 22.8 hoch 16.5 Plica 3.
obere Rand 5.1 links 1.5
rechts 1.6

Nicolaus IIII · · Officiali
Siluanecten

Conquesti sunt nobis
Dat Reate vjj Jd Aug a° 10

Bulle an Hanf

In plica links : O. Laud
Ecke oben rechts : R

a tergo oben Mitte :
N. de sto Victore

Verhältnismässig sehr grosse, fette
lange Schrift

Ohne jeden betonten Buchstaben
Erste Linie für Oberlängen

P. vacat

4230 (recto)

R

Paris Archives Nationales

J 685 n. 56

Breite 35.8 Rund links 1.8 rechts 2.
Höhe 23. Rand oben 6.9 plica 6.3

Erste Linie für Gitterschr. und
Oberlänges / Je eine Leitlinie

P. vacat **1288 Augusti 13**

Nicolaus IIII (Gitterschr.) Carmo
in xpo filio Philippo Regi Fran-
cie Illustri

Considerantes eximie deuotionis
Dat Reate/ Jd Aug a° 10

Bulle an Seide

In plica rechts : Maur

Sub plica links : Jac boel

Ecke oben rechts : R verte

4230 (verso)

a tergo oben Mitte :
R de montefalconis
darunter mit kleinem Schnörkel

Sehr schöne kleine fette Schrift

4231 (recto)

R

Paris Archives Nationales

J 690 n. 132

Breite 50.3 Rund links 2.8 rechts 2.9
Höhe 30.7 Rund oben 7.6 plica 4.2

Erste Linie für Oberlängen
Je zwei Leitlinien

P. vacat **1288 Augusti 13**

Nicolaus IIII · · sancti Dionisij
in Francia et · · sancti Germani
de Pratis Parisien Monasterio[rum]
Abbatibus

Grandis affectus quem
Dat Reate Jd Aug / a° 10

Bulle an Hanf

In plica rechts : Maur

Ecke oben rechts : R

verte

4231 (verso)

A tergo oben Mitte:
R. de monte Falconis

4232 (recto)

Paris archives Nationales
J 690 n. 232
Breite 50.3 Rand links 3.2 rechts 2.5
Höhe 32.9 Rand oben 8.7 plica 5.1
Erste Linie für Oberlängen
Je zwei Seitenlinien
P. vacat 1288 Augusti 13
Nicolaus IIII ... dilectis ... O'rionisij in Francia
et .. Sancti Germani de Pratis Mo-
nasterior abbatibus
Quanto maioris deuotionis
Dat Reate Id Aug a° 10
Bulle an Hanf
In plica rechts: N. Vrr
Sub plica links: ≡V̄
Jac boel
Ecke oben rechts: R ___ verte

4232 (verso)

A tergo Ecke oben links : B
oben Mitte :
R de Montefalconis
darunter schön schwungvoll

4233 (recto)

Paris archives Nationales
J 690 n. 132
Breite 46. Rand links 2.2 rechts 2.2
Höhe 31.2 Rand oben 8.9 plica 6.7
Erste Linie für Gitterschr. und Ober-
längen / Je zwei Seitenlinien
P. vacat 1288 Augusti 13
Nicolaus IIII (Gitterschrift) carmo
in xpo filio Philippo Regi Francie
Illustri
Grandis affectus quem
Dat Reate Id Aug a° 10
Bulle an Seide
In plica rechts : Manuc
Sub plica links : ≡V̄
Jac boet
Ecke oben rechts : R ___ verte

4233 (verso)

a tergo oben Mitte:
R de Montefalconis
darunter schlank schwungvoll

Sehr schöne fette kleine Schrift

4234 (recto)

R₄

Paris Archives Nationales
J 690 m 132 (24)
Breite 50.4 Rand links 2.4 rechts 2.5
Höhe 31.7 Rand oben 9.2 plica 4.9
Erste Linie für Gitterschr und klei-
nere Oberlängen / Je 2 Seitenlinien
P. vacat 1288 Augusti 13
Nicolaus IIII (Gitterschr) Carino in
Apo filio Philippo Regi Francie
Illustri
 Annuto maioris devotionis
Dat Reate Jd Aug / a⁰ 1⁰
Bulle an Seide
In plica rechts: n. Ver
Sub plica links: ꝟ̄
 Jac boel (Verso)
Ecke oben rechts: R₄

4234 (verso)

a tergo oben Mitte:
R de Montefalconis
darunter schön schwungvoll

4235

Bayer. Haupt- Staatsarchiv
Kl. Waldsassen fasc. 17

P. 22780ˣ 1288 Augusti 23
Nicolaus IIII (Gitterschrift) .. Abb-
ti et Conuentui Monasterij de
Waltsaschsen Cistercien ordinis
Ratisponen. dioc.
 Solet annuere Sedes
Reate X Kl. Septembris anno Primo

Bulle an Seide
 In plica rechts: Galganus
Sub plica links: Jac boel

Sehr weitgelegte Schrift, große zu-
len abstände, breite Räume, sehr
große plica. Unverständliche Raum
Verschwendung da die Urkunden
dadurch an Schönheit nicht gewinnen.

Archives nationales Paris

L 274 n. 7 **1288 Septembris 5**

Br. 39.6 hoch 31.9 Plica 5.9
oberer Rand 8.6 links 2.7
rechts 2.5

Nicolaus IIII fratribus Praedicatorum et minorum ordinum Inquisitoribus heretice pravitatis auctoritate sedis aplice deputatis et in posterum deputandis

Turbato corde audivimus
Dat Reate non Septembris a° 1°

Bulle fehlt, Hanf erhalten
In plica rechts: J. Laur
Sub plica links:
A tergo oben Mitte: predicator +

Sehr fette grosse Schrift
mit einem betonten Buchstaben

Erste Linie für Oberlängen

P. 22795

Toulouse, Archives Département
4. 30

P. — **1288 Septembris 5**

Nicolaus IIII .. abbati mon. fusen. Ord. Aug. Tholosan. dioc.

Ad audientiam nostram
Reate non. Sept. a° 1°
Bulle fehlt, Hanf erhalten
In plica rechts: J. amy
Sub plica links: —

Jac boel

Ecke oben rechts: +

Archives nationales Paris

L 274 n. 8 **1288 Septembris 11**

Br. 57.4 hoch 43 Plica 5.2
oberer Rand 12 links 5.
rechts 4.7

Nicolaus IIII
Carissimo in xpo filio — —
Regi Francorum Illustri

Querela gravis dilectorum
Dat Reate III Id Septembris a° 1°

Bulle an Hanf
In plica rechts: O. Laud
Sub plica links: X
A tergo oben Mitte:
deus in adiutorium

Sehr fette, sehr grosse regelm. Schrift
die grösste, die ich gesehen habe
mit einem betonten Buchstaben

Erste Linie für Oberlängen

P. vacat

RX

Paris Archives Nationales
J 686 n. 64

Breite 33.4 Rand links 2.6 rechts 2.4
Höhe 26.1 Rand oben 76 plica 4.5
Erste Linie für Gitterschr. und Oberlängen / Je zwei Seitenlinien

P. vacat **1288 Septembris 24**

Nicolaus IIII (Gitterschr.) Carmo in xpo filio Philippo Regi Fran. cie Illustri

Provido et salubri
Dat Reate / VIII Kl Octobris a° 1°
Bulle an feiner Seide
In plica rechts: R. Vor
Sub plica links: Jac boel
De Rand oben links: .l. vacat

4239 (verso)

Rand oben Mitte: dñs latũs
mandauit
Ecke oben rechts: Rt
A tergo oben Mitte:
R̄ de Montefalcone
Darunter Schlenk sehr ver-
schnörkelt:

scpo CCXXVIIj
cap

Ecke kleine kleine Schrift

4240 (recto)

card. Hostiensis

Archives Nationales Paris
L 274 n. 9 1288 Septembris 24

Br. 41.7 Hoch 29. Plica 5.3
oben Rand 10 links 3.1
rechts 3.4

Nicolaus IIII (Gitterschrift,
sehr grosse Initiale variiert) Carissi-
mo in xp̄ō filio Philippo Regi Francie
Illustri
Celsitudinis tue precibus
Dat Reate VIII Ide Octobr̄ a° 1°

Bulle an Seide P. vacat
In plica rechts : N. Vr̄
Sub plica links : Iac boet
Rand oben links : 9
" " Mitte : dñs Host quod petitio
per eum lecta super hijs que per hanc
litteram conceduntur iustificaretur
vidit notam in forma quam habet hec
littera acceptauit et mandauit grossari
Ecke oben rechts : Rt

Je zwei Seitenlinien verte

4240 (verso)

a tergo scpo CCXXVII
cap

clerici criminosi, die flüchten
wollen, darf er verhaften lassen,
ohne Censuren zu verfallen

4241 (recto)

Datum

Paris Archives Nationales
J 688 n. 10⁴
Breite 39.9 Rand links 3.2 rechts 3.8
Höhe 38.1 Rand oben 9.2 plica 6. —
Erste Linie für Oberlängen
Je eine Seitenlinie
P. vacat 1288 Octobris 5
Nicolaus IIII . . . Sancti Dioni-
sij in Francia et Sancti Germa-
ni de Pratis Parisien dioc̄
Monasteriorum Abbatibus
Habet in nobis
Dat Reate III Non Octobr̄ / a° 1°
III Non Octobr̄ ist nachgetragen
Bulle an Hanf
In plica rechts : H. Pad
verte

4241 (verso)

A tergo oben Mitte:
 R. de Montefalcon
Sehr schöne feste fette Schrift

4242

Arch. Arcis
Ann. I capo. 4 cap. 2
P. 22834 1288 Novembris 25
Nicol. IIII carmo in xpo filio Carolo
regi Aragonum illustri
 Privilegium post nostre
Rome ap. S. M. maiorem VII kl.
 Dec. a° 1°
Bulle an Hanfschnur
In pl. rechts ' de Cur
 u Mitte:
registretur ahhim et remittatur
A tergo Rein R. Zeichen

4243

Poitiers Archives départem.
 Noaillé
P. — 1288 Januarii 13
Nicolaus IIII Helye abbati mon.
Nobiliacen. Pictaven. dioc.
 Cum sicut in nostra
Rome apud Scam Mariam ma
iorem id. Januarii a° 1°
Bulle nur Hanf fehlen
Plica abgeschnitten
Erste Zeile frei. Unten mehrere
freie Linien

4244 (recto)

Arch. Arcis
Ann. XIII capo. 7 cap. 6
P. — 1289 Januarii 18
Nic. IIII Peregrino preposito Van
gi capellano nostro
 Perusinorum gremus erro-
neos
Rome apud S. Mariam Maio
rem XV kl. Februarii a° 1°
Bulle an Hanfschnur
Sub pl. links: l
 s. Atem
Darunter Hng ausgestrichen
R. pa. pen. M. Reco
Ecke oben links: l
 de Ma
u u rechts: R.

4244 (verso)

a tergo oben mitte:
Barthis de Fulg ...
........ :

4245

Poitiers Archives Départem.
Svêché Poitiers n. 7
P. — 1289 Januarii 20
Nicolaus IIII Galtero Episco.
po Pictaven.
Magne ~
Rome apud Scam Mariam
Maiorem XIII Kl. febr. a° 1°
Bulle und Seide fehlen
In plica rechts N. G.
Sub plica links . . .
 M. Roca
 nur unten R. de Vell
 M. Roca
Ecke oben links .l.
 I. M

4246

Archives Nationales Paris
L 274 n. 10 1289 Januarii 28
Br. 21. hoch 14.4 Plica 3.7
 oben Rand 4 links 0.9
rechts 0.9
 Nicolaus IIII . . Priori sue
ti Medardi Suessionen
 Dilectorum filiorum . . Abbatis
Dat Rome apud Scam Mariam Ma-
iorem V Kl Februar a° 1°

Bulle an Hanf
 In plica rechts: P benee
Ecke oben rechts: G
 A tergo oben mitte:
 N. de Sco Victore

Sehr kleine fette Schrift
 ohne jeden betonten Buchstaben

Erste Linie für Oberlängen

 P. 22866

4247

Bull. Gen. I cap. 8
P. — 1289 februarii 12
Nicolaus IIII Oddoni nato dil.
dr. Gittersch. Kl.
f. nob. viri Achenulphi quondam
Mathie dicti de papa de Anagnia
canonico scole S. Audomari
Morinen dioc.
 Intendentes tibi qui
Rome ap. S. M. maiorem V
w. febr. a° 1°
Rechter Rand und pl. abgeschn.
A tergo oben mitte
 Benedctus car.

4248

Bayer. Haupt. Staatsarchiv
Bamberg fasc. 198

P. 22875ᵃ 1289 Februarii 15

Nicolaus IIII (Gitterschrift) .. Abbati
et conventui monasterij de Ebraco
Cisterciensis ordinis Herbipolen. dioc.
 Cum a nobis
Rome apud sanctam Mariam Maiorem
XV Kl. Martij Anno Primo

Bulle und Seide liegen bei
 In plica rechts: Sy T
Sub plica links : --
 J. Ann

Die Schrift ist noch fast unbeeinflußt
von der neuen Gestaltung der Rundung,
Verkettung und der cursiven Character

Das Gleiche gilt für die Bulle dersel-
ben Schreibers ab dieselben: "Devotio-
nis nestre precibus" vom gleichen Datum
dagegen zeigt die Schrift von "Cum sicut
ex" denselben vom gleichen Datum größe-
re Rundung und Gebundenheit. Legt
man die drei Urkunden nebeneinander
so ergiebt sich ein auffallender Unterschied

4249

Bayer. Hauptstaatsarchiv
Bamberg fasc. 282

P. 22893 1289 Februarii 23

Nicolaus IIII (Gitterschrift!) .. Abbati
et Conventui Monasterij de Lam-
oheim (sic) Cisterciensis ordinis
Bambergen. dioc.
 Ex parte nestra
Rome apud Sanctam Mariam Ma-
iorem J. Kl. Martij Anno Secundo

Bulle und Seide ausgerissen. Reat.
 In plica rechts : J. Tem
Sub plica links :
 J. Ann

Ecke oben rechts : G

 A tergo . Ecke oben links : B

Schrift geht über nach der Rundung
schon ziemlich verbunden

4250 (recto)

P. — Paris Arch. Nat.
J 689 Cap. 75 1289 Martii 1
Nic IIII Phy regi Francorum
 illustri
Nuper ad nostrum
Rome apud S. Mariam
Maiorem Kl Martii aº 2º
Bulle fehlt ; Hanf erhalten
In plica rechts p Vet
Sub plica links x
 x
 F atin
 a " Hng ausgestrichen
R p Leo M Roﬆ
Ecke oben links ·L
 X M

 verte

4250 (verso)

Rand oben Mitte
Sie expedite inter fratres
 darunter erster mann
Iste non ponitur in andein
lie . Sie mandaver dni
M et B Cardinales
Ecke oben rechts R

A tergo täpi XLV

4251

Poitiers Archives départ.
Iutelle Poitiers n. 9
P. — 1289 Martii 4
Nicolaus IIII . . episcopo
 Pictaven.
Pastoralis officii cura
Rome apud Scam Mariam
Maiorem IIII id. Martii a° 2°
Bulle fehlt, Seide erhalten
Sub plica links =
 V
 f. Aug
 nur unten R̶ Aug. [...]
Ecke oben links R̶
 S. M.
A tergo oben Mitte schon kräftig

[[1071] xlvi ?
[cap°]

4252

Bayer. Hauptstaatsarchiv
 Bamberg fasc. 282
P. 22920ᵃ 1289 Martii 28
Nicolaus IIII . . abbati et Conventui
Monasterij de Lancheim Cisterciem. or-
dinis Bambergen. dioc.
 Cum a nobis
Dat. Rome apud Scam Maiorem V Id.
 Aprilis anno secundo

Bulle und Seide ausgerissen
 In plica rechts: f. Ann
Sub plica links: . .
 f. Ann
 Ecke oben rechts G ?
A tergo Ecke oben links B

Die Schrift ist im Ganzen erheblich von
der allgemeinen Kanzleischrift verschie-
den. Vielfach sind grössere Zwischen-
räume zwischen den Buchstaben. Das ö
sieht öfter fast genau wie das a gemacht
Die ct Ligatur ist ganz niedrig

4253

Firenze, Badia di Pas-
 signano
P. — 1289 Martii 28
Nicolaus IIII . . abbi mon. sci
 P̶a̶ Pancratii Florentin.
Conquesti sunt nobis
Rome apud Scam Mariam
Maiorem V Id. Aprilis a° 2°
 Bulle und Hanf fehlen
In plica rechts .f. P̶
 15 . 2 hoch
 3 . 4 plica
 22 . 9 breit

Kleine, ziemlich dünne
etwas spröde schwungvolle
Schrift

4254

Arch. Aras
Arm. III caps. 2 cap. 63
 1289
P. — 2̶7̶3̶ Maii 23
Nic. IIII . . ministro et . . custodi
ac conventui fratrum Minorum
Sancti Francisci de Assisio
 Cum iocalia sive
Reate X Kl. Iunii a° 2°
Bulle ist abgefallen und an der
Originalschnur (Hanf) wieder an-
gehängt worden.

Arch. Arcis
Arm. III cap. 2 cap. 64
 P. — 1289 Maii 24
Nic. IIII Rizardo de Ferentin. ca
pellano et fratribus Augustinis
ac Iacobo de Bcapalea cubicu-
lariis nostris
 Cum iocalia sive
Reate VIIII kl. Iunii a° 2°
Bulle au Hanfschnur
In pl. rechts: N. de Fract
 de Cur
Sub plica Rasur eines getilgten
Bullenaufrugs

Paris Archives Nationales R
 J 431 n. 39
Breite 70.8 Rand links 4.9 rechts 4.7
Höhe 50.3 Rand oben 9.2 plica 5.6
Erste Linie für Oberlängen / Je
 2 Seitenlinien
cf. P. 22971 1289 Maii 31
Nicolaus IIII. - - Archiepo Re-
men et eius Suffraganeis ac
dil filiis Electis Abbatibus Pri-
oribus Decanis Archidiaconis
prepositis Archipresbiteris et
aliis ecclesiarum prelatis necnon
Capitulis Conuentibus et Collegiis
Cisterciensium Cluniacensium Premonstra-
tensium Sci Benedicti Sci Augustini
Cartusiensium Grandimontensium et aliorum

ordinum ac ceteris aliis personis
ecclasticis secularibus J regu-
laribus non exemptis per Re-
men prouinciam constitutis
 Quantis abolim et
 Dat Reate IIII kl Iunii / a° 2°
Bulle au Hanf
In plica rechts: Iac Vit
Sub plica links q̄ Auf dem Bug:
R Iac Vit F. Atin ij
 R M ad
 F. Atin Ou plica links
I. e. m — ⁓
Ecke oben links : . l . fiant
Ecke oben rechts : R
A tergo oben links : N. de Fract
 scri R C L L X V
 Cap

 P. — Paris Arch. Nat.
J 714 cap. 305 12-a 1289 Maii 31
Nicol IIII Phy regi Francorum
 illustri
Quanto negotium Aragonie
Reate II kl. Iunii a° 2°
Bulle au Hanf
In plica rechts. M de Adr
In plica bei der Bulle
ascultata per m de Adr et g putata

J 715 cap. 305 13-a
Nic. IIII II kl. Iunii a° 2°
eodem loco :
ascultata per M de Adr

 rrelle

4257 (verso)

J 715 cap. 305 ¹³⁻ᶜ 1289 Junii 31
hic ꝳ π kl. Jun. a° 2°
eodem loco
 ascultꝵ per M. de Adria et
 9 putatꝵ

J 715 cap. 305 ¹⁵⁻ᶜ
hic ꝳ id Dec. a° 4°
eodem loco
 ascultatꝵ et coputatꝵ per me
 Sy. J

J 715 cap. 305 ¹⁸ 1289 Julii 7
hic ꝳ non. Jul. a° 2°
eodem loco
 ascultatꝵ p M. de Adr

4258

P. — Paris Arch. Nat.
J 715 cap. 305 ¹⁴⁻ᶜ 1289 Mnii 31
hic ꝳ .. Rothomagen - archep
et .. epo Autisiodoren.
 Cum sollicitudinem exigens
Reate π kl. Junii a° 2°
Bulle au Hanf
In plica rechts N de fractp
Sub plica links j atm
Sub pl. links Bng Rx j. Atm ꝳ
Ecke oben links fī ꝳ rechts Rx
A tergo Scp̄t CCLXIII
 cap

4259

Marseille Archives départem.
B 388
P. — 1289 Junii 22
Nicolaus ꝳ care in xpo filie
regine [ohne Punkte] Sicilie il
lustri
In hac terrestri
Reate X kl. Julii a° 2°
Bulle au Hanf
In plica rechts J. Lauca
 de Cur
Regelmässige, fette, eckige
unschöne Schrift.

4260

Bayer. Haupt- Staatsarchio
Memmingen Hospital Fasc. 1
 P. vacat 1289 Junii 27
Nicolaus ꝳ . .. Abbati monasterij
de Lubes Wratislavien. dioc.
 Qua refrigescente caritate
Reate T kl. Julij anno Secundo
Bulle au Hanf
 In plica rechts : Sy .
 Sub plica links : r
Ecke oben links : j. Ann
 oben Mitte : lecta 9

Übereynsschrift mit Bindungen
und Rasirungen

lecta

4261 (recto)

Bayer. Haupt. Staatsarchiv
Kl. Prüfenning U. fasc. 16

P. 22990 1289 Julii 1

Nicolaus IIII (Roman. Maj) e. s. s. Dei
dil. filijs.. Abbati Monasterij sci
Georgij in Prueninge eiusque fra-
tribus tam pres. quam futuris reli-
giosam vitam professis IN PPM.
 Religiosam vitam eligentibus
pacis inveniant AMEN A — AMEN

R. Ego Nicolaus cath. ecclie epo SS M.
1. presb. 4 epi 4 diaconi

Dat. Reate per manum Magri Johan-
nis decani Anicolen. sce Roman.
ecclie vicecancellarij Kl. julij Ind.
secunda Inc. dnice Anno M. CC
LXXXVIIIj Pontif. vero domni NICOLAI
pp IIII Anno secundo

Bulle an Seide
Rand oben links in Bullenschrift:
privilegium qd. ordinis sci Bene-
dicti O. Lauten.
Rand oben rechts: (portstnr) in
audientiam post d ... affriri
 Ascaltctur

4261 (verso)

Regelmässige ... Schrift und
niedrig hohem Oberlängen mit klei-
nen ... Unterlängen

4262

Napoli Curia Eccles. vol. 3°
P.— 1289 Julii 4
Nicolaus IIII .. archeps Baren.
Ad audientiam nostram
Reate IIII non. Julii a° 2°
Bulle mit Hanf fehlen
In plica rechts Alts p
Sub plica links _ _ _
 reput

4263

Avignon Archives Départem.
9. Evêché de Cavaillon

P.— 1289 Julii 7

Nicolaus IIII .. carpentoraten.
et .. Cavallicen. epis
 cum dilecto filio
Reate non. Julii a° 2°
Bulle mit Hanf fehlen
 plica fehlt.
Ecke oben links : J

4264

Arch. Arcis
Arm. IX cap. 7 cap. 1

P. 23010 1289 Jul. 18

Nicolaus IIII (ad perp. rei m.

mittelgr. Maj. mittelgr. Litt.

Celestis altitudo potentie

(R) Ego Nic. cath. eccle. ep (M)

I presb. II epi III diac

dat. Reate per manum magri

Johannis decani Baiocen. sce

Romane eccle vicecancellarii

XV kl. Aug. indict. secunda incar

nationis dnice anno M. CCL XXXVIII

p. vero domni Nichlai pp IIII anno secund

Bulle an feinen Faden

4265

Public Record Office London
Papal Bulls bundle 31 n. 9

P. 23049 1289 Augusti 21

Nicolaus IIII · · abbati et conventui

monasterii de Aberconeway

in Wallia, Cist. O. Bangoren. dioc.

Ex parte carissimi

Reate XII kl. Sept. a° 2°.

Bulle und Seide fehlen

In plica rechts p beneff

Sub plica links V fol ?

darunter ?

R Dominici

Amen

Ecke oben links ·j· und A· f. rechts R

a tergo oben Mitte

CCCC III

4266

Marseille Archives Départem.
B 388

P. — 1289 Sept. 4

Nicolaus IIII cmo in xpo filio

Carolo regi Sicilie illustri

Litteras regias nuper

Reate II non. Sept. a° 2°

Bulle an Hanf

In plica rechts N. de fractf

Gut erhaltenes Document

Schrift mässig schön

4267

P. — Paris Arch. Nat.
L. 275 cap. 27 1289 Sept. 10

Nic IIII universis xpifid. pres.

litt. inspecturis

Splendor paterne glorie

Reate IIII id. Sept. a° 2°

Bulle und Seide fehlen

In plica rechts: Guitt de moreti p°

Sub plica rechts Guitt de moreto

Sub plica links · · ·

F Atin

Ecke oben links ·l·

" " rechts R

A tergo CCCL III

4268

Bull. Gen. I cap. 14
P. — 1289 Sept. 18
Nicolaus IV Benedicto S. Nicolai
Arabesken in in Cur. Tull. diac.
den Buchst.
 no cardinali
Digne agere credimus
Reate XIIII kal. Octobr. a° 2°
Bulle und Seide fehlen (Augerina)
A tergo Mitte oben: Benedictus card.

4269

Public Record Office London
Papal Bulls bundle 60 n. 2
P. — 1289 Septembris 29
Nicolaus IIII . — regi Anglie
illustri
Ad fovendum in
Reate III kel. Oct. a° 2°
Bulle fehlt. Hanf erhalten
In plica rechts G. Alga
Sub plica links =
 x
Ecke oben rechts R
A tergo oben Mitte

Rscpt. DXLVI
Rcap.

4270

P. — Paris Arch. nat.
L 275 cap. 28 1289 Septembris 30
hic III .. priori domus de Vallvivi-
di Parisien. Cartusien. ordinis
Religiosam vitam eligentibus
Dat Reate per m. magistri Johan-
nis decani Baiocen. SRE vice
cancellarii II kal. Oct. a° 2°
Bulle und Seide fehlen
Rand oben halblinks: Coe priorit
ordis Cartusien
Rand oben Mitte ascult

(am Schlusse des Textes
nachgetragen wurde.

vice cancellarius

Als cap. 28bis liegt bei ein Original,
dessen unterer Teil von der Rota an ab-
geschnitten ist. Der Schreiber hatte in
dem Absatz Prohibemus insuper ein
Stück ausgelassen, die mit Verweis

4271

Public Record Office London
Papal Bulls bundle 31 n. 19
 Schwarze Capitelzeichen
P 22 099 1289 Octobris 7
Nicolaus IIII Edwardo regi Anglie illustri
Copiosus in misericordia
Reate non. Oct. a° 2°
 Bulle an Hanf
In plica rechts Jo. Pan.
Sub plica links xx
 xx
 f. Am
Ecke oben links . b.
rechts R S. f.
A tergo oben Mitte

Rscpt. DL
Rcap.

4272

Archivio di Sto. Milano
Bolle e Brevi . . . vicecancellaria
P. — 1289 Novembris 12
Nicolaus IIII dil. in xpo filiabus mi-
nistre domus S. Nazarii de Opreno
eiusque sororibus etc. in ppm
Religiosam vitam eligentibus
invariant Amen A Amen
R Ego nicolaus catholice ecclie
 Epo IS m
3 presb. 4 epi 5 diac.
Rome apud Scam mariam maio-
rem p. m. magri Johannis decani
Baiocen. SRE vicecanc. II iď. Nov.
Inc. Onice aº m CCLXXXVIIII ᵱ.
vero domni NICOLAI pp IIII aº secundo
Bulle an Seide

4273

Bull. Gen. I cap. 15
P. 23118 1289 Nov. 16
Nicolaus IIII nob. viro Giliberto
fell Rl. Gill. comiti Glovernie
et Herefordie
 Petitio tua nobis
Rome ap. S. M. maiorem XVI
Kal. Dec. aº 2º
Seidenfaden hellgelb . Bulle fehlt.
Rechter Rand abgeschnitten

4274

Instr. Mon. F. dom. c̄ 120 1289 Dec. 8
 P. 23133
hic. IIII .. mag. et prioribus ord. fra-
trum predic.
Tenorem quarum⁽ᵐ⁾dem litterarum
 datum die inscribirten Bulle: 3º
Lugduni II non. Apr. aº 3º
Unmittelbar dahinter: dat Rome
ap. S. mariam maiorem VI iď.
decembris aº 2º
II (VI) auf Rasur
In plica rechts: η pd
Sub plica links: v̄
A tergo: predicatorum
aber VI iď.
Dec. bei Potthast
nur auf die fol-
genden Urkunde
bezogen

4275

Instr. hist. F. dom. c̄ 395 1289 Dec. 8
 P. 23133
hic. IIII .. mag. et prioribus ord. fra-
trum predic.
Tenorem quarundam litterarum
Rome ap. S. m. maiorem π. iď.
 decembris aº 2º
Bulle an Hanffaden
In plica rechts: η pd
Sub plica links: v̄
Rᵵ g. alm./II f. dyter
 p. sutz II (Eug) unter dem Bug:
 p. Real II Bono
 p. Don Rᵵ Jo Rome #
 f. ann aº
Alles auf Rasur Visekanzler:
so andere Befehle stunden. Johannes
Ecke oben links: fiant VI. M
A tergo: predicatorum) Vt. Jo v est

4276

Public Record Office London
Papal Bulls bundle 31 nr 5
P. 23 137 1289 Decembris 11
Nicolaus IIII. E. regi Anglie illustri
 Pridem ad notitiam
Rome apud S. Petrum Mariam Maiorem
 III id. Dec. a° 2°
 Bulle fehlt, Hanf erhalten
In plica rechts N. de Frasch
Sub plica links
 Neput
Rand oben links .J. Mitte tcen
Ecke rechts R
a tergo oben Mitte [rept] DCLVII
 [capi]

4277

Arch. Arcis
Arm. III caps. 9 cap. 6
P. — 1289 Decembris 28
Nic. IV .. epo Signin. collectori
decime regni Sicilie negotio con-
cesse in Campania et Mariti-
me ac civitate et dioc. Reatin.
ac aliis certis partibus deputate
 Dilecti filii abbas
Rome ap S. M. Maiorem VKl.
 Ianuarii a° 20
 Bulle nur Hanf fehlen
In pl. rechts: H. Pad
Sub pl. rechts: - - -
 J. . . . [sehr
 beschä-
A tergo oben Mitte R CCI digt]

4278

Montepellier ville de montp.
2.V Louvet 2795
P. — 1290 Ianuarii 5
Nicolaus IIII consulibus, vicariis
et communi de Montepesulan.
magalonen. dioc.
 Honorem vestrum decere
Romam apud Sctam Mariam Ma-
iorem non. Ian. a° 2°
Bulle fehlt, Hanf erhalten
In plica links O. Laud.
 de Cur.

4279

Karlsruhe Gr. Bad. Gen. Landesar.
Select der Papsturk. cap. 295
 P. — 1290 Februarii 15
Nicolaus IV Bertholdo abbati
monast. de Gengenbach OSB
Argentinen. dioc.
 Tue religionis indueimur
Rome apud S. M. Maiorem
xv Kl. Martii a° 2°
Bulle an Seide
In plica rechts p de netz
Sub plica links

Ecke oben links .J. rechts R
 Beides klein
A tergo oben Mitte schön gezeich
net klein [sipt] LXVI
 [cap]

4280

Bayer. Haupt - Staatsarchiv
Bamberg fasc. 198

(1289 febr. 22 -
1290 febr. 21) Transsumtum vergessen

Nicolaus IIII .. Abbati et Conventui
Monasterii de Eberaco Cistercien.
ordinis Herbipolen. dioc.
　　　Ex parte nostra
Rome apud Sanctam Mariam Maiorem Anno Secundo

Bulle fehlt, feine Seide erhalten
In plica rechts : P. Deatp
Sub plica links : · · ·
　　　J. ánn

Ecke oben rechts : ₰
A tergo Ecke oben links : B

Schöne regelmäßige Schrift und deut-
lich erkennbaren Übergangscharak-
ter der Schrift aus der Mitte des Jahr-
hunderts zu jener Bonifaz' VIII

4281 (recto)

Bull - Gen. I. cap. 16
P. —　　　　1290 febr. 22

Nicolaus IIII Loffrido dicto Gai
Aus. in den Buletten tuo de Anagnia
nepoti B. S. hic . in Arc. Tul-
lien. dioc . cardinalis canoni-
co Carnoten.

Virtutum Studiis quibus
Rome apud S. M. Maiorem VIII
Kl. Martii a° 3°

Bulle und Seide ausgeschnitten
In pl. rechts :　　P. Eug
　　　　　ū de mandato
　　　　　dñi Benedñi card.

Sub pl. links : 9 | a tergo Ecke oben
　　　　　 | links : N
Rand oben Mitte　Cor ⌐

A tergo oben Mitte : Nicolaus de Kco
nomine dñi Bened. card.

4281 (verso)

Recto Ecke oben links :
₰ p.E.≠ ⌂

4282

Archivio di Stato Milano
Bolle e Brevi
A 23266　　　1290 Martii 7
Nicolaus IIII dil . in Xpo filiabus
. . . ministre et sororibus domus
de Cantalupo site iuxta portam
Favergiam Mediolanen. Ord.ug.
　　Religionis vestro meretur
Rome apud Scam Mariam Mai-
iorem non. Martii a° 3°

Bulle und Seide fehlen
Implica rechts m. de Roca
Sub plica links abgeklatscht
　　J. Any　　⌐ Rand oben links : L
　　9　　　　Mitte . L . rechts R⨯
A tergo schon　　(Sopr) · LXIIII
breit zierlich　　　⌐ð ap⨯

Toulouse, Archives départem.
H. 30

P. — 1290 Martii 7

Nicolaus IIII .. archipresbitero
ecclesie Sancti Africani Rutte-
nen. dioc.
Dilectorum filiorum .. prepo
preceptoris
Rome apud Scam Mariam
maiorem non · Martii aº 3º
Keine Bulle an Hanf
In plica rechts T. P.

Bayer. Haupt.- Staatsarchiv
Alderspach Kl. n. 109

P. 23212 1290 Martii 15

Nicolaus IIII .. abbati Monasterii
de Altah superiori Ratisponen.
dioc.
 Conquesti sunt nobis
Rome apud Scam Mariam Maio-
rem Jd. Martii pontificatus nri
Anno Tertio

Bulle an dickem Hanf
In plica rechts: nicbl. p men
Rand oben Mitte: dofr
Ecke oben rechts: g

q ... mundat 23.0 x 16.5
 plica 3.6

Breite Ränder, grosse plica

Bull. Gen. I cap. 17
 p. 23227a=
P. 26646= 1290 mart. 23
nic. IIII G. epo Sabinen. et B.
S. nic. in Carc. Tulliano diaco-
no card.

Sicut nuper ad
Rome apud S. M. maiorem
X Kal. Aprilis aº 3º
Bulle an Hanfschnur
In pl. rechts: de Cur
 nic. p m
Sub pl. links Jauf Bug durchstri-
chen. Strichs nur Schrift abge-
.. : R. ... N. Sax. de Curia
et cito / quod coas bulletur
 P. Reat.

Bull. Gen. I cap. 18
P. 23225 1290 mart. 23
nic. IIII Philippo regi Francie
 illustri

Attende fili et.
Rome apud S. M. maiorem X
Kal. Aprilis aº 3º
Hanf. Bulle fehlt
In pl. rechts : g de Cur
 T. P.

4287

Instr. misc. 1288 - 1295 cap. 28
 P. — 1290 Mart. 23
Nicol. III G. epo Sabinen. et B. s.
Nicolai in Carcere Tullian. diac.
cardinali
Sicut nuper ad
Rome apud S. Mr. Maiorem X
Kl. Aprilis a° 3°
Bulle und Hanf fehlen
In plica rechts: de Curia
 Nicol pm

4288 (recto)

Paris Archives nationales
 J 352 n. 1
Breit 46.8 Rand links 4.0 rechts
3.9 Hoch 30.0 Rand oben 5.8
plica 5.7
P. vacat 1290 Martii 23
Nicolaus III ven. fri G Epo Sabinen
et dil filio B sancti Nicolai in
Carcere Tulliam diacono Cardina-
li s.
 Pridem venerabilibus fratribus
Dat Rome apud Scam Mariam
Maiorem X Kl Aprilis anno 3°
Bulle an Hanf
In plica rechts : de Cur
 Jo · pis
Links auf dem inneren Bug ab.
geklatscht:
 Rx. Laurenti de Curia cito quod

4288 (verso)

— cras battentur
 p. Reat
Darüber 9
Ecke oben links : δ Jo
 X
· Rand oben mitte : - beg -
· A tergo : non valet.

4289

Paris Archives nationales
 J 352 n. 2
Breit 42.00 Rand links 2.6 rechts 2.6
Hoch 30.00 Rand oben 7.4 plica 5.00
Links 2, rechts 1 Linie. Oberste L.
für Oberlingen
P. vacat 1290 Martii 23
Nicolaus III G Epo Sabinen et dil
filio B sancti Nicolai in Carcere
Tulliam diacono. Cardinali
 Sicut nuper ad
Dat. Rome apud Scam Mariam
Maiorem X Kl Aprilis anno 3°
 Bulle an Hanf
In plica rechts : p bened
 de Cur
Sub plica unten links abgeklatscht:
Rx. m. Ro de Cur Darüber 9
 p. Reat Rand oben mitte ben

4290

Paris Archives Nationales
J 352 n. 3
Hoch 27.5 Schrift 12. plica 6.9
Breit 41.8 links 2.7 rechts 3.1
Erste Zeile für Oberlängen / Rand-
linien
P. vacat 1290 Martii 23
Nicolaus IIII G Epo Sabinen et di-
lecto filio. B sancti Nicolai in Car-
cere Tulliano diacono Cardinali
 Pridem dilectis filijs
Dat Rome apud Sm Mariam
Maiorem X Kl Aprilis anno 3°
Bulle und Hanf fehlen
In plica rechts: M de Adr
 de Cur
unten zwei Zeilen frei
 de Curia

4291

Paris Archives Nationales
J 352 n. 4
Breit 40.8 Rand links 3.2 rechts 3.3
Hoch 28.4 Rund oben 6.5 plica 6.7
Erste Linie für Oberlängen / Einfache
Randlinien
P. vacat 1290 Martii 23
Nicolaus IIII G Epo Sabinen et dil
filio B sancti Nicolai in Carcere
Tulliano diacono cardinali
Sicut nuper ad
Dat Rome apud Sam Mariam
Maiorem X Kl Aprilis a° 3°
 Bulle an Hanf
In plica rechts M de Adr
 de Cur
Kleine regelmässige Schrift

X Kl Aprilis mit schwärzerer Tinte

4292 (recto)

Paris Archives Nationales
J 435 n. 7
Breite 55. Rand links 5.1 rechts 4.7
Höhe 37.6 Rund oben 7.8 plica 6.6
Erste Linie für Oberlängen / Je eine
Seitenlinie
R vacat 1290 Martii 24
Nicolaus IIII (Mij) Carmo in Xpo filio
Carolo Regi Aragonie Illustri et
dilecte in Xpo filie Nobili mulieri
Margarete nate Carmi in Xpo filij
nri Caroli Regis Sicilie Illustris
 Et si coniunctis
Dat Rome apud SM Maiorem
VIIIj Kl Aprilis / a° 3°
 Bulle an feinem Seide
In plica rechts:

4292 (verso)

P. Eug
G.
 de mandato dni
 Bendoi Card
Mittelgrosse regelm. Schrift
Viele verzierte Buchstaben

Bull. Gen. I cap. 19
P. — 1290 Aprilis 9
Nic ̃ B. S. Nic. in Carc. Trul.
diac. card.
Cum te una
Rome apud S. M. Maiorem
V iδ. Aprilis a° 3°
Rechter Rand abgeschnitten
Bulle und Hanf fehlen

Bull. Gen. I cap. 21
P. — 1290 Aprilis 9
Nic. ̃ G. epo Sabinen. et B.
S. Nic. in Carc. Trull. diac.
cardinali
Magna vestre circumspectionis
Rome ap. S. M. Maiorem
V iδ. Aprilis a° 3°
Bulle an Hanfschnur
In pl. rechts: a med
 de Cur
Ecke oben links: ⌠ Rδ
Rand oben Mitte: ten

Bull. Gen. I cap. 20
P. — 1290 Aprilis 9
Nic ̃ G. epo Sabinen. et
B. S. Nicolai in Arc. Trl.
diac. cardinali
Magna vestre circumspectionis
Rome apud S. M. Maiorem
V iδ. Aprilis a° 3°
Bulle und Hanf fehlen
In pl. rechts a med
 de Cur
Sub pl. links : g
Auf Bug durchstrichen und ab-
gekentelt: Rδ T. p de Cur et
cito quod cras bullentur
 p. Reat
A tergo : Rδ est

Instr. Misc. 1288 – 1295 cap. 29
P. — 1290 Aprilis 9
Nicol. ̃ G. epo Sabinen. et B. S.
Nicolai in Carcere Tulliani. dia.
cono cardinali
Magna vestre circumspectionis
Rome apud S M. Maiorem V iδ.
Aprilis a° 3°
Bulle und Hanf fehlen.
In plica links : Jaδ Docet de Curia
Sub plica links : g
hinter dem Bug links : Rδ C p de
Curia ut in alia (durchstrichen)
 strahle abgekl.
 P. Reat.
Ecke oben link ⌠ .p. l.
Rand Mitte oben : quod possint con-
ferre beneficia clericorum suorum de-
cedencium vel descedentium durante pro-
secutione negotiorum

4297

Instr. misc. 1288–1295 cap 30
P. — 1290 Apr. 9
Nicol. IIII J. epo Sabinen. et B. S.
Nicolai in Carcere Tullian. diaco-
no cardinali
Magna vestre circumspectionis
Rome apud S. M. Maiorem V idus
Aprilis a° 3°
Bulle und Hanf fehlen
In plica rechts: Sy · Ro ·
 de Curia

4298

Instr. misc. 1288–1295 cap. 31
P. — 1290 Aprilis 13
Nicol. IIII J. epo Sabinen. et Benedi-
to S. Nicolai in Carcere Tullian.
diacono [cardinali]
Cum vos ad
[Rome] apud S. M. Maiorem
iii Aprilis a° 3°
andere Tinte
Bulle und Hanf fehlen.
Linke Seite ganz zerfressen
In plica rechts: ar. p

4299

Bull. Gen. I cap. 24
P. — 1290 Aprilis 13
Nic. IIII B. S. Nic. in Carc. Tul.
diacono cardinali
 magna tue circumspectionis
Rome apud S. M. Maiorem
V. Aprilis a° 3°
 Bulle fehlt. Hanf vorhanden
Rechter Rand abgeschnitten

4300

Bull. Gen. I cap. 25
P. — 1290 Aprilis 19
Nicolaus Guardo epo Sabinen.
 N. fell et Benedicto S. Nic
in Carc. Trull. diac. cardinali
 Attendentes quod fratres
Rome ap S M. Maiorem
XIII Kal. maii a° 3°
 Bulle und Seide fehlen
In pl. rechts: de Cur T. p.
Ins pl. links: Ry T. Pergamen.
de Cur. et cito ut in alia
 p. Reat
Durchstrichen, Strich abgekratscht
Ecke oben links: S f.
Oben Mitte: perpetuatio iurisdictionis
 und ben.

4301

Marseille Archives Départem.
B 389
P. — 1290 Maii 1
Nicolaus IIII carissimo in xpo
filio Karulo regi Sycilie il-
lustri
Progeni torum tuorum sequeris
Rome apud Scam Mariam Ma-
iorem Kl. Maii anno 3°
Bulle an Hanf
In plica rechts M. Roman
Sub plica links p. Reat.

Ecke oben links ./.

fette, kleine, nachlässige Schrift
lange Unter- und Oberlängen

4302

Firenze, Carmine di Firenze
P. 23262 1290 Maii 5
Nicolaus IIII [Ohne Punkte] uni-
versis xpi fidelibus presentes
litteras inspecturis
Virga venustissima et
Rome apud Scam Mariam
Maiorem III non. Maii a°3°
 Bulle fehlt, Seide erhalten
In plica rechts Cosmas
 Sub plica links ···
Ecke oben rechts
A tergo oben mitte
klein breit schön
verschnörkelt

4303

Madrid Arch. Histór. Nacional
Zamora Toro 9 6
 P. 23264 1290 Maii 5
Nicolaus IIII ·· magro et ge-
nerali capitulo ordinis fra-
trum Predicatorum apud
Ferrariam congregando
Processit ex intime
Rome ap. S. Mariam Maiorem
III non. Maii a° 3°
Bulle fehlt. Hanf erhalten
In plica rechts
 de Cur. Sy. J.
Sub plica links unten abge-
klatscht R/ f. R d. Cur pro bo-
na recopens/
 p. Reat.
Rand oben halblinks
R/ p. dupptr et shti de man. Dni
et remittatur in· ben

4304

Archivio di Stato Milano
Bolle e Brevi
 P. 23262 1290 Maii 5
Nicolaus IIII univ. xpi fideli-
bus pres. litteras inspecturis
Virga venustissima et
Rome apud Scam Mariam
Maiorem III non. Maii a°3°
Bulle fehlt, Seide erhalten
In plica rechts Cosmas
Sub plica rechts ···
Ecke oben rechts
A tergo oben mitt:

4305

Barcelona Corona de Aragón
P. — Leg. 17° n. 1°
 1290 Maii 5
Nicolaus IIII Constantie Rin
Regine Aragonum Illustri
Ad tuam carissimam
Rome ap. S. M. Maiorem III.
non. Maii a° 3°
Bulle und Hanf fehlen
In plica rechts Jo. pip.
Ecke oben links
 D. p. Innchen
 dann supl dsfh
 dann
Sub plica links f. Arn
unten Ansgestr. abgeblatod
 p. Rxat

4306

Instr. Misc. 1288 – 1295 cap. 33
P. — 1290 Maii 21
Nic. IIII A. duci Austrie
Confidimus firmiter et.
Rome apud S. P. XII Kal. Jun. a° 3°
Rund herum beschnitten
Bulle und Hanf fehlen deng...
A tergo ! topi 4I
 cap X
 duci Austrie

4307

Barcelona Corona de Aragón
P. — Leg. 17° n° 2°
 Clausa
 1290 Junii 20
Nicolaus IIII Constantie relicte
quondam Petri olim Regis Ara
gonum
Devotionis tue sinceritas
Ap. Vrbemveterem XII Kl.
Julii a° 3°
Bulle an Hanf
A tergo unten links unge
rechts (in plica) J. de J....

 Ränder links
 und rechts ab-
 geschnitten

4308

Firenze, Montepulciano
P. — 1290 Julii 7
Nicolaus IIII . . archipresbiter
ecclesie de Monte Pulisicino
Aretin. dioc.
 Ad audientiam nostram
Apud Vrbemveterem non.
Julii a° 3°
 Bulle und Hanf fehlen
In plica rechts J.. Sal
Sub plica links ..
 M. Roce
Oberste Zeile frei
Sub plica unlinirt,
Ecke oben rechts

4309

Firenze, S. Annunziata
di Firenze
P. 23324 1290 Julii 15
Nicolaus IIII [ohne Punkte] uni=
vasis xpi fidelibus presentes
litteras inspecturis
Virga venustissima et
Apud Vrbemveterem id
Julii a° 3°
Bulle fehlt, Seide erhalten
In plica rechts Jac. vit
Ecke oben rechts Pa.
A tergo klein
breit dünn

Sept cap° CCCX

4310

Poitiers Archiv. départ.
Évêchê Poitiers n. 6
P. — 1290 Julii 15
Martinus IIII .. epo Pcta.
ven.
Sincere devotionis integritas
Apud Vrbemveterem id. Jul.
a° 3°
Bulle mit Seide ausgerissen
In plica rechts G. de Asisis
Sub plica links regul
schrift leicht nach links geneigt
unruhig und in Einzelheiten
doch fest.
Erste Zeile frei
Sub plica nicht liniiert.
A tergo Magr Americus Spas.
Cardi.

4311

Firenze SS. Annunziata
di Firenze
P. — 1290 Julii 23
Nicolaus IIII Guillermo de An.
peminelli canonico Lucan.
Conquesti sunt nobis
Apud Vrbemveterem X kl.
Augusti a° 3°
Bulle an Hanf
In plica rechts Cosmas
Ecke oben rechts G
14.4 hoch. 3.00 breit
21.5 breit
Ecke oben rechts G

4312

Coblenz Stattarchiv
St. Mathias
P. — 1290 Julii 23
Nicolaus IIII .. abbati et con-
ventui monasterii Sancti
Mathie extra muros Treve-
renses OSB
devotionis vestre precibus
Apud Vrbenveterem X kl.
Augusti a° 3°
Bulle an Seide
In plica rechts Mau.
Sub plica links m. Rovo

4313

Marseille Archives départem.
B 395
P. — 1290 Augusti 6
Nicolaus IIII cmus in xpo filio
Carolo regi Sicilie illustri
tec de te
Apud Vrbemveterem VIII iđ.
Augusti aᵒ 3ᵒ
Bulle und Auf fehlen
In plica rechts m. de Rocca
Sub plica links ₌ Roce
 m. Reat. 2

Ecke oben links f
Ecke oben rechts J. de pen.

4314

Firenze, SS. Annunziata
Fehler di Firenze
P. — 1290 Augusti 28
Nicolaus IIII .. plebano p̄blei
sci Andree Pistorien.
 Conquesti sunt nobis
Apud Vrbemveterem V kl.
Septembris aᵒ 3ᵒ
 Bulle und Auf fehlen
In plica rechts Jo Catt
Ecke oben rechts Ofe
 14. 4 hoch
 3. 7 plica
 21. 1 breit

Etwas eckige kleine Schrift

4315

Firenze, SS. Annunziata
 di Firenze
P. — 1290 Augusti 28
Nicolaus IIII monacho archidi
acono Senen.
 Conquesti sunt nobis
Apud Vrbemveterem V kl.
 Septembris aᵒ 3ᵒ
Bulle fehlt, Auf erhalten
 In plica rechts Jo Catt
Ecke oben rechts Œ
 13. 8 hoch
 3. 6 plica
 20. 5 breit

Jahrige eckige Schrift.

4316

Firenze, SS. Annunziata
 di Firenze
P. — 1290 Augusti 28
Nicolaus IIII Monacho archidi
cono Senen.
 Conquesti sunt nobis
Apud Vrbemveterem V kl.
Sept. aᵒ 3ᵒ
Bulle fehlt, Auf erhalten
 In plica rechts Jo Catt
Ecke oben rechts Œ
 Jahrige Schrift mit gothischen
Elementen
 14. 8 hoch
 3. 5 plica
 21. 4 breit

Arch. Arcis
Arm. C fasc. 11 cap. 2
P. 23399 1290 Septembris 13
Nic. IIII universis xpi fidelibus
presentes litteras inspecturis
Cum dilectum filium
Apud Urbemveterem iv. Sept.
a° 3°
Bulle an Hanfschnur
In pl. rechts: a. med
 de cur

Arch. Arcis
Arm. XIII caps. 14 cap. 14
R 23399 1290 Sept. 13
Nic. IIII universis xpi fidelibus
presentes litteras inspecturis
Cum dilectum filium
Apud Urbemveterem [arg. soll. convexit] iv.
Sept. a° 3°
Bulle fehlt. Hanfschnur
In plica rechts: alb p

Rand links länger Correctur

Public Record Office London
Papal Bulls bundle 31 n. 3
P. 23404 1290 Septembris 17
Nicolaus IIII . E. regi Anglie illustri.
Regie celsitudinis litteras
Apud Urbemveterem XV kl. Oct. a° 3°
Bulle fehlt, Hanf erhalten
In plica rechts de Curia
In plica Mitte Angls Rom
 solt (?) - - -
Sub plica links X
 X
Ecke oben rechts R
a tergo oben Mitte dünn schlank

 script) CCCXXXVI

 cap

Npoli Cur. Eccles. vol. III
P.- 1290 Octobris 4
Nicolaus III -- magro et fribus
domus Hospitalis Sancte Marie
Theutonic. Jerosol.
Pridem venerabili fratri
[nro nicolao patriarche Jero]
Apud Urbemveterem III non.
Oct. a° 3°
Bulle und Hanf fehlen
In plica rechts m. de Reate

Toulouse, Archives Départem.
H . 30

P.— 1290 Octobris 7

Nicolaus IIII . . . archidiacono
ecclie Lectoren.
ad audientiam nostram
Apud Vrbemveterem non. Oct.
a° 3°
 Bulle und Hanf fehlen
 In plica rechts Name .
 Sub plica links — —

 Ecke oben rechts J

Public Record Office London
Papal Bulls bundle 30 n. 18
 P. 23481 1290 Decembris 2
Nicolaus IIII - - regi Anglie illustri
 Cum dilecti filii
 ap. Urbemveterem IIII non.
 Dec. a° 3°
 Bulle an Hanf
 In plica rechts de Curia
 f. B.

Bayer. Haupt. Staatsarchiv
 Kl. Secon fasc. 6
P. 23488ᵃ 1290 Decembris 5
Nicolaus IIII . . decano ecclie Salze-
 burgen.
Dilectorum filiorum . . abbatis
apud Vrbemveterem non . dec.
 anno Tertio

Gutgeprägte Bulle an starkem Hanf
In plica rechts : C. de Setia
Ecke oben rechts : J
A tergo Ecke oben links : a

 Mandat 70 Zeilen 20.2 × 14.9
 plica 3.2

 Basel Staatsarchiv
St. Leonhard Nrk 4. 75
 P.— 1290 Decembris 5
Nic . IIII . . preposito et conven-
tui monasterii S. Leonardi
Basilien. per prepositum
soliti gubernari O.S.Aug.
 Cum a nobis
Apud Urbemveterem non.
Dec . a° 3°
 Bulle an Seide
 In plica rechts b pX
 Sub plica links — — —
 M. Roso

Rand oben Mitte :
 de camer dni . v.
Ecke oben rechts bo

4325

Firenze, Badia di Passi-
gnano

P. — 1291 februarii 9
Nicolaus IIII. . abbi monast.
see Marie Maioris Florentin.
 Conquesti sunt nobis
Apud Vrbemveterem V id.
febr. a° 3°.
 Bulle und Hanf fehlen
In plica rechts N. J
 Ecke oben rechts a
 13. 7 hoch 2. 8 plica
 2h. 00 breit

4326 (recto)

Neapoli Curia Eccles. Vol. 3°
P. 23576 1291 februarii 20
Nicolaus IIII. . — magro et fribus
domus Hospitalis sancte Ma
rie Theutonicorum Ieros.
 Reducentes ad sedule
Apud Vrbemveterem X Kl. Mar
 tii a° 3°
 Bulle und Seide ausgeschnitten
Sub plica links V
 Cosmas
Rand oben mitte 9
Ecke oben rechts R
A tergo oben mitte zierlich

sepe . DCC xxx III

cip

4326 (recto)

Rand oben Mitte top
 „ „ links dom. l
 J. fieri

4327

Marseille Archives départem
H. O. M. 23
P. 23576 1291 februarii 20
Nicolaus IIII . . magro et fribus
Hospitalis sancti Johannis Ierg
 Reducentes ad sedule
Apud Vrbem veterem X Kl.
 Marcii a° 3°.
 Bulle an Seide
In plica rechts Ro . . .
Sub plica links — — — — nur
 R. Jy T fran.
Ecke oben links S J

4328

Toulouse, Archives Départem.
H. 30

P. — 1291 Martii 15

Nicolaus IIII . . ungro et fribus
Hospitalis sancti Johannis
Jerosolim.

Pridem ad nostram
apud urbemveterem id. Mar.
 to a° 4°

Bulle fehlt, Hanf erhalten
in plica rechts

pro Jac de Anagnia
 J. p

Sub pl. links ⫶̄

4329

Public Record Office London
Papal Bulls bundle 31 n. 21
P. 23 604 1291 Martii 16

Nicolaus IIII - E. regi Anglie illustri
Post tractatus varios
Apud Urbemveterem XVII kal
Aprilis a° 4°
Bulle an Seide
In plica rechts Ro par
Sub plica links ✗✗✗
Ecke oben rechts R͟
a tergo Mitte oben ohne alle Schrift

Public Record Office London
Papal Bulls bundle 30 n. 13: 1291.Martii 18
vide:
pag. 566 n. 4368

4330

Public Record Office London
Papal Bulls bundle 31 n. 4
P. 23 610 1291 Martii 18

Nicolaus IIII · E. regi Anglie illustri
Inter cetera de
Apud Urbemveterem XV kal Apr. a° 4°
Bulle fehlt, Hanf erhalten
In plica rechts B. F.
Sub plica links Ξ
 v
In plica Mitte · f.
Ecke oben rechts R͟
A tergo Mitte oben ohne alle Schrift schlank

4331

Public Record Office London
Papal Bulls bundle 31 n. 6
P. 23 607 1291 Martii 18

Nicolaus IIII · E · regi Anglie ill.
Et si iuxta
apud Urbemveterem XV kal Aprilis a° 4°
Bulle und Seide fehlen.
In plica rechts · N. G.
Sub plica links Ξ
 v
 R͟ Jo. Pan
 f. Ang

Ecke oben links δ f.
 Duplicat

4332

Public Record Office London
Papal Bulls bundle 31 n. 7
P 23 606 1291 Martii 18
Nicolaus IIIj . E. regi Anglie illustri
Confidentie necnon et
Apud Urbemveterem XV kel. Aprilis a° 4°
Bulle und Seide fehlen
 In plica rechts · U. G.
Sub plica links v̄ x̌ darunter
R Ambr. f. Amy
Rand oben links
 ð. f.
 Duplicat

4333

Public Record Office London
Papal Bulls bundle 31 n. 8
P. 23 613 1291 Martii 18
Nicolaus IIIj .. Carleolen. et .. Ca-
thanen. epis
 Non absque letitie
apud Urbemveterem XV kel. Aprilis a° 4°
Bulle fehlt, Hanf erhalten
 In plica rechts G. de Setia
sub plica links x̌
Ecke oben rechts R
a tergo oben Mitte sehr schön ohne
alle Schrift

4334

Public Record Office London
Papal Bulls bundle 31 n. 11
P. 23 611 1291 Martii 18
Nicolaus IIIj magistris Willermo de
Monteforti Capellano nostro decano
et Radulfo de Banduk archidiacono
Middelsexie in ecclesia S. Pauli Londonia
ac Gaufrido de Vesano camere nostre
clerico canonico Cameracen.
 Inter cetera que
Apud Urbemveterem XV kel. Aprilis a° 4°
Bulle fehlt, Hanf erhalten
In plica rechts · B. f.
Sub plica links Ξ̌
Ecke oben rechts R
a tergo oben Mitte
ohne alle Schrift

4335

Public Record Office London
Papal Bulls bundle 31 n. 13
P 23 610 1291 Martii 18
Nicolaus IIIj . E. regi Anglie ill.
 Inter cetera de
Apud Urbemveterem XV kel. Apr. a° 4°
Bulle fehlt, Hanf erhalten
In plica rechts · U. G.
Sub plica links Ξ̌
darunter R B. Fumon
 f. Amy
Ecke oben links ð. f.
 Duplicat

4336

Public Record Office London
Papal Bulls bundle 30 n. 14
P. 23 606 1291 Martii 18
Nicolaus IIII – E · regi Anglie illustri
Confidentie necnon et
Apud Urbemveterem XV kel. Aprilis a° 4°
 Bulle an Seide
In plica rechts b med
Sub plica links V̅
 ×
Ecke oben rechts Rx
 a tergo oben Mitte ohne alle Schrift

4337

Public Record Office London
Papal Bulls bundle 31 n. 18
P. 23 608 1291 Martii 18
Nicolaus IIII universis episcopis per
regnum Scotie constitutis
Terre Sancte miserabilem
Apud Urbemveterem XV kel. Aprilis a° 4°
 Bulle an Hanf
In plica rechts A de Guarcia
Sub plica links unten
 Rx Neput III · J · Amp·
Ecke oben rechts Rx
 a tergo oben Mitte ohne alle Schrift

4338

Public Record Office London
Papal Bulls bundle 31 n. 20
P. 23 607 1291 Martii 18
Nicolaus IIII · E · regi Anglie illustri
 Et si insta
apud Urbemveterem XV kel. Apr. a° 4°
 Bulle an Seide
In plica rechts Jo Pon̄
Sub plica rechts ≡
 V
Ecke oben rechts Rx
 a tergo oben Mitte ohne alle Schrift
 schlank, zierlich

4339

Public Record Office London
Papal Bulls bundle 31 n. 15
P. 23 631 1291 Martii 29
Nicolaus IIII – E · regi Anglie ill.
 Inter cetera de
Apud Urbemveterem IIII kel. Aprilis a° 4°
 Bulle und Seide fehlen
In plica rechts · U · G
Sub plica links ≡
 V
 Cosmas J
Darunter Rx B · Funon
 f/Amr
Ecke oben links S · f ·
 rechts Rx
 a tergo oben ohne alle Schrift

4340

Statsarchiv Wien Chronol.

P. — 1291 Aprilis 9

Nicolaus Chunrado archi-
epo Salzeburgen.

Anni presentis vite

Apud Urbemveterem V id.
Apr. a° 4°

Bulle und Hanf fehlen
In plica rechts p. Reat.
 Cor
Sub plica links
Rand oben
Ecke rechts X

A tergo mittelgross
schlank verziert |scpc| . CXLIII

4341 (recto)

Bayer. Haupt. Statsarchiv
Hochstift Augsburg fasc. 10

P. 23649 1291 Aprilis 17

Nicolaus III (venerite vonm. Mari
e. s. s. Dei dil. filijs . Priori Hoogi
tilis sci Spiritus in Dylingen eius
que fratrum tam pres. quam fut. regul.
uitam professis IN
Religiosam uitam eligentibus
pacis inueniant AMEN AMEN

R. Ego Nicolaus cath. ecclie eps SS M
3 presb. 2 epi 3 diaconi
Dat. apud Urbemveterem per manum
magri Johannis decani Baiocen. sce
Romani. ecclie Vicecancellarij XV Kl.
Maij jnd. quarta Jnc. dominice Anno
m. CC. L XXXX I pontif. uero donni
NICOLAS pp IIII Anno Quinto

Bulle an Seide
In plica links : . O. Laud.
Ecke oben rechts : C.
 a
 fant

Rand oben mitte : ascl
Sehr regelmässige schlanke schöne Gd
durchweg mit hohen Oberlängen ohne

4341 (verso)

aufgesetzte Schnörkel. Unterlängen
nur angedeutet.
Schöne grosse feste Schrift

4342

Public Record Office London
 Papal Bulls bundle 30 n. 15
 P. 23 664 1291 Maii 10
Nicolaus IV . E. regi Anglie ill.
Sit regalis providentie
Apud Urbemveterem VI id. Maii a° 4°
 Bulle an Hanf
 In plica rechts B. F
 de curia
 Sub plica links)
 Ecke oben links : .). rechts R

 A tergo ohne alle Schrift, sehr zierlich

4343

Bayer. Haupt- Staatsarchiv
Bamberg fasc. 199

P. 23673ˣ 1291 Maii 15

Nicolaus IIII (Gitterschrift) - - Abba-
ti et Conventui Monasterij de
Eberaco Cisterccii . ordinis kubigs.
...dioc.
 Devotionis vestre precibus
apud Vrbemueterem Jd. Maii
 Anno Quinto

Bulle an feiner Seide
 In plica rechts: ...

Sub plica links - -
 Cosmas
 Ecke oben rechts: J

A tergo Ecke oben links: n

...ige, zusammenhängende Schrift
...rechts geneigt. Schrift
Höhe steht mit Ober- und Unterlängen
...in gutem Verhältnis. Allgemeiner
Eindruck: unschön

4344

Montpellier Archives départm.
H. Gigean

P. — 1291 Maii 15

Nicolaus IIII Guillermo de Val-
huguesio canonico Lodoven.
 Sub religionis habitu
Apud vrbemueterem iħ Maii
 anno 4º
 Bulle fehlt, Hanf erhalten
In plica rechts Ro pe
Sub plica links _ʒ

Ecke oben links·C ε
 Rand oben mitte In aud
Ecke oben rechts pe

4345

Bayer. Hupt. Staatsarchiv
 Bamberg fasc. 284

P. 23690ˣ 1291 Junii 4

Nicolaus IIII . . Abbati et Conven-
tui Monasterij de Lancheuein Cister-
cien ordinis Bambergen. dioc.
 Devotionis vestre precibus
Apud Vrbemueterem II Non. Junij
 Anno Quinto

Gute Bulle an Seide
 In plica rechts: p. benefi
Sub plica links: - -
 Cosmas

Sehr feste, dicke, mittelgrosse Schrift
etwas rund und zusammenhängend

Breite Ränder

4346

Bayer. Haupt. Staatsarchiv
 Memmingen Hospital fasc. 1

P. vacat 1291 Junii 9

Nicolaus IIII (vorzug. Maii) - - Ma-
gro et fratribus Hospitalis sci Spiri-
tus de Saxia de Vrbe (nostri
 Ut eo libentius
apud Vrbemueterem V Jd. Ju-
nij Anno Quinto

Bulle an schlechter Seide
 In plica links: O. Lauden.

Sub plica links ! und da
neben : R. O. Lauden II
 Jd. Bio.

Sehr kräftige grosse übergroße.
Schrift mit schönen Ober- und
Unterlängen

Ungeheure Ränder vor Riesen.
plica

4347

Poitiers Archives départem.
Evêché Poitiers
P. — 1291 Iunii 20
Nicolaus IIII Galtero epī̄sco.
Po Pictaven.
Meritis tue devotionis
apud Urbemveterem XII kl.
Iulii aᵒ 4ᵒ
Bulle und Seide herausgeschn.
In plica rechts: P. TO Z
" " mitte C. dni Z
Sub plica links - - -
 Cronias
und unten Rᵰ 9 Io. Bon
 m. Rocꝰ
Ecke oben links de ut X. p.
Apud oben mitte dans prater in man
 dauit.

4348

Instr. Misc. 1288 - 1295 cap. 70
 P. 23720 1291 Iulii 11 Iunii 27
hic IIII mag. Raynerio de Piisi du-
catus Spoletan. rectori notario nro
Ad conservationem bonorum
Apud Urbemveterem V kl. Iulii
 aᵒ 4ᵒ
In plica rechts: A med
 de Curia
Sub plica links 9
Ecke oben links: · L.
A tergo: A. de Curia

4349

Arch. Arcis
Arm. C fasc. 35 cap. 1
 P. ? 1291 Iunii 30
hic IIII universis et singulis
Ecclesie Romane fidelibus
per Campaniam constitutis
Dat. apud Urbemveterem
II kl. Iulii aᵒ 4ᵒ
Bulle an Hanf.
 Schöne Bulle
In pl. rechts: h. de Fractis
 de man dni Gandulini Cꝰ

4350

Madrid Arch. Histór. Nacional
Orden de la Merced n. 11
 P. 23738 1291 Iulii 14
Nicolaus IIII .. magro et fribus
hospitalis S. Marie de Mer-
cede Captivorum Barchinoꝰ
nen. OSAug.
Petitionibus vestris benignum
Ap. Urbemveterem II iđ. Iulii
aᵒ 4ᵒ
Bulle an Seide
In plica links O Laud
Sub plica links m. Rocꝰ
 ·· ͺ̣
weiter unten:
Rᵰ Iaꝯ vir
 m. Rocꝰ
Ecke oben links L rechts Rᵰ
A tergo oben sĩꝯ Rᵰ M
mitte cap ꞁꞁꞁ CCCC biiii

4351

Madrid Arch. Histór. Nacional
Catedral de Toledo n. 8
P. — 1291 Julii 18
Nicolaus IIII .. archiepo Toletan.
Anxia nimis et
Apud Urbemveterem XV Kl.
Sept. a⁰ 4⁰
Bulle an Hanf
In plica rechts - Reput R
Rand oben Mitte ben
 supp in dat

4352

Bull. gen. I cap. 24
P. — 1291 Julii 31
Nicolaus IIII nob viro Edwardo
Kl. fell caris. in X fil. nri Edu-
ardi Anglie et etc. Blance clare
memorie Philippi Francor. regis
regum natis
Aplice sedis benignitas
Apud Urbemveterem II Kl.
Augusti a⁰ 4⁰
Plica abgeschnitten
Bulle und Seide ausgerissen

4353 (recto)

Bayer. Haupt. Staatsarchiv
Regensburg Augustiner fasc. 9
P. 237 60/61 1291 Augusti 1
Nicolaus IIII .. Priori Generali fratrum
Heremitarum ordinis sancti Augu-
stini vel eius vices gerenti
 Terre sancte miserabilem
Apud Urbem veterem Kl. Augusti
anno Quarto

Bulle an Hanf . N. G. (verte)
In plica rechts : computetur inter
 notas
Sub plica links : XX
Ecke oben rechts : p. Reat
 · a tergo oben Mitte

Rand oben links :
 In plica rechts :
 vnam pro Ste Ri
 vnam pro te
 boel pro Rom vnam
 pr. pu. vnam M. Roce

4353 (verso)

Sub plica links :
 pro pro
 pro B. Ani
 Padit
 Ig. T. pro Jo. Camp M. Roce

Sehr breite Ränder
Schöne kräftige enge Schrift

4354

Bayer. Haupt- Staatsarchiv
Regensburg Aug. Cr. Fasc. 9

P. 23756 1291 Augusti 1

Nicolaus IIII (roman. Mai.) Uni-
versis xpi fidelibus ad quos pre-
sentes littere pervenerint
 Illuminet super nos
apud Vrbemveterem Kl. Aug.
anno Quarto

Bulle an Seide
In plica rechts: Jo pie po
 Sao Amag.
Sub plica links x
 x
 x

Linie für die hohen Oberlängen
Je zwei Seitenlinien

4355

archivio di Stato Milano
Bolle e Brevi

P. — 1291 Augusti 5

Nicolaus IIII univ. xpi fidelibus
presentes litteras inspecturis
 Vite perennis gloria
Apud Vrbemveterem non. Aug.
a° 4°

Bulle an Seide
In plica rechts] Lauck
Sub plica links - - -
 p. Reat
 9
Ecke oben rechts] x

A tergo oben Mitte [Srpc] . cxl ?
leicht schlank klein
 cap

4356

Bayer. Haupt- Staats archiv
 Trellenhofen F. 6

P. vacat 1291 Augusti 5

Nicolaus (Gitterschrift) IIII . Ab-
batisse et Conventui Monasterij
de Buluhoven Cisterciensis ordi-
nis Ratisponen. Dioc.
 devotionis vestre precibus
Apud Vrbemveterem non. Aug.
anno Quarto

Bulle und Seide fehlen
In plica rechts : Jo. bonoff
Sub plica links : p. Reat
Ecke oben rechts :] x
A tergo Ecke oben links : F
fette niedrige invertierte Schrift
Je zwei Seitenlinien
 Duplicat

4357

Bayer. Haupt- Staats archiv
 Pielenhofen

P. vacat 1291 Augusti 5

Nicolaus IIII dil. in xpo filiabus
 — Abbatisse et Conventui
Monasterij de Buluhoven Cister-
tien. ordinis Ratisponen. Dioc.
 devotionis vestre precibus
apud Vrbemveterem non. Aug.
 anno Quarto

Bulle und Seide fehlen
In plica rechts : p. bonoff
Sub plica links : p. Reat
Je zwei schmale Seitenlinien

 Duplicat

Arch. Arcis

Arm. XIII aps 7 cap. 3

P. — 1291 Augusti 10

hic. IIII magistro Raynerio de

Pisis ducatus Spoletan. rectori

notario nostro vel eius vicario

Dutum ad audientiam

Apud Vrbemveterem IIII iꝰ. Aug.

a° 4°

Bulle an Hanfschnur

In pl. rechts: Io de Boṽ

 de Curia

Paris Archives Nationales

 J 337 431 n. 40

Breite 49. Randlinks 4.9 rechts 5.1

Höhe 30. Randoben 2.9 plica 5.7

Erste Linie für Oberlängen / Je

eine Seitenlinie

P. vacat 1291 Augusti 18

Nicolaus IIII Carmo in xpo filio

— — Regi Francie illustri

Dura nimis et

Dat apud Vrbemveterem XV

Kl Septembr / a° 4°

Bulle an Hanf

In plica rechts P. Reat

Regum. mittelgrosse Schrift

Firenze, domo Rinuccini

 P. 23 795 1291 Augusti 23

Nicolaus IIII . . plebano ecclie

beate Marie in Pineta eius

que fratribus etc. M PP M

 Officii nostri nos

R. Ego Nicolaus catholice

 ecclie eps SS M

4 presb. 3 epi 4 diac

Apud Vrbemveterem p. m. ma-

gistri Iohis decani Bitricen-

se Roman. ecclie vicecancella-

rii X Kl. Septembris ind. quarta

I. D. a°. m. CC. Lxxxxi p. vo don-

ni NICOLAI pp IIII anno quarto

 Bulle und Seide fehlen

In plica links O. Laud.

 verte

Am oberen Rande entlang:

p. ad instar. O. Laud. Giᴀ

R pier. R Iohes Sgar con-

servatores privilegiorum gene-

rant. v. — fuit rescriptum

quia primum fuit gratis pat

— appareat primum ut scia-

tur qui legit. dns J. eg.

— In aud pt dat aꝝon

Tum

Ecke oben rechts paul

4361

Firenze, R⁰ Augusto Mariotti
P. — 1291 Augusti 23
Nicolaus . . generali cete.
risque prioribus et fribus or.
dinis Sancti Guillermi
 Meditacio cordis nostri
Apud Urbemveterem X kl.
Sept. a° 4°
Bulle und Seide fehlen
In plica rechts β. Beat
 Sub plica links ×
 ×

Prachtvolle, schwungvolle
wohl proportionierte, feste
runde Schrift

4362

Bull. Gen. I cap. 25
 P. — 1291 Sept. 2
hie ... Sancti Pauli de Urbe et
" S. Germani de Pratis Parisien.
monasteriorum abbatibus ac
" decano ecclesie Parisien.
Ea superna providentia
Apud Urbemveterem III non.
Sept. a° 4°
Unnf. Bulle fehlt.
In pl. rechts: Jo pip de mã ᵗᵒ
 dñi B. Card.

4363

Bull. Gen. I cap 26
P. 1291 Sept. 2
Nicolaus III Benedicto S. Ni.
gr. nichvesint } Coliso in Cur. Tul.
diacono card.
 Ea superna providentia
Apud Urbemveterem III non.
Sept. a° 4°
Bulle fehlt. Seidenfäden
In pl. rechts: Jo pip de mã ᵗᵒ
 dñi B. Card
oben beschnitten

4364

Graz Landesarchiv u. 1408
P. — 1291 Septembris 11
Nicolaus III Ortolfo presbitero
rectori hospitalis S. M. in Mon
te Simernich Salzburgen.
diocesis
 Exhibita nobis tua
Apud Urbemveterem III iđ.
Sept. a 0 4°
Bulle an Seide
In plica rechts · p. C ...
Sub plica links :
 ×
Ecke oben rechts 24
A tergo oben
Mitte ziemlich sept CCCCLXXXIII
hinkelgross pip

4365

Paris Arch. nat.

J 449 cap. 119 1291 Dec. 13

Nic IIII Phylippo regi Francie ill.

Venerabilis fratri nostri

Rome apud S. M. maiorem

iđ. Dec. a° 4°

Bulle an Hanf

Prachtvoll geschrieben

In plica links P. de Caf

de camera

De sexenali decima

P. 23874

4366

Je camera

Paris. Archives Nationales

J 449 n. 119

Erste Linie für Obelängen/

Je zwei Seitenlinien

P. 23874 1291 Decembris 13

Nicolaus IIII Carmo in Xpo

filio Phylippo Regi Francie

Venerabilis frater nr

Dat Rome apud Scam Mariam

Maiorem Jđ Decembr a° 4°

Bulle an Hanf

In plica links : P. de Caf

de Camera

Herrliche große fette Schrift

Sechsjähriger Zehnt für den

König

4367

P. — Paris Archiv. nat.

J 700 cap. 87 1292 Januarii 3

Clausa

Breite Ränder

Die Schnitte tref-

fen die Schrift nicht

Nicol IIII n. Parisien. et n. Au-

relianen. epis

Nostis ut credimus

Rome apud St M Maiorem

iđ Jan. a° 4°

4368 (recto)

Public Record Office London

Papal Bulls bundle 30 n. 13

P. 23612 1291 Martii 18

Nicolaus IV universis episcopis et electis

abbatibus, prioribus, decanis, archidiaconis

etc per regnum Scotie constitutis

Propter miseriam Terre

Apud Urbemveterem XV kl apr. a° 4°

In plica rechts · h. g.

Sub plica links v̄

x̄

Cosmas, darunter Dachstriche

Rx̄ N. G ii

f an

Ecke oben links fi ii

" " rechts Rx̄

a tergo Mitte oben

4368 (verso)

4369

schließt mit
fein, ohne ...
de ' Schrift '

a tergo
Ecke oben rechts
R₄ n . 9 . II
et I alia consim.
II , de quibus III
III sunt com-
pletie

4369

Arch. Arcis
Arm. C Abt. fasc. 12 cap. 6
P. 23957 1294 Augusti 30
Celestinus V .. abbati et conven-
tui vasiat sui monasterii
Sancti Spiritus de Murrone OSB
Valven. dioc.
Dilectus filius Honufrius
Aquile III Kl. Septembris a° 1°
Bulle an feinen Seidenfäden
In pl. links P de Caff
G pro dño pp

4370

Arch. Arcis
Arm. C fasc. 12 cap. 5
P. – 1294 totus Aug. 31
Celestinus V .. abbati et conven-
tui vasiat sui monasterii
Sancti Spiritus de Murrone OSB
Valven. dioc.
Dilectus filius Honufrius
Aquile II Kl. Sept. a° 1°
Bulle an dünnen hellen S. fäden
In pl. links : P. de Caf.
de Cur

4371

Arch. Arcis
Arm. C fasc. 12 cap. 9
P. * 23956 1294 Septembris 2
Celestinus V universis xpi fide
libus presentes litteras inspectu-
ris.
Licet sanctorum cunctorum
Aquile III non. Sept. a° 1°
Bulle an feinen Seidenfäden
In pl. rechts : A. Med
pro recompens)
Sub pl. links : g
A tergo oben Mitte
de Tervento - daneben von anderen
hand : pro ordine

Public Record Office London
Papal Bulls bundle 9 n. 6
P. 23 957 1294 Septembris 3
Celestinus V E. regi Anglie illustri
Mirabilia Dei iudicia
Aquile III non. Sept. a° 10°
Alles nachgetragen
Bulle an Hanf
In plica rechts P. Reat

R
Paris Archives Nationales
J 686 n. 79 E
Breite 62.6 Rand links 7.1 rechts 6.6
Höhe 37.9 Rand oben G. + plica 8.1
Erste Linie für Gitterschr. und Ober-
längen / Je zwei Seitenlinien
P. vacat 1294 Septembris 5
Celestinus V (Gitterschr.) Carmo
in xpo filio Phylippo Regi Franc.
corp Illustri
Serenitatis Regie nota
Dat Aquile non Septemb RP 1
a° 1°
Bulle an Seide
In plica rechts !
N. de Limos
vult

Sub plica links : V̄ 9
Ecke oben links : V/ rechts : R
A tergo oben Mitte :
Francisco de Casalareto
Darunter ziemlich mit Schnör-
keln :
R (JTR) lxxxii
Cap
fette breite große Schrift

Paris Archives Nationales R
J 683 n. 7
Breite 42.4 Rand links 3.9 rechts 4.3
Höhe 25.9 Rand oben 6. plica 5.5
Erste Linie für Gitterschr. und
kleinere Oberlängen / Je 1 Seitenlinie
P. vacat 1294 Septembris 7
Celestinus V (Gitterschr.) Carmo in
xpo filio Phy Regi Francie Il-
lustri
Ob tuorum excellentiam
Dat Aquile VII Id Septemb RP
a° 1°
vult
Bulle an Seide
In plica rechts : M. de Adr
Sub plica links : J. Laur

Ecke oben rechts : R₄
A tergo Ecke oben links : · B
 Mitte oben :
Franciscus de Casalareta
Zierlich dünn ·

fette strumpfe unschöne Schr

Paris archives nationales
 J 683 n. 7 bis
Breite 47.9 Rand links 7.1 rechts 6.3
Höhe 33.4 Rand oben 7.4 plica 9.1
 Erste Linie für Oberlängen /
Links vier, rechts zwei Liniulinien
P. vacat 1294 Septembris 7
Celestinus v . . Abbati Monasterij
Sancti Dionisij in Francia Parisi.
in . . . dioc

 oo excellentium meritorum
dat aquile vij Jd septembrs /
a° 1°
Bulle an Hanf vide
 In plica rechts : h. de Limoß
 Sub plica links : ‾ ‾ ‾ ‾
 p. Reat)

Ecke oben links : ƫ
 A tergo Ecke oben links : · B·
oben Mitte : Franciscs de Casalareto
 fette weite Schrift

4376

 P. — Paris Arch. Nat.
J 683 cap. 19 **1294 Sept. 7**
Celestinus v . . abbati mones-
terii S. Dionisii in Francia
Parisien . dioc.
Amanto carissimus in
Aquile vij iv. Sept. a° 1°
Bulle an Hanf
 In plica rechts h de Limog
 Sub plica link - - - -
 p. Reat)
Ecke oben links ƫ

4377

P — Paris Arch. nat.
J 683 cap. 22 1294 Sept. 7
Celestinus V Philippo regi Fran-
cie illustri
Quanto maioris devotionis
Aquile VII id. Sept. a° 1°
Bulle an Seide
In plica rechts M de Adr
Sub plica links
 . J. Laur
Ecke oben rechts ——— R
A tergo Franciscus de Casalareto

(Sept) L x x x I
(cap) X

4378 (recto)

R
Paris Archives nationales
 J 684 n. 22
Breite 49. Rand links 5. rechts 4.8
Höhe 28.1 Rand oben 7.5 plica 7.2
Erste Linie für Gitterschr und Ober-
längen Je eine Seitenlinie
P. vacat 1294 Septembris 7
Celestinus V (Gitterschr) Carmo in
xpo filio Philippo Regi Francie
Jllustri
 Quanto maioris devotionis
Dat Aquile VII id Septembr
a° 1°
 Bulle an Seide
In plica rechts : m. de Adr
Sub plica links : J. Laur :
 vcote

4378 (verso)

Ecke oben rechts : R
A tergo oben Ecke links : B.
 Mitte mit dünnem Strich
schön gezeichnet :
 (Sept) R L X X X I
 (cap)

Darunter :
 Franciscus de Casalareto
Sehr fette stumpfe bänliche
Schrift

4379 (recto)

R
Paris Archives nationales
 J 685 n. 46
Breite 44.2 Rand links 4.1 rechts 4.1
Höhe 27.7 Rand oben 7.1 plica 5.6
 Erste Linie für Gitterschr und
einige Oberlängen Je eine Sei-
tenlinie
P. vacat 1294 Septembris 7
Celestinus V (Gitterschr) Carmo in
xpo filio . Pho. Regi Francie Jllustri
 Je in virtutum
Dat Aquile VII id Septembr / a° 1°
Bulle an Seide
In plica rechts : m. de Adr
Sub plica links : J. Laur
Ecke oben rechts : R
 vcote

4379 (verso)

A tergo oben Mitte:
Franciscus de Casalareto
Darunter sehr zierlich mit
schwunghaften kleinen Schnör-
keln (xpi) lxxxi
 cap

A tergo Ecke oben links : .B.
Sehr nachlässige fette stumpfe
Schrift.

4380

P. — Paris Arch. nat.
J 690 cap. 132 1294 Sept. 7
Celestinus V.. abbti monas.
terii S. Dionisii in Francia
Parisien. dioecesis
Puritas devotionis et
Aquile VII id. Sept. aᵒ 1ᵒ
Bulle an Hanf
In plica rechts h de Limos
Sub plica links x̄
In plica halbrechts
 ascult et q̄p per h de Adm

4381 (recto)

R+
Paris Archives nationales
 J 690 n. 132 ᴬ 26
Breite 61.8 Rand links 4 g rechts 4.4
Höhe 40.4 Rand oben 9, 3 plica 7.7
 Erste Linie für Gitterschr und
Oberlängen / Je eine Seitenlinie
 P. vacat 1294 Septembris 7
Celestinus V (Gitterschr) Carmo
in xpo filio Phy Regi Francie Jl
lustri
 Puritas et devotionis et
Dat Aquile / VII id septembr
aᵒ 1ᵒ
 Bulle an feiner Seide
 Sub plica links : ꞊ᷤ
 J. Laur · verte

4381 (verso)

In plica halbrechts : VI tror. lut
Ecke oben rechts : R+
A tergo oben Mitte sehr zierlich
mit kleinen Schnörkeln
 (xpi) lxxx
 cap

darüber :
 Franciscus de Casalareto
Fette mittelgrosse stumpfe Schrift

ascultata

Paris Archives nationales
J 690 a. 132 (27)
Breite 64. Rand links 7.4 rechts 7.3
Höhe 39.3 Rand oben 7.8 plica 8.1
Erste Linie für Überschrift,
Je zwei Zeilenlinien
P. vacat 1294 Septembris 7
Celestinus V . . Abbati monaste
rij sancti dionisij in Francia
Parisien̄ dioc
 Puritas devotionis et
dat Aquile VII Jd Septembr̄ a °10
Bulle an Hanf
 In plica rechts : N. de Limos
Sub plica links : X
In plica halbrechts : ascultz et . .
 per N. de Adria verte

à tergo ober Hnk :
 Franciscus de Casalareto
Tette Plire mittelgrosse Schiff

P— Paris Arch. Nat.
J 692 cap. 142² 1294 Sept. 7
Celestinus V Rfde Phylippo
regi francorum illustri
 Eximie tue devotionis
Aquile VII iv. Sept. a° 1°
Bulle an Seide
 In plica rechts N de limos
Sub plica links 9
In plica halbrechts
ascultz et gp p M de Adr
Ecke oben links . L

P— Paris Arch. Nat.
J 700 cap. 92 1294 Sept. 12
Celestinus V Philippo regi
Francorum illustri
Evidentia docet operis
Aquile X iv Sept. a° 10
 Bulle an Hanf
 In plica rechts : Ero ?

Napoli Curia Eccles. Vol. 3°
P. — 1294 Septembris 13
Celestinus V Pancratio abbi
et conventui mon. Sancte Ma-
rie de Gualdo ad Roman.
Ecclesiam nullo medio pati-
nentis OSB. Beneventan.
dioc.
Ecclesia Romana velut
Aquile iN Sept. a° 1°
Bulle und Seide fehlen
plica abgeschnitten

P. — Paris Arch. Nat.
J 700 cap. 93 1294 Sept. 13
Celestinus V Phy regi Fran-
corum illustri
divine gracie maiestatis
Aquile iN. Sept. a° 1°
Bulle an Hanf
In plica rechts N. de Frahis
Sub plica links v
 x
 J. laur
Ecke oben links [IV J] rechts
A tergo | Sept | X u VI |
 | cap | X

Firenze, Badia Fiorentina
P. — 1294 Septembris 13
Celestinus V . Hippolinaris et
.. sancti Sancti Marie maioris
prioribus et Rolando Gerardi
tu canonico Sancti Stephani
Florentin. ecclesiarum
Constitutus in presentia
Aquile iN. Sept. a° 1°
Bulle und Hanf fehlen
In plica rechts p
Sub plica links v
 . J. laur

Rand oben : — bn h. bn pbt
gbt - bn log latina z sau
bn XI bn h bn gbt bn lo.
gt latinum bn ta . Po.
(pauper clericus Bertinus de Campiano)

. Arch. Arcis
Arm. C fasc. 12 cap. 8
P. 23968 ? 1294 Septembris 20
Celestinus V universis xpi
fidelibus per tres civitates et dio-
ceses constitutis
Quoniam ut ait.
Aquile XII Kl. octobris a° 1°
Bulle an feinen Seidenfäden
In plica rechts :. N. g.
Sub pl. links : ..
 P. Real?
A tergo hutte oben : pro ordine

4389

Barcelona Corona de Aragón
Leg. 18° n. 10
P. — 1294 Septembris 24
Celestinus V nobili viro Jacobo
filio quondam Petri olim Regis
Aragonum ecclesiasticam reve
rentiam et spiritum veritatis

Peccasti? non adicias
Aquile VIII Kl. Oct. a° 1°
 Bulle und Hanf fehlen
 Ohne alle Notizen

4390

Public Record Office London
Papal Bulls bundle 9 n. 7
P. 23 473 1294 Septembris 24
Celestinus V E. regi Anglie illustri
Ad fovendum in
Aquile VIII Kl. Oct. a° 1°
 Bulle an Hanf
 In plica linkes G. Laud
 Sub plica linkes x
 x
 x

4391

P. 23976 Paris Arch. Nat.
L 278 cap. 1 1294 Sept. 27
Celestinus V Eunufrio patriab.
bati monasterii S. Spiritus de Sul-
mona Valven. dioc. eiusque co-
abbatibus ac prioribus et prela-
tis monasteriorum, prioratuum
ecclesiarum membrorum et loco-
rum dicto monasterio S. Spiritus
subiectis eorumque etc.
 SA si aneto
Aquile V Kl. Octobris a° 1°
 Bulle an Seide
 In plica links Jac Berl

4392

Arch. arcis
Arm. C fasc. 12 cap. 2 Septembris 27
 P. — 1294 Octobris 28
Cel. V magistro Nicolao de Tre-
bis notario nostro primicerio
Metev.
 Meditacio cordis nostri
Aquile V Kl. Octobris a° 1°
 Bulle an Hanfschnur
 Rand oben bütte:
 viele Rasuren

4393

Arch. Ascii
Arm. C fasc. 12 cap. 3
P. ×23978 1294 Septembris 27
Celestinus V .·. abbati et conventui monasterii Sancti Spiritus prope Sulmon. OSB Valven. dioc.

Meditatio cordis nostri
Aquile V Kl. Octobris a° 1°
Bulle an feinen Seidenfäden
In pl. rechts: K. p
 de Cur̄
Rand oben Mitte:
 Cgr et supt Dph

4394

Staatsarchiv Wien Chronol.
P. — 1294 Septembris 30
Celestinus V .·. Augusten. et .·. Frisingen. epis ac .·. abbati monasterii Wiltinen. Brisinen. dioc̄e̅sis̄
 Sua nobis nobilis
 Aquile π Kl. oct. a° 1°
 Bulle an Hanf
 Ohne jegliche Kanzleinotiz

4395

Staatsarchiv Wien Chronol.
P. — 1294 Septembris 30
Calestinus V .·. Augusten. et .·. Frisingen. epis ac .·. abbati monasterii Wiltinen. Brisinen. dioceris
 Sua nobis nobilis
 Aquile π Kl. oct. a° 1°
 Bulle an Hanf
 Ausgezeichnet erhalten
In plica rechts lange Bemerkung auf den Inhalt bezüglich
 fahrige ungeübte, schlechte Schrift

4396

Staatsarchiv Wien Chronol.
P. — 1294 Septembris 30
Celestinus V .·. Augusten. et .·. Frisingen. epis ac .·. abbati monasterii Wiltinen. Brisinen. dioceris
 Aquile π Kl. octobris a° 1°
 Prachtvolle Bulle an Hanf
 In plica rechts ein langes:
 volumus autem
 Sonst keinerlei Notizen

P. — Paris Arch. Nat.
J 700 cap. 91 _1294 Oct. 2_
Celestinus V Phy regi Fran-
corum illustri
.Scimus et facti
Aquile II non. Oct. aº 1º
Bulle au Hanf

Public Record Office London
Papal Bulls. handle 9 n. 8
P. 23 986 _1294 Octobris 2_
Celestinus V E. regi Anglie illustri
Fangentur pie patris
Aquile VI non. Oct. aº 1º
 Bulle au Hanf
 In plica rechts A Med
 de Cur.

Paris Arch. Nat.
J 715 cap. 305ᵉ¹ _1294 Oct. 5_
Celestinus V Phylippo regi
 Francorum illustri
Habet carissimi in
Aquile II non Oct. aº 1º
Bulle au Hanf
In plica rechts N de Limox
 de Curia

 P. 23989

Barcelona Corona de Aragón
 Leg. 18º n. 2º
Adresse _1294 Octobris 8_
Celestinus V Jacobo nato
quondam (nob. viro) Petri olim
Regis Aragonum spiritum
consilii sanioris
 Insinnavit nobis noster
Sulmone VIII iħ. Oct. aº 1º
Bulle au Hanf

 P. 23992

4401

P. —
Barcelona Corona de Aragón
Adresse Leg. 18° n. 3°
 1294 Octobris 8
Celestinus V nob. mulieri
Constantie Relicte quondam
Petri olim Regis Aragonum
ecclesiasticam reverentiam et
spiritum veritatis [fehlt cnic
in xpo filie]
Benigni patris eterni
Sulmone VIII id. Octobr. a° 1°
Bulle und Seide fehlen
 Ohne alle notizen

4402

P. — Paris Arch. Nat.
L 278 cap. 2 1294 Oct. 8
Celestinus V Phy Regi Francie
illustri
Excitat mentem nostram
Sulmon. VIII id. Octobris a° 1°
Bulle und Hanf fehlen
Sub plica links
 ✗vi

4403

Arch. Arcis
Arm. C fasc. 12 cap. 11
P. — Octobris 14
 1294 Septembris 30
Celestinus V .. priori et conventui
monasterii Sancti Petri prope Be-
neventum monasterio Sancti
Spiritus iuxta Sulmon. pleno
iure subiecti OSB Valven.
dioc.
Exultat mater ecclesia
Dat. Sulmon. II id. Oct. a° 1°
 nachgetragen
Bulle ausgerissen, aber mit der
Seide noch vorhanden
In pl. rechts: n. Luce
 de Cur

4404

Arch. Arcis
Arm. C fasc. 12 cap. 1
P. — 1294 Octobris 28
Celestinus V .. abbati et con-
ventui monasterii Sancti Spi-
ritus de Maiella OSB Theatin
dioc.
Gloria multa perfundimur
Thean. V Kl. Novembris a° 1°
Bulle an feinen Seidenschnüren
In pl. rechts Sy Aretin.

4405

Barcelona Corona de Aragón
P. — Leg. 18° n. 40
1294 Novembr. 9
Celestinus V Constantie quon.
dam Regine Aragonum.
Preces illas tibi.
Neapoli V iV. nov. a°1°
Bulle fehlt. Hanf erhalten
In plica rechts B. de Sugio
Sub plica links — — — —
P. Real.
Ecke oben rechts
Barth

4406

Paris Archives Nationales
J 435 n. 8
Breite 61. Rand links 5.8 rechts 6.
Höhe 47. 2 Rand oben 9.8 plica 6.3
Erste Linie für Oberlängen / Je eine
Seitenlinie
P. vacat 1294 Novembris 12
Celestinus V Carmo in xpo filio
Philippo Regi Francorum Illustri
dum inestimabilis muneris
Dat Neapoli P Jd Novemb a°1°
Bulle an feiner Seide
Ohne jede Kanzleinotiz
Kleine fette unruhige Schrift

4407

P. — Paris Arch. Nat.
J 435 ap. 8 1294 Nov. 12
Celestinus V Phylippo regi Fran.
corum illustri
Dum inestimabilis muneris
Neapoli P iV nov. a°1°
Bulle an Seide

4408

Paris Archives Nationales
J 435 n. 8 bis
Breite 42.1 Rand links 4.4 rechts 4.4
Höhe 23.3 Rand oben 7.5 plica 4.2
Erste Linie für Oberlängen / Je
drei Seitenlinien
P. vacat 1294 Novembris 12
Celestinus V Carmo in xpo fi
lio Philippo Regi Francorum Illustri
Quamquam per alias
Dat Neapoli P Jd Novembre
a°1°
Bulle an Hanf
Ohne alle Kanzleinotizen
Fette regelm. Schrift

4409

Instr. misc. 1288 - 1295 cap. 57

P. 24 002 1294 Novembris 13

Celest. V .. abbati et conventui mo-
nasterii S. Spiritus de Sulmon. OSB
Valven. dioc.

Dum infra mentis

Neapoli id Novembris a° 1°

Bulle mur Seide ausgerissen

In plica rechts : Ly g
 de Curia

4410

Arch. Arcis

Arm. C fasc. 12 cap. 4

P. - 1294 Novembris 16

Celestinus V universis xpi fi-
delibus presentes litteras inspec-
turis.

Quoniam ut ait

Neapoli XVI kl. Dec. a° 1°

Bulle an dünnen hellen faden

In pl. rechts :

h. de Fratis G pro mon. l

dni pp de man Magri B. de l
 Bucclanio

4411

Arch. Arcis

Arm. C false. 12 cap. 12

P. - 1294 Novembris 17

Celestinus V .. abbati et conven-
tui monasterii sancti Petri de
foris portam Beneventan. OSB

Dum virtutum studia

Neapoli XV kl. Decembris a° 1°

Bulle an feinem Seidenfaden

In pl. rechts :

I Conus G de man
 fni Placidi

4412

Instr. misc. 1276 1286 cap. 52

P. 24 008ᵃ 1294 Novembris 22

Celest. V .. preceptori et fratribus
hospitalis sancti Nicolai de Ferrato
OSB Musican. dioc.

Inter ecclesiastica loca

Neapoli X kl. Decembris a° 1°

Bulle mur Seide ausgerissen

In plica rechts : h. de Fratis G
 ex parte fratris Placidi

Ecke oben rechts RX

A tergo : [...] . CV
 [...] Photo

4413

P. — Paris Arch. Nat.
L 278 cap. 3 1294 Nov. 22
Celestinus V magistris Euurardo
de Noyentello et Gerardo de Sancto
Justo canonicis Belvacen. bo-
ne memorie Iohannis tit. Sancte
Cecilie presb. cardinalis in certis
bonis executoribus
Vobis tenore presentium
Neapoli X kl. Dec. a° 1°.
Bulle und Hanf ausgerissen
In plica rechts g̅ C de Setia

4414

Firenze, Bonifazio
P. — 1294 Novembris 26
Celestinus V .. priori et conven-
tui mon. Sancti Iacobi de
Podio OSB Pisan. dioc.
 Licet is de
Neapoli VI kl. Dec. a° 1°
 Bulle fehlt, Seide erhalten
In plica rechts h pd
 Sub plica links — — —
 f. am

4415

Firenze, Bonifazio
P. — 1294 Novembris 27
Celestinus V .. abbi et conv.
mon. Sancti Michaelis de Di-
chalsio OSB Pisan. dioc.
 Devotionis vestre precibus
Neapoli V kl. Dec. a° 1°
 Bulle fehlt, Seide erhalten
In plica rechts h pd
 Sub plica links — — —
 f. am

4416

P. 2406 Paris Arch. Nat.
L 278 cap. 4 1294 Nov. 27
Celestinus V .. generali et priori-
bus provincialibus ordinis fra-
trum Heremitarum Silvestrin.
 Ad fructus uberes
Neapoli V kl. Dec. a° 1°
 Bulle an Seide.
In plica rechts: p. ve (bo)

4417

Archives Nationales Paris
L 279 n. 1 1295 Februarii 8

Br. 23.6 hoch 13.7 Plica 2.4
oberer Rand 4.6 links 1.3
rechts 1

Bonifatius VIII Magro Henrico de Cauchi Canonico ecclie
S͞te Martini Leodien

Dilectorum in xpo
Dat Laterani VI Id Februarii a⁰ 1⁰

Bulle fehlt, Hanf erhalten
In plica rechts: P. Reat

Ohne jede Bemerkung

Ohne jeden betonten Buchstaben

Drei freie Linien über dem Text

Oberer Rand verhältnismässig
sehr gross

P. vacat

4418 (recto)

Archives Nationales Paris
L 279 n. 2 1295 Februarii 13

Br. 44.9 hoch 31.7 Plica 7.9
oberer Rand 8.3 links 4.5
rechts 4.3

Bonifatius VIII (sehr
grosse Gitterschrift, Initiale ausgespart) nobili viro Carolo nato
clare memorie Philippi Regis Francie
Alençonis et Andegavie Comiti et
dilecti in xpo filie nobili mulieri
Margarete uxori eius

Pium arbitramur et
Dat Laterani Id Februarii a⁰ 1⁰

Bulle an Seide P. vacat
In plica rechts: P de VI
Sub plica links: ̈ ̈ ̈ ̈mas
 9
Ecke oben links : l.
Rand oben Mitte :
A tergo Ecke oben links : C

Je zwei Seitenlinien verte

4418 (verso)

A tergo oben Mitte : J. de Sama

Sehr fette grosse regelm. Schrift

Erste Linie für Gitterschrift und
Oberlängen

4419

Archives Nationales Paris
L 279 n. 3 1295 Februarii 13

Br. 41.7 hoch 31.3 Plica 3.9
oberer Rand 8 links 4
rechts 4.3

Bonifatius VIII
wie in n.2
Desideriis vestris
Dat Laterani Id Februarii a⁰ 1⁰

Bulle an Seide
In plica rechts : P de VI
Sub plica links : - - - -
 mas
Ecke oben links : l. 9
Rand oben Mitte :
A tergo oben Mitte : J de Sama

P. vacat

Je zwei Seitenlinien

4420

Archives Nationales Paris
L 279 n. 4 1295 februarii 13
Br. 37, hoch 31, Plica 4.7
oberer Rand 8.7 links 4.4
rechts 4
 Bonifatius VIII
 wie in n. 2
 Personas generositatis titulo
Dat Lateran. Jd Februar a° 10

Bulle fehlt, Seide erhalten
 Iu plica rechts : P de Vi

 Alle Andere wie in n. 3

 P. vacat

4421

Archives Nationales Paris
L 279 n. 5 1295 februarii 13
Br. 44.5, hoch 32 Plica 5.4
oberer Rand 9.7 links 4.6
rechts 4.5
 Bonifatius VIII
 wie in n. 2
 Prius arbitramur et

Bulle an Seide

 Alles Andere wie in n. 2

 P. vacat

 Je zwei Seitenlinien

4422

Archives Nationales Paris
L 279 n. 6 1295 februarii 13
Br. 64, hoch 59.6 Plica 8.3
oberer Rand 15.5 links 4.8
rechts 4.8
 Bonifatius VIII
sancti Dyonisii in Francia et
sancti Germani de Pratis Pari
sün divo Monasteriorum Abba
 tibus
 Personas dilecti filii
Dat Lateran. Jd februar a° 10

Bulle an Hanf
 Iu plica rechts : M. de Roca
Sub plica links: =
 x
 Cosmas P. vacat
A tergo oben mitte : J. de Zauna

Sehr sehr große Schrift. Mit einem
betonten Buchstaben
 Erste Linie für Oberlängen

 Je zwei Seitenlinien

4423

Archives Nationales Paris
L 279 n. 7 1295 februarii 13
Br. 61, hoch 46.0 Plica 7.5
oberer Rand 15.7 links 4.8
rechts 4.9 Bonifatius VIII
 wie in n. 2
 Personas nostras benevolentia

Bulle an Seide
 Iu plica rechts : M. de Roca

 Alles Übrige wie in n. 2

 P. vacat

 Je zwei Seitenlinien

Public Record Office London
Papal Bulls bundle 6 n. 18
P. 24 027 1295 Februarii 19
Bonifacio VIII Eduardo regi Anglie
 illustri

Movet animum mentemque
 Lateran. X kel. Martii a° I°
 Bulle an Hanf
 In plica rechts M. de Adr.
 de Cur

Sub plica links)
 " " Rand unten:
 R Ja Cellirani
 p. Am
Ecke oben links : L S

Archives Nationales Paris
L 279 n. 8 1295 Februarii 27
Br. 20.1 hoch 14.1 Plica 2.7
 oberer Rand 2.7 links 1.4
rechts 1.5 Bonifatius VIII Di
lecto filio .. Succentori ecclie sanct
Juliani de ... Teuoien dioc
 Conquesti sunt nobis
Dat Lateran III kl martij a°1°

Bulle an dickem Hanf
 In plica rechts : C de ...
A tergo oben Mitte : Villaregia
Ganz kleine enge Schrift
 Ohne jeden betonten Buchsta-
 ben
Erste Linie für Oberlängen

 P. vacat

Archives Nationales Paris
L 279 n. 9 1295 Martii 10
Br. 32.4 hoch 24.2 Plica 4.1
 oberer Rand 7.4 links 3.6
rechts 3.4 Bonifatius VIII (Gitterschrift
Initiale ausgespart) dilectis in xpo
filiabus .. Abbatisse et Conuentui Mo
nasterij beate Marie de Pentheomonte
Cistercien ordinis Belnacen dioc
 Cum a nobis
Dat Lateran VI Jd martij a°1°

Bulle an Seide
 In plica rechts : Bonifatius
Sub plica links : --
 Cosmas
Rand oben Mitte : off
 A tergo Ecke oben links : os
Unruhige mittelgrosse Schrift

Erste Linie für Gitterschrift und Ober-
 längen
P. vacat

Archives Nationales Paris
L 279 n. 10 1295 Martii 13
Br. 32.8 hoch 22.4 Plica 4.6
 oberer Rand 6.6 links 1.9
rechts 1.9 Bonifatius VIII (Gitterschrift
Initiale ausgespart) . . Abbati et
Conuentui monasterij de sancto
diouisio ad Romam ecclam nullo
medio pertinentis ordinis sancti
Benedicti Parisien dioc
 Deuotionis vre precibus
Dat Lateran VI Jd martij a° 1°

Bulle an Seide
 In plica rechts : Maur
Sub plica links : --
 Cosmas
A tergo oben Mitte : Villaregia
Jetzt regelmäßige Schrift

 P. 24 042

über dem Text zwei freie Linien

4428

Barcelona Corona de Aragón
Adresse Leg. 19º n. 70
P. — 1295 Martii 15
Bonifatius VIII nobili viro Jacobo
nato quondam Petri olim Regis
Aragonum spiritum consilii
sanioris
 Litteras tuas missas
Lateran. iv. Martii aº 1º
Bulle und Hanf fehlen (Cum
In plica rechts R. de Linos de
Ecke oben rechts R
A tergo oben Mitte klein
 R Capitlo x x x viii

4429

Firenze, Castello
P. — 1295 Martii 15
Bonifatius VIII .. abbi et con-
ventui mon. Sci Salvatoris
de Septimo Cist. Florentin.
dioc.
 Cum a nobis
Lateran. iv. Martii aº 1º
 Bulle fehlt, Seide erhalten
In plica rechts scriptor
 Sub plica links --
Ecke oben links · R.q

4430

Marseille Archives Départem.
B 398
P. — 1295 Martii 15
Bonifatius VIII Guillermo titu-
li Sancti Clementis presbitero
cardinali
 Pro parte carissimi
Lateran. iv. Martii aº 1º
 Bulle an Hanf
Ohne Scriptoren notis
 Sub plica links g
Ecke oben links · L.
Ecke oben rechts R
A tergo oben Mitte klein
 R Caputo. CXV ?

4431

Statsarchiv Wien Chronol.
P. — 1295 Martii 21
Bonifatius VIII -- preposito
eccle Ottingen Salzeburgen.
diocesis
 Conquesti sunt nobis
Lateran. XII Kl. Aprilis aº 1º
 Bulle an Hanf
In plica rechts · F. B.
Ecke oben rechts R

Paris Arch. Nat.
J 701 cap. 104 1295 Martii 28
Bon VIII Phy regi Francorum
illustri
Rationis oculis intuentes
Laterani V kl. Aprilis a° 1°
Bulle an Hanf
In plica rechts p Reat
druneben asculta et q puls
 M Sic (?)
Sub plica links F
Ecke oben rechts
A tergo BR ohne Zahl
 auch cap 107
 109 und will an
cap. 103 eodem loco dene
arit et qf . n . Ver.

Archives Nationales Paris
L 279 n. 11 1295 Aprilis 9
Br. 38.1 hoch 26.4 Plica 4.2
oberer Rand 8.2 links 3.9
rechts 4.3
 Bonifatius VIII (Gitterschrift
Initiale ausgespart) - - Abbati et
Conventui Monasterij sancti
Dyonisij in Francia ad Romam
eccliam nullo medio pertinentis or-
dinis sancti Benedicti Parisien dioc
 Cum sicut ea
Dat Laterani V Id Aprilis a° 1°

Bulle an feiner Seide
 In plica rechts : M. de Adr
Sub plica links : --
A tergo oben mitte : Villaregia et
 de sco Victore
Fette kleine ordentliche Schrift
Erste Linie für Gitterschrift

 P. vacat

Archives Nationales Paris
L 279 n. 12 1295 Aprilis 9.
Br. 37.8 hoch 26.6 Plica 5.8
oberer Rand 8.7 links 3.9
rechts 4.1
 Bonifatius VIII (Gitterschrift
Initiale ausgespart) - - Abbati et Con-
ventui Monasterij sancti Dyonisij
in Francia ad Romam eccliam nullo
medio pertinentis ordinis sancti Bene-
dicti Parisien dioc
 Devotionis tue precibus
Dat Laterani V Id Aprilis a° 1°

Bulle an Seide
 In plica rechts : M . de . Adr
Sub plica links : --
A tergo oben mitte : Villaregia et de
 sco Victore
Fette kleine ordentliche Schrift
Erste Linie für Gitterschrift und
 Oberlängen
 P. 24066

Archives Nationales Paris
L 279 n. 13 1295 Aprilis 9
Br. 34.1 hoch 22.6 Plica 3.7
oberer Rand 6. links 2.8
rechts 3.
 Bonifatius VIII (Gitterschrift
Initiale ausgespart) . . Abbati et
Conventui Monasterij sancti dio-
nisij in Francia ad Romam eccliam
nullo medio pertinentis ordinis sancti
Benedicti Parisien dioc
 Solet annuere sedes
Dat Laterani V Id Aprilis a° 1°

Bulle an Seide
 In plica rechts : Jo. Gall
Sub plica links : --
 Cosmas?
A tergo oben mitte : Villaregia
 n de sco Victore
Feste offene regelm. Schrift
Erste Linie für Gitterschrift und untere
 Oberlängen

 P. vacat

4436

Archives nationales Paris
L 279 n. 14 1295 Aprilis 12

Br. 33.4 hoch 25.8 Plica 5.1
oberer Rand 8.3 links 3.
rechts 3.3
 Bonifatius VIII (Gitterschrift
Initiale ausgespart). - Abbati et
Conventui Monasterij sancti Dyo-
nisij in Francia ad Roman ...
ecclam nullo medio pertinentis
ordinis sancti Benedicti Parisien dioc ...
 ... Cum a nobis
Dat Lateran ... Jd Aprilis a° 1°

Bulle an Seide
 In plica rechts: m de Adr
Sub plica links: --
 Cosmas,
A tergo oben mitte: Villaregia

Fette kleine eilige Schrift
 Erste Linie für Gitterschrift und
 Oberlängen

 P. 24070

4437

Archives Nationales Paris
L 279 n. 15 1295 Aprilis 13

Br. 43.9 hoch 32.2 Plica 5.6
oberer Rand 8.2 links 3.8
rechts 3.8
 Bonifatius VIII . . abbati
Monasterij sancti Audoeni Rothoma
gen.
 Pium esse dinoscitur
Dat Lateran Jd Aprilis a° 1°

Bulle an Hanf
 In ... plica rechts: so Gatt
Sub plica links: ?
 A tergo oben mitte: Villaregia

Sehr klare fette Schrift
 Erste Linie für Oberlängen

 P. vacat

 mit je 2 Seitenlinien

4438

Archives Nationales Paris
L 279 n. 18 1295 Aprilis 13

Br. 42.8 hoch 27.4 Plica 5.7
oberer Rand 6.5 links 3.8
rechts 3.8
 Bonifatius VIII (Gitterschrift
Initiale ausgespart) - - Abbati Mo-
nasterij sancti Dyonisij in Francia
ad Roman ecclam nullo medio per-
tinentis ordinis sancti Benedicti
Parisien dioc
 Ex parte tua
Dat Lateran Jd Aprilis a° 1°

Bulle an Seide P. 24071
 In plica rechts: m. de Adr
Sub plica links: - - -
 Cosmas,
Ecke oben links: ·l·
 9
 Ecke oben rechts: R+
A tergo oben mitte: Villaregia
 darunter klein
umbeholfen 1.7 ℞ capitlo cxxij
Eilige fette Schrift
Erste Linie nur für Oberlängen,
 schneidet die Gitterschrift

4439

Archives Nationales Paris ℞
L 279 n. 17 1295 Aprilis 13

Br. 47.3 hoch 31.2 Plica 5.2
oberer Rand 9.3 links 4.9
rechts 5.2
 Bonifatius VIII (Gitterschrift
Initiale besiegt). - - Abbati et Con-
ventui Monasterij sancti Dyo-
nisij in Francia ad Roman
ecclam nullo medio pertinentis
ordinis sancti Benedicti Parisien dioc
 Ex parte tua
Dat Lateran Jd Aprilis a° 1°

Bulle an feiner Seide P. 24072
 In plica rechts: m de Adr
Sub plica links: - - - -
 Coсмas?
Ecke oben links: ·l· 9?
 Ecke oben rechts: ℞
A tergo Ecke oben links: [
 " oben mitte: Villaregia
Fette kleine weite 1.4 ℞ Zahl ganz
Schrift. Erste Linie abgerieben
für Gitterschrift und
 Oberlängen

4440

Karlsruhe Gr. Bad. Gen. Landesar
Salem 4/5
 P. — 1295 Aprilis 13
Bon. VIII .. abbati et conventui
monasterii de Salem Cisterciensis
Ordinis Constantien. dioc.
 Devotionis vestre precibus
Laterani III. aprilis a° 1°
Bulle an Seide
Sub plica links
 Cosmas

4441

Napoli Pergam. Farn. Bolle n. 12
P. —
 1295 Maii 16
Bonifatius VIII Rolando Lupo
Morinen. et Bernardo Rubeo
Cameracen. ac Gregorio de Ge
negano Constantien ecclesia
rum Canonicis.
 Probitatis merita dilecti
Apud monasterium Sancti
Pauli de Urbe XVII Kl. Ju
nii a° 1°
Bulle und Hanf fehlen
In plica links B. de Caf —

4442

Archives nationales Paris
L279 n. 19 1295 Junii 17
Br. 43,5 hoch 30.9 Plica 4.9
oberer Rand 6.9 links 3.9
rechts 4.1
 Bonifatius VIII - - Abbati
monasterii sancti Odoeni Rotho
magen Ex parte dilectorum
Dat Anagnie XV Kl Julii a° 1°

Bulle an Hanf
 In plica rechts : D Adr
Sub plica links : - - -

Jede kleine nachlässige Schrift
 Erste Linie für Oberlängen.

 P. 24102

4443

Napoli Curia Eccles. Vol. III
P. —
 1295 Junii 17
Bonifatius VIII [ohne Punkte]
Wultmarien et .. montiscor
vium epis ac d. f. - - archi
presbitero eccle de Petra Mon
tiscorium. dioc.
 Conquesti sunt nobis
Anagnie XV Kl. Julii a° 1°
Bulle an Hanf
In plica rechts A. Romanucio

In praesentia domi-
ni papae
1295 Iunii 20.
Notariatsinstrumente auf-
genommen Anagnie in
Camera predicti dni nri tunc
nri pontificis et in eius
presentia
1295 Iunii 20

Bonifatii VIII

Barcelona Corona de Aragón
Leg. 19° n. 10°

Barcelona Corona de Aragón
Leg. 19° n. 9°
P. –
1295 Iunii 20
Bonifatius VIII ad perp. rei m.
Et si propter
Anagnie XII Kl. Iulii a° 1°
Bulle an Seide
In plica rechts Mnur
Sub plica links ...
Ecke oben rechts R4
A tergo oben Mitte Plein
R Capitlo CLXXIX

Barcelona Corona de Aragón
Unterschrift Leg. 19° n. 10°
vicecancellarius
P. – 1295 Iunii 21
Bonifatius VIII ad certitudinem
presentium et mem. futurorum
Splendor glorie et
si noverit incur...rum
(R) Ego Bonif. C. E. Epus (M)
7 presb. 4 epi 6 diac
Dat. Anagnie p. m. magri Petri
de Piperno SRE vicecancellarii
XI Kl. Iulii Ind. VIII I. d. a° M. CC.
LXXXXV p. vero domni BONIFATII
pp. VIII anno primo
Bulle an Seide
Ohne Notizen
Sub plica in ganzer Länge grosse
Rasuren
verte

Ecke oben rechts R4
A tergo oben Mitte Plein
R Capitlo CLXXXIIII

die erste presbyter. Unterschrift
lautet
⊕ Ego Petrus tt sti Marci pbr Card
...m pei me no possem... petrum
Bonegetis capellanm men me ss

4447 (recto)

Barcelona Corona de Aragón
Leg. 19° n. 11°
vicecancellarius
P. 24106 1295 Iunii 21
Bonifatius VIII ad certitudinem
presentium et mem. futurorum
Splendor glorie et
se noverit incursurum
(R) Ego Bonif. C. E. Eps SS (M)
7 presb. 4 epi 6 diac.
Dat. Anagnie per m. Magri Petri
de Piperno SRE. vicecancellarii
XI Kl. Iulii Ind. VIII I.D. a° MCCLXXX
LXXXXV pont. vero domni Bonif.
pp VIII a° primo
Bulle an Seide
In plica links)
Sub plica in der ganzen Länge
grosse Rasuren vale

4447 (verso)

A tergo oben mitte klein
R Capitlo CLXXXV

Die erste presbyter-Unterschrift
lautet
⊕ Ego Petrus tt. Sce Marie pbr. card
cum per me non posset pa Petrus
Donegentis capellanum meum
me subscripsi

4448

Barcelona Corona de Aragón
Leg. 19° n. 11°
P.— 1295 Iunii 21
Bonifatius VIII ad perp. r. mem
Diligentes pacis commoda
Anagnie XI Kl. Iulii a° 1°
Bulle an Seide
Ohne alle Notizen

4449

Barcelona Corona de Aragón
Leg. 19° n. 15°
P.— 1295 Iunii 21
Bonifatius VIII eps s. s. dei Iacobo
nato quondam Petri olim Regis
Aragonum spiritum consilii
sanioris
Et si propter
Anagnie XI Kl. Iulii a° 1°
Bulle an Hanf
Sub plica links X
Ecke oben rechts R
A tergo oben mitte klein
R Capitlo CLXXIII olim VIII

4450

Barcelona Corona de Aragón
Leg. 19° n. 14°
P. —
1295 Iunii 21
Bonifatius VIII Guillermo tit.
S. Clementis presbitero cardinali
Et si propter
Anagnie XI Kl. Iulii a° 1°
Bulle an Hanf
Sub plica links
Ecke oben rechts R
A tergo oben mitte klein

R Capitto CLXXVI

4451

Barcelona Corona de Aragón
Leg. 19° n. 18°
P. —
1295 Iunii 21
Bonifatius VIII ad perp. rei mem.
Et si propter
Anagnie XI Kl. Iulii a° 1°
Bulle und Seide ausgerissen
Ohne Schreibernamen
Sub plica links
Ad tergo unten mitte
Ad ppetuum [rei] memoriam
mit Inhaltsangabe
Ecke oben rechts R
A tergo oben mitte klein

R Capitto CLXXVIII

4452

Barcelona Corona de Aragón
Leg. 19° n. 8°
P. —
1295 Iunii 22
Bonifatius VIII e. ss. dei Iacobo
nato quondam Petri olim Regis
Aragonum spiritum consilii
sanioris
Inest cordi nostro
Anagnie X Kl. Iulii a° 1°
Bulle an Hanf
Schreibername fehlt
Sub plica links
Cosmas
Ecke oben rechts R
A tergo oben mitte klein

R Capitto CLXXI

4453

Barcelona Corona de Aragón
Leg. 19° n. 16°
P. —
Clausa
1295 Iunii 22
Bonifatius VIII eps. s. s. dei Iaco.
bo nato quondam Petri olim
Regis Aragonum spiritum
consilii sanioris
Ex debito pastoralis
Anagnie X Kl. Iulii a° 1°
Bulle an Hanf.
Ränder oben und unten ab-
geschnitten

Salting

- 590 -

Barcelona Corona de Aragón
Leg. 19° n. 19°
P.— 1295 Iunii 22
Bonifatius VIII Nobili viro Al
fonso primogenito quondam
primogeniti clare memorie
Alfonsi regis Castelle ac Yo
lande nate quondam Petri
olim Regis Aragonum
Et si inter
Anagnie X Kl. Iulii a° 1°
Bulle an Seide
X ist durch Rasur verbes
sert aus XVIII
In plica links Iao boet
Sub plica links X
Ecke oben rechts Rx
A tergo oben
mitte klein Capitto CLXXXII

Barcelona Corona de Aragón
Leg. 19° n. 20°
P.— 1295 Iunii 22
Bonifatius VIII Iacobo nato
quondam Petri olim Regis
Aragonum spiritum consi
lii sanioris
Gaudet sancta Mater
Anagnie X Kl. Iulii a° 1°
Bulle an Hanf
Raum oben bietet längere radi
te notiz für die Adresse. Jetzt
die jetzige Adresse steht dort
da die alte radirte die gewöhn
liche war ohne spiritum etc.

Barcelona Corona de Aragón
Leg. 19° n. 21°
P. 24108 1295 Iunii 22
Bonifatius VII Iacobo nato quon
dam Petri olim Regis Aragonum
spiritum consilii sanioris
Dilecta pax in
Anagnie X Kl. Iulii a° 1°
Bulle an Hanf
In plica rechts Namen radirt.
Darunter (rechts) abscultata p
ne petru de Sig (?) et etiam regis
tata
Sub plica links nichts
Ecke oben rechts Rx
A tergo oben mitte ganz klein

Capitto cl XIII cf du
plicat

Barcelona Corona de Aragón
Leg. 19° n. 21 bis
P. 24108 1295 Iunii 22
Bonifatius Iacobo nato quon
dam Petri olim Regis Arago
num spiritum consilii sa
nioris
Dilecta pax in
Anagnie X Kl. Iulii a° 1°
Bulle an Hanf
In plica rechts N. de Limoch
Sub plica links xxv
 Connas
Ecke oben rechts Rx

A tergo oben mitte
Rein Rx

4458

Barcelona Corona de Aragón
P. — Leg. 19° n. 23°
1295 Junii 22
Bonifatius VIII .. epo Valentin.
Amamus utique puro
Anagnie X Kl. Julii a° 1°
Bulle an Hanf
Sub plica links
Ohne Schreibernamen
Ecke oben rechts R/
A tergo oben Mitte klein
Rx Capitto CLXXVII

4459

Barcelona Corona de Aragón
P. — Leg. 19° n. 24°
1295 Junii 22
Bonifatius VIII Guillermo tit. S.
Clementis presb. cardinali
Amamus utique puro
Anagnie X Kl. Julii a° 1°
Bulle an Hanf
In plica rechts he de (?) citius ...
. . . .
Sub plica links V
Ecke oben rechts R/
A tergo oben etwas rechts klein
Rx Capitto clxxvii ?

4460

Barcelona Corona de Aragón
Adresse P. — Leg. 19° n. 25°
1295 Junii 23
Bonifatius VIII ad notitiam
presentium et memoriam
futurorum
Fructus pacis Deo
Anagnie VIII Kl. Julii a° 1°
Bulle an Seide

Ohne alle Notizen

4461

Barcelona Corona de Aragón
Leg. 19° n. 26°
P. — ad eternam rei m.
1295 Junii 23
Bonifatius VIII ad eternam rei m.
Conditionis humane lubricum
Anagnie VIII Kl. Julii a° 1°
Bulle an Seide

Ohne alle Notizen

Barcelona Corona de Aragón
Leg. 19° n. 27°
P. — 1295 Junii 24
Bonifatius VIII . . eps Valentin
Amannus utique puro
Anagnie VIII Kl. Julii a° 1°
Bulle und Hanf fehlen

Ohne alle Notizen

Barcelona Corona de Aragón
Leg. 19° n. 28°
P. 24112 ad eternam rei m.
1295 Junii 24
Bonifatius VIII ad eternam rei m
Obligationes turpes et
Anagnie VIII Kl. Julii a° 1°
Bulle an Seide

Ohne alle Notizen

Barcelona Corona de Aragón
Leg. 19° n. 22°
P. 24112 ad eternam rei mem.
1295 Junii 24
Obligationes turpes et
Anagnie VIII Kl. Julii a° 1°
Bonifatius VIII ad eternam r. m.
Bulle an Seide.

Ohne alle Notizen

Barcelona Corona de Aragón
Leg. 19° n. 29°
Adresse P. — 1295 Junii 25
Bonifatius VIII eps s. s. Dei Ja-
cobo Aragonum Regi Illustri
salutem et ap. ben.
Et si inter
Anagnie VIII Kl. Julii a° 1°
Bulle an Seide
Sub Plica links \bar{x}
Schreibernamen fehlt.
Ecke oben rechts R
A Seite oben etwas rechts klein
R capitto clxxvi

In der Adresse fehlt cmo in
Xps filio

4466

Barcelona Corona de Aragón
Leg. 19° n. 30°
P. — 1295 Iunii 25
Bonifatius VIII Carolo Siciliae
Regi Illustri
Et si inter
Anagniae VII Kl. Iulii a° 1°
Bulle und Seide fehlen
Sub plica links x
Ecke oben rechts R
A tergo oben mitte klein

R Capittlo CLXXX

4467

Barcelona Corona de Aragón
Leg. 19° n. 31°
P. 24117 1295 Iunii 27
Bonifatius VIII ad perp. r. mem
Nuper divina favente
Anagniae V Kl. Iulii a° 1°
Bulle an Seide
In plica rechts de Cur
O. Ser.

4468

Barcelona Corona de Aragón
Leg. 19° n. 32°
P. — 1295 Iunii 27
Bonifatius VIII Guillermo tit.
S. Clementis presb. cardinali
Amamus utique puro
Anagniae V Kl. Iulii a° 1°
Bulle an Hanf
Sub plica links
Ecke oben rechts R
A tergo oben mitte sehr klein

R Capittlo CLXXV

4469

Barcelona Corona de Aragón
Leg. 19° n. 33°
ad eternam r. m.
P. — 1295 Iunii 27
Bonifatius VIII ad eternam r. m.
Pacis amene semina
Anagniae V Kl. Iulii a° 1°
Bulle an Seide
In plica rechts N. de Frachis
Sub plica links V

4470 (recto)

Paris Archives Nationales ℞
J 683 n. 8
Breite 49.3 Rand links 4.3 rechts 4.3
Höhe 32. Rand oben 8.8 plica 7.7
Erste Linie für Gitterschr. und
Oberlängen. Je zwei Litenlinien
P. vacat 1295 Junie 27
Bonifatius VIII (Gitterschr.) Carmo
in xpo filio pho Regi Francie
Jllustri
Oß tuorum excellentiam
Dat Anagnie ⅴ Kl Julij. a° 10
Bulle an Seide
In plica rechts : Sy . T
Sub plica links : F. AM
 9
 verte

4470 (verso)

Ecke oben rechts : ℞
links : i
Oben Mitte klein verknuppelt
℞ Capillo cl ix.

Große sehr schöne weitgela.
gute Schrift

4471 (recto)

 ℞
Paris Archives Nationales bis
J 683 n. 8
Breite 55.3 Rand links 4.1 rechts 3.9
Höhe 31.3 Rand oben 8.3 plica 5.8
Erste Linie für Oberlängen.
Je zwei Litenlinien
P. vacat 1295 Junii 27
Bonifatius VIII . . Abbti mons
terij Sancti Dyonisij in Francia
Parisien diöc
Oß excellentiam meritorum
Dat Anagnie ⅴ Kl Julij a° 1°
Bulle an Hanf
 In plica rechts : Sy. T.
Sub plica links : F. any
 9 verte

4471 (verso)

A tergo oben Mitte verknuppeltes
kleines R :
℞ Ohne alle Zahlen

Sehr große weitgelagerte pracht
volle Schrift von größter Regel
mäßig keit .

Paris Archives Nationales ℞
J 684 n. 38

Breite 64.3 Rund links 6.2 rechts 6.5
Höhe 41.6 Rund oben 10. plica 7.

Erste Linie für Oberlängen / Je
eine Leitenlinie

P. vacat 1295 Junii 27

Bonifatius VIII . . Epo Aurelia-
nen

Carissimo in Xpo
Dat Anagnie V Id Julij / a° 1°
Bulle an Hanf
In plica rechts : p. Reat.
Sub plica links : $\frac{\overline{x}}{9}$

Ecke oben links : L.
rechts : ℞
verte

A tergo oben mitte : Maurof
darunter Klein ohne caudae

℞

Runde eng stehende deutliche
Schrift

4473

Barcelona Corona de Aragón
℞ P. 24118 Leg. 19 ° n. 35°
1295 Junii 30
Bonifatius VIII Guillermo tit.
S. Clementis presb. Cardinali
Rex pacificus cuius
Anagnie II Kl. Julii a° 1°
Bulle an Hanf
Sub plica links $\frac{x}{x}$
Ecke oben rechts ℞

A tergo oben mitte Klein

℞ ohne Ca

pitelsau_

gabe

4474

Arch. Arcis
Arm. XIV caps. 9 cap. 11
P. 24120 1295 Julii 2
Bon. VIII nobili viro frederico
nato quondam Petri olim regis
Aragonum
Ferventibus studiis anelamus
Anagnie VI non. Julii a° 1°
Bulle an Hanfschnur
In pl. rechts : R. Luce
de Cur
Ecke oben rechts : 22
A tergo oben mitte Klein JH

4475

Barcelona Corona de Aragón
R̶ P.– Leg. 19 u. 36⁰
1295 Iulii 3

Bonifatius VIII ep. s. s. Dei Iacobo
nato quondam Petri olim Regis
Aragonum spiritum consi-
lii sanioris

In tractatu pacis
Anagnie V non. Iulii a⁰ 1⁰

Bulle an Hanf

In plica rechts Maur ?
 P

Sub plica links xx
 J. Arn
Ecke oben rechts R̶
A tergo oben mitte ganz klein
 R̶ ohne Capitels
 angabe.

4476

Barcelona Corona de Aragón
R̶ P.– Leg. 19 u. 37⁰
1295 Iulii 3

Bonifatius VIII ep. s. s. Dei Iaco-
bo nato quondam Petri olim
Regis Aragonum spiritum con-
silii sanioris

Pia Mater Ecclesia
Anagnie V non. Iulii a⁰ 1⁰

Bulle an Hanf

Sub plica links V

Ecke oben rechts R̶

A tergo oben mitte klein

 R̶ ohne Capi-
 telsangabe

4477

Barcelona Corona de Aragón
R̶ P.– Leg. 19 u. 38
1295 Iulii 3

Bonifatius VIII ep s. s. Dei Iacobo
nato quondam Petri olim Ara-
gonum Regis spiritum consi-
lii sanioris

In tractatu pacis
Anagnie V non Iulii a⁰ 1⁰

Bulle und Hanf fehlen

In plica rechts n. Ver

Sub plica links x
 J. Arn

Ecke oben rechts R̶
A tergo oben mitte klein
 R̶ ohne Capi
 telsangabe

4478

Archives Nationales Paris
L 279 u. 20 1295 Iulii 7

Br. 45. hoch 33.7 plica 4.3
 oberer Rand 8.5 links 4.3
rechts 4.3
 Bonifatius VIII . . Epo Ca-
notin
 Quia nonnulli sic
dat Anagnie Non Iulij a⁰ 1⁰

Bulle an Hanf
 In plica rechts : Jo gatt
Sub plica links : F. arn
 V
 R̶ Jac E Maur 9
 Ecke oben links : . l.
Rand oben mitte : at Jud ordungstf
 Ecke oben rechts : R̶
A tergo oben mitte : n. de sco Victore
sehr grosse schöne
Schrift. mit einem R̶ Capitlo eccl.
betonten Druck.
Stehen
Erste Zeile für Guitto de ar
Oberlängen P vacat

4479

Archives Nationales Paris

L 279 n. 20 bis **1295 Julii 7**

Br. 49. hoch 31.5 Plica 5.2
oberer Rand 8.3 links 4.6
rechts 4.8
 Bonifatius VIII
 wie in n. 20
Bulle an Hanf
 In plica rechts : Jac. G.
Sub plica links : --
 In plica halblinks :
ascultata et B. P. J. de fract
A tergo oben mitte : Nicolaus de ~~Bon~~ Be
 nefatia (nefacta)
Sehr schöne feste Schrift
 Erste Linie für Oberlängen.

 P. vacat

Mit je zwei Seitenlinien

4480

ascultata

Archives Nationales Paris

L 279 n. 21 **1295 Julii 7**

Br. 41.8 hoch 29.8 Plica 6.6
 oberer Rand 8.8 links 4.3
rechts 4.4
 Bonifatius VIII .. Decano et
Capitulo eccliae Parisien
 Meritis ure devotionis
Dat Anagnie non Julij a° 1°
Bulle an Seide
 In plica rechts : Jac. G
Sub plica links : --
 In plica halblinks :
 ascultata et B. P. J. de Fract
A tergo oben mitte : Nicolaus
Schöne feste weite Schrift
 Erste Linie für Oberlängen
 P. x 24195

Mit je zwei Seitenlinien

4481

Archives Nationales Paris

L 279 n. 21 bis **1295 Julii 7**

Br. 41.2 hoch 28. Plica 6.2
 oberer Rand 7.4 links 4.3
rechts 4.
 Bonifatius VIII
 wie in n. 20
Bulle an Seide
 In plica rechts : Jo Gatt
Sub plica links : --
 F. atim
 ~~R Jac G (VII)~~ minor
Ecke oben links : . l. Drouata B. m.
Ecke oben rechts : R
A tergo Ecke oben links : a
 " oben mitte R Capitto cccxxxvij
 1.3
Sehr schöne feste grosse Schrift
 Erste Linie für Gitterschrift und
 kleine Oberlängen
Mit je zwei Seitenlinien P. 24125

4482

ascultata

Archives Nationales Paris

L 279 n. 22 **1295 Julii 11**

Br. 34.5 hoch 22.2 Plica 4.4
 oberer Rand 8.2 links 3.5
rechts 3.7
 Bonifatius VIII (Gitterschrift
Initiale ausgespart) . . Decano et
Capitulo eccliae Parisien
 Devotionis ure precibus
Dat Anagnie V jd Julij a° 1°
Bulle an Seide
 In plica rechts : Jac. G
Sub plica links : --
 In plica halblinks
 ascultata et B. P. J. de fract
A tergo oben mitte : H. de Benefacia
 facta
Schöne feste Schrift
 Erste Linie für Gitterschrift und
 untere Oberlängen
Mit je zwei Seitenlinien **P. vacat**

4483

Archives Nationales Paris
L 279 n. 22 bis 1295 Julii 11

Br 32.9 hoch 24.4 Plica 5.8
obere Rand 8 links 2.5
rechts 2.4
Bonifacius VIII
mein n. 22

Bulle an Seide
In plica rechts: . a. med
Sub plica links : --
F. atin

Ecke oben links : .l. und β . φ
Ecke oben rechts : Ry
A tergo oben mitte : Guitts de ar
Fette etwas undeutlich
.size Schrift. Erste
Linie für Gitterschrift
nur oben längs

Mit je zwei Seitenlinien

Capitulo CCCXXXVI

P. vacat

4484

Barcelona Corona de Aragón
P. - Leg. 19° n. 39°
1295 Julii 13
Bonifacius VIII f. Archepo
Messanen.
Ad instar illius
Anagnie III id. Julii a° 10
Bulle an Hanf
In plica rechts P. Reat
de Cur

4485

Barcelona Corona de Aragón
P. - Leg. 19° n. 40°
1295 Julii 13
Bonifacius VIII Francisco Archi
epo Messanen.
Ad instar illius
Anagnie III id. Julii a° 10
Bulle an Hanf
In plica rechts B. de Sufio
de Cur

4486

de Curia

Paris Archives Nationales
J 435 n. 10
Breite 54.8 Rand links 5.1 rechts 4.9
Höhe 38.8 Rand oben 10.5 plica 8.6
Erste Linie für oben längen / Je zwei
Seitenlinien / ganz rechts am Rand
eine dritte Linie
P. vacat 1295 Julii 13
Bonifacius VIII Carmo in xpo filio
Phylippo Regi Francie Illustri
Postquam divina miseratio
dat Anagnie I iij Jd Julij a° 10
Bulle an Hanf
In plica rechts : de Cur
J. de Fractis
Ecke oben rechts :
Rückwärts klein Ry Zeichen
Kleine Fette Siegelnar Schrift

4487

pro dño Cardi

R

Archives Nationales Paris

L 279 n. 23 bis 1295 Julii 18

Br. 50.1 hoch 36.7 Plica 7.3
oberer Rand 11.5 links 5.2
rechts 4.9
 Bonifacius VIII
 wie in n. 23

Bulle an Seide
 In plica rechts : Jac · G
Sub plica links : V̄
 g Bt Jac C minor
Ecke oben links : l.
Ecke oben rechts : R
A tergo oben Mitte : Jacobus Vallilarga
 pro domino Cardi
 capitlo CCCLXXXIX

Klein Jota regelm.
Schrift
Erste Linie für Gitterschr.
mit Oberlängen
 P. vacat

Mit je zwei Seitenlinien

4488

ascultata

Archives Nationales Paris

L 279 n. 23 1295 Julii 18

Br. 49.8 hoch 31.5 Plica 8.4
oberer Rand 8.8 links 5.
rechts 4.5
 Bonifacius VIII (Gitterschrift
Initiale ausgespart) .. decanus et
Capitulo ecclie Parisien
 dignum et congruum
Dat Anagnie XV kl Augusti a° 10

Bulle und Seide fehlen
 In plica rechts : Jac · G
Sub plica links : V̄
 In plica Mitte : ascultp et g p J. de frat
A tergo oben Mitte : Nicolaus de Benefacta

Jette blqre Schrift
 Erste Linie für Gitterschrift und
 unter Oberlängen

 P. vacat

Mit je zwei Seiten linien

4489

Public Record Office London
Papal Bulls bundle 6 n 14
 P. 24 144 1295 Julii 21
Bonifacius VIII .. regi Anglie illustri
Statum miserabilem
Anagni XII kel Aug. a° 1°
 Bulle an Hanf
In plica rechts p. Cen
Sub plica links ≡
 V
 f. Am̄
 ?
Ecke oben links : l. rechts RR
Rand oben Mitte cor
A tergo oben Mitte klein dünn schmal

 R cap. CCCCLXXXIX

4490

ascultata

Archives Nationales Paris

L 279 n. 24 1295 Julii 23

Br. 66.3 hoch 39.3 Plica 5.9
oberer Rand 10.6 links 4.2
rechts 4.1
 Bonifacius VIII .. . Albanen
et Penestrin Epis aplice sedis nun-
tijo Petitio dilectorum filiorum
Dat Anagnie X kl Augusti a° 10

Bulle an Hanf
 In plica rechts : J de Fractis
Sub plica links : ≡
 X
 A tergo oben Mitte : Villargia

Sehr regelm. fette Schrift
 Mit einem betonten Buchstaben
Erste Linie für Oberlängen

In plica halblinks : ascultatp g per
 J. de Fractis

De zwei Seitenlinien P. vacat

4491

Brit. Mus. Cott. Chart. XI. 19
P.— 1295 Julii 23
Bonifatius VIII .. abbatisse et conventui mon. Pietatis Sancte
Marie de Waterbeche Osttave.
Elyen. dioc.
 Cum a nobis
dat. Anagnie X Kl. Augusti
a° 1°
 Bulle und Seide fehlen.
In plica rechts Sy. J.
Sub plica links ..
 fau
Links auf inneren plica
ausgestrichen und die Strche
abgeklabcht
 R C. Setia Man

Rand oben Mitte cor
Ecke oben rechts R

4492

Bonifatius VIII Corona de Aragón
 Leg. 19° u. 41°
P.— 1295 Julii 31
Bonifatius VIII nobili mulieri
Constantie Relicte quondam
Petri olim Regis Aragon.
Ad statum prosperum
Anagnie II Kl. Aug. a° 1°
Bulle an Hanf
In plica rechts
 G. de Setia de Cur

4493

Barcelona Corona de Aragón
 Leg. 19° u. 42°
P.— Adresse
 1295 Augusti 29
Bonifatius VIII nobili viro Jacobo nato quondam Petri olim
Regis Aragonum spiritum
consilii sanioris
 Sicut nuper ad
Anagnie IIII Kl. Sept. a° 1°
Bulle an Hanf
In plica rechts Jo pip
 de Cur
Ecke oben rechts R
A tergo oben mitte ganz blein

In den früheren R capitto cxxII
Bullen fehlt
nobili viro in
der Adresse

4494

Barcelona Corona de Aragón
 Leg. 19° u. 43°
P.— 1295 Septembr. 19
Bonifatius VIII Guillermo tit.
sancti Clementis presbitero
cardinali
 Nuper non sine
Anagnie XIII Kl. Octobris a° 1°
Bulle an Hanf
In plica rechts de Cur
 p. Reat
Sub plica links
Ecke oben links J.
Ecke oben rechts R

 A tergo Rein R

4495

Barcelona Corona de Aragón
Leg. 19° n. 440°

P.— Registratur
1295 September 19

Bonifatius VIII .. Arelaten.
et .. Ebredunen. archiepis ac
.. epo Massilien.
Pridem ad paris
Anagnie XIII Kl. Oct. a° 1°
Bulle an Hanf
In plica rechts de Cur
Sy. T
Subplica links 9
Ecke oben links .l.
Ecke oben rechts Rx
A tergo oben mitte Dorsualbe
Rx klein, eilig hingeworfen

4496

Bonif Barcelona Corona de Aragón
Leg. 19° n. 455°
P.— 1295 September 19
Bonifatius VIII uni versis presen-
tes litteras inspecturis
Pridem ad paris
Anagnie XIII Kl. Oct. a° 1°
Bulle an Seide
In plica rechts de Cur
Sy. T
Sub plica links 9
Ecke oben links .l.
Ecke oben rechts Rx

A tergo oben mitte klein Rx

4497

Firenze, R° Acquisto Pinelli
P.— 1295 Octobris 6
Bonifatius VIII Renutio Sen
ni civi Florentin.
Te nuper significante
Anagnie † non. Oct. a° 1°
Bulle und Seide fehlen
In plica rechts Maur.
Ⅹ
Sub plica links 9
Ecke oben links :

.l. Dorsunten Ɖ . m.

Ecke oben rechts Rx
A tergo oben mitte
ganz klein Rx Capitto cccclxxxv

4498

Firenze, S. Martino di Fir.
P.— 1295 Octobris 6
Bonifatius VIII Renutio Sen
ni Civi Florentin.
Te nuper significante
Anagnie II non. Oct. a° 1°
Bulle und Seide fehlen
In plica rechts br aur
Sehr eckige und fahrige
Schrift

4499

Napoli Perg. Farn. Bolle n. 13°
P. — 1295 novembris 12
Bonifatius VIII Bernardo nato di
lecti filii nobilis viri Hugolini Ia
cobi de Rubeis civis Parmen.
Senatoris Urbis canonico ec
clesie Dolen.
Obsequiosa devotio et
Rome apud Sctm Petrum II id.
Novembris a° 1°

 Bulle und Seide fehlen
In plica rechts Jac de pis
Sub plica links ≡

4500

Napoli Perg. Farn. Bolle n° 23
P. — 1295 novembris 12
Bonifatius VIII — archipbro ecclie
de Fornovo Parmen. dioc. et
Armano Mantello de Parm.
ac Nicolao de Cazagatis cano
nicis Regiis.
 Obsequiosa devotio et
Rome apud Sanctum Petrum
II id. Nov. a° 1°
 Bulle und Hanf fehlen
In plica rechts
 pro Johanne de pen J. S.
Ecke oben links ⋈ m.
Sub plica links (x
 Manu sua
unten R Jac pis Meur ?

4501

Napoli Pergam. Farnes. Bolle sciolte
 P. — 1295 novembris 14
Bonifatius VIII . . archipbro ecclie
 Viterbien
Ad audientiam nostram
Rome apud Sctm Petrum XVIII
 kl. Decembris a° 1°
Bulle an Hanf
In plica rechts p Jac° de Sct.
Sub plica links ⌐|⌐
 p. Reat
Ecke oben rechts ℋ

4502

Archives Nationales Paris
L279 n. 25 1295 novembris 17
 Br. 23.4 hoch 15.1 Plica 2.9
 oberer Rand 3.2 links 1.3
rechts 1.5
 Bonifatius VIII .. Priori sanc
ti Germani de Prtis Parisien
 dilectorum filiorum .. Abbatis
dat Rome apud Sctm Petrum XV kl
 decemb R a° 1°
Bulle an Hanf
 In plica rechts : C de Sctro
Ecke oben rechts : ℋ
 A tergo oben mitte :
 Villarefin h. de Sco Victore

Kleine fette regelm. Schrift
 Erste Linie für grosse Abkürzungen
ohne jeden betonten Buchstaben

 P. 24221

4503

Archives Nationales Paris

L 279 n. 26 _1295 Novembris 21_

Br. 25.9 hoch 18. Plica 3.4
oberer Rand 4.6 links 1.8
rechts 1.6

Bonifatius VIII . . Cantori
ecclie de Sancto Clodoaldo Parisien
dioc
dilectorum filiorum . . Decani
Dat Rome apud Scm Petrum
XI Kl decembr a° 10

Bulle an Hanf
In plica rechts : P Gatij de Ver
Ecke oben rechts : η
A tergo oben mitte : G. de Vico novo

Kleine fette regeln. Schrift
Erste Linie für Überlängen
ohne jeden betonten Buchstaben

P. vacat

4504

Archives Nationales Paris

L 279 n. 27 _1295 Novembris 21_

Br. 22.6 hoch 18.9 Plica 3.5
oberer Rand 4.8 links 1.5
rechts 1.4

Bonifatius VIII . . decano
ecclie sancti Marcelli iuxta Pari-
sius
dilectorum filiorum .. decani
Dat Rome apud Scm Petrum
XI Kl decembr a° 10

Bulle an Hanf
In plica rechts . P Gatij de Ser
Ecke oben rechts : η
 X
A tergo oben Mitte : G. de Vico Novo
Fette regeln. Schrift
Ohne jeden betonten Buchstaben
Erste Linie für einige Überlängen

P. vacat

4505

Bayer. Haupt. Staatsarchiv
Kl. Waldsassen fasc. 19

P. 24223ᵃ 7295 Novembris 22

Bonifatius VIII .. Abbati Monasterij
de Waldsassen Superiori Ratisponen.
dioc.
Conquesti sunt nobis
Rome apud Scm Petrum X
Kl. decembris anno Primo

Bulle an Hanf
In plica rechts : Schreibername

15 zeiliges Mandat 27. 5 × 78.4
plica 3. 4
Schöne enge Schrift ; Ränder ziem
lich breit

4506

Firenze, Badia di Passi-
gnano
P. — _1295 Novembris 24_

Bonifatius VIII .. priori sancti
Stephani ad Pontem Florentin
Conquesti sunt nobis
Rome apud Scm Petrum
VIII Kl. Dec a° 10

Bulle fehlt, Hanf erhalten
In plica rechts R. Ver
Rand oben mitte ccpr und ccpr
Ecke oben rechts X

20. 3 hoch
3. 8 plica
24. 7 breit

Kleine etwas fette Schrift

4507

Bayer. Haupt. Staatsarchiv
W.↑ Waldsassen fasc. 19

P. orest 1295 Novembris 28

Bonifatius VIII (Gitterschrift). Ab
bati et Conventui Monasterii de
de Waldsachsen Cistercien ordinis
Ratisponen. diöc.
 Cum a nobis
Rome apud sanctum Petrum
IIII kl. decembris Anno primo

Bulle an feiner Seide
In plica rechts: Anglo Rom.
Sub plica links: p. Reat

Ecke oben rechts 2f

Eine für diese Zeit ungewöhnlich
schöne zierte Schrift, die aus
der Mitte des Jahrhunderts stam-
men könnte.

4508

Public Record Office London
Papal Bulls bundle 8 n. 1
 P 24 238 1295 Decembris 13
Bonifacius VIII Bartholomeo nato
nob. viri Francisci de Sancto
Angelo rectori parrochialis ecclesie
S. Nicolai de Midalton. Wintonien. diöc.
Olim dilectus filius
Rome apud S. Petrum id. Dec. aᵒ 1ᵒ

 Bulle an Seide

 In plica rechts ⌐
 ascultata per me
 P. Sct.

4509

Graz Landesarchiv h. 1473
 P.— 1295 Decembris 21
Bonifatius VIII — magro et fri
bus Hospitalis S. M. sub Monte
Semeinich Salzeburgen. diöc.
Justis petentium desideriis
Rome apud Sm. Petrum
XII Kl. Jan. aᵒ 1ᵒ
Bulle an Seide
In plica rechts Cosmas
Sub plica links ⊞ —
 p. Reat
Ecke oben links 2f rechts 2X

4510

Barcelona Corona de Aragón
Adresse P.— Leg. 19ᵒ n. 2ᵒ
 1296 Januarii 2
Bonifatius VIII cario in xpo filio
Jacobo Aragonum Regi Illustr
In publici scripti serie
Rome apud Sm Petrum IIII non.
Januarii aᵒ 1ᵒ
Bulle an Seide
Sub plica links ≡ Schreiben
 fehlt
Ecke oben rechts R
A tergo oben etwas links klein
 R Capillo CLXI ?

4511

Barcelona Corona de Aragón
Leg. 19° n. 1°
P. — 1296 Ianuarii 2
Bonifatius VIII universis clericis et religiosis in Regnis Aragon. et Comitatu Barchinon constitutis cuiuscumque condicionis aut status existant
Cupientes per exuberantem
Rome apud Scm Petrum VIII
non. Ian. a° 1°
Bulle an Seide
In plica rechts Maur
Sub plica links n. Ver.
Rand oben Mitte at quia non debeat intitulari dilectis filiis
Ecke oben rechts R4
A tergo oben Mitte plein
R Capitlo CLx

4512

Arch. Arcis
Arm. 8 capo 4. Cap 3
P. 24256 1296 Ianuarii 2
Bon VIII Constantie olim regine Aragonum
hone te credimus
Dat Rome ap. S. Petrum III non.
Ianuarii a° 1°
Bulle aur Auf fehlen
In pl. rechts : J. de Fractis
Sub pl. links mit versch. Münte:
XV
n. Ver.
Ecke oben rechts :
A tergo oben Mitte : capitlo CLXI

4513

Arch. Arcis
Arm. XIV capo. 9 cap. 20
P. 24252 1296 Ianuarii 2
Bon. VIII universis hominibus Parnorni aliisque per insulam Sicilie constitutis spiritum consilii sanioris.
Post apostolatus apicem
Rome apud Sanctum Petrum III non. Ianuarii a° 1°
Bulle an Hanffaden
In pl. rechts : n. Ver.
Sub pl. links : n. Ver.
Ecke oben rechts :
A tergo oben Mitte : capitlo CLXIIII

4514

Arm. C. fasc. 38 cap. 3
P. 24254 1296 Ianuarii 2
Bon. VIII nobili viro Johanni de Procida spiritum consilii sanioris
In tractatu pacis
Dat. Rome apud Sanctum Pe.
Arum III non. Ianuarii a° 1°
nachgetragen
Bulle an Hanffaden
Sub plica links : V
n. Ver.
Ecke oben rechts :
A tergo oben Mitte : capitlo CLVIII

Barcelona Corona de Aragón
P.— Leg. 19° n. 30
1296 Januarii 5
Bonifatius VIII univ. xpi fideli-
bus ad quos littere iste perve-
nerint
Quis carissimum in
Rome apud Scm Petrum non.
Januarii a° 1°
Bulle an Hauf
In plica rechts J. d. Fractis
Sub plica links N. Ver.

Barcelona Corona de Aragón
P.— Leg. 19° n. 4°
1296 Januarii 8
Bonifatius VIII Cmo in xpo filio
Jacobo Aragonum Regi Il-
lustri
Letatur pia mater
Rome apud Scm Petrum VI
iV. Januarii a° 1°
Bulle an Hanf
In plica rechts N. de Fractis de Cur

de Curia
 Clausa
Paris Archives nationales
 J 435 n. 9
Breite 50.8 Rand links 4.7 rechts 6.
Höhe 39.7 Rand oben 9. unten 16.2
Erste Linie für Oberlängen / Je zwei
Seitenlinien
P. vacat 1296 Januarii 9
Bonifatius VIII Carmo in xpo filio
Philippo Regi Francorq Jllustri
Sincera caritas est
Dat Rome ap. S.P. / V Jd Januar
anno 1°
Bulle an Hauf A tergo unten
 rechts :
 P de Vi
 de Cur
Sehr fette kleine Schrift

P.— Paris Arch. nat.
J 435 cap. 9 1296 Januarii 9
 Clausa
 Bon VIII Philippo
regi Francorum
Sincera caritas et
Rome apud S. Petrum V
iV. Januarii a° 1°
Adrene Carmo in xpo filio Phy
Regi Francorum illustri
A tergo links unten umgekehrt
(plica - Platz) P de Vi
 de Cur
Bulle wieder angeknüpft

4519

consanguineus dni nri

Archives Nationales Paris
L 279 n. 28 1296 Januarii 13

Br. 63.3 hoch 44. Plica 7
oberer Rand 12.4 links 3.6
rechts 3.7

Bonifatius VIII Carissimo
in xpo filio Philippo Regi Franco-
rum Illustri

Firmum gerimus de
Dat Rome apud Sanctum Petrum Jd.
Januar. a° 1°

Bulle an Hanf
In plica rechts: P. Gen Gratis pro
consanguineo dni nri
Ohne alle weiteren Bemerkungen

Feste Regeln. Schrift
mit einem schönen Buchstaben
Erste Linie für Obaütüngen

monstrum an Grösse

Je zwei Seitenlinien P. vacat

4520

Nîmes Archives Départem.
G. 1319

P.— 1296 Januarii 15

Bonifatius VIII . . abbi mon.
Sandracen. Nemausen. dio.
Ad audientiam nostram
Avinion VIII (Calend. VIII) Kl. febr.
a° 1°

Bulle an Hanf
In plica rechts RP
xpianus

Sub plica links --
vitalis
Ecke oben rechts F

4521

Innsbruck Brixener Archiv
P.— 1296 Januarii 16
Bonifatius VIII Landulfo Bri-
xinen. electo
Devotionis tue precibus
Rome apud Sanctum Petrum
XVII Kl. februar. a° 1°

Bulle und Seide fehlen
In plica rechts m de Rocca
Sub plica links ...

Ecke oben
rechts J. Jo pp
g

Feste künftige Schrift mit
schwungvollen Längen

4522

Instr. misc. 1288-1295 cap. 53

P.— 1296 Januarii 18

Bonif. VIII Amato vicario nobilis viri
Petri Gaietan. rectoris patrimonii beati
Petri in Tuscia nepotis nostri
Considerantes grata et
Rome apud S.P. XV Kal. februarii a° 1°
Bulle und Hanf fehlen.
Sub plica links : 9
Unter dem Bug unten : R G. Set pro
bona recompositione
Jo pp
Ecke links oben : . L.
X. J
Ecke oben rechts 22

4523

Public Record Office London
Papal Bulls bundle 7 n. 4
P. 24 263 1296 Januarii 18°
Bonifacius VIII E. regi Anglie illustri
Confidimus fili carissime
Rome apud S. Petrum IX kel. febr. a° 1°
 Bulle an Hanf

In plica rechts N. de Fract
Sub plica links N. Ver.

ganz unten durchstrichen

R̥ Jac Mag
 Jo pip
Ecke oben links .L.
 R̥ . J.

4524

Barcelona Corona de Aragón
ohne Datum Leg. 19° n. 46°
 1295 – 1296 I. 25.
Bonifatius VIII ad perpet. rei m.
Romana inter Ecclesia
Rome apud Sanctum Petrum
[Lücke] a° 1°

Bulle an Seide
In plica rechts
 De Cur J. P.
Sub plica links =X
 N. Ver

das Tagesdatum fehlt

4525 (recto)

P. 24270 Paris Arch. Nat.
L 280 cap. 31 1296 Jan. 26
Bon VIII custodibus, magistris et
scholaribus domus pauperum sco-
larium prope ecclesiam S. Ste-
phani de Grevibus Parisien.
 Cum a nobis
Rome apud S Petrum VII
kl. Februarii a° 2°
Bulle an Seide
In plica rechts h Ver
Sub plica links v̄
 N. Ver

Sub plica Bug durchstrichen
und abgeklatscht:
R̥ B. de Sue
 Jo pip

4525 (verso)

Ecke oben links .L.
 N J
Rand oben Mitte
 dns Jo monach cur
Ecke oben rechts R̥

A tergo R̥ capitlo CLXIIII
 ganz klein

dieselbe hdtr über Jo Mon
cap. 30 und 29 bis

4526

P. — Paris Arch. Nat.
J 70⁵ cap. 14 1296 Januarii
Clausa

Breite Rän-
der
Bon VIII Phi-
lippo regi Fran-
corum illustri
Serenitatis tue nuntios
Rome ap. S Petrum VIII Rl.
febr. a° 2°

4527

P. — Paris Arch. Nat.
J 70⁵ cap. 12 1296 Februarii 4
Dat VIII ii non febr.
a° 2°
In plica rechts M Roo
dneben nach links
ascut et g putf
M Roo
Sub plica links X
Sub plica links Bug durch-
strichen und alles abgeklebt
R/ m de Roo
Jo pp

4528

Firenze, Olivetani di Pistoia
P. — 1296 Februarii 9
Bonifatius VIII .. plebano ple-
bis sancti Pauli de Petroio
Pistorien.
Conquesti sunt nobis
Rome apud Scm Petrum
VIII. febr. a° 2°
Bulle und Hanf fehlen
In plica rechts Jo Catt
Ecke oben rechts X

16.0 hoch
3.6 plica
21.3 breit

Kleine, aube etwas spitze
Schrift

4529 (recto)

Barcelona Corona de Aragón
P. — Leg. 20° n. 4°
1296 Februarii 13
Bonifatius VIII patriarchis ar-
chepis et epis ac electis abbatibus
prioribus et aliis ecclarum pre-
latis et eorum vices gerentibus
ac eccliasticis personis religio-
sis et aliis ecclarum et monaste-
riorum capitulis et conventibus
Idemptis et non exemptis Cisti.
Cluniac. Cartus. Premonst.
Sanctorum Benedicti et Augusti-
ni ac aliarum ordinum necnon
magris et preceptoribus domo-
rum Milicie Templi Hospitalis
Sancti Johannis Jerlinitan.
beate Marie Theutonicorum et
Calatraven. ad quos littere iste

4529 (verso)

pervenerint
Cum carissimus in
Rome apud Sanctum Petrum
iv. febr. a° 2°
Bulle und Hanf fehlen
Ohne alle Notizen

4530

Barcelona Corona de Aragón
Leg. 20° n. 5°
P. — 1296 februarii 13
Bonifatius VIII universis Regia
ducatus marchionatus comita
tus et cuiuscumque Baronie
dignitate vel preheminencie pre
ditis necnon potestatibus capita
neis rectoribus consiliis commu
nitatibus et universitatibus tam
civitatum quam castrorum
aliorumque locorum ceterisque
xpi fidelibus cuiuscumque sta
tus dignitatis vel conditionis
existunt ad quos littere iste per
venerint
Cum carissimus in
Rome apud Sanctum Petrum
iv. febr. a ° 2° In plica rechts: de Ciu
n. P.

4531

Bayer. Haupt- Staatsarchiv
Kl. Diessen fasc. 5
P. 24284ª 1296 Februarii 13
Bonifatius VIII - - Epo Augusten.
Conquesti sunt nobis
Rome apud Sem Petrum Id. fe.
bruarij Anno Secundo

Bulle an Hanf
In plica rechts : f. R
Ecke oben rechts : XX

Gewöhnl. nicht besonders runde, aber
Zusammenhängende Schrift

Mandat : 24.1 × 15.7
plica : 4.0

4532

Firenze, S. Agnese di Mon.
tepulciano
P. — 1296 Februarii 13
Bonifatius VIII . priori ...
Petri de Petroio Clusin.
dioc.
Petitio dilecti filii
Rome apud Sem Petrum
id. febr. a ° 2°
Bulle und Hanf fehlen
In plica rechts m) de Rocca
Sub plica links - - -
n. Ver.
Ecke oben.
links. [9

Weite, eckige, gedrungene
etwas nach rechts geneigte
Schrift 13

4533

Archivio di Stato Milano
Bolle e Brevi
P. 24291 1296 februarii 25
Bonifatius VIII ad perp. rei mem.
Clericis laicos infestos
Rome apud S. Petrum VI kl.
Martii a° 2°
Bulle fehlt, Seide erhalten
In plica rechts P. Œ
Sub plica links $\bar{\bar{x}}$
 O. Ser

4534

München Reichsarchiv. Bamberg
Clericis laicos infestos
1296 februarii 25
Bonifatius VIII epo s. s. dei ad perp.
rei mem. Alles in Gitterschrift
Clericis laicos infestos
Dat Rome apud sem Petrum VI
kl Martij / pontificatus nri anno
secundo
Bulle an Seide. In plica rechts : P.
Set.
Sub pl. links : \bar{x}
Je zwei Leitenlinien . Erste Linie nur
für Oberlängen
Fette mittelgrosse feste Schrift
Drei betonte Satzanfänge
A tergo oben mitte : Petrus de Assisio

P. 24291

4535

Staatsarchiv Wien Chronol.
P. 24291 1296 Februarii 25
Bonifatius VIII ad perp. r. mem
Clericis laicos infestos
Rome apud Sem Petrum
VI kl. Martii a° 2°
Bulle an Seide
In plica rechts O Ser.
Sub plica links $\bar{\bar{x}}$

4536

Barcelona Corona de Aragón
Leg. 20° n. 6°
P. — 1296 februarii 29
Bonifatius VIII emo in xpo filio
Jacobo Regi Aragonum Illustri
Affluentis devotionis affectus
Rome apud sem Petrum II
kl. Marcii a° 2°
Bulle und Seide fehlen
Plica abgeschnitten
Sub plica links n. Ver
 g

4537

Bull. Gen. I cap. 28
[P. 24298] 1296 Martii 14
Bon. VIII .. epo Aurasicen.
 Inter alia que
 Rome apud S. Petrum ꝓ id. Mar
ᵗⁱⁱ aᵒ 2⁰
 Bulle und Hanf ausgerissen
Rechter Rand Zerfressen
Ecke oben rechts

A tergo oben Mitte

4538

Bull. Gen. I cap. 29
P. 24298 1296 Martii 14
Bonif VIII .. priori et convent
prioratus S. Saturnini de Portu
Cluniacen ordinis Uticen.
dioc.
 Inter alia que
 Rome ap. S. Petrum ꝓ id.
 Martii aᵒ 2⁰
 Bulle und Hanf fehlen
 In plica rechts : de Cur
 P. Reat.
Ecke oben rechts :
A tergo oben Mitte :
 R caplo XX II

4539

Arch. Arcis
Arm. C fasc. 9 cap. 12
 P. — 1296 Aprilis 4
Bonifatius VIII ad perp. rei mem.
Constitutioni felicis recordatio.
nis
 Rome apud Sanctum Petrum
ꝓ non. Aprilis aᵒ 2⁰
Bulle an aber feinen hellen Sei
denfäden
In pl. rechts : de Cur
 B. de Sugio
Ecke oben rechts : 22/

4540

Arch. Arcis
Arm. II cap. 6 cap. 4
P. — 1296 Aprilis 13
Bonifacius VIII ad perp. rei mem.
Mag. fett mittelgr. dick. Gitt.
Ad statum orbis
· Rome ap. S. Petrum id. Aprilis
aᵒ 2⁰
Bulle an feinen Seidenfäden
In pl. rechts : de Cur
 ·J. Laur.

Firenze, Cestello
P.— 1296 Maii 7
Bonifatius VIII .. [graecus] abba
ti non. Sancti Salvatoris de
Septimo eiusque — JN ppm

 Religiosam vitam eligentibus
 amen et amen
 R. Ego Bonifatius Cattoli
 ce ecclie. Eps ss M
 4 presb. 3 epi 6 diac
Rome apud Sctm petrum per ma
num petri Sce Marie Noue dia
con. Cardinalis et Sce Roman
ecctie Viccancellarii non. Maii
Indictione VIII Incarnationis dnice
. Mo. CC. LXXXXVI pontificatus vero
dmni BONIFATII pp VIII Anno
Secundo vale

die Vicecanzler hat auch als
letzter der Diacone unterschrie
ben . † Ego Petrus Sce Marie
Noue diacon Cardl ss
gut erhaltene Bulle an seid
 Rand oben mitte . jn
and. post datum apponitur

 Eingestellt mtte
 1297 Maii 7

Firenze, S. Maria Nuova
P.— 1296 Maii 17
Bonifatius VIII .. epo Floren
tin.
 Exposita nobis dilectorum
Rome apud Sanctu Petrum
XVI Kl. Junii ao 2o
Bulle und Hanf fehlen
 In plica rechts Jo pap
Sub plica links ≡
 ✳
Ecke oben 9
links . j.
Ecke oben rechts XX
a tergo oben mitte klein
 R . capto CCXIII
 In plica mitte :
 ascut et cop per me
 B. pads

Arch. Histor. Nacional Madrid
 Dominicos Palma 27 E
 P. 24344 1296 Maii 4
Bonifatius VIII .. magro, prioribus
et fribus universis Ó Praed
Virtute conspicuos sacri
Rome ap. S. Petrum XIIII Kl.
Junii ao 2o
Bulle fehlt, seide erhalten
In plica rechts dominicus

Grosse Bulle in runder, enger
sehr schöner und regelmässi
ger Schrift

4544

Bayer. Haupt- Staatsarchiv
Würzburg n. 3507

P. 24344 1296 Junii 19

Bonifatius VIII (sehr verwischt grosse
roman. Mai.).. Magro prioribus et fra-
tribus universis ordinis Predicatorum
 Virtute conspicuos sacri
Dat. Rome apud Sanctum Petrum
XIII Kl. Junij a° secundo

Bulle an Seide
In plica rechts: A. Medl
Sub plica links : L x
 O. Ser.

4545

Instr. non. T. Dom. c. 7a 1296 Maii 19
 P. 24344

Bon. VIII .. mag. prioribus et fratribus
universis ordinis Predca.
Virtute conspicuos sacri
Rome ap. St. P. XIII Junii a° 2°
Bulle an dickeren Seidenfäden.
In plica rechts: J de Ver.
Sub plica links : L x
A tergo : [Predicatorum]

 Mare Magnum

4546

Archivio di Stato Milano
Bolle e Brevi fehlen

 P. 24346 1296 Junii 2

Bonifatius VIII universis abba-
tissis et conventibus monialium
inclusarum sive S. Clare sive
S. Damiani seu Minorisse dicun-
tur
 Laudabilis sacra religio
Anagnie V non. Jun. a° 2°
Bulle fehlt Seide erhalten
In plica rechts P. Alearii.

 V non. Junii fehler

4547

Graz Landesarchiv n. 1506

 P. —
 1296 Junii 4

Bonifatius VIII universis abba-
tissis et conventibus monia-
lium inclusarum Ord S.
Clare sive S. Damiani seu
Minorisse dicuntur
Laudabilis sacra religio
Anagnie V non. Junii a° 2°
Bulle an Seide
In plica links heure
Sub plica links R n. p. Ag.
 h. Dard
Eckstein links S h. V.

4548

Barcelona Corona de Aragón
Leg. 20° n. 7°

P. — Clausa
1296 Junii 15

Bonifatius VIII · J. Regi Arago-
rum Illustri
In suavitatis et
Anagnie XVII Kl. Julii a° 2°
Bulle an Hanf

Ränder und
Löcher rechts
und links
abgeschnitten

A tergo unten links umge.
Kehrt (in plica) de Cur
B. de Sugio

4549 (recto)

Barcelona Corona de Aragón
Adresse P. — Leg. 20° n. 8°
1296 Junii 15

Bonifatius VIII omnibus in xpo
filiis Regibus et venerab. Fribus
archiepis et epis ac dil. filiis electis
abbatibus prioribus decanis ar-
chidiaconis plebanis archipres-
biteris et aliis ecclarum prelatis
et eorum vices gerentibus ac no-
bilibus viris marchionibus, comi-
tibus et Baronibus potestatibus
quoque capitaneis seu rectori-
bus consulibus antianis consi-
liis populis communibus com-
munitatibus et universitatibus
civitatum castrorum et locorum
ac aliis universis et singulis
ad quos littere iste pervenerint

4549 (verso)

Cum carissimus in
Anagnie XVII Kl. Julii a° 2°
Bulle an Hanf
In plica rechts Jy. J. de Cur

4550

Barcelona Corona de Aragón
Leg. 20° n. 9°
P. — 1296 Junii 19

Bonifatius VIII .. potestati..
capitaneo Antianis consi-
liis et communi Lucan.
Sollicitudines et labores
Anagnie XVII Kl. Julii a° 2°
Bulle an Hanf
In plica rechts Jo Pon. de Cur

4551

Barcelona Corona de Aragón
Leg. 20° n. 10°
P.— 1296 Iunii 19
Bonifatius VIII Iacobo regi
Aragonum Illustri
Cum ad presentiam
Anagnie XIII Kl. Iulii a° 2°
Bulle an Seide
In plica rechts N. Vet
de Cur

4552

Barcelona Corona de Aragón
Adrest P.— Leg. 20° n. 11°
1296 Iunii 19
Bonifatius VIII Iacobo Regi
Aragon Illustri
Manentibus in Curia
Anagnie XIII Kl. Iulii a° 2°
Bulle an Hanf
In plica rechts B. J.

In der Adresse
cmo in xpo filio nostro

4553

Barcelona Corona de Aragón
Leg. 20° n. 12°
P.— 1296 Iunii 19
Bonifatius VIII ad perpet. r. m.
Cum sicut abolim
Anagnie XIII Kl. Iulii a° 2°
Bulle an Seide
In plica rechts de Cur
Z ped

4554

Barcelona Corona de Aragón
Leg. 20° n. 13°
P.— 1296 Iunii 19
Bonifatius VIII Iacobo Regi
Aragon Illustri
Post confectionem aliarum
Anagnie XIII Kl. Iulii a° 2°
Bulle an Hanf
In plica rechts Jy. J

Barcelona Corona de Aragón
R̆ P.— Leg. 20° n. 14°
 1296 Julii 5
Bonifatius VIII Jacobo regi Ara-
gonum Illustri
Ad fovendum in
Anagnie III non Julii o °2°
Bulle an Hanf
In plica rechts N. de Fractis
Sub plica links ̿
 =
 x
 J. de Fractis
Sehr oben rechts R̆
A tergo oben mitte klein
 N. de Fractis

 R̆ ohne
 Capitels
 Zahl

Arch. Arcis
Arm. C fasc 67. cap. 1
P. 1296 Augusti 1
Bonifatius VIII ad perp. rei mem.
Sepe sanctam Ecclesiam
Anagnie Kl. Augusti a° 2°
Bulle an Seidenfäden
In plica rechts : A. Med
A tergo oben mitte :
 Contra hereticos

 Clausa
Paris Archives nationales
 J 449 n. 120
Erste Linie für Oberlängen /
Je zwei Leitenlinien
P. vacat 1296 Septembris 22
Bonifatius VIII Carus in xpo
filio Pho Regi Francor. Illustri
 licet Occasione cum constitution
Dat Anagnie X Kl Octobr. / a° 2°
a° 2°
 Bulle an Hanf
Sehr regelm. mittelgr. Schrift

Firenze, Volterra
P.— 1296 Septembris 26
Bonifatius VIII .. potestati,
consilio et communi Vul-
terru
 Speramus quod more
Anagnie VI Kl. Oct. a° 2°
 Bulle an Hanf
In plica rechts Cur
 Jo Gall de
 Runde, feste, etwas enge
Schrift

4559

Barcelona Corona de Aragón
Leg. 20° u. 15°
P.—
1296 Septembr. 27
Bonifatius VIII Jacobo Regi
Aragón Illustri
Cum ad presentiam
Anagnie V Kl. Octobr. a° 2°
Bulle und Seide fehlen
In plica rechts
P. Geñ. de Car

4560

Barcelona Corona de Aragón
Leg. 20° u. 16°
P.—
Clausa
1296 Septembr. 27
Bonifatius VIII cmo in xpo
filio Jacobo Regi Aragonum
Illustri
Grate venerunt in
Anagnie V Kl. Octobris a° 2°
Bulle anheuh

Ränder und Lö-
cher links und
rechts abgeschnit-
ten

4561

Firenze, Badia Fiorentina
P.—
1296 Novembris 16
Bonifatius VIII . . epo et capi-
tulo Eugubin.
Sincera caritas et
Rome apud Sanctum Petrum
XVI Kl. Dec. a° 2°
Bulle und Seide fehlen
In plica rechts N. de Fractis
Ziemlich eckige, steile
Schrift. Etwas nach rechts
geneigt

4562

Napoli Curia Ecles. Vol. 3°
P.—
1296 Novembris 20
Bonifatius VIII . . epo Melfiten.
Ad audientiam nostram
Rome apud Sem Petrum XII Kl.
Decembris a° 2°
Bulle und Hanf fehlen
In plica rechts Jorda[nus]
Sub plica links .⁓
J. de Fractis

4563

Instr. Mon. F. Dom. c. 6 1296 Nov. 22
P. 24432

Bon. VIII universis prioribus et con-
ventibus ac sororibus monasteriorum
et prioratuum O. S. Aug. sub cura et
institutionibus fratrum Praed. exien-
tibus per Italiam constitutis
Caritatis opere quibus
Rome ap. S. P. X Kal. Decembris a° 2°
Bulle an Seidenfäden.
In plica rechts : Jordanus
Sub plica links :
A tergo : Praedicatorum

4564

Barcelona Corona de Aragón
Leg. 20° n. 17°
Aragonie Clausa
P. — 1296 December. 5
Bonifatius VIII Jacobo regi
Aragonie Illustri
Per litteras tuas
Rome apud Sanctum Petrum
Non. Dec. a° 2°
Bulle an Hanf.

Ränder und
Löcher oben
und unten
abgeschnitten

Aragonie auf sechs weiteren
Bullen

4565

Paris Arch. Nat.
J 705 cap. 111 1296 Dec 17
Bon VIII XVI Kl. Jan. a° 2°
Sub plica links

$\frac{=}{x}$

H Pad ista computetur inter
rescriptas
9

4566

Marseille Archives Départem.
H. Dom. 22
P. — 1296 Decembris 18
Bonifatius VIII ... magro et fra-
tribus Hospitalis S. Johan-
nis Jerosol.
Dum future considerationis
Rome apud Scm Petrum
XV Kl. Jan. a° 1°
In plica links Jac Boel
Sub plica links

4567

Bull. gen. I cap. 30
P. — 1296 Dec. 19
Bon VIII .. epo Aretin.
 Sua nobis dilecti
Rome ap. S. Petrum XIIII Kal.
Januarii a° 2°
Plica abgeschnitten
Bulle und Hanf fehlen
A tergo oben Mitte: Petrus Fabri

4568

Barcelona Corona de Aragón
Fehler Leg. 20° n. 1°
P. — 1297 Januarii 13
Bonifatius VIII - - Sancti Petri
de Rosis Gerunden. dioc ar - -
Sancte Felicis monasteriorum
abbatibus et - - archidiacono
Gerunden.
 Sua nobis dilecti
Rome apud Sem Petrum id
Januarii a° 2°
Bulle an Hanf
In plica rechts m. de Adr.

In der adresse Fehler:
 sancte fui sancti

4569

Barcelona Corona de Aragón
R Leg. 20° n. 2°
 P. 24460 1297 Jan. 20
Bonifatius VIII ad futuram r. m.
Redemptor mundi in
Rome apud Sem Petrum XIII
Kl. febr. a° 2°3°
Bulle und Seide fehlen
In plica rechts
 Bonusanus de Cur
Ecke oben links D n
Sub plica links x̄ darunter
unten R̄ p. de Aveto et ipos
remittes dno vic et non alii
 n. pad
Rand oben Mitte apo
A tergo oben Mitte klein etwas rechts
 R Capto xxx z. Capto
 nicht Capitto

4570

Barcelona Corona de Aragón
 Leg. 20° n. 3°
P. — si clausa vel apeta
 1297 Januarii 21
Bonifatius VIII nobili mulieri
Constantie Relicte quondam
Petri olim Regis Aragonum
Salutem tuam cupientes
Rome apud Sem Petrum
XII Kl. febr. a° 2°
Bulle an Hanf
In plica rechts de Curia ||
 F. R
|| Rand oben Mitte
 at. si clausa ut apeta

4571

Toulouse, Archives Départem.
H. 3+ 31

P.— 1297 Januarii 31

Bonifatius VIII archiepis et epis
et abb. prior. decan. archidiac.
et aliis ecclesiarum prelatis ad
quos littere iste pervenerint
 Cum dilectis filiis
Rome apud Sanctum Petrum
II kl. febr. a° 3°
 Bulle an Seide
In plica rechts pro P. de Anagnia +
 pro me A. med. V

Sub plica links X
 X

4572

Toulouse, Archives Départem.
H. 3+ 31

P.— 1297 Januarii 31

Bonifatius VIII archiepis et
epis. et abb. prior. decanis
[Rasur mit Strich] archid.
prepos. archipresb. et aliis eccle-
siarum prelatis ad quos littere
iste pervenerint
 Religiosos viros fratres
Rome apud Sen Petrum
II kl. febr. a° 3°
 Bulle an Seide
In plica rechts J. de Murro
Sub plica links S

4573

Toulouse, Archives Départem. pro infirmo
H. 31

P.— 1297 Januarii 31

Bonifatius VIII .. archiepis et
epis et abb. decanis et aliis ec-
clesiarum prelatis ad quos lit.
seu iste pervenerint
 Si diligenter attenditis
Rome apud Sen Petrum
II kl. febr. a° 3°
 Bulle fehlt, Seide erhalten
In plica rechts
 pro N. de Setia infirmo

Sub plica links V

4574

Toulouse, Archives Départem.
H. 31!

P.— 1297 Januarii 31

Bonifatius VIII .. magro et
fribus Hospitalis S. Johannis
Jerosolim.
Considerantes attentius discri-
mina
Rome apud Sanctum Petrum
II kl. febr. a° 3°
Bulle an Seide
In plica rechts G. de Setia
Sub plica links

4575

Toulouse, Archives Départem.
H. 31

P. — 1297 Januarii 31

Bonifatius VIII .. Biterren.
et .. Magalonen. epis et
Rendoni de Tornello canoni-
co Anicien.
Dum sollicita consideratione
Rome apud Scm Petrum II
Kl. febr. a° 3°
Bulle am Hanf
In plica rechts p. Set.
Sub plica links ꞊ₓ bac (?)
 Jac. boer

Ecke oben rechts
A tergo oben klein

R₄

cf. P. 24456

4576

Marseille Archives Départem.
H. o.M. 22
P. — 1297 Januarii 31

Bonifatius VIII .. magro et
fratribus Hosp. S. Johannis
Jerosol.

Considerantes attentius discrimĩ
Rome ap. Sanctum Petrum^na
II Kl. febr. a° 3°

Bulle und Seide ausgerissen

In plica rechts pro ar ꝑ m
Sub plica links ꞊̄ᵥ

4577

Marseille Archives Départem.
H. o.M. 22
P. — 1297 Januarii 31

Bonifatius VIII .. magro et
fratribus Hosp. S. Johannis
Jerosol.

Eo nobis quilibet
Rome apud Sanctum Pe-
trum II iV. febr. a° 3°

Bulle fehlt Seide erhalten

In plica rechts P. Reat
Sub plica links ‒ ‒ ‒ ‒
 R₄ P. de Anag VI
 R₄ a. med VII } ꝉ pad.
 R₄ Sy T. IIII
 R₄ P. de Acuto VI
Ecke oben links ꝑ ꜧ XIX

(Distribuas H. XIX)

Distributor H. Padnanus cf 1297 Sept. 13

4578

Coblenz Staatsarchiv
Stift Carden
 P. — 1297 Februarii 1
Bon. VIII .. decano et capitulo
ecclesie Sancti Castoris Carde-
nen. Treverensis diocesis
 Solet annuere sedes
Rome apud Sanctum Petrum
Kl. februarii a° 3°
Bulle an Seide
In plica rechts J. de Asisio
Sub plica links ꞁ̄ pad g
Ecke oben links ꝑ rechts H.

4579

Barcelona Corona de Aragón
Leg. 21° u. 2°
P. 24473 1297 februarii 21
Bonifatius VIII Carolo Regi Si-
cilie Illustri
Incumbit nobis non
Rome apud Sem Petrum
XI Kl. Martii a° 3°
Bulle fehlt. Seide erhalten
In plica rechts do Por
sub plica links ≡)

Ecke oben links L

4580

Barcelona Corona de Aragón
Leg. 21° u. 3°
P. — 1297 februarii 25
Bonifatius VIII Jacobo Regi
Aragonie Illustri
Patronum tuum speciali
Rome apud Sem Petrum
V Kl. Martii a° 3°
Bulle an Seide
In plica rechts de Curia
F. R

4581

Madrid Arch. histór. nacional
Santa Creus n. 4
P. — 1297 Martii 14
Bonifatius VIII .. archidiacono
Terraconen.
Sua nobis .. abbas
Rome ap. S. Petrum II id.
Martii a° 3°
Bulle an Hanf
In plica rechts (Scriptor)

Regelmässige, aber schon leid-
lich eckige Schrift.

4582

Paris arch. nat.
J 705 cap. 116 1297 Martii 16
Breite Rän-
der

Bon VIII Phi-
lippo regi Francie
..rum illustri
Per nuntium regium
Rome apud S. Petrum
XVII Kl. Apr. a° 3°

P. —

4583

Barcelona Corona de Aragón
Leg. 21° n. 4?

P.- 1297 Martii 17

Bonifatius VIII nobili viro
Roberto primogenito Caroli
Illustris Siciliae ac nobili
mulieri Violante uxori quon-
dam Petri olim Aragonum
Regum

Licet inter illos

Rome apud Scm Sanctum
Petrum XII Kl. Aprilis a° 3°
Bulle fehlt. Seide erhalten
In plica rechts P. Reat
Sub plica links =/×

4584

Bayer. Haupt. Staatsarchiv
Bamberg fasc. 33

P. 24488 c°× 1297 Martii 21

Bonifatius VIII Subdecano et Ca-
pitulo ecclie Amunbergen.
Sponso celesti cui
Rome apud Scm Petrum XI Kl.
Aprilis Anno Tertio

Bulle an dickem Hanf Duplicat
In plica rechts: n. p
 p. Gabino

Sub plica links: =/×
 Jac bat. pro Gabino ?

Ecke oben links:
 Ecke oben rechts: R
Zwei lange Rasuren die mit einem
Ruchern Strich gefüllt sind.
A tergo oben mitte klein R

A tergo Ecke oben links: .l.
Ungeheure Ränder, sehr grosse Zei-
lenabstände, runde, zusammenhän-
gende Schrift mit grossen Ober- und
Unterlängen

4585

Bayer. Haupt- Staats archiv
Bamberg fasc. 33

P. 24488 b× 1297 Martii 21

Bonifatius VIII Lupoldo Epo Bam-
bergen.
Sponso celesti cui
Rome apud Scm Petrum XI Kl.
Aprilis Anno Tertio

Bulle an dickem Hanf.
In plica rechts: n. p
 pro Gabino

Sub plica links: =/×
 Jac bat (?) pro Gabino ?

Ecke oben links: L rechts: R
A tergo Ecke oben links: .l.
a tergo oben mitte klein
 R capto. CCC.IIII.

Duplicat

4586

Barcelona Corona de Aragón
Leg. 21° n. 5?

P.- 1297 Martii 28

Bonifatius VIII Jacobo Illustri
Regi Aragonie
Claris tue celsitudinis
Rome apud Scm Petrum
V Kl. Aprilis a° 3°
Bulle an Seide
Sub plica links ---
 Jac bar?

Schreiber fehlt.
A tergo Ecke oben links .l.

Barcelona Corona de Aragón
Leg. 21º u. 6º
P.— 1297 Martii 28
Bonifatius VIII .. priori Sci
Pauli Barchinonen.
Cum olim dilecti
Rome apud Scm. Petrum
V Kl. Aprilis aº 3º
Bulle an Hanf
In plica rechts, Anne
Sub plica links —

Barcelona Corona de Aragón
Leg. 21º u. 7º
P.— 1297 Martii 28
Bonifatius VIII Jacobo Illustri
Regi Aragonie
Quanto uberioris devotionis
Rome apud Scm Petrum
V Kl. Aprilis aº 3º
Bulle an Seide
In plica rechts Bonifacius
Sub plica links V
Oat bac ?
A tergo Ecke oben links ?

Barcelona Corona de Aragón
Leg. 21º u. 8º
P.— 1297 Martii 28
Bonifatius VIII Jacobo Illustri
Regi Aragonie
Desideriis tuis in
Rome apud Scm Petrum
V Kl. Aprilis aº 3º
Bulle an Hanf
In plica rechts Bonifatius
Sub plica links — — —
Jac bac ?

Barcelona Corona de Aragón
Leg. 21º u. 10º
P.— 1297 Martii 31
Bonifatius VIII Jacobo Regi
Aragonie Illustri
Cum impa de
Rome apud Sanctum Petrum
II Kl. Aprilis aº 3º
Bulle an Hanf bac ?
In plica links Jac bac ?
Sub plica links — —
Jac bac ?
Aragonie

4591

Barcelona Corona de Aragón
Leg. 21° . n.° 11°

P. 24498 1297 Aprilis 1

Bonifatius VIII Jacobo Regi
Aragonie Illustri
Cedit nobis ad
Rome apud Sem . Petrum
Pl. Aprilis a° 3°
Bulle fehlt Seide erhalten
In plica rechts Jo hi
Sub plica links - - -
 Jat bar ?
A tergo Ecke oben links
 . l .

4592

Barcelona Corona de Aragón
Leg. 21° n. 12°

P. — 1297 Aprilis 1

Bonifatius VIII Jacobo Regi
Aragonie Illustri
Hebet in nobis
Rome apud Sem Petrum Pl.
Aprilis a° 3°
Bulle an Seide
In plica links Jat bue ?
Sub plica links
 Jat bue ?

Aragonie

4593

Barcelona Corona de Aragón
Leg. 21° n. 13°

P. — 1297 Aprilis 1

Bonifatius VIII .. Epo Derter
sen.
Carissimus in xpo
Rome apud Sem . Petrum
Pl. Aprilis a° 3°
Bulle und Bruf fehlen
 Schreibername fehlt.
Sub plica links - - -
 Jat bar
 bar ?
A tergo Ecke oben links
 . 2 .

4594 (recto)

Arch. Arcis
Arm II app. 4 cap. 5
P. 24507 1297 Aprilis 4
Bonifacius Carissimo in Xpo filio
vacante pl.
 maj. Jacobo Sardinie el
Corssice regi illustri . Ad perpetu
am rei memoriam [Rota fehlt mittelfr.]
 Super reges et
Rome apud Sem Petrum II non
Aprilis a° 3°
Bulle an Seidenfäden
In pl. rechts : Ascultata
 P. Vet.
Sub pl. links : Lxxx Curte
Auf dem Bug : pro p. Re. x Pro
u. vivinii x pro Demetrio x v pro
Merit x pro se p ter x
 H. Pad.

A tergo oben Mitte:

R/ cepto XXXVII

Barcelona Corona de Aragón
Leg. 21°. n°. 14°
P. 24511　　Adresse
1297 Aprilis 4
Bonifatius VIII Carissimo in
xpo filio Jacobo Sardinie
Corsice Regi Illustri Ad per-
petuam rei memoriam
fehlt in Gitterschrift
Super reges et
Rome apud Sanctum Petrum II
non. Aprilis a° 3°
Bulle in Seide
　　Schreibername fehlt.
Sub plica rechts L x x x
unten R/ p. Set et assignabis
michi litteras ut dno vic et
non alii et respondebis pro ut
michi videbitur.
　　　　　1) Pad　　verte

Ecke oben links $ 1)

A tergo oben Mitte klein

R/ Capto XX ?

Infeudatio

Barcelona Corona de Aragón
Leg. 21° n. 15°
P. 24502　　1297 Aprilis 4
Bonifatius VIII Jacobo Regi Sar-
dinie et Corsice Illustri
　　Cum Regnum Sardinie
Rome apud Sanctum Petrum
II non. Aprilis a° 3°
Bulle an Seide
In plica rechts Vg. T.
Ecke oben links
　　　　$ 1). secrete　　　　|||
Sub plica links - - -
unten
R/ 1) Vernt
　　　1) Pad
A tergo oben Mitte klein
　　R/ Capto XXVIII

4597

Barcelona Corona de Aragón
Leg. 21° n. 16°
1297 Aprilis 5
Bonifatius VIII univarsis xpi
fidelibus ad quos litterae istae
pervenerint
Sincere puritatis affectus
Rome apud Sen Petrum
non . Apr . a° 3°
Bulle an Hanf
Schreibername fehlt.
Sub plica links _ _ _ _

4598

Arch. Arcis
Arm. IX caps. 7 cap. 2
P. — 1297 Aprilis 6
Bonifatius VIII ad perp. rei mem.
Sublim aplice sedis
Literen . VIII id Aprilis a° 3°
Bulle an sehr feinen Seiden.
fäden .
In pl. rechts : N. de Fratis
 de mandato dni IIIII
Ganz violett
Sub pl. links riels Rx
A tergo procurator
schwer lesalich

4599

Barcelona Corona de Aragón
P. — Leg. 21° n. 11°
 1297 Aprilis 8
Bonifatius VIII .. Ilerden et..
Cesaraugusten Epis
Sincere pietatis affectus
Rome apud Sen Petrum
VI id. Aprilis a° 3°
Bulle an Hanf
In plica rechts de Cur
Ecke oben links Jo pip
 y y
Sub plica links v
unten Rx Jo Pen
 y Pad
A tergo oben mitte klein
 Rx Capto xxxii ?

4600

Barcelona Corona de Aragón
 Leg. 21° n. 18°
P. — 1297 Aprilis 8
Bonifatius VIII .. Barchinonen.
et .. Dertusen. Epis
ßu alias nostras
Rome apud Sen Petrum VI
id. Aprilis a° 3°
Bulle an Hanf
In plica rechts de Cur
 Jo pip
Ecke oben links Q y
Sub plica links v y
 unten Rx Ja pe ?
A tergo oben mitte klein
 Rx Capto xxxii

4601

Barcelona Corona de Aragón
Leg. 21° n. 19°
P. —
1297 Maii 5
Bonifatius VIII . J. Aragonum
Sardinie ac Corsice Regi
Illustri
Pridem tanquam qui
Rome apud Scm Petrum III
Non. Maii a° 3°
Bulle und Hanf fehlen
In plica rechts III
J. de Murro de Cur

4602 (recto)

Arm. C fasc. 47 cap. 5
P. 24573 1297 1297 Maii 10
Bonifatius VIII ad perpetuam r. m.
In excelso throno
Actum Rome apud Sanctum
Petrum in publico consistorio
nostro VI id. Maii a° 3°
Bulle an Seidenfäden
In pl. rechts : de Curia
Jordani
5 b
vide oben.
plica abgeschnitten
5 c
wie oben verte
In pl. rechts : de Curia
Sy Aretin)

4602 (verso)

5 a
wie oben
In plica rechts : de Curia
O. Ver

4603

Arch. Arcis
Arm. IX caps 2. cap. 15
P. 24573 1297 Maii 10
Bonifatius VIII ad perp. ri mem.
Pl. mg. mittelgr. Schr.
In excelso throno
Actum Rome apud Sanctum
Petrum in publico consistorio
nostro VI id. Maii p. n. a° 3°
Bulle an feiner Seide
In pl. rechts : de Cur
p
In pl. mitte: Rf B... anag

4604

Paris Arch. Nat.
J 716 cap. 3^bis 1297 Maii 12
Bon VIII III id. Maii a° 3°
Bulle an Hanf
In plica links P. de Caf.
Sub plica links x
 H. Pad pro Jac Jut
abgekratzt.
A tergo ziemliches kleines R

4605

Arch. Arcis
Ann. C fasc. 34 cap. 1
P. - 1297 Maii 13
Bonifatius VIII ad perp. rei mem.
Cum nuper dilectum
Rome apud S. Petrum
III id. Maii a° 3°
Bulle an feinem Seidenfaden
In pl. rechts:
G. de Setia de Cur
Ecke oben rechts: R
A tergo oben mitte: R

4606

P. - Paris Arch. Nat.
L 281 cap. 62 1297 Maii 17
Bon VIII universis prioribus hos-
pit. S. Joh. Jeros. per regnum
Francie constitutis
Rome ap S Petrum 16 Kl Jun. a 3°
Bulle an Hanf
In plica rechts h de Fractis
Sub plica links H. x Pad
Ecke oben rechts R
A tergo Jupiter de Boso
 R . capto CLXXVI

4607

Ann. C fasc. 47 cap. (6a)
P. 24579 1297 Maii 23
Bonifatius VIII ad perp. rei mem.
Lapis abscisus de
Actum Rome in basilica su-
pradicta in die Ascensionis
Domini p. n. a° tertio
Bulle an Seidenfaden
In pl. rechts: A. med.
 de Cur

Arm. C fasc. 47 cap. 6ᵈ

P. 24579 1297 Maii 23

Bonifatius VIII ad praep. r. mem

Lapis abscisus de

Actum Rome in basilica supra-
dicta in die Ascensionis Domi-
ni p. 4. aᵒ 3ᵒ

Bulle an Seidenfäden

In pl. rechts: Jac̄ G. de Cur

⎯⎯ 6 c

In pl. rechts: de Cur
 P. asin...

⎯⎯ 6

In plica rechts: de Cur
⎯⎯ 6 c O. Ser

In plica rechts:
 A. Med
 de Cur verte

Barcelona Corona de Aragón
 Leg. 21ᵒ 4. 20ᵒ

P. - Clausa
 1297 Iunii 5

Bonifatius VIII Iacobo Arago-
nie Sardinie et Corsice Re-
gi Illustri

Statum tuum semper
apud Urbemveterem non.
Iunii aᵒ 3ᵒ

Bulle an Hanf

 Ränder links
 und rechts ab-
 geschnitten

Bayer. Haupt. Staatsarchiv
 Würzburg n. 3509

P. ohne Nummer nach 1297 Iulii 18
 24546

Bonifatius VIII (non. univer. Mai.) ..
prioribus et Conventibus sororum
inclusarum Monasteriorum ordinis
sanct Augustini secundum instituta
et sub cura fratrum Predicatorum
viventium

 Laudabilis sacra religio
Dat. apud Urbemveterem XV. Kl. Aug.
anno Tertio

Bulle an Seide
In plica rechts : P. Set.
Sub plica links V̄

Instr. Mon. F. Dom. c. 50 1297 Iul. 18
 P 24546ᵃ p. 1964

Bon. VIII .. prioribus et conventibus
sororum inclusarum monasterio-
rum o. s. Aug. secundum instit.
et sub cura ord. fratr. Predicat.
viventium

Laudabilis sacra religio
apud Urbemveterem XV Kal. August
aᵒ 3ᵒ

Bulle an Seidenfäden

Sub plica links V̄

A tergo : predicatorum

In der ersten und zweiten Reihe
zu pressen.

4612

Firenze, S. Domenico nel Ma-
pag. 1964 glio
P. 24546ª 1297 Julii 18
Bonifatius VIII .. priorissis et
conventibus sororum inclusa-
rum monasteriorum ordi-
nis sancti Augustini secun-
dum instituta et sub cura fra-
trum Ord. Bed. viventium
 Laudabilis sacra religio
apud Urbemveterem XV kl.
 Augusti a° 3°
Bulle fehlt. Seide erhalten
In plica rechts pro She. Ri.
Sub plica links
Ecke oben links
Sub plica links unten
R̶ N. p H. pd

4613 (recto)

P. 24545 Arch. Nat. Paris
L 281 cap. 65 1297 Julii 18
Bon VIII .. priori et conventui
monasterii Montis Rubei per
priorem soliti gubernari OS
Guillermi Parisiis. diocesis
 Quia ex apostolica
Apud Urbemveterem XV kl.
 Augusti a° 3°
Bulle an Hauf
In plica rechts J de Ver.
Sub plica links
 M. de Adr. g
Sub plica links Bug durchschnitten
R̶ Jao Vrhyt
 H. Pad
 verte

4613 (verso)

Rand oben Mitte
dui ecct niut
 cfr
Ecke oben rechts R̶
a tergo J. de Ver not
 dui Tuscant
 R̶ capto CCCXXXVI
 dieselbe Form auch
 anno quarto

4614

Barcelona Corona de Aragon
 Leg. 21° n. 21°
 P.- 1297 Julii 22
Bonifatius VIII Jacobo Ara-
gonie Sardinie et Corsice Re-
gi Illustri
 Regiam cupientes noie
Apud Urbemveterem XI kl.
Augusti a° 3°
Bulle an Hanf
In plica rechts
 J. Cotin de Tur

4615

Barcelona Corona de Aragón
Leg. 21° n. 22°

P. — 1297 Julii 22

Bonifatius VIII Jacobo Arago-
nie Sardinie et Corsice Regi
Illustri

Dum inter alia

Apud Vrbemveterem XI Kl.
Augusti a° 3°

Bulle an Hanf

In plica rechts de Cur
O. Ser

4616

Firenze, Arte di mercatura
P. — 1297 Julii 30

Bonifatius VIII . — officiali
Avinionen.

Exhibita nobis dilectorum
Apud Vrbemveterem III Kl.
Aug. a° 3°

"Bulle und Hanf fehlen
In plica rechts a. med
Sub plica links X

Cameralis
Zu gunsten der Spini

Eingestellt 1397 Jul. 30

4617 (recto)

Paris Archives Nationales
J 684 n. 39

Breite 53.8 Rand links 4.2 rechts 4.5
Höhe 35.6 Rand oben 7.2 plica 3.7
Erste Linie für Oberlängen / Je
zwei Seitenlinien

P. vacat 1297 Augusti 9

Bonifatius VIII Magris Johanni
de Capriaco Archidiacon Rotho-
magen et Petro de Bellapertica
Autisiodoren ac qd Guillermo
de Cuspeyo Sancti Quintini in
Viromandia Noviomen dioc
canonicis ecclesi

Meruit sincera devotio
Dat apud Vrbemveterem V Jd
Augusti a° 3° vacat

4617 (verso)

Bulle an Hanf
In plica rechts : n. de frechi
Wüste fette deutliche Schrift

4618

Paris Archives Nationales
J 684 n. 39 bis.
Breite 54. Rand links 4.7 rechts 4.7
Höhe 32.7 Rand oben 7.1 plica 6.3
Erste Linie für Gitterschrift und
Oberlängen / Je zwei Seitenlinien

P. vacat **1297 Augusti 9**

Bonifatius VIII .. Carmo in xpo
filio .. Phy. Regi Francor\bar{u} Jllustri
Meruit sincera devotio
Dat apud Vrbemueterem V Jd.
Augusti / a° 3°

 Bulle an Seide
Jn plica rechts: N. de Gractis
Fette weite deutliche Schrift

4619

Paris Archives Nationales
J 684 n. 33
Breite 62.4 Rand links 5.3 rechts 5.
Höhe 44.9 Rand oben 10.8 plica 7.6.
Erste Linie für Oberlängen /
Je eine Seitenlinie

P. vacat **1297 Augusti 12**

Bonifatius VIII Morino Urbe-
rum et .. Dolen ac .. Antisiodo-
ren Epis
Considerantes attentius eximie
Dat apud Vrbemueterem II Jd.
Augusti a° 3°

 Bulle an Hanf
 Jn plica rechts: J. Cotin
A tergo oben Eckelinks : . C.
Fette etwas unruhige Schrift

4620

Bayer. Haupt- Staatsarchiv
Bamberg fasc. 37

p. 24563 1297 Augusti 13
Bonifatius VIII .. Epo. Ratisponen
 Ad audientiam nostram
Apud Vrbemueterem Jd. August.
 Anno Tertio

Bulle an dickem Hanf
 Jn plica rechts : J. P.
 Sub plica links : —
Breite Ränder. Zwei Zeilen frei. Sei-
tenlinien. Grosse Schrift, engere
Zeilenabstände, wie bei Mandaten

 Mandat : 41.3 × 29.1
 plica : 6.4
Runde fast grau verbundene Schrift

4621

Barcelona Corona de Aragón
P. — Leg. 21° n. 23°
1297 Sept. 4 **Clausa**
Bonifatius VIII Jacobo Ara-
gonie Sardinie et Corsice
Regi Jllustri
Veniens nuper ad
Apud Vrbemueterem II non
Sept. a° 3°
Bulle und Hanf fehlen
Durch die kleine plica gehen
Zwei Löcher. Ob zuerst clausa
und dann patens?

 die Ränder
 oben und un-
 ten sind ab-
 geschnitten

4622

Arm. C fasc. 47 cap. 3
P. 24586 1297 Sept. 4
Bon. VIII nobili viro Landulpho
de Columpna civi Romano
 Ut depressio et
Apud Urbemveterem ✠ non.
Septembris a° 3°
 Bulle an Hanf
 In pl. recht. Mine
 de Cur

4623

Archives Départem. Marseille
B 400
P. — 1297 Septembris 13
Bonifatius VIII . . Nemausen
et . . Vivarien. epis
 Ina nobis venerabilis
Apud Vrbemveterem iu. Sep.
tembris a° 3°
 Bulle an Hanf
 In plica. rechts Jo Gaut
 Sub plica links ≡

4624

Marseille Archives Départem.
B 400
P. — 1297 Septembris 13
Bonifatius VIII . . Nemausen.
et . . vivarien. epis
 Ina nobis venerabilis
Apud Vrbem veterem iu.
 Septembris a° 3°
 Bulle an Hanf
 In plica rechts Sy. J.
 Sub plica links ≡
 H. Pad. ☺ nur
R. Ja. de Gaut | Ecke oben links
 H. Pad | L nur Ø η
Ecke oben rechts R✠
A tergo oben Mitte Blein

 R✠ capl. CCCC LX

4625

Arm. C fasc. 47 cap. 4
P. 24578 1297 Sept. 29
Bon. VIII nobili viro Pandulpho
de Sabello senatori et populo
Urbis
Romanum populum peculiari
Apud urbemveterem III Kl.
 Octobris a° 3°
 Bulle an Hanfschnur; plica
eingerissen
 In plica rechts: de Curia

4626

Bayer. Hauptst. Staatsarchiv
Niederviehbach fasc. 5
P. ohne Nummer
nach 24580 <u>1297 Octobris 13</u>

Bonifatius VIII Dil. in xpo filia-
bus... priorisse et Conventui Mo-
nasterii de Viethpac pu prio-
rissam soliti ordinis
sancti Augustini Ratisponen
dioc. Cum a nobis
apud Urbemveterem III Jd. Octo-
bris anno Tertio

Gutgeprägte Bulle an mitteldicker
Seide
In plica rechts : O. Ser.

Sub plica links S

 m. de adr.

Je zwei Seitenlinien

4627

Arm. C fasc. 47 cap. 1
P. 24599 1297 nov. 27
Bonifatius VIII ad certitudinem
presentium et memoriam futu-
rorum

Locum dei licet

Actum Rome apud Sanctum
Petrum in minori aula pala
tii nostri V kl. Decembris p. n.
a° 3°

Bulle an Seidenfäden
Impl. rechts : G de Curia
 Sy. Aretin

Ecke oben rechts : R

4628

Barcelona Corona de Aragón
 Leg. 21° n. 24°
 P. — <u>1297 Decembris 13</u>
Bonifatius VIII Jacobo Aragon
Sardinie et Corsice Regi Illustri
Supplicante nuper nobis
Rome apud sem Petrum
iu. Dec. a° 3°
Bulle an Hanf
In plica rechts G. Aglen
Sub plica links V
 H. Pad

4629

Barcelona Corona de Aragón
 Leg. 21° n. 280
 P. — <u>1297 Decembris 18</u>
Bonifatius VIII ad certitudi-
nem presentium et memo-
riam futurorum
Intendentes abolire ad
Rome apud Sanctum Pe-
trum XV kl. Januarii a° 3°
Bulle und Seide fehlen
In plica rechts p. Reat
Sub plica links L x
Ecke oben rechts R
A. tergo oben mitte klein

 R capto D. XIII

4630

Barcelona Corona de Aragón
Leg. 21° n. 1°
Clausa
P. —
1297 Decembris 30
Bonifatius VIII Jacobo Arago-
nie Sardinie et Corsice Regi
Illustri
Dilectum filium nobilem
Rome apud Sanctum Petrum
III Kl. Jan. a° 3°
Bulle an Hanf

Ränder und Lö-
cher oben und
unten abge-
schnitten

4631

Public Record Office London
Papal Bulls bundle 8 n. 7
Clausa
P. —
1298 Januarii 15
Bonifatius VIII Eduardo regi An-
glie illustri
Regalis excellentie litteras
Lateran. XVIII kel. Febr. a° 4°
Bulle an Hanf

4632

Barcelona Corona de Aragón
Leg. 20° n. 10
P. —
1298 Januarii 29
Bonifatius VIII B. Barchinon.
et A. Dertusien. Epis
dudum per nostras
Rome apud Sanctum Pe-
trum III Kl. febr. a° 4°
Bulle fehlt. Schnur erhalten
In plica rechts G. de Sang.
Sub plica link
 ═
 x

 6. Ser.
Ecke oben rechts Rf
A tergo oben etwas rechts klein

R[Captlo ? VII
 nicht mehr
 Captlo unten tho

4633 (recto)

Datum Rf
Paris Archives nationales
J 684 n. 33 bis
Breite 74.3 Rand links 4.6 rechts 4.5
Höhe 48.4 Rand oben 10 plica 6.1
Erste Linie für Oberlängen /
Je zwei Seitenlinien.
P. vacat 1298 Februarii 9
Bonifatius VIII .. Archiepo Urbo
nen et .. Dolen ac .. Antisio
doren Epis
 Pridem Carissimi in
Dat Rome apud Sem Petrum V
Jd Februarii a° 4°
V Jd Febr. ist nachgetragen
Bulle an Hanf
 In plica rechts: p. Cen
 vacat

4633 (verso)

Sub plica links : v
× ×
J. Laur.

Ecke oben rechts : R/
A tergo oben mitte klein

R/. Capllo XXXXI

Weite grosse regelm. Schrift

4634 (recto)

R/

Paris Archives Nationales
J 684 n. 33 See
Breite 63.3 Rand links 4.7 rechts 4.8
Höhe 41.6 Rand oben 8.3 plica 7.1
Erste Linie für Oberlängen
Je eine Sextulinie
P. vacat 1298 Februarii 22

Bonifatius VIII . . Archiepo Nar-
bonen et .. Dolen ac . . Ott An-
tisiodoren Epis

Volentes hactenus carissime
Dat Rome apud Scm Petrum VIII
Kl Martij / a° 4°

Bulle an Strch

In plica rechts : Jm. de Rocca
Sub plica links : ×
J. Laur. verte

4634 (verso)

Ecke oben rechts : R/
A tergo oben mitte klein

R/. Capllo XXXIII

Jede weite deutliche Schrift

4635 (recto)

Arch. Arcis
Arm. III cap. 2 cap. 62
P. — 1298 Martii 7

Bonifacius VIII .. potestati consilii
grosse dicke Gitter. et communi Asisinat
Aplice sedis circumspecta
Rome apud S. Petrum non. Mar-
tii a° 4°

Bulle an feinen Seidenfäden

In pl. rechts : . N. p.
Sub pl. links : o. ×. See
Auf dem Bug links : R/ M. de Adr.
O. See

" " mitte ausgestrichen :
hizer N. p. restituas notas quia ego
O. See habeo pecuniam verte
Ecke oben rechts : Ca R/

Zellerische Cameralaqui auf dem
Rand und auf dem plica
A tergo oben:
 N. de Vico

Intr. non. T. Dom. c. 1298 Apr. 22
 38 P. 24 665

Bon. VIII .. epo Senen.
Sua nobis dilecti
Rome ap. S. P. X bal. maii a° 40
Bulle fehlt. dünne Hanfschnur Rest
vorhanden
In plica rechts: Jac. G.
Ecke links oben: δ OL
 " rechts " : Pt
In plica halblinks: Epo Agennen.
 In provincia provinci
 Epo Cesaraugustan
 in provincia
Sub plica links: V̄
 .X.
 O. Ser
 durchstrichen
Auf Bug links: Zweiteil abgeklatscht
R G. Set I pro a. de Real (?)
 O Ser
R m Roet I R m Roet I
O. Ser. O Ser.
R Jo Pip I A tergo: | N. Waldini |
O. Ser. R cap110 CXL

Napoli Curia Eccles. Vol. 3°
P. — 1298 Maii 19
Bonifatius VIII Panerino ab-
bati et conventui mon. Sce Ma-
rie de Gualdo ad RE. n. m. per-
tinentis OSB. Beneventan. dioc.
Sanberimus aplice sedis
Rome apud Sanctum Pe-
trum XIII kl. Iunii a° 40
Bulle nur Seide fehlen
Plica abgeschnitten
Sub plica links X 9
Ecke oben links)
 Rand oben
 mitte dnus
 L sedi Thomas
 δ o card. misit

Napoli Curia Eccles. Vol. 3°
P. — 1298 Maii 19
Bonifatius VIII Panerino abbi
et conventui Sce Marie de Gual-
do ad Rom. Eccl. nullo medio
pert. OSB. Beneventan. dioc.
Sanberimus aplice sedis
Rome apud Scm Petrum XIII
kl. Iunii a° 40
Bulle nur Seide fehlen
In plica rechts Silu
Sub plica links X (X̄)
Ecke oben links)L
 δ o
 " " mitte dnus Thomas
card. misit

4639

Bayer. Haupt. Staatsarchiv
Herrenchiemsee fasc. 6
P. 24694ᵃ 1298 Junii 13
Bonifatius VIII .. Epo Augusten.
 Ad audientiam nostram
Rome apud Scm Petrum Id. Ju-
nij Anno Quarto

Bulle an Hanf
 In plica rechts : C. de Setia
Sub plica links : ⌐
 J. Laurof
 Ecke oben rechts XX
A tergo Ecke oben links : b

Ausgesprochener Vertreter der unsel-
nen Schrift dieses Papstes. Gar
eng zusammenhängend

Mandat : 33.9 × 25.0
 plica : 3.0

4640

Public Record Office London
Papal Bulls bundle 8 n. 4
P. 24 696 1298 Junii 17
Bonifatius VIII .. regi Scotie
illustri
Grande divine premiunm
Rome ap. S. Petrum XV kl. Julii aº 4º
 Bulle an Hanf
In plica rechts Dat G (C)
Sub plica links V̄
 J. × Laur
Rand oben Mitte cor
 Sxpl. dat
a tergo oben Mitte klein ohne Zahl

 R

4641

Public Record Office London
Papal Bulls bundle 7 n. 5
P. 24 707 1298 Junii 27
Bonifacius VIII universis presentes
litteras inspecturis
Quietem et pacem
Rome ap. S. Petrum V kl. Julii aº 4º
Bulle an Hanf
 In plica rechts O (?)
Sub plica links — — — —
 O V̄r

a tergo oben sehr dünn, klein, best

 R capitlo CCCC XVIIIº

4642

Public Record Office London
Papal Bulls bundle 6 n. 13
P. 24711 1298 Junii 30
Bonifacius VIII universis presen-
tes litteras inspecturis
Rome apud S. Petrum II kl. apr. aº 4º
 Bulle an Hanf
 In plica rechts O. Ser
Sub plica links V̄
 ×
 O. Ser.
A tergo oben Mitte, klein, dünn

 R capitlo CCCCXVIIº

4643

Public Record Office London
Papal Bulls bundle 6 n. 8
P. 24 713 1298 Junii 30
Bonifacius VIII Philippo Francie
et Eduardo Anglie regibus illustribus
Pronuntiationem quandam super
Rome apud S. Petrum II kl. Julii aᵒ 4ᵒ
Bulle und Seide fehlen
In plica links p. de Caf.
Sub plica links L xxx
 O. Ser

A tergo oben Mitte

R Capito CCC XXV ᵒ

4644

Public Record Office London
Papal Bulls bundle 7 n. 7
P- 1298 Julii 1
Bonifacius VIII Eduardo regi Anglie
 illustri

Dilecte in Xpo
Rome apud S. Petrum
 kl. Julii aᵒ 4ᵒ
 Bulle an Seide
In plica rechts Cosmas
Sub plica links x
 x
 O Ser.

Ganz unten
 R. p. asibit pro J. Laur.
 O Ser
Ecke oben links Ø. T.
 " " rechts 12

4645 (recto)

Sumpta de Registro
Paris Archives Nationales
 J 435 n. 11
Breite 7 9.5 Rand links 7.2 rechts 7.2
Höhe 54 Rand oben 10.9 plica 9.2
P. 24714 1298 Julii 1
Bonifatius VIII (Vex. Initiale Maj.)
nob viro Eduardo Eduardi Anglie ac
dil in Xpo filie nob Mulieri Isabelle
Philippi Francie Regum carissimorum
in Xpo filiorum nrorum natis
 Regis eterni mira
Dat Rome ap S.P. Kl Julij aᵒ 4ᵒ
Bulle an feiner Seide
In plica rechts : Jac Pip
 Sub plica links : N. de Tructis x
 x
Rand oben Mitte : Sumpta de Registro
A tergo oben Mitte : VT verte

4645 (verso)

Erste Linie für Maj und Oberlängen
Initiale sehr verziert
Weite Zeilenregelung. Schrift

4646 (recto)

Sumpta de Regestro

Paris Archives Nationales
 J 435 n. 12
Breite 79.8 Rand links 7.3 rechts 7.1
Höhe 55. Rand oben 10.3 plica 8.7
Erste Linie für Hrsg. und überhängus
Je zwei Seitenlinien

<u>P. 24714</u> <u>1298 Julii 1</u>

Bonifacius VIII (Maj.) Carmo in Xpo
filio Eduardo Regi Anglie Jllustri et
dil in Xpo filie Nob mulieri Margarete
nate clare mem. Philippi Regis Franco-
rum

 Regis eterni mira
Dat Rome ap St. Kl Julij a° 4°
Bulle an feiner Seide
In plica rechts : Jo. prip
Sub plica links †
 N. de Fractis verte

4646 (verso)

Rand oben Mitte :
 Sumpta de Regestro
A tergo oben Mitte : A

4647

Public Record Office London
Papal bulls bundle 7 n. 13
 Clausa
P— 1298 Julii 10
Bonifacius VIII Eduardo regi
Anglie illustri
Si missa patris
Rome ap. S. Petrum VI id. Julii a° 4°
 Bulle an Hanf
A tergo links unten
 N de Fractis

4648

Instr. Misc. 1296-1300 cap. 20
 P. — 1298 Julii 15
Bonif. VIII epis ac electis, abbatibus
etc. per patrimonium beati Petri
in Tuscia constitutis
 Dum imbecillitatis humane
Rome apud St. id. Julii a° 4°
Bulle und Hauf fehlen
In plica rechts : de Curia
 P. Ascubelis
Ecke oben rechts : Ca Pf
A tergo h. de Vico

4649

Public Record Office London
Papal Bulls bundle 7 n. 16
P. 24 737 1298 Octobris 5
Bonifatius VIII E. regi Anglie illustri
Carissimi in Christo
Reate III non. Oct. aᵒ 4ᵒ
 Bulle an Hanf.
In plica rechts G. de Sang
Sub plica links V̄ .
 O. Ser
ganz unten X p. G
Ecke oben links ♂ O O Ser
 " " rechts R
A tergo klein ohne Zahl

4650

Bayer. Haupt. Staatsarchiv
Regensburg St. Gutrud n. 3
P. 24747ˣ 1298 Novembris 3
Bonifatius VIII .. decano ecclie Augustensis.
 Sua nobis dilecti
Reate II non Novembris anno Quarto
Bulle an dunnem Hanf
In plica rechts : N. de Vetix
Sub plica links : z
 g. Aquilen
Rand oben halbrechts :
 X non cadit communio'
 ∞∞
Aus dem Inhalt ergibt sich kein Anhalts
punkt, der diese Bemerkung verständ
lich machen könnte
Ecke oben rechts : X
A tergo Ecke oben links : b

 Mandat : 32.8 × 20. 6
 plica : 3.8
Zwei Wörte ausradirt; die Lücke ist durch
einfachen Strich ausgefüllt

4651

Poitiers Archives Départem.
Ordre de Malte
P. — 1298 Novembris 6
Bonifatius VIII magno et fribus
domus Militie Templi Ierosol
 Cum a nobis
Reate VIII iꝰ Nov. aᵒ 4ᵒ
Bulle und Seide fehlen
In plica rechts unleserlich
fette kleine Schrift. Unterlänge
verjüngen sich etwas bei f und s
p und j
Ecke oben links L rechts X ?

4652

Barcelona Corona de Aragón
Pro Curia Leg. 22ᵒ n. 3ᵒ
P. — 1298 Novembris 17
Bonifatius VIII Jacobo Regi
Aragon. Illustri
Hüs que transmisse
Reate XV Kl. Dec. aᵒ 4ᵒ
Bulle und Hanf ausgerissen
In plica rechts
 p. G. pro Cur

4653

Arch. Arcis
Arm. C fasc. S cap. 4
P. — 1298 novembris 25
Bon. VIII nobili viro Ragnaldo
de Lupino militi familiari
nostro
Nobilitati tue per
Reate VII kl. Dec. a° 4°
Bulle au Hanf
In pl. rechts : Blasius de Anagnia
 de Curia

Sub pl. (Bug) links :
R/ B de Anagnia de Cur
 Q (?) Vir (?)
 wohl O. Ser.

4654

Barcelona Corona de Aragón
 Leg. 22° n. 2°
 P. — 1298 novembr. 28
Bonifatius VIII .. priori sancte
Eulalie Barchinonen.
Dilectorum filiorum .. pre-
 ceptoris
Reate III kl. Dec. a° 4°
Bulle au Hanf
In plica rechts :-) F

Ecke oben rechts X

 ganz kleines
 Mandat

4655 (recto)

(Taxen)

Paris Archives Nationales
 J 690 n. 132 (28)
Breite 59,5 Rand links 7,1 rechts 7,5
Höhe 30. Rand oben .. plica 6,9
Erste Linie für Maj und Oberlän-
gen, Je zwei Zeilenlinien
 P. vacat 1298 Decembris 20
Bonifatius VIII (vez. Maj) Carmo
in xpo filio . Phy. Regi Francie
Jllustri
 Libenter illam tibi
Dat Laterani XIII kl Januar /a° 4°
Bulle au Seide
In plica rechts : pro N. de Setia
Sub plica links : =
 G. Aglen (verte

4655 (verso)

In plica links :
Item pro scriptura tür VI
Item 1 flor pro bullis

A tergo oben mitte : N. de F.

Große sehr fette . sehr weite
schöne Schrift

4656

Paris Arch. Nat.

J 702 cap. 127 1298 Dec. 29
Clausa

Breite Ränder

Bon. VIII Phylippo
regi Francie illustri

Venientes ad apostolicam

Laterani IIII Kl. Jan. a° 4°

P. 24754

4657

Paris Arch. Nat.

J 702 cap. 130 1298 Dec. 29
Clausa

Breite Ränder.

Bon. VIII Phy regi
Francie illustri

Pridem celsitudini regie

Laterani IIII Kl. Januarii
a° 4°

P. 24755

4658

Barcelona Corona de Aragón
Leg. 22° n. 40

Sehr breite _Clausa_
1299 Januarii 15

P. —

Bon Fatius VIII Jacobo Arago-
nie Regi Illustri

Adhibe fili quesumus

Laterani. XVIII Kl. febr. a° 5°

Bulle an Hanf
Ränder und Löcher abge-
schnitten

76 cm breit.

25 Zeilen

4659

Bayer. Hpript. Staatsarchiv
Regensburg Augustiner fasc. 10

P. 24767 1299 Januarii 21

Bonifatius VIII. — Priori Generali
et universis prioribus et fratribus
ordinis Heremitarum sancti au-
gustini tam presentibus quam fu-
turis religiosam vitam professis

Sacer ordo vester

Laterani. XII Kl. februarij Anno
Quinto

Bulle an feiner Seide
In plica rechts : J. de fractis
Sub plica links : ✗

Weitgelagerte kleine Schrift.
Aussergewöhnlich breite Ränder über-
all. Zwei Seitenlinien

Duplicat.

4660

Bayr. Hpt. Staatsarchiv
Regensburg Augustiner fasc. 10

P. 2 + 7 6 7 1299 Januarii 21

Bonifatius VIII (Gitterschrift) .. priori
Generali et universis Prioribus et
fratribus ordinis Heremitarum
sancti Augustini tam presentibus
quam futuris religiosam vitam pro-
fessis Sacer ordo vester
Lateran. XII kl. februarij Anno
Quarto

Bulle an feiner Seide
In plica rechts : G. de Setia
 Sub plica links : X

Größte Raumverschwendung.

 Duplicat

4661

Firenze, Camaldoli
· P. 24770 1299 Januarii 27
Bonifatius VIII .. epo Aretin.
Ad audientiam nostram
Lateran. VI kl. febr. aº 5º
 Bulle und Hanf fehlen
In plica rechts E de Setia
 Sub plica links S
 N · de Frabis

4662

Instr. mon. T. dom. c. 9 1299 mart. 23
 P. 24 803
Devotorum vota que
Seidenfäden. Bulle fehlt.
In plica rechts : P. G. Septr.
Sub plica links : V / X
A tergo : Dni vicecomitis und
 N. de Vico

Rx capto LXXXI

4663

Public Record Office London
Papal Bulls bundle 8 n. 6
 Clausa

P. 24 801 1299 Martii 23
Bonifacius VIII E. regi Anglie
illustri
 Movet nos fili
Lateran. 8 kl Aprilis aº 5º
 Bulle an Hanf

4664

Bayer. Haupt. Staatsarchiv
Bamberg fasc. 34

P. 24810ˣ 1299 Aprilis 1

Bonifatius VIII .. Abbati Monasterii
Montis Monachorum prope muros
Bambergen.
 Dilectorum filiorum Capituli
Lateran. Pl. Aprilis Anno Quinto

Bulle an dickem Hanf
In plica links: Jo. Pon

Rand oben rechts: cor
 Ecke rechts: X

Mandat: 21.7 × 16
 plica: 3.2

Steile, nicht runde Schrift

4665

Firense, Badia di Ripoli
P. — 1299 Aprilis 5

Bonifatius VIII .. priori sci Petri
Piccoli Aretin.

 Conquesti sunt nobis
Lateran. non. Apr. a° 5°

 Bulle und Hanf fehlen
In plica rechts m. de Rocca

Ecke oben rechts X
 19. 2 loch
 3. 5 plica
 28. 9 breit

Gewöhnliche dicke, nur ver
hältnismässig niedrigere
Schrift.

4666

Arch. Arcis
Arm. C fasc. 23 cap. 6
 P. 24826ˣ 1299 Iunii 3
Bon. VIII mag. Mathie de Thea
te camere nostro clerico co
mitatus Venaysin. rectori
 Et si exigente
Anagnie III non. Iunii a° 5°
 Bulle und Hanf ausgerissen
In pl. rechts: h Ver
 de Cur

4667

Bull. Gen. I Cap. 31
 P. 24828 1299 Iunii 3
Bon. VIII epis et electis abba
bus etc. per terram Venaysin.
constitutis
 Et si exigente
Anagnie III non. Iunii a° 5°
Hanf. Bulle fehlt.
Rechter Rand abgeschnitten

4668

Bull. Gen. I cap. 32
P. 24827 1299 Iunii 3
Bon VIII universis baronibus
etc. per terram Venaysin. con
stitutis
 Et si exigente
Anagnie III non. Iunii a° 5°
Transf. Bulle fehlt.
In pl. rechts: h. Ver

4669

Bull. Gen. I cap. 33
P. (24828-31) 1299 Iunii 4
Bon. VIII mag. Mathео de Theate
camere nre clerico comitis-
bus Venaysin rectori
 Et si exigente
Anagnie III non. Iunii a° 5°
Plica nur rechter Rand abgesch.

4670

Bull. Gen. I Sap. 34
P. 24853 1299 Iulii 1
Bonifatius VIII communi et
gr. tell cus sill. singularibus per-
sonis civitatis Papalis
 Aphce sedis circumspecta
Anagnie Dat Iulii a° 5°
Seidenfaden - Bulle fehlt.
Rechter Rand abgeschnitten
Sub pl. links:
R . n. par. pro recompensatione
 M. de Adr.
a tergo oben Mitte:
 vicecamerarius
Ecke vorne oben links

4671

Public Record Office London
Papal Bulls bundle 7 n. 18
 Clausa
P. 24869 1299 Iulii 29
Bonifatius VIII Edwardo regi
Anglie illustri
Laterano Letamur admodum fili
Anagnie IIII kel. Aug. a° 5°
 Bulle an Hanf
a tergo unten links umgekl.
 h. de Fractis

4672

Firenze, Rocchettini di
Fiesole
P. 24878 1299 Septembris 3
BONIFATIVS VIII [Rest Gitterschrift]
ad perpetuam rei mem.
Romane ecclesie que
Trebis III non. Sept. a° 5°
Bulle, Seide, plica fehlen
Sub plica links ū
 ×
Ecke oben rechts 24

4673

Public Record Office London
Papal Bulls bundle 6 n. 20
 Clausa
P. 24879 1299 Septembris 11
Bonifatius VIII E. regi Anglie
illustri
 Dum habuerimus ad
Dat. Trebis III id. Sept. a° 5°
 Bulle an Hanf
ganz unten Ecke rechts
 n. de Fractis
 rechts, oben, links breite Ränder
 unten sehr breiter Rand

4674

Public Record Office London
Papal Bulls bundle 6 n. 17
 Clausa
P. 24886 1299 Novembris 14
Bonifatius VIII E. regi Anglie
illustri
Veniens ad apostolicam
Lateran. XVIII kl. Dec. a° 5°
 Bulle an Hanf
A tergo unten links umgekehrt
(also in plica rechts) nichts

4675

Instr. misc. 1296 · 1300 cap. 36
 18
 P. 24913 1300 februarii 14
Bonif VIII ad perpetuam rei mem.
Super cathedram preeminentie
Laterani XII kal. Marcii a° 6°
Bulle und Seide ausgerissen
Rechts und links zerfressen und
Löcher
In plica links: Iac Bar pro domi-
no vicecancellario
 clericus
A tergo: Boninus III ... rus
 dni vicecancellarii

4676

P. — Paris Arch. Nat.
L 284 cap. 90 1300 Martii 9
Bon VIII Johanni tit. SS. Mar-
cellini et Petri presb. card.
olim bone memorie
Laterani VII id. Martii a° 6°
Bulle an Hanf
In plica rechts B de Sugio g(u)
pro dno suo card
Sub plica links c)
Rand oben mitte
I card de mau dñs
A tergo
+ B de Sugio pro dno suo card

4677

Madrid Arch. Histor. Nacional
Poblet E 4. oront
P. —
1300 Martii 10
Bonifatius VIII .. priori de Sancto
Paulo extra muros Barchinon.
Conquesti sunt nobis
Lateran. VI id. Martii a° 6°
Bulle und Hanf fehlen
In plica rechts p. Aout
Rand oben
Ecke oben rechts XX

4678

P. — Paris Arch. Nat.
L 284 cap. 91 bis 1300 Martii 11
Bon VIII .. epo horoiomen. et ma-
gistris Bertando electo Aure-
lianen. ac Jacobo Normanni
archidiacono ecclesie Narto-
nen.
Exposuit nobis dilectus
Laterani V id. Martii a° 6°
Bulle an Hanf
In plica rechts: B de Sugio g(u)
de mau dñi sui card
Sub plica Aug bei Bulle
asct per Jac de Vico ?
A tergo Villa regia und
pro persona dñi sui card
cap. 91 quater ungefähr ds.
91 selbe

4679

P. — Paris Arch. Nat.
L 284 cap. 91 ter 1300 Martii 11
Bon VIII .. epo horoiomen. et ma-
gistris Bertando electo Aurelia-
nen. ac Jacobo Normanni ar-
chidiacono ecclesie Narbonen.
Exposuit nobis dilectus
Laterani V id. Martii a° 6°
Bulle an Hanf
In plica rechts B. de Sugio g(u) pro
dño suo card
Sub plica links)
Ecke oben links L
Rand oben mitte I card de mau dñs
A tergo Villaregia

4680

Madrid Arch. Histór. Nacional
P. — Poblet C n. vacat
 1300 Martii 18
Bonifatius VIII .. precentori ec-
clie Terraconen.
Conquesti sunt nobis
Lateran XV Kl. Aprilis a° 6°
Bulle und Hanf fehlen
In plica rechts Angls Rom̄
Ecke oben rechts ✗

4681

Public Record Office London
Papal Bulls bundle 6 n. 7
 Clausa
P. 24937 1300 Aprilis 7
Bonifacius VIII Edwardo regi
Anglie illustri
 Nova grandia fili
Lateran. VII id Apr. a° 6°
 Bulle und Hanf fehlen
Auf allen vier Seiten breite Ränder

a tergo links
unten umgekehrt
 J. F. de Cur.

Plica war schon gemacht
und der Scriptorname stand loco
solito. Dagegen war die Urkunde noch
nicht more solito bulliert.

4682

Barcelona Corona de Aragón
P. — Leg. 22° n. 5°
 1300 Aprilis 11
Bonifatius VIII Jacobo Regi
Aragonum Illustri
Inter ceteros regularis
Lateran. III id. Aprilis a° 6°
Bulle an Hanf
In plica rechts Jac de Roca
Sub plica links ≡

4683

Barcelona Corona de Aragón
℞ P. — Leg. 22 n. 6
 1300 Aprilis 28
Bonifatius VIII cmo in xpo filio
nro [auf Rasur eingefügt] Jaco-
bo Regi Aragonum illustri
Paterna fiducia quam
Anagnie III Kl. Maii a° 6°
Bulle und Hanf fehlen
In plica rechts N. Leonardi
Sub plica links v̄
 O. Ser

A tergo oben mitte klein
℞ ohne Copi-
 Felsangabe

4684

Arch. Arcis
Arm. XIII cap. 2 cap. 1
P. 24953 1300 Maii 13
Bon. VIII .. duci Saxonie
Apostolica sedes divinitus
Anagnie III idus Maii a° 6°
Bulle an Hanpschnur
In plica rechts:
Jo. Pon̄ de Cur̄

4685

Barcelona Corona de Aragón
 Leg. 20° n. 70
P. — 1300 Maii 15
Bonifatius VIII Jacobo Regi
Aragonie Illustri
Dilectum filium fratrem
Anagnie Id. Maii a° 6°
Bulle an Hanf
In plica rechts
N. Leonardi de Cur̄

4686

Instr. mon. F. Dom. C. 10 1300 (1290) Maii 26
 P. 24959
Bon. VIII .. mag. et fratribus ord. Predic.
nuper ut discordie
Anagnie VII Kal. Iunii a° 6°
Bulle fehlt. Seidenfäden.
In plica rechts: J. de Ver
In plica mitte : +
A tergo : predicatorum
 Duplicat

cap. 65 Dickere Seide. Bulle fehlt.
In plica rechts: N. G.
Sub plica links : x̄ A tergo : predicat.
 Triplicat

cap. 5. Bulle an dickerer Seidenfäden
In plica rechts: N. G
Sub plica links x̄ A tergo: Predicat.

4687

Carcassonne Archives départem.
H . 318

P. 24958? 1300 Maii 26
Bonifatius VIII . . magistro et fra-
tribus ordinis Predicatorum
nuper ut discordie
Anagnie VII Kal. Iunii a° 6°
Bulle an Seide
In plica rechts N. de Fractis
Sub plica rechts x̄

4688 (recto)

Paris Archives Nationales
J 435 n. 13
Breite 71.6 Rand links 6.3 rechts 6.3
Höhe 43.1 Rand oben 8.4 plica 7.1
Erste Linie für Gitterschrift nur Ober-
längen / Je zwei Seitenlinien
P. vacat 1300 Augusti 4
Bonifatius VIII (Gitterschrift) Johanni
Arturis primogeniti Johannis du-
cis Britanie et Dil in xpo filie
Ysabelli Caroli Andegavie Comitis
dilectorum filiorum Nobilium viro-
rum natis
 Romani Pontificis precellens
Dat Anagnie II non Augusti a° 6°
Bulle an feiner Seide
In plica rechts : Pro O Ser
 J. F. Crete

4688 (verso)

Sub plica links : xx
Ecke oben rechts : Rx
à tergo : N de Vico
ohne Rx - Zeichen

4689

P. — Paris Arch. nat.
J 723 ap. 8² 1300 Aug. 4
Bon VIII R. Vicentin aposto-
lice sedis nuntio, .. Ambia-
nen. et .. Autisiodoren. epis
 Dudum vobis duximus
Anagnie II non. Aug. a° 6°
Bulle an Hanf
In plica rechts P Acutf
Sub plica links X
 O. Ser

Ecke oben rechts Rx

A tergo N de Vico
 R· ccxv·
 Rx

4690

Public Record Office London
Papal Bulls bundle 7 n. 11
 Clausa
P. 24974 1300 Augusti 24
Bonifatius VIII E. regi Anglie
illustri
Venerabilem fratrem nostrum
Sculcule VIII kl. Sept. a° 6°
 Breite Ränder
 Bulle an Hanf

4691

Bayr. Haupt. Staatsarchiv
Kl. Steingaden fasc. 15

P. vacat 1300 Octobris 1

Bonifatius VIII (Gitterschrift) .
Abbati et Conventui Monasterii
in Steingaden Premonstratensis
ordinis Augusten. dioc.

Cum a nobis petitur
~~Anasia~~ Anagnie Kl. octobris
anno ~~sexto~~

Bulle an Seide
 In plica rechts : M. Leonardi
Sub plica links :
 M. Ric

Fast die Hälfte der letzten Zeile ist
freigeblieben. Die Urkunde ist von
der Ausgabe nicht durchgesehen
worden.

4692

Barcelona Girona de Aragón
 Leg. 22° n. 8°
 P. —
 1300 Octobris 1
Bonifatius VIII Jacobo Regi Ara-
gonum Illustri
 Grata et utilia
Anagnie Kl. Octobris a° 6°
Bulle an Hanf
In plica rechts
 g— de mandato
 dñi Landulfi card
 Silvest S
Sub plica links g)

 Rogerius de Loria

4693

Instr. Misc. 1296-1300 cap. 40
 P — 1300 Oct. 23
Bonif. VIII nobilibus viris Urso et Gen-
tili de filiis Ursi de Urbe
ne nimis excrescat.
Laterani X Kal. Nov. a° 6°
Bulle und Hanf fehlen
In plica rechts : G. de Sang
 de Curia

4694

Paris Archives Nationales
 J 435 n. 14
Breite 72.5 Rand links 5.4 rechts 5.8
Höhe 50.1 Rand oben 10. plica 7.5
Erste Linie für Oberlängen / Gitter-
schrift ist höher / Je 2 Zeilenlinien
P. vacat 1300 Octobris 31
 Bonifatius VIII (Gitterschr.) Carmo in xpo
filio Phy. Regi Francorum Illustri et
Dil filio Nob viro Roberto Duci Burgun-
die
 Regis eterni mira
Dat Laterani / IP Kl Novembr a°6°
Bulle an Seide
 In plica rechts :. P. Gen.
 Sub plica links : X
a tergo oben Mitte : N. de Vico
Sehr schöne weite grosse Schr.

4695

Instr. misc. 1296 – 1300 cap. 14

P. — 1300 nov. 30

Bonif. VIII .. epo Lucan.

hupa ad nostrum

Laterani π kal. decembris a° 6°

Bulle und Hanf fehlen.

In plica rechts: de Curia

 O. Ser.

4696

Paris Archives Nationales
 J 449 n. 121

Erste Linie über Ohrlingen /

Je drei Seitenlinien

P. vacat 1301 februarii 11

Bonifatius VIII Carmo in Xpo

filio Phylippo Regi Francorum

Illustri

 Celsitudinis tue grata

Dat Lateran π Jd februar

a° 7°

Bulle an dicken Hanf,

In plica rechts: p. Sct

Sub plica links: XXXX

 m. Rott

A tergo oben mitte : n. de Vico

Weite fette regelm Schrift

4697

Public Record Office London
 Papal Bulls bundle 6 n. 15
 Clausa

 P. 25 015 1301 Februarii 22

Bonifacius VIII Eduardo regi Anglie
 illustri

 Celsitudinis tue nuntios

 Laterani VIII kl. Martii a° 7°

 Bulle an Hanf

Sehr breite Ränder auf allen vier Seiten

A tergo unten links, umgekehrt

(also in plica rechts)

 U. Leonardi

4698

Arch. Arcis

Arm. IX caps. 7 cap. 8

 P. — 1301 febr. 24

Bonif. VIII .. abbati monasterii

S. Iohannis iuxta Ambianum

ac Thome de Pabiano archidia-

cono Cameracen.

 Petitio dilecti filii

 Laterani VI kl. martii a° 7°

 Bulle an Hanf

In pl. rechts :

Q de mandato, dni vicecancellarii dni

 Adenulphi

Ecke oben links : E. m. a

daneben odr ; rechts : sapt

A tergo mitte oben :

Mag. Reinaldus de Frohis

4699

Barcelona Corona de Aragón
Leg. 22° n. 9°
P. — 1301 februarii 26
Bonifatius VIII Jacobo Aragonie
Regi Illustri
Habet facta nobis
Laterani. IIII kl. Martii a° 7°
Bulle an Hanf
In plica rechts N. de Trottis
de Cur

4700

Barcelona Corona de Aragón
Leg. 22° n. 9°
P. — 1301 februarii 26
Bonifatius VIII Jacobo Arago-
nie Regi Illustri
Habet facta nobis
Laterani. IIII kl. Martii a° 7°
Bulle an Hanf
Ohne alle Notizen.

4701

Public Record Office London
Papal Bulls bundle 7 n. 10
Clausa
P. 25018 1301 Februarii 26
Bonifatius VIII Eduardo regi
Anglie illustri
Confodimur anxietatibus et
Lateran IIII kel. Martii a° 7°
Bulle an Hanf
a tergo unten links umgekehrt
(also in plica rechts
de Cur
Jac. G

4702 (recto)

Paris Archives Nationales
) 435 n. 16
Breite 67.9 Rand links 6.7 rechts 6.1
Höhe 46.6 Rand oben 10. plica 7.5
Erste Linie für Gitterschr und Ober-
längen / Je zwei Zeilenlinien
P. vacat 1301. Februarii 28
Bonifatius VIII (Gitterschr) Nob vir
Ludovico nato clare memorie Phi-
lippi Regis Franco & Comiti Ebroi
Ebroicen et dil in xpo filie Nob Mu-
lieri Margarete nate quondam Phi-
lippi filij Nob Viri Roberti Comitis
Atrebaten
Cum summus Pontifex
dat Lateran IJ kl Martij / a° 7°
Bulle an Seide
rvit

4702 (verso)

In plica rechts: Jac. G
Sub plica links: v̄
x
m. R
a tergo oben Mitte:
N. de Vico
R̃ VI

Fehlt grössere regelm. Schrift

4703

Public Record Office London
Papal Bulls bundle 6 n. 1
P. 25 025 1301 Martii 1
Bonifacius VIII Eduardo regi Anglie illustri.
Personam tuam devotione
Lateran. kl. Marcii a° 7°
Bulle m. Seide ausgerissen
In plica rechts N. Leonardi
Sub plica links v̄
m Rac

Ecke oben rechts ſ. oben links
Rand oben Mitte dns eps Burgen.
per N. de Vico. Der letztere war Agent
(Procurator) steht auch a tergo

a tergo oben Mitte klein und dünn,
etwas breit

R̃ LXXI

4704

Public Record Office London
Papal Bulls bundle 6 n. 12
P. 25 024 1301 Martii 1
Bonifatius VIII Eduardo regi
Anglie illustri
Dignum arbitramur et
Lateran. kl. Martii a° 7°
Bulle an Seide
In plica rechts N. Leonardi
Sub plica links ≡
v̄
m Rac
ɔi
Ecke oben links ſ. rechts R̃
Rand oben Mitte copr
darüber dns eps Burgen. per
N. de Vico
A tergo oben N. de Vico
R̃ LXXII

4705

Madrid Arch. Histor. Nacional
Santander Liébana 3 E
P. — 1301 Martii 17
Bonifatius VIII. - abbi monast.
S. Ysidori Legionen.
Conquesti sunt nobis
Lateran. xvi kl. aprilis a° 7°
Bulle und Hanf fehlen
In plica rechts Jo. fulg
Rand oben Mitte at
Ecke oben rechts R̃

Kleine Urkunde mit verhält-
nismässig kleinen Rändern
Schöne Schrift

4706

Public Record Office London
Papal Bulls bundle 6 n° 6
R ohne Zahl
P. 25030 1301 Martii 18
Bonifatius VIII - - regi
Anglie illustri
Audito erga Romanam
Lateran. XV kl. Aprilis a° 7°
Bulle und Hanf ausgerissen
In plica rechts de Cur
 P. Reat
Sub plica links
Ecke oben links. rechts R
A tergo mitte oben R
 ohne Zahl

4707

Instr. Misc. 1301-04, cap. 6 1301 Martii 21
Ego frater Bartholomeus eps Fesu-
lan ab hac hora
A tergo senkrecht an der mittelfalte
 forma iuramenti pro Epo fesulan
A tergo Ecke rechts unten:
 Jo de asisio de mandato Card
 ist nicht gebraucht und darum zu-
 rückgeordnet worden.
Cedula interclusa von der größe
der epistula

Bullenlöcher rechts und links

1301 Oct. 2 wurde Antonius Orso er-
nannt, nachdem Angelus de Ca-
merino resignirt und Bartholo-
maeus de Senis O Min. verzichtet
hatte, der am 21. März 1301 provi-
dirt worden war.

4708

Instr. Misc. 1301-1304 cap. 7
 P. — 1301 Martii 21
Bonif. VIII populo civitatis et dioc. Fe-
sulan.
 Ex incumbenti nobis
 Laterani XII kal. Aprilis a° 7°
 Bulle und Hanf fehlen
In plica rechts: Jo de Treb.
Sub plica links: m. Rar
 m. Rar (?)
 Ric.
Ecke oben links : . L.
Ecke oben rechts : R
Rand oben mitte : man qui in alia
und suppl dat XII kl. aprl
A tergo : h. de Vico
 R (klein)

4709

Instr. Misc. 1301-1304 cap. 10
 P. — 1301 Martii 21
Bonif VIII .. preposito et Capitulo ec-
clesie Fesulan.
 Ex incumbenti nobis
 Laterani XII kal. Aprilis a° 7°
 Bulle und Hanf fehlen
In plica rechts : pro p asibilis
Sub plica links :
 m. Rir (?)
Ecke links oben : L
a rechts oben : R
Rand mitte oben : man q in alia
und suppl dat XII kl. Aprilis
A tergo : h de Vico
 R ziemlich
 klein

Arch. Arcis
Arm. IX caps 2 cap. 8
 P. 25036 1301 Aprilis 13
Bonif. VIII .. Maguntin. et ..
Colonien. ac .. Treveren. ar-
chiepiscopis
Romano pontifici successori
Literam. IV. Aprilis a° 7°
Bulle an Hanf
In pl. rechts: G. de Sang
 de Cur
A tergo oben Mitte:
 Litera Theotonicorum

Brügg. Haupt-Staatsarchiv
Kl. Steingaden fasc. 15
P. vacat 1301 Maii 1
Bonifatius VIII (Gitterschrift) .. Ab-
bati et Conventui Monasterii in
Steingaden Premonstratensis or-
dinis Augusten. dioc.
 Cum a nobis
Dat. Anagnie Kl. Maji anno
Septimo
Bulle an dicker schlechter Seide
In plica rechts: N. Leonardus
 Sub plica links: .. w
 m. Ric
In Anschrift Augusten. im Texte Au-
gusten.
Sehr merkwürdige ungelenke Schrift
eines neueingestellten scriptor.
Die Reinschrift ist unverbessert aus-
gegeben worden. Sie enthält mehrere
schwere Fehler. In der letzten Zeile ist 1/8 derselben
freigeblieben.

4712 (recto)

de mandato dni / fiant due J.
card. de mand. dni.
Paris Archives Nationales
 J 435 n. 17
Breite 78. Rand links 8.9 rechts 8.
Höhe 54.3 Rand oben 11.1 plica 6.4
Erste Linie für Maj und mehrere
Oberlängen / Je zwei Seitenlinien
P. vacat 1301 Septembris 2
Bonifatius VIII (Maj) Nob Viro
Carolo Comiti Andegavie fratri
Carmi in xpo filij nri Philippi
Regis Francor Illustris et
Carme in xpo filie Catherine
Imperatrici Constantinopolitan
Illustri
Dudum exposita nobis
Dat/ IIII Non Septembr a° 7°
 verte

4712 (verso)

In plica rechts:
 P. Set de mandato dni
 J. Card
Ecke oben rechts:
 fiant due J. Card. de
man. dni
Sub plica links: xxx
 G. Aglen
Regelm. feste kleine Schrift

4713 (recto)

Paris Archives Nationales
 J 435 n. 17 bis
Breite 75.5 Rand links 5.7 rechts 5.3
Höhe 50.6 Rand oben 10. plica 8.4
Erste Linie für Maj und einige
Oberlängen / Je zwei Seitenlinien
P. vacat 1301 Septembr. 2
Bonifatius VIII (Maj) Nob. viro
Carolo Comiti Andegavie fratri
Carmi in xpo filij nri Philippi
Regis FrancoR Illustris etiam
me in xpo filie Catherine
Imperatrici Constantinopoli
tan Illustri
 dudum exposita nobis
dat Anagnie IIII non Septembr
anno 7°
 / vate

4713 (verso)

Bulle au Seide
In plica rechts : pro Jac Rott
Sub plica links : x
 x
 x
fette etwas unruhige Schrift

4714 (recto)

 P. – Paris Arch. nat.
L 285 cap. 96 1301 Sept. 3
Bon VIII Carolo nato clare memo
rie Phy regis Francorum comi
ti Andegaven. in Temporalibus.
Mane Trabarie et Terre Sancte
Agathe ac pertinentiarum ip-
sorum rectori
 Supra gregem dominicum
Anagnie IIII non. Sept. a° 7°
Bulle au Hanf.
In pli. rechts Jo dd Anag
 de Curia
Sub plica links Bng
R+ g. Sep et fac fi per bonu scripto.
 rem de Curia
 – g. Aquilen

4714 (verso)

Sehe oben links 8 g R+
u rechts

4715

Paris Arch. Nat.
J 722 cap. 5 ter 1301 Sept. 3
Bon VIII III non Sept. a° 7°
Bulle au Hanf
Pater futuri seculi
In plica rechts de cur?a
 Jo. Ni
Ausserordentlich schöne
und regelmässige Schrift

 P. 25069

4716

P. — Paris Arch. Nat.
L 285 cap. 97 1301 Sept. 18
Bon VIII Carolo nato clare memorie
Ph. regis Francorum comiti And.
faven. H
Personam tuam devotione
Anagnie XIII kl. oct. a° 7°
Bulle au Seide
In plica rechts D. Acut ?
Sub plica links v̄/x

 g. aglen
 †

Ecke oben links L rechts R†
Rund oben mitte Dns eps Burgen.
 per N de Vico

 A tergo S. de Villaregia

4717

Toulouse, Archives départem.
 St. Sernin

P. — 1301 Septembris 24
Bon. Ptris VIII conventui mo-
nasterii S. Saturnini Tholo-
san. ad Rom. Ecclesiam nullo
medio pertinentis osthg.
 Et si de
Anagnie VIII kl. oct. a° 7°
 Bulle au Hanf
 In plica rechts N. de Frositi
Sub plica links × g
 ×

Ecke links L rechts R†

A tergo oben mitte

 R ohne Zahl

4718

Toulouse, Archives départem.
 St. Sernin

P. — 1301 Septembris 24
Bon. Ptris VIII Raymundo ab-
bati mon. S. Saturnini Tholo-
san. ad Roman. Ecclesiam nullo
medio pertinentis osthg.
 Et si de
Anagnie VIII kl. oct. a° 7°
 Bulle au Hanf
 In plica rechts Situs
Sub plica links †
 g
 Ecke oben links L
rechts R†
A tergo oben R CCXXVIII

4719

P. 25079 Paris Arch. nat.
L 285 ap. 98 **1301 Oct. 2**
Bon VIII Caterine imperatrici Con-
stantinopolitane illustri
Pium arbitramur et
Anagnie VI non. Oct. a° 7°
Bulle au Seide
Implica rechts P Margariti
Sub plica links g Aquilen

Ecke oben links L rechts R
Rand oben Mitte
dñs Jac de Pisis p h de Vico
A tergo a de Villaregia
. VII . und
. CCLXXXIII
rep. 99 jenau das-
selbe
rep. 100 jenau
dasselbe

4720

Fiscale, Voltera
P. — **1301 Decembris 22**
Bonifacius VIII [ohne Punkte]
populo civitatis et diocesis
Vulteran.
Inter sollicitudines alias
Lateran. XI kl. Jan. a° 7°
Bulle fehlt, Hanf erhalten
In plica rechts N. Leonardi
Sub plica links ⊼
Sub plica links Jac ad[r]
gñus unten:
R P. Arun
Jo. M
Ecke oben
links: L
Ecke oben rechts
R
A tergo zu
links,
kein
. CCCXXI

4721

Public Record Office London
Papal Bulls bundle 6 n. 4
P. 25114 **1301 Decembris 23**
Bonifatius VIII Ad fut. rei mem.
Dudum inter carissimos
Lateran. X kl. Jan. a° 7°
Bulle und Seide ausgerissen
In plica rechts be a J. (?)
Sub plica rechts x
Jo Ni
Ecke oben links L rechts R
A tergo oben Mitte klein dünn
schmal
. CCC LXXVII

4722 (recto)

Paris Archives Nationales
J 435 n. 15
Breite 75.4 Rand links 7.6 rechts 7.6
Höhe 50.2 Rand oben 12.9 plica 8.2
Erste Linie für Gitterschr. und Oberlin-
gen / Je 2 Seitenlinien
P. vacat 1302 Januarii 10
Bonifatius VIII (Gitterschr.) Carmo in
xpo filio Philippo Regi Francorum
Illustri et dil. filio nob viro Roberto
Duci Burgundie
Pro parte nostra
dat Lateran / IIII Jd Januar.
anno Septimo
Bulle au Seide
In plica rechts: Jo Fulg
Sub plica links: ⫤
X
(verte

4722 (verso)

Ecke oben rechts ꝗ

A tergo oben Mitte : N de Vico

Ohne Rx - Zeichen

4723

Brit. Mus. Egerton Chart. 60

Rx P. — 1302 Martii 8

Bonifatius VIII Johanni tit. ♃

Marcellini et Petri presbiteru

cardinali

Peticio tua nobis

Laterani VIII id. Marcii a° 8°

Bulle und Seide fehlen

In plica rechts

B. de Sugio Gratis pro

dno suo Cardinali

Sub plica unten

ascl per me Jac Rorr.

A tergo oben Mitte ganz klein

Rx sub XIII capitlo

4724 (recto)

Instr. Misc. 1303–1304 Cap. 17

P. — 1302 Martii 19

Bonif. VIII .. epo Viterbien collectori deci

me per nos pridem imposite pro prose

cutione querre ac negotii regni Sicilie

contra hostes in patrimonio beati Pe

tri in Tuscia ac in civitate et dioc. V.

terbien. infra eorum fines institutis

deputato

Accepimus nuper ex

Laterani XIIII Kal. Aprilis a° 8°

Hanf und Bulle ausgeschnitten.

In pl. rechts : Jo Fulg.

Sub plica links : v̄
 Jo × m
 9

Ecke oben links : L

„ „ rechts : Rx

(verte)

Rand Mittel
cor

4724 (verso)

A tergo . N de Vico

Rx XXXVII

4725 (recto)

Marseille Archives Départem.
B 416
P. — 1302 Aprilis 17
Bonif. papa VIII archiepis et epis
ac electis, abbatibus, prioribus,
decanis, prepositis, archidiaconis, archipresbiteris et aliis,
clericorum prelatis et eorum vices gerentibus ac ecclesiasticis
personis religiosis et secularibus
ecclesiarum et monasteriorum capitulis et conventibus exemptis et
non exemptis Cistercien. Cluniacen. Cartusien. Premonstraten.
sanctorum Benedicti et Augustini ac aliorum ordinum necnon
magistris et preceptoribus Hospita

4725 (verso)

lis sancti Johannis Jerosolimitani,
Militie Templi et beate Marie
Theutonicorum et Calatrava.
per comitatibus Provincie et Forchalquerii et per cetera terras et
loca vicinarum partium eius in
christo filio nostro Carolo regi Sicilie
illustri subiecta constitutis
 Dum ad memoriam
Lateran. XV kl. Maii a° 8°
Bulle an Hanf
In plica rechts · p. Realf
Sub plica links $\frac{=}{x}$ d

 Ecke oben links · L̄i
Ecke oben rechts ⟨symbol⟩
A tergo R̄ · CVIII
[ohne Cap. und ann.]

4726 (recto)

Arch. Arcis
Ann. IX epo. 2 cap. 9
P. — 1302 Maii 4
Bonif. VIII .. epo Florentin.
 Nuper ad audientiam
Lateran. VIII non. Maii a° 8°
Bulle an Hanf
In pl. rechts : O Ler.
Sub pl. links : $\frac{=}{x}$
 Bug " ___9___ : R̄ p. aciti
 Jo. m
Ecken oben : [und ⟨symbol⟩

Links oben : ⟨symbol⟩ · J.
Mitte oben : cor
A tergo oben : nichts :

4726 (verso)

Gulterottus de Tigneno

R̄ CXLI

4727

Coblenz Staatsarchiv
Kurtrier
P. — 1302 Maii 31
Bon. VIII ad perp. rei mem.
Provide attendentes quod
Anagnie II kl. Junii a° 8°
Bulle an Seide
In plica rechts Jo de Tret

4728

P. — Paris Arch. Nat.
L 286 cap. 163 1302 Julii 11
Bon VIII .. priori monasterii S.
Viviani Sanctonen. eiusque
Dat. Anagnie p. m. Papiniani
epi Parmen. SRE vicecan.
Cellarii V id. Julii a° 8°
Bulle an Seide

Vicecancellarius

4729

Public Record Office London
Papal Bulls bundle 8 n 5
P 25170 1302 Augusti 13
Bonifatius VIII epis per regnum
Scotie constitutis
Inter assiduas curas
Anagnie id. Augusti a° 8°
Bulle an Hanf
In plica rechts Jac. G.
Sub plica links V
ganz unten: Tenetor
R P. Ascibilis
Tenetor
Ecke oben links S. T.
" " rechts R
a tergo oben klein R CCXIII

4730

Public Record Office London
Papal Bulls bundle 7 n. 6
P. 25 171 1302 Augusti 13
Bonifatius VIII .. epo Glasguen.
Gravi mentis turbatione
Anagnie id. Augusti a° 8°
Bulle an Hanf
In plica rechts p Gen
Sub plica links X
Tenetor
ganz unten durchstrichen, Strich abge-
kratzt R P. G.
Tenetor
Ecke oben links S. T. oben rechts R
a tergo oben Mitte
N. de Vico
R CCXIIII

4731

P. — Paris Arch. Nat.
J 723 cap. 10 bis 1302 Nov. 22
Bon VIII Carolo nato clare me
morie Phy. regis Francorum
comiti Andegaven.
Personas generositatis titulo
Laterani X Kl Dec. a° 8°
Bulle an Seide
In plica rechts M. de Adr.
Sub plica links Tenetor

Ecke oben links L rechts
Rand oben mitte
Dns Eps Burgen p N de Vico

A tergo CCLXXXVIII
Petrus epus Baer
gen. referendarius
S. P.

4732

Montpellier archives départem.
H. Gigeau

P. — 1302 Novembris 22

Bonifatius VIII . prioris de Cas.
tronovo Magalonen. dioc.
Ad audientiam nostram
Laterani X Kl. Dec. a° 8°
Bulle an Hanf
In plica rechts Agt
Sub plica links
sar
Ecke oben rechts

Doppelte Seitenlinien

4733

P. — Paris Arch. Nat.
J 723 cap. 10 1302 Nov. 26
Bon VIII Carolo nato clare
memorie Philippi regis Fran
corum comiti Andegaven.
Eximie devotionis affectus
Laterani VI Kl Dec. a° 8°
Bulle an Hanf
In plica rechts
Sub plica links
Ecke oben links L rechts

A tergo CCLXXXXVI

4734

Coblenz Staatsarchiv
Himmerode
P. 25200 1302 Decembris 18
Bon. VIII universis abbatibus
et conventibus ord Cist. tam
presentibus quam futuris
In ecclesie firmamento
Laterani XV Kl. Januarii
a° 8°
Bulle und Seide ausgerissen
In plica rechts Jo Zanu
Links sub texto
Links sub plica X
Ecke oben rechts

Duplicat Bulliert.
In plica Sar G.

4735

Marseille Archives départem.
H. S. 4
P. — 1302 Decembris 28

Bonifatius VIII universis abba-
tibus, abbatissis et conventibus
Cist. tam presentibus quam
futuris

In ecclesie firmamento
Lateran. V Id. Ian. a° 8°

Bulle an Seide

Sub plica links X

Sonst ohne alle Notizen

4736 (recto)

Firenze, Arte di Merca-
tanti
unbulliert P. — 1303 februarii 24

Bonifatius VIII .. priori sci Mi-
chaelis de Vinci et .. guardiano
frum Min. de sancto Geminiano
Wlteran. dioc. ac .. archipresb.
 tio ecclesie Wlteran.

. Sua nobis consules
Lateran. VI Id. Martii a° 9°

War nie bulliert

Plica vorhanden

ganzer Text durchstrichen

In plica rechts: Jo. fulg
Sub plica links: Tenetor und unten
Re p. de Anag Jo Ki
C. de Petia verte

4736 (verso)

Ecke oben rechts W

Rand oben Mitte P G

Drunter Aufrage:
ab. si arch. debet precedere
. Guard.

Antwort von andern Hand:
Tp̄ōe archiep̄m Guardiano

Zwei Silbo unterstrichen und
gelöscht mit ve —————— cat
drei Worte rcblszut:
 se intromictteri
iniuti orgnovere

Eingestellt unter 1303
 febr. 20

4737

Bayer. Haupt. Staatsarchiv
Kl. Weissenbrunn fasc. 6

P. vacat 1303 Martii 28

Bonifatius VIII .. Abbati monasterij
in Campidona Constantien. dioc.
Dilectorum filiorum .. Abbatis
Lateran. V Kl. Aprilis anno nono

Bulle an sehr dickem Hanf
 In plica rechts: N. J.
Ecke oben rechts: W

Stapo Ecke oben links: 6

Neunzeiliges Mandat 26. 4 x 16. 52
 plica 3.8

Bayer. Haupt. Staatsarchiv
Kl. Wessobrunn fasc. 6

P. 25224 1303 Martii 28

Bonifatius VIII .. Abbati Monasterij
in Campidona Constantien. dioc.
Conquesti sunt nobis
Laterani . V Kl. Aprilis anno nono

Bulle an dickem Hanf
In plica rechts : ♑

Neunzeiliges Mandat 37.9 × 18.3
 plica 3.5

Im Gegensatz zu den Mandaten aller
Mynigen ist hier eine ungeraume große
Zeumverschreitung eingetreten. Die
Linien entsprechen in ihrer Breite jener
der anderen Bullen, so daß die Mandate
sich nur noch durch den kurzen Text
unterscheiden.

P. 25230 Paris Arch. Nat.

J 478 cap. 9 1303 Aprilis 13

Bon. VIII Johanni Clausa
tit. SS Marcellini et Petri pres-
bitero cardinali

Per procerus nostros
Laterani iV. Aprilis a° 9°

Solte erst als patens
gesandt werden, hatte
also noch deutlich
erkennbare plica erhalten,
auf der rechten Stelle :

Jo Bon de Cur
Später wurde sie als clausa
gesandt, ohne etwas zu ändern
Adresse: Johanni tit Sacrp Marcelli
ni et Petri pbro card

P. - Paris Arch. Nat.

J 490 cap. 754 1303 Aprilis 13
 Clausa

Bon VIII Johanni
tit. N. Marcellini
et Petri presbitero
cardinali

Venerabiles fratres nostros
Laterani iV. Apr. a° 9°

Paris Arch. Nat.

J 490 cap. 756 1303 Apr. 13
 Clausa

Bon. VIII nob. viro
C. comiti Alençon
Litteras dilecti filii
Laterani iV. Apr. a° 9°

P. 25229

4742

Barcelona Corona de Aragón
Leg. 23º n. 1º
P.— 1303 Aprilis 20

Bonifatius VIII .. archiepis et epis ac electis etc. prelatis et eorum vices gerentibus ac personis ecclesiasticis religiosis etc.

Regi Illustri constitutis

Dum ad memoriam

Lateran. XII Kl. Maii aº 9º
Bulle an Hanf
In plica rechts p. Ascibilis
„ „ links VII
Sub plica links — G. Aglen
Ecke oben links L
Ecke oben rechts Rx
Rand oben Mitte
dns Sabinen. per N. de Vico
A tergo cum cauda l xxxx
ohne Capto

4743 (recto)

Barcelona Corona de Aragón
Leg. 23º n. 2º
Rx P.— 1303 aprilis 20

Bonifatius VIII universis comitibus et baronibus ceterisque notibus ac populis sive communitatibus et universitatibus civitatum Castrorum et aliorum locorum per Regnum Sardinie et Corsice constitutis.

Divine sapientie inscrutabilis

Lateran. XII Kl. Maii aº 9º
Bulle an Hanf
In plica rechts N. Ver.
Sub plica links ≡ V x

G. Aglen 9 vacat

4743 (verso)

Ecke oben links L
Ecke oben rechts Rx

Rand oben Mitte
man qui in alia

A tergo oben Mitte Klein mit
Cauda ohne Capto
l xxxvii

Rx Zahl neben dem Bogen.

4744

Barcelona Corona de Aragón
Leg. 23º n. 3º
P.— 1303 aprilis 20

Bonifatius VIII .. potestati .. capitaneo .. abbati consilio et communi Januen.

Tanquam discretionis fulti

Lateran. XII Kl. Maii aº 9º
Bulle an Hanf
In plica rechts p. Set
Sub plica links V x 9
Ecke oben links L

Ecke oben rechts Rx
A tergo oben Mitte mit kleiner
cauda ohne Capto
l xxxi

4745 (recto)

Barcelona Corona de Aragón
℞ P.— Leg. 23° n. 4°
1303 Aprilis 20

Bonifatius VIII archiepis et epis
ac electis abbatibus prioribus
decanis archidiaconis preposi
tis archipresbiteris et aliorum
ecclesiarum prelatis capitulis
collegiis et conventibus Cist. Clun.
Premonstr. Scorg Benedicti et Au
gustini Cartus. Grandimonten et
aliorum ordinum ceterisque per
ecclesiasticis regularibus et seculari
bus exemptis et non exemptis per
Regna Aragonie ac Valentie et co
mitatum Barchinonie omnesque
terras quo ac xpo filio nro Iaco
bo Aragonie Sardinie et Corsice
Regi Illustri immediate ac de

4745 (verso)

iure et de facto subiecta constitu
tis Sardinie et Corsice Regnoet
terris exceptis.
Romane Matris Ecclesie
Lateran. XII Kl. Maii a° 9°
Bulle an Hanf
In plica rechts Iac March
Sub plica links x / x x / Aglen.
 G. Aglen.
 9
Ecke oben links ⌐
Rand oben Mitte dns Sabinen
p. n. de Vico
Ecke oben rechts ℞
A tergo oben Mitte ℞
℞ LXXXVIII
 ℞ ohne Capto
 mit langer Cauda

4746

Barcelona Corona de Aragón
P.— Leg. 23° n. 5°
1303 Aprilis 20

Bonifatius VIII Raymundo
Epo Valentin. apostolice sedis
legato
Divine Sapientie inscruta
bilis
Lateran. XII Kl. Maii a° 9°
Bulle an Hanf
In plica rechts Jo de Treb.
Sub plica links
 G. ˣAglen
 9 ┬
Ecke oben links ⌐
Ecke oben rechts ℞
Rand oben Mitte
dns Sabinen. p. n. de Vico
A tergo mit Cauda ℞ LXXXVII
ohne Capto

4747

Barcelona Corona de Aragón
P.— Leg. 23° n. 6°
1303 Aprilis 20

Bonifatius VIII archiepis et epis ac
el. abb. prior. dec. archid. prep
et aliis eccl. prel. sive rectoribus
earumque conventibus et colle
giis per regnum Sardinie et
Corsice constitutis
Divine Sapientie inscrutabilis
Lateran. XII kl. Maii a° 9°
Bulle an Hanf
In plica rechts n. Ver.
 Sub plica links G. Aglen
 9
In plica links . IIII .
Ecke oben links
Ecke oben rechts ℞
Rand oben Mitte
man mit gri in alia
 ℞ LXXXVII

4748

Barcelona Corona de Aragón
Leg. 23° n. 7°
P. —
BO3 Aprilis 20
Bonifatius VIII Reymundo
Epo Valentin. aplice sedis
legato
Cum dudum carissimo
Lateran. XII Kl. Maii a° 9°
Bulle an Hanf
In plica rechts h. Ver.
In plica links II
Sub plica links g. aglen 79
Ecke oben links L
Ecke oben rechts R
Rand oben mitte man qui in alia
A tergo mit cauda
ohne capto R lxxxviii

4749 (recto)

Barcelona Corona de Aragón
R P. — Leg. 23° n. 8°
BO3 aprilis 20
Bonifatius .. Cesaraugusta
et .. Vicen. Epis collectori
bus decime in Regnis Arago
nie et Valentie constituta dni
Chinonie omnibus que terri
torio in xpo filio nostro Ia
cobo Aragonie Sardinie et
Corsice Regi Illustri imme
diate ac de iure et de facto
subiectis pro prosecutione
negozii Regni Sardinie et
Corsice deputate
Romane matris Ecclesie
Lateran. XII Kl. Maii a° 9°
Bulle an Hanf. vide

4749 (verso)

In plica rechts Jo Gan
Sub plica links v
x
x
g. aglen
79
Rand oben mitte
man qui in alia
off
Ecke oben rechts R, das
ganz verschieden von dem
bisherigen nachlässigen R ist
A tergo oben mitte
L xxxviii
R mit cauda,
gu cauda nach
unten rechts.
die Zahl ohne Capitel
steht oben neben dem
Bogen

4750

Barcelona Corona de Aragón
P. — Leg. 23° n. 9°
BO3 aprilis 20
Bonifatius VIII .. potestati ..
capitaneo antianis consilio
et communi Pisan.
Tanquam discretionis fulti
Lateran. XII Kl. Maii a° 9°
Bulle an Hanf
In plica rechts Jo. n.
In plica links .vj.
Sub plica links v
x
g
Ecke oben links L
Ecke oben rechts R
A tergo oben mitte mit cauda
ohne capto R lxxxxi

4751

Ausstellung Staatsarchiv Wien

P.- 1303 Aprilis 30

Bon. VIII ... in epm filio Alberto
regi romanorum illustri ad
perp. rei mem.
 Patris eterni filius
Datum ... kl. Maii a° 9°
Bulle an Seide
In pl. rechts N. Leonardi
Sub plica links L

4752

Barcelona Corona de Aragón
RL Leg. 23° n. 16°
 P.- 1303 Maii 9
Bonifatius VIII Raymundo Epo
Valentin. aplice sedis legato
 Cum carissimus in
 Anagnie VII id. Maii a° 9°
Bulle an Hanf
In plica rechts N. Leonardi
Sub plica links =×/9

Ecke oben links L
Ecke oben rechts RL
A tergo oben Mitte plein
mit cauda

ohne Zahl R
ohne Capto

4753

Barcelona Corona de Aragón
RL P.- Leg. 23° n. 11°
 1303 Maii 9
Bonifatius VIII .. Cesaraugustan.
et .. Vicen. Epis collectoribus deci-
me in Regnis Aragonie et Valentie
comitatui Barchinonie omni-
busque terris etc. subiectis
pro prosecutione negocii Regni
Sardinie et Corsice deputate
 Cum carissimus in
 Anagnie VII id. Maii a° 9°
Bulle an Hanf
In plica rechts Silvester S
Sub plica links =×/9

Ecke oben links L
Ecke oben rechts RL mit cauda
A tergo oben Mitte R ohne Zahl
 und capto

4754

Avignon, Archevêché d'Avignon
 G. 7
P. 25269 1303 Julii 1

Bonifatius VIII ad perp. rei mem.

Conditoris omnium immensa

Anagnie kl Julii a° 9°
 Bulle an Seide
In plica rechts N. de Fractis
 Sub plica rechts ×
 × ×

4755 (recto)

Avignon Ville d'Avignon
Boîte 5

P. 25269 1303 Julii 1

Bonifatius VIII ad perp. rei mem.

Conditoris omnium immensa

Anagnie Kl. Julii aᵒ 9

Bulle au Seide
In plica rechts Jo. Pon.
Sub plica links x
 x x

 G. Aglen
 † G

 R⟩ p. de Setia ⟩
 R⟨ n. de prete ·⟩·
 G. Aglen·

Ecke oben links ⟩ daneben :
S bis G.

Rand oben Mitte Dns Sabiner
 pro N. de Vico
Ecke oben rechts R⟨

4755 (verso)

A tergo oben Mitte
 N. de Vico
 ·R⟨· CCXXVIII

4756

Avignon Villa d'Avignon
 Boîte 5
P. 25 269 1303 Juli 1
Bonifatius VIII Ad perp. rei memoriam
Anagnie Kl. Julii aᵒ 9ᵒ
 Bulle au Seide
In plica rechts P. Set.
Sub plica links x
 x
 x

4757 (recto)

Instr. mon. F. dom. c. 106 1303 Aug. 9
 P. — P 25275
Bon. VIII ad perpet. rei mem.
Inter dilectos filios.
Anagnie V id. Augusti aᵒ 9ᵒ
Bulle au Seidenfäden.
In plica rechts: P. Set
Sub plica links:
·xxx· x
 x x
 G. Aglen
 G

unter dem Bug links:
R⟨ P. Relat. R⟩ Tere ſ ⟨ ſfue
/ G. Agl R⟨ P. de Setia I
Ecke oben links: R⟨ P. Asibit I
d . G. finit G. Aglen.
tres G.
oben rechts: A tergo: R⟨ CLxxxx
 R⟨

 Duplicat verte

 — 674 —

cap. 13

Bulle an Seidenfäden

In plica rechts: Tenetur

Sub plica links :

Paris Arch. Nat.

J 449 Cap. 121

Clausa

Bon VIII Pho
regi Francorum
illustri

Licet occasione constitutionis

A tergo links oben

Public Record Office London

Papal Bulls bundle 5 n. 8

P. 25 284 1303 Octobris 31

Benedictus XI E. regi Anglie illustri

Dominus ac redemptor

Laterani II kl. Nov. a° 1°

 Bulle an Hanf

In plica rechts P. Set

 de Cur

Archives Nationales Paris

L 288 n. 1 1303 Novembris 16

Br. 50.3 hoch 34.5 Plica 6.6
 oberer Rand 11. links 5.8
rechts 5.2

 Benedictus XI (sehr feine
Gitterschrift ⧾ Initiale ausgespart)
- - Abbati monasterii sancti
Germani de Pratis iuxta Pari-
sius ad Romanam ecclesiam nullo
medio pertinentis ordinis sancti
Benedicti

 Devotionis tue promeretur
Dat Laterani XVI kl Decembris a° 1°

Bulle und Seide fehlen P. vacat
 In plica rechts : Jo hi
Sub plica links : - - -
 Jo. hi ⦚
Ecke oben links : L
 " " rechts : R
A tergo oben linke :

P. de Scto Laur

 verte

4760 (verso)

Ungemein fette grobe Schrift
Sehr weite Rilinatürme

Erste Linie für Gitterschrift und
Oblängen

Ungemeine Raumverschwendung

4761

Bayer. Haupt- Staatsarchiv
Kl. Bergen fasc. 3

P. vacat 1303 Novembris 16

Benedictus XI . . Abbati mon-
sterii in Werdea Augusten. dioc.
Dilectorum in Xpo
Lateran. XVI Kl. decembris Anno
primo

Bulle an dickem Hanf
In plica rechts : B. de Aney
 Ecke oben rechts : XX

Nageln Schrift siehe Novembris 17

Mandat : 22.2 × 14.9
 plica 3.6

4762

Bayer. Haupt- Staatsarchiv
Kl. Bergen. fasc. 3

P. vacat 1303 Novembris 17

Benedictus XI . . Decano ecclie
Onolspatin. Herbipolen. dioc.
 Conquesti sunt nobis
Lateran. XV Kl. decembr. Anno
 Primo

Bulle an dickem Hanf
 In plica rechts : B. de Aney

Ecke oben rechts : XX

Nuschöne zusammenhängende
Schrift. Unterlängen (mit eckigen
Haken) laufen ganz dünn zu

4763

Instr. mon. F. Dom. c. 9 1303 Dec. 12

Dec 128 P. 25320

Ben. XI ad perpetuam rei memoriam
Devotorum vota que

Lateran. II iv. Dec. aᵒ 1ᵒ

Bulle fehlt- Seidenfäden

In plica rechts : A. medd

Sub plica links : x̄
 sequ.

A tergo : predicatorum de Viterbio

℞ . CCCLXXXIII

4764

Arch. Arcis

Arm C fasc. 17 cap. 19

P. 25324 1303 decembris 23

Benedictus XI ad perp. rei m.

dudum bone memorie

Lateran. XI Kl. Ianuarii a° 1°

Bulle an dünnen hellen fäden

In pl. rechts: de Cur

P. Vet

A tergo oben mitte: RX

4765

Bayer. Haupt. Staatsarchiv
Bamberg fasc. 37

P. 25352ᵃ 1304 Ianuarii 31

Benedictus XI Wulingo Epo
Bambergen.
Roman. Pontificis quem
Lateran. II febr. Anno Primo

Bulle an sehr dickem Hanf. Sehr
gut geprägt und erhalten
In plica rechts: G. de Setia
In plica mitte: II Dat. febr.

Sub plica links: v̄/x

Triplicat Jo Fulg.

Ecke oben links L
Oben mitte suppl. dat.
Ecke oben rechts RX

A tergo oben mitte
klein breit: RX · ccclxxvj

ungeheuer breite
Ränder. Drei Seiten.
linien. sehr weite
Zeilenabstände

4766

Bayer. Haupt. Staatsarchiv
Bamberg fasc. 37

P. 25352ᵃ 1304 Ianuarii 31

Benedictus XI Clero Civitatis et dioc
Babenbergen.
Roman. Pontificis quem
Lateran. II Kl. Febr. Anno Primo

Bulle an dickem Hanf
Seriptor fehlt.
Sub plica links: v̄/x Jo. Fulg.

Triplicat

Oben mitte: suppl. dat.
Ecke oben links: L
Ecke oben rechts: RX

A tergo oben mitte klein: RX

A tergo Ecke oben links: B

ungeheuer breite Ränder
Drei Seitenlinien

Runde, etwas geschnörkelte, verbun-
dene Schrift mit starken Ober-
und Unterlängen

4767

Bayer. Haupt. Staatsarchiv
Bamberg fasc. 37

P. 25352ᵃ 1304 Ianuarii 31

Benedictus XI Universis vassallis
ecclie Bambergen.
Roman. Pontificis quem
Lateran. II Kl. februarij Anno Primo

Gutgeprägte Bulle an dickem Hanf
In plica rechts: P. Vet
Sub plica links: v̄/x Jo. Fulg.

Ecke oben rechts: L

Oben mitte: dat und suppl. dat.
Ecke oben links: RX

A tergo Ecke oben links: B
oben mitte klein: RX

Triplicat

4768

Firenze, Communità di
Prato

P.— 1304 Januarii 31

Benedictus XI .. archiepiscopis
epis ac electis, abbibus, priori-
bus, decanis, prepositis, archi-
diaconis, archipresbiteris, ple-
banis et aliis ecclarum prelatis
et eorum gerentibus ac ecclesiis per-
sonis religiosis et aliis ecclarum
et monasteriorum capitulis et con-
ventibus exemptis et non exemp-
tis Cist, Cluniac, Carthusien. Pre-
monstraten. S. Bened. et S. Aug. ac
aliorum ordinum necnon magistris
et preceptoribus militie Templi, hospi-
talis S. Johannis Jerosol. et b. Marie
Theotonic. ad quos littere presentes
pervenerint.
 Cum venerabilem fratrem
Lateran. VI kl. febr. a° 1°
 Bulle und Hanf fehlen
In plica rechts De cur
 Jac. Mus
Sub plica links J
Ecke oben links n rechts Rx

4769

de mand. Dni sui cardinalis

Archives Nationales Paris
L 288 n. 2 1304 februarii 8

Br. 57.2 hoch 37.8 Plica 6.4
oberer Rand 11.2 links 5.4
rechts 5.1
 Benedictus XI . . Parisien
. . Ambianen et XI . . novionen
ecclian decanis
 Loca scienturarum deputata
Ant Leteran VI Jd Februarij a°1°

Bulle an Hanf
 In plica rechts : B. de Sugio gra
 fis de mand dni
 sui card
A tergo oben Mitte:
 B. de Sugio

Jede regelm. Schrift
 Erste Linie für Oberlängen
Mit einem betonten Buchstaben

 P. vacat

Mit je zwei Seitenlinien

4770

Archives Nationales Paris
L 288 n. 2bis 1304 februarii 8

Br. 56.5 hoch 35.3 Plica 5
oberer Rand 10. links 4.8
rechts 4.7
 Benedictus XI
 wie in n. 2

Bulle an Hanf
 In plica rechts : u
 B. de Sugio G de
 mudo dni sui Card

Jede regelm. Schrift
 Erste Linie für Oberlängen
Mit einem betonten Buchstaben

 de mandato dni sui

cardinales

 P. vacat

Mit je zwei Seitenlinien

4771

Archives Nationales Paris
L 288 n. 2ter 1304 februarii 8

Br. 57.9 hoch 40.4 Plica 5.6
oberer Rand 10.4 links 5.3
rechts 5
 Benedictus XI
 wie in n. 2

Bulle an Hanf
 In plica rechts wie n. 2
Sub plica links : J
 Rand oben halblinks :
 Jo Card de man Dni
Ecke oben rechts : Rx
 A tergo oben Mitte : B. de Sugio
 . x x v .

 1.5 Rx Jo Card de
 mand Dni

Mit je zwei Seitenlinien P. vacat

Erste Linie für Oberlängen

4772

Madrid Arch. Hist. Nacional
Dominicos Huesca 20 E
 P. 25365 1304 februarii 13
Benedictus XI universis xpi
fidelibus pres. litt inspecturis
 In ordine fratrum
Lateran. iv. febr. a° 1°
Bulle fehlt. Seide erhalten
In plica rechts N. G.
Sub plica links v̄

4773 (recto)

Instr. Mon. F. Dom. c 120 1304 febr. 13
 130 P. 25365
Bened. XI univ. x fidelibus presen-
tes literas inspecturis.
In ordine fratrum.
Lateranni iv. febr. a° 1°.
Bulle fehlt. Seidenfäden.
In plica rechts: de Curia
 Fg. T.
Sub pl. links: v̄
 Jo Julg.
Unter dem Bug: Jac Borck seq tres
Daneben mit ande- | G. Aguil dzas
rer Tinte: | N. Ver
R. G. Seb. dzas | Bc. G. Set. quatuor
P. Ascifilis duas | Tenstur
 N. G. duas | 2
N. Leon duas | Bc Jac. Mug quatuor
 N. Ver | N. Ver
R4 G. Set seq tres | . R. Jo Ver. III Jo de
 N. Ver |
R Ver | Reg III N. Ver ute

4773 (verso)

Rand oben links:
 fiunt III T.
 multiplica ut vis N.
A tergo : predicatorum
 Duplicat
cap. 15 Domenicani, 129
Bulle fehlt. Seidenfäden
In plica rechts: G. de Setia
Sub plica links: v̄

A tergo: [† N Waldini]

4774

Instr. Mon. P. 25370 1304 febr. 17
F. Dom. c. 3, ora 137
Ben. XI. ad perpetuam rei memoriam
Inter cunctas sollicitudines
Lateranni XIII kal. Martii a° 1°
Bulle an Seidenfäden.
In plica rechts: P. Real.
Sub plica links : L
A tergo [† N Waldini]

 Duplicat
 Domenicani, 134
cap – Inter cunctas (sic) sollic.
Bulle und Seide ausgerissen
In plica rechts : Cosmas
Sub plica links : L
A tergo : wie oben

Napoli Curia Ecclesiast. Vol. 5°
P. —
Benedictus XI .. epo Asculan.
Dilect. filiorum .. commendatoris
Lateran. XII Kl. Martii a° 1°
Bulle und Hanf fehlen
In plica rechts Kammer

Instr. Mon. F. dom. c. 150 1304 febr. 24
131 P. 25376
Ben. XI .. abbati monasterii Sancti Se-
veri Urbevetan.
Ex parte dilectorum
Lateran. VII Kal. Martii a° 1°
Bulle fehlt. Hanffaden
In plica rechts: Jac. C.
Sub plica links: \bar{v} (abgeklatscht)
2
Unter dem Bug links am unteren
Rande: pro p. gen.
A tergo :

N Waldini

R

Graz Landesarchiv n. 1659 e
P. 25379 1304 Februarii 28
Benedictus XI universis prio-
rimis et sororibus monasterio-
rum O.S.Aug. secundum in-
stituta et sub cura frum ordi.
Predicatorum viventibus tam
presentibus quam futuris salu-
tem et aplicam bened.
Sacra vestra religio
Lateran. III Kl. Martii a° 1°
Bulle an Seide
In plica rechts p. ascibilis
Sub plica links $\frac{\bar{=}}{v}$

Wien Staatsarchiv Chronol.
P. 25379 1304 Februarii 28
Benedictus XI universis pri-
orimis et sororibus monaste-
riorum O.S.Aug. secundum
instituta et sub cura frum or.
Bened. viventibus tam pres. quam
futuris S. et ap. ben.
Sacra vestra religio
Lateran. III Kl. Martii a° 1°
Bulle fehlt. Seide erhalten
In plica rechts p. ascibilis
Sub plica links $\frac{\bar{=}}{v}$

4779

Instr. Mon. F. dom. c. 86 1304 febr. 28
132 P. 25379

Den. ... Univ. prioribus et sororibus
monasteriorum ord. S. Aug. secun
dum instituta et sub fratrum ord.
Pred. viventibus tam presentibus quam
futuri

Sacra vestra religio

Laterani ... Kal. Martii a° 1°

Bulle an Seidenfäden

In plica rechts. P. Ascibilis

Sub plica links ≡/v
 +

a tergo [N Walvini]

4780

Archivio di Stato Milano
Bolle e Brevi
 P. — 1304 Martii 2

Benedictus ... - priori et fri
bus O.Pred. Papien.

Meritis vestre religionis
Laterani. VI non. Martii a°. 1°

Bulle fehlt, Seide erhalten.
In plica rechts M de Adr.
Sub plica links 9
Ecke oben links L rechts ...
A tergo klein, dünne Striche
ohne Zahl

4781

Archivio di Stato Milano
Bolle e Brevi
 P. — 1307 Martii 3

Benedictus ... priori et fri
bus O.Pred. Papien.

Cum a nobis

Laterani V non. Martii a° 1°

Bulle an Seide
In plica rechts M. de Rocca
Sub plica links ≡/v Julg
 9

Rand oben links L Mitte asot
rechts ...

A tergo oben Mitte klein DXVIII°

4782

Madrid Arch. Histór. Nacional
Dominicos Palma 40 E
P. 25387 1304 Martii ...

Benedictus XI .. Valentin, --
Oscen., .. Vrgellen. et .. Vicen.
episcopis.

Super egenum nuper
Laterani. VI id. Martii a° 1°

Bulle fehlt. Hanf erhalten
In plica rechts G. de Setia
Sub plica links ≡/x

Kleine eckige Schrift. Große
Wortabstände. Sehr breite Rän
der. Breite Zeilen. Nicht
sehr schön.

Instr. Mon. F. Dom. c. 6 1304 Mart. 10

136 P. 25387

Ben. XI .. archiepo Mediolanen. ..
Asten. .. Brixien. et .. Papien. epis
Super egenum nuper (intendentes?)
Lateran. II id. Martii aᵒ 1ᵒ
Bulle an Hanfschnur
In plica rechts: P. Ascibilis
Sub plica links: ⸺
 x
A tergo: +

N. Waldini

Instr. Mon. T. Dom. c. – 1304 Mart. 10

135 P. (25387) i. e. m

Ben. XI .. Luccan., .. Senen., .. Perusin.
et .. Reatin. episcopis
Super egenum nuper.
Lateran. II id. Martii aᵒ 1ᵒ
Hanfschnur – Bulle fehlt.
Brüchig und unverfleckig
In plica rechts: P. Ascibilis
Sub plica links: ⸺
 x
A tergo:

N. Waldini

Bei Potthast : Super egenum in
 tendentes

Instr. Mon. F. Dom. cap 19c 1304 Mart. 12

137 P 25396

Ben. XI .. magistro, prioribus ac fratribus uni-
versis ord. Predic.
Inter ceteros ordines
Lateran. III id. Martii anno 1ᵒ
Seidenfäden. Bulle fehlt.
In plica rechts: g ntis
 Jo de Trebis
A tergo N. Waldini

Statsarchiv Wien Chronol.
P. – 1304 Martii 15
Benedictus XI H. magistro et
fribus Hospitalis Sancte Marie
in Alpibus Patavien. diôc.
Sacrosancta Romana Ecclia
Lateran. id. Martii aᵒ 1ᵒ
Bulle an Seide
In plica rechts a. med
Sub plica links Jo. July.
Ecke oben rechts

4787

Instr. Mon. f. Dom. c. 16 1304 Martii 19
138 P. 25403
Ben. XI ad perpetuam rei memoriam
Ut moniales secuntum —
Laterani XIIII kal. Aprilis a° 1°
Bulle an Seidenfäden angeknüpft.
In plica rechts P de Imola
Sub plica links : T
A tergo

N. Waldini

4788

P. II. 2043 Paris Arch. Nat.
J 470 cap. 768 1304 Apr. 2
Ben XI Clausa
Philippo Brete Rin-
regi Fran- der
corum illustri
Aurunta nos fili
Rome apud S Petrum IIII non.
Aprilis a° 1°

4789

Wiesbaden Staatsarchiv
Rossdorf Höchst
 1304 Aprilis 16
Benedictus XI .. decano eccle
S. Theobaldi Meten.
Ad compescendos conatus
Viterbii XVI Kl. Maii a° 1°
 Bulle und Hanf fehlen
In plica rechts p. Set
Sub plica links =x
 N. Leon
Ecke oben link | rechts R
A tergo Mitte oben klein
B

4790

Bayer. Haupt. Staatsarchiv
 Bamberg fasc. 37
P. 25422ᵃ 1304 Aprilis 18
Benedictus XI (selbe Gitterschrift)
Wluingo Epo Bambergen.
 Personam tuam sincera
Viterbij XIIII Kl. Maij Anno Primo
Bulle an guter Seide
In plica rechts : Romanus
Sub plica links : =v
 Cosmas
 9
 Ecke oben links : L
Rand oben Mitte : assel nur at.
Ecke oben rechts R
A tergo Mitte klein R

4791

Bayer. Haupt. Staatsarchiv
Bamberg 234.

P. vacat 1304 Aprilis 18

Benedictus XI. - Archiepo Salze-
burgen.
 Exponit nobis venerabilis
Viterbij XIIII kl. maij anno Primo

Gutgeprägte Bulle an dickem Hanf
In plica rechts : Jo. m

Sub plica links : x/

 Ecke oben links : L
 Ecke oben rechts :

A tergo oben Mitte klein :

Ungeheure breite Ränder
 Zwei enge Seitenlinien

Runde, fette, ganz verbundene Schrift

4792

Paris Archives Nationales
 J 689 n. 123
Breite 6.2. Rand links 6.3 rechts 6,2
Höhe 74. 1 Rand oben 11. plica 6.3
Erste Linie für Gitterschr. und
Oberlängen / Je zwei Seitenlinien
P. vacat 1304 Aprilis 18
Benedictus XI (Gitterschr.) Carmo
in xpo filio Philippo Regi et Car-
me in xpo filie Johanne eius
Vxori Regine Francorum Illustribus
 Magnitudo Regalis excellentie
Dat Viterbij / XIIII kl. maij aº 1º
Bulle in Seide
 In plica rechts : h. Leonardi
Sub plica links :
A tergo oben Mitte : Petrus de Castello

4793 (recto)

Paris Archives Nationales
 J 689 n. 123
Breite 68.4 Rand links 7.2 rechts 6.5
Höhe 47.5 Rand oben 12.5 plica 7
 Erste Linie für Gitterschr. und Ober-
längen / Je zwei Seitenlinien
P. vacat 1304 aprilis 18
Benedictus XI (Gitterschr.) Carmo
in xpo filio Philippo Regi et
Carme in xpo filie Johanne
eius Vxori Regine Francorum
Illustribus
 Magnitudo Regalis excellentie
Dat Viterbij / XIIII kl. maij aº 1º
Bulle an schlechter Seide
In plica rechts : h. Leonardi
Sub plica links : verte

4793 (verso)

A tergo oben Mitte :
 Petrus de Castello
Sehr weite fette Schrift

4794

Firenze, Carte Cerchi, Carta.
pecore Tom. I, 40
P. – 1304 Maii 12
Benedictus XI Petro nato
quondam Consilii de Circu-
lis clerico Florentin.
Ut tua et
Perusii III id. Maii aº 1º
Bulle und Seide ausgerissen
In plica rechts · p. Eug.
Sub plica links ≡x und
R Jo Rigr
K · Leon Ecke oben links
und S N.
Ecke oben rechts
A tergo oben Mitte
klein

4795

Paris Arch. Nat.
J 490 cap. 763 1304 Maii 13
Ben XI ad papetuam rei mem.
Sancte matris Ecclesie
Perusii III id. Maii aº 1º
Bulle an Seide
In plica rechts Jac Marsf
Sub plica links xx
Cosmas
9
Ecke oben links { rechts R
A tergo
Petrus de Castello
R
Losprechung aller mit Aus-
nahme Guillermi de
Nogareto

4796

Bayer. Haupt. Staatsarchiv
Mainz Erzstift fasc. 49
P. 25430 1304 Maii 23
Benedictus XI .. Decano ecclie
Frankenfordensi Maguntin. dioc.
Ad audientiam nostram
Perusij X kl. Junij anno Primo
Bulle an dickem Hanf.
In plica rechts! p. Set.
Sub plica links! Γ
Cosmas
Ecke oben rechts XX

4797

Bayer. Haupt. Staatsarchiv
Mainz Erzstift fasc. 49
P. vacat 1304 Maii 27
Benedictus XI .. Abbati monasterij
Fuldn. Maguntin. dioc.
Pium esse dinoscitur
Perusij III kl. Junij anno Primo
Bulle an dickem Hanf. Sehr gut
geprägt
In plica rechts: p. Set.
Sub plica links: ^ —
Cosmas
Ecke oben rechts: XX

neapoli Curia Eccles. Vol. 3°
p. —
Box Maii 27
Benedictus XI . . priori et con-
ventui S. Petri Martiris O. Pred.
de neapoli
Laudabilis ordinis vestri
Pensii II kl. Iunii a° 1°
Bulle und Seide fehlen
Plica abgeschnitten
Sub plica links v̄
 h. ˣ Leon 9)
Ecke oben links ⌐ rechts R
A tergo oben mitte klein

 R

neapoli Curia Eccles. Vol. 3°
p. —
Box Iunii 4
Benedictus XI . . archiepo Tranen.
Et si cunctos
Pensii II non. Iunii a° 1°
Bulle und Hanf fehlen
A̶c̶a̶ Plica abgeschnitten
Sub plica links ˣ
 h. Leon
 9
Ecke oben links ⌐
Ecke oben rechts ⋈
A tergo oben
mitte sehr nachlässig
klein B δccxxx

INDICI

INDICE DEGLI INIZI

L'inizio del testo manca nelle schede n. 2282, 2914, 3043, 3171, 3247, 3532, 3916, 3937, 3938, 4009, 4010, 4166, 4167, 4349, 4527, 4565, 4604, 4606, 4642, 4728, 4756.

A

A felicis recordationis, 3577.

Ab hiis tua, 3643.

Ab illis christianissimis, 3283.

Abbas et conventus, 3116.

Accedentes ad apostolicam, 4096.

Accepimus nuper ex, 4724.

Ad assiduum Christi, 2449, 2619, 2620, 2652.

Ad audientiam apostolatus, 4182, 4183.

Ad audientiam nostram, 2431, 2432, 2618, 2647, 2648, 2900, 2936, 2957, 3020, 3052, 3083, 3106, 3280, 3285, 3295, 3296, 3361, 3375, 3411, 3693, 3739, 3958, 3982, 3994, 3995, 3011, 4044, 4045, 4128, 4237, 4262, 4308, 4321, 4501, 4520, 4562, 4620, 4639, 4661, 4732, 4796.

Ad capiendum vulpeculas, 2593.

Ad compescendos conatus, 4789.

Ad consequendam gloriam, 3535, 3536.

Ad conservationem bonorum, 4348.

Ad domum militie, 2881.

Ad excellencie tuam, 3805.

Ad extollendam fidei, 3647.

Ad fovendam in, 4269, 4390, 4555.

Ad fructus uberes, 4416.

Ad gaudium plurimum, 2675.

Ad hoc ordo, 3176.

Ad instar illius, 4484, 4485.

Ad monasterium vestrum, 4146, 4149, 4150.

Ad nostram audientiam, 2790.

Ad nostram noveris, 2595, 3017, 3092, 3797.

Ad nostram noveritis, 3198, 3540.

Ad notitiam regiam, 4065.

Ad recipiendum pro, 3690.

Ad reformandum negotium, 2750.

Ad religiosorum locorum, 3538.

Ad statum orbis, 4540.

Ad statum prosperum, 4492.

Ad statum universitatis, 4080.

Ad tuam carissimam, 4305.

Ad universalis ecclesie, 3864.

Adaperiat Dominus suorum, 3706.

Adhibe fili quesumus, 4658.

Affectu sincero sic, 3594.

Affluentis devotionis affectus, 3999, 4536.

Agimus fili carissime, 4022.

Amamus utique puro, 4458, 4459, 4462, 4468.

Amara est potio, 3511.

Animarum salutem desiderio, 2735.

Animarum salutem plenis, 2609.

Apertis paterne gratie, 3934.

Apostolica sedes divinitus, 4684.

Apostolice sedis benignitas, 2275, 3073, 4129-4132, 4352.

Apostolice sedis circumspecta, 4635, 4670.

Apud eternorum regie, 2417.

Apud sedem apostolicam, 3598.

Attende fili et, 4286.

Attendens sollicite felicis, 3836.

Attendentes dudum dilecte, 3107.

Attendentes dudum dilectus, 2982.

Attendentes laudabile et, 4204.

Attendentes quod fratres, 4300.

Attendentes quod si, 3669.

Attenta sedis apostolice, 2835, 2836, 3588.

Audiendo vix credimus, 2442.

Audito nuper quod, 4177.

B

Benedicta filia tu, 2519-2522.

Benedictus dominus qui, 3522.

Benigna divine operatio, 2416.

Benigni patris eterni, 4401.

Bona meritoria per, 2695, 2696.

Bone memorie . . Suanen., 2949.

C

D

E

L

M

N

O

Q

R

S

INDICE DEI DESTINATARI

Sotto i nomi personali sono indicati i documenti, in cui tali nomi sono espressi; così per es., sotto Ludovicus, rex Francorum *si trovano indicati dieci documenti, ma altri a lui diretti, in cui il nome non è espresso, si trovano sotto* Francia: ... rex.

I documenti diretti a destinatari non localizzati, sono indicati sotto i rispettivi nomi comuni; così per es., i documenti diretti universis archipresbiteris *sono indicati sotto* archipresbiteri, *quelli* universis christifidelibus *sotto* christifideles.

L'indicazione del destinatario manca nelle seguenti schede: nn. 2290, 2296, 2305, 2603, 3532, 3624, 3871, 3991, 4009, 4010, 4075, 4166, 4167, 4444, 4527, 4565, 4662, 4664, 4707, 4715.

Nelle seguenti schede si ha, in luogo del destinatario:

Ad certitudinem presentium et memoriam futurorum, 2313, 3240, 3241, 3745, 4047, 4055, 4056, 4446, 4447, 4627, 4629.

Ad eternam rei memoriam, 4461, 4463, 4464, 4469.

Ad futuram rei memoriam, 3202, 3286, 3287, 3518, 4540, 4569, 4721.

Ad notitiam presentium et memoriam futurorum, 4460.

Ad perpetuam memoriam futurorum, 2659, 2660.

Ad perpetuam rei memoriam, 2568, 3619, 3620, 3768, 3840, 3978, 4079, 4109, 4110, 4264, 4445, 4448, 4451, 4467, 4524, 4533-4535, 4539, 4553, 4556, 4598, 4602, 4603, 4605, 4607, 4608, 4672, 4675, 4727, 4754-4757,, 4763, 4764, 4774, 4787, 4795.

A

A. comes Pictaven. et Tolosan., *v.* Alphonsus.

— dux Austriae, *v.* Albertus.

— episcopus Dertusen., *v.* Arnaldus.

— regina Angliae, *v.* Alienora.

abbates, *v.* archiepiscopi, reges; abbates et priores universi, 2507.

Abbaye-aux-Bois, v. Libera Abbatia.

Aberconeway, mon. de, in Wallia, dioc. Bangoren., abbas et conventus, 4265.

Abiennen. canonicus, *v.* Helias de Brolio.

Adenulphus qd. Mathiae dicti de Papa, de Anagnia: filius eius, *v.* Oddo.

Admonten. mon., dioc. Salzeburgen., abbas et conventus, 3282.

Aeduen., *v.* S. Stephani de Beln.

Aegidii, *v.* Raimundus.

Aegidius, archidiaconus Rothomagen., magister in theologica facultate Parisius constitutus, 2893.

— archiepiscopus Tyren., 2993, 2994, 2995, 3123-3126, 3128, 3145, 3155-3160, 3164-3170, 3173, 3317, 3325, 3327-3331, 3353, 3354-3356, 3358-3360, 3362-3366, 3369, 3370, 3372-3374, 3376-3377, 3379, 3380, 3382, 3383, 3396, 3397, 3468, 3477-3483.

— de Castelleto, magister, notarius papae, 4040, 4041.

Agantico, *v.* S. Petri de.

Albanen. episcopus, 3660, 4490; — *v.* Palatiolis.

Albertus, dux Austriae, 4306.

— magister, notarius papae, 3236.

— rex Romanorum, 4751.

Alcoçer, mon. de, dioc. Conchen., abbatissa et conventus, 2901, 2902.

Alemannia: prior et fratres heremitae, 2429; prior provincialis ord. Praed., 3232; *v.* Teutonia.

Alençonis comes, *v.* Carolus, Petrus.

Alienora, regina Angliae, 3736.

Alix, comitissa Burgundiae Palatin. (*Franche-Comté*), 2932.

Alphonsus, comes Pictaven. et Tolosan., 3186, 3199, 3298-3000, 3512.

— primogenitus qd. Fernandi primogeniti Alphonsi (X) regis Castellae, 4454.

— (X) rex Castellae et Leonis, *v.* Fernandus filius eius.

Alpibus, *v.* S. Bartholomaei de Prato Episcopi de.

Altach Superiori, mon. de, dioc. Ratisponen., abbas, 4284, 4505.

Altha Inferiori (*Niederaltaich*), dioc. Patavien., *v.* Inferiori Alhta.

Amatus, vicarius Petri Gaietani rectoris Patrimonii B. Petri in Tuscia, nepotis papae, 4522.

Ambianen., canonicus *v.* Loffridus dictus Gaitanus.

— decanus, 4769, 4770, 4771; episcopus 4689; praepositus, 3017; — *v.* Pontivo, S. Iohannis iuxta Ambianum.

Anagnin. canonicus, *v.* Bartholomaeus dictus Testa; cives, *v.* Nicholaus de A., Oddo filius Adenulphi qd. Mathiae dicti de Papa; episcopus, 3138, 3178, 3196, 3214, 3277, 3297, 3556, 3567, 3618, 3631, 3634.

praepositus, 3494; prior et fratres ord.
Praedicatorum, 2674, 2681, 2682, 2686,
2687, 2697; vicarius comitis Provinciae
et Andegaviae in Arelato, 2417; — v. S.
Clarae mon., S. Mariae de Rochetta.

Aretin. episcopus, 2550, 2937, 4567, 4661;
praepositus, 2292, 2685; — v. Biblena,
Cortona, Farneta, S. Mariae de Monte
Pulciano, S. Mariae de Tarcia extra mu-
ros, S. Petri Piccoli.

Aria, plebs de, dioc. Camerinen., plebanus,
4095.

Armanus Mantellus de Parma, can. Regin.,
4500.

Arnaldus, abbas S. Saturnini Tolosan.,
3114.
— episcopus Dertusen., 4632.

Arturus, primogenitus Iohannis ducis Bri-
tanniae: Iohannes filius eius, 4688.

Asculan. episcopus, 4775.

Asinden. eccl. saecularis abbatissa et capi-
tulum, 3823.

Asisium, v. Assisinat.

Asloen. (Oslo) episcopus, 3091.

Asnello, v. S. Mariae de

Assisinat. potestas, consilium et commune,
4635; — v. S. Francisci de Assisio.

Asten. episcopus, 3668, 4783.

Athanacen. (Athaneins) mon., dioc. Lugdu-
nen., abbas, 2787.

Atrebaten. comes, v. Robertus; dioc., v. S.
Amati, S. Sansonis de Duaco.

Augusten. decanus, 4650; episcopus, 4394,
4395, 4396, 4531, 4639; scholasticus,
3739; — v. Cesarien., Domus Dei in Hes-
libach, Heubach, Ottemburron, S. Ma-
riae de Medelingen, S. Mauricii, Schone-
velt, Steingaden, Tyrhaupt, Werden.

Auhausen, v. Hausen.

Aurasicen. episcopus, 4537; praepositus,
4098.

Aurelianen. electus, v. Bertandus, 2323,
2426, 2431, 2432, 2456, 4367, 4472;
— v. S. Benedicti Floriacen., S. Mariae
inter Muros et Fossata.

Austriae dux, v. Albertus.

Auxitan. archiepiscopus, 3470.

Aversa, v. S. Laurentii de.

Avinionen. canonici, v. Berengarius Capel-
larii, Pontius ...ini; Christifideles, 3499,
3500; civitas, 3298-3300; episcopus., v.
Bertrandus; officialis, 4616.

B

B., card. S. Nicholai in Carcere Tulliano,
v. Benedictus.
— episcopus Avinionen., v. Bertrandus.
— episcopus Barchinonen., v. Bernardus.

Babembergen., v. Bambergen.

Balduinus imp. Constantinopolitan.: filius
eius, v. Philippus.

Balneoregen. episcopus, 3621.

Bambergen., clerus, 4180, 4766; decanus et
capitulum, 2570; episcopus, 3581, v. Lu-
poldus, Vulvingus; praepositus, 2570;
subdecanus et capitulum, 4584; vassalli
eccl. 4181, 4767; — v. Lancheim, Montis
Monasterii.

Banduk, v. Radolfus de.

Bangoren., dioc. v. Aberconeway mon.

Barchinonen. canonicus, v. Petrus Alberti;
comitatus 4511, 4742, 4745, 4749, 4753;
episcopus, 3198, 4600, v. Bernardus; —
v. S. Cucufatis, S. Eulaliae, S. Mariae de
Mercede Captivorum, S. Michaelis de
Tallio, S. Pauli extra Muros.

Baren. archiepiscopus, 4262; — v. Renardus
de Bari.

Bar-le-Duc, v. Barri.

barones universi, v. reges.

Barri (Bar-le-Duc) comes, v. Theobaldus.

Bartholomaeus, abbas mon. S. Marie Flo-
rentin., 2510.
— filius Francisci de S. Angelo, rector par-
rochialis eccl. S. Nicholai de Midalton.,
dioc. Wintonien., 4508.
— dictus Testa, can. Anagnin., 3567.

Basilien. dioc., v. S. Leonardi.

Baumberg, v. Boumburc.

Beatae, Beati, ecc., v. Sanctae.

Bellapertica, v. Petrus de.

Bellicen. episcopus, 2495.

Belli Loci, v. Libera Abbatia.
— Podii (Belpuig), dioc. Urgellen., abbas,
2612.

Beln., dioc. Aeduen., v. S. Stephani de.

Belpuig, v. Belli Podii.

Belvacen. canonicus, v. Evrardus de Nogen-
tello; cantor, 2455; episcopus, 2772; offi-
cialis, 2523, 2632; — v. S. Mariae de
Pentheomonte.

Benedictus, card. S. Nicolai in Carcere Tul-
liano, 4042, 4094, 4207, 4208, 4268, 4285,
4287-4291, 4293-4300, 4363; nepotes eius,
v. Benedictus dictus Gaitanus, Loffridus.

C

2526; prior et alii praelati, 2591; prior heremi, 2938; prior heremi, abbates, abbatissae, priores, priorissae, fratris et sorores, 2963; prior heremi et conventus, 2928.

Cameracen. archidiaconus, *v.* Thomas de Paliano; canonici, *v.* Bernardus Rubeus; Gaufridus de Vesano; episcopus et caeteri praelati, 3171, 3172, 3367; episcopus, abbates, priores, decani, archidiaconi, priores Praedicatorum, ministri, custodes, seu guardiani Minorum, 3188, 3189, 3247, 3252.

Camerinen. dioc., *v.* Aria.

Campania: fideles Ecclesiae, 4349.

— et Bria: comes, 3469; E. comes, 3960.

— et Maritima: barones, potestates, etc., 3568; collector decimae, 4277; episcopi, 2572, 2573; rector, *v.* Iordanus Perunctus; vicarius rectoris, *v.* Iohannes Perunctus; — *v.* Campania.

Campidona, mon. in, dioc. Constantien., abbas, 4737, 4738.

Campis, Parisien., *v.* S. Mariae de, S. Martini de.

Cantalupo, domus de, iuxta portam Favergiam Mediolanen., ministra et sorores, 4282.

Cantuarien. archiepiscopus, 2340, 2344, 2832; archiepiscopus, suffraganei, abbates, priores, decani, archidiaconi, praepositi et alii eccl. praelati, 2794.

Capellarii, Berengarius, can. Avinionen., 3718.

capitanei universi, *v.* reges.

Capriaco, *v.* Iohannes de.

Capuan. archiepiscopus, 3719.

Carasio, dioc. Vivarien., *v.* S. Michaelis de.

Cardineto Parisien., prior de, 3112, 3113.

Cardona, dioc. Urgellen., abbas de, 2789.

Cardonen., dioc. Treveren., *v.* S. Castoris.

Carinthiae dux, 3643.

Carleolen. episcopus, 4333.

Carmeli, *v.* S. Mariae ord. de Monte Carmeli.

Carnoten. canonicus, *v.* Loffridus dictus Gaitanus; comes, *v.* Petrus comes Alençonis episcopus, 4018, 4478, 4479, 4481; — *v.* Pissiacen., S. Iohannis de Nongento Retrodi.

Carolus, comes Alençonis, 4741.

— comes Alençonis et Andegaviae, filius cl. m. Philippi (III) regis Franciae, 4418, 4419, 4420, 4421, 4423; comes Andega-

viae, filius Philippi (III) regis, 4716, 4731, 4733; comes Andegaviae, frater Philippi (IV) regis, 4712, 4713; comes Andegaven., rector Massae Trabariae et terrae S. Agathae, 4714; filia eius, *v.* Isabella; uxor eius, *v.* Margareta filia Caroli (II) regis Siciliae.

— comes Andegaviae et Provinciae, 2825, 2337; *v.* Carolus (I) rex Siciliae.

— rex Aragonum, 4242, 4192; rex Aragonum et Valentiae, 4082-4085.

— (I), rex Siciliae, 3990; *v.* Carolus comes Andegaviae et Provinciae.

— (II), rex Siciliae, 4266, 4301, 4313, 4466, 4579; archiepiscopi, episcopi, etc. in terris eius, 4725; filia eius, *v.* Margareta.

Carpentoraten. episcopus, 3725, 3726, 4263.

Cartusien. prior et priores, 2314-2316, 2349, 2350, 3698, 3700-3702; priores et fratres, 2401, 2402, 2604-2609, 3386-3388, 3399, 3812; capitulum generale, 2592, 2596; conventus etc., 4086, 4529, 4768, in Aragonia etc., 4745, in Provincia et comitatu Forchalquerii, 4725, in provincia Remen., 4256.

Casadei, dioc. Claromonten., abbas, 2454, 2475.

Casale, dioc. Vulterran., *v.* Pini de Casale.

Cashel, v. Cassellen.

Cassellen. (*Cashel*), archiepiscopus, 2922.

Castella, *v.* Alphonsus primogenitus qd. primogeniti Alphonsi regis Castellae.

Castelleto, *v.* Aegidius de.

Castello, *v.* Oppizo de.

Castriduni (*Châteaudun*) vicecomes, *v.* R.

Castro Nantonis, *v.* Guillermus de.

Castronovo, dioc. Magalonen., prior de, 4732.

Casulis, dioc. Vulteran., praepositus eccl. de, 2956.

Cathalanen. episcopus, 4048, 4333.

Catherina, imperatrix Constantinopolitan., 4712, 4713, 4719.

Cauchi, *v.* Henricus de.

Cavallicen. episcopus, 3571, 4263; — *v.* Insulan.

Caynonen. eccl., dioc. Turonen., canonicus, *v.* Riccardus dictus Anglicus.

Cayphae dominus, *v.* Iohannes de Valençenis.

Cazagatis, *v.* Nicholaus de.

Cendras, v. Sendracen.

Cenomanen. magister scholarum, 2509; — *v.*

Abiennen.

Cereto (*Cerreto*), mon. de, dioc. Lauden., abbas et conventus, 4214.

Cervo Frigido, domus de, dioc. Melden., maior minister et fratres ord S. Trinitatis, 3775.

Cesaraugustan. camerarius, 4215; cantor, 4215; episcopus, 2943, 2989, 3013, 3038, 4599; episcopus, collector decimae, 4749, 4753; — *v.* S. Mariae de Olivario.

Cesarien. mon., dioc. Augusten., abbas et conventus, 3651.

Chableys, eccl. de, dioc. Lingonen., cantor, 3983.

Châteaudun, v. Castriduni.

Chiemsee, v. Chimen.

Chimen., Kimen. (*Chiemsee*) episcopus, 2274, 2743; praepositus et capitulum, 2278.

Chotessovicen. (*Chotischau*) mon., magistra et sorores, 3784.

christifideles universi, 2452, 2466, 2610, 2665, 2670, 2813, 2821, 2872, 2894, 3313, 3501, 3979, 4267, 4302, 4304, 4309, 4317, 4318, 4354, 4355, 4371, 4388, 4410, 4496, 4515, 4530, 4597, 4641, 4642, 4772, 4773; *v.* reges; — chr. per tres civitates et dioc., 4388.

Cicestren. decanus, 4045.

Circulis, *v.* Petrus filius qd, Consilii de

Cistercien., Cistercii abbas et capitulum generale, 2373; abbas et coabbates ord. Cist., 2585, 2678; abbas, coabbates et conventus, 2311, 2321, 2339, 2361, 2366-2369, 2400, 2433, 2434, 2436, 2469, 2617, 2672, 2704, 2708-2710, 2712, 2717, 2719, 2732, 2753, 2815, 2829, 2834, 2866, 3011, 3046, 3799, 3811, 3853, 4734; abbates, etc., 4086, 4529, 4768; abbates, abbatissae et conventus, 3827, 3828, 4735; — *v.* Aragonia etc., Provincia et com. Forchalquerii, Remen.

Civitas Papalis (*Palestrina*) commune et singulae personae, 4670.

Clairvaux, v. Clarae Vallis.

Clarae Vallis (*Clairvaux*), dioc. Lingonen., abbas et conventus, 4211.

Clarimonten. comes, *v.* Robertus.

Claromonten. officialis, 2454; — *v.* Casedei, S. Genesii.

Claustro (*Himmerod*), mon. de, dioc. Treveren., *v.* Hymmenrode.

Clermont, v. Clarimonten.

Cluniacen., dioc. Matisconen., abbas, coab-

bates, priores et conventus, 3862; abbas et conventus, 2584, 2797, 3728-3730, 3738, 3964-3966; abbates, *v.* Guillermus, Ivo, ordo, 4086, 4529, 4768, *v.* Aragonia, Provincia et Forchalquerii, Remen.

Clusin. dioc., *v.* S. Petri de Petroio.

Cociaco, *v.* I. dominus de.

Colimbrien. decanus, 2762.

Colonien. archiepiscopus, 4710; archiepiscopus, suffraganei, abbates, priores, decani, archidiaconi, praepositi, archipresbiteri et alii eccl. praelati, 2809; praepositus, 3884.

Columpna, *v.* Landulfus de.

comites universi, *v.* reges.

communia universa, *v.* reges.

communitates universae, *v.* reges.

Compendien. (*Compiègne*), dioc. Suessionen., abbas, 2382, 4148; — *v.* S. Cornelii de Compendio.

Compostellan, *v.* Montis Ferri.

Conchen. dioc., *v.* Alcoçer.

Conradus, archiepiscopus Salzeburgen, 4340.

consilia (civitatum) universae, *v.* reges.

Consilii de Circulis, *v.* Petrus filius.

Constantia, filia Petri de Monte Cathano, dioc. Ilerden., 3601.

— relicta qd. Petri regis Aragonum, 4305, 4307, 4401, 4405, 4492, 4512, 4570.

Constantien. canonicus, *v.* Gregorius de Geneçano; episcopus, 2971; — *v.* Campidona, Domo Petri, Klingental, Salem.

Constantinopolitan. imperator, *v.* Philippus filius Balduini imp.; imperatrix, Catherina, 4712, 4713, 4719; S. Sansonis hospitale, 2334.

consules universi, *v.* reges.

Conventren. dioc., mon. de..., 3792.

Corboliacen. canonicus, *v.* Petrus dictus Rufus.

Corsica, *v.* Sardiniae et Corsicae regnum.

Cortona, dioc. Aretin., potestas et capitaneus de, 2554; *v.* S. Mariae de Tarcia.

Couceroys, *errore nella scheda, vedi*: Cruceroys.

Couchy, v. Cociaco.

Cremonen, *v.* S. Iohannis de Pipia.

Crucerois (*Royston*), dioc. Londonien., prior de, 4030, 4032.

Crucis, *v.* Podio Crucis, mon. de.

Cuculla, *v.* S. Aemiliani de.

Curonia, *v.* Livonia.

Cuspeyo, *v.* Guillermus de.

Cutien. eccl. decanus, 2942.

D

Dammartin, v. Donnimartini.

Dauraten. (*Le Dorat*), dioc. Lemovicen., cantor, 2786, 2796.

decani universi, *v.* archiepiscopi, reges.

Derlenton, Iohannes de, 3913.

Dertusen. episcopus, 4593, 4600, *v.* Arnaldus.

Dilingen, *v.* S. Spiritus in.

Dinimonen. (*err.*), *v.* Divionen.

Divionen., *v.* S. Benigni.

Dokzan, mon. de, magistra eiusque etc., 3781.

Dolen. canonicus, *v.* Bernardus episcopus, 4619, 4633, 4634.

Dominici, *v.* Stephanus.

Domo Petri, mon. de, dioc. Constantien., abbas, 3892.

Domus Dei in Heslibach, dioc. Augusten., Henricus prior et fratres, 4078.

Donatus, filius qd. magistri Guidonis Nasi de Florentia, 2960.

Donnimartini comes, *v.* I.

Dreux, v. Drocen.

Drocen. (*Dreux*) comes, *v.* Robertus.

Duaco (*Douai*), *v.* Robertus de; hospitale, *v.* S. Sansonis.

duces universi, *v.* reges.

Duodecim Apostolorum, Placentin., *v.* S. Raimundi.

E

E., archiepiscopus Tyren., *v.* Aegidius.

— comes Campaniae et Briae, 3960.

— primogenitus regis Angliae, *v.* Eduardus.

— rex Angliae, *v.* Eduardus.

Eberaco, mon. de, *v.* Ebracen.

Ebersberg, Ebersperc, Hebersperch (*Ebersberg*), mon. de, dioc. Frisingen, abbas, 2939 3563, 3564; abbas et conventus, 2664, 3822.

Eboracen., *v.* Rayfuryae.

Ebracen., de Eberaco (*Ebrach*) mon. dioc. Herbipolen., abbas et conventus, 3152, 3744, 4248, 4280, 4343.

Ebredunen. archiepiscopus, 4495.

Ebroicen. archidiaconus, 3692; comes, *v.* Ludovicus.

Edmundus, rex Siciliae, 2569.

Eduardus, filius Eduardi (I) regis Angliae, 4352, 4645.

Eduardus, primogenitus regis Angliae, 3516; *v.* Eduardus (I) rex.

— (I) rex Angliae, 3720, 3800, 3878, 4089, 4186, 4204, 4271, 4276, 4319, 4329-4332, 4335, 4336, 4338, 4339, 4342, 4372, 4390, 4398, 4424, 4523, 4631, 4643, 4644, 4646, 4647, 4649, 4663, 4671, 4673, 4674, 4681, 4690, 4697, 4701, 4703, 4704, 4759, *v.* Eduardus primogenitus; filius eius *v.* Eduardus filius.

Eduen., *v.* Aeduen.

Egidius, *v.* Aegidius.

Eisteten. plebanus, 3803; — *v.* Hausen.

electi universi, *v.* archiepiscopi, reges.

Elien., *v.* Pietatis S. Mariae.

Elizabet, *v.* Helizabet.

Engolismen. archidiaconus, 2915; canonicus, *v.* Rampnulfus Andreae; comes, *v.* H. comes Marchiae decanus, 2915.

episcopi universi, *v.* archiepiscopi, reges.

Erardus de Valeri, 3674, 3675.

Erbo canonicus. Ratisponen., 3312.

Etel, mon. de, dioc. Frisingen. abbas, 2939.

Eugubin. episcopus et capitulum, 4561.

Eunufrius, *v.* Honufrius.

Evrardus, monachus Vallis Scholarum, magister in theologica facultate, Parisius constitutus, 2893.

— magister, de Nogentello, can. Belvacen. executor Iohannis card. S. Caeciliae, 4413.

F

F., archiepiscopus Messanen., *v.* Franciscus.

Faesulan. archipresbiter, 3671; episcopus, 2962; populus, civitas et dioc., 4708; eccl. praepositus, 2964; praepositus et capitulum, 4709; — *v.* Fonte Domini, Podio Crucis, Vallis Umbrosae.

Farneta, abbas de, Aretin. dioc., 2479.

Farpha, *v.* S. Mariae Farphen.

Favarchiis, Favarcheto (*Fervaques*), mon. de, dioc. Noviomen., abbatissa et conventus, 3007, 3315, 3716, 3876, 3877.

Faventin. praepositus, 2536.

Favergia porta, Mediolanen., *v.* Cantalupo.

Ferentin. civis, *v.* Rizardus de; episcopus, *v.* Iacobus.

Fernandus, filius (Alphonsi X) regis Castellae et Legionis, 3588, 3664.

Ferrandus, *v.* Fernandus.

Ferrarien. dioc., *v.* S. Mariae de Ferraria; ord. Praed. capitulum in Ferraria, 4303.

Ferrariis (*Ferrières-en-Gâtinais*), dioc. Senonen., abbas de, 3092.

Ferrières-en-Gâtinais, v. Ferrariis.

Fidelium societas seu schola Mediolanen., 2933.

Flandriae, G. comes, 3960.

Florentin. cives, *v.* Bonutius (Renutius?) Senni, Donatus filius mag. Guidonis Nasi; clericus, *v.* Petrus filius qd. Consilii de Circulis; episcopus, 2550, 4221, 4542, 4726; potestas, capitaneus, antiani et consilium, 2430; praepositus, 2896; ord. Min. minister, 2529, 2895; ord. Praed. prior, 2895; — *v.* S. Ambrosii extra Muros, S. Apollinaris, S. Mariae de Cafagio iuxta Florentiam, S. Mariae ad S. Gallum, S. Mariae Maioris, S. Michaelis Buteldi, S. Pancratii, S. Petri Skeradii, S. Salvatoris, S. Salvatoris de Septimo, S. Salvi, S. Spiritus ad Pontem, S. Stephani, S. Trinitatis.

Floriacen. mon., *v.* S. Benedicti.

Foigny, v. Funiacen.

Foix, v. Fuxen.

Folquini, v. Guillermus.

Fonte Domini, mon. de, dioc. Faesulan., abbatissa et conventus, 3589, 3590.

Fonte Gratiae in Studeniz, dioc. Aquilegen., mon. de, priorissa et conventus, 2487.

Forchalquerii comitatus, *v.* Provincia.

Formbach, v. S. Mariae de Vormbach.

Fornovo, dioc. Parmen., archipresbiter de, 4500.

Fossaten. mon., *v.* S. Mauri de Fossatis.

Franche-Comté, v. Burgundia.

Francia: archiepiscopi et episcopi, 2822, 3676, 3918, 3921, 3922, 3924, 3925, 4176; a., e. et alii eccl. praelati, 2920, 3171, 3172, 3367, 3875, 3925; a., e., abbates, priores, et alii eccl. praelati, 4182, 4183; a., e., abb., pr., decani, archidiaconi et alii eccl. praelati, 2907; a., e., abb., pr., d., archidiaconi, priores Praedicatorum, ministri, custodes, seu guardiani Minorum, 3188, 3189, 3247, 3252; a., e., abb., pr., archidiaconi, archipresbiteri et alii eccl. praelati, 2578; a., e., dec., archid., officiales et universi eccl. praelati, 3760; archiepiscopus Tyren., executor negotii Crucis, 3301, 3304, 3305; buticularius, *v.* Iohannes; Christifideles, 3392; confessores, 3919, 3920; constabularius, *v.* I:; fra-

trum Minorum minister provincialis, 3096; fratrum Praedicatorum prior provincialis, 2428, 2441, 2877, 3035, 3037, 3053, 3054, 3056, 3058, 3059, 3061, 3064, 3065, 3067, 3068, 3071, 3074, 3078, 3080, 3096, 3625, 4200, prior provincialis et fratres, 2701, 3560, inquisitores, 2930, 3298-3300, 3732; hospitalis Ierosolimitan. prior et fratres, 3026; hospitalis S. Iohannis Ierosolimitan. pr. et fr., 3682, priores, 4606; militiae Templi praeceptor et fratres, 2397, 2398, 3428; regina, *v.* Iohanna, Margarita, Maria; rex, 2331, 2332, 2338, 2405, 2406, 2497, 2533, 2534, 2571, 2575, 2576, 2695, 2696, 2700, 2781, 2784, 2826, 2873, 2914, 2916, 2985-2987, 3002, 3283, 3604-3612, 3690, 3749, 3750, 3771, 3773, 3774, 3805, 3807, 3814, 3831, 3834, 3835, 3864, 3886, 3888, 3916, 3959, 3985, 3997, 4002, 4014, 4015, 4046, 4071, 4074, 4076, 4238, 4359, *v.* Ludovicus, Philippus (III), Philippus (IV).

Franciscus, archiepiscopus Messanen., 4484, 4485.

Francorum rex, *v.* Francia.

Frankenforden., dioc. Maguntin., decanus, 4796.

Fredentius, abbas S. Stephani Ianuen., 2913.

Fridericus, abbas mon. S. Emmerammi Ratisponen., 3565, 3566.

— archiepiscopus Salzeburgen., 3779.

— filius Petri regis Aragonum, 4474.

Friesach, v. S. Virgilii Frisacen.

Frigionaria, *v.* S. Mariae de.

Frisacen., de Frisaco (*Friesach*), *v.* S. Bartholomaei, S. Virgilii.

Frisingen. episcopus, 3454, 3539, 3764, 4394-4396; — *v.* Ebersberg, Etel, S. Martini de Roth, S. Spiritus de Monaco, Schiren, Tegernsee, Vallis Salutis.

Frosinone, v. Frusinone.

Frowz, dioc. Aquilegen, *v.* S. Mariae in.

Frusinone, Frisinone, *v.* Iohannes de.

Fulden. mon., dioc. Maguntin., abbas, 4797.

Fultenbach, v. Vultembach.

Funiacen., Fusinacen., de Fusniaco (*Foigny*) mon., dioc. Laudunen., abbas et conventus, 2419, 2707, 3849.

Furstenvelt (*Fürstenfeld*), mon. de, abbas et fratres, 3595.

Fusinacen. mon., *v.* Funiacen.

Fusniaco, mon. de, *v.* Funiacen.

Fuxen. (*Foix*) mon., dioc. Tolosan., abbas, 3237.

G

G., comes Flandrie, 3960.
— comes S. Pauli (*St-Pol, Pas-de-Calais*), 3960.
— dominus de Archiepiscopo, 3960.
— episcopus Sabinen., *v.* Gerardus.
— vicecomes Thoartii, 3960.
Gaitanus, *v.* Benedictus card., Loffridus, Petrus.
Galdericus, monachus Cluniacen. magister in theologica facultate Parisius constitutus, 2893.
Galdo, *v.* S. Mariae de Gualdo, dioc. Beneventan.
Galliae partes, *v.* Francia.
Galterus, episcopus Pictaven., 4245, 4347.
Gars (*Gars*), mon. in, praepositus et fratres, 2975.
Garsia Petri, canonicus Zamoren., 4103.
Gaufridus, episcopus Taurinen., 3868, 3871, 3873.
— de Vesano, clericus Camerae Ap., can. Cameracen., 4334.
Gebennen. dioc. inquisitores ord. Praedicatorum, 3623.
Geneçiano (*Genazzano*), *v.* Gregorius de.
Gentilis de filiis de Urbe, 4693.
Gerardus, episcopus Sabinen., 4285, 4287-4291, 4294-4298, 4300.
— de Goignelvi, magister, canonicus Remen., Parisius commorans, 3055.
— de Marbais, 3674, 3675.
— de Rampelione, magister, archidiaconus Senonen., capellanus card. S. Caeciliae, 3679, 3680.
Gerardutii, *v.* Rolandus.
Gerunden. archidiaconus, 4568; sacrista, 4012; — *v.* S. Felicis, S. Petri de Gallicantu, S. Petri de Rosis.
Gilebertus, comes Gloverniae et Herefordiae, 4273.
Glasguen. episcopus, 4730.
Gloria, *v.* S. Mariae de.
Gloverniae et Herefordiae comes, *v.* Gilebertus.
Godesowe (*Godshof*), mon de, abbas, 2981, 2991.
Godshof, *v.* Godesowe.
Goignelvi, *v.* Gerardus de.
Gomiel, dioc. Oxomen., *v.* S. Petri de.
Gosse (*Göss*), mon. in, dioc. Salzeburgen. abbatissa et conventus, 4028, 4029.
Gradus, *v.* S. Mariae ad.

Graecorum patriarcha, archiepiscopi, episcopi, abbates caeterique praelati, 3870.
Grandimonten. ordo, conventus in Aragonia etc. 4745; in provincia Remen., 4256.
Gregnano, dioc. Pistorien., *v.* S. Mariae de.
Gregorius IX papa: nepos eius, *v.* Nicholaus de Anagnia.
— de Geneçiano, canonicus Constantien., 4441.
— de Neapoli, magister, subdiaconus et capellanus pape, 3190.
Grimerius, archiepiscopus Aquen., 3820.
Grossetan. dioc., *v.* S. Willermi.
Gualdo, dioc. Beneventan., *v.* S. Mariae de.
Guazalongo Pisan., *v.* S. Martini de.
Guido Nasi de Florentia, magister: Donatus filius eius, 2960.
— de Zena, can. Mantuan., familiaris papae, 3715.
Guillermus, card. S. Clementis, 4430, 4450, 4459, 4468, 4473, 4494.
— notarius papae, abbas Cluniacen., 2355.
— patriarcha Ierosolimitan., legatus, 3175.
— de Anterminelli, can. Lucan., 4311.
— de Castro Nantonis, magister, can. Senonen., 4113, 4114, 4115.
— de Cuspeyo, magister, can. S. Quintini in Viromandia, dioc. Noviomen., 4617.
— Folquini, magister, capellanus papae, can. Narbonen., 3663, 3665, 3666, 3672, 3673.
— de Lauro, rector ecclesiarum S. Mariae et S. Andreae de Congeniis, dioc. Nemausen., 4218.
— de Monteforti, magister, capellanus papae, decanus Middelsexiae in eccl. S. Pauli Londonien., 4334.
— de Sancto Amore, 2698.
— de Serano, magister, can. de Tutela, dioc. Tirasonen., 2943.
— de Tuningo ord. Praed., 3653.
— de Valhanquesio, can. Lodoren., 4344.
Gumiel, *v.* S. Petri de Gomiel.
Gurcen. episcopus, 3495, *v.* Iohannes.

H

H., comes Marchiae (*La Marche*) et Engolismae (*Angoulême*), 3960.
— magister hosp. S. Mariae in Alpibus, dioc. Patavien., 4786.
— rex Angliae, *v.* Henricus.
Haussen (*Auhausen*), mon. in, dioc. Eisteten., abbas et conventus, 4088.

I

Inferiori Alhta (*Niederaltaich*), mon. de, dioc. Patavien., abbas, 3708.

Insulan. eccl., dioc. Cavallicen., praepositus, 3689.

Iohanna, regina Francorum, 4792, 4793.

Iohannes, buticularius Franciae, 3960.

— card. S. Caeciliae, 4070, 4077, 4087, 4169, 4170, 4171, 4172; executores eius, *v.* Evrardus de Nogentello, Gerardus de Sancto Justo.

— card. SS. Marcellini et Petri, 4676, 4723, 4739, 4740.

— (I), comes Pontivi (*Penthièvre*), 3960.

— (III), comes Rociaci (*Roucy*), 3960.

— (I), comes Sacri Caesaris (*Sancerre*), 3960.

— (III), comes Suessionen., 3960.

— dux Britanniae, 3960; Iohannes filius Arturi primogeniti eius, 4688.

— episcopus Gurcen., 3976.

— filius Arturi, primogeniti Iohannis ducis Britanniae, 4688.

— filius Paganelli de Montemagno, can. Pisan., 4140.

— de Capriaco, magister, archidiaconus Rothomagen., 4617.

— de Cauter O.F.M. Wigornien. (*Worcester*), 2378.

— de Derlenton, 3913.

— de Frisinono, (*Frosinone*) magister, sub-

— Perunctus, nepos et vicarius magistri Iordani vicecancellarii R.E. et notarii et rectoris Campaniae et Maritimae, 3050.

— de Procida, 4514.

— de Valencenis (Valençenis, Valentinis), dominus Cayphae, 3238, 3250, 3276, 3372, 3373.

Iolanda, filia qd. Petri (III) regis Aragonum, 4454.

Iordanus Perunctus, vicecancellarius etc., *v.* Iohannes Perunctus.

Isabella, filia Caroli comitis Andegaviae, 4688.

— filia Philippi (IV) regis Franciae, 4645.

Italia: priorissae et conventus sub cura fratrum Praed., 4563.

Ivo, abbas Cluniacen., 3970.

K

Kalhohus, canonicus eccl. Ratisponen., 3312.

Karulus, *v.* Carolus.

Kimen., *v.* Chimen.

Klingental, mon. de, dioc. Constantien., priorissa et conventus, 2639.

L

L., rex Francorum, *v.* Ludovicus.

Lancheim (*Langheim*), mon. de, dioc. Bambergen., abbas et conventus, 4249, 4252, 4345.

Landulfus, electus Brixinen., 4521.

— de Columpna, civis Romanus, 4622.

Langheim, v. Lancheim.

Lauden. dioc., *v.* Cereto.

Laudunen. decanus et capitulum, 2450, 3032, 3099, 3100; — *v.* Funiacen., Roseten., S. Mariae, Vallis Clarae.

Laurentius, magister, notarius papae, scholasticus Treveren., 3584.

Lauro, *v.* Guillermus de.

Lausanen. dioc. inquisitores ord. Praedicatorum, 3623.

Lavent, dioc. Salzeburgen., *v.* S. Pauli in

Lectoren. archidiaconus, 4321.

Le Dorat, v. Dauraten.

Legionen. episcopus, 2869, 2900, 2931, 4133; magister scholarum, 2694; thesaurarius, 3570; — *v.* S. Facundi, S. Isidori.

Leicestriae, in eccl. Lincolnien., archidiaconus, 4035.

Lemovicen. dioc., *v.* Dauraten.

Leodien. episcopus, abbates, priores, decani, archidiaconi, priores Praedicatorum, ministri, custodes, seu guardiani Minorum, 3188, 3189, 3247, 3252; episcopus et caeteri praelati, 3171, 3172, 3367; — *v.* S. Aegidii de Publico Monte, S. Martini.

Lérins, v. S. Honorati Lirinen.

Leubus, v. Lubes.

Lewellinus princeps Walliae, 3809.

Libera Abbatia (*Abbaye-aux-Bois*), iuxta Bellum Locum, dioc. Noviomen., abbatissa et conventus, 3732.

Liert, dioc. Oscen., prior de, 4091.

Lincolnien. cancellarius, 2992, *v.* Leicestriae.

Lingonen., *v.* Chableys.

Lingonen. dioc., *v.* S. Benigni Divionen.

Lirinen. (*Lérins*) mon., *v.* S. Honorati.

Livonia: fratres hosp. S. Mariae Theutonicorum praedicantes in subsidium Livoniae, Curoniae et Prussiae, 3177.

Lodoicus, *v.* Ludovicus.

Lodoren. canonicus, *v.* Guillermus de Valhanquesio.

Loffridus dictus Gaitanus de Anagnia nepos B. card. S. Nicolai in Carcere Tulliano, can. Ambianen., 4206; can. Carnoten., 4281.

Lombardia: archiepiscopus et episcopi, 2572, 2573; potestates, capitanei et rectores etc., 3963; Heremitarum prior et fratres, 3657; ord. Praed. inquisitores, 2336, 2476, 2545, 2593, 2882, 2919, 2953, 2954, 3519, 3546, v. Rainerius de Placentia; eiusdem ord. prior provincialis, 2959, 3027, 3033, 3528, prior provincialis, priores conventuales et superiores, 2755; ord. S. Dominici religiosi, 2447.

Londonien. episcopus, 3913; — v. Cruceroys, Middelsexiae, S. Pauli, S. Trinitatis, Waltham, Westmonasterii.

Lubes (*Leubus*), mon. de, dioc. Wratislavien., abbas, 4260.

Lucan. archipresbiter, v. Rainerius de Montemagno; canonici, v. Guillermus de Anterminelli, Opizo de Castello, Ubaldus; episcopus, 4695, 4784; potestas, capitaneus, antiani, consilium, et commune, 4550; primicerius, 4107; ord. Praed. lector conventus Lucan., v. Salvus; — v. S. Cerbonii, S. Frigdiani, S. Petri, S. Petri de Montecatino.

Ludovicus, filius qd. Philippi (III) regis Francorum, comes Ebroicen., 4702.

— marchio de Hohenburch, 2282, 2298, 2299, 2301-2303.

— (VIII) rex Francorum: filia eius, v. Elizabet.

— (IX), rex Francorum, 2408, 2409, 2483, 2484, 2488, 2857, 2917, 3371, 3384, 3577; filii eius, v. Blanca, Philippus; soror, v. Elizabet.

Lugdunen. archiepiscopus et suffraganei, 4054; electus et suffraganei, 3185; — v. Athanacen. mon.

Lunen. episcopus, 2550.

Lupi, v. Rolandus.

Lupoldus, episcopus Bambergen., 4585.

M

Magalonen. christifideles, 3603; episcopus, 2457, 3434, 3602, 3633, 3641, 3743, 3829, 4575; — v. Castronovo, Montispesulan., S. Petri de Agantico.

Maguntin. archiepiscopus, 4710; archiepiscopus, suffraganei et alii eccl .praelati, 2443; archiepiscopus, suffraganei, abbates, priores, decani, archidiaconi, praepositi, archipresbiteri et alii eccl. praelati, 2809; — v. Frankenforden., Fulden., S. Stephani.

Maiella, dioc. Theatin., v. S. Spiritus de

Mainen. episcopus, v. Rainerius de Papia.

Maioris Monasterii (*Marmoutier*) Turonen. abbas, 3699.

Mansuetus, ord. Min., capellanus et paenitentiarius papae, 2921.

Mantellus, v. Armanus.

Mantuan. canonicus, v. Guido de Zena; dioc., v. S. Francisci.

Marbais, Gerardus de, 3674, 3675.

Marchia (*La Marche*), comes, v. H. comes.

— Anconitana, episcopi, 2572, 2573; episcopi, abbates ..., magistri et fratres hosp. Ierosolimitan., priores et fratres ord. Praed. et Min., 3874.

— Ianuen.: ord. Praed. inquisitores, 2476, 2545, 2593, 2882, 2919, 2953, 2954, 3519, 3546, v. Rainerius de Placentia et fratres; ord. Praed. prior provincialis, priores conventuales et superiores, 2755.

— Trevisina episcopi, 2572, 2573.

Marchiones universi, v. reges.

Margareta, filia Caroli (II) regis Siciliae, 4292; uxor Caroli comitis Alençonis et Andegaviae, 4418-4421, 4423.

— filia qd. Philippi filii Roberti comitis Atrebaten., 4702.

— filia Philippi (IV) regis Francorum, 4646.

— regina Franciae, 2484.

Maria, regina Francorum, 3933, 3934, 3944, 3945, 4005.

Maritima, v. Campania et M.

Marmoutier, v. Maioris Monasterii.

Marsican. dioc., v. S. Nicholai de Ferrato.

Massa Trabaria, rector, v. Carolus, comes Andegaviae.

Massan. episcopus, 2828; — v. S. Mariae de Massa.

Massilien. episcopus, 4495.

Mathias dictus de Papa, de Anagnia, v. Oddo filius Adenulphi qd. Mathiae.

— de Theate, magister, clericus Camerae Ap., rector comitatus Venaysin., 4666, 4669.

Matthaeus, abbas S. Dionisii, dioc. Parisien., 2780, 2798, 3940, 3946, 3947, 3962, 4024-4027, 4175.

Medeligen, Medigen, dioc. Augusten., v. S. Mariae de.

Medina, dioc. Salamantin., archidiaconus de, 3089, 3109; cantor, 3109; decanus, 3089, 3109.

Mediolanen. archiepiscopus, 4783; christifideles de congregatione B. Virginis ac de societate seu schola Fidelium, 2933; ord. Praed. prior et fratres, 2611; — v. Cantalupo, S. Mariae in hosp., S. Laurentii extra Portam Ticini, S. Mariae Reginae Virginum Porte Vercellen., S. Mariae et S. Apollinaris extra Portam Romanam.

Melden. dioc., v. Cervo Frigido.

Melfiten. episcopus, 4562.

Meneven. episcopus, 3206, 3207, 3210, 3211, 3216, 3217, 3254.

Merauda, soror mon. S. Clarae, dioc. Arelaten., 2465.

Mercede Captivorum, v. S. Mariae de, S. Mariae de Olivario.

Meten (*Metten*), mon. de, abbas et fratres, 3825.

Meten. episcopus et caeteri prael., 3171, 3172, 3367; episcopus, abbates, priores, decani, archidiaconi, priores Praedicatorum, ministri, custodes, seu guardiani Minorum, 3188, 3189, 3247, 3252; ord. Praed. inquisitores, 3623; primicerius, v. Nicholaus de Trebis; — v. S. Theobaldi.

Metten, v. Meten.

Michelsteim, v. Valle S. Mariae.

Midalton, dioc. Wintonen., v. S. Nicholai de.

Middelsexiae (*Middlesex*), dioc. Londonien., archidiaconus, 2378, v. Radolfus; decanus, v. Guillermus de Monteforti.

Milstaten. mon., dioc. Salzeburgen., abbas et conventus, 3904.

Mindonen. dioc., v. Vivario.

Minnebach, v. S. Mariae de.

minorissae, abbatissae et conventus, 4546, 4547.

Minorum ord. frater, v. Mansuetus; inquisitores, 3630, 3793, 3794, 4236; minister et capitulum generale, 3174; minister generalis et fratres, 2345, 2352, 2544, 3456, 3474, 3645, 4123, 4124, 4135, 4136; minister generalis, alii ministri et fratres, 3658; ministri generalis et provinciales, 2413; ministri generalis et provinciales, et custodes, 4051; ministri generalis et provinciales, custodes, guardiani et fratres, 2414; ministri generalis et provinciales, et fratres, 2558, 2792, 2816, 3498, 3661, 3984, 4216; ministri provinciales et fra-

tres, 2517; v. Farfensis mon. terrae, Florentin., Marchia Anconitana, Parisien., S. Francisci de Assisio, S. Geminiani, Terra Sancta, Tullen., Virdunen.

Monaco (*München*), dioc. Frisingen., v. S. Spiritus de.

Monachus, archidiaconus Senen., 4315, 4316.

Monoascha, v. S. Salvatoris de.

Montebello, mon. de, Placentin. dioc., abbas, 2411.

Monte Carmeli, ord. de, v. S. Mariae.

Monte Cathano, v. Constantia, filia Petri de.

Montecatino, dioc. Lucan., v. S. Petri de.

Monteforte, v. Guillermus.

Montemagno, v. Iohannes Paganelli de, Rainerius de.

Monte Pulisiano, eccl. de, dioc. Aretin., v. S. Mariae de Monte Pulciano.

Monte Semernich, v. S. Mariae de.

Montfort-l'Amaury, v. Montisfortis.

Montierneuf, v. S. Iohannis Novi Monasterii.

Montiscorvini episcopus, 4443; — v. Petra.

Montis Ferri (*Monfero*), dioc. Compostellan., abbas et conventus, 2911.

Montisfortis (*Montfort-l'Amaury*) comes, v. Robertus comes Drocen. et M.

Montis Monachorum, prope muros Bambergen., abbas, 4664.

Montispesulan., dioc. Magalonen., cives et populus, 3791; consules, 2458, 2482; consules et commune, 2615, 3278; consules, consilium, commune, 3727; consules et universitas hominum, 2601, 2614, 2668, 3706; consules, vicarii et commune, 4278; populus, 3733; ord. Praed. capitulum generale, 3316.

Montis Radelach, v. S. Mariae in Pede.

— Rubei (*Montrouge*) mon., dioc. Parisien. prior et conventus, 4613.

— Sancti Tudertin., v. S. Mariae.

Montrouge, v. Montis Rubei.

Morinen. canonicus, v. Rolandus Lupi; — v. S. Audomari.

München, v. S. Spiritus de Monaco.

Murrone, dioc. Valven., v. S. Spiritus de.

Muscello, v. S. Agnetis de Burgo S. Laurentii de.

N

Nagera, in eccl. Calaguritan., archidiaconus de, 3967.

Nantonis castrum, v. Guillermus de castro Nantonis.

Narbonen archidiaconus, *v.* Iacobus Normanni; archiepiscopus, 4619, 4633, 4634; archiepiscopus, et suffraganei, 3830; canonicus, *v.* Guillermus Folquini; electus, 2950.

Nasi, Guido, *v.* Donatus, f. qd. mag. Guidonis Nasi.

Navarrae rex, 3777, comes palatinus Campaniae et Briae, 3469.

Neapoli, *v.* Gregorius de.

Neapolitan. dioc., *v.* S. Petri Martiris.

Nemausen. christifideles, 3499, 3500, 3603; episcopus, 3561, 4623, 4624; praepositus et capitulum, 2865, 2934, 3502-3504; — *v.* S. Baudilli, S. Mariae et S. Andreae de Congeniis, Sendracen.

Nesle, v. Nigella.

Nevers, v. Nivernen.

Nicholaus, nepos Gregorii IX, *v.* Nicholaus de Anagnia.

— de Anagnia, capellanus papae, nepos Gregorii IX, 3297, 3556.

— de Cazagatis, can. Regin., 4500.

— de Trebis, magister, notarius papae et primicerius Meten., 4392.

Nidrosien. archipresbiter et capitulum, 3091, 3579.

Niederaltaich, v. Inferiori Alhta.

Niederviehbach, v. Viethpac.

Nivernen. (*Nevers*) comes, *v.* Robertus.

Nobiliacen. (*Nobiliae*), dioc. Pictaven., abbas et conventus, 4117; Helias abbas, 4243.

Nogent-le-Rotrou, v. S. Iohannis de Nongento Retrodi.

Nogentello, *v.* Evrardus de.

Nongento Retrodi (*Nogent-le-Rotrou*), *v.* S. Iohannis de.

Normanni, *v.* Iacobus.

Normannia: episcopi ac abbates, priores, archidiaconi, archipresbiteri et alii eccl. praelati, 2578.

Novarien. episcopus, 4210.

Noviomen. decanus, 3200, 4769, 4770, 4771; episcopus, 4678, 4679; — *v.* Favarchiis, Libera Abbatia, S. Eligii, S. Quintini in Viromandia.

O

O., card. S. Hadriani, *v.* Ottobonus.

Oddo, filius Adenulphi qd. Mathiae dicti de Papa de Anagnia, can. S. Amati Duacen.,

dioc. Atrebaten., 4199; can. S. Audomari, dioc. Morinen., 4247.

Oddo, marchio de Hohenburch, 2282, 2298, 2299, 2301-2303.

Oeningen, eccl. in, praepositus, 2505.

Oetingen, Ottingen, eccl. in, dioc. Salzeburgen., praepositus, 3857, 4431.

Olomucen, episcopus, 3291, 3444, 3446, 3453, 3495, 4023.

Onolspacen. eccl., dioc. Herbipolen., decanus et capitulum, 2412; decanus, 4762.

Oppizo de Castello, canonicus Lucan., 4141.

Opreno, *v.* S. Nazari de.

Ormannorio, *v.* S. Crucis de.

Ortolfus, presbiter, rector hospitalis S. Mariae in Monte Simernich, dioc. Salzeburgen., 4364.

Oscen. episcopus, 2771, 4782; ord. Praed. prior et fratres, 2739; — *v.* Iacten, Liert.

Osera, v. S. Mariae de Ursuaria.

Oslo, v. Asloen.

Ottemburron (*Ottobeuron*), mon. de, dioc. Augusten., abbas et conventus, 2539.

Ottingen, dioc. Salzeburgen., *v.* Oetingen.

Ottobeuron, v. Ottemburron.

Ottobonus, card. S. Hadriani, legatus, 3513, 3514, 3515, 3517, 3626, 3636, 3642.

Oxomen. dioc., *v.* S. Petri de Gomiel.

P

P., comes Alenconae et Carnoten., *v.* Petrus.

Paganelli de Montemagno, *v.* Iohannes filius.

Palatiolis, mon. de, dioc. Albanen., abbas et conventus, 2951.

Palentin. episcopus, 2600.

Palestrina, v. Civitas Papalis, Praenestrin.

Paliano, *v.* Thomas de.

Pandulfus de Sabello, senator Urbis, 4625.

Panerinus, abbas mon. S. Mariae de Gualdo, dioc. Beneventan., 4385, 4637, 4638.

Panormi homines, 4513.

Papa, *v.* Oddo filius Adenulphi Mathiae dicti de Papa.

Papien. archipresbiter, 4198; episcopus, 4783; ord. Praed. prior et fratres, 4780, 4781; — *v.* Rainerius de Papia; — *v.* S. Agathae, S. Mariae foris Portam civ. Papiae, S. Mariae Theodotis, S. Salvatoris, Senatoris.

4066, 4092, v. Philippus filius Ludovici IX; filii eius, v. Carolus comes Andegaviae, Ludovicus.

— (IV), rex Franciae vel Francorum, 4138, 4152-4161, 4165, 4168, 4178, 4179, 4230, 4233, 4234, 4239, 4240, 4250, 4257, 4286, 4365, 4366, 4373, 4374, 4377-4379, 4381, 4383, 4384, 4386, 4397, 4399, 4402, 4406-4408, 4432, 4470, 4486, 4517, 4518, 4519, 4526, 4557, 4582, 4618, 4643, 4655-4657, 4694, 4696, 4722, 4758, 4788, 4792, 4793; filiae eius, v. Isabella, Margareta; frater eius, v. Carolus comes Andegaviae.

Piccardia: episcopi, abbates, priores, archidiaconi, archipresbiteri et alii eccl. praelati, 2578.

Pictaven. comes, 3395, 3437, 3562, 3659, v. Alphonsus; episcopus, 2445, 4251, 4310, v. Galterus; ord. Praed. inquisitores in comitatibus Pictaviae ac Tolosae, 3298, 3299, 3300; — v. Nobiliacen. S. Iohannis Novi Monasterii.

Pielenhofen, v. Pulenhofen.

Pietatis S. Mariae de Waterberche (*Waterbeach*) mon. dioc. Elien., abbatissa et conventus, 4491.

Pineta, v. S. Mariae de.

Pini de Casale, dioc. Vulteran., praepositus, 4031.

Pisan. archiepiscopus, 2725; canonicus, v. Iohannes filius Paganelli de Montemagno, potestas, capitaneus, antiani, consilium et commune, 4750; — v. Rainerius de Pisis; — v. Quiesa, Ruxorii, S. Iacobi de Podio, S. Michaelis Discalciatorum.

Pissiacen., in eccl. Carnoten., archidiaconus, 3119.

Pistorien. archidiaconus, 3537; — v. S. Andreae, S. Bartholomaei de Prato Episcopi de Alpibus, S. Mariae de Gregnano, S. Michaelis, S. Pauli de Petriccio.

Piter, eccl. de, dioc. Salzeburgen., Werncherus de Sancto Georgio rector, presbiter, 3290.

Placentin. dioc., v. Montebello, S. Mariae Duodecim Apostolorum, S. Raimundi Duodecim Apostolorum

plebani universi, v. archiepiscopi, reges.

Poblet, v. Populeto.

Pocapalea, Iacobus de, cubicularius papae, 4255.

Podio, v. S. Iohannis de.

Podiobonizi (*Poggibonsi*), dioc. Florentin, praepositus de, 4031.

Podio Crucis, mon. de, dioc. Faesulan., abbatissa et conventus, 3591.

Poggibonsi, v. Podiobonizi.

Pontiano, dioc. Tolosan., v. S. Mariae de

Pontius ...ini, can. Avinionen., 3718.

Pontivo (*Ponthieu*), dioc. Ambianen., archidiaconus de, 3055; comes, v. Iohannes.

Populeto (*Poblet*), mon. de, dioc. Terraconen., abbas, 2549; abbas et conventus, 2448, 2832, 2891, 2897, 2899, 2908, 3723, 3992, 4034.

populi universi, v. reges.

Porta Pedrioli, Brixien., v. S. Mariae de.

— Ravenate Bononien., v. S. Bartholomaei.

— Ticini Mediolanen., v. S. Mariae in hosp. S. Laurentii.

— Vercellen. Mediolanen., v. S. Mariae Reginae Virginum.

Portu, dioc. Uticen., v. S. Saturnini de.

Portugaliae episcopi, 3558.

potestates universi, v. reges.

Praedicatorum ord. capitulum generale, 2322, v. Montispessulan.; capitulum apud Ferrariam congregandum, 4303; fratres, 2304, 2500, 2542, 2736, v. Bernardus Antisiodoren., Guillermus de Tuningo, Raimundus de Penna Forti Rainerius, Rainonus, Salvus; inquisitores, 3630, 3793, 3794, 4236, v. Lausanen., Pictaven., Provincia, Sedunen., Tolosan., Tullen., Virdunen.; magister, 2285, 2322, 3036, 3057, 3060, 3066, 3070, 3075, 3076, 3077, 3078, 3081, 3082, 3085, 3655, 3948, 4129, 4130, 4303; magister generalis, 3232; magister et fratres, 2294, 2387, 2388, 2499, 2508, 2713-2715, 2734, 2741, 2770, 2791, 2802, 2814, 2827, 2868, 2912, 2918, 2923, 2968, 2970, 2977, 3121, 3391, 3401, 3406, 3433, 3457-3466, 3471-3473, 3475, 3485, 3622, 3644, 3662, 4106, 4108, 4111, 4112, 4116, 4122, 4125, 4126, 4127, 4222, 4223, 4224, 4225, 4226, 4227, 4228, 4686, 4687; magister et priores, 2287, 2288, 2531, 2658, 4274, 4275; magister et priores provinciales, 3489-3491, 3492, 3594; magister, priores provinciales, et vicarii, 2671, 2673; magister, priores ac eorum vicem gerentes, 2776, 2777, 2976, 3405, 3484; magister, priores et fratres, 2501-2503, 2627-2629, 2633, 2634, 2636-2638, 2679, 2680, 2691, 2769, 3006, 3400, 3401, 3439-3443, 3484, 3523, 3524, 3525-3527, 3535, 3536, 4543, 4544, 4545, 4785; — v. Alemannia, Bisuntin., Burgen.,

Burgundia Farfensis mon. terrae, Florentin., Gebennen., Hispania, Lucan., Marchia Anconitana, Marchia Ianuen., Mediolanen., Oscen., Papien., Parisien., Salamantin., S. Mariae ad Gradus Viterbien., S. Petri Martiris de Neapoli, Terra Sancta, Tullen., Virdunen.; — priorissae et sorores ord. S. Aug. sub cura fratrum Praed., 4610-4612, 4777-4779; in Italia, 4563; v. B. Mariae de Pontiano.

praelati ecclesiarum universi, v. archiepiscopi, reges.

Praemonstraten. ord. abbates, priores, etc., 2830, 4529, 4768; in Aragonia, etc., 4745; in Provincia, in comitatu Forchalquerii, etc., 4725; in prov. Remen., 4256.

Praenestin. episcopus, 4490; v. Civitas Papalis.

praepositi ecclesiarum universi, v. archiepiscopi ...

Pragen. episcopus, 3039, 3549, 3740; praepositus, 3540; — v. Zederaz.

Prato Episcopi, dioc. Pistorien., v. S. Bartholomaei de.

Principis Apostolorum bas., v. S. Petri de Urbe.

priores universi, v. abbates; archiepiscopi, reges.

Procida, Iohannes de, 4514.

Provincia et Forchalquerii comitatus: archiepiscopi, episcopi ... et conventus Cistercien., Cluniacen., Cartusien., Praemonstraten., S. Benedicti, S. Augustini etc., magistri hosp. S. Iohannis Jerosolimitani, militiae Templi, S. Mariae Theutonicorum et ord. Calatraven., 4725; v. Carolus; comitis vicarius in Atrebato, 2417; hosp. S. Iohannis Ierosolimitan. prior et fratres, 3850, 3852; inquisitores, 2393, 2394; militiae Templi Ierosolimitan. magister et fratres, 3510, praeceptor et fratres, 3488.

Pruel (*Prül*), mon. de, dioc. Ratisponen., abbas, 3667.

Prüfening, v. S. Georgii Pruvinigen.

Pruliano, *v.* S. Mariae de.

Pruscia, Prussia, magister et fratres S. Mariae Theutonicorum, 3047, 3648; v. Livonia.

Pruvinigen., *v.* S. Georgii Pruvinigen.

Psalmodien. mon., dioc. Nemausen., abbas, 3585; abbas et conventus, 3586.

Publico Monte, dioc. Leodien., v. S. Aegidii de.

Pulenhoven, Bulnhoven (*Pielenhofen*), mon. de, dioc. Ratisponen., abbatissa et conventus, 2887, 4356, 4357.

Q

Quiesa, mon. de, dioc. Pisan. abbas, 4141.
Quinchi, *v.* Robertus de.

R

R., card. S. Angeli, *v.* Romanus.
— comes Atrebaten., *v.* Robertus.
— comes Clarimontis, *v.* Robertus.
— comes Drocen. et Montisfortis, *v.* Robertus.
— comes Nivernen., *v.* Robertus.
— dux Burgundiae, *v.* Robertus.
— episcopus Vicentin., *v.* Rainaldus.
— vicecomes Castriduni (*Châteaudun*), 3960.

Radelach, *v.* S. Mariae in Pede Montis Radelach.

Radolfus de Banduk, archidiaconus Middelsexiae, in eccl. S. Pauli Londonien., 4334.

Raimundus, abbas S. Saturnini Tolosan., 4718.
— episcopus Valentin. legatus, 4746, 4748, 4752.
— Aegidii, can. Vicen., 4013, 4016.
— de Bisulduno, archidiaconus Tarantonae, in eccl. Ilerden, 4013, 4016.
— de Penna Forti, ord. Praed., capellanus et poenitenciarius papae, 3198.
— de Vallibus, can. Ilerden., 4013, 4016.

Rainaldus, episcopus Vicentin., nuntius, 4689.
— de Supino, miles, familiaris papae, 4653.

Rainerii Gacti, *v.* Silvester.

Rainerius, frater ord Praed., inquisitor, *v.* Rainerius de Placentia.
— de Montemagno, archipresbiter Lucan., 3923.
— de Papia, episcopus Mainen., 2464.
— de Pisis, magister, rector ducatus Spoletan, notarius papae, 4348, 4358.
— de Placentia, ord. Praed. et fratres, inquisitores in Lombardia et Marchia Ianuen., 2329, 2375, 2376, 2389, 2957, 3095.
— de Viterbio, capellanus papae, rector Patrimonii b. Petri in Tuscia, 2949.

Rainonus, prior conventus Praed. Viterbien., 3868, 3871, 3873.

Raithenhaselach, v. S. Mariae in Reytenhaselac.

Rampelione, *v.* Gerardus de.

Rampnulfus Andreae, magister, can. Engolismen., 2915.

Ratisponen. canonici, *v.* Erbo, Kalholus; decanus, 3806; electus, Sedis Ap. legatus, 2799; episcopus, 4050, 4620; praepositus, 3312, 3907; — *v.* Altach Superiori, Pulenhoven, Pruel, S. Emerammi, S. Georgii Puvinigen., Vallis Speciosae, Viethpac, Waltsaschsen.

Ravennaten. dioc., *v.* S. Mariae in Portu Rav., S. Petri ad Vincula.

Rayfuryae mon., dioc. Eboracen., abbas et conventus, 4073.

Reatin. episcopus, 3093, 4784.

rectores civitatum universi, *v.* reges; rectores ecclesiarum universi, *v.* archiepiscopi ...

Regen. episcopus, 3116.

reges, archiepiscopi, episcopi, electi, abbates, priores, decani, archidiaconi, plebani, archipresbiteri et alii eccl. praelati et eorum vices regentes, ac marchiones, comites, barones, potestates, capitanei, rectores, consules, antiani, consilia, populi, communis, communitates, et universitates, 4549; reges, duces, marchiones, comites, barones necnon potestates, capitanei, rectores, consilia, communitates et universitates caeterique Christifideles, 4530.

Regin. canonici, *v.* Armanus Mantellus, Nicholaus de Cazagatis.

Remen. archiepiscopus et suffraganei, 3184; a., suffr., abbates, priores, decani, archidiaconi et alii eccl. praelati, 2775, 2795; a., suffr., electi, abbates, priores, decani, archidiaconi, praepositi, archipresbiteri et alii eccl. praelati, necnon capitula, conventus et collegia Cisterc. Cluniacen., Praemonstraten., S. Benedicti, S. Augustini, Cartusien., Grandimonten. et aliorum ord., 4256; a., suffr., vicarii et officiales, 2927; canonicus, *v.* Gerardus de Grignelvi; decanus, 2693, 2774.

Renardus de Bari, 3674, 3675.

Renutius (Bonutius?) Senni civis Florentin., 4497, 4498.

Reun, v. Runen.

Reytenhaselac, *v.* S. Mariae in.

Riccardus dictus Anglicus, magister, canonicus Cainonen., dioc. Turonen., 2786, 2796.

Ripacuria, in eccl. Ilerden. archidiaconi de,

Ripacuria, in eccl. Ilerden., archidiaconus de, 3670, 3678.

Rizardus de Ferentino, capellanus papae, 4255.

Robertus, comes Atrebaten., 3960; filia Philippi filii eius, *v.* Margareta.

— comes Clarimonten. (*Clermont*), 3960.

— comes Drocen. (*Dreux*) et Montisfortis (*Montfort-l'Amaury*), 3960.

— comes Nivernen., (*Nevers*), 3960.

— dux Burgundiae, 3960, 4694, 4722.

— primogenitus Caroli (II) regis Siciliae, 4583.

— de Duaco, magister, canonicus Silvanecten., 2455.

— de Quinchi, can. Rothomagen. magister in theologica facultate Parisius constitutus, 2893.

Rochetta, dioc. Arelaten., *v.* S. Mariae de.

Rociaci, *v.* Iohannes comes.

Roda, v. S. Petri de Rosis.

Rofeno, v. Rufena.

Rolandus Gerardutii, can. S. Stephani Florentin., 4387.

— Lupi, canonicus Morinen., 4441.

Roma: cives, *v.* Bernardus filius Hugolini Iacobi de Rubeis senatoris Urbis, Gentilis de filiis Ursi, Landulfus de Columpna; Ursus de filiis Ursi; populus, 4625; senator, *v.* Pandulfus de Sabello; — *v.* S. Pauli de Urbe, S. Petri de Urbe, S. Spiritus in Saxia; — *v.* Romanorum rex.

Romaniola: archiepiscopus et episcopi, 2572, 2573.

Romanorum rex *v.* Albertus.

Romanus, card. S. Angeli, 3804, 3826.

Roncodoveze, *v.* S. Annae de.

Rondo, *errore per* Bondo.

Rosendal, mon. in, dioc. Wormatien., abbas et conventus, 2890.

Roseten. (*Rozoy*) eccl., dioc. Laudunen., decanus, 2767.

Rostandus, magister, subdiaconus et capellanus papae, 2340, 2344, 2724.

Rot (*Rott am Inn*), *v.* S. Mariae de Roth.

Rota (*Rueda*), mon. de, dioc. Cesaraugustan., abbas et conventus, 3841.

Rothomagen. archidiaconi, *v.* Aegidius, Iohannes de Capriaco; archiepiscopus, 2577, 2641, 2820, 3977, 3981, 4039, 4258; archiepiscopus, suffraganei, abbates, priores, praepositi, decani, archidiaconi, et

alii eccl. praelati R. provinciae, 2284, 2805; canonicus, *v.* Robertus Quinchi; — *v.* S. Audoeni.

Rott am Inn, v. Roth.

Roucy, v. Rociaci.

Royston, *v.* Cruceroys.

Rozoy, v. Roseten.

Rubeis, Bernardus filius Hugolini Iacobi de, can. Dolen., 4499; *v. anche* Rubeus.

Rubertus, *v.* Robertus.

Rubeus, Bernardus, can. Cameracen., 4441; *v. anche* Rubeis.

Rueda, v. Rota.

Rufena (*Rofeno*), mon. de, dioc. Aretin., abbas, 4219.

Ruffinus, canonicus Vercellen., rector eccl. S. Petri de Agantico, dioc. Magalonen., 2342.

Rufus, *v.* Petrus dictus.

Ruitenhaselach, *v.* S. Mariae in Reytenhaselac.

Runen., de Run, de Runa (*Reun, Rein*), mon. dioc. Salzeburgen., abbas et conventus, 2666, 2669, 3108, 3153.

Ruthenen. dioc., *v.* S. Africani, S. Amancii.

Ruxorii, dioc. Pisan. abbas, 2583.

S

S., card. S. Caeciliae, *v.* Simon.

— dominus de Nigella (*Nesle*), 3960.

Sabello, *v.* Pandulfus de.

Sabinen. episcopus, *v.* Gerardus.

Salamantin. cantor, 3089; ord. Praedicatorum prior et fratres, 2692.

Salem (*Salem*), mon. de, dioc. Constantien., abbas et conventus, 3893, 4440.

Salmodien., *v.* Psalmodien.

Salpitan. episcopus, 3705.

Salvus, lector conventus Lucan. ord. Praed., 3868, 3871, 3873.

Salzeburgen. archiepiscopus, 2746, 3652, 3691, 4036, 4791, *v.* Conradus, Fridericus; a., episcopi, abbates, ac alii eccl. praelati, 3896; a., e., abb., priores, decani, archidiaconi, praepositi et alii eccl. praelati, 3677; decanus, 2716, 4323; ministeriales et vassalli ecclesiae, 2744; praepositus, 3285; praepositus et capitulum, 2737; — *v.* Admonten., Gosse, Milstaten., Ottingen, Piter, Runen, S. Bartholomaei Frisacen., S. Mariae in Monte

Simernich, S. Mariae in Reytenhaselac, S. Pauli in Lavent, S. Petri, S. Petri de Berthersgaden, S. Virgilii Frisacen., Sewen., Snatzsee.

Sancerre, v. Sacri Caesaris.

Sanctae, Sancti, Sanctorum, *San, St-*:

S. Aegidii prioratus hosp. Ierosolimitan., prior et fratres, 3063.

— de Publico Monte, dioc. Leodien., prior, 4220.

S. Aemiliani de Cuculla (*San Millán de la Cogolla*), abbas etc., 2885.

S. Africani eccl., dioc. Ruthenen., archipresbiter, 4283.

S. Afrodisii, dioc. Biterren., saecularis eccl. abbas, 3982.

S. Agathae terra, rector, *v.* Carolus, comes Andegaviae.

— de Papia, abbatissa et conventus, 2353, 2354.

S. Agnetis de Burgo S. Laurentii de Muscello, priorissa et sorores, 3795.

— Herbipolen. abbatissa et conventus, 4081; a. et sorores, 2598, 2599.

S. Amancii Ruthenen. prior, 3599.

S. Amati Duacen., dioc. Atrebaten., canonicus, *v.* Oddo filius Adenulphi qd. Mathiae dicti de Papa de Anagnia.

S. Ambrosii extra Muros Florentin. abbatissa et conventus, 2983.

S. Andreae (*St Andrews*) episcopus, 3208, 3209, 3213, 3222, 3226, 3237.

— de Congeniis eccl., dioc. Nemausen., Guillermus de Lauro rector, 4218.

— Pistorien. plebanus, 4314.

— Wormacien. decanus et capitulum, 3656.

S. Angeli card., *v.* Romanus.

— de Lombardis (*Sant'Angelo de' Lombardi*), guardianus et fratres ord. Min., 2293.

S. Annae de Roncodoveze de Supramonte priorissa et fratres (!), 3279.

S. Antonii hospitalis, dioc. Viennen. magister et fratres, 3120, 3554, 3900.

S. Apollinaris Florentin. prior, 4387.

S. Apollinaris, *v.* S. Mariae et Apollinaris extra Portam Romanam Mediolanen.

S. Audoeni, S. Odoeni Rothomagen. abbas, 4437, 4442.

S. Audomari, dioc. Morinen., canonicus, *v.* Oddo filius Adenulphi qd. Mathiae dicti de Papa, de Anagnia.

S. Audomari eccl., dioc. Morinen., praepositus, 4040, 4041.

S. Viviani Xanctonen prior, 4728.

S. Willermi, v. S. Guillermi.

Sancto Angelo, Bartholomaeus filius Francisci de, v. Bartholomaeus.

— Amore, Guillermus de, 2698.

— Georgio, v. Werncherus de.

Sandracen. mon., dioc. Nemausen., v. Sendracen.

Saracen., v. Petrus.

Sardiniae et Corsicae regnum: archiepiscopi, episcopi, abbates, priores, decani, archidiaconi, praepositi et alii eccl. praelati, 4742, 4745, 4747; collectores decimae, 4749, 4753; comites, barones, nobiles et populi sive communitates, 4743; v. Aragonia.

Saresbirien. episcopus, decanus et capitulum, 2675.

Saxia, v. S. Spiritus in.

Saxoniae dux, 4684.

Schiren, mon. de, dioc. Frisingen, abbas, 2997; abbas et conventus, 3538.

Schonevelt (Schönfeld), mon. superius, dioc. Augusten., abbatissa et conventus, 2474.

Schönfeld, v. Schonevelt.

Scotiae regnum: archiepiscopi, episcopi et alii eccl. praelati, 3220, 3221; Scotiae, 4337, 4729; episcopi, electi, abbates, priores, decani, archidiaconi etc., 4368; rex, 4640.

Secowen., Secuen. (Seckau), praepositus et capitulum, 3467; praepositus et conventus, 2892, 3154.

Secuen., v. Secowen.

Sedunen. dioc., ord. Praed. inquisitores, 3623.

Segobicen. episcopus, 3052.

Senatoris Papien. mon., conventus, 2833.

Sendracen. (Cendras), Sandracen. mon., dioc. Nemausen., abbas, 2979, 4520.

Senen. archidiaconus, v. Monachus; episcopus, 2437, 4636, 4784; prior et fratres Servorum S. Mariae, 2958; — v. S. Eugenio, S. Iacobi, S. Vigilii.

Senni, Bonutius (Renutius?) civis Florentinus, 4497, 4498.

Senonen. archidiaconus, v. Gerardus de Rampelione; archiepiscopus et suffraganei, 3487; a., s., abbates, priores, decani, archidiaconi, praepositi, archipresbiteri et alii ecclesiarum praelati, 2805; a., s., abb., pr., abbates, praepositi, decani, archidiaconi, et alii eccl. praelati Senonen. provinciae, 2286; canonicus, v. Guil-

lermus de Castro Nantonis; officialis, 4119; — v. Ferrariis, S. Columbae, S. Iuliani.

Septimo, dioc. Florentin., v. S. Salvatoris de.

Sepulchri Dominici Ierosolimitan. eccl., prior et capitulum, 3182; prior et fratres, 3084; domus in Zederas (Zderas), prior et fratres, 4064; — v. Hispania.

Serano, v. Guillermus de.

Servorum S. Marie ord., minister generalis, priores et fratres, 3635; prior gen. et caeteri pr., 2880; priores et fratres, 3195, 3445; v. Senen.

Sewensis mon., dioc. Salzeburgen., abbas, 3569.

Sicilia insula, homines, 4513; — regnum: archiepiscopi, episcopi, etc., 2548, 4725; decima pro negotio Siciliae, 4277; regina, 4259; rex, v. Carolus (I), Carolus (II), Edmundus.

Signin. episcopus, collector decimae in Campania et Maritima ac dioc. Reatin., 4277.

Silvae Canae (Silvacane) mon., dioc. Aquen., abbas et conventus, 4033, 4061, 4062, 4063.

Silvae Maioris mon., dioc. Burdegalen., abbas et conventus, 3493, 3802.

Silvanecten. canonicus, v. Robertus de Duaco officialis, 4229; — v. S. Mauricii.

Silvester Raynerii Gacti, miles de Viterbio, 3949.

Simon, card. S. Caecilie, 3308, 3309, 3310, 3315, 3531, 3576, 3613, 3614, 3806, 3808, 3810, 3815, 3836, 3883, 3939, 3950, 3951.

Sistaricen. episcopus, 3844, 3859, 3860.

Sits, domus de, dioc. Aquilegen., prior et conventus, 2625.

Skeradii, Florentin., v. S. Petri.

Snatzse, eccl. de, dioc. Salzeburgen., decanus, 3597.

Sonneburg, v. S. Mariae in Sunburch.

Spiren. officialis, 4093.

Spital am Pyr, v. S. Mariae in Alpibus.

Spoletan. episcopus, 4090; — ducatus: episcopi, 2572, 2573; rector, v. Rainerius de Pisis.

Steingaden, Stenigaden (Steingaden), mon. in. dioc. Augusten., abbas et conventus, 2946, 4691, 4711.

Stephanus Dominici, canonicus Zamoren., 4103.

Studeniz, v. Fonte Gratiae.

Suessionen. comes, *v.* Iohannes; decanus, 3200; dioc., *v.* S. Cornelii de Compendio, S. Mariae, S. Medardi, S. Petri de Calce.

Sulmona, *v.* S. Spiritus de.

Sunburch, dioc. Brixinen., *v.* S. Mariae in.

Supino, *v.* Rainaldus de.

Supramonte, *v.* S. Annae de Roncodoveze de.

T

Tallio, dioc. Barchinonen., *v.* S. Michaelis de.

Tarantonae, in eccl. Ilerden., archidiaconus, *v.* Raimundus de Bisulduno.

Tarcia, dioc. Aretin., *v.* S. Mariae de.

Tarentin. archiepiscopus, 3239.

Tarrachonen., *v.* Terraconen.

Taurinen. episcopus, *v.* Gaufridus.

Tegernsee, mon. de, dioc. Frisingen. abbas, 4128.

Templi Ierosolimitani militiae magister et fratres, 2358, 2362, 2363, 2374, 2383, 2384, 2396, 2451, 2468, 2556, 2557, 2630, 2631, 2779, 2878, 2990, 3015, 3016, 3094, 3424, 3425, 3505, 3529, 3638, 3683-3685, 3687, 3688, 3721, 3722, 3813, 3839, 3856, 3858; praeceptor et fratres, 3412, 3429, 3898, 3899, 3927, 4104, 4105, 4209, 4651; praeceptores, 3161-3163, 3242-3245, 4768; *v.* Aquitania, Parisien., Provincia; — archiepiscopi et episcopi, in quorum diocesibus eccl. ac domus militiae Templi consistunt, 2420.

Terraconen. archidiaconus, 4581; archiepiscopus, 3602, 3776; a., et suffraganei, 3627; a. s. et praelati, 2421; praecentor, 4680.

Terra Sancta: archiepiscopi, abbates, priores, decani, archidiaconi, ord. Praed. priores, ord. Minorum ministri, custodes, guardiani, etc. ad colligenda subsidia pro T. S. deputati, 3143, 3144, 3146-3151, 3188, 3189, 3247-3249, 3252, 3272, 3326; archiepiscopi, episcopi, ord. Praed. et Min. executores pro subventione T. S., 3187, 3227-3229, 3233,-3235, 3246, 3251, 3253, 3255-3271, 3332-3352, 3407; praedicatores verbi Crucis pro subsidio T. S., 3062, 3127, 3129-3137, 3223-3225, 3230, 3438.

Testa, Bartholomaeus, can. Anagnin., 3567.

Teutonia: ord. Praed. prior provincialis, 4129, 4130; *v.* Alemannia; S. Mariae Theutonicorum.

Theatin. dioc., *v.* S. Spiritus de Maiella; — *v.* Mathias de Theate.

Theobaldus, comes Barri (*Bar-le-Duc*), 3960.

Theodotis Papien., *v.* S. Mariae Theodotis.

Theotonia, *v.* Teutonia.

Thoartii, G. vicecomes, 3960.

Thomas de Paliano, archidiaconus Cameracen., 4698.

Throni (*Thron*) B. Virginis mon., abbatissa et sorores, 2747.

Tiarcia, dioc. Aretin., *v.* S. Mariae de Tarcia.

Tirasonen. decanus, 3013; — *v.* Berola, Calataiuben., Tutelan.

Toletan. archiepiscopus, 3776, 4351.

Tolosan comes, 3395, 3437, 3562, 3659, *v.* Alphonsus; episcopus, 4043; ord. Praed. inquisitores, 2676, 2748, 2754, 3298-3300; — *v.* Fuxen., S. Mariae, S. Mariae de Pontiano, S. Saturnini.

Tornello, *v.* Bondo de.

Tranen. archiepiscopus, 3639, 4799.

Transligeren. (= *oltre la Loira, ma nel testo si legge* Transvigenen.), in ecclesia Turonen., archidiaconus, 2726.

Transvigenen., *v.* Transligeren.

Trebis, *v.* Nicholaus de.

Trecen. officialis, 2341; — *v.* S. Lupi.

Treveren. archiepiscopus, 4710; a., suffraganei, abbates, priores, decani, archidiaconi, praepositi, archipresbiteri et alii eccl. praelati, 2809; capitulum, 2952, 2955; scholasticus, *v.* Laurentius; — *v.* Claustro, Hymmenrode, S. Castoris Cardonen., S. Eucherii, S. Matthiae extra Muros, S. Simeonis.

Tuckelhusen., eccl. de, dioc. Herbipolen., praepositus, 3649.

Tudertin. dioc., *v.* S. Francisci, S. Mariae Montis Sancti.

Tullensis cancellarius, 3090; episcopus et caeteri praelati, 3171, 3172, 3367; ord. Praed. inquisitores, 3623; episcopus, abbates, priores, decani, archidiaconi, priores Praedicatorum, ministri, custodes, seu guardiani Minorum, 3188, 3189, 3247, 3252; — *v.* S. Gengulfi.

Tulna, *v.* S. Crucis in.

Tuningo, Guillermus de, ord. Praed., 3653.

Turonen. archiepiscopus, 2577, 2641, 3980; a., suffraganei, abbates, priores, decani,

rum, ministri, custodes seu guardiani Minorum, 3188, 3189, 3247, 3252; ord. Praed. inquisitores, 3623.

Virginis (Beatae), *v.* S. Mariae.

Virzeliaco, *v.* Henricus de.

Viterbien. archipresbiter, 4044, 4501; episcopus, collector decimae, 4724; ord. Praed. prior., *v.* Rainonus; — *v.* Rainerius de Viterbio, Silvester Rainerii Gacti miles de Viterbio; — *v.* S. Mariae ad Gradus, S. Sixti.

Vivarien. episcopus, 4623, 4624; — *v.* S. Michaelis de Carasio.

Vivario, in eccl. Mindonen., archidiaconus de, 3580.

Vormbach, dioc. Patavien., *v.* S. Mariae de.

Vultembach (*Fultenbach*), mon. de, dioc. Augusten., abbas et conventus, 4072.

Vulterran. commune, 3901; electus, 2973; populus, civitas et dioc., 4720; potestas, consilium et commune, 4558; — *v.* Casulis, Pini de Càsale, S. Galgani, S. Geminiani, S. Michaelis de Unci.

Vulturarien. episcopus, 4443.

Vulvingus, episcopus Bambergen., 4665, 4790.

Weihenstephan, *v.* S. Stephani in Wihenstenen.

Werdea, mon. in, dioc. Augusten., abbas, 4761.

Werncherus de Sancto Georgio, presbiter, rector eccl. de Piter, dioc. Salzeburgen., 3290.

Westmonasterii (*Westminster*), dioc. Londonien., abbas, 3711.

Wigornen. (*Worcester*), episcopus, *v.* Walterus; Iohannes de Cauter O.F.M., 2378.

Wihenstenen, *v.* S. Stephani in.

Willermus, *v.* Guillermus.

Wiltinen. (*Wilten*), dioc. Brixinen., abbas, 4394, 4395, 4396; abbas et fratres, 2947.

Wintonien. dioc., *v.* S. Nicholai de Midalton.

Wlodislaus, capellanus papae, praepositus eccl. Wissegraden., filius qd. Henrici ducis Slosiae, dioc. Pragen., 3073.

— electus Salzeburgen., 3541, 3542.

Worcester, *v.* Wigornien.

Wormatien. dioc., *v.* Rosendal, S. Andreae.

Wremuç, dioc. Aquilegen., *v.* S. Mariae in.

Wulteran., *v.* Vulterran.

Wulturarien., *v.* Vulturarien.

Wulvingus, *v.* Vulvingus.

W

W., electus Salzeburgen., *v.* Wlodislaus.

Waldsassen, *v.* Waltsaschsen.

Wallia: archiepiscopi, episcopi ac caeteri praelati, 3218, 3219; princeps, *v.* Lewellinus; — *v.* Aberconeway.

Walterus, episcopus Wigornien., 3205, 3212.

Waltham (*Waltham*), dioc. Londonien., abbas de, 3711.

Waltsaschsen (*Waldsassen*), mon. de, dioc. Ratisponen., abbas et conventus, 4235, 4507.

Wastinen. archidiaconus, 4113-4115.

Waterberche (*Waterbeach*), *v.* Pietatis S. Mariae de.

X

Xanctonen., dioc., *v.* S. Viviani.

Y *vedi* I

Z

Zamoren, canonici, *v.* Garsia Petri, Stephanus Dominici; cantor, 2647, 2648; decanus, 2647, 2648.

Zederaz (*Zderas*), dioc. Pragen., domus Sepulchri Dominici, prior et fratres, 4064.

Zena, *v.* Guido de.

CONCORDANZA

TRA I *REGESTA* DEL POTTHAST E LO SCHEDARIO

Nella presente concordanza sono riportati i numeri dei *Regesta* del Potthast ai quali corrispondono — secondo l'accertamento compiuto dal B. — i documenti descritti nello Schedario. Quando l'attribuzione è rimasta incerta, il numero dello Schedario è seguito da un punto interrogativo; i numeri tra parentesi indicano documenti diretti ad un destinatario diverso da quello menzionato dal Potthast.

I riferimenti al Potthast per altro motivo (per es., per confronto) non sono qui riportati.

POTTHAST	SCHEDARIO	POTTHAST	SCHEDARIO	POTTHAST	SCHEDARIO
15602	2271	15824	2329	16129	(2437)
»	2272	15831	2336	16131	2440
»	2273	15863	2344	16132	2441
15612	2275	15874	2345	16134	2438
15633	2277	15892	2346	16137	2443
*15635	2278	15906	2352	16138	2444
15646	2287	15927	2364	16139	2442
»	2288	15930	2366	*16198	2451
15647	2289	»	2368	16203	2584
15651	2290	»	2369		(*data errata*)
15655	2292	15940	2373	16215	2454
15657	2293	15948	2376	16229	2462
15661	2294	15952	2377	16233	2463
15668	2295	15959	2378	16236	2464
»	2297	*15986	2389	16261	2470
15669	2296	15995	2390	16271	2472
15677	2298	16007	2393	»	2473
15678	2299	»	2304	16284	2475
*15685	2300	16018	2403	16286	2476
15691	2302	16030	2409	16313	2488
15692	2303	*16038	2410	16316	2490
15693	2301	16053	2412	16320	2491
15699	2304	16063	2413	»	2494
»	2305	16071	2414	16321	2493
*15707	2307	16104	2423	16324	2492
15753	2311	»	2424	16338	2497
*15765	2313	»	2427	16359	2503
15790	2318	16105	2426	16360	2500
»	2320	16115	2429	16361	2502
15801	2324	16118	2430	16362	2504
15802	2323	16121	2431	16365	2499
15811	2325	»	2432	16366	2501
15814	2328	16122	2435	16371	2506
15822	2331	16123	2434	16378	2508
»	2332	16124	2433	16395	2515

POTTHAST	SCHEDARIO	POTTHAST	SCHEDARIO	POTTHAST	SCHEDARIO
16398	2517	16767	2620	17055	2727
16418	2525	»	2652?	17056	2725
16422	2526	16770	2621	17058	2728
16424	2527	16785	2627	17060	2729
16426	(2529)	»	2629	17064	2730
16428	2531	16797	2633	17069	2733
16435	2532	»	2634	17072	2734
16436	2533	16804	2636	17077	2736
»	2534	»	2637	17092	2741
16438	2535	»	2638	17096	2743
16445	2537	16808	2640	»	2744
»	2538	»	2641	17102	2748
*16451	2539	»	2643	*17104	2749
16453	2540	16809	2642	17105	2750
*16457	2541	»	2644	17107	2751
16458	2542	16832	2650	17112	2754
16466	2544	16837	2653	17117	2756
16470	2543	16838	2654	17125	2757
16480	2545	16842	2659	17135	2758
16489	2546	»	2660	17163	2763
»	2547	16847	2662	17171	2765
»	2548	»	2663	17172	2766
16511	2552	*16851	2664	17188	2769
16531	2555	*16863	2665	17191	2770
16534	2558	16870	2670	17194	2772
16555	2561	16874	2671	17202	2773
»	2562	»	2673	17216	2776
16565	2568	16899	2679	»	2777
16566	2569	»	2680	17226	2780
*16567	2570	16900	2681	17233	2781
16583	2572	16901	2683	17236	2783
»	2573	16914	2685	17237	2784
16585	2575	16915	2688	17240	2782
16586	2576	16916	2686	17245	2785
16589	2578	»	2687	17260	2788
16590	2577	16924	2690	17269	2791
16611	2581	16933	2691	17287	2793
16624	2583	16954	2695	17288	2794
16657	2590	»	2696	17291	2797
16665	2591	16972	2699	17302	2799
16667	2593	16977	2698	17310	2801
16680	2596	16978	2700	17311	2802
16698	2597	16987	2701	17316	2807
16720	2609	16993	2702	17320	2812
16721	2604	17005	2711	17321	2811
»	2606	17009	2713	17327	2814
»	2608	»	2714	17352	2806
16722	2605	»	2715	17356	2816
»	2607	17010	2718	17376	2827
16723	2610	17022	2721	17379	2828
16724	2611	17029	2722	17420	2834
16757	2618	17030	2723	17426	2855
16767	2619	17035	2724	17449	2867

POTTHAST	SCHEDARIO	POTTHAST	SCHEDARIO	POTTHAST	SCHEDARIO
17452	2868	18186	2996	18712	3234
17497	2874	18189	2997	»	3235
17506	2875	18190	2998	18715	3236
17517	2876	18194	2999	18779	3240
17526	2879	18196	3002	»	3241
17528	2880	18213	3006	18788	3249
17536	2882	18215	3004	»	3250
17539	2883	18216	3003	18789	3248
17554	2885	18219	3009	»	3272
17575	2890	»	3010	18801	3274
17620	2893	18223	3014	18810	3277
	(*data errata*)	18237	3021	18907	3285
*17653	2903	18256	3027	18943	3288
17676	2904	»	3033	18955	3289
»	2905	*18256ᵃ	3029	18987	3294
17679	2906	18261	3034	19080	3311
17721	2912	18278	3025	19093	3312
17751	2918	18284	3039	19095	3313
17761	2919	18311	3046	19102	3316
17790	2921	18318	3056	19113	3318
17802	2923	*18325	3055	»	3319
17835	2928	18330	3064	»	3320
17845	2930	»	3065	»	3321
17846	2931	18335	3067	»	3322
17847	2933	18357	3079	»	3323
17867	2937	18377	3093	»	3324
17868	2938	18383	3095	»	3357
17871	2939	18424	3106	19115	3366
17909	2947	18457	3112	»	3372
17911	2949	»	3113	»	3373
17950	2953	18461	3110	19120	3384
17951	2954	*18464	3111	19126	3386
17966	2956	*18471	3117	»	3387
17977	2957	»	3118	»	3388
17980	2958	*18479	3119	19134	3399
17984	2959	18488	3121	19137	3400
17994	2963	18503	3139	»	3401
17995	2964	18506	3140	19144	3405
17996	2965	18507	3141	19165	3432
17997	2966	18510	3143	19167	3433
18002	2968	»	3144	19175	3439
»	2970	»	3146	»	3440
18026	2971	»	3147	»	3441
18051	2972	»	3148	»	3442
18052	2973	»	3149	»	3443
18073	2974	»	3150	19179	3444
*18088	2975	18513	3153	19184	3445
18089	2976	*18514	3152	19209	3458
18090	2977	18517	3154	»	3460
18148	2984	18597	3195	»	3464
18155	2985	*18706	3231	19209*	3456
18156	2986	*18707	3232	19210	3459
18180	2992	18712	3233	»	3461

POTTHAST	SCHEDARIO	POTTHAST	SCHEDARIO	POTTHAST	SCHEDARIO
19210	3462	19948	3595	20675	3739
»	3463	19966	3597	*20679	3744
»	3466	19996	3604	20682	3745
19216	3471	»	3605	*20683	3746
»	3472	»	3606	20705	3764
»	3473	»	3607	20712	3768
»	3474	»	3608	20718	3794
»	3475	»	3609	20719	3771
19222	3484	»	3610	20720	3772
19225	3485	»	3611	20731 (*per errore* 21731)	
19233	3486	»	3612		3781
19235	3489	»	3613	20737	3784
»	3490	20060	3622	20798	3793
»	3491	*20064	3623	20800	3795
»	3492	20069	3624	20816	3797
19255	3497	20080	3626	20826	3799
19280	3498	20081	3628	20828	3800
19338	3517	20082	3627	20876	3804
19339	3514	20095	3630	20903	3809
19340	3518	20186	3643	20905	3811
19341	3516	20193	3644	20940	3815
19342	3513	20197	3639	20946	3816
19343	3515	»	3645	21007	3824
19382	3522	20229	3646	21013	3825
19398	3523	20246	3647	21014	3826
»	3524	20252	3648	21020	3827
»	3525	20291	3650	»	3828
»	3526	20331	3653	21052	3832
19399	3527	20333	3651	21139	3870
19406	3528	20355	3654	21159	3854
19430	3531	20364	3655	21161	3857
19436	3533	20372	3658	*21163	3861
19454	3534	20398	3660	21173	3863
19455	3535	20408	3661	21184	3869
»	3536	»	3662	21201	3875
19460	3538	20463	3668	21203	3878
19467	3539	20464	3667	21204	3879
19477	3543	20525	(3677)	*21216	3885
19522	3546	20558	3687	*21223	3889
19539	3553	20594	3706	21263	3897
19559	3555	20605	3708	21264	(3896)
19585	5358	20608	3709	21358	3909
19609	3560	20615	3711	21373	3911
19632	3563	20617	3712	21374	3910
»	3564	20619	3714	21392	3913
19638	3565	20621	3715	21401	3916
»	3566	20635	3717	21410	3923
19645	3567	20643	3720	21450	3940
19685	3572	*20649-51	3730?	»	3946
19776	3577	20664	3736	21484	3956
19821	3579	20665	3734	»	3957
*19856	3581	»	3735	*21513-21	3966?
19935	3594	*20673	3738	»	3964?

POTTHAST	SCHEDARIO	POTTHAST	SCHEDARIO	POTTHAST	SCHEDARIU
*21513-21	3965?	22353	4127	23262	4304
*21551	3970	*22356	4128	23264	4303
21585	3976	22372	4135	23324	4309
21630	3979	»	4136	23399	4317
21731 (errore), v. 20731		22375	4139	»	4318
21744	3990	22393	4142	23404	4319
*21767	3995	22419	4147	23481	4322
21795	4003	22420	4146	*23488	4323
21798	4007	»	4149	23576	4326
*21798	3998	»	4150	»	4327
21825	(4014)	22421	4151	23604	4329
21842	4021	22422	4167	23606	4332
21844	4022	22423	4168	»	4336
21848	4023	22427	4174	23607	4331
21865	4026	22430	4175	»	4338
»	4027	*22443	4180	23608	4337
21866	4024	*22443*	4181	23610	4330
»	4025	22481	4186	»	4335
21875	4028	22533	4193	23611	4334
21876	4029	22534	4194	23612	4368
21886	4057	22535	4195	23613*	4333
21894	4030	22548	4200	23631	4339
21911	4032	22596	4204	23649	4341
21947	4047	22688	4213	23664	4342
21976	4051	22707	4216	*23673	4343
21998	4055	22758	4222	*23690	4345
»	4056	»	4223	23720	4348
*22030	4064	»	4224	23738	4350
*22071	4072	»	4228	23756	4354
22093	4077?	22759	4225	23760-61	(4353)
22094	4077?	»	4226	23795	4360
22099 (errore), v. 23099		»	4227	23874	4365
22112	4080	*22780	4235	»	4366
22131	4082	22795	4236	23951	4369
»	4083	22834	4242	*23956	4371
»	4084	22866	4246	23957	4372
»	4085	*22875	4248	*23968	4388
22143	4089	22893	4249	23973	4390
22230	4096	*22920	4252	23976	4391
22231	4097	22990	4261	*23978	4393
22274	4099	23010	4264	23986	4398
22277	4101	23049	4265	23989	4399
22287	4106	23099 (per errore 22099)		23992	4400
»	4108		4271	24002	4409
22290	4109	23118	4273	*24008	4412
22291	4110	23133	4274	24016	4416
22299	4111	»	4275	24027	4424
»	4112	23137	4276	24042	4427
22333	4116	23206	4282	24066	4434
22352	4123	23212	4284	24070	4436
»	4124	23225	4286	24071	4438
»	4126	23227ª	4285	24072	4439
22353	4125	23262	4302	24102	4442

POTTHAST	SCHEDARIO		POTTHAST	SCHEDARIO		POTTHAST	SCHEDARIO
24106	4447		24545	4613		24959	4686
24108	4456		24546	4610		24974	4690
»	4457		*24546ª	4611		25015	4697
24112	4463		»	4612		25018	4701
»	4464		24563	4620		25024	4704
24117	4467		24566	4622		25025	4703
24118	4473		24578	4625		25030	4706
24120	4474		24580	4626		25036	4710
*24125	4480		24599	4627		25069	4715
24144	4489		24665	4636		25079	4719
24221	4502		*24694	4639		25114	4721
*24223	4505		24696	4640		25170	4729
24238	4508		24707	4641		25171	4730
24252	4513		24711	4642		25200	4734
24254	4514		24713	4643		25224	4738
24256	4512		24714	4645		25229	4741
24263	4523		»	4646		25230	4739
24270	4525		24737	4649		25269	4754
*24284	4531		*24747	4650		»	4755
24291	4533		24754	4656		»	4756
»	4534		24755	4657		25275	4757
»	4535		26767	4659		25284	4759
24298	4538		»	4660		25320	4763
24344	4543		24770	4661		25324	4764
»	4544		24801	4663		*25352	4765
»	4545		24803	4662		»	4766
24346	4546		*24810	4664		»	4767
24432	4563		*24826	4666		25365	4772
24460	4569		24826	4669?		»	4773
24473	4579		24827	4667		25370	4774
*24488ᵇ	4585		»	4668		25376	4776
*24488ᶜ	4584		*24829-31	4669?		25379	4777
24498	4591		24853	4670		»	4778
24501	4594		24869	4671		»	4779
»	4595		24878	4672		25387	4782
24502	4596		24879	4673		»	4783
24513	4602		24886	4674		»	4784
»	4603		24913	4675		25396	4785
24519	4607		24937	4681		25403	4787
»	4608		24953	4684		*25422	4790
			24958	4687		26616	4285

EMENDANDA

Vol. I

Pag. XXXIV, lin. 28: SB 6393 *correggi*: SB 6397.

» XLVII, col. 1, lin. 27: Werhinstephan » Weihenstephan.

Vol. II

Pag. 82, n. 2584: 1256, decembris 21 *correggi*: 1256, ian. 21.

» 96, n. 2636: « Exultatione... » » « Exultante... ».

» 161, n. 2893: 1259, maii 25 » 1257, maii 23 (P. 17620).

» 400, n. 3781: P. 21731 » P. 20731.

» 540, n. 4271: P. 22099 » P. 23099.

» 557, n. 4332: *porta qui il n. 4368, che è fuori ordine.*

» 576, n. 4398: « Fungentur... » *correggi*: « Fungentes... ».

» 607, n. 4517: « Sincera caritas est » » « Sincera caritas et ».

» 649, n. 4669: 1299, iunii 4 » 1299, iunii 3.

LA RIPRODUZIONE ANASTATICA È STATA ESEGUITA

NEI LABORATORI DELLA « MULTI GRAFICA »

E LA STAMPA DALLA « TIPOGRAFIA DELLA PACE »

IN ROMA